THE BEST OF
BRITAIN &
IRELAND
FROM THE AIR

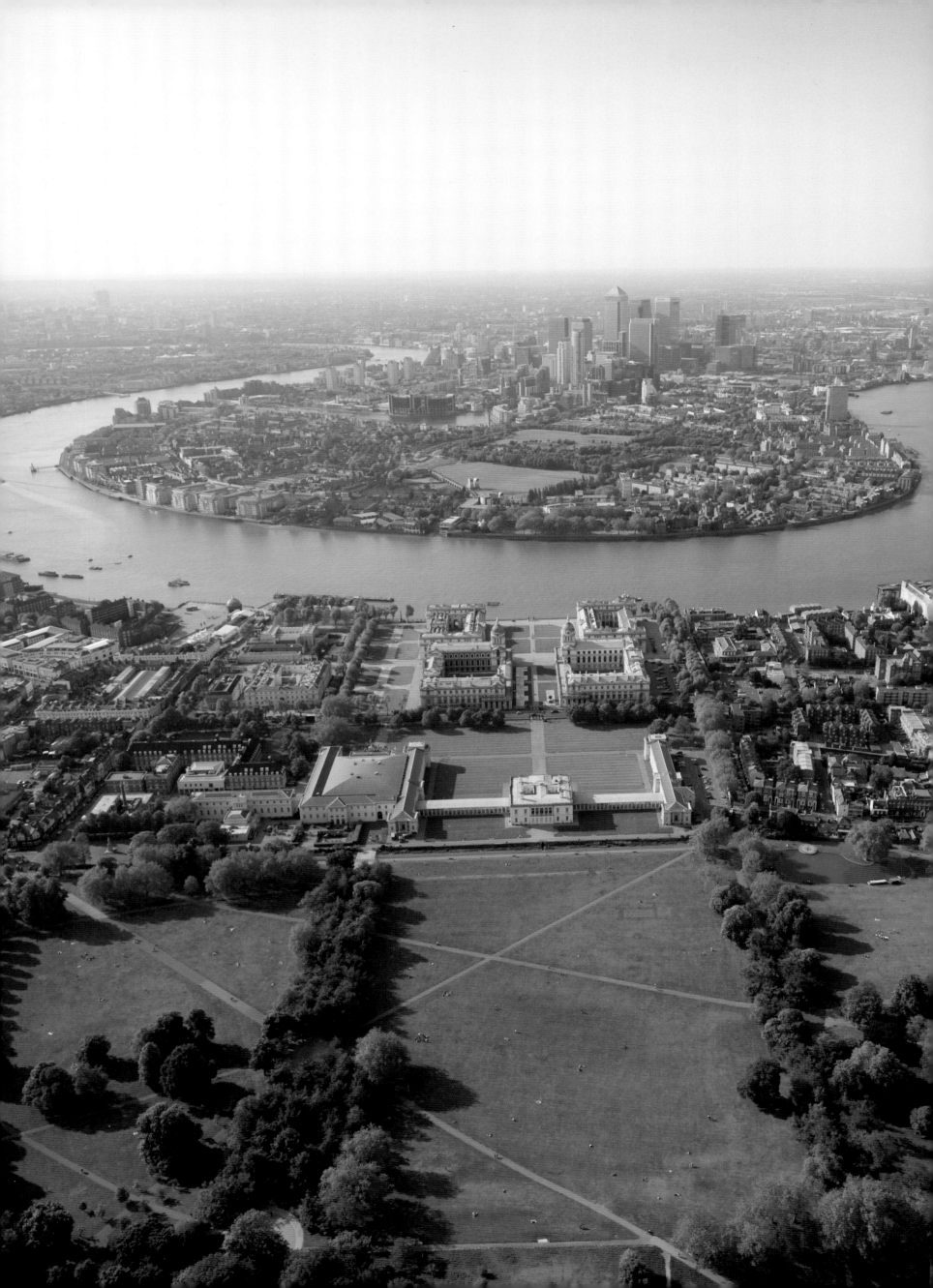

THE BEST OF
BRITAIN &
IRELAND
FROM THE AIR

PUBLISHED BY THE READER'S DIGEST ASSOCIATION, INC.
LONDON SYDNEY NEW YORK MONTREAL

Contents

Guide to Mapping

Great Britain & Ireland at 1:1,000,000

This series of maps covers Great Britain and Ireland at a scale of 1:1,000,000 and is designed to be viewed alongside the like-for-like satellite images of the same areas that appear between pages 20 and 49. Together they offer a broad overview of the landscape and topography of both countries, along with the main water resources, large conurbations and important towns. The layout of the primary transport routes is also clearly illustrated.

The vivid satellite images provide a unique opportunity to make a direct comparison between the two views of Great Britain and Ireland, with each complementing and enhancing the other.

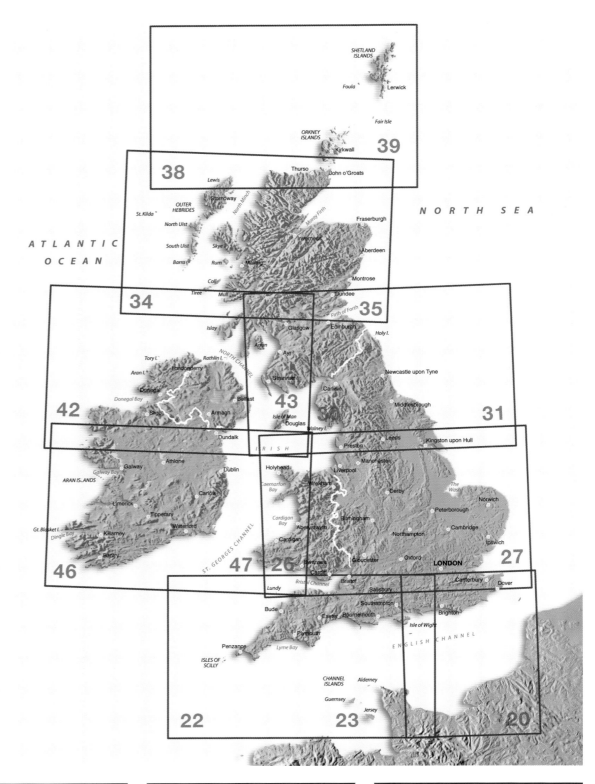

1:1,000,000

| 0 | 10 | 20 | 30 | 40 | 50 miles |
| 0 | 10 | 20 | 30 | 40 | 50 km |

Communications

———— Motorway and Major Road

- - - - Motorway/Major Road (under construction)

———— Important Main Road

- - - - Important Main Road (under construction)

———— Main Road

- - - - Main Road (under construction)

———— Secondary Road

- - - - Secondary Road (under construction)

———— Railway

———— Freight Railway

Places of Interest

✈ International Airport

✈ Regional Airport

≍ Pass

779 Summit Height (metres)

Other Information

//////// International Boundary

/////// County Boundary

Forest

Marshland

Great Britain & Ireland at 1:600,000

These more detailed maps, covering Great Britain and Ireland at a scale of 1:600,000, introduce each regional section between pages 52 and 241. Each of these maps shows the network of roads, both major and minor, that connect with the main transport arteries. They also show the distribution of smaller towns and villages, all of which are listed for reference in the Cartographic index at the end of the book, which provides a detailed index of place names.

Every regional section of the book opens with one of these regional maps, on each of which blue boxes identify the location of the aerial images in the feature pages that follow. Special features of interest are marked on the aerial images with numbers and each is described on the facing page.

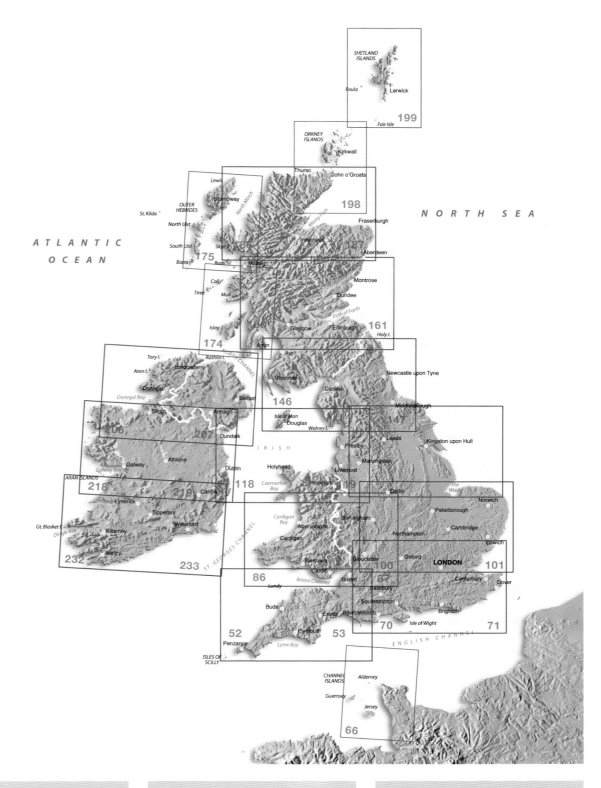

1:600,000

Communications

▬▬▬	Motorway	
▬ ▬	Motorway (under construction)	
▬▬▬	Dual Carriageway and Major Road	
▬ ▬ ▬	Dual Carriageway/Major Road (under construction)	
▬▬▬	Important Main Road	
▪ ▬ ▬	Important Main Road (under construction)	
▬▬▬	Main Road	
▪ ▬ ▬	Main Road (under construction)	
▬▬▬	Trunk Road	
▬ ▬ ▬	Trunk Road (under construction)	

Secondary Road	
Secondary Road (under construction)	
Minor Road	
Minor Road (under construction)	
Car Ferry	
Railway	
Freight Railway	
✈ International Airport	
✈ Regional Airport	

Places of Interest

🏰 Windsor Castle	Castle of Interest
✝ Muckross Friary	Church of Interest
✱ Stonehenge	Historic Site of Interest
✳ Cliffs of Moher	Natural Site of Interest
National Park	
Military Range	
⤬	Pass
779	Summit Height (metres)

Other Information

International Boundary	
County Boundary	
Forest	
Marshland	

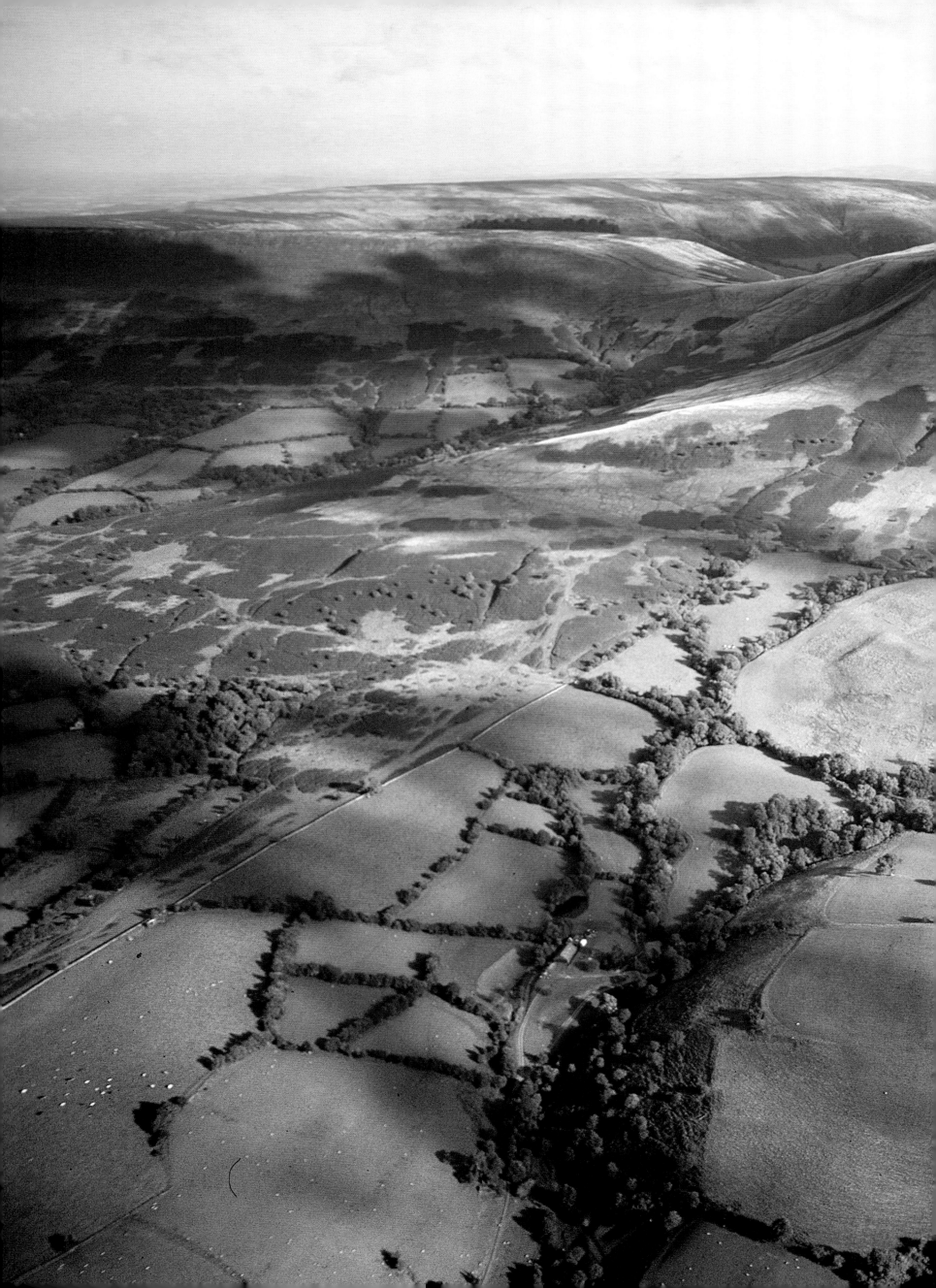

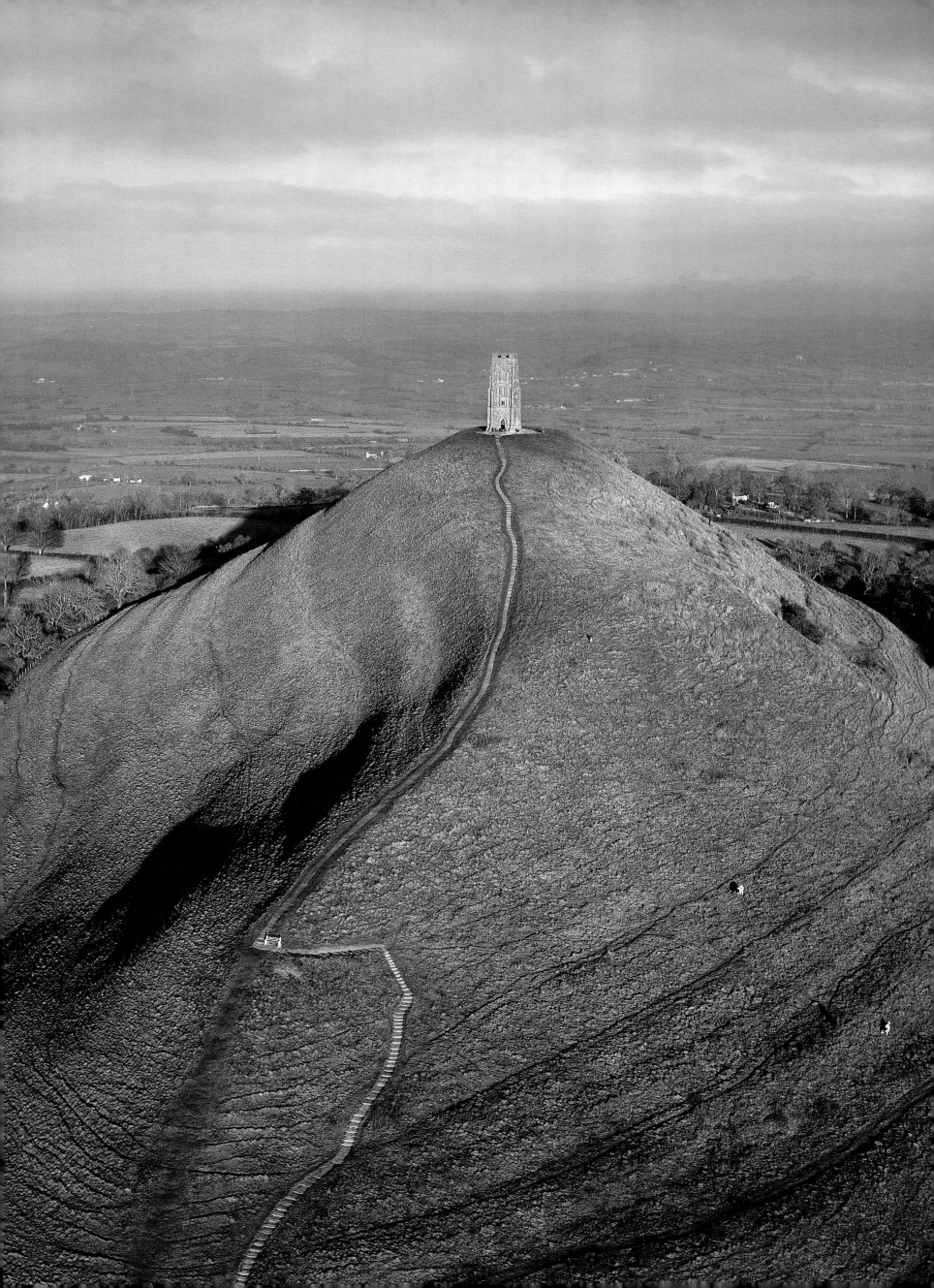

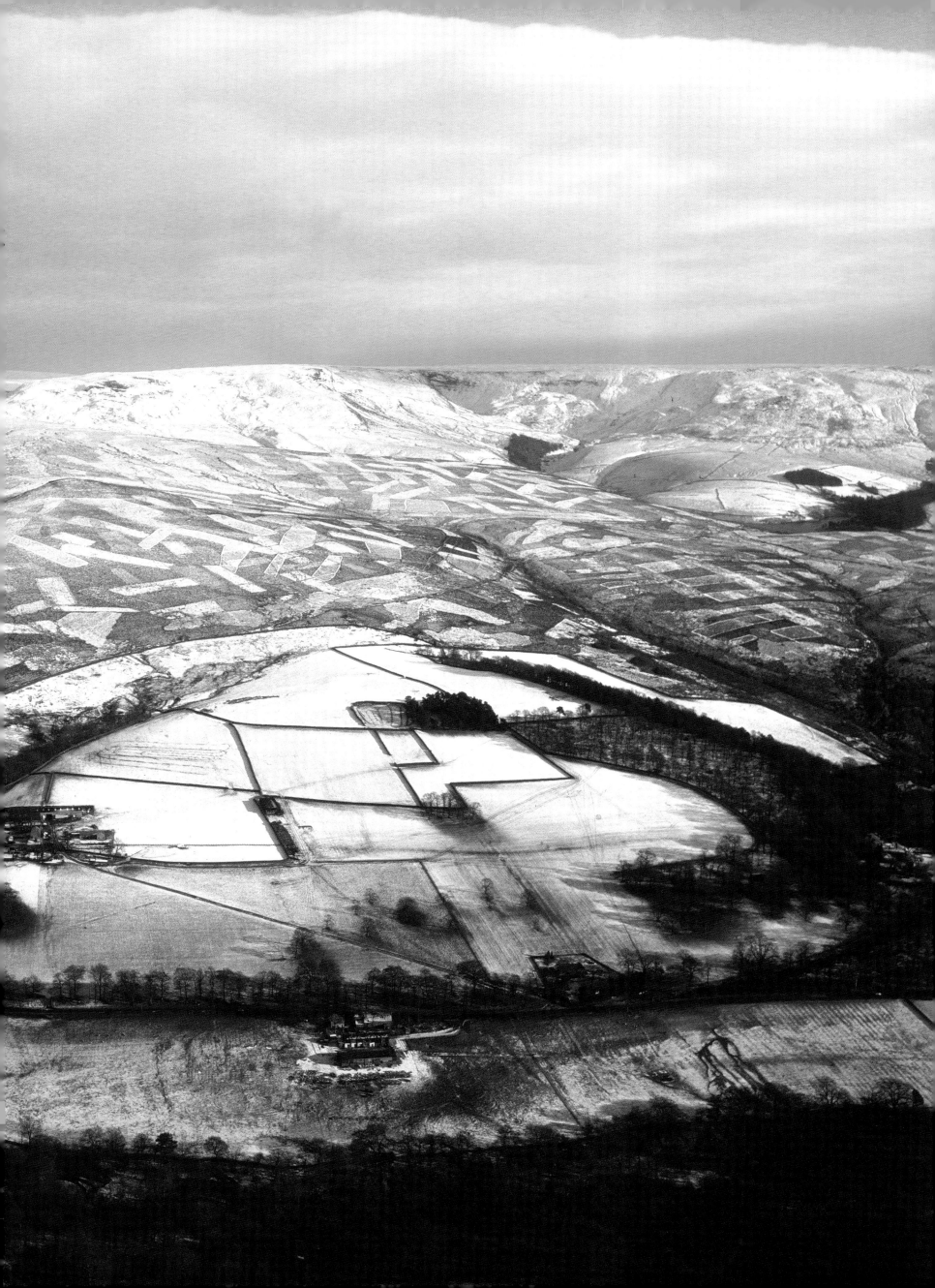

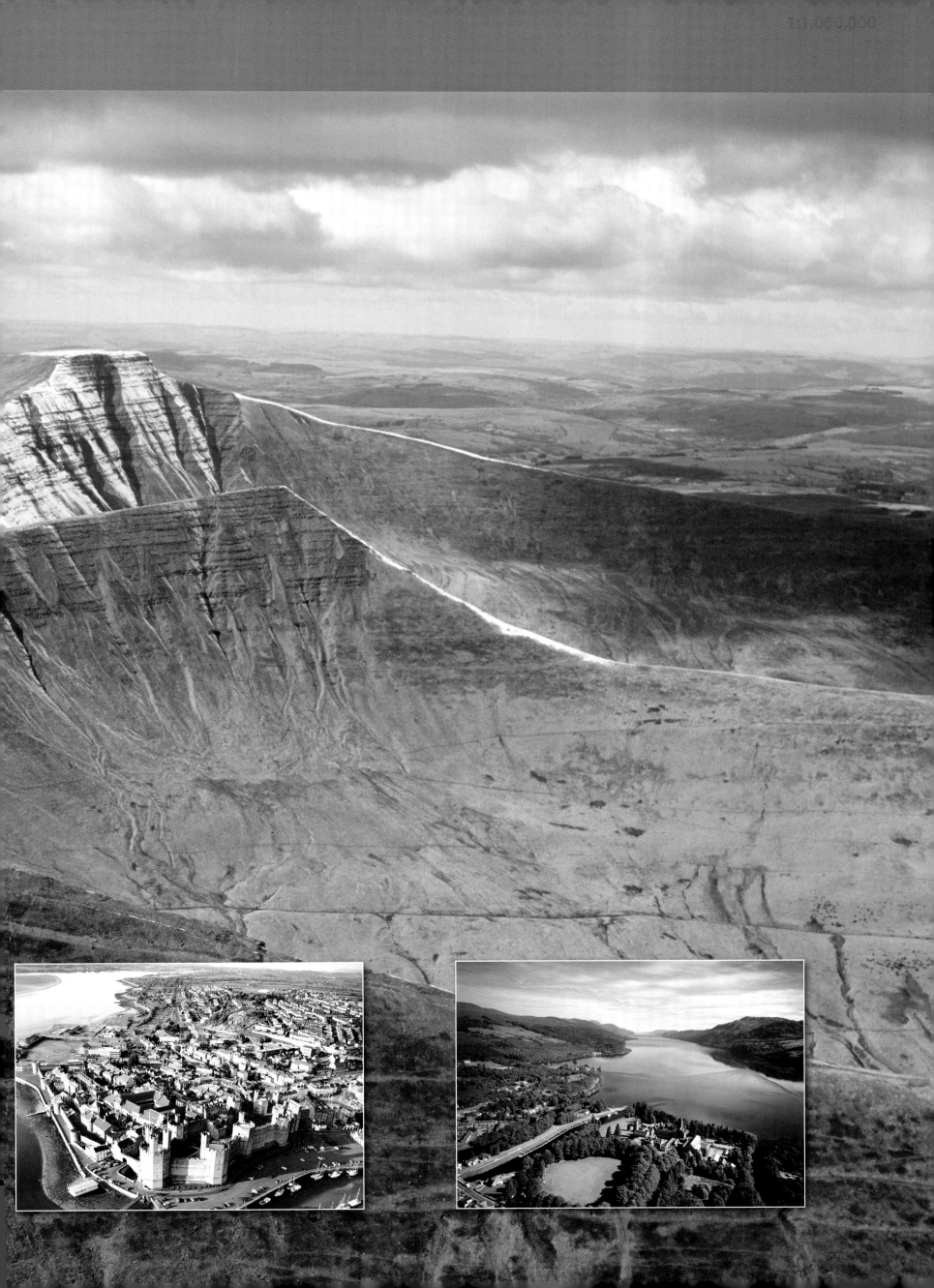

1:1,000,000

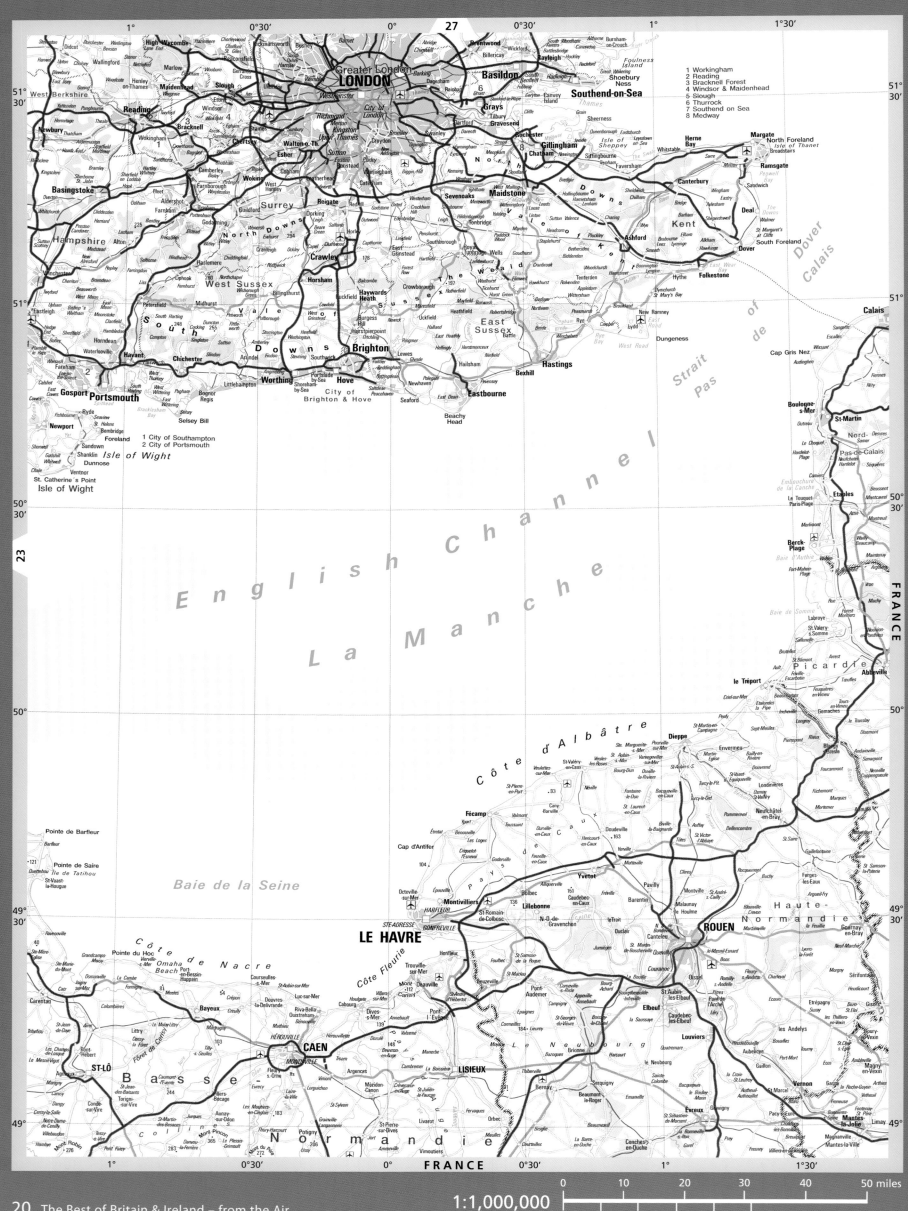

1 Workingham
2 Reading
3 Bracknell Forest
4 Windsor & Maidenhead
5 Slough
6 Thurrock
7 Southend on Sea
8 Medway

1 City of Southampton
2 City of Portsmouth

1 City of Southampton
2 City of Portsmouth

1:1,000,000

0	10	20	30	40	50 miles
0	10	20	30	40	50 km

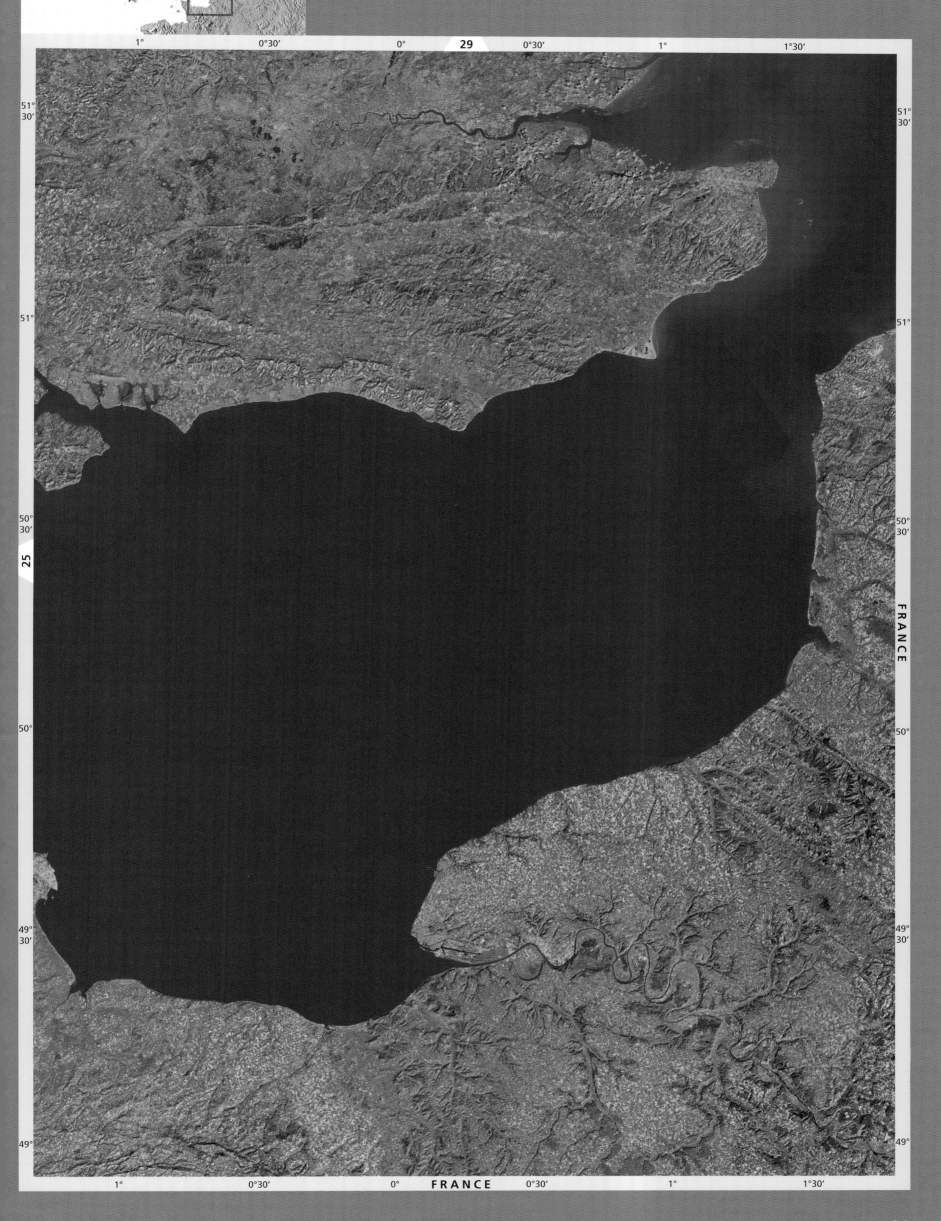

SOUTH-WEST ENGLAND

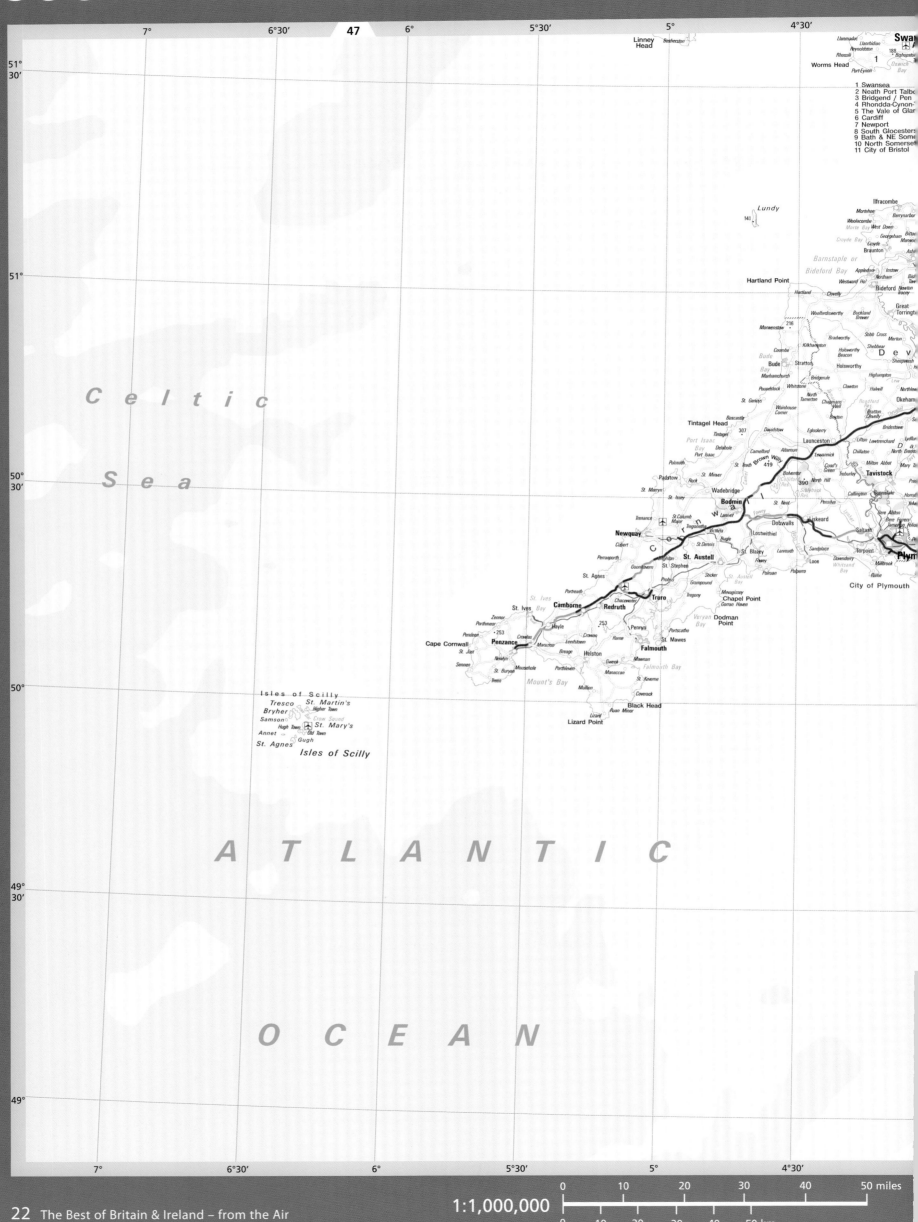

Celtic Sea

ATLANTIC

OCEAN

Lundy

Isles of Scilly
Tresco St. Martin's
Bryher Higher Town
Samson
Annet Hugh Town Old Town
Gugh
St. Agnes
St. Mary's
Isles of Scilly

Linney Head

Worms Head

1 Swansea
2 Neath Port Talbot
3 Bridgend / Pen
4 Rhondda-Cynon-
5 The Vale of Glam
6 Cardiff
7 Newport
8 South Glocesters
9 Bath & NE Some
10 North Somerset
11 City of Bristol

Ilfracombe
Mortehoe Berrynar
Woolacombe
Morte Bay West Down
Georgeham
Croyde Bay Croyde Marwo
Braunton
Barnstaple or Appledore Instow
Bideford Bay Northam Bio
Hartland Point Bideford Newton
Hartland Clovelly Great
Torringt
Woolfardisworthy Buckland
Brewer
Morwenstow Bradworthy Shbb Cross
Holsworthy Shebbear
Beacon
Bude Holsworthy
Bay Stratton Highampton
Marhamchurch Bridgerule
Poughill Whitstone North Chapmans Northlew
Tamerton Well
St. Gennys Roadford Okeham
Boscastle Res
Tintagel Head Davidstow Eggloskerry Lifton Lewtrenchard
Tintagel 307 Altarnun Coad's Treburley
Port Isaac Delabole Camelford Green North Hill Milton Abbot
Bay Port Isaac Brown Willy Trewannick
Polzeath 419 Bokenver St. Neot Callington
Padstow St. Minver 390 Pensilva
Rock Sibleyback
St. Merryn Res
Wadebridge Bodmin
Trenance St. Columb Victoria Lanivet Dobwalls Liskeard
Newquay Major Bugle St. Neot
Crantock St. Dennis Lostwithiel
Perranporth Goonhavern St. Austell St. Blazey Lanreath Looe
St. Agnes St. Stephen Fowey Downderry
Probus Sticker St. Austell Pelynt Whitsand
Portreath 253 Bay
St. Ives Grampound Tregony
Bay Chacewater Truro Mevagissey Chapel Point
Camborne Redruth Gorran Haven
St. Ives Penryn Veryan Dodman
Zennor Hayle Portscatho Bay Point
Porthmeor 253 Penryn St. Mawes
Pendeen Crowas Leedstown Falmouth
Cape Cornwall Maracion Breage Helston Mawnan
St. Just Penzance Gweek Manaccan
Newlyn Mousehole Porthleven Falmouth
Sennen Breage Multon Bay
Treen Breage St. Keverne
Mount's Bay Coverack
Black Head
Lizard Ruan Minor
Lizard Point

City of Plymouth

Swa

Dev

D

Tavistock

Plym

141

188

1

1:1,000,000

| 0 | 10 | 20 | 30 | 40 | 50 miles |

| 0 | 10 | 20 | 30 | 40 | 50 km |

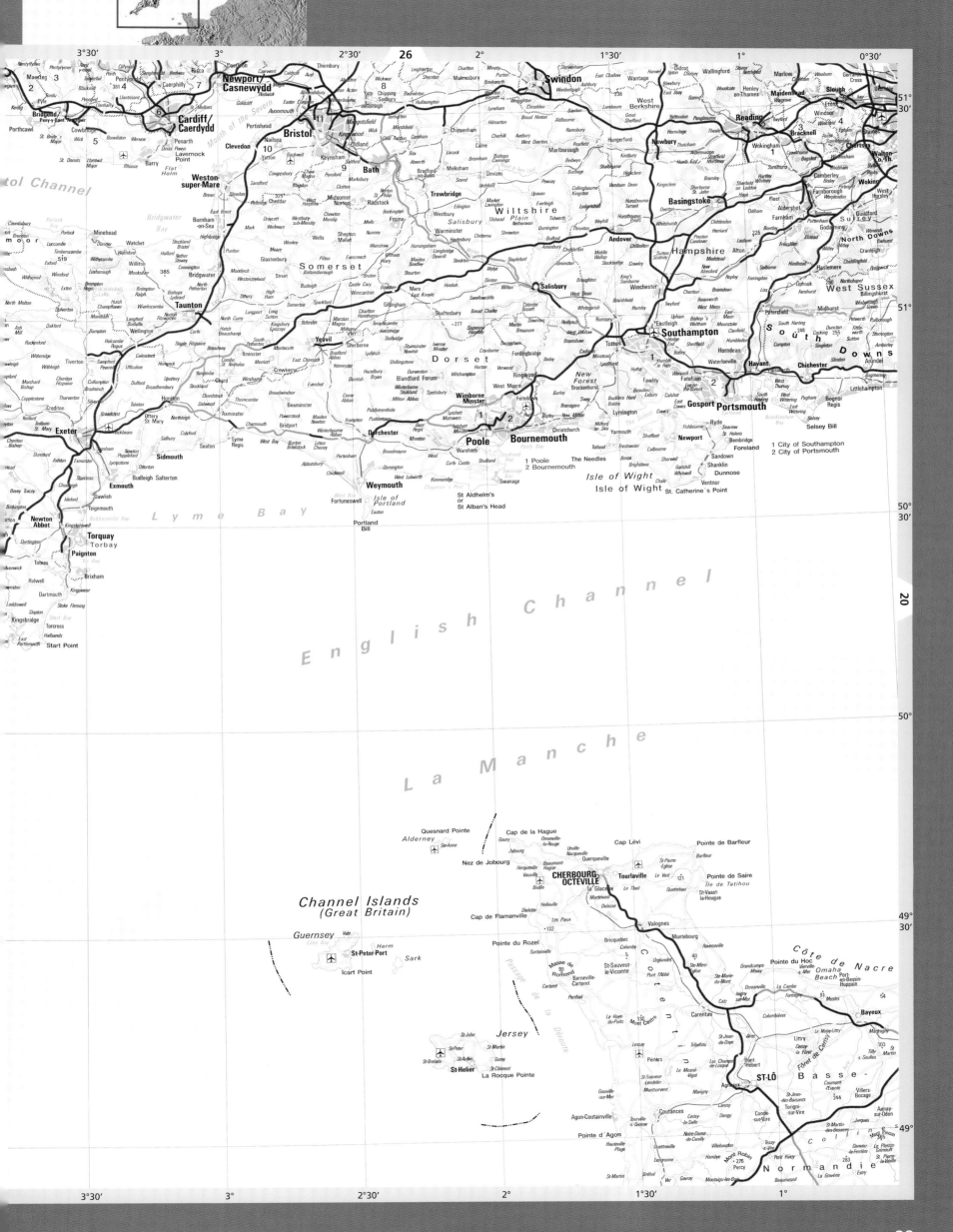

English Channel

La Manche

Channel Islands
(Great Britain)

Lyme Bay

Bristol Channel

Mouth of the Severn

Bridgwater Bay

1 Poole
2 Bournemouth

1 City of Southampton
2 City of Portsmouth

Cardiff/Caerdydd
Newport/Casnewydd
Bristol
Bath
Swindon
Reading
Slough
Maidenhead
Bracknell
Chertsey
Woking
Basingstoke
Andover
Winchester
Southampton
Portsmouth
Gosport
Havant
Chichester
Salisbury
Trowbridge
Weston-super-Mare
Taunton
Yeovil
Exeter
Torquay
Torbay
Paignton
Dorchester
Weymouth
Poole
Bournemouth
Newport
Isle of Wight

Somerset
Wiltshire
Salisbury Plain
Dorset
Hampshire
West Sussex
North Downs
South Downs
Surrey
New Forest
Isle of Wight

Guernsey
St-Peter-Port
Sark
Herm
Alderney
Jersey
St-Helier

CHERBOURG OCTEVILLE
Cap de la Hague
Cap Lévi
Pointe de Barfleur
Valognes
Montebourg
Ste-Mère-Église
Carentan
ST-LÔ
Bayeux
Côte de Nacre
Omaha Beach
BASSE-
Normandie

1:1,000,000

3°30' 3° 2°30' 2° 1°30' 1° 0°30'

51°
30'

51°

50°
30'

20

50°

49°
30'

49°

3°30' 3° 2°30' 2° 1°30' 1°

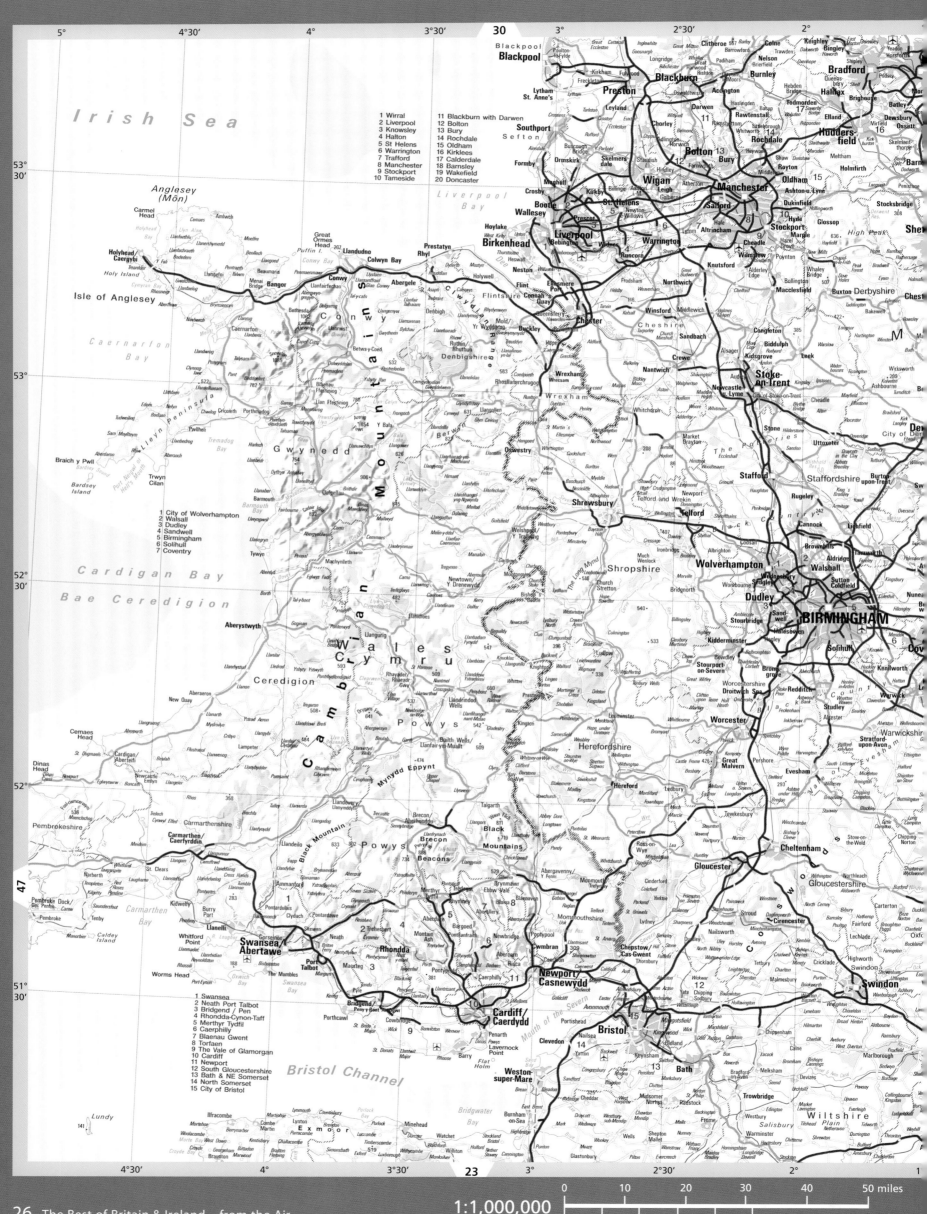

1:1,000,000

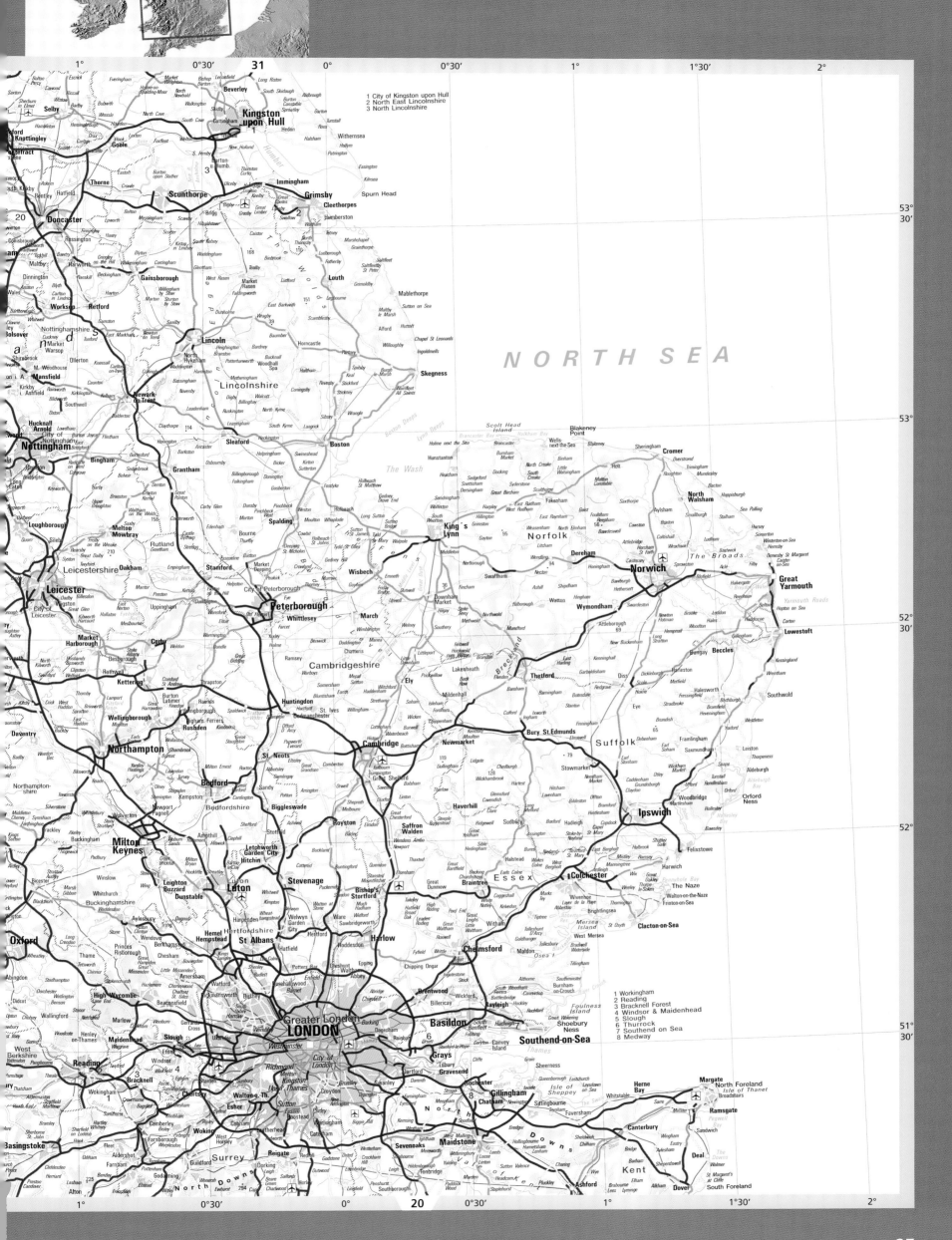

NORTH SEA

1 City of Kingston upon Hull
2 North East Lincolnshire
3 North Lincolnshire

Lincolnshire

Norfolk

The Wash

The Broads

King's Lynn

Cambridgeshire

Suffolk

Northamptonshire

Bedfordshire

Hertfordshire

Essex

Greater London
LONDON
Westminster
City of London

1 Wokingham
2 Reading
3 Bracknell Forest
4 Windsor & Maidenhead
5 Slough
6 Thurrock
7 Southend on Sea
8 Medway

West Berkshire

Surrey

North Downs

Kent

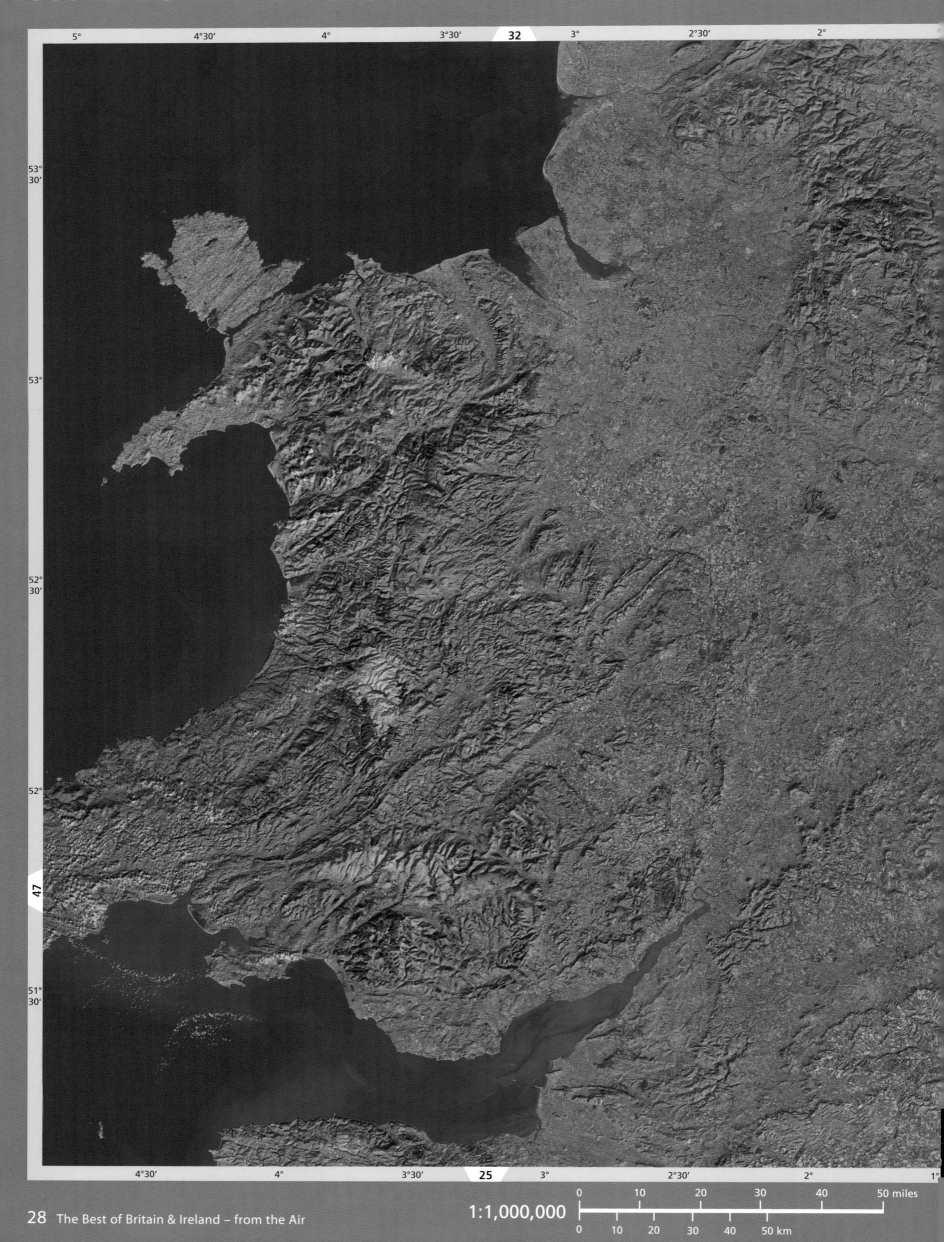

1:1,000,000

| 0 | 10 | 20 | 30 | 40 | 50 miles |

| 0 | 10 | 20 | 30 | 40 | 50 km |

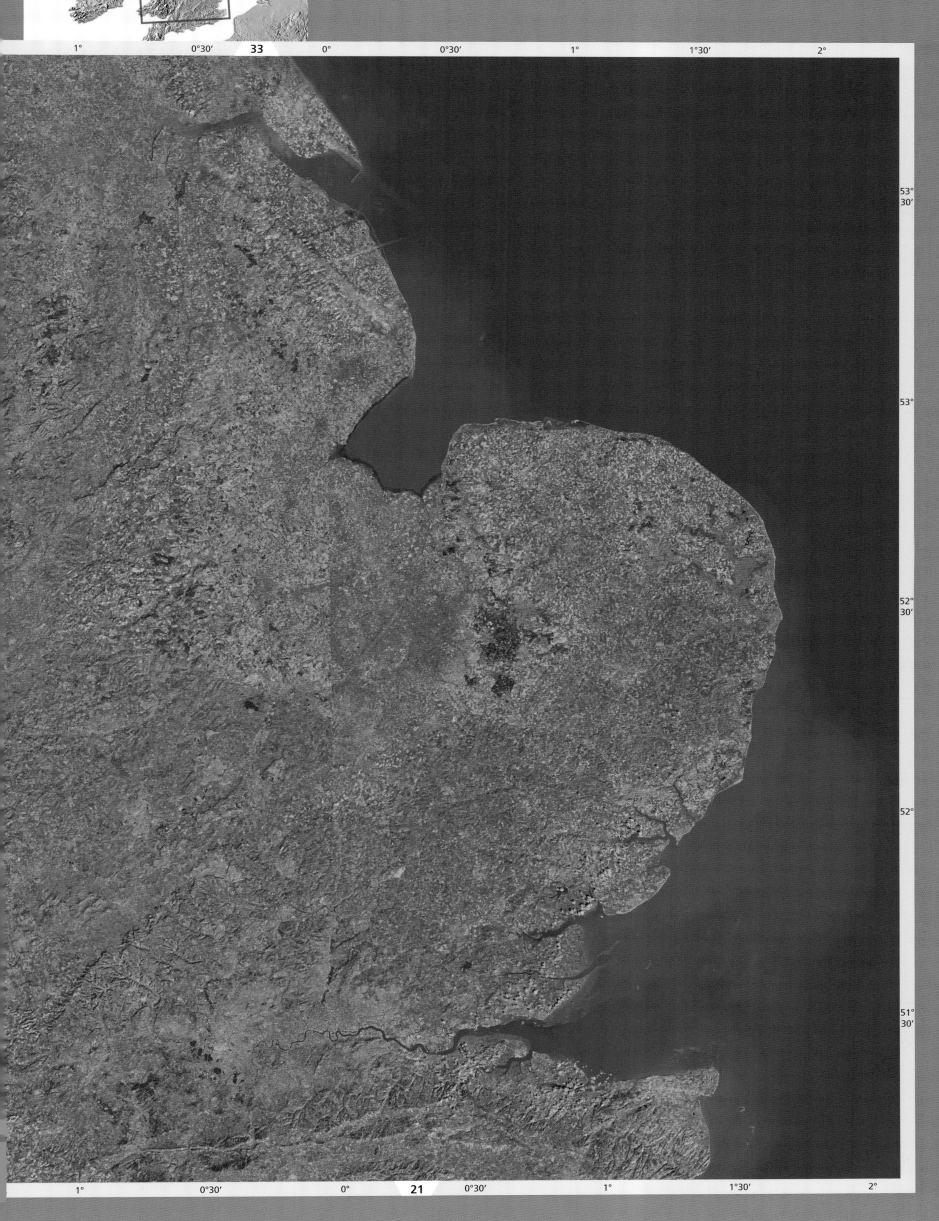

53°
30'

53°

52°
30'

52°

51°
30'

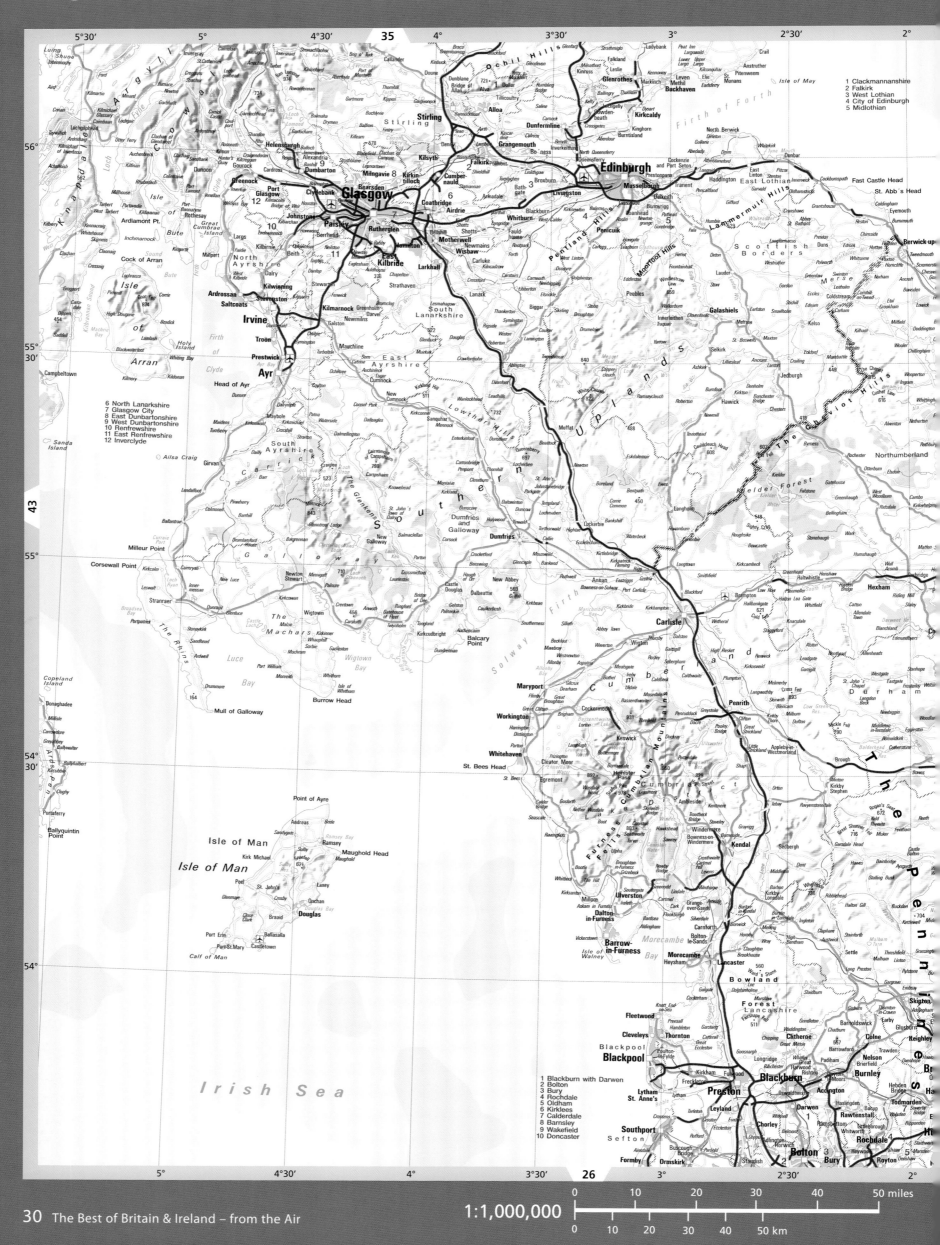

1 Clackmannanshire
2 Falkirk
3 West Lothian
4 City of Edinburgh
5 Midlothian

6 North Lanarkshire
7 Glasgow City
8 East Dunbartonshire
9 West Dunbartonshire
10 Renfrewshire
11 East Renfrewshire
12 Inverclyde

1 Blackburn with Darwen
2 Bolton
3 Bury
4 Rochdale
5 Oldham
6 Kirklees
7 Calderdale
8 Barnsley
9 Wakefield
10 Doncaster

1:1,000,000

0 10 20 30 40 50 miles

0 10 20 30 40 50 km

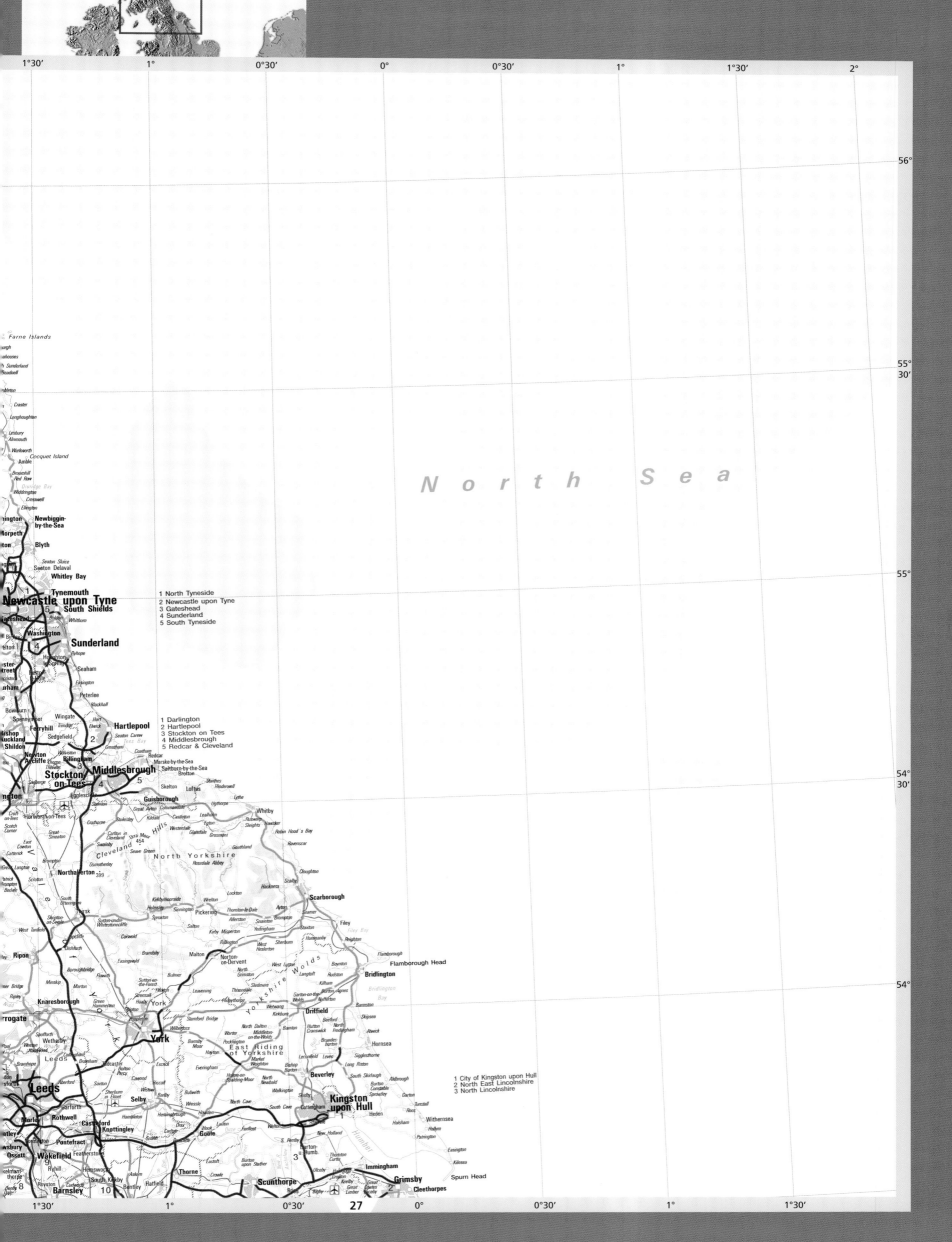

1°30' 1° 0°30' 0° 0°30' 1° 1°30' 2°

56°

Farne Islands

55°
30'

N o r t h S e a

55°

1 North Tyneside
2 Newcastle upon Tyne
3 Gateshead
4 Sunderland
5 South Tyneside

Newcastle upon Tyne
South Shields

Washington

Sunderland

1 Darlington
2 Hartlepool
3 Stockton on Tees
4 Middlesbrough
5 Redcar & Cleveland

Hartlepool

54°
30'

Stockton-on-Tees **Middlesbrough**

Guisborough Whitby

Cleveland Hills

North Yorkshire

Scarborough

Filey

54°

Flamborough Head

Yorkshire Wolds **Bridlington**

York **Driffield**

Leeds *East Riding of Yorkshire*

Beverley

1 City of Kingston upon Hull
2 North East Lincolnshire
3 North Lincolnshire

Selby **Kingston upon Hull**

Leeds

Castleford **Knottingley** **Goole**

Wakefield **Thorne** **Scunthorpe** **Immingham** **Grimsby**
Barnsley **Cleethorpes** Spurn Head

1°30' 1° 0°30' 0° 0°30' 1° 1°30'

27

37

45

28

1:1,000,000

0 10 20 30 40 50 miles

0 10 20 30 40 50 km

1°30′ 1° 0°30′ 0° 0°30′ 1° 1°30′ 2°

56°

55°
30′

55°

54°
30′

54°

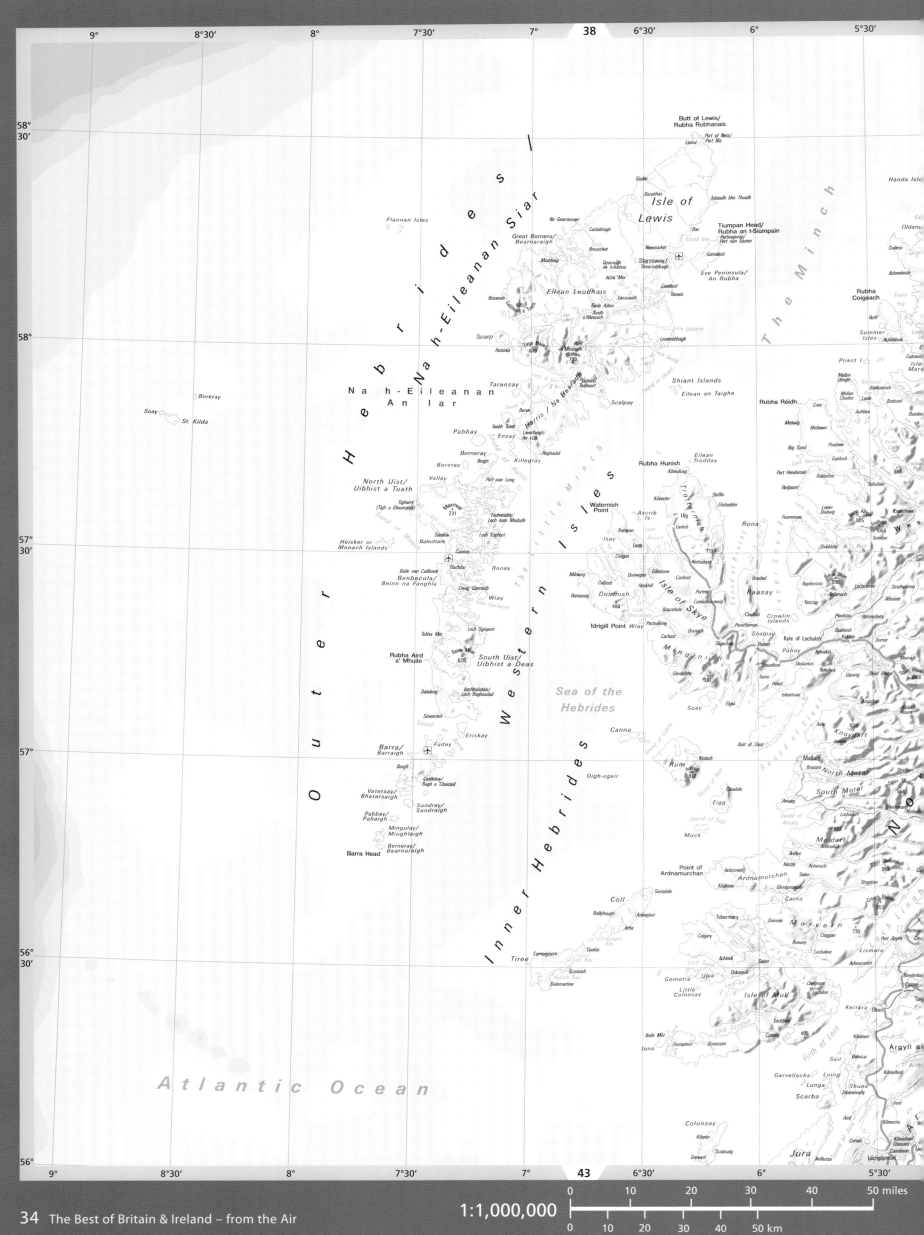

Butt of Lewis/
Rubha Robhanais

Port of Ness/
Port Nis

*Isle of
Lewis*

Tiumpan Head/
Rubha an t-Siùmpain

Handa I.

Flannan Isles

Great Bernera/
Bearnaraigh

Stornoway/
Steòrnabhagh

Eye Peninsula/
An Rubha

Rubha
Coigeach

Ellean Leodhais

The Minch

Scarp

Summer
Isles

Priest I.

H e b r i d e s

N a h - E i l e a n a n S i a r

Taransay

Na h-Eileanan
An Iar

Shiant Islands

Eilean an Taighe

Rubha Réidh

Boreray

St. Kilda

Soay

Scalpay

Herris / Na Hearadh

Pabbay

Ensay

Rubha Hunish

Eilean
Trodday

H e b r i d e s

Berneray

Killegray

Borgh

*North Uist/
Uibhist a Tuath*

Vallay

Waternish
Point

Ascrib Is.

Uig

Rona

Isle of Skye

Heisker or
Monach Islands

Baleshare

Ronay

Isay

Dunvegan

Raasay

Applecross

O u t e r

Benbecula/
Beinn na Faoghla

Wiay

Duirinish

Idrigill Point Wiay

Crowlin
Islands

Portree

Kyle of Lochalsh

Rubha Aird
a' Mhuile

*South Uist/
Uibhist a Deas*

W e s t e r n I s l e s

Soay

Broadford

*Sea of the
Hebrides*

Canna

The Little Minch

Knoydart

Barra/
Barraigh

Fuday

Eriskay

Mallaig

North Morar

I n n e r H e b r i d e s

Rum

Canna

South Morar

Vatersay/
Bhatarsaigh

Sandray/
Sandraigh

Eigg

Moidart

Pabbay/
Pabaigh

Muck

Mingulay/
Miughlaigh

Berneray/
Bearnaraigh

Point of
Ardnamurchan

Ardnamurchan

Barra Head

Coll

Morvern

Tobermory

Calgary

Tiree

Isle of Mull

Little
Colonsay

Gometra Ulva

Iona

Firth of Lorn

Atlantic Ocean

Garvellachs Luing

Lunga

Scarba

Colonsay

Jura

1:1,000,000

| 0 | 10 | 20 | 30 | 40 | 50 miles |

| 0 | 10 | 20 | 30 | 40 | 50 km |

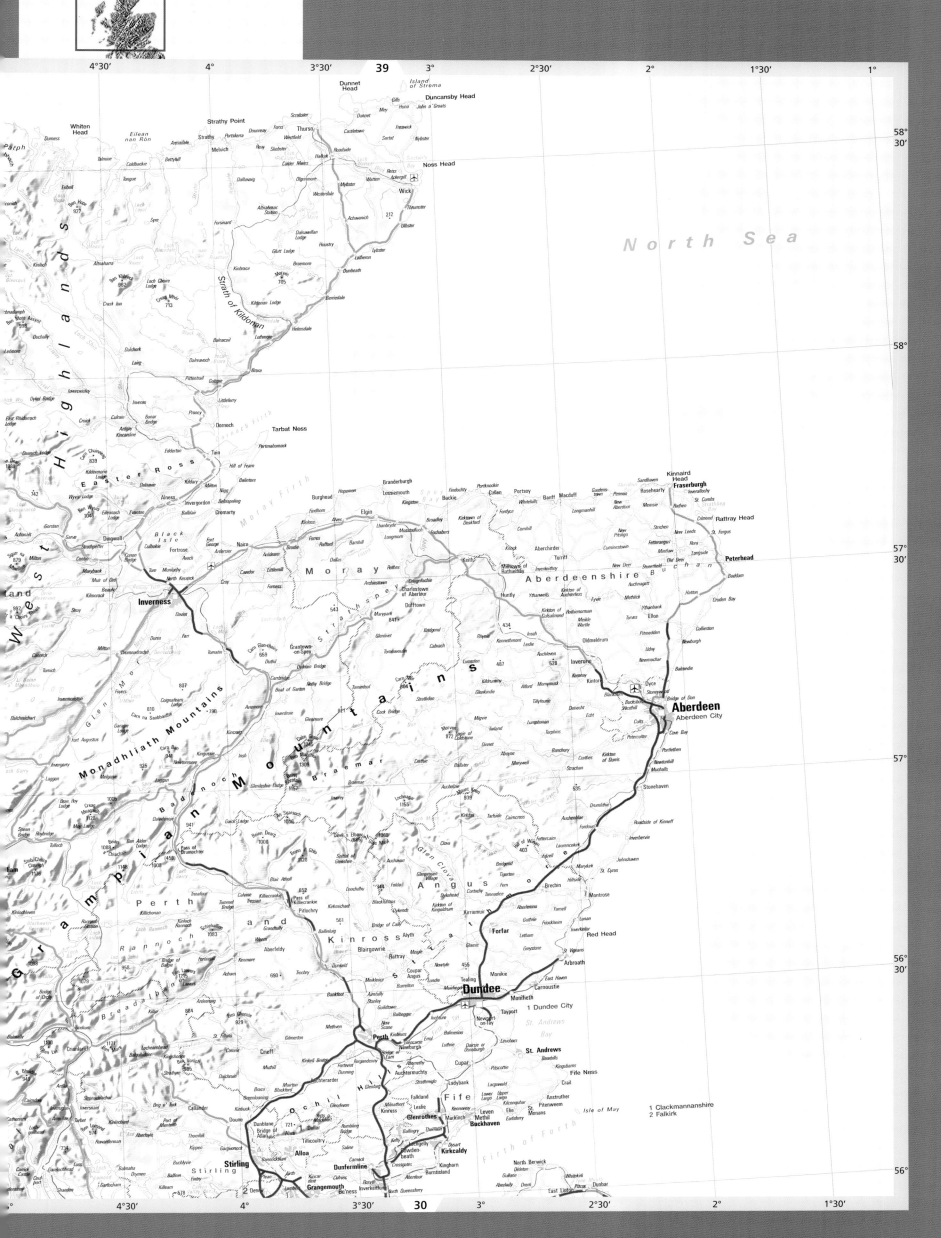

North Sea

Easter Ross

West Highlands

Strath of Kildonan

Black Isle

Inverness

Moray

Aberdeenshire

Buchan

Fraserburgh

Peterhead

Monadhliath Mountains

Strathspey

Grampian Mountains

Badenoch

Braemar

Aberdeen
Aberdeen City

Stonehaven

Perth and Kinross

Breadalbane

Angus

Glen Clova

Strathmore

Forfar

Arbroath

Red Head

Ochil Hills

Perth

Dundee
1 Dundee City

St. Andrews

St. Andrews Bay

Fife

Fife Ness

Isle of May

1 Clackmannanshire
2 Falkirk

Stirling

Alloa

Dunfermline

Glenrothes

Kirkcaldy

Buckhaven

Grangemouth

Firth of Forth

56°

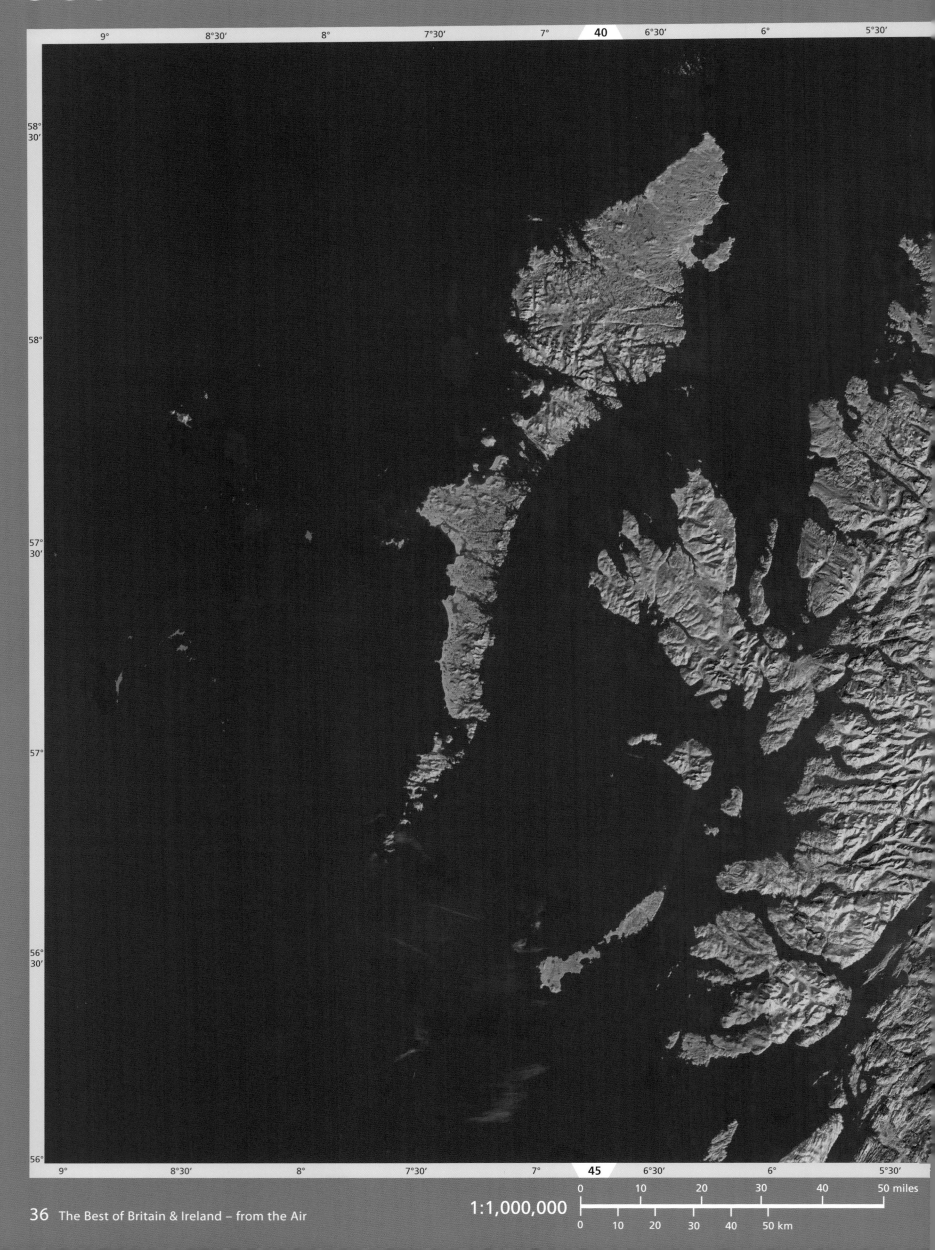

1:1,000,000

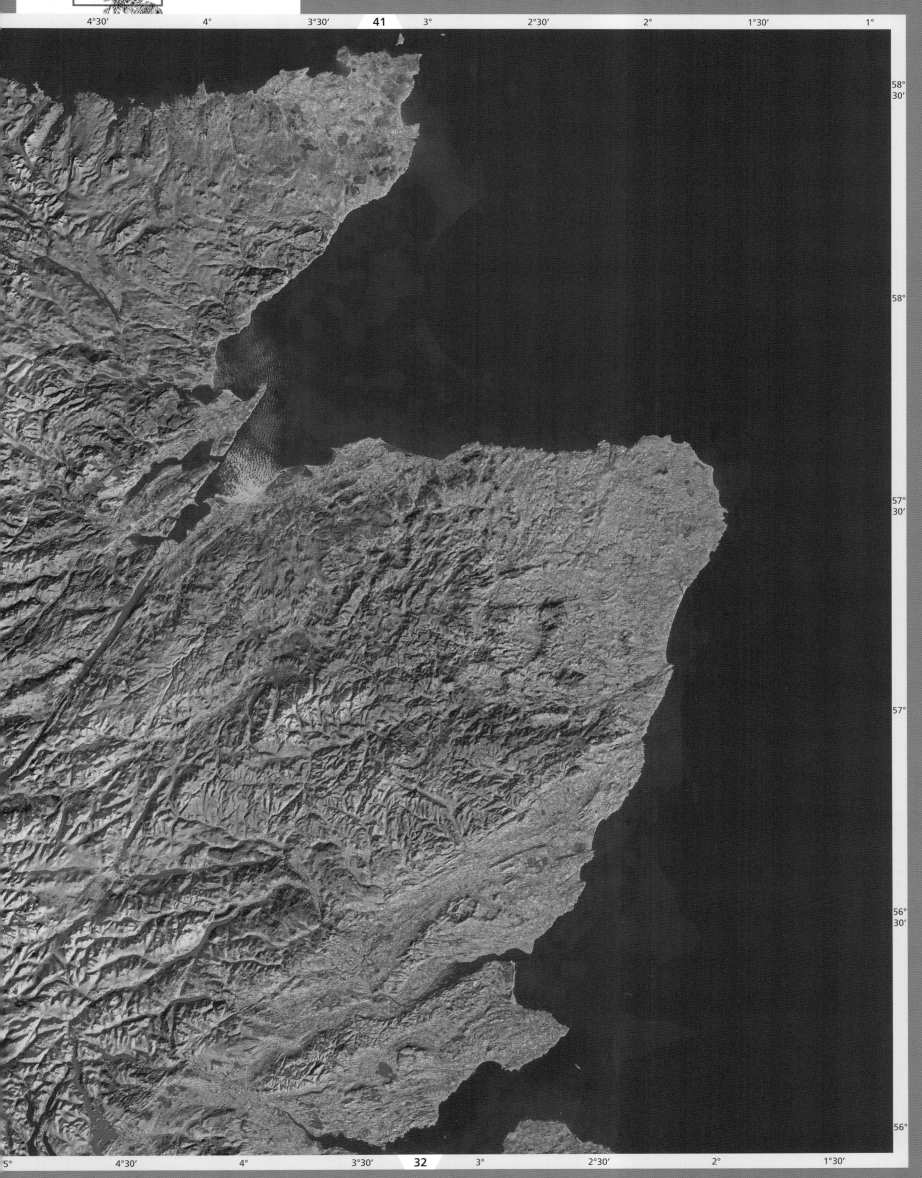

4°30' 4° 3°30' **41** 3° 2°30' 2° 1°30' 1°

58°30'

58°

57°30'

57°

56°30'

56°

5° 4°30' 4° 3°30' **32** 3° 2°30' 2° 1°30'

ATLANTIC OCEAN

Suilsker
Rona

Cape Wrath
The Parph
Craig Rubhach
485

Butt of Lewis/
Rubha Robhanais

Port of Ness/
Port Nis
Lional

Kinlochbervie

Rhiconich

Siadar
Tolstadh bho Thuath
Handa Island
Turbet

Barabhas
Bac
Scourie
Badhaidh

Flannan Isles
No Gearrannan
Carlabhagh
Eddrachillis
Oldany I. Bay

Great Bernera/
Bearnaraigh
Breasclet
Isle of
Lewis
Tiumpan Head/
Rubha an t-Siùmpain
Portmaguran/
Port nan Giuran

Kylesmorie
Loch Glencoul

Timsgearraidh
Miabhig
Broad Bay
Stornoway/
Steornabhagh
Newmarket
Garrabost
Culkein
Drumbeg

0 10 20 30 40 50 miles

1:1,000,000

0 10 20 30 40 50 km

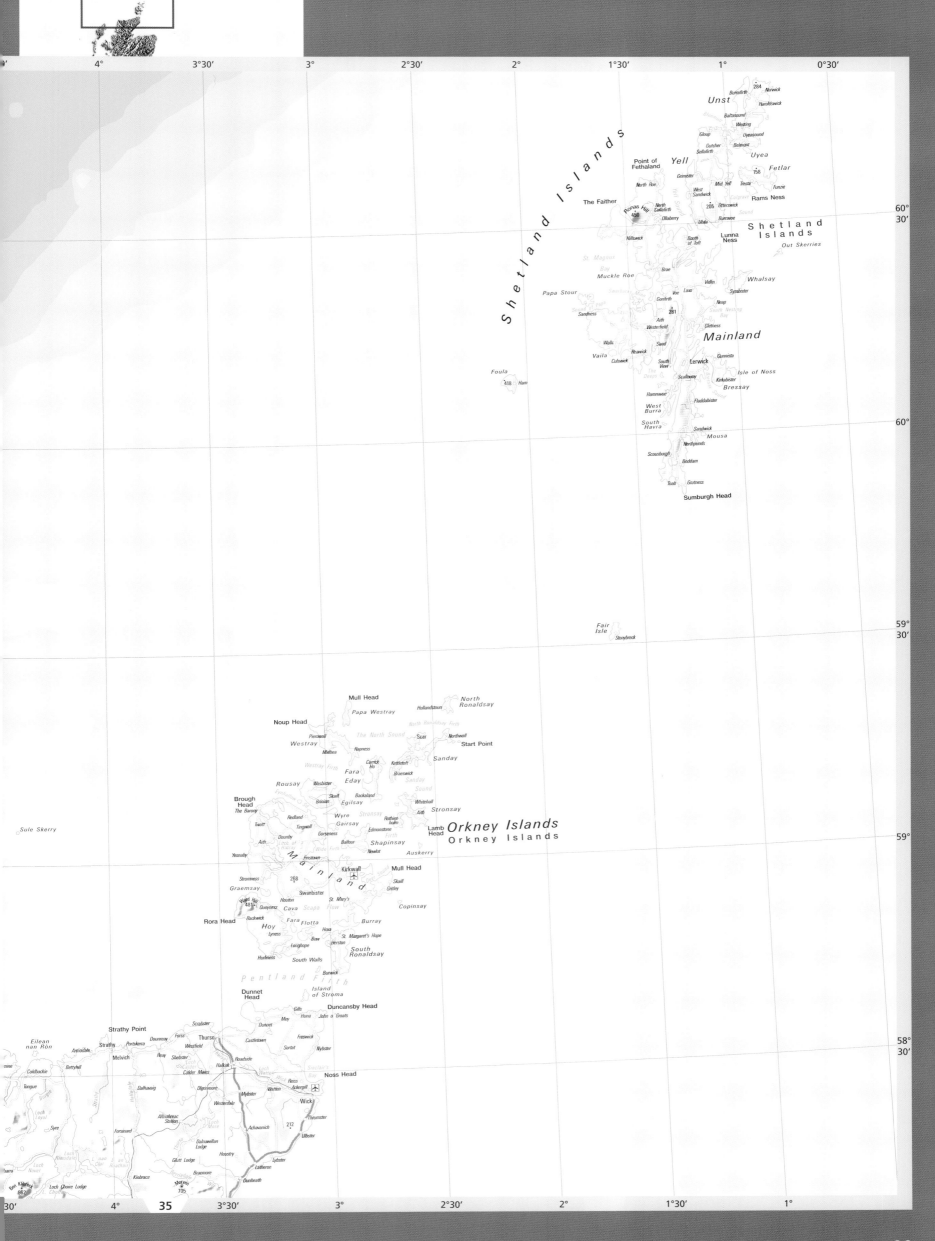

36

1:1,000,000

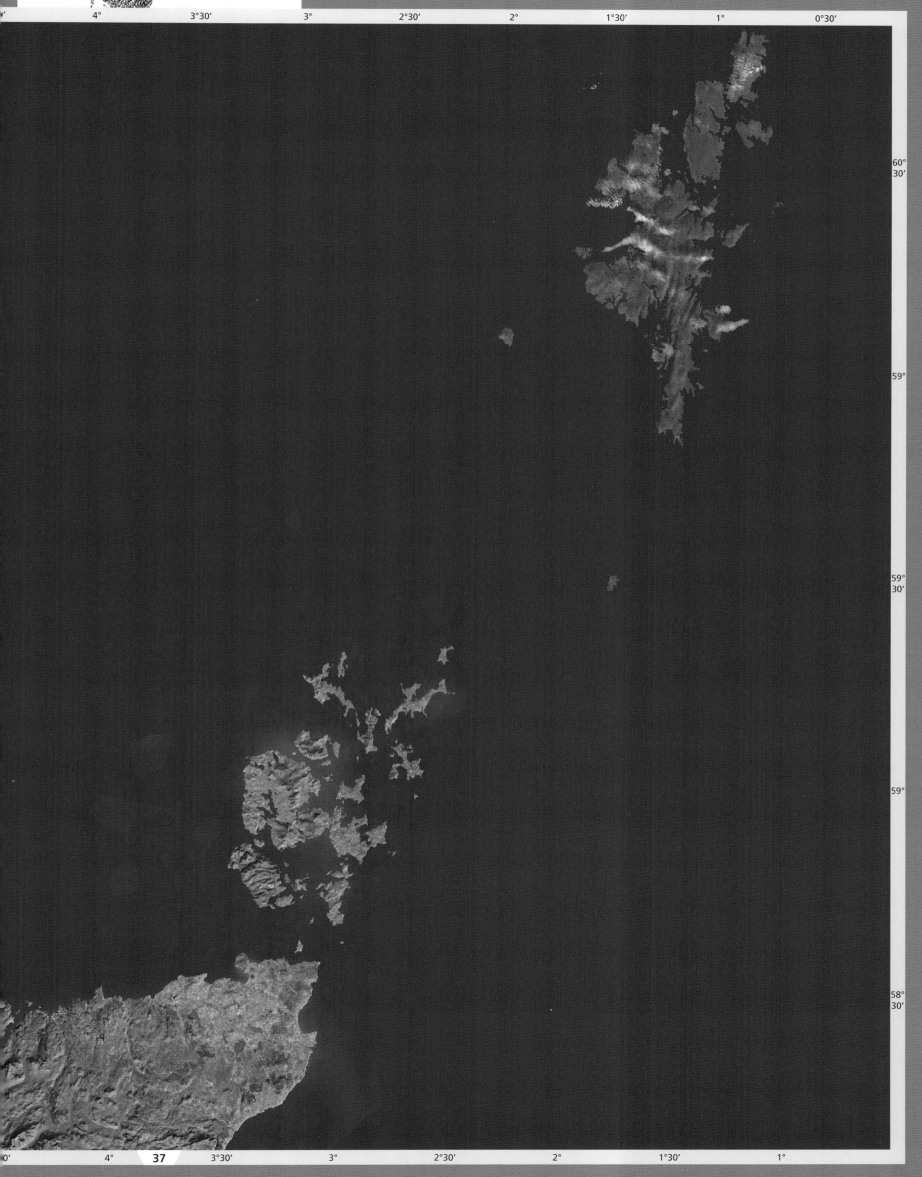

4° 3°30' 3° 2°30' 2° 1°30' 1° 0°30'

60°
30'

59°

59°
30'

59°

58°
30'

0' 4° **37** 3°30' 3° 2°30' 2° 1°30' 1°

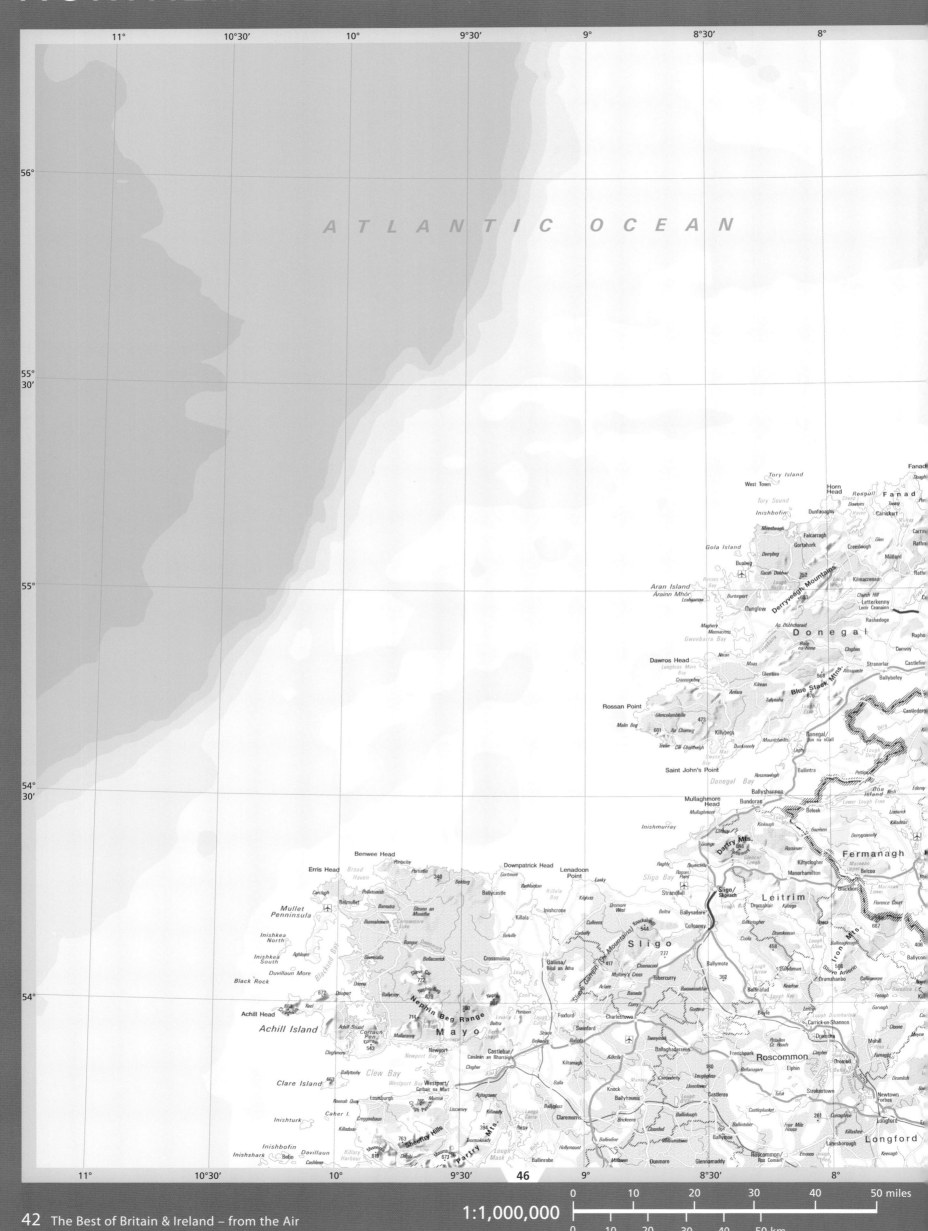

ATLANTIC OCEAN

Tory Island
West Town
Inishbofin
Tory Sound
Fanad
Horn Head
Resgull Head

Gola Island
Falcarragh
Gortahork
Creeslough
Milford
Rathmel

Bunbeg
Gweedore
Dunfanaghy
Kilmacrenan

Aran Island
Árainn Mhór
Dunglow
Derryveagh Mountains
Letterkenny
Leitir Ceanainn
Rashedoge

Maghery
Meenacross
Gweebarra Bay
Donegal
Cloghan
Convoy
Raphoe

Dawros Head
Glenties
Stranorlar
Ballybofey

Rossan Point
Glencolumbkille
Ardara
Killybegs
Dunkineely
Mountcharles
Donegal/
Dún na nGall

Malin Beg
Teelin
Saint John's Point
Ballintra

Donegal Bay
Rossnowlagh
Bundoran

Mullaghmore Head
Mullaghmore
Ballyshannon
Kinlough
Belleek
Lower Lough Erne

Inishmurray
Darty Mts.
Fermanagh

Raghly
Sligo/
Sligeach
Leitrim
Manorhamilton

Benwee Head
Erris Head
Downpatrick Head
Lenadoon Point
Sligo Bay
Strandhill

Broad Haven
Portacloy
Belderg
Ballycastle
Killala Bay
Dromore West
Collooney

Belmullet
Barnatra
Killala
Inishcrone
Ballysadare

Mullet Penninsula
Bangor
Crossmolina
Ballina/
Béal an Átha
Knocknarea
Sligo
Iron Mts.

Inishkea North
Bunnahowen
Ballygass
Tobercurry
Ballymote

Inishkea South
Duvillaun More
Slieve Car
Foxford
Banada
Bellavary

Black Rock
Doogort
Ballycroy
Nephin Beg Range
Swinford
Charlestown
Roscommon/
Ros Comáin

Achill Head
Keel
Achill Island
Corraun Pen
Newport
Castlebar/
Caislean an Bharraigh
Kiltamagh
Ballaghaderreen
Frenchpark
Roscommon

Clare Island
Westport/
Cathair na Mart
Balla
Knock
Ballyhaunis
Castlerea
Elphin

Inishturk
Louisburgh
Claremorris
Ballinlough
Strokestown

Inishbofin
Inishshark
Davillaun
Sheefry Hills
Partry Mts.
Lough Mask
Dunmore
Glennamaddy
Longford

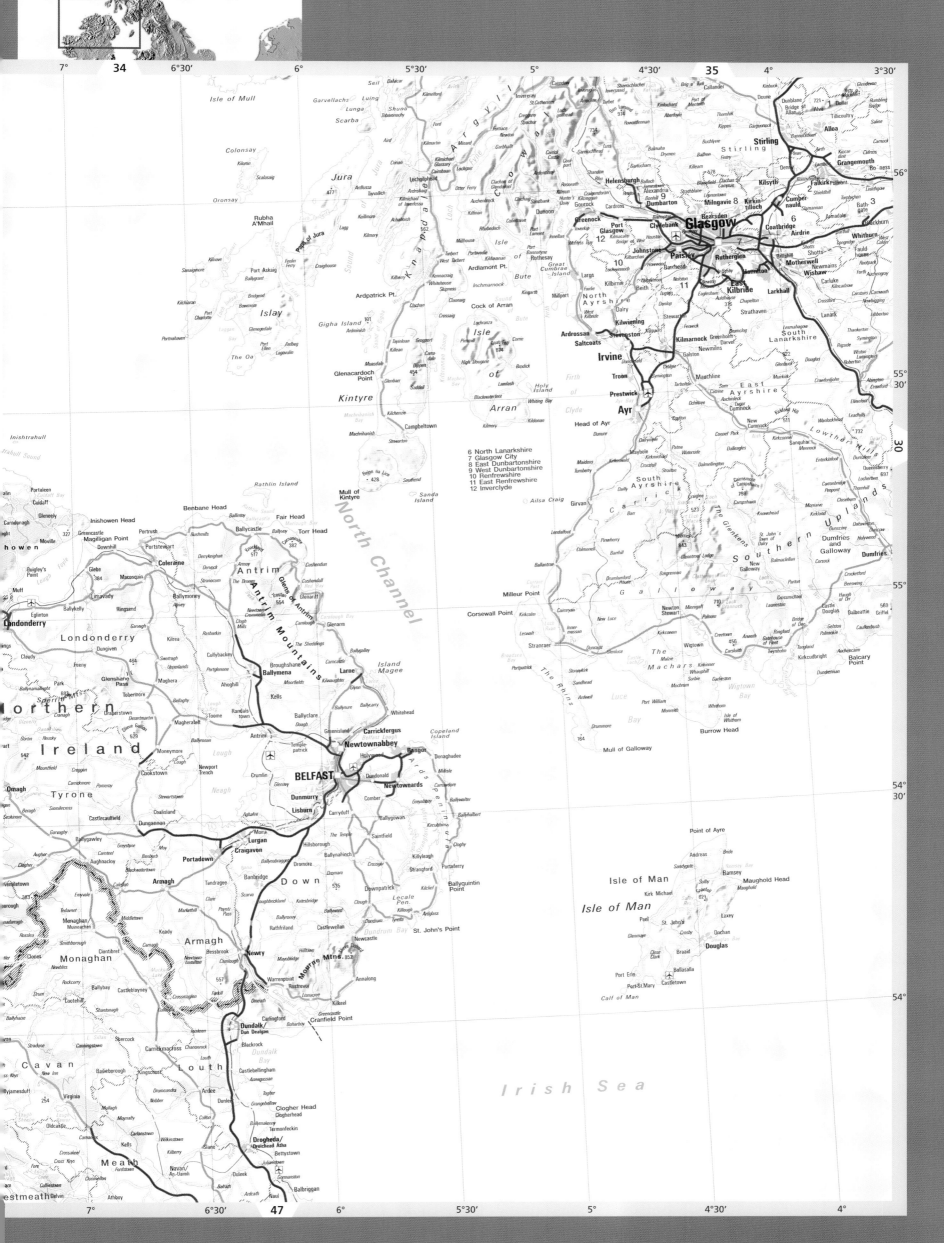

6 North Lanarkshire
7 Glasgow City
8 East Dunbartonshire
9 West Dunbartonshire
10 Renfrewshire
11 East Renfrewshire
12 Inverclyde

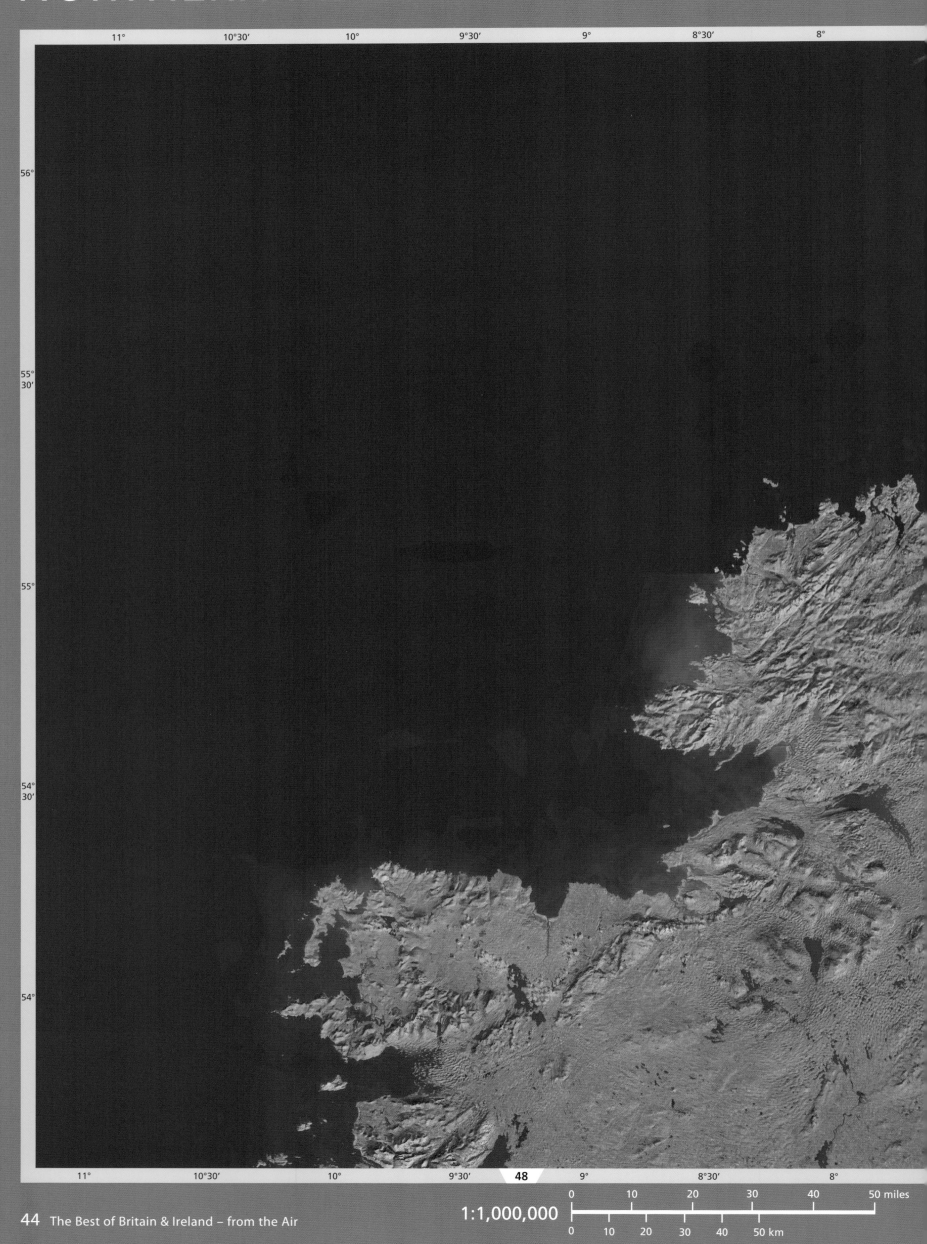

1:1,000,000

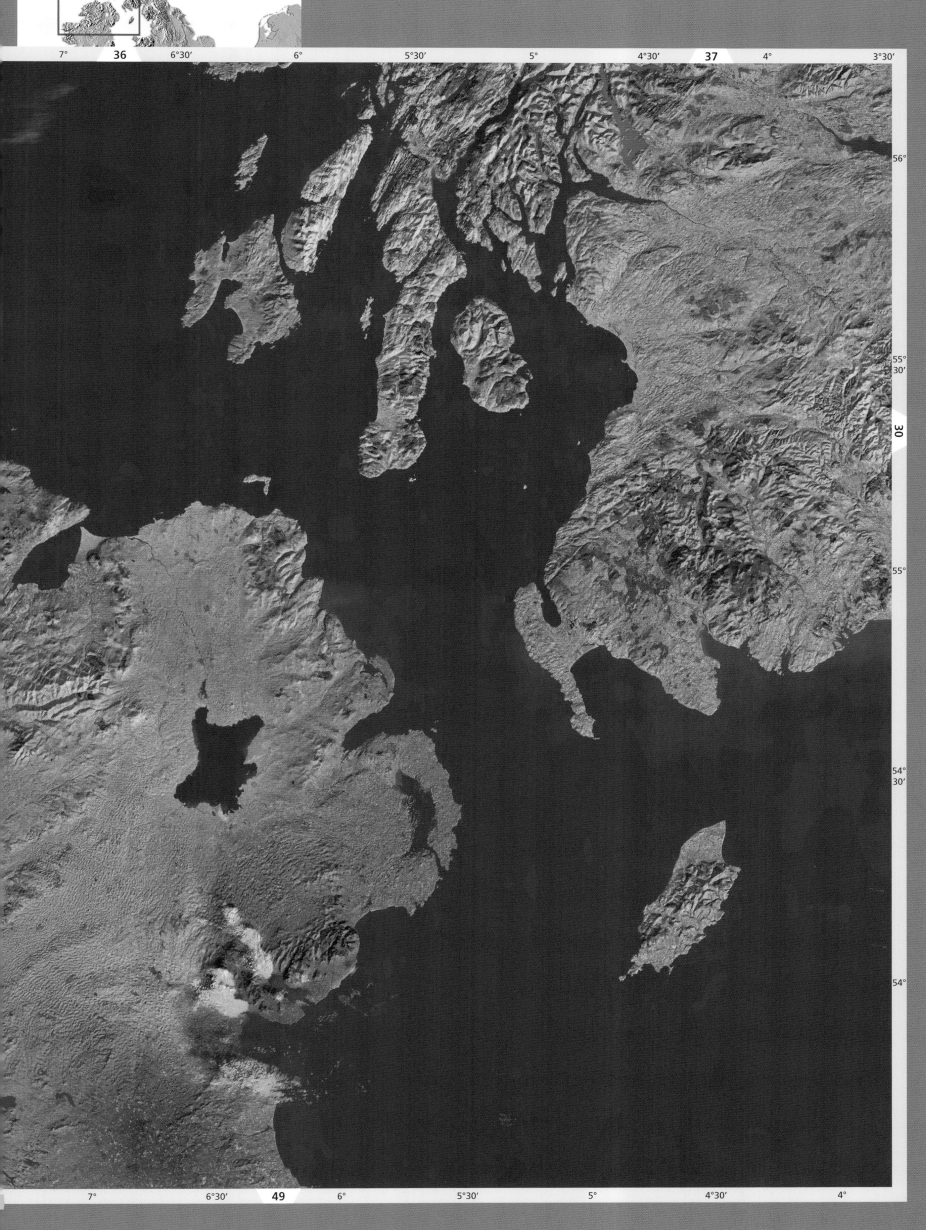

7° 36 6°30' 6° 5°30' 5° 4°30' 37 4° 3°30'

56°

55°
30'

30

55°

54°
30'

54°

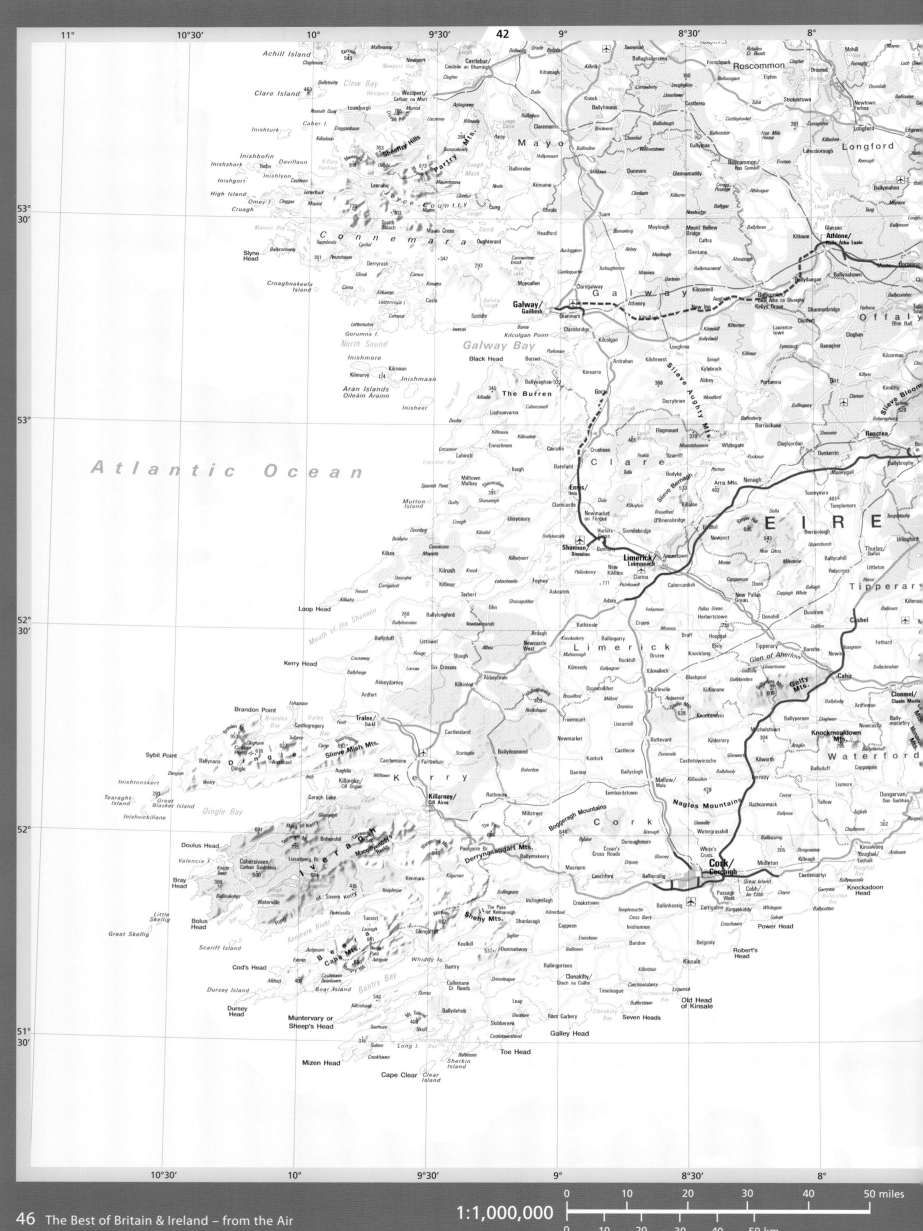

1:1,000,000

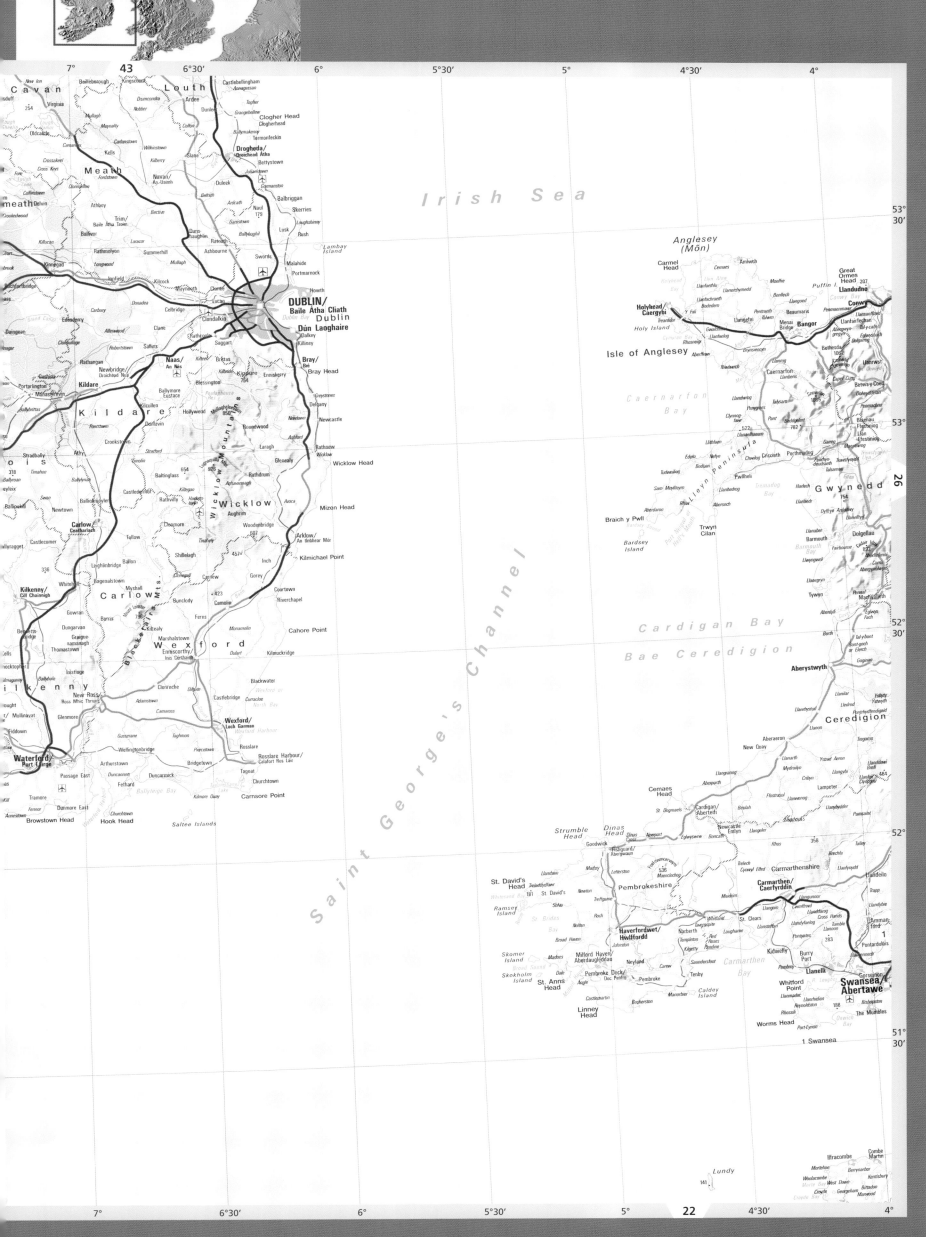

Irish Sea

Saint George's Channel

Cardigan Bay

Bae Ceredigion

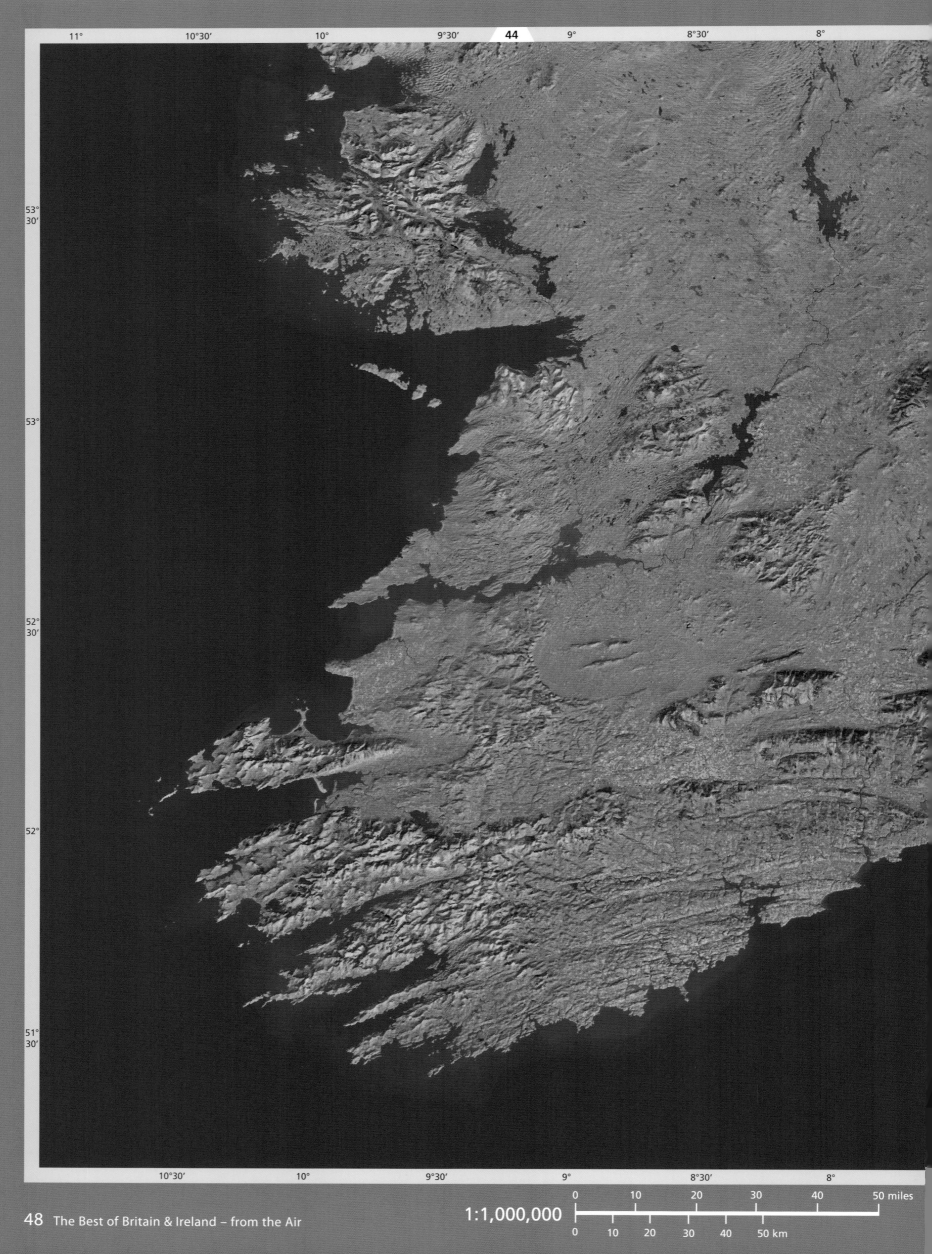

11° 10°30' 10° 9°30' **44** 9° 8°30' 8°

53°30'

53°

52°30'

52°

51°30'

10°30' 10° 9°30' 9° 8°30' 8°

1:1,000,000

0 10 20 30 40 50 miles

0 10 20 30 40 50 km

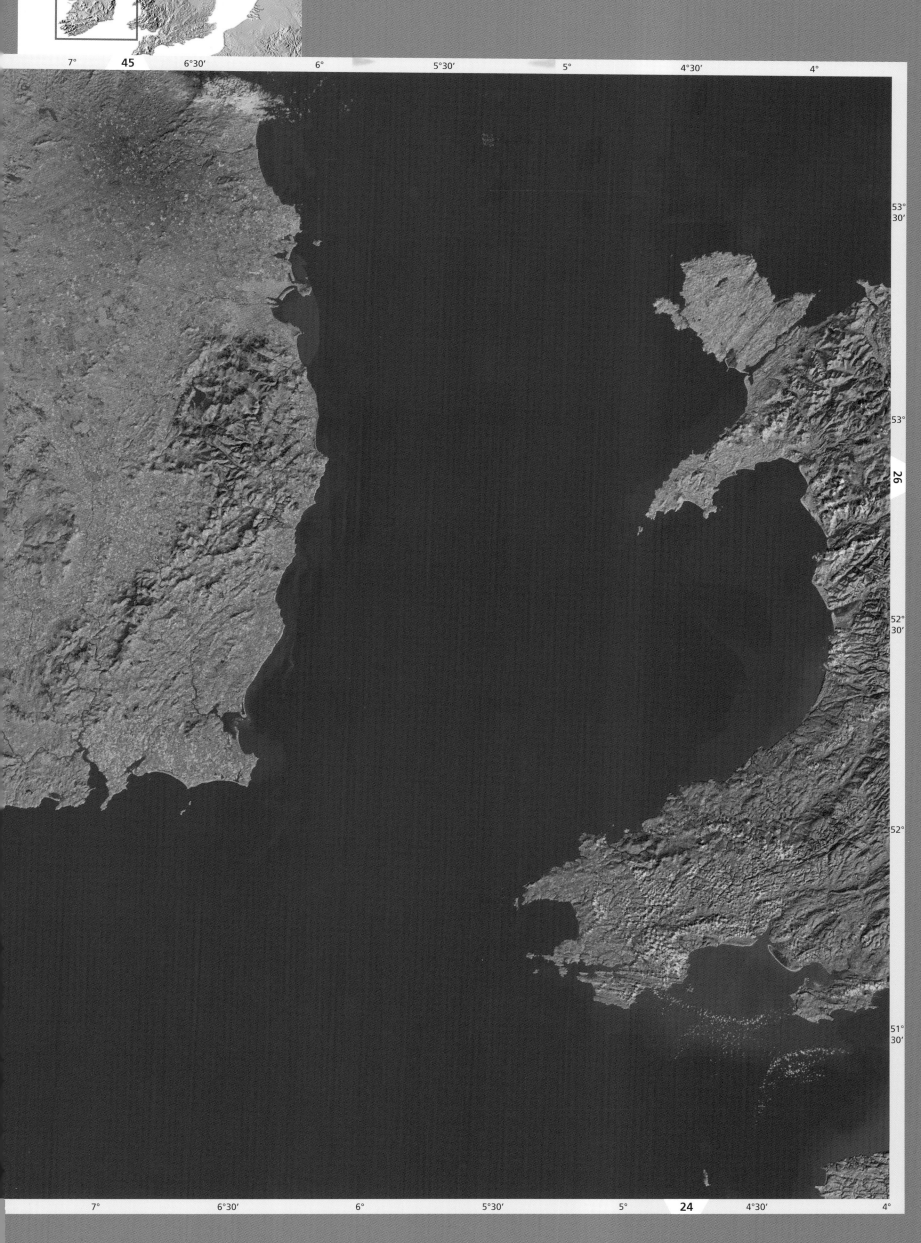

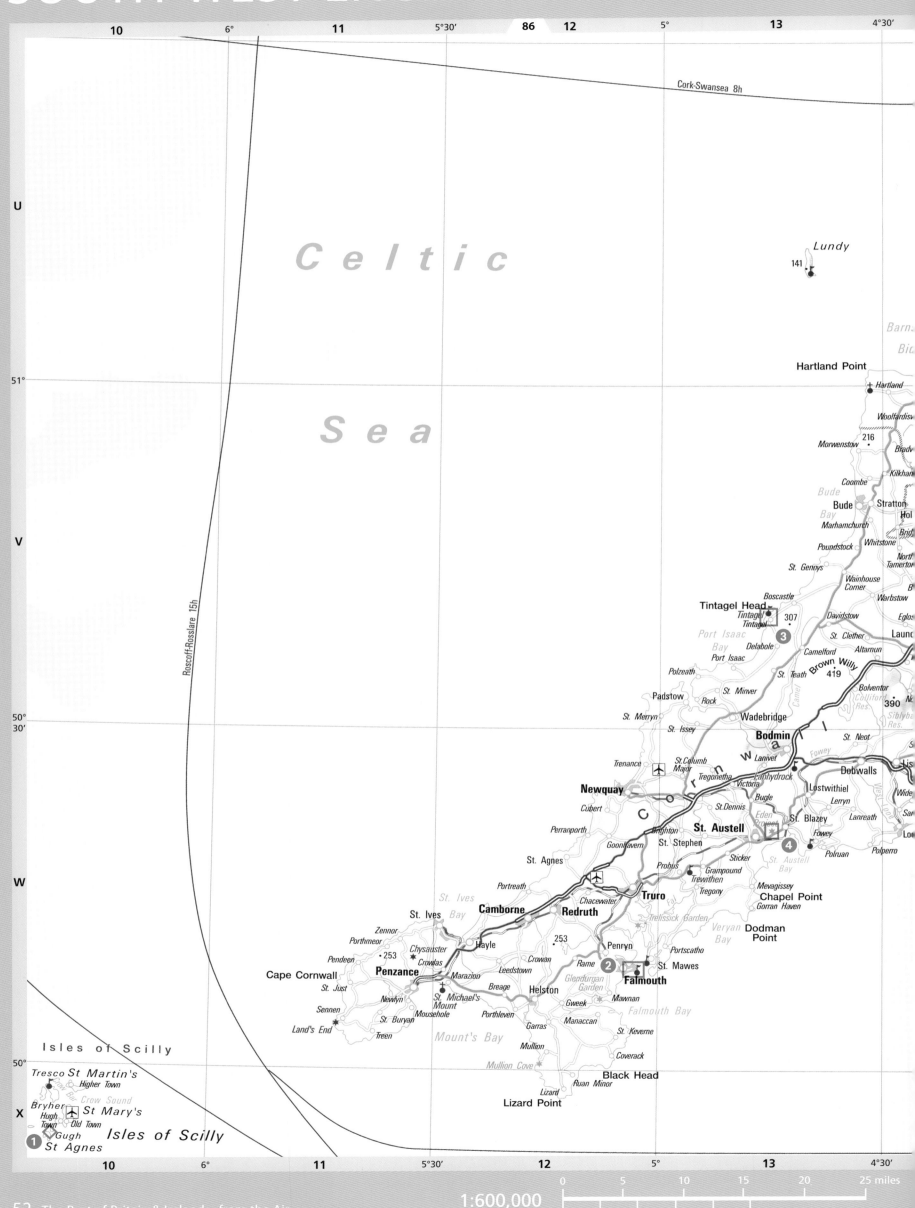

Celtic

Sea

Cork-Swansea 8h

Roscoff-Rosslare 15h

Lundy
141

Hartland Point
+ Hartland

Woolfardisw

Morwenstow 216 Brady
•

Coombe Kilkham
Bude
Bay Bude Stratton
Marhamchurch Hol
Poundstock Whitstone Brid

North
St. Genoys Tamerton

Wainhouse
Corner Warbstow
Boscastle B
Tintagel Head Davidstow Eglos
Tintagel 307
Tintagel St. Clether Laun
Port Isaac 3
Bay Delabole Camelford Altarnun
Port Isaac Brown Willy Bolventor
Polzeath St. Teath 419 No
St. Minver 390
Padstow Rock Colliford Sibly
St. Merryn Res. Res.
St. Issey Wadebridge St. Neot

Bodmin
a
Lanivet Fowey Lis
St. Columb n Dobwalls
Trenance Major w Lanhydrock
Tregonetha Victoria Lostwithiel Wide
Newquay Bugle Lerryn Sa
Cubert St.Dennis St. Blazey Lanreath
C Eden St. Blazey Lo
Perranporth Project Fowey
Brighton St. Austell 4 Polruan Polperro
Goonhavern St. Stephen St. Austell
St. Agnes Sticker Bay
Probus Grampound Mevagissey
Portreath Trewithen Chapel Point
Camborne Chacewater Tregony Gorran Haven
St. Ives Truro Trelissick Garden
St. Ives Redruth Veryan Dodman
Bay Bay Point
Zennor Portscatho
Porthmeor 253 Penryn Rame Portscatho
Pendeen Chysauster Crowlas 2 St. Mawes
• 253 Crowan
Cape Cornwall Penzance Leedstown Falmouth
St. Just Marazion Breage Glendurgan
Newlyn St. Michael's Helston Garden Mawnan
Sennen Mount Porthleven Gweek Falmouth Bay
Mousehole Manaccan
Land's End Garras St. Keverne
Treen Mount's Bay Mullion Coverack

Black Head
Lizard Ruan Minor
Lizard Point Mullion Cove

Isles of Scilly

Tresco St Martin's
Higher Town
Crow Sound
Bryher St Mary's
Hugh
Town Old Town
1 Gugh Isles of Scilly
St Agnes

0 5 10 15 20 25 miles

1:600,000

0 5 10 15 20 25 km

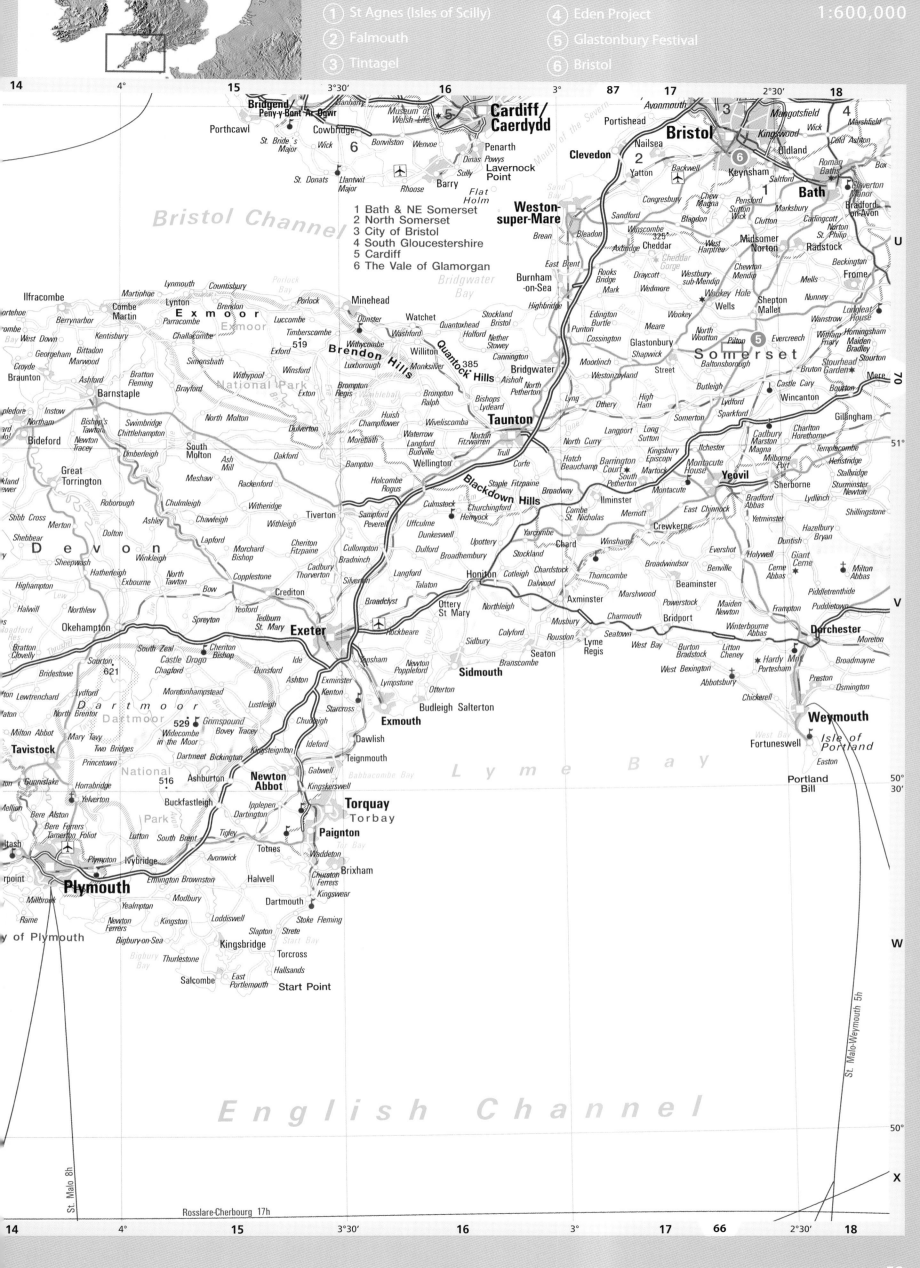

14 4° 15 3°30' 16 3° 87 17 2°30' 18

Bridgend/
Peny-y-Bont Ar Ogwr Llanharry
Porthcawl St. Bride's Major Cowbridge Bonvilston Wenvoe
Wick Museum of Welsh Life 5 Cardiff/Caerdydd Avonmouth Portishead Bristol 3 Mangotsfield Wick Marshfield 4
St. Donats Llantwit Major Rhoose Barry Dinas Powys Penarth Nailsea Kingswood Oldland Cold Ashton
Sully Lavernock Point Clevedon 2 Yatton Backwell Keynsham 1 Saltford Roman Baths Box Bath
Flat Holm Weston-super-Mare Congresbury Chew Magna Pensford Sutton Wick Marksbury Carlingcott Norton St. Philip Bradford-on-Avon
Brean Bleadon Sandford Winscombe Blagdon Clutton Midsomer Norton Radstock Beckington Frome U

Bristol Channel

1 Bath & NE Somerset
2 North Somerset
3 City of Bristol
4 South Gloucestershire
5 Cardiff
6 The Vale of Glamorgan

Bridgwater Bay
Minehead East Brent 325 Cheddar Cheddar Gorge Axbridge Westbury-sub-Mendip Chewton Mendip Mells Nunney Longleat House Wanstrow
Burnham-on-Sea Rooks Bridge Draycott Wedmore Wookey Wells Shepton Mallet William Friary Maiden Bradley Stourton
Highbridge Mark Burtle Meare North Wootton Wookey Hole Pilton 5 Evercreech Stourhead Garden Mere

Ilfracombe Lynmouth Countisbury Porlock Bay Watchet Stockland Bristol Moorlinch Glastonbury Shapwick Somerset Baltonsborough Castle Cary Bruton Bourton
Combe Martin Martinhoe Lynton Brendon Porlock Luccombe Quantoxhead Holford Nether Stowey Westonzoyland Street Butleigh Lydford Wincanton Gillingham
Berrynarbor Parracombe Exmoor Dunster Washford Williton Monksilver Cannington Bishops Lydeard High Ham Somerton Sparkford Charlton Horethorne Templecombe 70
Kentisbury Challacombe 519 Timberscombe Withycombe Bridgwater Aisholt North Petherton Long Sutton Ilchester Cadbury Marston Magna Henstridge Stalbridge
West Down Simonsbath Exford Brendon Hills Luxborough Brompton Regis Wiveliscombe Norton Fitzwarren Taunton Lyng Othery Kingsbury Episcopi Montacute House Milborne Port Sherborne Sturminster Newton
Georgeham Bittadon Marwood National Park Winsford Brompton Ralph Huish Champflower Waterrow Trull Corfe North Curry Langport South Petherton Yeovil Bradford Abbas Lydlinch 51°
Croyde Ashford Bratton Fleming Withypool Brayford Exton Wellington Hatch Beauchamp Barrington Court Martock Montacute East Chinnock Crewkerne Yetminster Shillingstone

Braunton Instow Bishop's Tawton Swimbridge Chittlehampton South Molton North Molton Dulverton Morebath Bampton Holcombe Rogus Staple Fitzpaine Broadway Ilminster Merriott Winsham Hazelbury Bryan Duntish
Northam Umberleigh Meshaw Oakford Rackenford Witheridge Withleigh Culmstock Churchingford Yarcombe Combe St. Nicholas Chard Eversbot Holywell Giant Cerne
Bideford Newton Tracey Roborough Chulmleigh Chawleigh Tiverton Uffculme Dunkeswell Upottery Stockland Chardstock Broadwindsor Benville Cerne Abbas Milton Abbas
Great Torrington Ashley Lapford Cheriton Fitzpaine Cullompton Dulford Broadhembury Langford Talaton Cotleigh Dalwood Marshwood Powerstock Maiden Newton Piddletrenthide V
Stibb Cross Merton Dolton Morchard Bishop Cadbury Thorverton Bradninch Honiton Northleigh Axminster Musbury Charmouth Bridport Winterbourne Abbas Puddletown
Shebbear Sheepwash Winkleigh North Tawton Copplestone Silverton Broadclyst Ottery St. Mary Sidbury Colyford Rousdon Lyme Regis West Bay Burton Bradstock Litton Cheney Dorchester Moreton
Highampton Hatherleigh Exbourne Bow Crediton Yeoford Tedburn St. Mary Ashton Exeter Topsham Newton Poppleford Talaton Seaton Branscombe West Bay Abbotsbury West Bexington Hardy Mnt Portesham Broadmayne
Halwill Northlew Spreyton Ide Dunsford Exminster Kenton Lympstone Sidmouth Budleigh Salterton Chickerell Osmington Preston
Okehampton South Zeal Cheriton Bishop Starcross Exmouth Portland Bill Weymouth
Bratton Clovelly Sourton 621 Castle Drogo Chagford Moretonhampstead Lustleigh Chudleigh Dawlish Dartmoor Fortuneswell Isle of Portland Easton 50° 30'
Lewtrenchard Lydford North Brentor Dartmoor 529 Grimspound Bovey Tracey Ideford Teignmouth Lyme Bay
Milton Abbot Mary Tavy Widecombe in the Moor Bickington Kingsteignton Gabwell Babbacombe Bay
Tavistock Two Bridges Dartmeet Ashburton Newton Abbot Kingskerswell Torquay
Gunnislake Princetown 516 National Buckfastleigh Ipplepen Dartington Torbay Torbay W
Horrabridge Park Tigley South Brent Totnes Paignton
Yelverton Bere Ferrers Lutton Waddeton Tor Bay
Bere Alston Tamerton Foliot Avonwick Brixham
Saltash Plympton Ivybridge Ermington Brownston Halwell Churston Ferrers Kingswear
Millbrook Yealmpton Modbury Dartmouth
Plymouth Newton Ferrers Kingston Loddiswell Stoke Fleming
Rame Bigbury-on-Sea Slapton Strete
y of Plymouth Bigbury Bay Thurlestone Kingsbridge Torcross Start Bay
Salcombe East Portlemouth Hallsands Start Point

St. Malo 8h

English Channel

50°

St. Malo–Weymouth 5h X

Rosslare–Cherbourg 17h

14 4° 15 3°30' 16 3° 17 66 2°30' 18

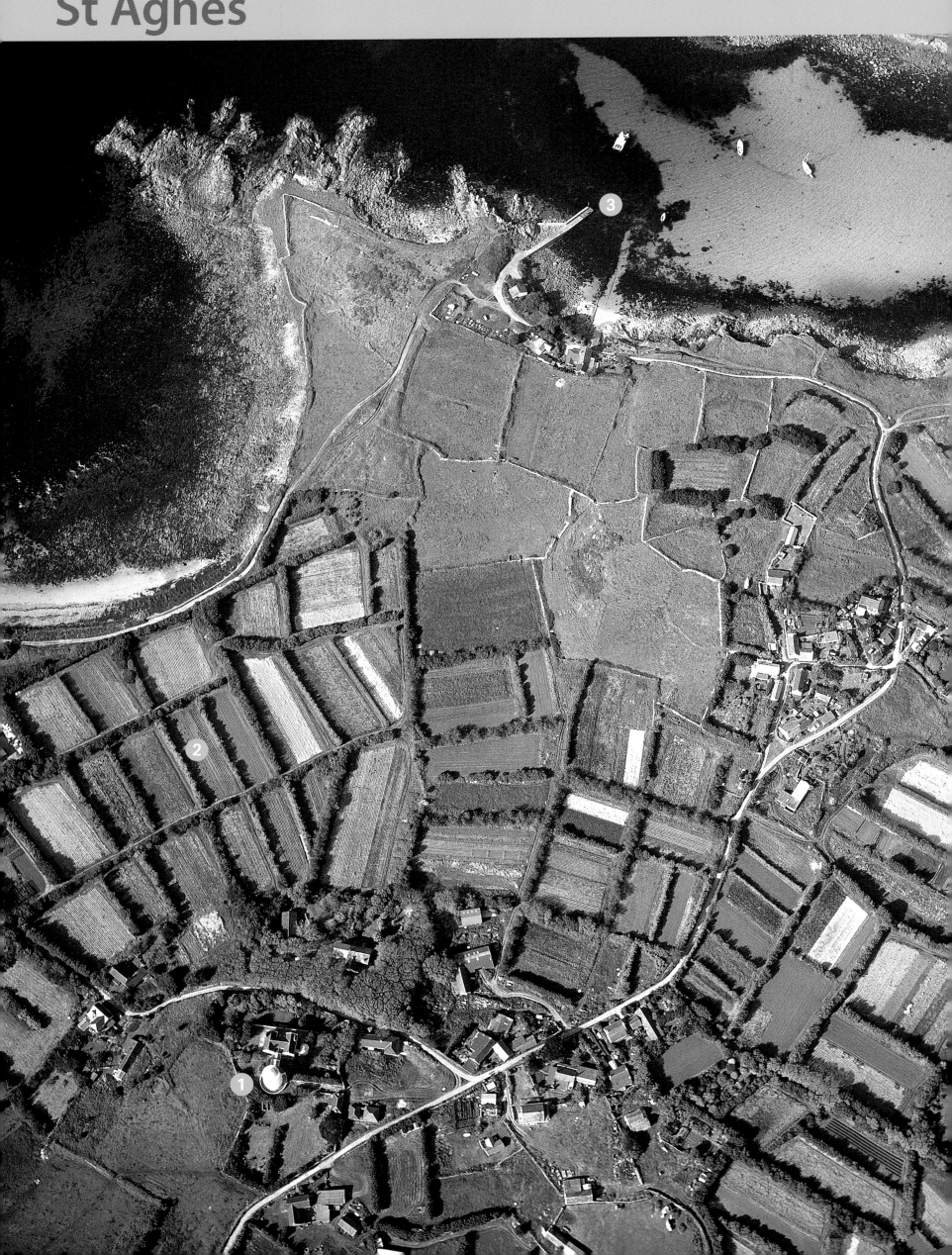

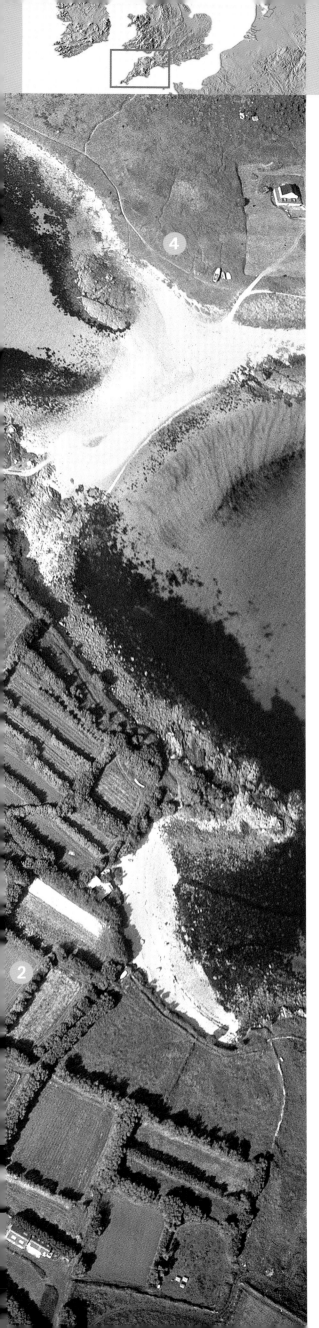

St Agnes

The Isles of Scilly consist of more than 200 granite islands and islets 40km (25 miles) southwest of Land's End, the furthest point west in mainland Britain. St Agnes is one of only five inhabited islands which have a total population of some 2,000. Bathed by the warm waters of the Gulf Stream, the Scillies enjoy a mild climate that could almost be called Mediterranean in the summer. Like the other islands, St Agnes formerly made its living mostly by fishing, but this has given way to tourism and flower-growing. In 1868, William Trevellick, from St Mary's, happened to include a hatbox of cut flowers with his regular consignment of vegetables to Covent Garden in London, thus beginning the present industry. Even today, many islanders continue to make their living by flower farming. They export mostly narcissi and daffodils to the mainland in spring.

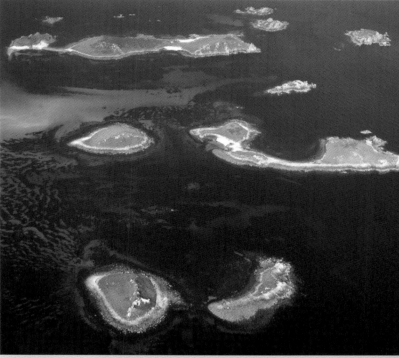

Part of the Scillies' granite archipelago.

① St Agnes Lighthouse

Situated near Middle Town, this is the second oldest lighthouse in Britain: a stone tower approximately 21m (70ft) high, active from 1680 until 1911 when its function was taken over by the Peninnis Head lighthouse. Built for Trinity House, the general lighthouse authority for Britain, the light was much needed, since the Scillies were notorious for shipwrecks, which provided a good living for islanders. Although still owned by Trinity House, the adjacent former lighthouse keeper's dwelling is now leased as a private residence.

② Flower fields

Like other islands in the Scillies, St Agnes makes a large part of its living from growing flowers. The warmth of the Gulf Stream ensures that the flowers bloom here before those on the mainland. The cultivation of the plants occupies the months from October to April, when tourism is at its slowest. The plants are grown in small fields boxed in by sheltering hedges of Pittosporum or Hedge Veronica, both from New Zealand, or Escallonia, from South America. Narcissi and daffodils are the staples of the industry.

③ St Agnes Quay

Boat services to and from neighbouring islands use the small quay, facing onto Porth Conger, the bay separating St Agnes from Gugh on the north side of the sandbar. A good viewpoint is afforded by the Turk's Head which overlooks the quay and is Britain's most south-westerly pub. From April to September these waters feature in gig-racing. Gigs are six-oared boats, designed originally to carry pilots to ships needing navigational assistance in treacherous waters; at one point there were four pilots living on St Agnes. Though gigs are raced elsewhere, the enthusiasm for them here is unequalled, with races held weekly for male and female crews as well as the annual World Championships.

④ Gugh

St Agnes is connected to the islet of Gugh by a sandbar that is only exposed at low tide, revealing a fine beach of white sand. The bay to the south of the sandbar is called The Cove; that to the north is called Porth Conger. Among Gugh's mysterious prehistoric remains are the Old Man of Gugh, a Bronze Age standing stone, and Obadiah's Barrow, a burial site. Like St Agnes, Gugh also possesses cairns (monuments of piled stones) and isolated rocks carved into fantastic shapes by the wind.

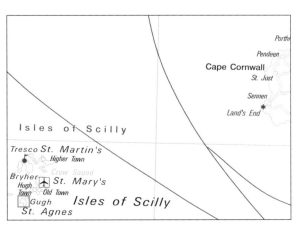

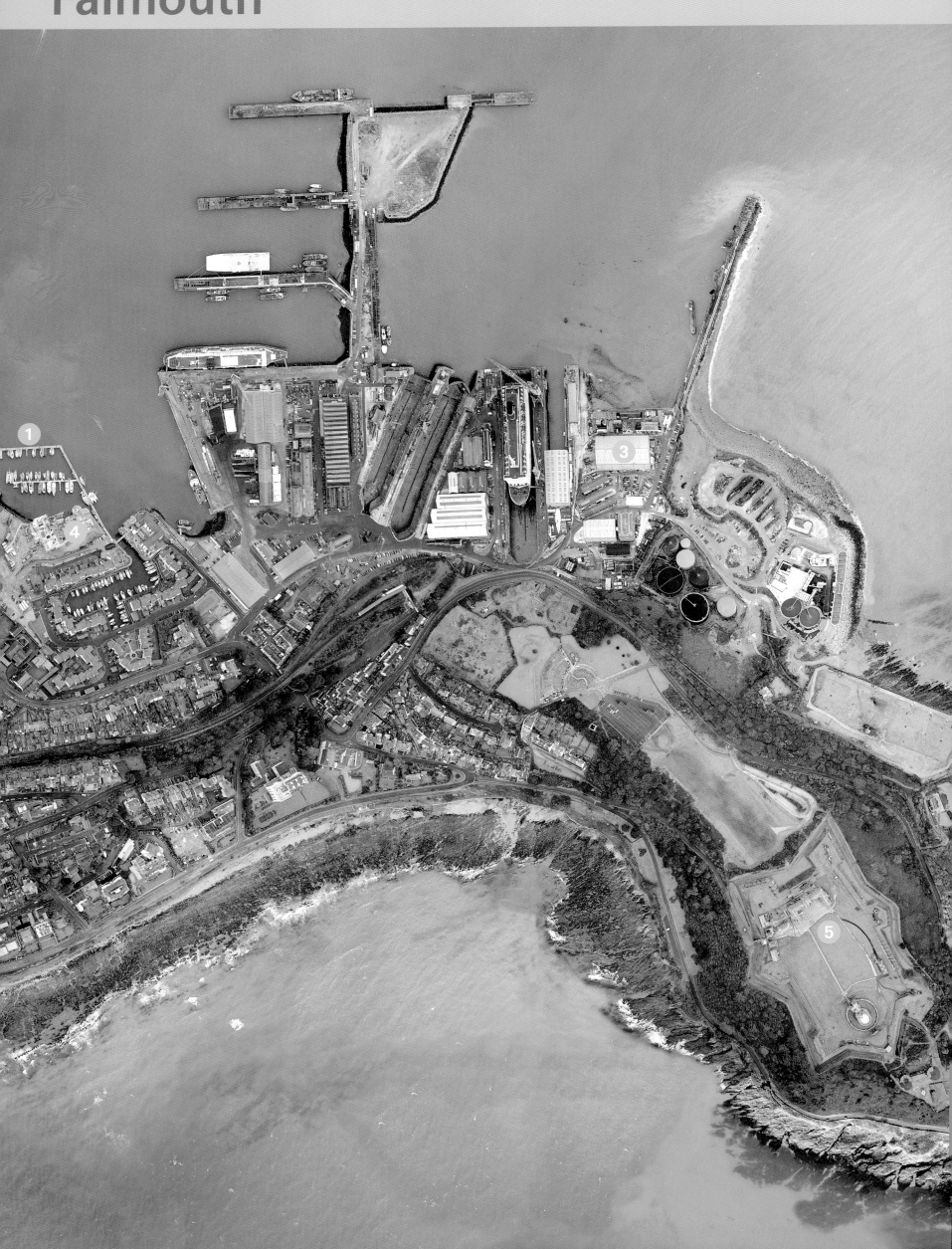

Falmouth

Falmouth is a port town with 21,000 inhabitants. In past times it was mainly dependent upon fishing, but this has been replaced in recent years by tourism. The town developed from a community founded by a local landowner, Sir Peter Killigrew, in the 17th century and received its charter from Charles II in 1661. Falmouth grew in importance as the fishing industry expanded. The railway reached the town in 1863, and its eastern extension can be seen here, stopping just short of the docks. The view in the main photograph shows Pendennis Point, a headland extending east from the town into Falmouth Bay. From the top of the headland, Flushing can be seen to the north and St Anthony Head and the village of St Mawes to the east.

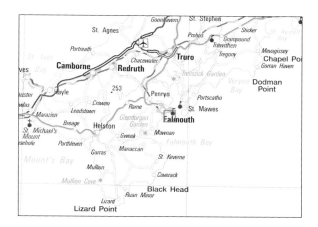

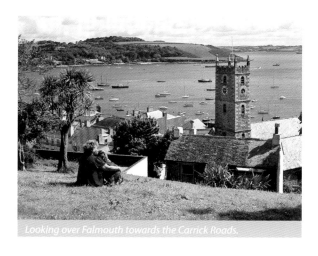

Looking over Falmouth towards the Carrick Roads.

① Port Pendennis Marina

Sailing for sport and for leisure in general is now an important sector of the economy of Falmouth. Many small craft can be seen moored in the basin and alongside the pontoons of the Port Pendennis Marina, adjoining the National Maritime Museum. The marina has been the point of departure and return for many round-the-world yachtsmen and yachtswomen including Ellen MacArthur, who made her record-breaking 71-day solo voyage around the globe between November 2004 and February 2005. The RNLI (Royal National Lifeboat Institution) station is nearby.

② Little Dennis Blockhouse

On the rocks below Pendennis Point, at the very tip of the headland, lies Little Dennis Blockhouse, an artillery fort built in the 1540s. Although now roofless, it still retains its D-shaped ground plan and massive walls. The fort's gunports once commanded the estuary and the open sea.

③ Falmouth Docks

Falmouth possesses the largest natural deepwater harbour in the Northern Hemisphere. An artificial haven is provided for Falmouth Docks by the Eastern Breakwater (jutting into Falmouth Bay at the top right of the main picture) and by a complex of wharves to the west, bearing evocative names such as Empire Wharf and King's Wharf. Vessels can be seen here moored alongside the wharves. Four dry docks extend from the southern side of the main dock.

④ National Maritime Museum

The National Maritime Museum Cornwall was opened in 2002 at Discovery Quay and includes exhibitions on boatbuilding, navigation and the fishing life of Cornwall. One gallery tells the story of the packet service for which Falmouth is famous. The town received a great stimulus in 1688, when it became the Westward Station for the Royal Mail's packet ships carrying mail around the world. The war with France necessitated a new route for ships travelling to Spain, Portugal and the West Indies. The packet service was transferred to Southampton in 1852. The museum also has a lookout tower and an underwater viewing platform with floor-to-ceiling windows looking out over the harbour.

⑤ Pendennis Castle ▽

Pendennis Castle was built by Henry VIII in the 1540s. Since then it has commanded the western side of Carrick Roads, an extensive waterway created when melt waters formed at the end of the Ice Age and caused a sharp rise in the sea level. The resulting natural harbour is navigable from Falmouth to Truro. The castle itself formed part of Henry's South Coast fortifications when he anticipated hostility from Catholic Europe after his break with Rome. Its counterpart on the eastern side is St Mawes Castle. Fortunately, Pendennis Castle was never called on to defend the country against the Spanish Armada, whose attack proved abortive. As a Royalist stronghold during the Civil War, the castle briefly sheltered the Prince of Wales, the future Charles II. It was besieged by the Parliamentarians in 1646 and it held out for six months before becoming the last Royalist stronghold to surrender, except for Raglan Castle in Wales. The castle was refortified during the Second World War.

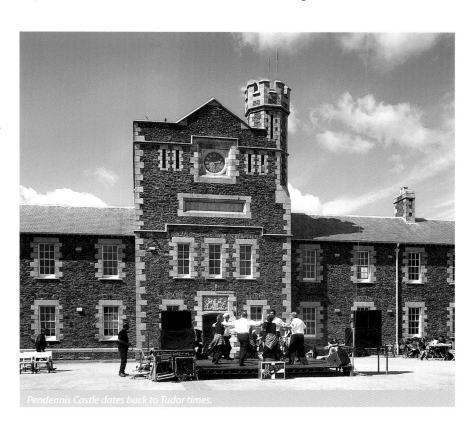

Pendennis Castle dates back to Tudor times.

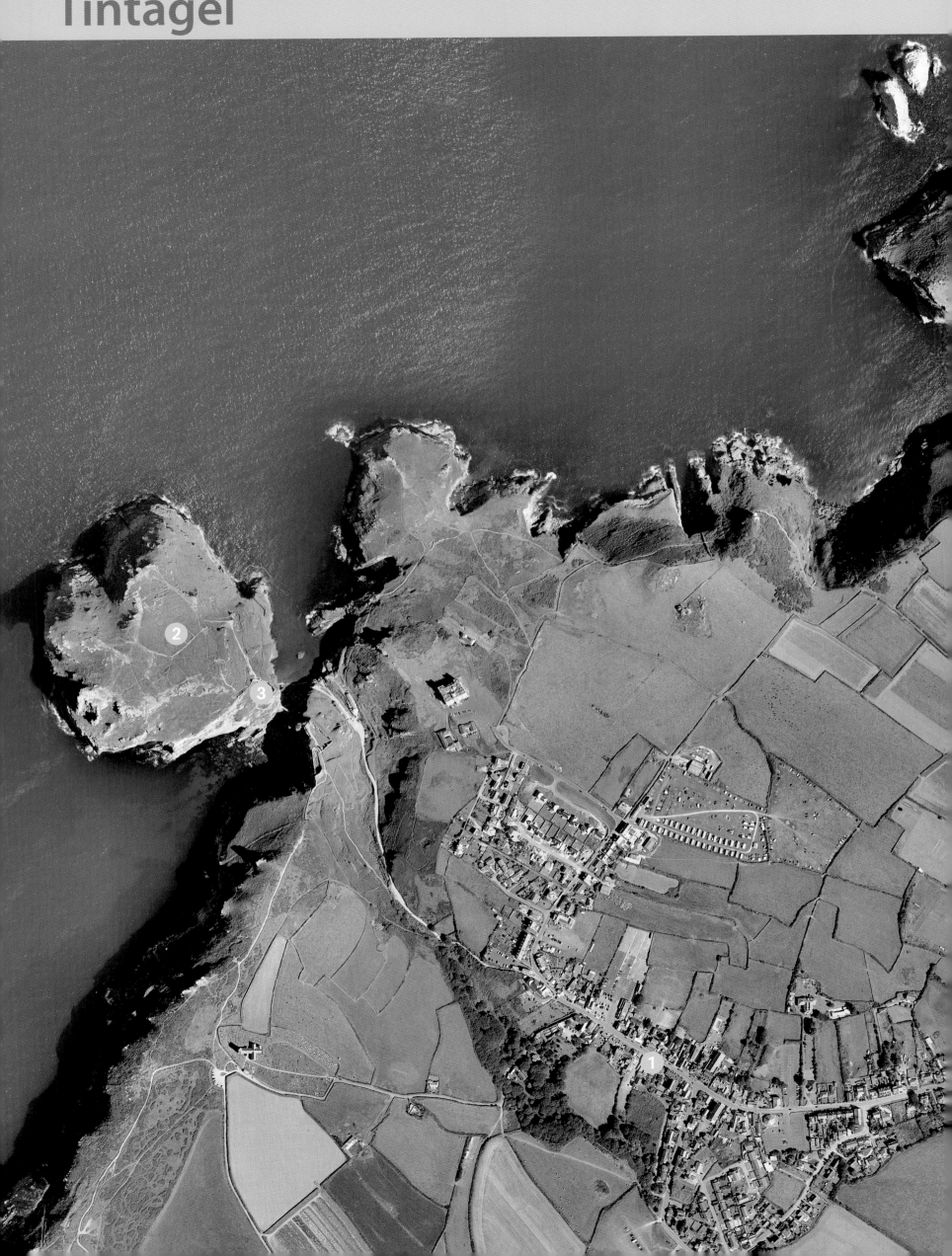

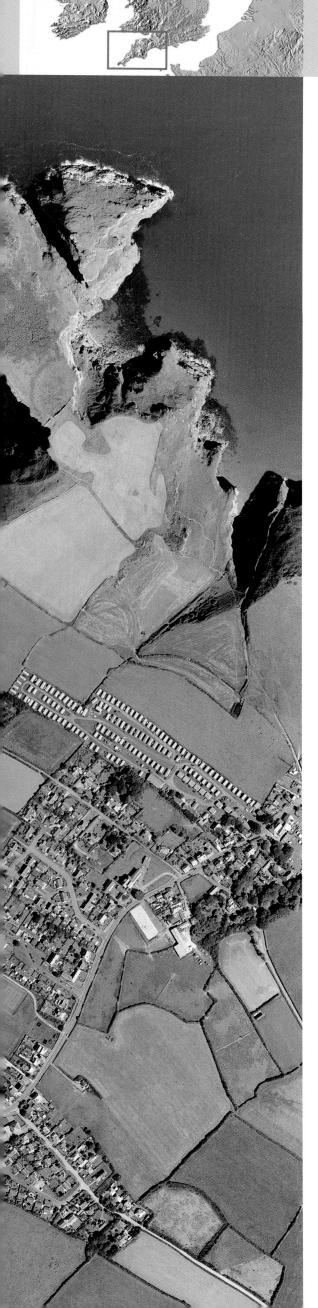

Tintagel

Located on a wild stretch of the Atlantic coast, Tintagel is forever linked with the legend of King Arthur, Lancelot and Merlin. In August 1998, a stone bearing a Latin inscription referring to King Arthur was uncovered at the ancient ruined castle in Tintagel where Arthur was alleged to have been born. Originally Tintagel was the name given to the headland but, in the mid-19th century, the village was renamed to promote tourism based on the Arthurian legend.

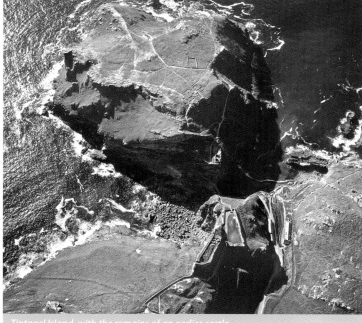

Tintagel Island, with the remains of an earlier castle.

1 King Arthur's Great Halls

The legend of Arthur has been built on flimsy historical evidence. If such a person did exist, he was possibly a 5th-century warlord engaged in resisting Saxon invaders. In the 12th century Geoffrey of Monmouth, author of *The History of the Kings of Britain*, described him as an historical figure; subsequently, many people have been fascinated by Arthur, including a retired London businessman, Frederick Glasscock, who built King Arthur's Great Hall, first opened in 1933. Constructed from stone quarried all over Cornwall, the Halls are dedicated to the legend of Arthur and house a version of the celebrated round table and 72 stained glass windows.

2 Tintagel Island

Twentieth-century excavations, which uncovered a large quantity of Mediterranean pottery, show that Tintagel Island was occupied during the 5th century. At this time it was was still connected to the mainland by a natural causeway. When Geoffrey of Monmouth was writing in the 12th century, erosion had reduced this causeway to 'a narrow isthmus of rock'. Monmouth described the castle as being 'built high above the sea, which surrounds it on all sides'. The connection to the mainland was so narrow that it was said 'three armed soldiers could hold it…even if you stood there with the whole of the kingdom of Britain at your side'. In the 16th century it could only be approached by a bridge made of elm and today the castle can be reached by a steep climb up a hundred rock-cut steps.

Two tunnels run beneath Tintagel Island. The shorter tunnel was produced using metal tools and opens out in the meadow above the cliffs. The larger, known as Merlin's Cave, has been created through tidal erosion. According to local legend, the wizard can still be heard in the cave.

3 Tintagel Castle

The ruins of Tintagel Castle reveal several phases of development on the island, and include the remains of an entrance on the mainland. Popularly known as King Arthur's Castle, it is in fact a Norman fortress, most of which was constructed in the 1230s on the probable site of a Roman settlement by Prince Richard, Earl of Cornwall, the younger brother of Henry III.

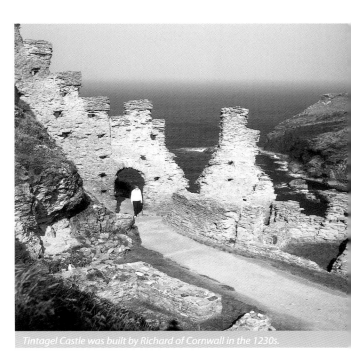

Tintagel Castle was built by Richard of Cornwall in the 1230s.

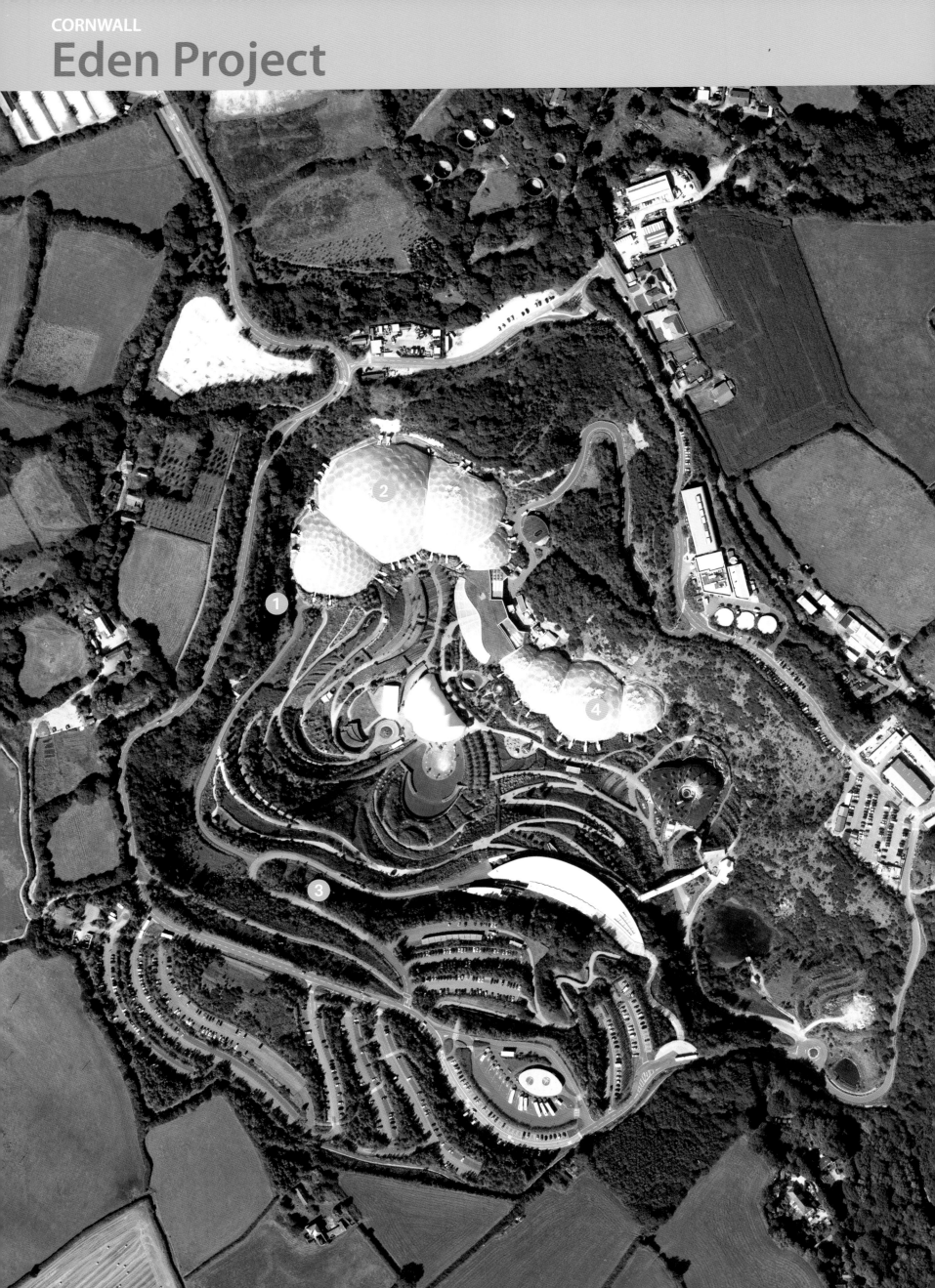

Eden Project

An environmental theme park and educational centre near St Austell, the Eden Project opened in March 2001. It was an immediate hit, welcoming nearly 2 million visitors in its first year. The park contains two vast enclosed conservatories or biomes, made of steel tubing and bubbles of clear plastic. They recreate the natural environments of the tropical rainforest and of warm temperate lands like those in the Mediterranean region. Developed by Anglo-Dutch entrepreneur Tim Smit in disused china clay pits over three years at a cost of £86.5 million, the project recouped this outlay in its first two years.

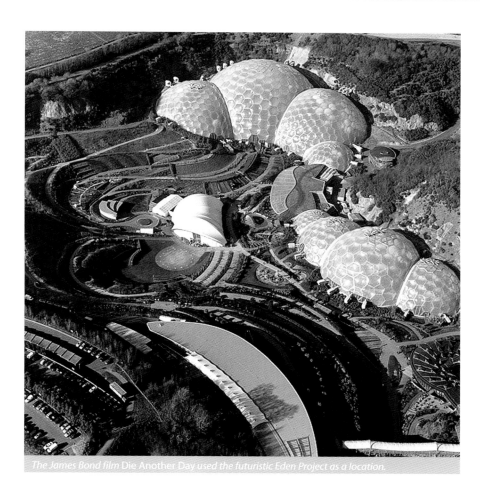

The James Bond film Die Another Day used the futuristic Eden Project as a location.

1 China Clay Pits

When Smit and the other members of the Eden development team bought the recently abandoned Bodelva china clay pits near the village of St Blazey in 1998, the site was a vast hole more than 60m (200ft) deep. Moving 1.8 million tonnes (1.9 million tons) of earth in just six months, they landscaped the area, installed an underground drainage system and added 2,000 rock 'anchors' to stabilise the slopes. The development is so large that, for people unable to walk the distance, a train runs from the visitor centre at the entrance down to the lake adjoining the large biomes at the bottom of the site.

2 Rainforest Biome

The Rainforest Biome is the world's largest greenhouse: 50m (160ft) high, 110m (360ft) wide and 240m (790ft) long. More than a thousand plant species thrive inside, in a recreation of the rainforests of tropical South America, the Oceanic Islands, West Africa and Malaysia. Pathways lead among the carefully labelled plants, with educational exhibits, footbridges over waterways and benches for those overcome by the temperature, which is maintained between 18°C and 35°C, increasing with the height inside the dome. All the rain falling on the outside of the steel and plastic structure is recycled within; irrigation, waterfalls and artificial misters reproduce the moist conditions prevalent in the rainforests, where typical rainfall is 1,500mm (60in) every year.

The Malaysian area contains a timber, rattan and bamboo house set within a recreation of a typical Malaysian home garden growing herbs, flowers, vegetables, rice and fruit as well as the horseradish and neem trees. Beyond the garden grows an elegant Bo tree of the kind that the Buddha reputedly settled beneath in northern India when he discovered enlightenment through meditation.

The Tropical Islands section contains examples of rare protected plant species including the St Helena Ebony, believed to be extinct for more than a hundred years until two examples were discovered in 1980. The section also includes the remarkable Coco-de-Mer palm from the Seychelles; it has the world's largest seed, which resembles the human bottom. Two of its rare seeds were donated to Eden by the Seychelles government: one has been planted in the Tropical islands section and the other can be viewed in the project's 'peepshow' attraction. Plants from outside the EU are quarantined at a nursery to comply with regulations for the control of pests and disease.

3 Outdoor landscape

A carefully planted and maintained outdoor landscape – or 'roofless biome' – features the plants that thrive in cooler temperate regions such as Britain, parts of America, Russia and the foothills of India. This includes a section recreating the tall grasses and wild flowers of the American prairies; one celebrating the steppes of Central Asia and Eastern Europe; and an outdoor Mediterranean area growing plants such as agave and sisal. Many of the plants for this landscape are grown from seed at the Eden Project Nursery on a 5-hectare site at nearby St Blazey.

4 Mediterranean Biome

A second, smaller biome recreates the hot, dry summers and cool, wet winters of temperate areas such as the Mediterranean region, parts of California and South Africa, Chile and South-West Australia. In this biome the soil is dry and dusty; shrubs outnumber trees; and many plants have small, hairy leaves, spines or waxy evergreen leaves that develop in the wild as protection against the summer sun. The temperature is kept in the range 15–25°C in summer and no lower than 9°C in winter. The Mediterranean section contains terraced olive groves while the South Africa section contains a recreation of the Fynbos, an area of 46,000 sq km in the Cape that includes 7,000 plant species, some 5,000 of which are unique to the region. The California section recreates areas of chaparral grasslands, containing the scrub oak or 'chaparro'.

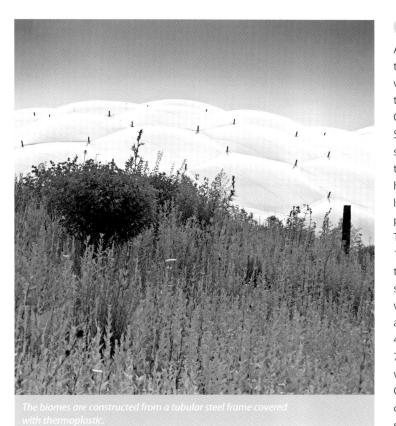

The biomes are constructed from a tubular steel frame covered with thermoplastic.

Glastonbury Festival

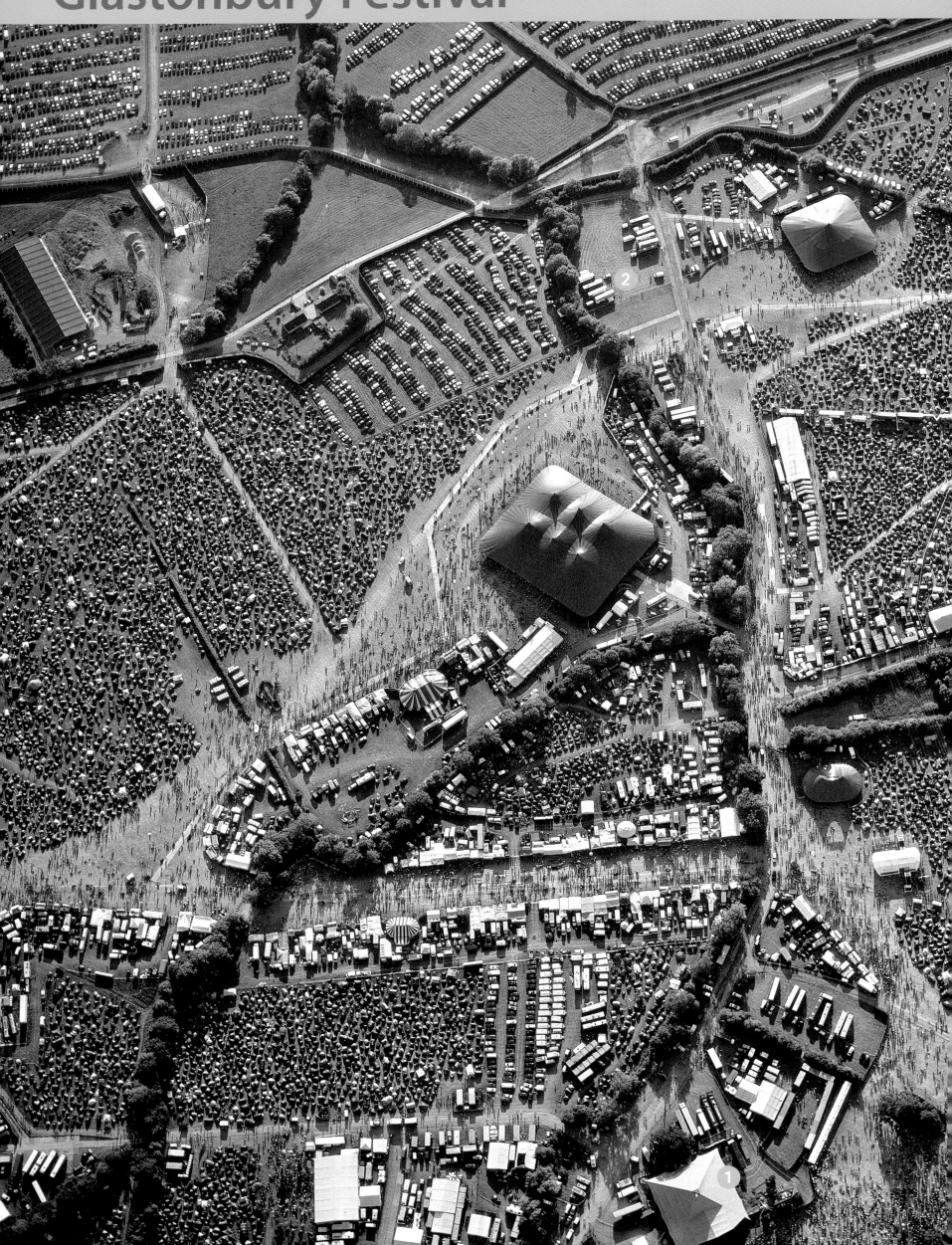

Glastonbury Festival

The first Glastonbury Festival – the Pilton Pop Festival – took place in 1970. It was a three-day event held on a Somerset dairy farm and was the brainchild of farmer Michael Eavis. Inspired by the Bath Blues Festival, he decided to host an event at Worthy Farm near Glastonbury. The first festival attracted 2,000 people who came

to listen to Marc Bolan and drink free milk. Although initially not a financial success, Glastonbury has since become an institution, giving its profits to charity.

❶ The Pyramid ▽

The first Pyramid stage was built in 1971, on a spot considered to make the most of the natural energies felt at Worthy Farm. The area around Glastonbury is rich in legend and religious connections; Glastonbury Abbey was an important place of pilgrimage in the Middle Ages. The performers during that first year included David Bowie, Fairport Convention and Joan Baez.

A permanent Pyramid stage was built in 1979, designed to have a parallel function as a barn the rest of year. This was destroyed by fire in 1994 and the present structure was built in 2000.

❷ Worthy Farm

Worthy Farm is situated close to the small village of Pilton, originally a harbour and, according to legend, the place where Joseph of Arimathea landed in Britain. In 1985 Glastonbury Festivals Ltd acquired an extra hundred acres from neighbouring Cockmill Farm.

Michael Eavis at Worthy Farm in 2009.

Michael Eavis △

Michael Eavis has been central to Glastonbury. In 1979, he put his livelihood on the line when, in order to provide financial backing, he obtained a bank loan on the security of his farm. Since 2000, the Glastonbury Festival has raised more than £1m each year for charities and local causes such as Oxfam, Water Aid and the Sudan Appeal. In June 2010, Michael Eavis celebrated the festival's 40th year by appearing on stage with the American singer Stevie Wonder.

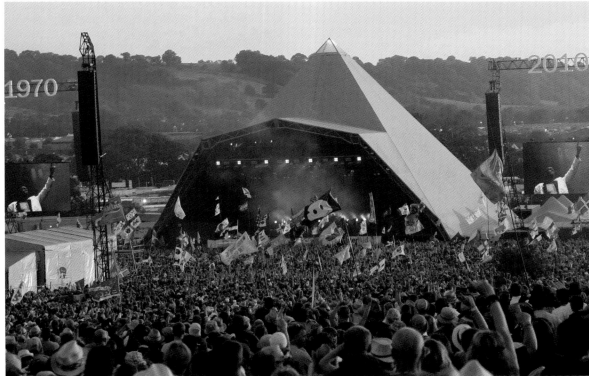

Glastonbury's anniversary festival in 2010 was held from June 23 - June 28 and experienced the hottest average temperatures since the early 1990s.

Overleaf: the Bristol Balloon Fiesta.

THE CHANNEL ISLANDS

1. St Helier
2. St Anne
3. St Peter's Port
4. Herm
5. Sark

English Channel

Weymouth 3.25h
Guernsey-Weymouth 2.5h
St. Malo-Weymouth 5h
Bournemouth 2.5h
Poole 4h
Bournemouth 4.5h
2.5-4.5 h
Portsmouth
Portsmouth
Portsmouth
6.5 h
9h
5-9 h

Rosslare 17h
Bilbao 30h

Quesnard Pointe
Alderney
Ste-Anne
Nez de Jobourg

Channel Islands
(Great Britain)

Cap de la Hague
Goury
Auderville
Omonville-la-Rouge
Créville-Hague
Jobourg
Urville-Nacqueville
Cap Lévi
Fermanville
Gatteville-le-Phare
Pointe de Barfleur
Herqueville
Beaumont-Hague
Querqueville
Barfleur
Vauville
CHERBOURG, OCTEVILLE
Tourlaville
St-Pierre-Eglise
Biville
La Glacerie
Le Vast
121
Pointe de Saíre
Île de Tatihou
Martinvast
Le Theil
Quettehou
St-Vaast-la-Hougue
Helleville
Delasse
Dielette
Flamanville
Valognes
Quinéville
Cap de Flamanville
Les Pieux
·132
Quettetot
Les Gougins
Pointe du Rozel
Bricquebec
Montebourg
Ravenoville
Surtainville
Colomby
Utah Beach
La Madeleine
5
Orglandes
40
Grandcamps-Maisy
Masse de Romond
99
Ste-Mère-Eglise
Ste-Marie-du-Mont
Barneville-Carteret
St-Sauveur-le-Vicomte
Pont l'Abbé
Chef-du-Pont
Osmanville
Carteret
Ste-Côme-du-Mont
Isigny-sur-Mer
Portbail
Baupte
Catz
La-Haye-du-Puits
130
Mont Castre
St-Jores
Carentan
St-Patrice-de-Claids
St-Germain-sur-Ay
Sainteny
Airel
Lessay
Tribehou
St-Jean-de-Daye
Périers
Pont-Hébert
St-Sauveur-Lendelin
Les Champs de Losque
St LÔ
Agneaux
Gouville-sur-Mer
Montsurvent
Le Mesnil-Vigot
Marigny
Gratot
Canisy
St-Samson-de-Bonfossé
Coutances
Cerisy-la-Salle
Dangy
Agon-Coutainville
Tourville-s.-Sienne
Montmartin-s.-Mer
Le Mesnil-Herman
Roche de Ham
Pointe d'Agon
Notre-Dame-de-Cenilly
Villebaudon
Tessy-s.-Vire
Hauteville-Plage
Quettreville
Hambye
Mont Robin
276
Percy
Lengronne
Anc. Abb. d'Hambye
Îles Chausey
St-Martin
Cérences
Gavray
188
Villedieu-les-Poêles
Grande Île
Bréhal
Ver
Montaigu-les-Bois
Beauchamps
Granville
Donville-les-Bains
Pointe du Roc
La-Haye-Pesnel
St-Pair-s.-Mer

Guernsey
Vale
Côbo Bay
St-Sampson
St Peter Port
Herm
St-Martin
Sark
Icart Point

Passage de la Déroute

Jersey
St-John
Trinity
St-Peter
St-Martin
Jersey
St-Aubin
Mont-Orgueil
Gorey
St-Brelade
St-Helier
St-Clément
La Rocque Pointe
1 h
2 h
1.25 h
St. Malo
St. Malo

C O T E N T I N
Douve
Douve
Taute
B A S S E - N O R M A N D I E
FRANCE

66 The Best of Britain & Ireland – from the Air

1:600,000

0 5 10 15 20 25 miles
0 5 10 15 20 25 km

St Helier

Jersey's capital is named after the 6th-century saint, who was born in Gaul and believed to have lived on Hermitage Rock, near where Elizabeth Castle now stands; he was reputedly beheaded by marauding pirates. Today, the town is a tourist centre and working port with a daily fish market.

① Island Fortress Occupation Museum

Jersey's proximity to France made it a target for invasion during the Second World War and the Island Fortress Occupation Museum charts the island's experience of occupation and privation. The museum also houses a collection of rare motorbikes, contemporary vehicles and military paraphernalia.

② Elizabeth Castle

Sir Walter Raleigh named Elizabeth Castle after Elizabeth I, while he was Governor of Jersey. The castle was built on a small islet in St Aubin's Bay as a 16th-century replacement for Mont Orgueil, which had become vulnerable to the newly adopted cannon. But since the causeway from Elizabeth Castle was cut off from Jersey by the tide, it was a poor site for defence. After French troops realised this and captured St Helier in 1781, another castle was built above the town. Since 1923, when it was sold to the Jersey government, the castle has been a public monument, although it was used by German forces during the Second World War. It currently houses a local museum and is a conference venue as well as a popular place for weddings and other celebrations. At low tide Elizabeth Castle can be accessed by foot.

③ States Chamber

As a British Crown Dependency, Jersey is governed by an appointed governor, and a parliament of elected members called the States Assembly. During the 18th and 19th centuries the assembly met in the Royal Court House, a 12th-century building. But in 1887 the States Chamber was opened, and is now the permanent venue for all significant States meetings. It is decorated in a Jacobean style, lined with oak and plaster carved panels, and is located on the south side of the spacious Royal Square, alongside the Royal Court. The Jersey £20 note shows the States Chamber alongside Queen Elizabeth II.

Guernsey, Alderney, Herm and Sark

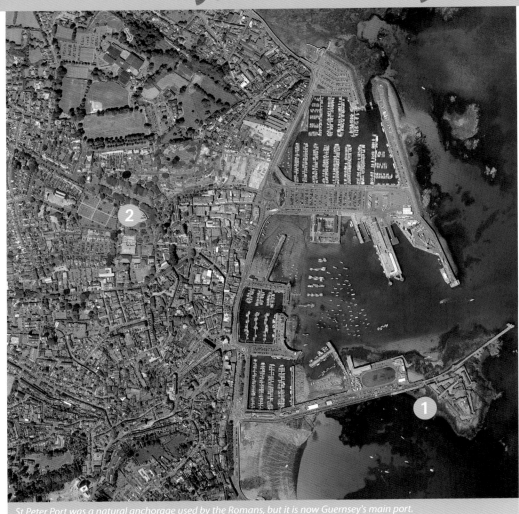

St Peter Port was a natural anchorage used by the Romans, but it is now Guernsey's main port.

Guernsey, Alderney, Herm and Sark

Guernsey is the second-largest of the Channel Islands while Herm, at barely 2.5km (1.5 miles) long, is the smallest. Alongside Alderney and Sark the islands are all dependencies that share a history of allegiance to the British Crown but independence from the British state. The islands lie west of the Cherbourg peninsula of the Normandy coast and are located closer to France than to Britain.

① Castle Cornet, St Peter Port, Guernsey

Castle Cornet is named after the rock on which it has stood since the mid-13th century. Originally an isolated English stronghold protecting Guernsey from the constant threat of attack from France, it was not until the 19th century that it was connected to the mainland by a breakwater and bridge. Much of the original castle was destroyed in 1672 as the result of an accidental gunpowder explosion during a thunderstorm, and by the late 1700s its role as a garrison was largely taken over by Fort George, at the other, southern end of St Peter Port. During the Second World War, the occupying German forces modified the building to accommodate modern artillery. George VI donated the castle to the Islanders of Guernsey in 1947 and it has been a tourist attraction ever since, currently housing four museums relating to its history.

St Anne is the main parish of Alderney and it also doubles as the main town.

② Guernsey Museum and Art Gallery

Located in the Victorian Candie Gardens, the Museum and Art Gallery has a commanding position looking out over the sea. Opened in 1978, its innovative design incorporates an original cast iron bandstand from the pleasure gardens in its structure. In addition to temporary exhibitions the museum has a number of items that trace the history of Guernsey, as well as information on the island's wildlife and geology. The gardens are a rare example of 19th-century pleasure grounds and include two large statues, of Queen Victoria, and the French novelist Victor Hugo who was exiled to Guernsey between 1855 and 1870.

③ The Breakwater

Alderney's harbour in Braye Bay is exposed to ocean swells, so in 1847 the Royal Navy began constructing a long breakwater to provide a safe anchorage large enough for the entire Channel fleet if necessary. Building was painfully slow and was finally abandoned in 1872, since steamships had replaced sailing vessels and such harbours of refuge were no longer required. Today, only the last 870m (2,855ft) are currently maintained but the breakwater still provides essential protection to the harbour that underpins Alderney's economy.

④ Alderney Museum

Alderney's Museum is open in the summer months and is run by volunteer members of the Alderney Society. Originally housed in the basement of the Island Hall, since 1969 the museum has been based in the former St Anne's School building, built in 1790 in the island's main settlement, St Anne. The collection contains more than 12,000 items; these include coins from a 4th-century Roman fort, a rudder excavated from an Elizabethan shipwreck, and memorabilia from the time of the island's occupation in the Second World War.

⑤ Shell Beach, Herm

Herm's reputation as an island paradise comes from its clean sandy beaches, rock pools and the wild flowers along its clifftop paths. The island's chief source of income is tourism and Shell Beach, a stretch of golden sand 1km (¾ mile) long near Alderney Point, is one of its major attractions. As its name suggests the beach is made up of millions of small shells washed up by the Gulf Stream.

⑥ Manor House, Herm

The 15th-century Manor House, with its castellated exterior and well-preserved 10th-century chapel, is home to Herm's small school and is situated at the centre of this small community of less than a hundred permanent residents. Until 1737 the Manor was used by the governors of Guernsey while visiting the island for recreational hunting. After that Herm was quarried for its rich granite resources and was then rented by the Crown to Prince Blücher, grandson of the Prussian field marshal who had fought at Waterloo. Blücher, who introduced a colony of wallabies to the island, made the Manor House his home, as did the next tenant, the comic novelist Compton Mackenzie. The subsequent tenant, Sir Percival Perry, a chairman of the Ford Motor Company, appropriately enough introduced the first car to the island. Today neither cars or bicycles are allowed.

⑦ La Seigneurie, Sark

Sark is owned by its hereditary Seigneur, who holds it from the British Crown, making it the last remaining feudal state in the world. The family of the present Seigneur, Michael Beaumont, have owned Sark since 1852. The family's residence is the Seigneurie, a late-17th century mansion built on the site of the 6th-century monastery of St Magloire, the island's earliest recorded inhabitant. The house was extended in the 19th century, when a watchtower was also added. Until the view was obscured by trees, the islanders could signal to nearby Guernsey from this watchtower.

⑧ Sark Cliffs

Contrasting with the sandy beaches found on other Channel Islands, Sark is a natural rampart surrounded by cliffs, averaging 90m (300ft) high, all around its 65km (40 miles) coastline. Above the cliffs, the ground is gently rolling, and the island's high point is only some 25m (75ft) above the clifftops. This means that plant and animal species have been unusually isolated since glaciers retreated some 8,500 years ago. The cliffs are a haven for a wide variety of birds, including Manx shearwaters, common guillemots and peregrine falcons. The absence of motor vehicles on Sark has helped by reducing pollution.

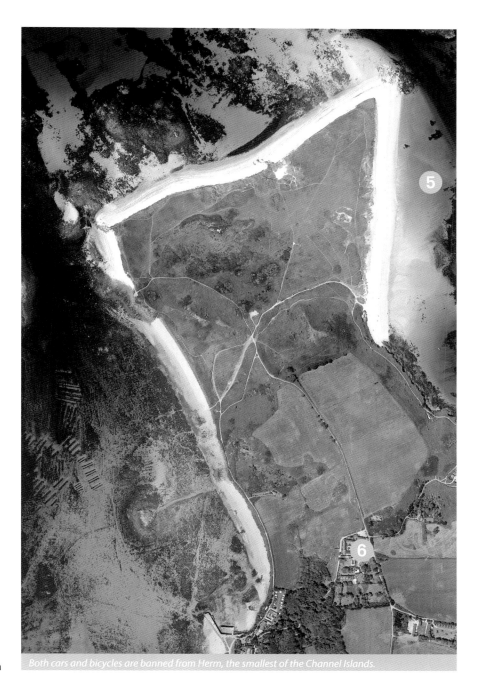

Both cars and bicycles are banned from Herm, the smallest of the Channel Islands.

The island of Sark is divided into two areas: Little Sark and Greater Sark.

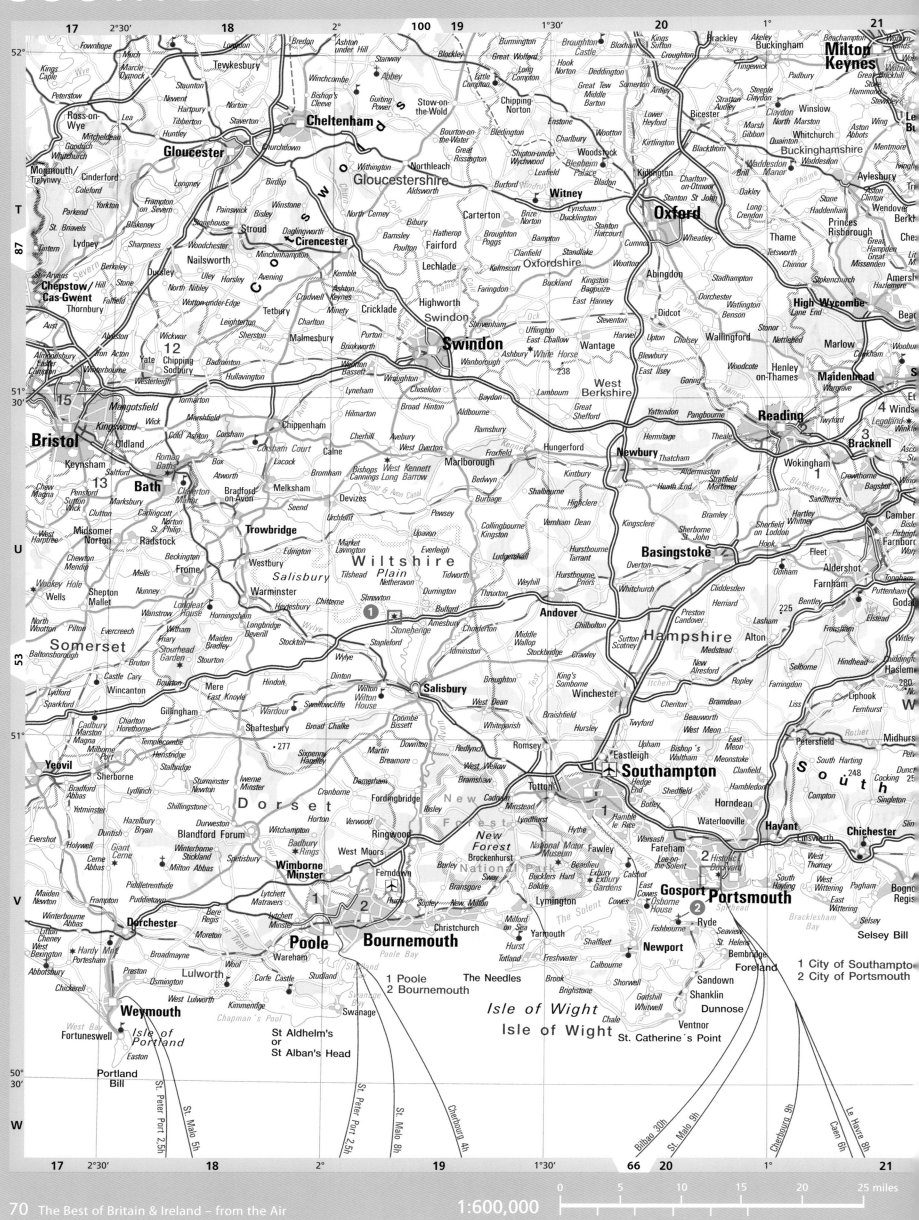

1:600,000

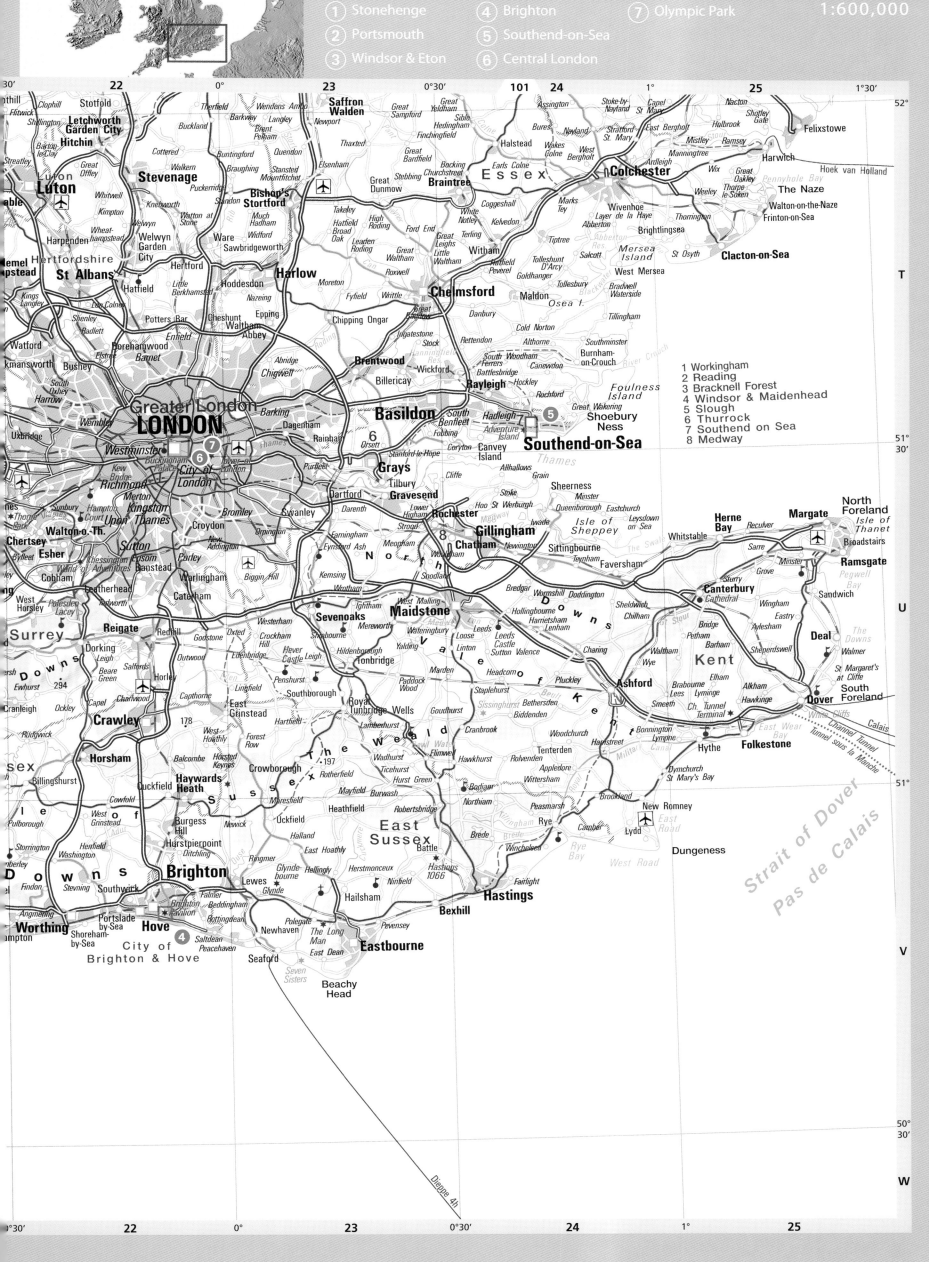

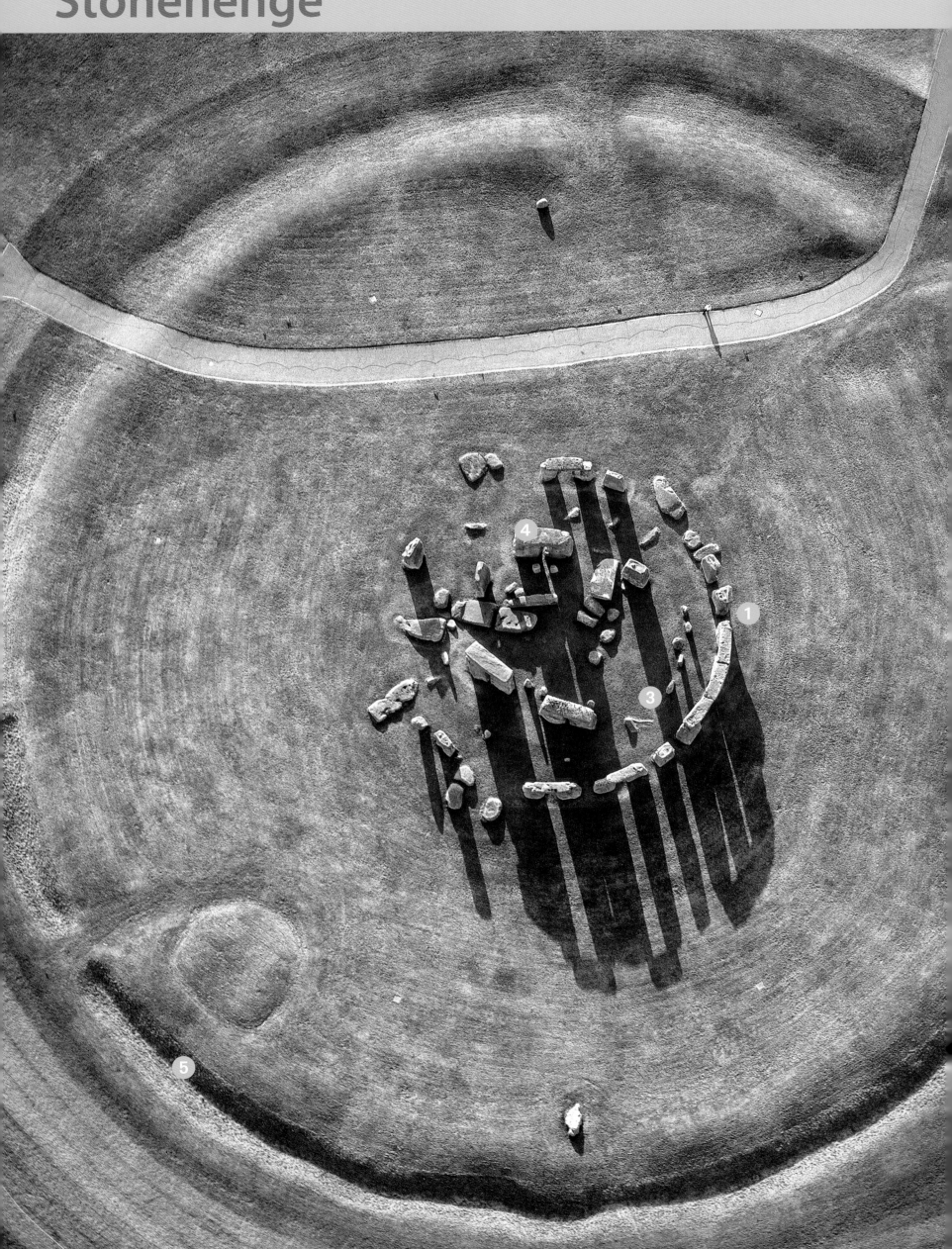

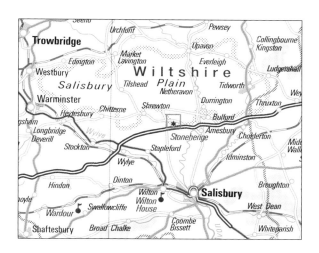

Stonehenge

Set high on the rolling expanses of Salisbury Plain, Stonehenge is an English icon, a symbol of the mysteries of ancient religion and the past's enduring power to surprise and enthral. The stone circle and earthworks visible today are the ruins of structures erected in three main stages between 3000 BC and 1500 BC. How and why Stonehenge was built remains unclear. The site may once have been a temple, an elite burial ground or an astronomical observatory. Investigations carried out in 2009 resulted in the discovery of a new henge in 2010.

1 Stone circle ▷

Thirty vast sarsen stones brought 30km (20 miles) from the Marlborough Downs to the north were erected in a circle and capped with stone lintels in around 2000 BC. Seventeen of these uprights are still standing, some with their original lintels. The sarsens are as much as 9m (30ft) in length and weigh up to 45,000kg (50 tons). Skilled workers used stone hammers to smooth the rough surface of the rocks and to cut the mortise-and-tenon joints that connect the uprights to the lintels. The lintels themselves were curved to form a continuous circle and were fitted together using tongue-and-groove joints.

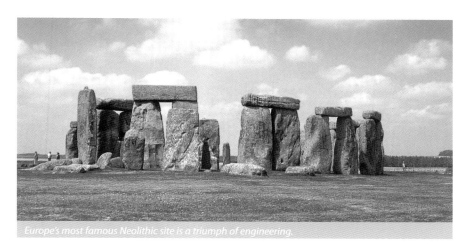

Europe's most famous Neolithic site is a triumph of engineering.

2 Northeastern entrance

An entrance in the northeastern part of the circle is aligned to the point on the horizon where the sun rises at the midsummer solstice. Two parallel stones were raised to mark the entrances; one of these survives, now fallen and known as the 'Slaughter Stone'. Arranged around the inner edge of the circle is a series of 56 shallow holes. These were discovered by the 17th-century English antiquarian John Aubrey and are called the 'Aubrey holes'. They were not used to hold posts or stones but as burial spots for cremated human remains, perhaps as part of a ceremony to dedicate the site after the completion of the first henge.

Between 2900 and 2400 BC, labourers added wooden structures to Stonehenge. Archaeologists have found holes used to hold wooden posts in the middle of the Stonehenge site and at the northeastern entrance, which was widened at this time so that it was in line with the midsummer sunrise and midwinter sunset at this period. They may have supported wooden temples or other buildings, or they may have been freestanding religious totems.

The first stones were raised at Stonehenge around 2600 BC. Eighty pillars of blue stone, specially transported from the Preseli Mountains in southwestern Wales, a distance of 385km (240 miles), were put up in a double crescent within the earthen bank and henge. The bluestones weighed as much as 3,600kg (4 tons) each. They were transported by sea and river, but were dragged overland for the last mile and a half by labourers using wooden rollers. The entrance to the bluestone crescent was aligned to the sunrise at the summer solstice. A new approach (the Avenue) was built along this alignment. The bluestones were later taken down and rearranged (see below). Most have since been removed from Stonehenge.

4 Trilithons

Within the stone circle the labourers arranged a horseshoe design of five 'trilithons', each consisting of a pair of sarsen uprights and a stone lintel. Some of the stones in the circle and the trilithon arrangement had designs resembling axes and daggers cut into them. The trilithons were raised in around 2000 BC.

5 Earthwork enclosure

The first construction at Stonehenge was a roughly circular bank and ditch (or henge) about 98m (320ft) in diameter which is still visible around the outer edge of the site. Labourers dug the structure using deer antlers as tools. The rubble they dug up was used to build the bank within the circle of the henge.

3 Bluestones

Around 1550 BC about 20 of the Priseli Mountain bluestones were put up within the sarsen circle, in a horseshoe pattern, while the other 60 bluestones were put up in a circle just within the circle of sarsen stones, the arrangement duplicating the pattern. The largest bluestone, now fallen, survives and is known as the 'Altar Stone'.

In the last piece of ancient construction work around 1100 BC, the avenue that leaves the main Stonehenge site to the northeast was extended in an easterly and southeasterly direction and as far as the River Avon around 2,780m (1.7 miles) away.

Stonehenge and the circular monument at Avebury about 30km (18.5 miles) to the north were collectively declared a UNESCO World Heritage site in 1986. The monuments lie within a landscape that was used as a burial ground for more than 1,000 years. Ten communal burial chambers, or long barrows, were built near Stonehenge between 4000 and 3000 BC. In the Bronze Age (2000–700 BC), 348 round barrows were built in the area to house the remains of local chieftains.

Today 800,000 visitors come to Stonehenge and the surrounding area each year to gaze in awe at the vast prehistoric stones, to wonder at the advanced technology required to manoeuvre such vast pillars, and to try to imagine the skill needed to align the structure so precisely to the ancient midsummer sunrise. Popularly associated with the Druids (ancient Celtic prophet-priests), Stonehenge was in fact completed about 800 years before the first historical records of the Druids in around 300 BC. This did not deter groups of revivalists from holding ceremonies at the site; to this day, many people gather each year to celebrate the summer solstice.

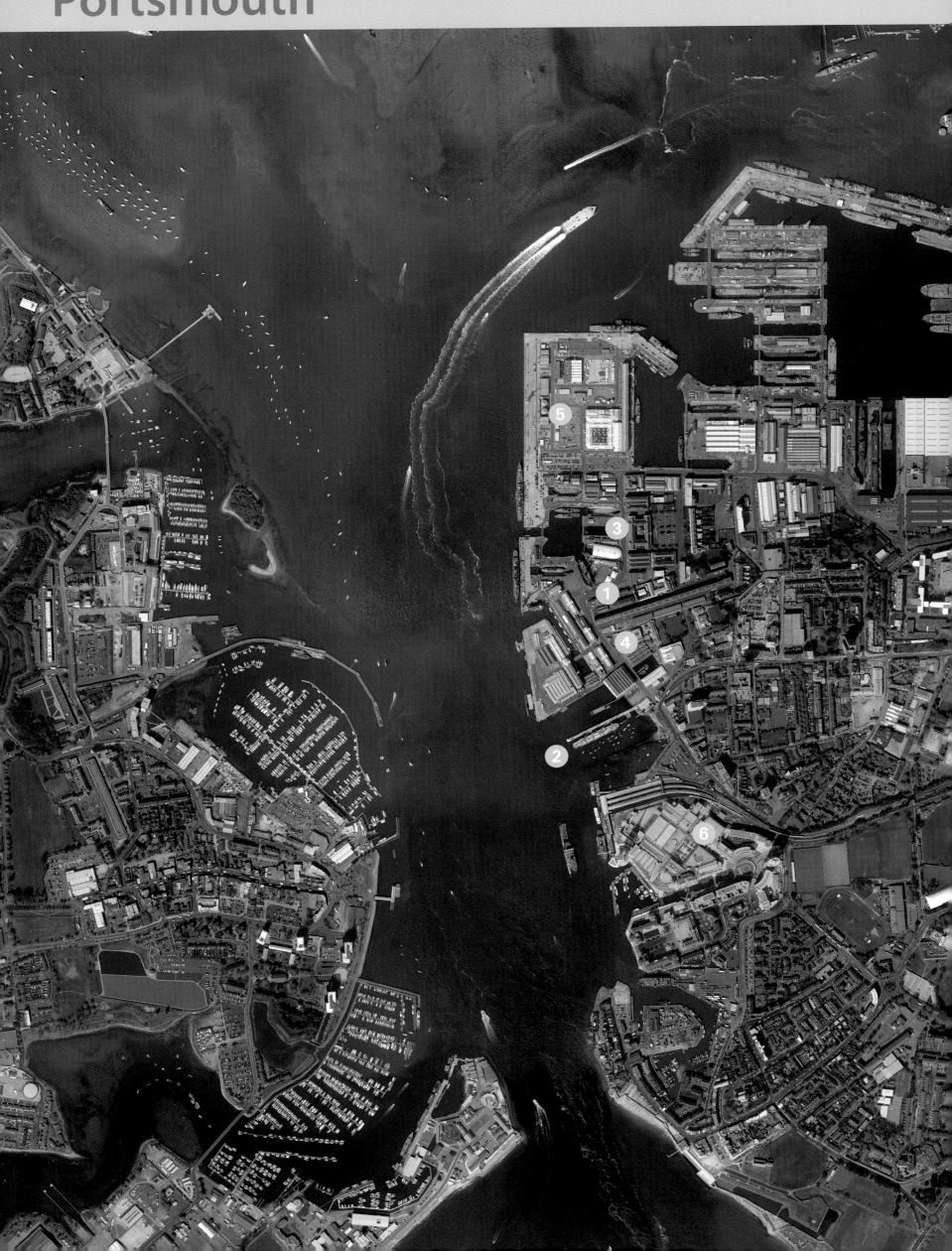

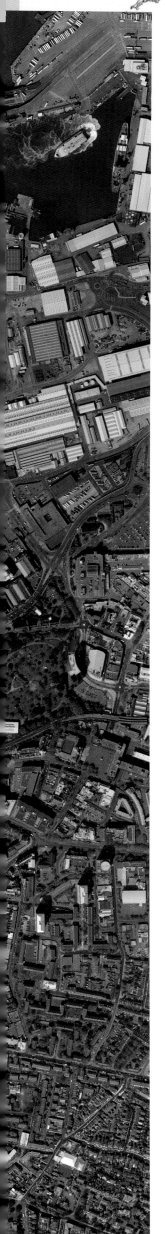

Portsmouth

There can be few naval heritage sites anywhere in the world that have played such a vital role in a nation's history, and which continue to hold such a grip on the national imagination, as Portsmouth's historic dockyard. Home to HMS *Victory*, Admiral Nelson's flagship at the battle of Trafalgar in 1805, today the dockyard is the home of the National Museum of the Royal Navy. The historic buildings all around have played a central role in the development of the Royal Navy. The dockyard also houses King Henry VIII's capsized flagship the *Mary Rose*, and HMS *Warrior*, a steam-powered, iron-clad warship. The continuity of this heritage can still be seen in the constant arrivals and departures of the modern 'ships-of-the-line' of the Royal Navy.

① HMS *Victory*

Admiral Nelson's flagship at the battle of Trafalgar on October 21, 1805 is the world's oldest commissioned warship. Nelson died in the 'orlop' below decks after being fatally wounded. Launched at Chatham in 1765, the *Victory* was already an elderly ship by the time of Trafalgar, and was saved for the nation by a campaign led by the wife of Captain (later Admiral) Hardy. Weighing 2,162 tons, 70m (227.5ft) long, built mainly of oak and with 100 guns and a crew of more than 800 men, she had seen active service off France and Portugal in 1797. Today she provides a unique opportunity to see conditions in a naval ship during the Napoleonic War. She has been in a dry dock since 1922 to ensure her preservation, and was opened to the public in 1928. HMS *Victory* is still used by the Royal Navy for ceremonial occasions.

② HMS *Warrior*

Launched in December 1860, HMS *Warrior* was the fastest and most heavily armed warship of her day. She was the first warship with a wrought iron hull, and was powered by both steam and sail. This was because her fuel consumption was so heavy that she could not carry sufficient coal. She had been built in response to a perceived threat from France's *La Gloire*, though such was her reputation that she never had to fire a shot. So rapid was the development of naval technology in the 19th century that she became obsolete within ten years. After years of serving as a support vessel in Portsmouth, she was sold as a floating oil jetty at Pembroke Dock (Wales) where she served for 50 years, before being rescued as Britain's only surviving iron hull warship. Painstakingly restored, she provides an immaculate example of one of Queen Victoria's great warships.

③ *Mary Rose*

The *Mary Rose* was the flagship of Henry VIII. His development of the navy was an essential riposte to French naval superiority, and the *Mary Rose* was launched in 1511. Originally weighing 500 tons, her weight was increased to 700 tons during two refits. At 38.5m (125ft) at the waterline, she was briefly the largest ship in the English fleet. She was fitted with newly invented gun-ports, and armed with a mix of cannons, demicannons and culverins. She enjoyed a successful career, but sank suddenly while sailing from Portsmouth to confront the French fleet in 1545. Substantially preserved on the sea bed, she was finally raised in 1982. Her hull is in the ship hall (closed until 2012 while a new museum is built). Hundreds of retrieved artefacts including shoes, plates, arms and games are displayed in the *Mary Rose* Museum.

④ National Museum of the Royal Navy

Apart from the great historic warships located there, the Historic Dockyard also houses the National Museum of the Royal Navy (founded 1911) that tells more than 500 years of history of the fleet, and has a fine range of artefacts including the carved figures that once decorated the bows of many ships-of-the-line. The Trafalgar Experience brings the Battle of Trafalgar to life. Other buildings and docks include the rope hall where the ropes for the rigging of the 'men-of-war' were produced, and landing craft and other small boats from the Second World War. And all around visitors are surrounded by the bustle of a working naval base. Interactive exhibits provide visitors with an opportunity to experience naval life at first hand through simulators, experiments and physical challenges.

⑤ Royal Naval base

Portsmouth naval dockyard was established in 1495 with the building of the world's first dry dock, though the dockyard's traditions go back to at least 1212. Backing onto the Historic Dockyard site is the modern naval base with HMS *Nelson* at its heart. It is home to a significant part of Britain's Royal Navy, and is its main supply depot. At any time Portsmouth will be home to a number of frigates and destroyers stationed there between commissions for a refit. A major scheme to enhance the facilities is planned, including the dredging of the main approach channel and the refurbishment of several jetties to accommodate the new aircraft carriers due to enter service in 2014.

⑥ Spinnaker Tower ▽

Portsmouth's newest attraction is the elegant Spinnaker Tower, a 170m (552.5ft) high concrete, steel and composite structure that is the focus of a regeneration of the Gunwharf Quays. A popular event location, it has three viewing platforms affording breathtaking views over the city, southern Hampshire and towards the Isle of Wight. The 'spinnaker' billows out at 35m (114ft) and reconnects with the main shafts at 120m (390ft).

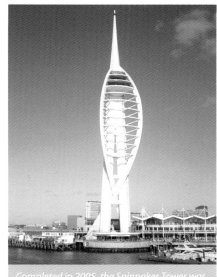

Completed in 2005, the Spinnaker Tower was designed by the architects Scott Wilson and has won several prizes for its design.

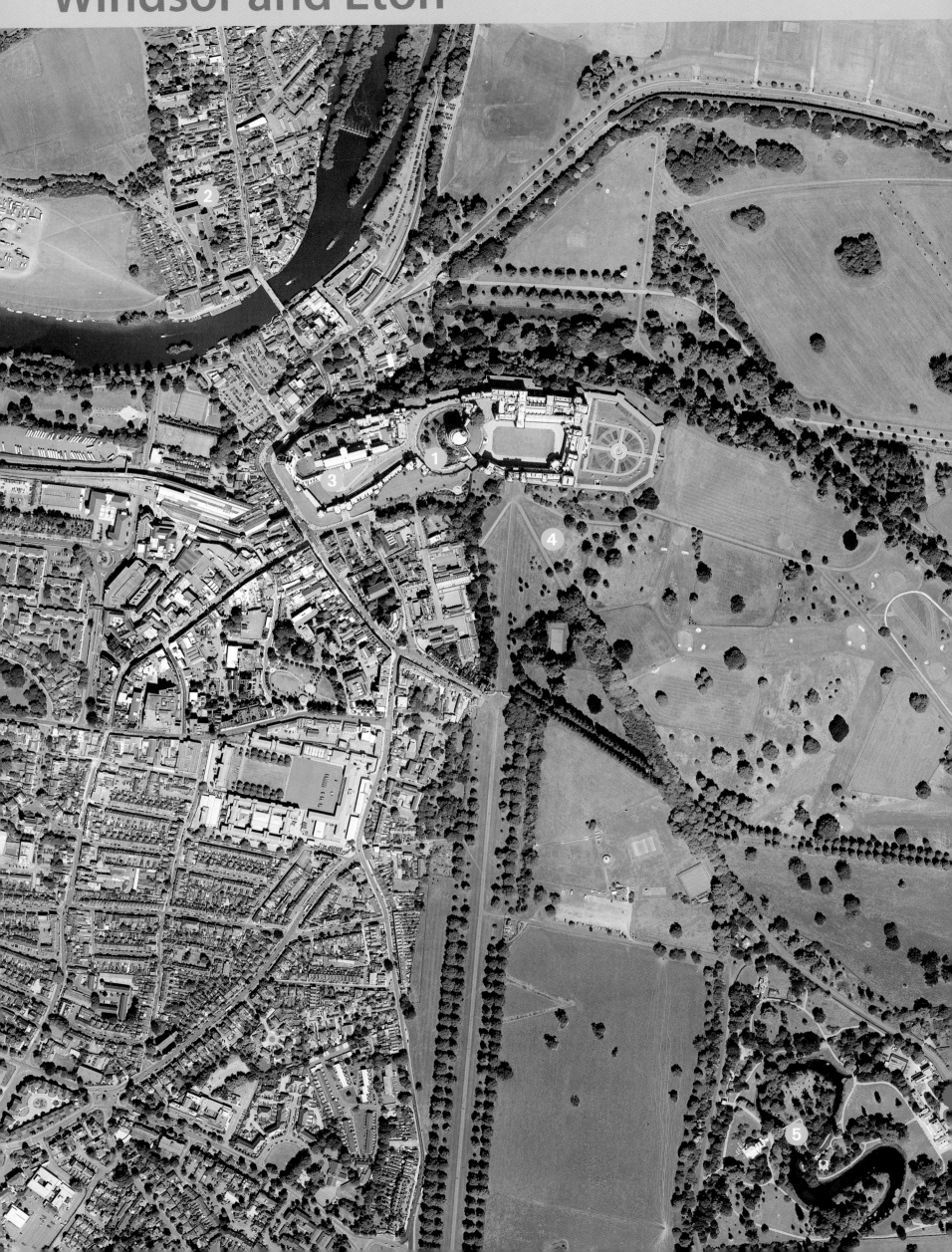

Windsor and Eton

It is rare to find a castle built on the scale of Windsor. Founded by William the Conqueror, it has the double claim of being the largest inhabited castle in the world and the oldest in continuous occupation; it has been the home of English monarchs for more than 900 years. It is in fact only one of numerous royal residences in Britain. Ten monarchs are buried inside the 14th-century St George's Chapel. Just across the River Thames lies Eton College, Britain's most famous public school, founded by Henry VI in 1440.

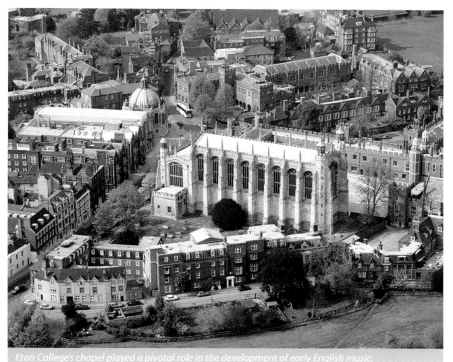

Eton College's chapel played a pivotal role in the development of early English music.

① Windsor Castle

Windsor has been the site of a royal residence since Saxon times, and there has been a castle on the site above the River Thames at Windsor since Norman times, over 900 years ago. The huge 12th-century Round Tower stands on the site of the original motte and bailey. After centuries of building and re-building, the castle today covers 5 hectares (13 acres), with the Lower Ward to the west of the Round Tower and the Upper Ward to the east. The latter includes the monarch's private apartments as well as the State Apartments and the Grand Reception Room (restored after being badly damaged in a fire in 1992 that affected one-fifth of the castle). The castle, which is occupied by the royal family for only part of the year, is also a huge museum, containing priceless paintings by Holbein, Van Dyck, Rembrandt and Rubens, a unique collection of the drawings of da Vinci, rare tapestries and furniture. A landscaped garden was created to celebrate Elizabeth II's Golden Jubilee.

② Eton College and Chapel △

Eton College is not the oldest of the British public schools, but its royal foundation by Henry VI in 1440 gave it a particular status in the social fabric of the nation. The king planned that it would have 70 scholars enjoying a free education, and sought their teachers from Winchester College, founded 100 years earlier. It was also well-endowed, thanks to the holy relics donated by the king, and to the right he had granted it to sell indulgences (pardons) for sins committed. The Chapel became a major European pilgrimage site. It grew in a rather uncontrolled manner, the main school buildings (around the School Yard) expanding slowly over the centuries. Though the chapel is a fine example of English Perpendicular Gothic architecture, Henry VI had previously planned a much larger structure. It also contains wall paintings from the late 15th century and a fan-vaulted roof that was only constructed in 1959. During the Wars of the Roses, its association with the Lancastrian cause nearly brought about the school's closure by Edward IV. Today it educates around 1,300 boys.

③ St. George's Chapel

This jewel of a chapel was founded by Edward IV as the home to one of the great chivalric orders, the Order of the Garter, founded by Edward III in 1348. The Garter is a personal honour bestowed by the monarch. The Garter Service, attended by the Queen and other members of the Royal Family, is held every year in June. The insignia of the current knights (including banners and swords) hang over the choir. All present and past members of the Order live on through their heraldic stallplates, which constitute one of the world's finest collections of heraldry. With its painted ceiling and stained glass west window, the main structure dates from the late 15th century. It also contains more tombs of monarchs than anywhere except Westminster Abbey.

④ The Home Park

The area surrounding Windsor Castle is divided in two. The 200 hectares (500 acres) immediately around the castle are known as The Home Park, and contain Frogmore House and Mausoleum. The 700 hectares (1,800 acres) of Windsor Great Park (the setting for part of Shakespeare's *The Merry Wives of Windsor*) stretch away to the south, and include the Royal Lodge, Cumberland Lodge and Savill Gardens, and many other features. The Long Walk acts as the western boundary of the park where the town of Windsor encroaches, and connects the two areas.

⑤ Frogmore House and Mausoleum

Frogmore House, lying less than a mile from the Castle, has acted as a country retreat for monarchs since the 17th century. Though enjoyed by members of the royal family past and present, the area is most notable for its connection with Queen Victoria. Such were her ties to the place that she chose a nearby site (where her mother the Duchess of Kent was already buried) for the Royal Mausoleum, within days of the death of her husband Prince Albert. The Mausoleum's interior is decorated with coloured marbles from all over the world and took ten years to complete. Out of respect for Albert's artistic preferences, the paintings and sculptures within were in the style of Raphael. Queen Victoria visited it every 14th December, the anniversary of his death, and was buried alongside him in 1901. Frogmore House is no longer a royal residence.

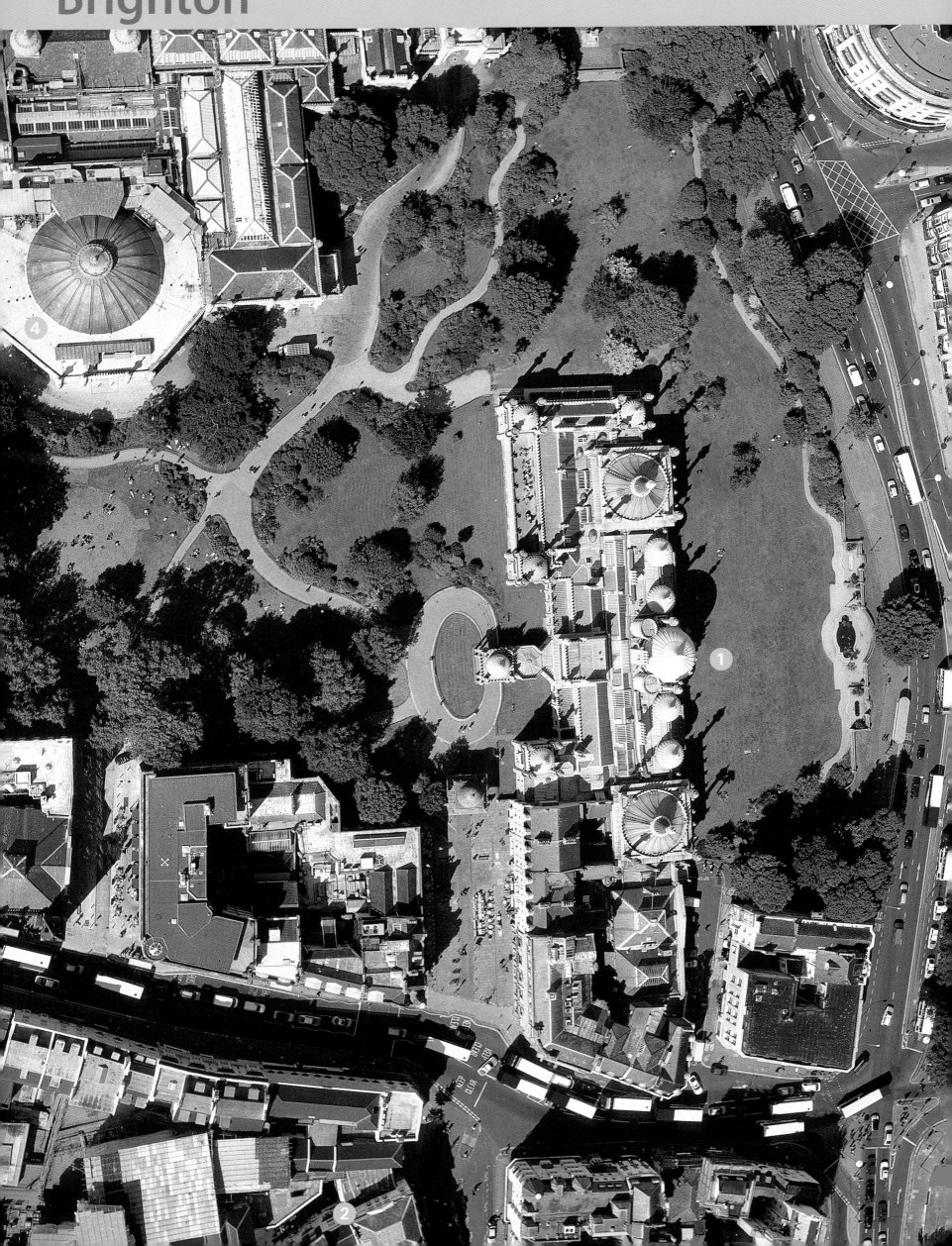

Brighton

Brighton lies between the South Downs and the English Channel on Britain's south coast, and has long been a favourite seaside resort. The centrepiece to the resort is the exotically-domed Royal Pavilion, a 19th-century creation of the Prince Regent, later George IV. Fashionable Victorians followed the prince down to the coast, and the resulting development of terraces and elegant squares enveloped the original fishing village of Brighthelmstone. Of the two piers that were built, the Brighton (formerly Palace) Pier survives as a well-preserved seaside structure, while the West Pier closed in 1975, and has since fallen into disrepair, mostly collapsing into the sea. Today the city still thrives on a lively mixture of commerce, arts, leisure and tourism. The expanding resort was granted city status in 2000 and, along with its quieter neighbour, forms the City of Brighton and Hove.

① Royal Pavilion ▷

One of the most exotic and remarkable buildings in Britain, the Royal Pavilion was the seaside residence of the Prince Regent. It was developed from Brighton House, a simple farmhouse that the prince began renting in 1786. The house was transformed and extended regularly, with a mixture of architectural styles, including opulent Chinese and Indian influences that were applied to both the interior and exterior of the building over the years. It also included fashionable Regency features such as bow windows and iron balconies. George IV was rumoured to have cried with joy when he first saw the magnificence of the Pavilion, and it became his favourite creation. At the age of 60 the Prince Regent became king, and slept at the pavilion for the last time in March 1827, three years before he died. In the latter half of the 20th century the Pavilion and gardens have been restored to their former glory, and are a popular tourist attraction.

② The Lanes

A maze of narrow streets, the Lanes, are the oldest part of Brighton and date back to the time of the old fishing village of Brighthelmstone in the 17th century. Bordered by North Street, South Street, East Street and West Street, they were once the location of a monastic farm, poorhouse and fishermen's cottages. Today, the now pedestrianised Lanes are home to a large number of fashionable shops, pubs and restaurants, and remain popular with visitors.

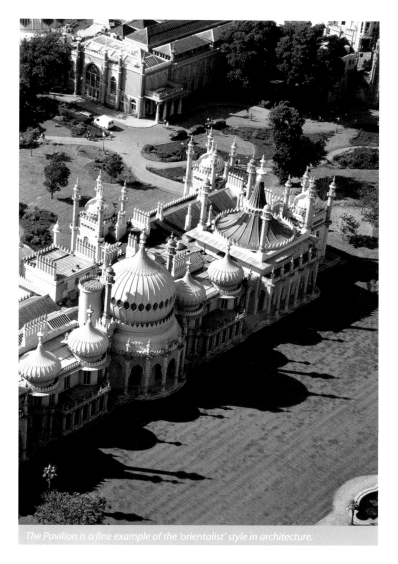

The Pavilion is a fine example of the 'orientalist' style in architecture.

③ The Steine

A grassy area of ground next to the old town, the Steine was used by fishermen as a workplace, where they would mend their boats, repair nets and cure fish. As the area became gentrified, the fishermen gradually moved away, and the area was landscaped with flowerbeds and paths so that the upper classes could gently promenade and take in the sea views and sea air. Further into town the main feature of the Steine is St Peter's Church.

④ The Dome

Brighton's Dome was part of the Royal Pavilion Estate, and was inspired by the Corn Exchange in Paris. Originally built as riding stables for the Prince Regent in 1805, it was covered by a huge segmented glass dome to top the Regency architecture. It was converted to a concert hall in 1866, with the interior being restored in 1935 with an ornate Grade I listed art-deco interior. Today, recently renovated, the Dome continues to be a popular live music venue, and hosts regular concerts from world famous recording artists as well as theatre productions. It is especially busy during the Brighton Festival in May each year.

Southend-on-Sea

Southend was originally a village at the 'south end' of Prittlewell Priory. It became a popular seaside resort in the early 19th century, booming during the Victorian era, when it spread to embrace surrounding villages. Tourism was encouraged by the arrival of the first railway line to Southend from London's Fenchurch Street Station in 1856, and the resort soon became known as Whitechapel-on-Sea, after the inner city district of Whitechapel in London's East End. With London being only 40 miles away, the proximity to the capital was an important factor in its appeal. During the 1960s Southend was also developed as a major residential area and centre of commerce, a position which it retains to this day.

1 Southend Carnival

The first carnival at Southend was in the summer of 1906, and was a fundraising exercise for the Victoria Cottage Hospital. Horse-drawn floats travelled from the Bandstand, through the town and finished at The Kursaal Centre. By 1930, the carnival had grown to become a week-long event, raising funds for the new General Hospital. A Carnival Queen attends every year with her court to add a regal air to the festivities. The Southend Carnival continues to be a popular annual event right up to the present day, and celebrated its centenary year in 2006.

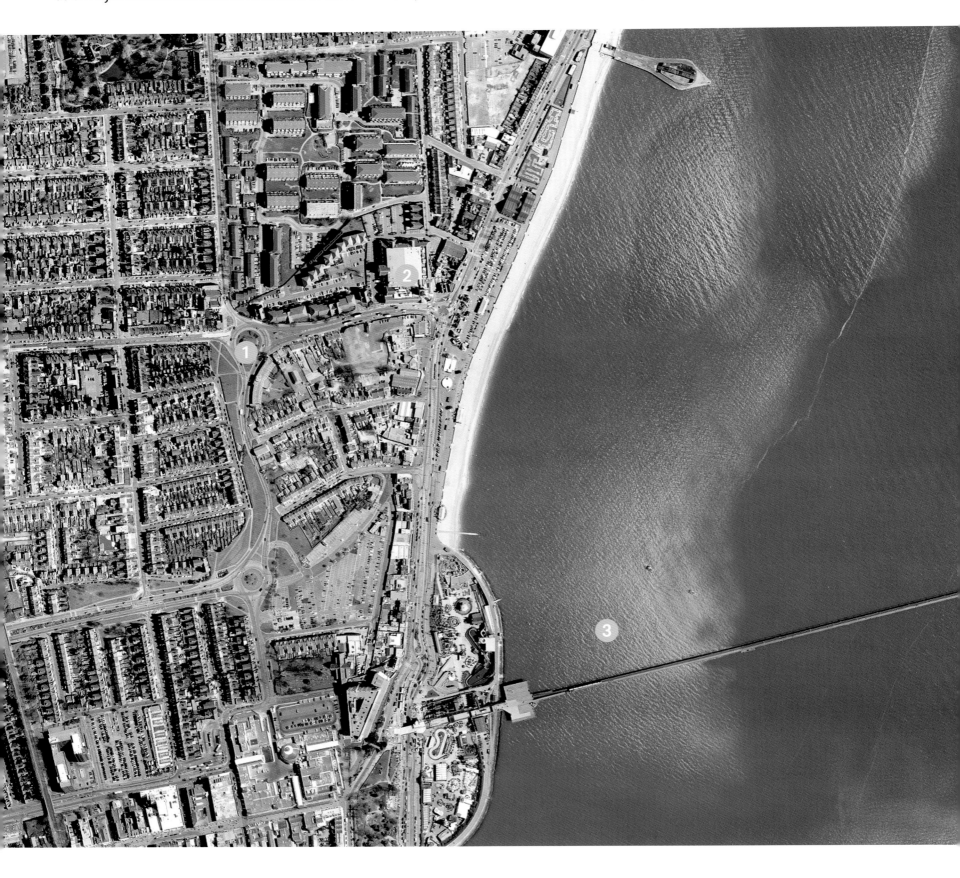

2 Kursaal Centre

In 1893, a four-acre plot of land at the east end of the town was reserved for the creation of a new amusement park. This was called the Marine Park and was completed in 1894. The popularity of the park soon increased, and in 1901 the Kursaal Centre was opened to the public, complete with a brand new grand entrance topped with a great silver dome. The word 'Kursaal' is German in origin, and means a 'cure hall' or spa. The park was given this name to promote it as a place for healthy amusement. The centre became a major destination for day-trippers and works outings from London, and visitors could also attend such events as the New Year's Eve ball, charity dinners for needy children and the Old People's Dinner. Largely self-supporting, the centre included its own laundry, an ice cream parlour and a seaside rock factory. With the introduction of cheap package holidays to foreign resorts, and the increasing use of the family motorcar, the centre became less popular from the mid 1960s, and closed in the early 1970s. However, the centre was redeveloped and now enjoys a new lease of life as the Kursaal Bowl, a modern computerised ten-pin bowling alley. Other attractions include a circus big top offering amusement machines and cafés.

3 Pier ▷

The pier at Southend is the longest pleasure pier in the world, first opening to the public in 1889. It has been extended on several occasions, with the final extension being completed in 1929 at a total length of 2km (1.34 miles). The pier was closed during the Second World War, and reopened in 1945. Visitors can access the pier either with a ride on the electric railway, or can enjoy the fresh sea air and impressive views over the Thames estuary with a gentle stroll along the walkway, which extends almost the whole length of the structure.

Attractions held on the pier each year include visits by tall ships and a Punch and Judy Festival which attracts over 300,000 visitors, as well as sea-fishing which is available all-year round. There is a half-size replica of Drake's *Golden Hind* next to the pier. Illuminations along the pier were completed in 2000, and can be seen from dusk throughout the year. Over the years, the pier has suffered several fires and even a ship collision, but has been restored to its former glory each time. It remains a popular tourist attraction and a peculiarly British feat of engineering.

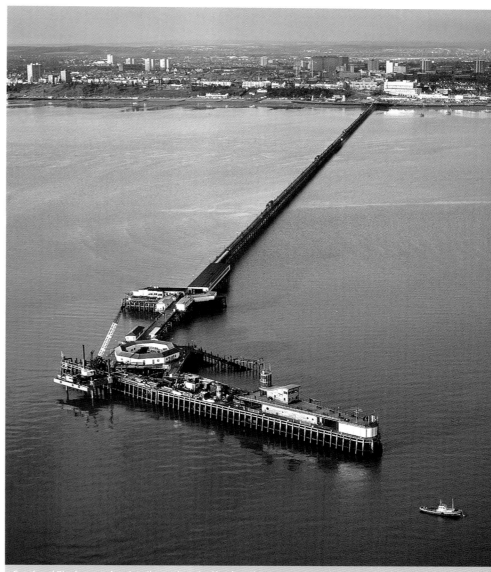

Southend Pier has an electric railway along its 2km length.

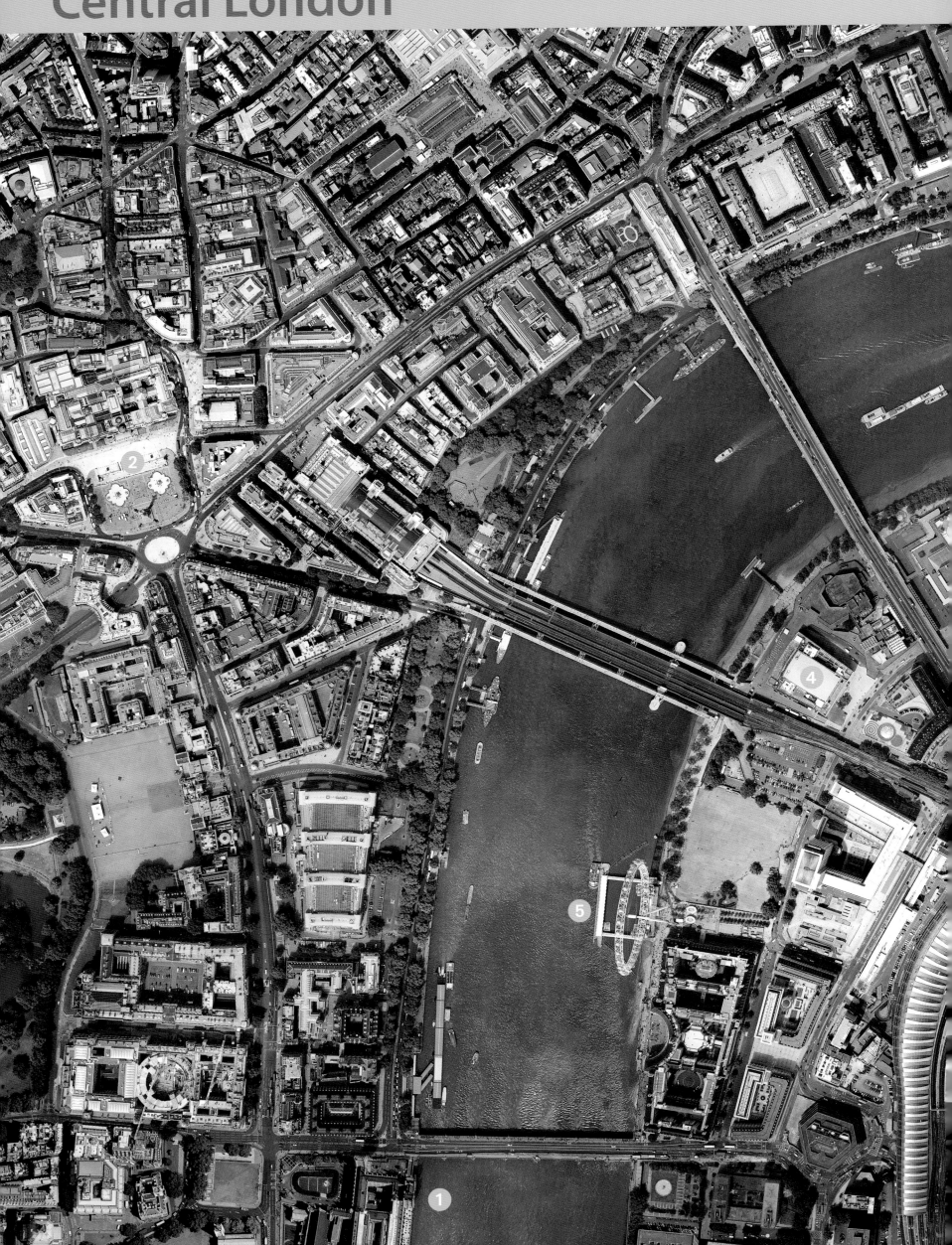

Central London

Bordered by the Embankment and Jubilee Gardens to left and right, the River Thames is still tidal as it flows through Central London. The bridges have always been essential to the city's prosperity. Built in 1862 to replace its 18th-century predecessor, Westminster Bridge (bottom) is the oldest river crossing in Central London. The Golden Jubilee Bridges are cable-stayed pedestrian walkways – complete with lifts – flanking Hungerford railway bridge (centre). At the top of the photograph is Waterloo Bridge.

① The Houses of Parliament and Big Ben

The Houses of Parliament, also called the Palace of Westminster, are the seat of the two chambers of Parliament, the House of Commons and the House of Lords. The Commons was granted a permanent home in the palace's St Stephen's Chapel in 1547, having previously held its meetings in Westminster Abbey. The House of Lords has always been housed here. Although the palace's origins go back to Saxon times, most of the original building was destroyed by fire in 1834. It was rebuilt in Victorian Gothic style to designs by Charles Barry and Augustus Pugin and re-opened in 1870, although much of the House of Commons had to be rebuilt again after being destroyed in an air raid in 1941. The buildings occupy approximately 3.24ha (8 acres) and include some 1,200 rooms and 3km (2 miles) of corridor. Visitors enter through St Stephen's Porch and the octagonal central lobby. Westminster Hall, the only significant surviving mediaeval structure, was built in 1097 to 1099 by William II and has a magnificent hammer-beam roof. It was the seat of the highest court in the land until 1882 and has seen countless historic occasions, from the trials of Sir Thomas More, Guy Fawkes and Charles I to the lying-in-state of Sir Winston Churchill in 1965 and Queen Elizabeth, the Queen Mother in 2009. The clock tower on the north-east corner is 98.50m (320ft) high and is often referred to inaccurately as Big Ben; this is actually the name of the bell it houses.

Nelson's Column in Trafalgar Square.

② Nelson's Column and Trafalgar Square ◁

Designed by John Nash in 1820 and completed by Sir Charles Barry some 20 years later, Trafalgar Square is a popular gathering point for demonstrations and celebrations. At the centre stands Nelson's Column, 56m (186ft) high and surmounted by a statue of the naval hero who won the Battle of Trafalgar in 1805. Adorned with fountains and Sir Edwin Landseer's huge bronze lions, the square is bordered by the National Gallery, Canada House, South Africa House and St Martin's-in-the-Fields, one of London's best-loved churches. All distances from London are measured from the statue of Charles I to the south of Trafalgar Square.

③ Waterloo Station

Waterloo Station is one of the busiest railway terminuses in Europe and the point of departure for trains to the south-west of England. It is also a major transport interchange which includes the London Underground as well as a bus station. Until 2007 Waterloo served as the London hub for Eurostar trains to France and Belgium. Completed in 1848 and named after the battle in which Napoleon was defeated in 1815, the station was rebuilt from 1904 to 1922 and again following bomb damage in the Second World War. It retains many of its historical features, including the huge clock suspended above the main concourse which is a popular rendezvous in novels, films and real life.

④ Royal Festival Hall and the South Bank

Planned as a concert, dance and performing arts venue on the South Bank near Hungerford Bridge, the Royal Festival Hall was built for the 1951 Festival of Britain. Its original appearance, revolutionary at the time, has been compromised by the addition of terraces and walkways that obscure its modernist lines. It forms part of the Southbank Centre, which also includes the Queen Elizabeth Hall and Purcell Room concert halls and the Hayward Gallery exhibition space. Its open-foyer policy makes the entrance area accessible to the public even when there are no concerts.

The Millennium Wheel takes 30 minutes to go full circle.

⑤ The London Eye ◁

Intended as a temporary structure, the London Eye or Millennium Wheel has become one of London's most striking landmarks. The giant Ferris wheel on London's South Bank, just downstream from the Houses of Parliament, has become the most popular paid tourist attraction in the country since it was inaugurated by Tony Blair, the then Prime Minister, for the millennium celebrations in 2000. Standing 135m (443ft) high, its 32 capsules offer spectacular views of the capital as it rotates at a speed of 1.6kmph (1mph), taking about 30 minutes to complete a revolution. Visitors are advised to book well in advance.

Overleaf: London Olympic Park. By 2012 the former industrial site in east London will have become landscaped parkland. This aerial view of the Olympic Park taken in early November 2010 shows the Olympic Stadium, Aquatics Centre, Basketball Arena and Velodrome taking shape.

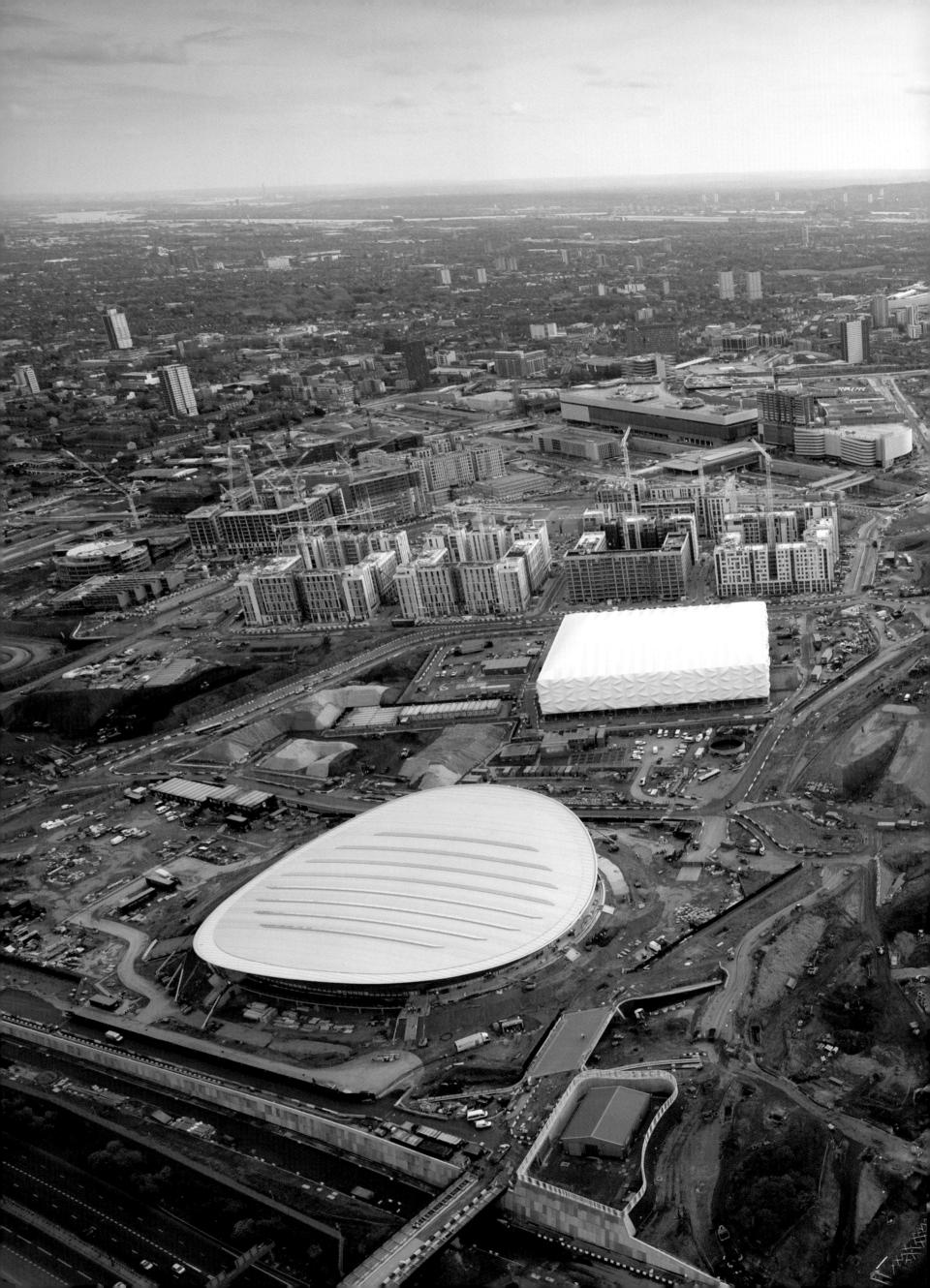

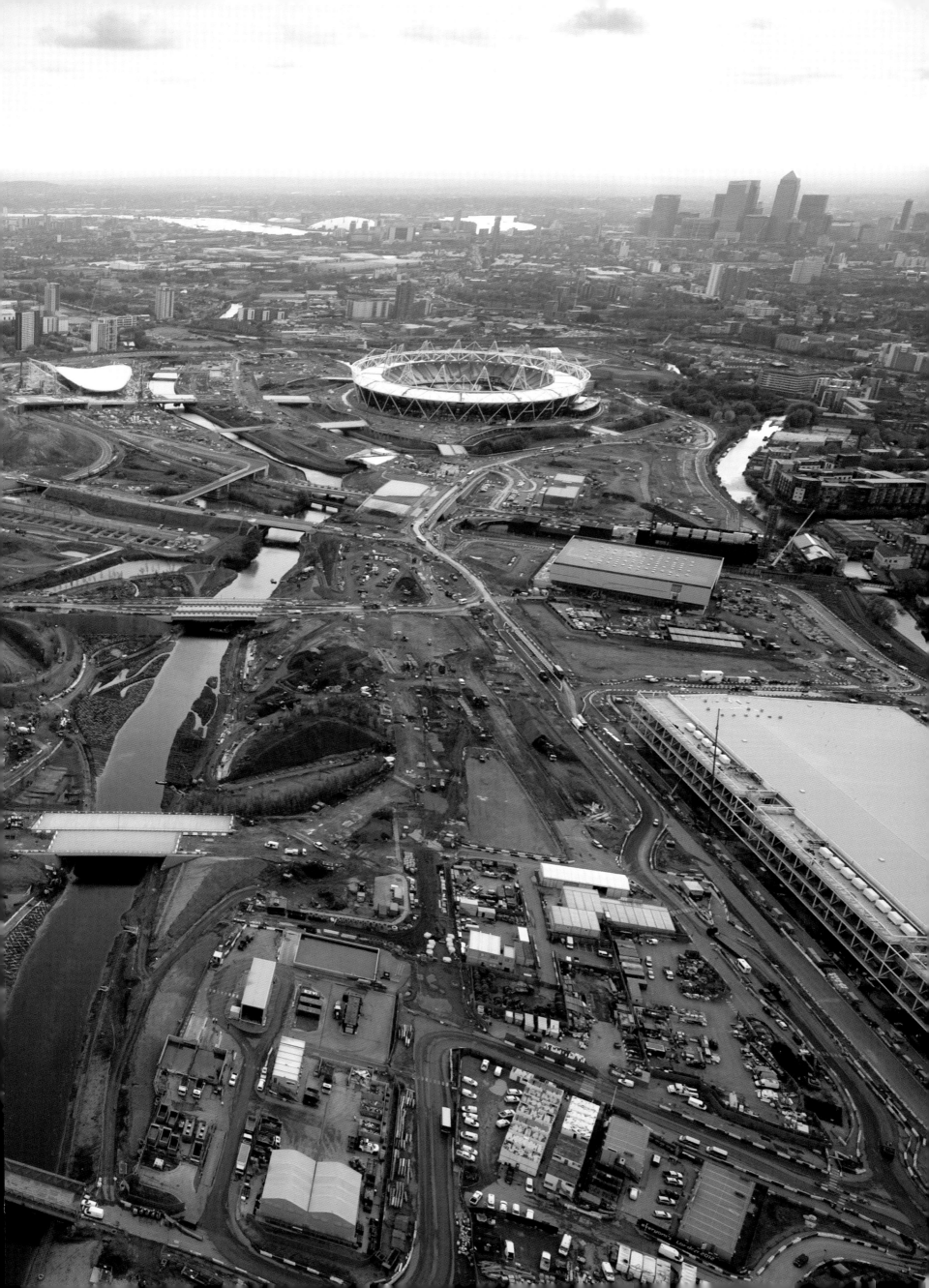

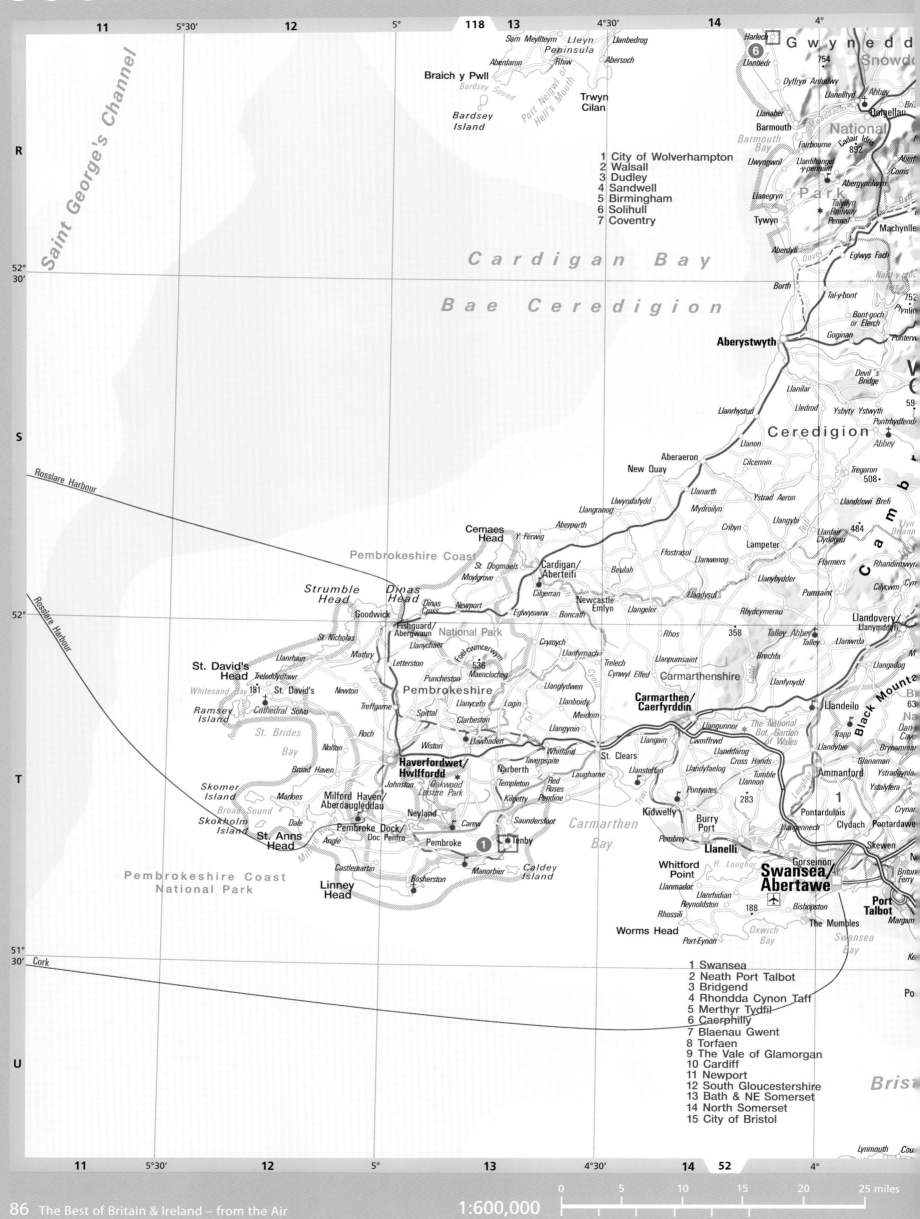

1 City of Wolverhampton
2 Walsall
3 Dudley
4 Sandwell
5 Birmingham
6 Solihull
7 Coventry

1 Swansea
2 Neath Port Talbot
3 Bridgend
4 Rhondda Cynon Taff
5 Merthyr Tydfil
6 Caerphilly
7 Blaenau Gwent
8 Torfaen
9 The Vale of Glamorgan
10 Cardiff
11 Newport
12 South Gloucestershire
13 Bath & NE Somerset
14 North Somerset
15 City of Bristol

1:600,000

0 5 10 15 20 25 miles

0 5 10 15 20 25 km

① Tenby		④ Bath	
② Porth		⑤ Ironbridge	
③ Cardiff		⑥ Harlech	

3°30' 16 3° 17 2°30' 119 18 2° 19

Oswestry · Shrewsbury · Telford · Stafford · Staffordshire · Burton-upon-Trent · Swadlincote · Rugeley · Cannock · Lichfield · Brownhills · Aldridge · Tamworth · Atherstone · Wolverhampton · Walsall · Sutton Coldfield · Kingsbury · Dudley · Sedgley · Sandwell · BIRMINGHAM · Solihull · Kenilworth · Warwick · Stourbridge · Halesowen · Kidderminster · Bewdley · Bromsgrove · Redditch · Studley · Alcester · Stratford-upon-Avon · Worcester · Droitwich Spa · Great Malvern · Evesham · Pershore · Cheltenham · Gloucester · Gloucestershire · Cirencester · Stroud · Swindon · Chepstow/Cas-Gwent · Newport/Casnewydd · Bristol · Bath · Cardiff/Caerdydd · Rhondda · Merthyr Tydfil · Brecon/Aberhonddu · Hereford · Herefordshire · Ross-on-Wye · Monmouth · Monmouthshire · Ludlow · Shropshire · Ironbridge · Telford and Wrekin · Powys · Welshpool/Y Trallwng · Newtown/Y Drenewydd · Weston-super-Mare · Trowbridge · Wiltshire · Salisbury Plain

The Long Mynd · Black Mountains · Brecon Beacons · Cotswolds · Vale of Evesham · Mouth of the Severn · Bridgwater Bay

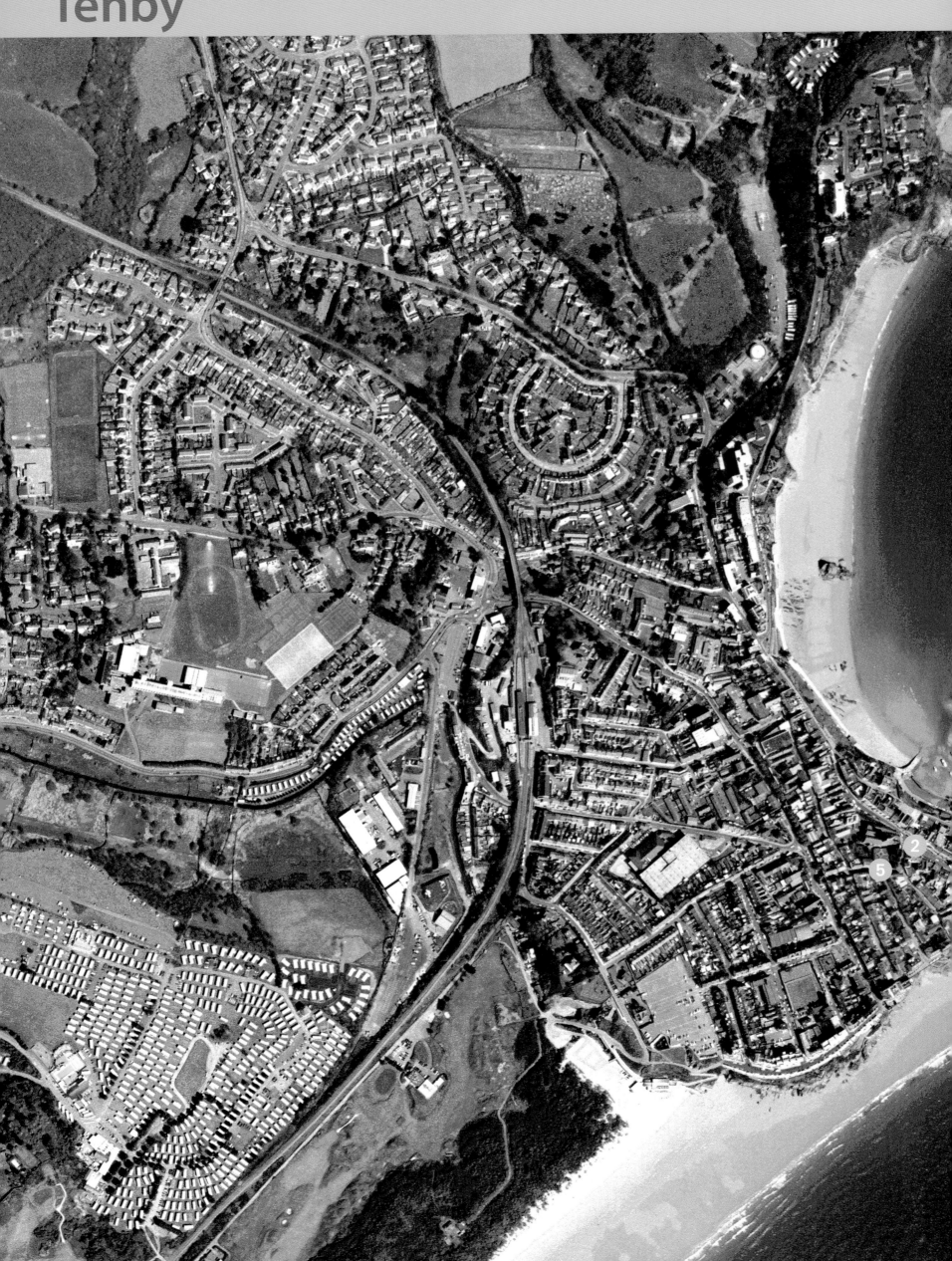

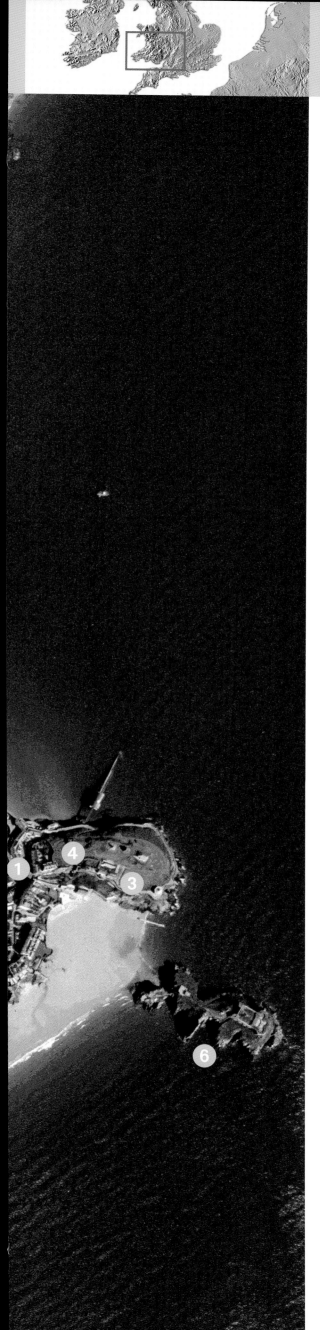

Tenby

On the coast of south Pembrokeshire facing Carmarthen Bay, Tenby combines sheltered sea bathing with a 4km (2.5 miles) long beach of fine sand. Forming the backdrop to the historic town are the remains of a Norman castle, an ornate mediaeval church and the town walls dating from the 13th century. In the late 11th century, Tenby became a garrison town and later flourished under the Earls of Pembroke. Later on, in the 19th century, the town enjoyed prosperity when Sir William Paxton, a merchant returned to Tenby from India and promoted it as a Regency bathing spa.

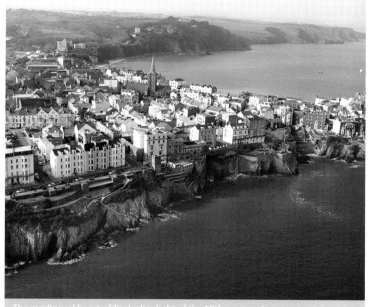

The mediaeval heart of Tenby lies behind the 19th-century houses.

① Mediaeval walls

Tenby's position as a Norman stronghold made it a target for violent attacks by the native Welsh. The town's defensive circle of walls, gateways and towers was built following the sacking of the town in 1260 by the Welsh Prince Llewelyn. The walls were strengthened in the early 14th century, following Edward III's grant allowing Tenby to impose a levy on all incoming goods, with the addition of extra towers in the wall and the celebrated D-shaped Barbican tower at the West Gate – now known as 'The Five Arches'.

In the mid-15th century, the moat (now St Florence Parade) was extended to a width of 9m (30ft), and the existing walls widened. At one time the walls contained 12 towers and three gates. Today only one gate (the West) and seven towers can be seen; the walls are most complete along South Parade and White Lion Street.

② St Mary's Tower

Those who climb the stairs to the parapet of the tower – 25m (83ft) above ground – are rewarded with splendid views of Tenby's narrow streets, defensive wall and harbour. The church tower, one of the oldest in Pembrokeshire, was built in the 13th century. The spire, added to the tower in the late 15th century, rises to 46m (152ft). Its copper weathercock was restored in 1963; according to some authorities, this is the original 1715 weathercock that was torn down and hurled into the harbour by a gale in 1894. In the belfry within the tower are four of the eight bells from a set originally cast in 1789; the tenor bell bears the inscription 'I to the Church the living call and to the grave doth summon all'.

④ The Castle

Tenby Castle occupies a forbidding clifftop position on a headland. A watch-tower and parts of the defensive wall along the north of the headland survive, along with a mediaeval hall that adjoins the modern castle museum. The oldest surviving stone remains date from the 13th century, but an earlier earthwork structure was standing by at least the mid-12th century – records tell of its capture by Welsh noblemen Maredudd and Rhys ap Grufydd in 1153, in revenge for an attack on their brother.

③ Tenby Museum and Art Gallery

Located on Castle Hill, the museum includes exhibitions on the maritime and social history of Tenby. The paintings collection contains works by Augustus John, who was born in Tenby in 1878, and John Piper.

⑤ Tudor Merchant's House

The refurbished 15th-century merchant's house is located on Bridge Street. The house has period furnishings and a magnificent fireplace.

⑥ St Catherine's Island

The tidal island, which can be reached on foot at low tide, is the site of a 19th-century Palmerston fort. These defensive structures were built around the coastline to protect major harbours, including Milford Haven to the west, from invasion.

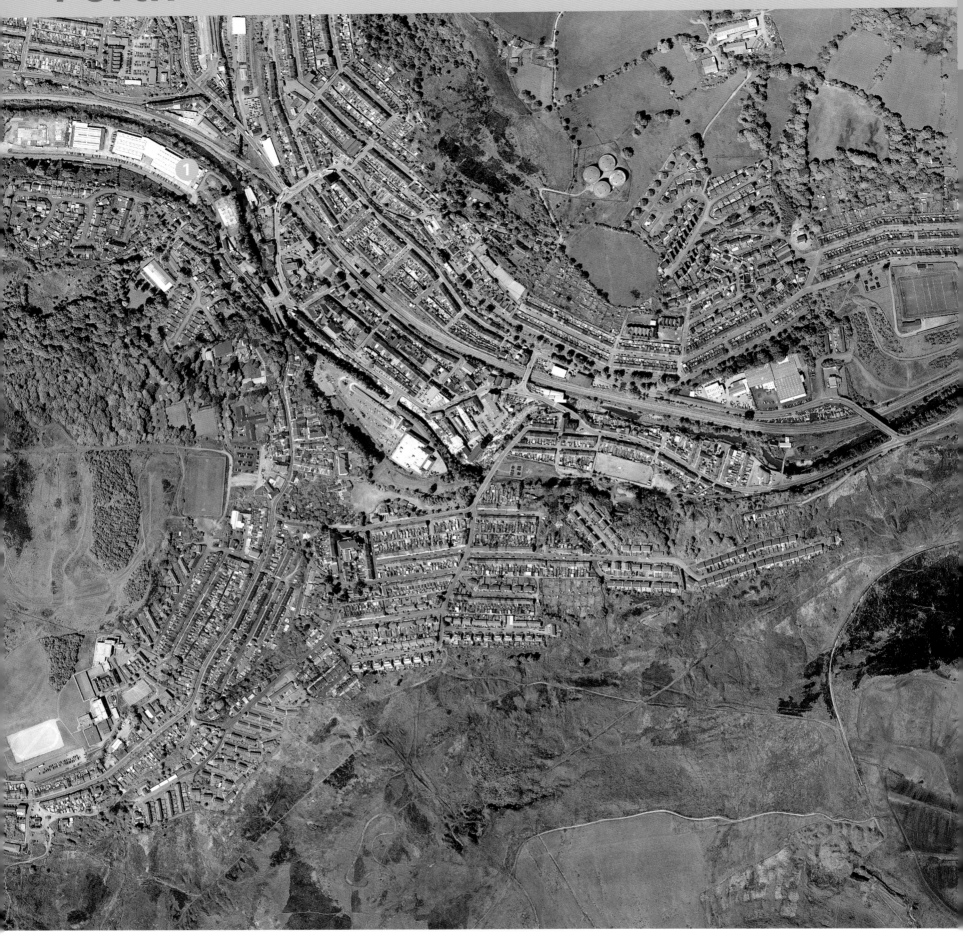

Porth

Porth lies at the convergence of the two rivers – the Rhondda Fawr ('Great') and Rhondda Fach ('Small'). At its peak, the Rhondda Valley had 53 coal mines in an area 25km (16 miles) long – with a population of almost 170,000, including 40,000 miners. The decline of the coal mining industry culminated in the closure of the last pit in 1990.

① Porth Industrial Centre

In the first half of the 20th century, Porth and its adjoining settlements of Cymmer and Ynishyr were home to seven working mines. The last surving mine – until 1983 – was the Lewis Merthyr Colliery that is now the Rhondda Heritage Park. An alternative source of employment in the area was the Porth factory operated by soft drink company Corona. The Corona Pop Company was founded in the 1920s by grocer William Evans, the first captain of the Porth fire brigade. The Corona building, with its landmark tower, is now a television studio known as 'the Pop Factory'.

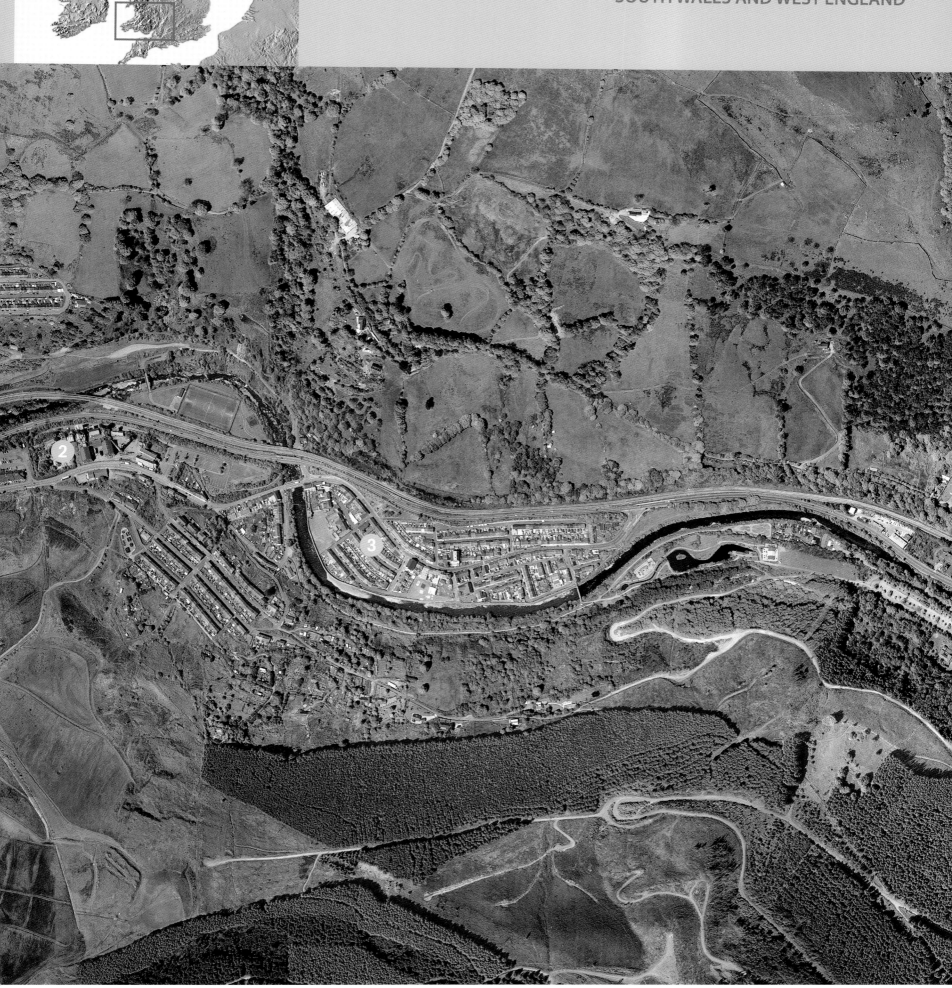

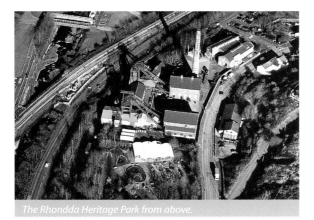

The Rhondda Heritage Park from above.

② Rhondda Heritage Park
Lewis Merthyr Colliery ◁

The Rhondda Heritage Park contains a memorial to the thousands of miners killed or injured in local coal mines. An estimated 30,000 miners were injured or killed during 150 years of mining, or died from work-related diseases. Life could be very hard in these communities: in The Great Depression of the 1930s, unemployment rose to 47 per cent. Between 1918 and 1939, more than 50,000 people left the Rhondda – many emigrating to the United States and Canada. The museum offers visitors a glimpse of a working shift in a mine on its underground tour, including a visit to the coalface. Other attractions include a children's adventure playground, the 'Energy Zone' and an audio-visual display.

③ Historic village of Trehafod

The village of Trehafod close to the former Lewis Merthyr pit dates from the 1890s and early 1900s. The mining work has resulted in the valley floor falling by 4m (14ft) and the buildings in the village and the lie of the land show the effects of severe subsidence.

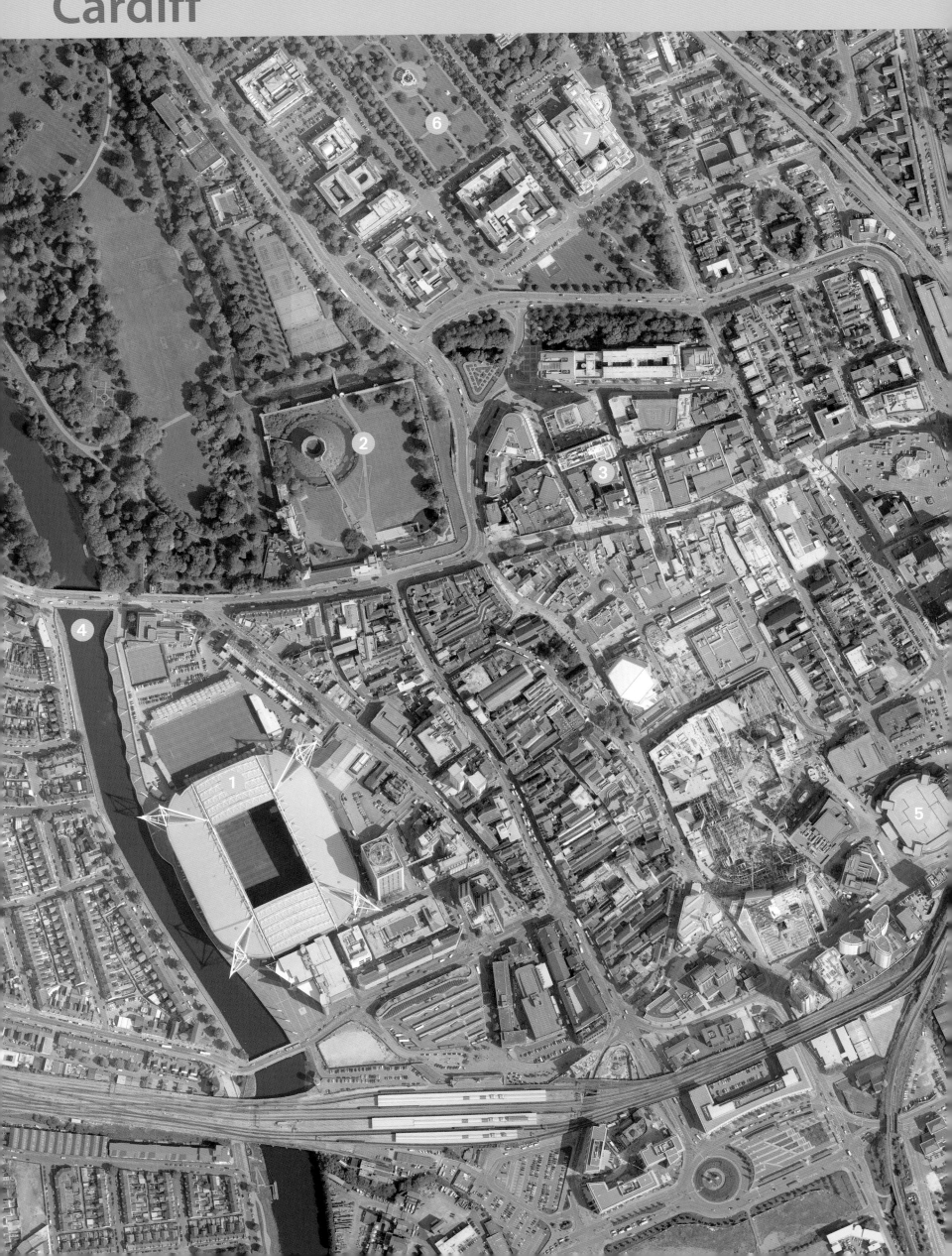

Cardiff

Cardiff (*Caerdydd* in Welsh) claims to be Europe's youngest capital, having only become the capital of Wales in 1955. There was a settlement here in Neolithic times, however, and the derivation of the name, the 'Fort on the Taff', refers to a Roman outpost. About 320,000 people live in the city proper and 1.1 million in the metropolitan area – more than one-third of the national population. It is the country's commercial hub, a cultural and sporting centre, home of the Welsh National Assembly and the main tourist destination. During the 19th century coal from the pits of South Wales was exported through Tiger Bay. For many years Cardiff Bay lay derelict following the decline of the Welsh coal-mining industry. Its redevelopment during the 1990s was highly controversial at the time but is now regarded as one of the most successful urban regeneration projects in the country. The main image shows the heart of the city with the buildings that give it the confidence of a metropolis, from the Norman castle to the Millennium Stadium.

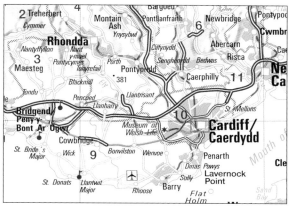

① Millennium Stadium

The second-largest retractable roof in Europe covers the Millennium Stadium, on the site of the former Cardiff Arms Park Stadium. The stadium is not only large in area; it is actually the tallest building in Wales because the masts supporting its superstructure at each corner are 90m (296ft) tall. Built at a cost of roughly £121 million to provide an arena for the 1999 Rugby World Cup, the stadium can accommodate 74,500 spectators. It has a modular grass pitch with built-in irrigation and drainage; mounted on pallets, the pitch can be removed for concerts. The stadium regularly stages the matches of the Welsh national rugby and football teams as well as mass events from international boxing matches to rock and pop concerts by world stars. During its construction, the Welsh rugby team found a temporary home at Wembley Stadium in London. Appropriately, the new stadium was inaugurated in 1999 just in time for the millennium celebrations on New Year's Eve that lasted throughout the following day.

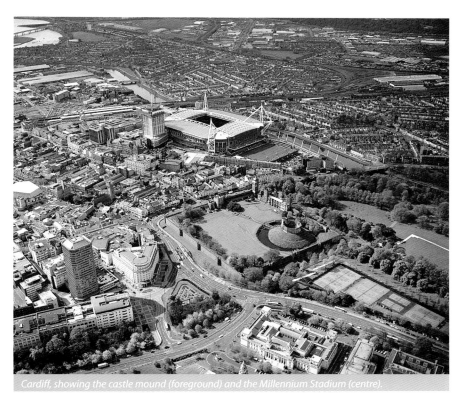

Cardiff, showing the castle mound (foreground) and the Millennium Stadium (centre).

② Cardiff Castle

The magnificent castle rising above the city is partly authentic Norman and partly flamboyant Victorian makeover. At the base of the walls by the main entrance can be seen the remains of the last of several Roman forts built on this site from about AD 50. The Norman castle is perched on a motte (artificial mound) built here in about 1091 by Robert Fitzhamon, Earl of Gloucester. The first timber structure was reinforced with stonework in the following century. The castle was remodelled in the 19th century by the 3rd Marquess of Bute and his architect, William Burges. They transformed it with Gothic Revival anachronisms including a clock tower, fountains and exuberant interiors with marble fireplaces and Moorish designs.

③ Civic Centre

The heart of Cardiff's municipal life lies in the Civic Centre, an area of distinguished buildings built in white Portland stone in an architectural style now called 'Edwardian baroque'. The buildings are grouped in Cathays Park, a district north-east of the castle. They include the County Law Courts, the main buildings of the University, the main offices of the Welsh Assembly and the City Hall. The City Hall was designed by the architectural team of Lanchester, Stewart and Rickards and completed in 1906. It has a 59m (194ft) tall clock tower and is topped with a dome carrying an imposing Welsh dragon. Inside, a marble-lined foyer is lined with statues of Welsh heroes including Owain Glyndŵr and William Morgan.

④ River Taff

The River Taff, which winds southwards through the centre of Cardiff, is one of two rivers draining into Cardiff Bay (the other is the Ely, which flows into Cardiff from the west). The Taff Trail, running alongside the river for 88km (55 miles) as far as Brecon, provides walkers with a scenic route through the city. Within the urban boundaries the river flows through Bute Park and past the Millennium Stadium; out of town you will pass the Taff Gorge and adjacent Castell Coch (Red Castle), another 19th-century fantasy castle built by the 3rd Marquess of Bute and William Burges. The river is now much cleaner than it was in the industrial era of the 19th and early 20th centuries. Salmon and other types of fish have even returned to its waters.

⑤ Cardiff International Arena

Cardiff's principal entertainment venue, the Cardiff International Arena, accommodates 7,500 people for standing room-only concerts. The arena offers a variety of events as a concert venue; it benefits from its closeness to the Millennium Stadium, which it supports in its capacity as a conference and convention centre.

⑥ Alexandra Gardens

Alexandra Gardens is an island of tranquillity in the heart of the Civic Centre. At the centre is the Welsh National War Memorial, dedicated in 1928. The solemn atmosphere is complemented by the gravity of the surrounding buildings. On the southern side of the gardens is City Hall, flanked by the National Museum and Gallery of Wales.

⑦ National Museum of Wales

Built in white Portland stone and matching the nearby buildings of the Civic Centre, the National Museum and Gallery of Wales was opened to the public in 1927. Its outstanding art collections include celebrated artworks from the collection of Sir Watkin Williams-Wynn, a great 18th-century art patron, among them a fine portrait of his second wife, Charlotte, in Turkish costume by Sir Joshua Reynolds. The Davies Sisters Collection, consisting of the acquisitions of Gwendoline and Margaret Davies from 1908 onwards, contains numerous French Impressionist and Post-Impressionist paintings, including examples of Monet's paintings of water-lilies and one of his series of paintings of Rouen Cathedral, as well as Renoir's *La Parisienne* (The Parisian Girl). The museum also has collections of Bronze Age gold, Celtic artworks, ceramics and fossils.

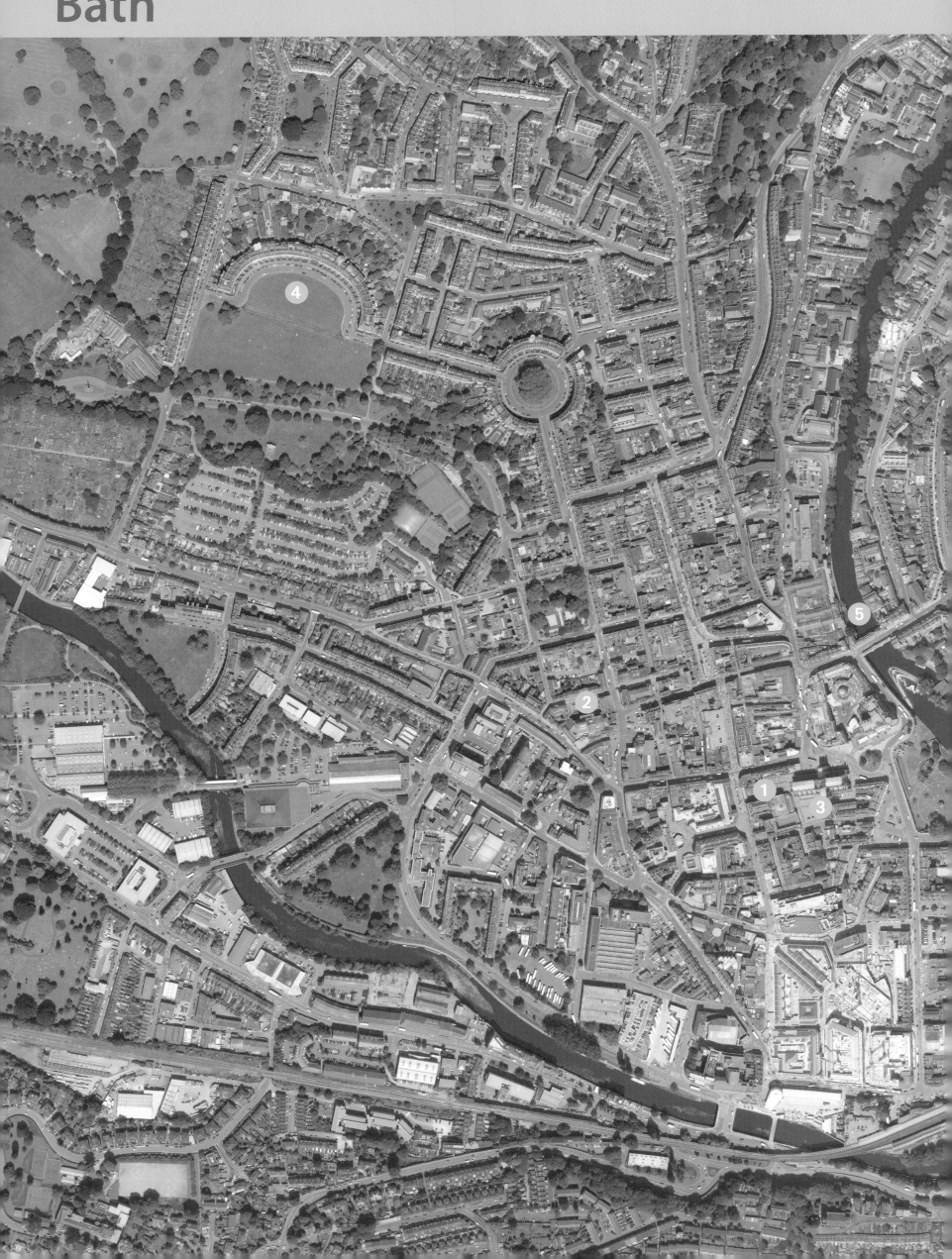

Bath

"Oh! Who can ever be tired of Bath?" exclaims Jane Austen's heroine Catherine Morland in her novel *Northanger Abbey*. Established in AD 43 by the Romans, Bath owes its harmonious appearance today to the honey-coloured 'Bath Stone' buildings dating from the 18th and early 19th century, when elegant society flocked here to take the waters. Nestled in the limestone hills of the River Avon valley, Bath has changed little since its Georgian heyday. It was listed as a World Heritage site in 1987.

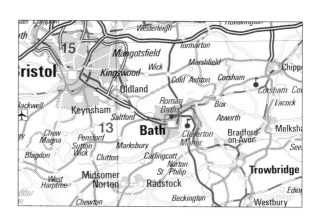

① Roman Baths

It was the Celts who first dedicated a shrine to their goddess Sulis on the site of the only natural hot springs in England; in around AD 65 the Romans built a temple to Sulis Minerva on the same spot, making Aquae Sulis into a spa resort with a *caldarium* (hot bath), *trepidarium* (warm bath) and *frigidarium* (cold bath) to enable visitors to take advantage of the healing properties ascribed to the warm, mineral-rich water. After the Romans left Britain the baths fell into disrepair until the early 18th century, when Beau Nash opened the first Pump Room and Bath became the most fashionable city in England. Visitors spent hours at the baths, exercising, eating and discussing politics. Although the vaulted ceiling that once sheltered the Great Bath has long since crumbled away, visitors today can see evidence of life in Roman Britain in the remains uncovered by archaeological excavations below modern-day street level. Today the Roman Baths are reached via a Victorian reception hall opposite Bath Abbey. Metallic-tasting water from the Sacred Spring can still be sampled in the neoclassical Pump Room.

② Theatre Royal

The Theatre Royal stands on the site of the celebrated dandy Beau Nash's home on Sawclose. This Grade II listed building is considered an important example of Georgian architecture. The main entrance was designed by Thomas Greenway and dates from 1720; the theatre itself was built in 1806 under George Dance the Younger and John Palmer. The celebrated theatre architect and native of Bath, Charles J. Phipps, restored the interior after it was destroyed by a fire in 1862. Further refurbishments, which included extending and remodelling the foyer, were carried out in 2010. The elaborate red and gilt décor and the imposing trompe-d'oeil ceiling still provide a sumptuous setting for today's theatrical productions, many of which subsequently transfer to London's West End.

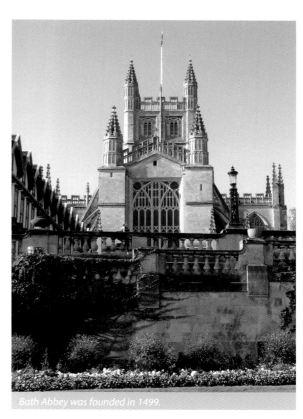

Bath Abbey was founded in 1499.

③ Bath Abbey ▷

The Abbey Church of Saint Peter and Saint Paul is not only a place of worship but also one of Bath's most distinguished historic monuments. Founded as a convent in the 7th century, it was rebuilt by King Offa of Mercia who confiscated the property in 781. John of Tours, a royal physician and Bishop of Wells, moved the episcopal see to Bath in 1090. He started building a vast Norman cathedral on the site of what had become by then a Benedictine abbey, but it was never completed. Damaged by fire and allowed to fall into disrepair, the abbey church was rebuilt in the Perpendicular Gothic style in 1611, stripped of its decorations following the Dissolution of the Monasteries during the reign of Henry VIII in 1539 and subsequently restored on the orders of Elizabeth I. Further major renovations were carried out by Sir Gilbert Scott in the 1860s.

④ Royal Crescent

Built between 1767 and 1775 by John Wood the Younger, the Royal Crescent is one of the finest examples of Georgian architecture in the country. The regularity of the windows, the horizontal mouldings and the sweep of the Ionic columns create an impression of harmony and grandeur. The concave arc of 30 houses borders a lawn that is separated from the Royal Victoria Park by a ha-ha. During Bath's golden age in the 18th and early 19th century fashionable members of London society would lodge in houses on the Royal Crescent for the season, taking the waters during the daytime and entertaining guests at night. Despite the uniformity of the famous façade the interiors of the buildings are all different, since the original owners were permitted to determine the layout of each house. No. 1, Royal Crescent has been converted into a museum. The exhibits include porcelain and glassware of the period as well as furniture by Chippendale, Sheraton and Hepplewhite.

⑤ Pulteney Bridge ◁

Pulteney Bridge is a Grade I listed building and one of Bath's most famous historic sights. The 18th-century local landowner William Pulteney wished to link the sleepy village of Bathwick across the River Avon to Bath and commissioned Robert Adam to design a bridge. Inspired by the Ponte di Rialto in Venice and the Ponte Vecchio in Florence, Adam created a triple-arched bridge lined with shops. Construction was completed in 1773. Following the remodelling and alterations that had been carried out over the years, the bridge's original design was restored in 1951 and 1975.

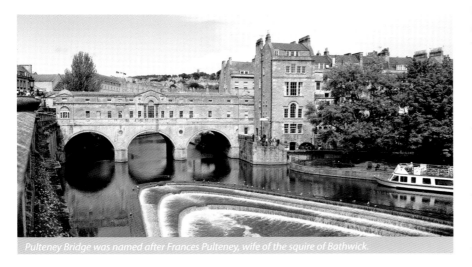

Pulteney Bridge was named after Frances Pulteney, wife of the squire of Bathwick.

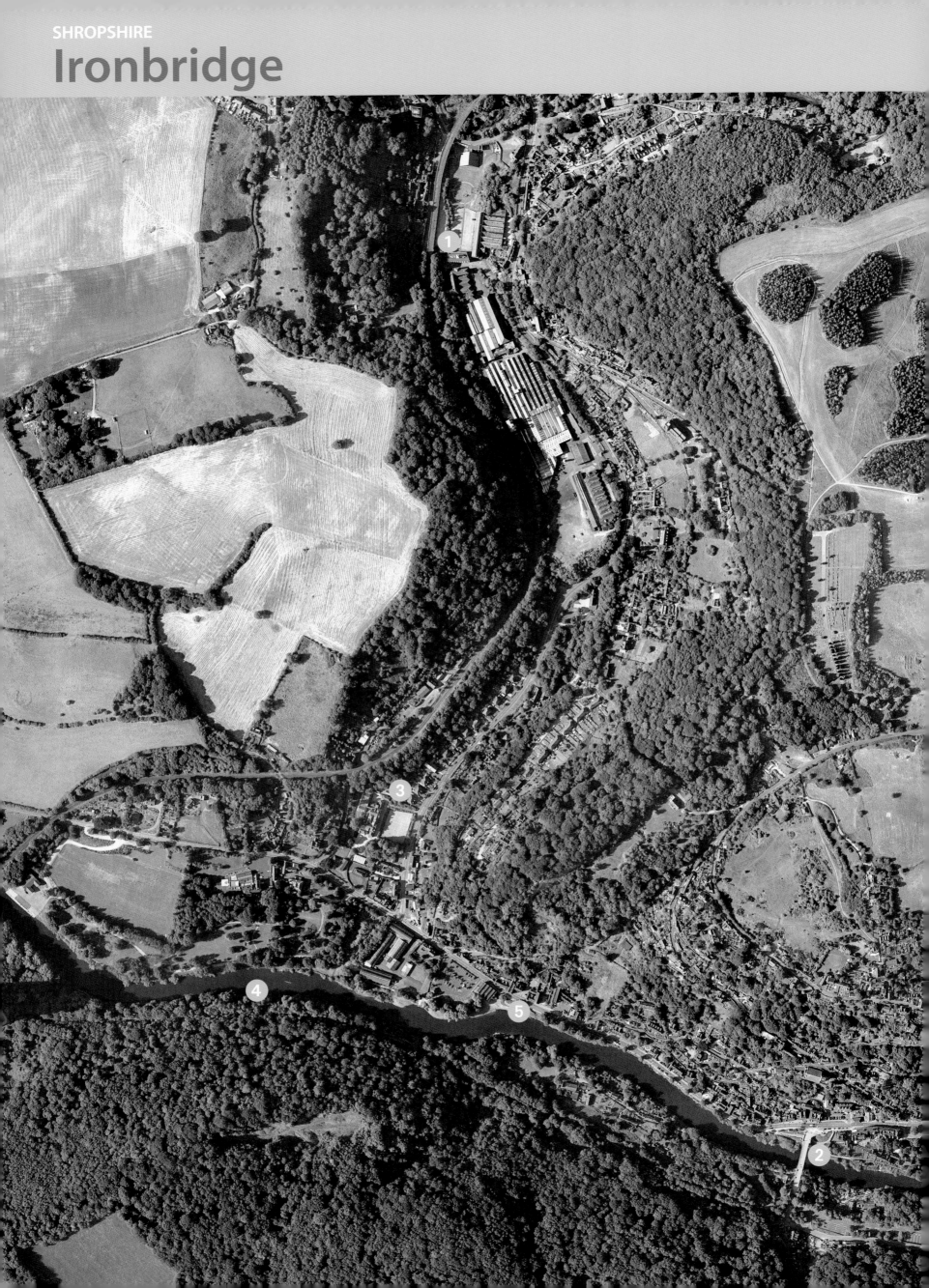

Ironbridge

Two hundred years ago, this lush and peaceful valley in Shropshire was at the heart of the young Industrial Revolution. Abraham Darby, a Quaker ironmaster, had his works at the village of Coalbrookdale, just to the north of this area, when he found the secret of smelting iron with coke in 1709. His son improved iron-making still further, and his grandson continued the tradition building the world's first cast iron bridge here. This stimulated the growth of the local community; in addition to the iron foundries there were factories making clay pipes, ceramic tiles and china ware. The coal pits of East Shropshire provided the basis for the emerging new industries. Even tourism was nurtured here, and a hotel was built specifically to accommodate the visitors drawn by the wonder of the Iron Bridge. This part of the Severn Valley was declared a World Heritage Site by UNESCO in 1986.

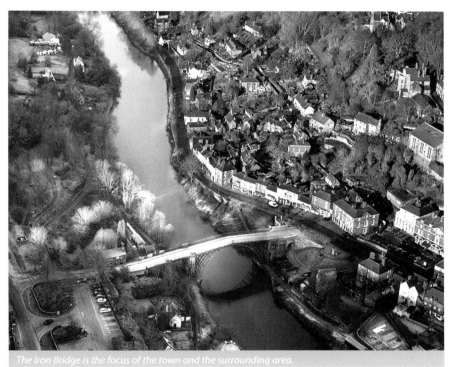
The Iron Bridge is the focus of the town and the surrounding area.

1 Enginuity

Visitors to Ironbridge can learn about science and technology in the Enginuity interactive exhibit. This modern display is located in an old building that once belonged to the Coalbrookdale Corporation, and is on the same site as the Museum of Iron in the Ironbridge Gorge. The themes often begin with engineering artefacts old and new, from steam engines to mobile phones. But visitors are invited to play with them, design them anew, and generally push, pull and handle exhibits. Visitors can also get the experience of operating X-ray machines or 'floating on air', thanks to magnetic levitation.

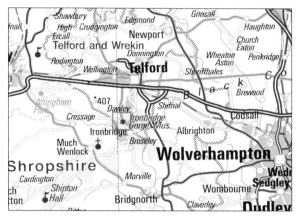

2 The Iron Bridge ◁

Construction of the world's first bridge made wholly of iron began in late 1777, and it was formally opened on New Year's Day 1781. It was the creation of the architect Thomas Pritchard and the iron-maker Abraham Darby III. Pritchard died a month after work on the bridge began, but Darby was to receive a gold medal from the Royal Society of Arts in 1785 for his achievement. Though repainted and smartened up in recent years, the bridge can no longer take vehicles. But pedestrians can cross it, admire the beauty of the gorge, and visit the tollhouse on the south bank, where a tariff of tolls dating from Victorian times can still be seen posted on the outside of the building.

3 The Green Wood Centre

Green Wood Centre, formerly known as Greenwood Trust, is devoted to keeping alive old country crafts and finding new solutions for modern living. The community room is made of local timber and positioned to make the best use of sunlight for warmth. Non-toxic plant materials were used in place of conventional paints and stains, and recyclable materials were used for insulation. Waste water is filtered through reed beds and flows into a 'wildlife-friendly' pond. Green Wood Centre relies on experts in forestry and country crafts, together with artists and teachers, to keep alive ancient skills.

5 The Museum of the Gorge ▽

A short walk along the river from the Iron Bridge is the Museum of the Gorge. It is housed in a building erected in 1834 in a striking Gothic style – yet this is the Old Severn Warehouse, once used for storing goods by the Coalbrookdale Company. The exhibition inside includes a scale model of the gorge as it was in 1796.

4 River Severn

The Ironbridge Gorge is home to a short stretch of the longest river in Britain. The Severn rises in the Cambrian Mountains in mid-Wales and flows 354km (220 miles) to the Atlantic Ocean, its estuary forming the Bristol Channel. There are six bridges over the river in the Ironbridge area. The Iron Bridge was built following the loss of a previous bridge during floods. The riverside dwellers used coracles, small bowl-shaped craft still made at Ironbridge. An annual regatta attracts coraclers from near and far.

The unique gothic building at the Museum of the Gorge.

Overleaf: the castle and village of Harlech.

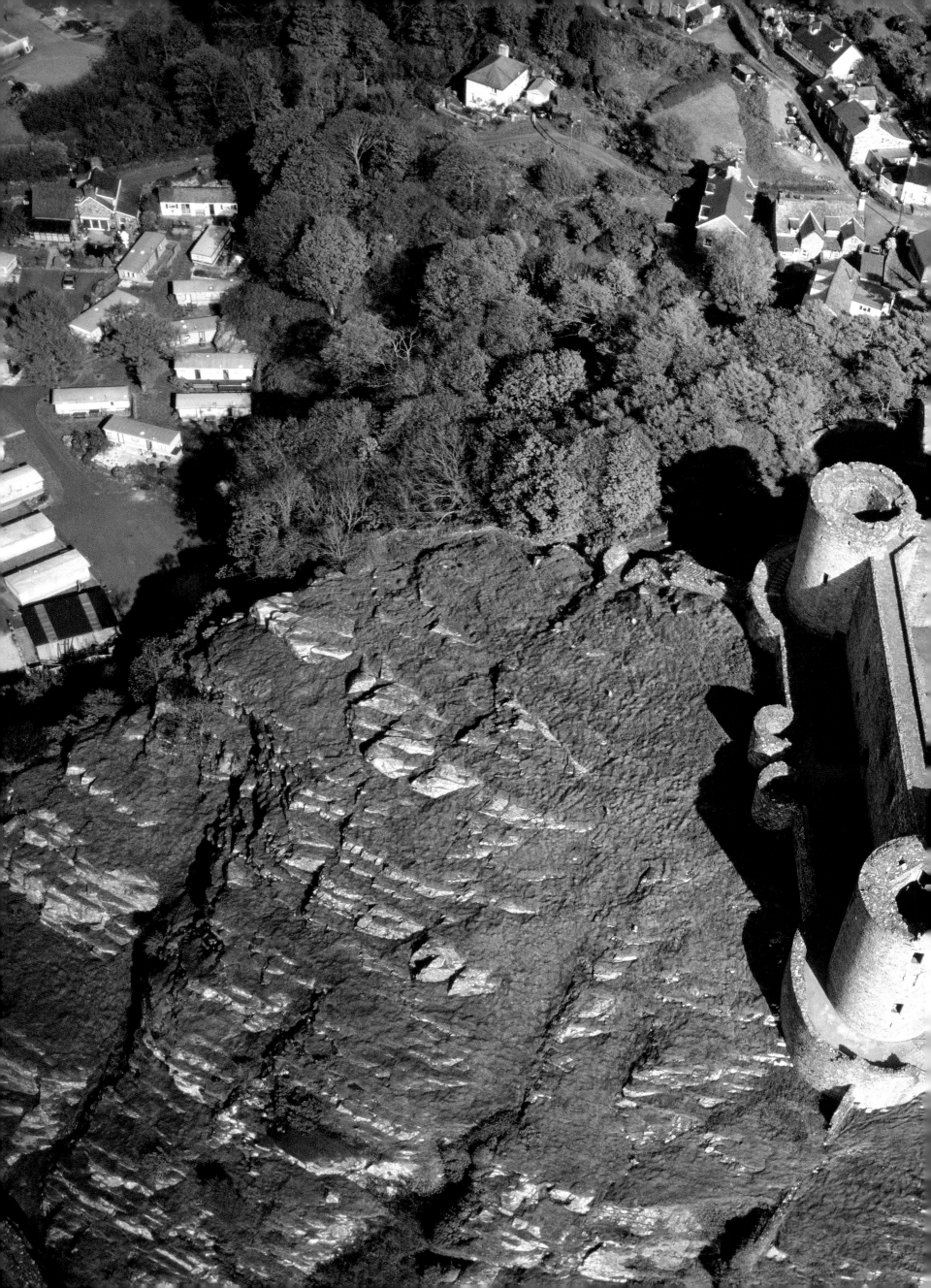

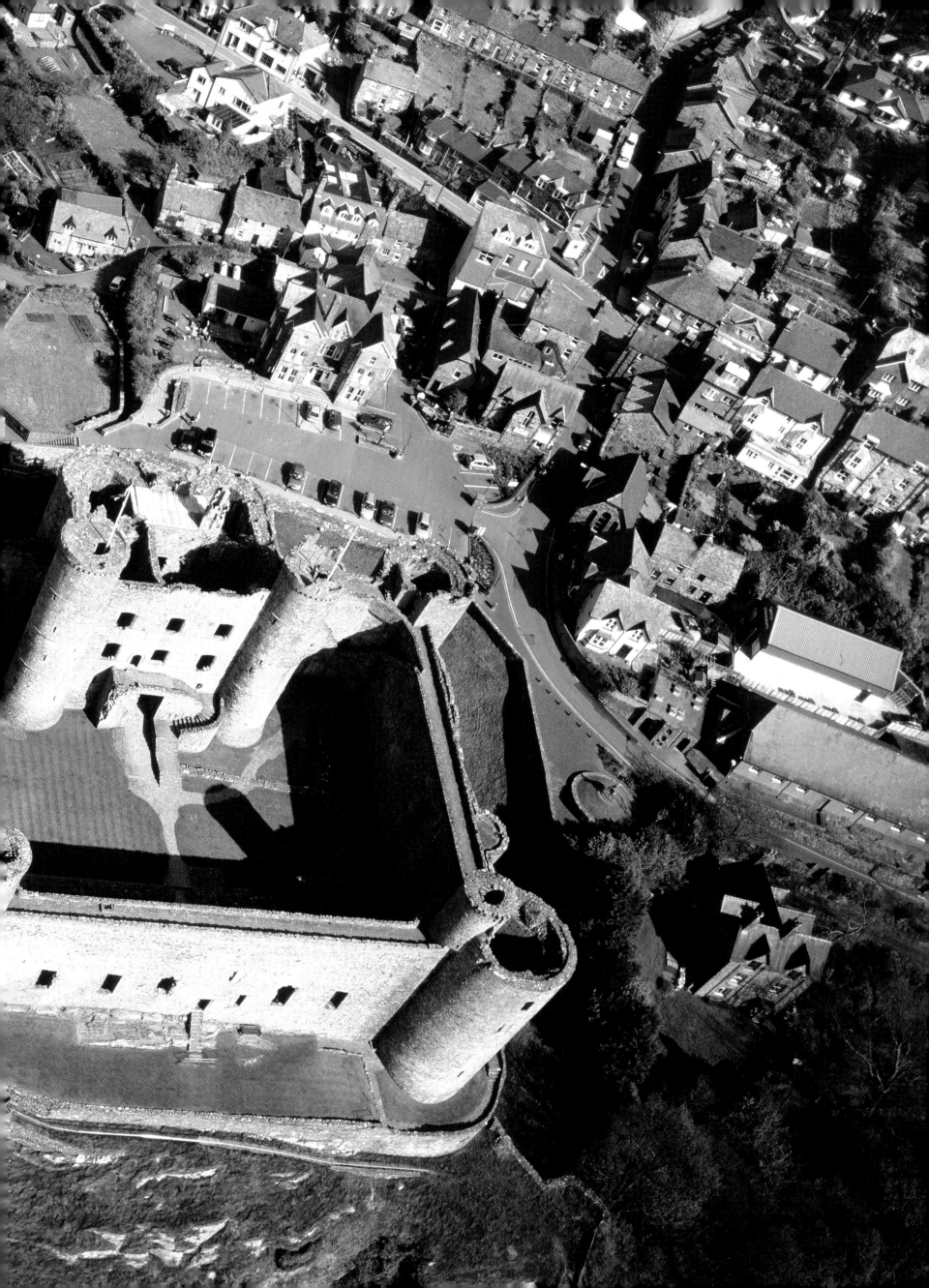

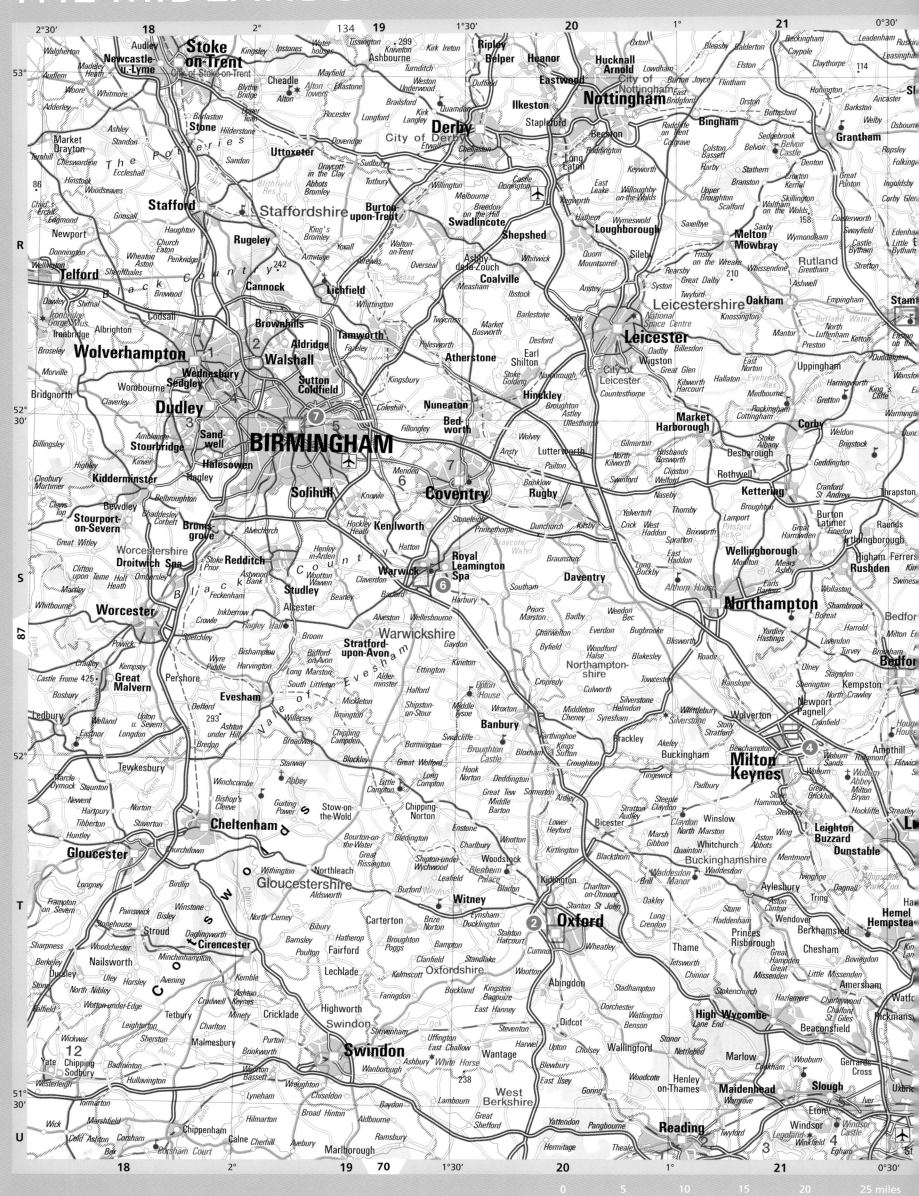

1:600,000

| 0 | 5 | 10 | 15 | 20 | 25 miles |

| 0 | 5 | 10 | 15 | 20 | 25 km |

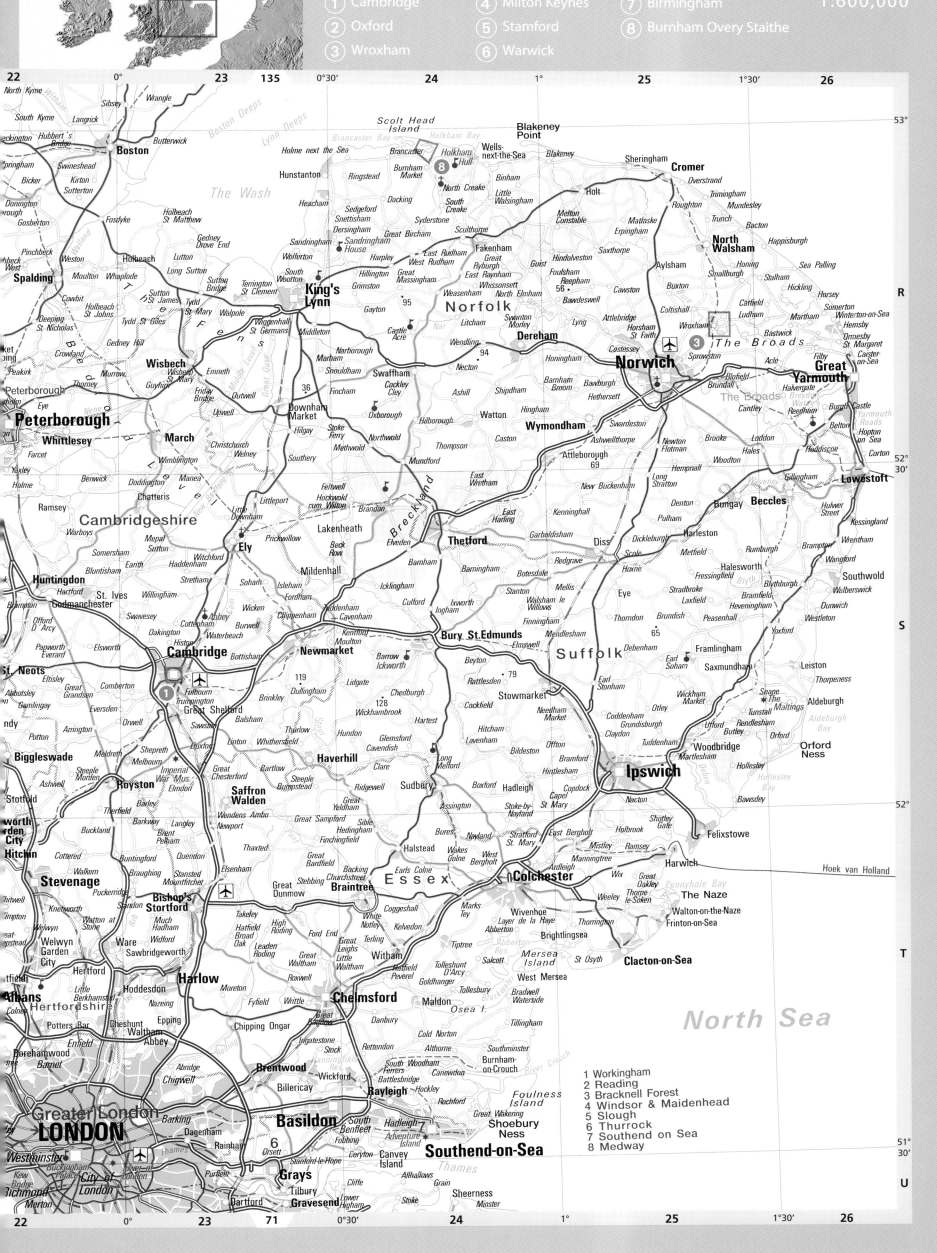

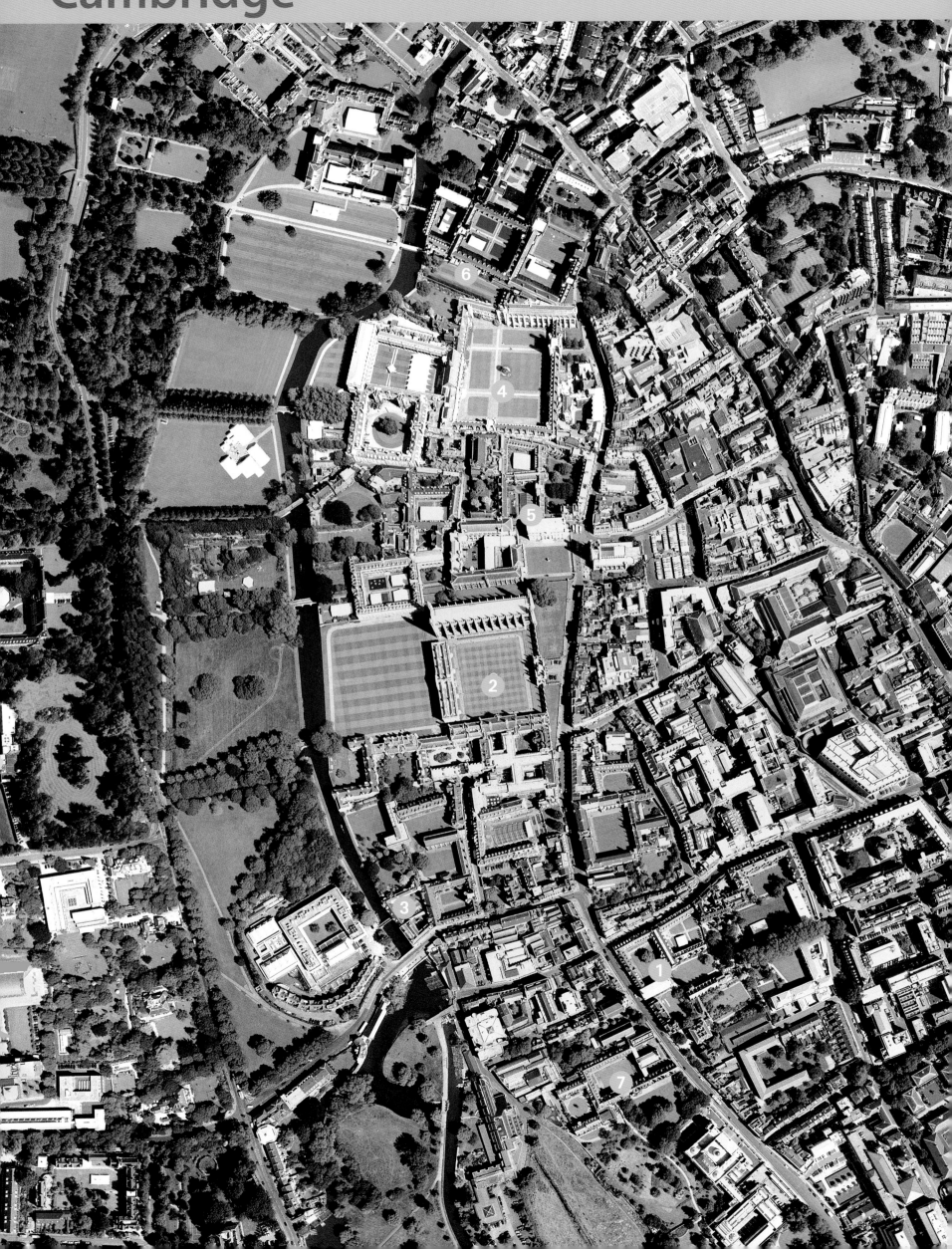

Cambridge

Cambridge University is one of Europe's oldest universities and, after Oxford, the second oldest university in the English-speaking world. Richly endowed by patrons, Cambridge is an architectural jewel containing some fine examples of craftsmanship. The university was formed in 1209 by a group of scholars who left Oxford following a dispute with the town's citizens. Its main expansion took place in the late Middle Ages when the academic focus switched from ecclesiastical law to Classics and mathematics. The first all-women's colleges were added in 1869 (Girton) and 1872 (Newnham). Robinson College, founded in 1979, brought the total of colleges to 31. In 2009 Cambridge celebrated its 800th anniversary.

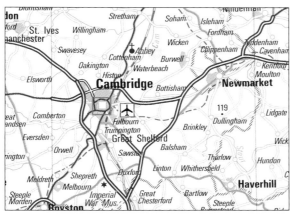

① Pembroke College

Pembroke was the third college to be founded in Cambridge, in 1347. Its founder was Mary de Pol, wife of the Earl of Pembroke, and the college was originally called Marie Valence Hall. First Court is the original college, containing all the accommodation and catering facilities originally required, as well as the chapel, the first college chapel in Cambridge. During the Reformation Mary I had several college fellows martyred, including the Master, Nicholas Ridley. The chapel was re-designed by Sir Christopher Wren in classical style in 1665. The college has a strong tradition of oriental studies, especially Arabic, and has produced a number of distinguished alumni, both literary and political, including the poets Edmund Spenser and Ted Hughes.

② King's College

In a university where colleges jostle for special recognition, King's still manages to stand out, thanks to its glorious chapel and internationally renowned choir. King's was founded by Henry VI in 1441 as a college for pupils from Eton, and the choir too owes its existence to him. The choir includes 16 boy choristers, and the annual service of nine lessons and carols before Christmas from King's College chapel is broadcast to a worldwide audience. The chapel took a century to built and has twelve huge windows on each side and the world's largest fan-vaulted ceiling. King's also boasts one of the best college libraries, with 130,000 items, including many rare manuscripts and books, and estate records going back to its foundation year. The universities of Oxford and Cambridge, and their colleges, are among the biggest landowners in Britain.

③ Queens' College

The college was founded in 1448 by Margaret of Anjou, and re-founded in 1465 by Elizabeth Woodville, Edward IV's wife. Its official name is The Queens' College of St Margaret and St Bernard. It is only one of two colleges that has buildings on either side of the River Cam; the President's Lodge is the oldest building on the river. The two sides of the college are connected by the Mathematical Bridge, widely believed to have been designed and built by Sir Isaac Newton, but actually the work of James Essex the Younger.

⑤ Gonville & Caius College

The original college foundation was by Edward Gonville, Rector of Terrington, in 1348 as Gonville Hall, a place for prayer and study. Later the college went into a prolonged decline and was re-founded in 1557 by a former student, Dr John Keys, a name he subsequently changed to Caius. He is best remembered for the elegant Caius Court and the college's three gates – 'Honour', 'Humility' and 'Virtue'. The college's fortunes rose and fell over the years, declining between the 17th and 19th centuries.

④ Trinity College

Trinity is the largest and wealthiest of the Cambridge colleges, with around 900 undergraduate and postgraduate students. It was founded by Henry VIII in 1546, and most of the college's buildings were added over the next 100 years. A key influence in its development was Thomas Nevile, who became Master in 1593, and re-built many of the existing buildings. One of the quadrangles (Nevile's Court) bears his name.

⑥ St John's College

St John's is the university's second largest college. It was founded in 1511 on the site of the Hospital of St John by Lady Margaret Beaufort, who died soon after. Nothing now remains of the original hospital, part of which had formed the First Court until it was demolished in the 19th century. The court had been used to house prisoners in the English Civil War. The Second Court was built between 1589 and 1599, and is claimed to be England's finest Tudor court. The college chapel was designed by George Gilbert Scott in the mid-19th century. Other important features include the Old Library (1624) and New Bridge over the River Cam. This leads to the 19th century Gothic New Court on the west bank. The college choir of St John's is one of Britain's finest.

⑦ Peterhouse

The oldest and smallest of the Cambridge colleges, Peterhouse was founded by Hugo de Balsham, Bishop of Ely, in 1284. The early founders expected students to pray for their souls. It has been traditionally strong in the sciences, and counts Charles Babbage (inventor of the first computer), Henry Cavendish (after whom the Cambridge research laboratory was named), and Christopher Cockerell (inventor of the hovercraft) among its alumni.

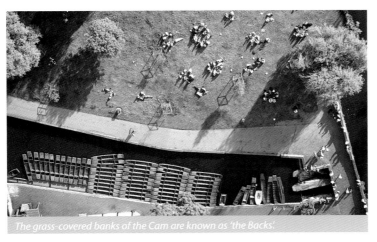

The grass-covered banks of the Cam are known as 'the Backs'.

Cambridge, Cambridgeshire **103**

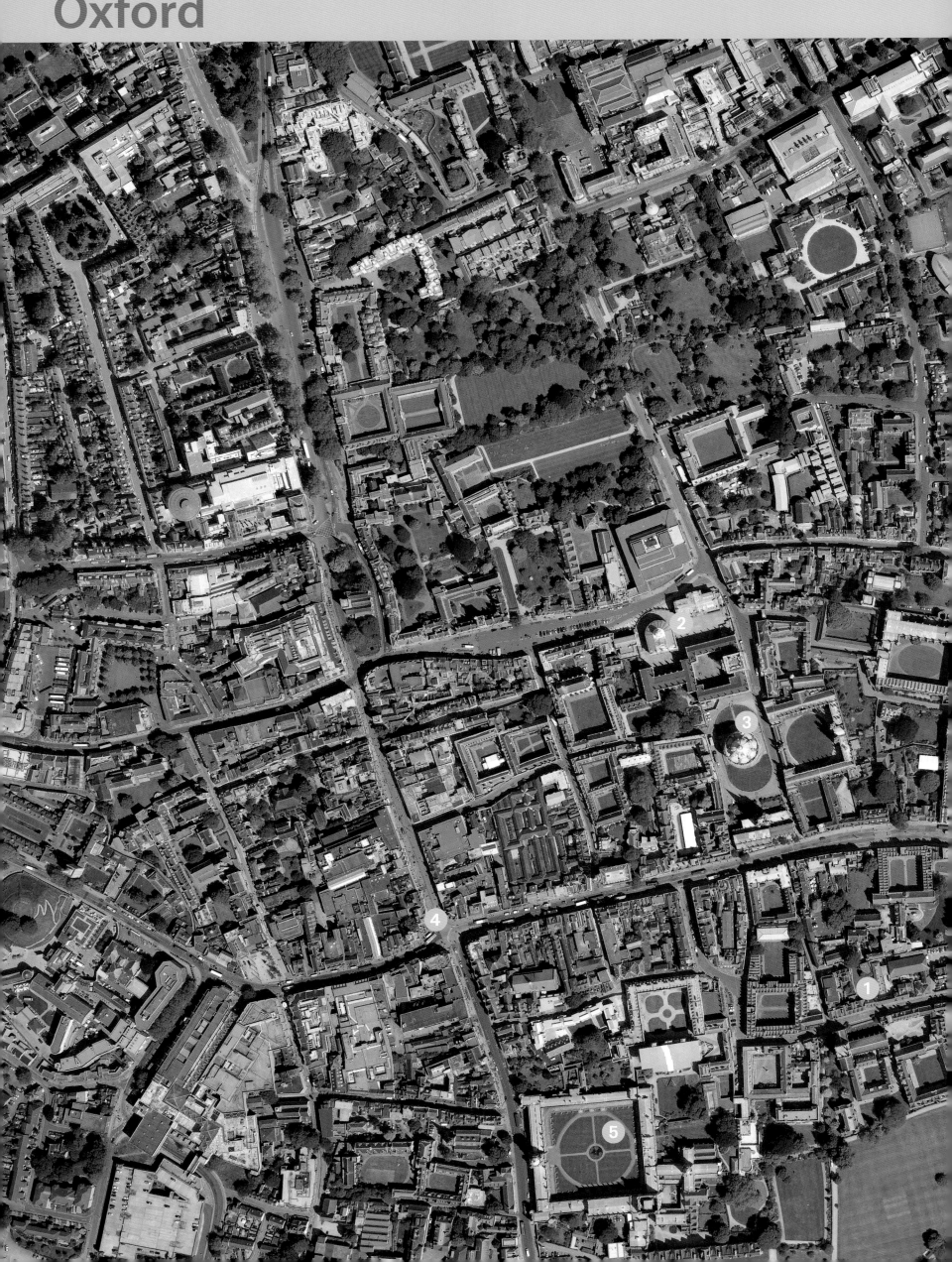

Oxford

Framed by the picturesque hills and villages of the Cotswolds to the west, Oxford lies in the Thames valley to the northwest of London. The city's origins date back to an 8th-century convent founded on the site of a ford used by oxen (hence the name) at the confluence of the River Cherwell and the River Thames, known locally as the Isis. The university emerged during the 12th century; by about 1250 several of today's 38 colleges had been founded. Many of the magnificent college buildings, libraries and chapels have survived largely unchanged to this day. The 'dreaming spires' of the colleges cast their shadows over what has become a thoroughly modern, medium-sized English city with a population of more than 151,000, the alma mater of some 50 Nobel Prize-winning academics as well as home to workers from the local BMW Mini car-manufacturing plant.

① University College

University College, known as 'Univ' by its students, is the oldest college in the university. Its traditional focus on the study of theology contributed to its reputation as one of the more conservative colleges. It was founded in 1249, but the current layout and dominant architectural style date from the Restoration period that followed the Civil War in the 17th century. Wandering along Logic Lane towards the Main Quadrangle, visitors today tread in the footsteps of countless famous former students, from C. S. Lewis, author of the *Narnia* stories, to, more recently, former US president Bill Clinton. The monument to 'Univ' alumnus Percy Bysshe Shelley, who was sent down, or expelled, from the college also attracts admirers of the Romantic poet's work, as well as practical jokes by irreverent students.

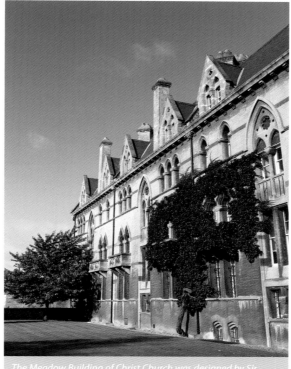

The Meadow Building of Christ Church was designed by Sir Thomas Deane and built in 1863 in the Venetian style.

② Sheldonian Theatre

Twelve grotesque stone heads on pillars stand guard in front of the Sheldonian Theatre. Gilbert Sheldon, a student of the university, who later became Archbishop of Canterbury, commissioned the building, which was completed in 1668. Designed by Sir Christopher Wren, it was Oxford's first classical building. Although public concerts (but, ironically, no theatrical performances) are held there, the Sheldonian is best known as the site of university lectures and graduation ceremonies that take place beneath its eight-sided cupola.

③ Radcliffe Camera ▷

Known affectionately as the 'Rad Cam', the reading rooms of Oxford University's world-famous Bodleian Library are housed in a three-storey circular building constructed of local stone. Dating from the 18th century, its dome has become emblematic of Oxford, an extraordinary feat in a city so full of architectural landmarks. Originally designed to house the Radcliffe Science Library, the building was designed by James Gibbs in the English Palladian style. It dominates Radcliffe Square, flanked by All Souls College and the University Church of St Mary the Virgin. Both the square and the library are named after John Radcliffe, physician to the ruling monarchs William and Mary in the early 18th century, and a major benefactor of the university. In his trilogy *Lord of the Rings* the writer J.R.R. Tolkien, a graduate of Exeter College was inspired by this illustrious temple of learning when describing the Dark Lord Sauron's temple to Morgoth, the power of darkness.

④ Carfax Tower

Located in the centre of the city at the busy junction of the Cornmarket and the High Street, Carfax Tower is all that remains of the 13th century St Martin's Church. The rest of the church was demolished in 1896 when the road was widened to accommodate increasing traffic. The name Carfax derives from the French word *carrefour* meaning 'crossroads'. Standing 23m (74ft) tall, visitors can climb the 99 steps to reach the top of Carfax Tower and enjoy a fine view over the centre of Oxford.

⑤ Christ Church ◁

Christ Church is one of the largest and most celebrated institutions in the university. Founded in 1525 by Cardinal Wolsey, Henry VIII's Lord Chancellor, its Renaissance buildings are among the grandest in Oxford. Known originally as 'Cardinal's College' and then as 'King Henry VIII's College', 'Christ Church', as it was rechristened in 1546, has been the alma mater of 13 British Prime Ministers. A more recent claim to fame is the college's starring role as a location in the Harry Potter films, since its cloisters and quadrangles made it an ideal backdrop for Hogwarts School as described in J.K. Rowling's series of novels. Christ Church Cathedral serves a dual role as college chapel as well the cathedral of the diocese of Oxford. It is the home of the eponymous choir of 12 men and 16 boys; the latter attend the Cathedral School, which is known for its rigorous musical and academic training.

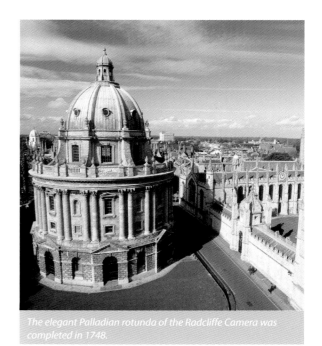

The elegant Palladian rotunda of the Radcliffe Camera was completed in 1748.

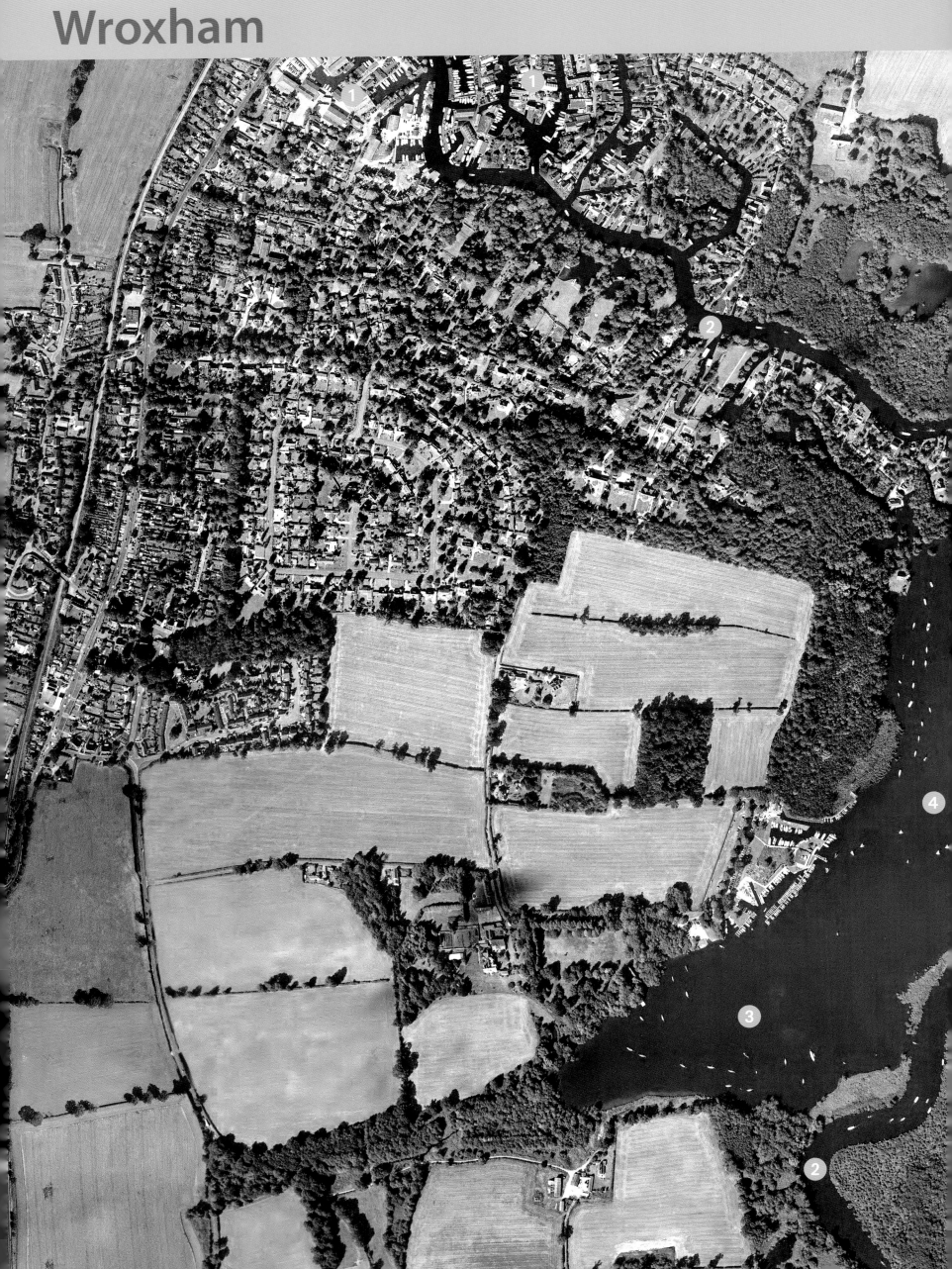

Wroxham and the Norfolk Broads

The Norfolk Broads comprise a multitude of wide, shallow lakes and rivers in northeastern Norfolk. Often called the capital of the Broads, Wroxham and the adjoining village of Hoveton are surrounded by large stretches of water, once thought to be natural phenomena. However, in the 1960s it was revealed to be a series of waterways produced artificially by digging for peat in mediaeval times and the subsequent flooding of the excavations. The Norfolk Broads have been a major tourist attraction since the late 19th century; they are still as popular as ever today.

① Wroxham and Hoveton

Situated about 11km (7 miles) from Norwich, the villages of Wroxham and Hoveton are linked by a small hump-back bridge spanning the River Bure. Together, these villages form the boating heart of the Norfolk Broads. In the summer months, the local population of 3,200 is swelled massively by tourists taking cruises around the local area, hiring leisure craft and using Wroxham as a base for exploring the 303sq km (117sq miles) of the surrounding waterways. Some of the major attractions include a riverside park, the Bure Valley steam railway and Hoveton Hall gardens.

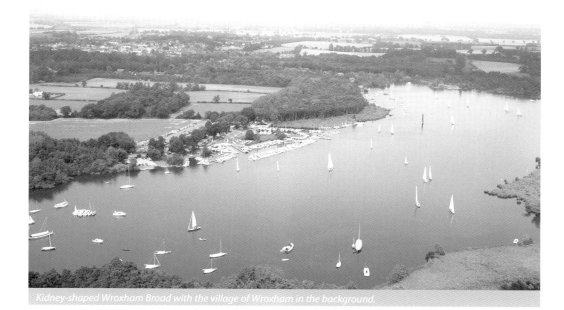
Kidney-shaped Wroxham Broad with the village of Wroxham in the background.

② The River Bure ▽

The River Bure is one of the major rivers flowing through the Norfolk Broads. It is especially busy where it reaches Wroxham due to the multitude of tourist craft. Intensive arable farming in the immediate catchment area has caused agricultural phosphates to drain into the river resulting in a reduction in oxygen supply and a growth of algae, a process known as eutrophication. Intensive work is being undertaken by the Broads Authority to combat the effects of climate change and improve the water quality.

③ The History of the Broads

The true origins of the Norfolk Broads were not revealed until the late 1960s when research into the vertical banks of the lakes revealed that the vast areas of water were actually man-made, the result of peat collection as a source of fuel. This occurred on a massive scale until the 14th century, when flooding caused the diggings to be abandoned. The resulting waterways became a haven for wildlife and an essential aid to commerce.

④ Wroxham Broad △

Wroxham Broad is one of the largest Norfolk Broads, covering nearly 40 hectares (98 acres) at an average depth of 1.3m (4.3ft). The lake itself lies to the south-east of the village of Wroxham in the middle reaches of the Bure; a narrow bank of trees separates it from the main river channel. Small areas of wet woodland also surround the Broad. Wroxham Broad is home to a great diversity of wildlife, including bitterns, marsh harriers, swallowtail butterflies and the Norfolk hawker dragonfly, all of which are rare or absent from the rest of the country.

A rigorous programme of phosphorus removal has improved the water quality. The aquatic plant community here now includes yellow waterlilies, stonewort and Canadian waterweed.

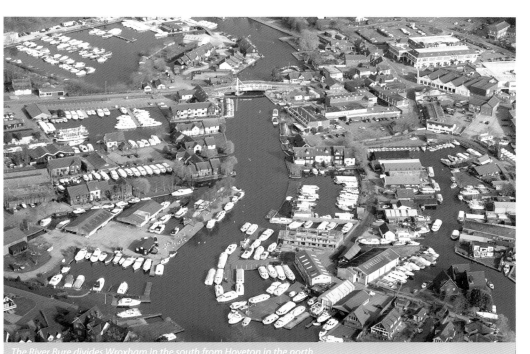
The River Bure divides Wroxham in the south from Hoveton in the north.

Milton Keynes

Formally designated as a new town in 1967, Milton Keyne lies 80km (50 miles) to the north-west of London, and is unique in Britain as a planned new community that was designed to balance industry, leisure and transport. Shopping, recreation and housing are carefully zoned. The sprawling town, with its population of more than 230,000, embraces ten mediaeval villages, 15 lakes and 18km (11 miles) of canals. Twenty-two per cent of Milton Keynes' area is parkland. The view (left) shows Willen Park.

1 Peace Pagoda ▷

The pagoda in North Willen Park was built by a Japanese Buddhist group, the Order of Nipponzan Myohoji. It was inaugurated in 1980 by the Order's founder, the Most Venerable Nichidatsu Fujii. The order began building such pagodas around the world after the Second World War, the first being in Hiroshima. The first in the Western Hemisphere was this one at Milton Keynes. Around the outside of the pagoda is a sequence of carvings representing eight stages in the life of the Buddha, from his birth to his death. Inside the pagoda there are relics of the Buddha.

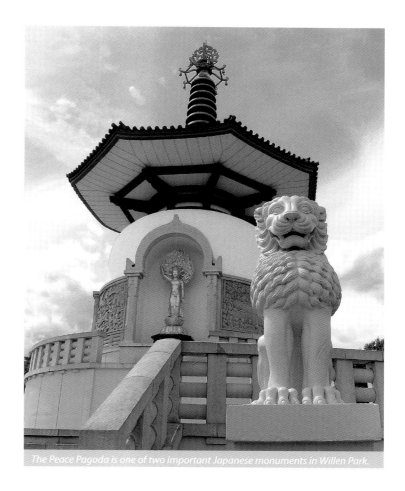
The Peace Pagoda is one of two important Japanese monuments in Willen Park.

2 Cathedral of Trees

The Cathedral of Trees, designed by the landscape architect Neil Higson and planted in 1986, reproduces the ground plan of Norwich Cathedral. Evergreens define the central tower, the spires and the walls. The nave is lined with hornbeam and limes. The choir is planted with golden ash and the chancel with holm oak. Variations in tree species define points of interest throughout the cathedral: for example, flowering cherries and apple trees mark the chapels. A large, slightly sunken square on the south side represents the cathedral cloisters. A mound to the south-east is the chapter house and also provides a viewing point. At different seasons patches of colourful bulbs planted within the cathedral represent the effect of sunlight shining onto the floor through stained-glass windows.

3 Japanese temple and gardens △

Near the Peace Pagoda the monks and nuns of Nipponzan Myohoji live in a Buddhist temple of traditional Japanese design and cultivate the gardens around the temple. There are prayers every morning and evening, and special ceremonies on New Year's Day. The temple is a centre of instruction for Buddhism, one of the most flourishing religions in the area.

4 Willen Maze

Willen Maze is an elaborate pattern cut into the turf near the North Lake. It is not a puzzle maze but rather a labyrinth, consisting of a single winding path that leads you by a circuitous route from the outside to the centre. It is a larger version of the labyrinth cut into turf at Saffron Walden in Essex. Willen Maze is 70m (230ft) across, making it one of the largest in the world. The full path is 3km (1.9 miles) long.

5 Circle of Hearts Medicine Wheel ◁

The Circle of Hearts Medicine Wheel was designed by Roy Littlesun, who drew on the traditions of the Hopi people of North America. The Wheel consists of two concentric circles of 108 limestones. They include larger stones marking the four points of the compass. Extra marker stones align with the rising sun at midsummer. The area between the circles represents the elements of air, earth, fire and water.

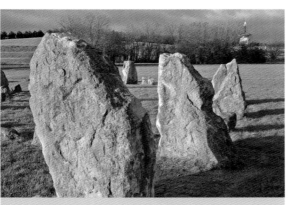
The North American medicine wheel is a universal symbol of peace.

6 Road network

This intersection hints at the nature of Milton Keynes' road network. When the town was first being designed, it was proposed that transport would be provided by a public transport system based on monorail. As it became clear that the private car was to be the preferred mode of transport, the town adapted and is now based on a sprawling grid of roads. Roads have numbers as well as names: those running roughly north–south have numbers beginning with V (for 'vertical'); those running roughly eastwest have numbers beginning with H (for 'horizontal'). The large road running vertically here is Brickhill Street, V10. The large road running horizontally is Portway, H5. Traffic flows freely through intersections that are roundabouts rather than junctions. Around 200 km of cycle routes complement the system.

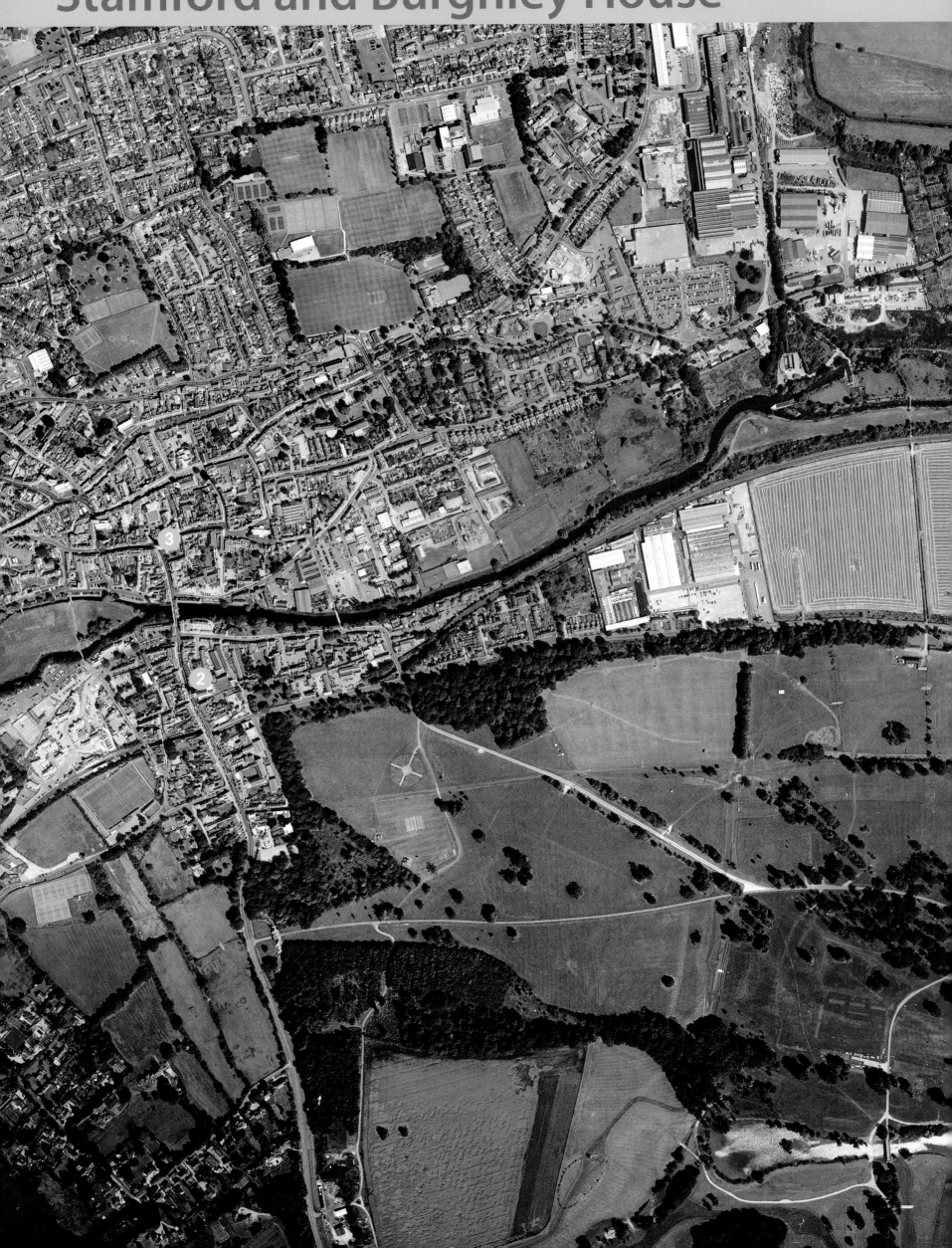

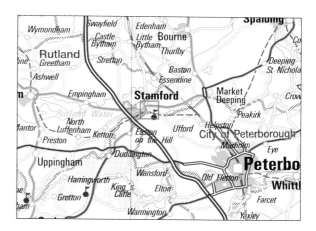

Stamford and Burghley House

For many centuries the 'Great North Road' ran through the town of Stamford, though now it sits a mile or so away from the modern A1 road. It was the nearby ford crossed by the Roman road Ermine Street that gave the town the name of Stane ('Stone') Ford. Under Viking rule, Stamford was capital of one of the five boroughs of the 'Danelaw'. Henry III confirmed its status when he granted the town's charter in 1254. Until Stamford lost out to other mediaeval towns further south in East Anglia, its fortune was made on the backs of sheep (the local wool being turned into 'Stamford cloth'), as well as pottery. The Wars of the Roses in the 15th century saw the town's fortunes decline briefly, but development continued, with a further burst of building activity in the Georgian period. Such events have combined to create an attractive townscape with many elegant streets. It is also popular as a location for historical television dramas.

Burghley House is the backdrop for the annual Burghley Horse Trials.

① Burghley House and Grounds △

Burghley House is one of the finest Elizabethan houses in England. Built between 1555 and 1587, it was not only commissioned but designed by William Cecil, Elizabeth I's Lord High Treasurer, and one of the most powerful men in the kingdom. Though the Elizabethan house, with its 35 large rooms and more than 80 smaller ones, was sumptuous enough, later Cecils were keen to change it. John Cecil, the 5th Earl, transformed the house in the 17th century. The Earl and his wealthy wife, Lady Anne Cavendish, daughter of the Duke of Devonshire, collected innumerable paintings, sculptures and objets d'art on their Grand Tour in Italy to add to the wealth of treasures on display.

A substantial number of state rooms are open to visitors, and it is as much the rooms as the contents themselves that are of interest. The park was laid out by the landscape gardener Capability Brown in the 18th century. His carefully created views from the house, such as the lake seen from the Blue Silk Bedroom, are breathtaking. To the north, the spires of Stamford's many fine churches can be seen through the trees.

② St Martin's Church

St Martin's was founded in 1146, though it may be older. A ruin by the late 15th century, it was comprehensively rebuilt in English Perpendicular Gothic style by 1482. Today, it is the only mediaeval church to have survived outside the old town walls. St Martin's houses the tomb of William Cecil, Lord Burghley, who died in 1598. He was the builder of Burghley House and a trusted advisor and confident to Elizabeth I. His effigy shows him in armour, with his badges of office.

③ Stamford Town Centre

The prosperity of medieval Stamford, from the 'haberget' or 'Stamford cloth' it made, is still evident in the town, even though the Norman castle mound was bulldozed to make a car park, and only a postern gate and a tower remain from the original town walls. Brasenose College's gateway still stands in Bath Street as witness to the brief period when academics and students from Brasenose and Merton Colleges in Oxford tried to set up a breakaway university in 1333. A mediaeval legacy is also apparent in the fine churches throughout the town. St Mary's, with its 13th-century 50m (163ft) tower, stands surrounded by Georgian houses. The original church of All Saints in Red Lion Square was recorded in the Domesday Book of 1086. Stamford has suffered little industrialisation and still enjoys the reputation of being the 'finest stone town in England'.

Warwick

Warwick, the county town of Warwickshire, lies on the River Avon at an historically important crossing-place. The line of the river curves from the bottom centre of the picture, through the centre, to the top right-hand corner. The town received its first charter, granting rights and privileges to its merchants and other citizens, in 1545. Its castle is the most celebrated feature of the town, but the town centre is rich in ancient buildings – both those mediaeval structures that survived the town's great fire in the 17th century and those from the 18th century. The history of the settlement was dominated for centuries by the Earls of Warwick, who owned the castle until 1978.

② Collegiate Church of St Mary

One of the Earls of Warwick, Robert de Newburgh, founded St Mary's in Church Street in 1123. Some of the original Norman features of this splendid building can still be seen in the crypt, which also houses a genuine ducking stool, a device for publicly dipping miscreants into water. The nave and tower were rebuilt following the fire of 1694, as were many other of Warwick's buildings. Visitors can climb the tower for magnificent views of the castle and of the town. The interior of this church, which is one of the largest in England, includes the Beauchamp Chantry that is regarded by some as the finest mediaeval chapel in England.

③ Lord Leycester Hospital

Towards the end of the 14th century, Thomas Beauchamp, 12th Earl of Warwick, built the Chantry Chapel of St James at Warwick's West Gate, and later granted it to one of the town's powerful guilds, the Guild of St George, which was later joined by the Guild of the Blessed Virgin. These guilds, later called the United Guilds of Warwick, erected several buildings at the site, including fine halls and living quarters. The guilds were dispersed by Henry VIII in 1546, and the property here was acquired in 1571 by Robert Dudley, Earl of Leicester (spelled 'Leycester' at this time). He founded a 'hospital', or charitable home, for aged or disabled soldiers and their families. The hospital survived Warwick's great fire of 1694. The hospital still fulfils this role and is occupied today by eight ex-servicemen and their wives. On the same site is the regimental museum of the Queen's Own Hussars, an armoured regiment.

① Castle Park and River Avon

The town's population of just over 25,000 inhabitants can enjoy rest and relaxation in the extensive park, across the river from the town and taking its name from the castle. Its boundaries are marked on three sides by the River Avon. Below the castle, the Avon is regulated by weirs. (The name 'Warwick' means 'dwellings by the weir'.) The river is linked with the Grand Union Canal, which passes north of the town, north-westward to Birmingham and southward to London. From the great Hatton flight of 21 locks which is located 5km (3 miles) to the northwest of Warwick there is a fine view of St Mary's and the castle.

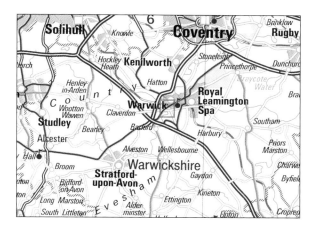

④ Warwick Racecourse

Warwick Racecourse has its home on Warwick Common, and lays claim to be one of the oldest racecourses in the country. Races have been held here since 1728, with a major interruption during the Second World War, when much of the common was given over to a prisoner-of-war camp. The course holds both flat and National Hunt (steeplechasing) events, which means that there is racing around the year, with 22 fixtures in all. Flat racing takes place from April until October, and steeplechasing from November until May.

The biggest event held at the racecourse is the Warwick National, held in January. The main flat race event is the two-day Warwick Festival, held in June. The first grandstand was built here in 1808. The present grandstand was refurbished in 2000, and now holds over 1,200 spectators.

⑤ Warwick Castle ◁

One of England's best-preserved castles, Warwick Castle lies on the north side of the River Avon. Queen Ethelfleda, daughter of Alfred the Great and sister of Edward the Elder, ordered an earth rampart to be built here in the 10th century to defend the area against the Danes. William the Conqueror ordered that the existing fort be enlarged. The wood of the castle was replaced with stone in the 13th century, and the castle was continually strengthened, remodelled and extended in the centuries that followed. Most of the fabric that can be seen today dates from the 14th and 15th centuries. In 1750 'Capability' Brown landscaped the gardens. The castle is now owned by the company that operates Madame Tussaud's Waxworks in London, and visitors to the castle can see wax figures of historical personages occupying some of the rooms, together with a waxwork recreation of a royal weekend party held in 1898.

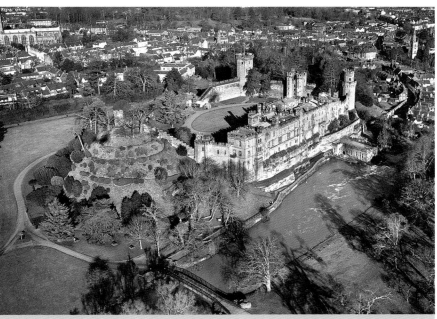
The mound of the early motte and bailey fort abuts Warwick Castle.

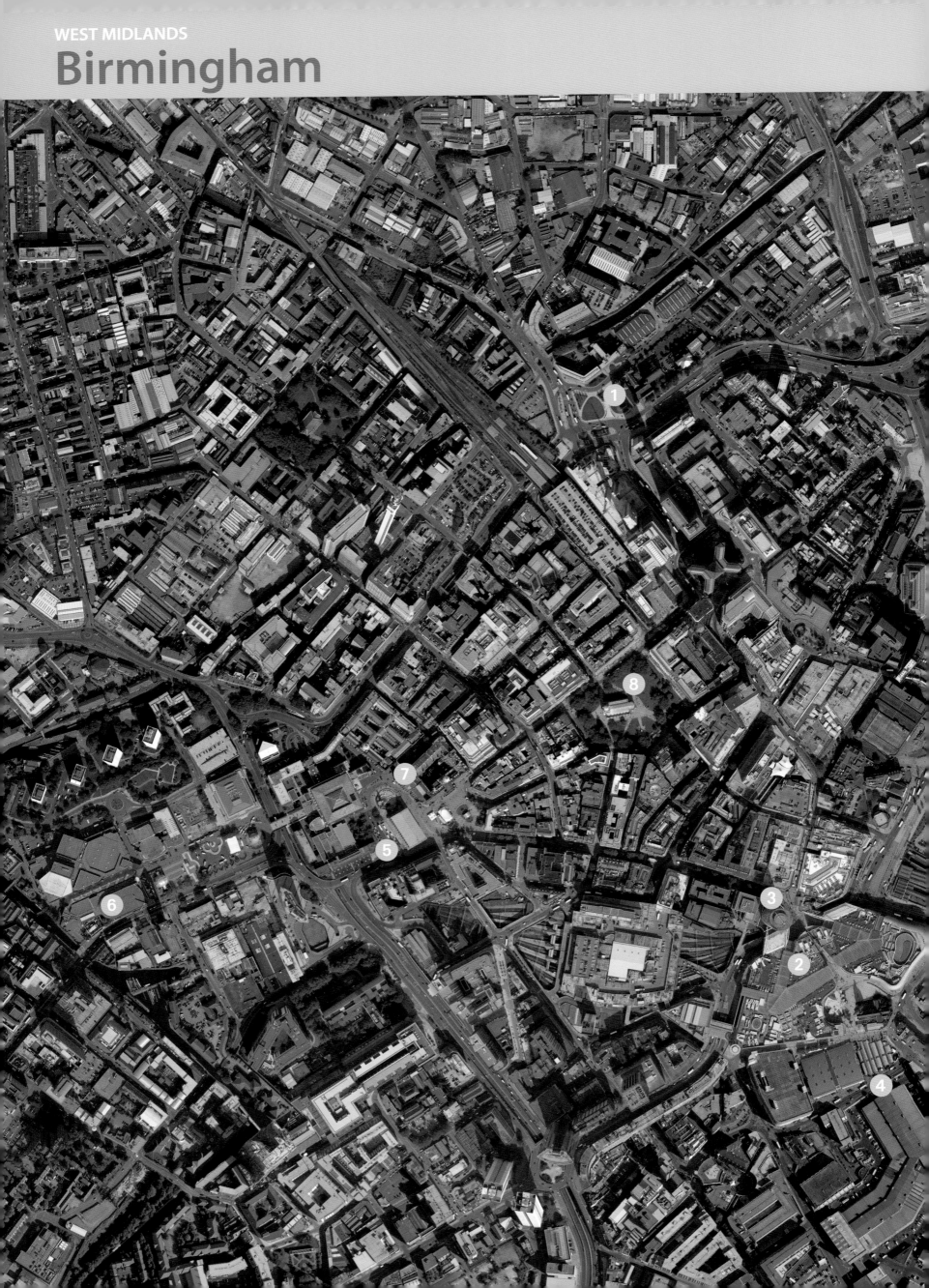

Birmingham

Home to more than 3.5 million people, the bustling metropolis of Birmingham covers an area of 80 sq miles, making it one of the largest cities in Europe. In the 19th century it was a thriving centre of industry, producing almost 50 per cent of the globe's manufactured goods, making it renowned as 'the workshop of the world'. Birmingham has retained its name as a centre of enterprise, supplemented in the 21st century by a growing reputation as a cultural centre. Since 1991 the city has been home to one of the world's finest concert venues in the Birmingham Symphony Hall.

① St Chad's Cathedral

Birmingham's Roman Catholic Cathedral is a magnificent neo-Gothic building designed by Augustus Pugin, the celebrated architect of the Houses of Parliament in London. Opened in 1841, St Chad's was the first Roman Catholic church constructed in England since the Reformation in the 16th century. The Cathedral, built of brick with stone facing, contains a mediaeval statue of the Virgin Mary, a 15th-century Flemish pulpit and stalls and stained-glass windows designed by Pugin and made by John Hardman of Birmingham. Pugin also designed the six vast candlesticks that stand on the impressive Bath-limestone altar. The United Kingdom's largest manual organ was installed in 1993.

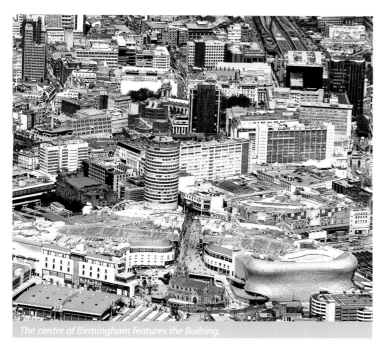

The centre of Birmingham features the Bullring.

② The Bullring ◁

Birmingham's state-of-the-art Bullring shopping complex began life in the 12th century as a marketplace. In the early 1960s an enclosed shopping centre – one of the world's biggest outside North America – was built on the site. The Bullring fell into decline in the 1980s and 1990s and was demolished 2001 to make way for a £500 million complex containing more than 140 shops and kiosks. The new Bullring – featuring the eye-catching 'bubble-wrap' surface of Selfridge's futuristic department store – opened 2003. Now, 36.5 million shoppers visit the new centre every year.

③ The Rotunda

Overlooking the Bullring shopping centre is the 81m (266ft)-tall 25-floor Rotunda in New Street. Designed by architect James Roberts and opened in 1965, the 23-floor Rotunda building houses offices. In August 2000 it was granted Grade II listed building status. From 2004 to 2008 the Rotunda was restored and partially converted for residential use.

④ St Martin's in the Bullring Church

A church has stood on this site since Norman times: the original was rebuilt in the 13th century, but most of the building was constructed in the 19th century. Sometimes called the 'Cathedral of the Bull Ring', St Martin's, like Birmingham's Anglican Cathedral, St Philip's, contains fine stained-glass windows designed by the artist Edward Burne-Jones. The church has recently been renovated.

⑤ Birmingham Town Hall

This splendid Grade I listed colonnaded building was designed by Joseph Hansom in 1831. Construction work began the following year and although the town hall was formally opened in 1834, building continued until 1849. Made of local Selly Oak brick with Anglesey marble facing, the town hall has the appearance of a Greek temple and when first built dominated the skyline from its elevated position at the top of Hill Street. Initially a venue for Birmingham's Triennial music festivals, the building became a celebrated concert hall, hosting premieres by Edward Elgar and Felix Mendelssohn and, in recent years, rock concerts by Bob Dylan and The Beatles. It was the home of the City of Birmingham Symphony Orchestra until the orchestra moved to the Symphony Hall in 1991. It was closed for renovation in 1996 and reopened in 2007. In 2009, the Town Hall marked its 175th anniversary.

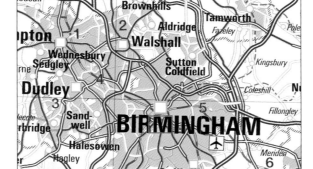

⑥ Symphony Hall

Opened in 1991 as part of Birmingham's International Convention Centre, Symphony Hall is the performance home of the City of Birmingham Symphony Orchestra. Its 10th anniversary year was celebrated with the installation of a 6,000-pipe symphony organ. Each year around 370,000 people attend events in the Hall, which hosts concerts, conferences and other promotions like community events or graduation ceremonies.

⑦ Council House

The Council House, used for all council and committee meetings, was built to designs by architect Yeoville Thomason between 1874 and 1879. Its clock, known as 'Big Brum', was once lit by gas. Thomason also designed the adjacent Birmingham Museum and Art Gallery, built in 1885, which contains a celebrated collection of Pre-Raphaelite paintings. Above its entrance, the carved inscription declares 'By the gains of Industry we promote Art'.

In Victoria Square in front of the Council House stand contrasting pieces of public art: a 19th-century statue of Queen Victoria, a 6.6m (21ft)-tall figure entitled Iron: Man (1993) by the sculptor Antony Gormley and a fountain with a reclining River Goddess designed by Indian-born artist Dhruva Mistry, also dating from 1993.

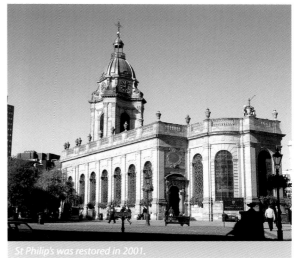

St Philip's was restored in 2001.

⑧ Birmingham Cathedral △

Consecrated in 1715, St Philip's Church in Colmore Row was designed as a parish church by the leading English Baroque architect Thomas Archer. It was then named the Cathedral for the newly created diocese of Birmingham in 1905. Birmingham-born Pre-Raphaelite painter Edward Burne-Jones designed four stained-glass windows – depicting the Nativity, the Crucifixion, the Ascension and the Last Judgement – between 1885 and 1891. The windows were made by William Morris & Co at no cost. St Philip's Churchyard was restored in 2000–2001 and contains a double line of plane trees.

Overleaf: the salt marshes at Burnham Overy Staithe, Norfolk.

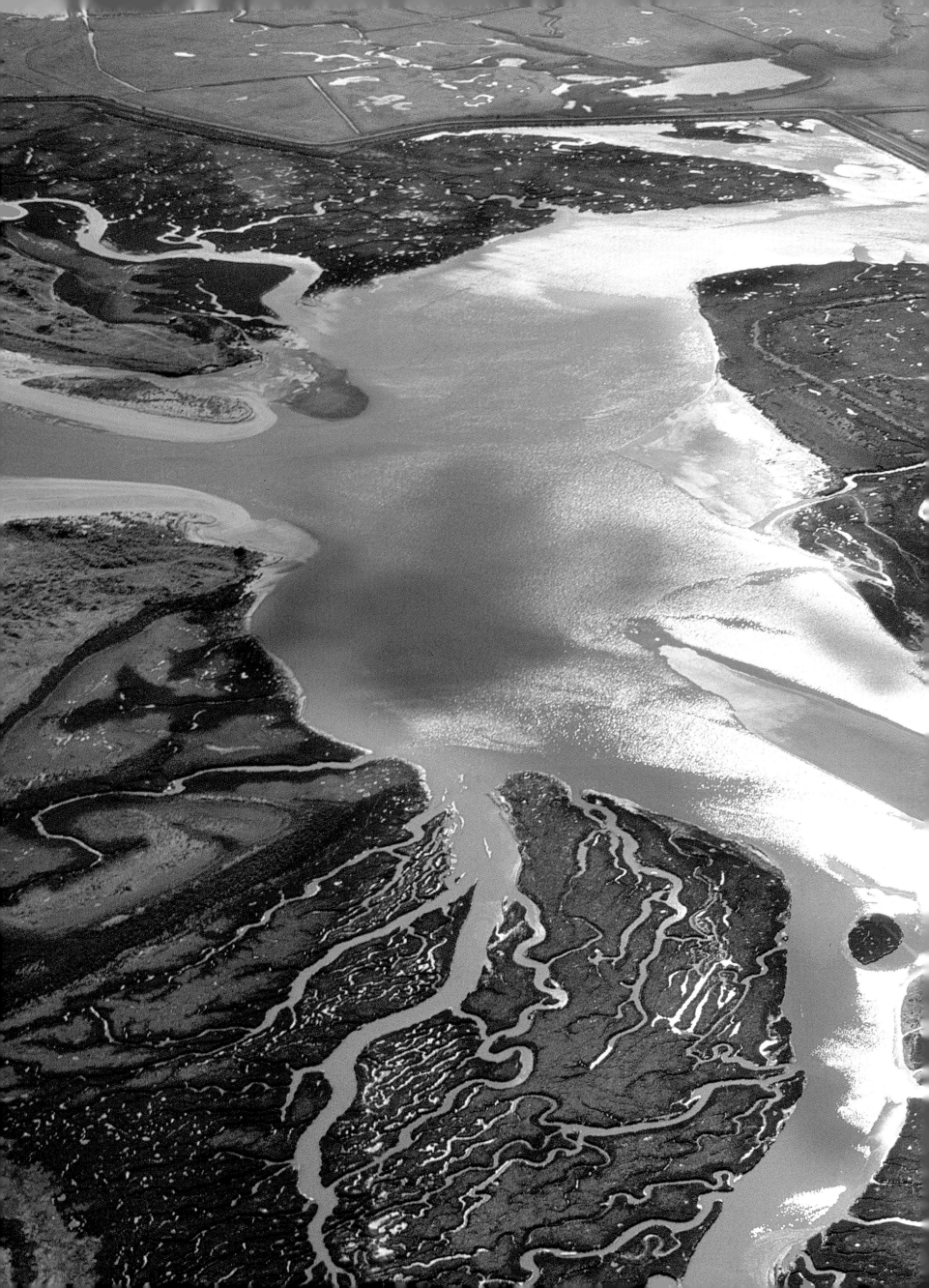

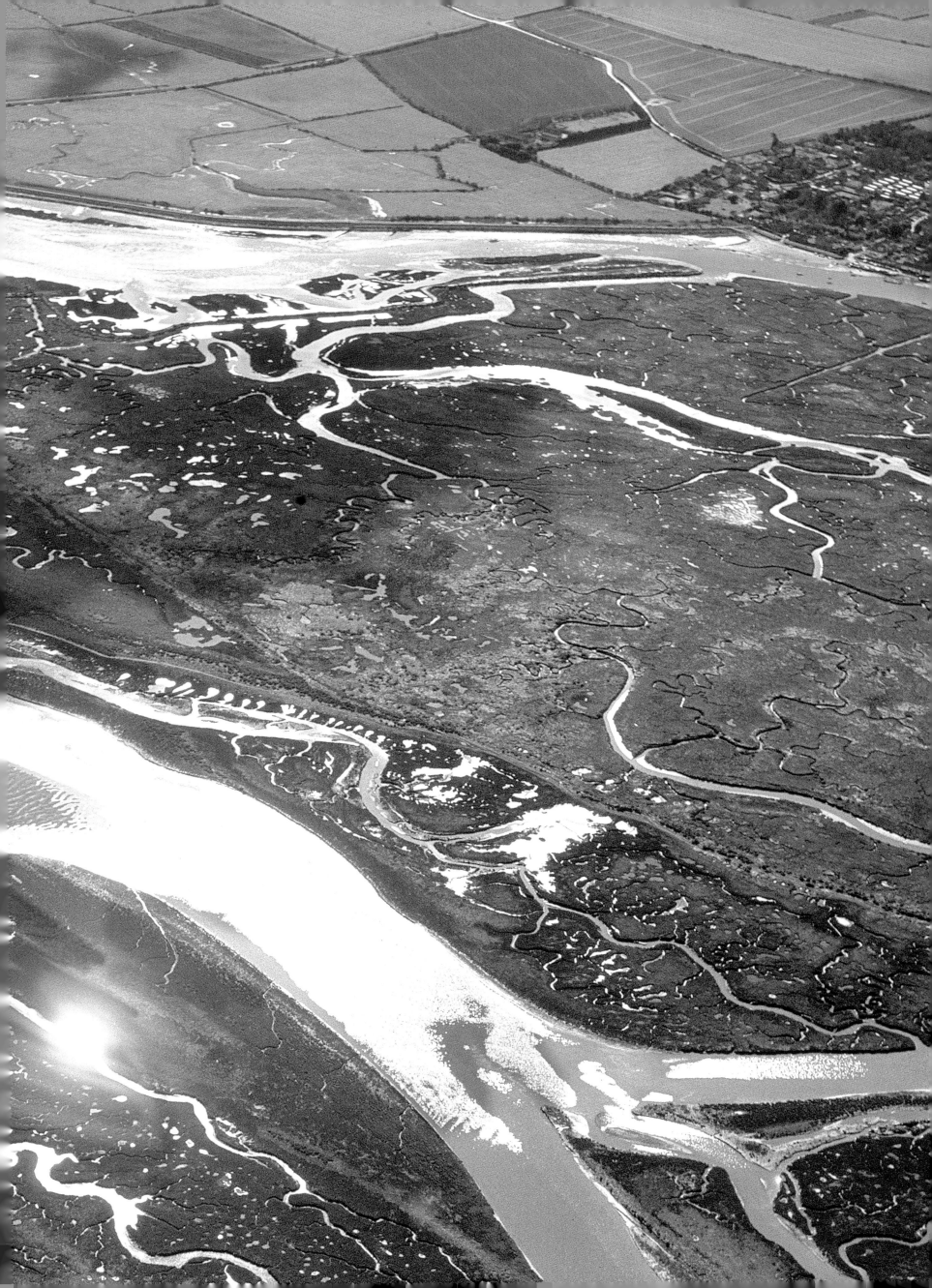

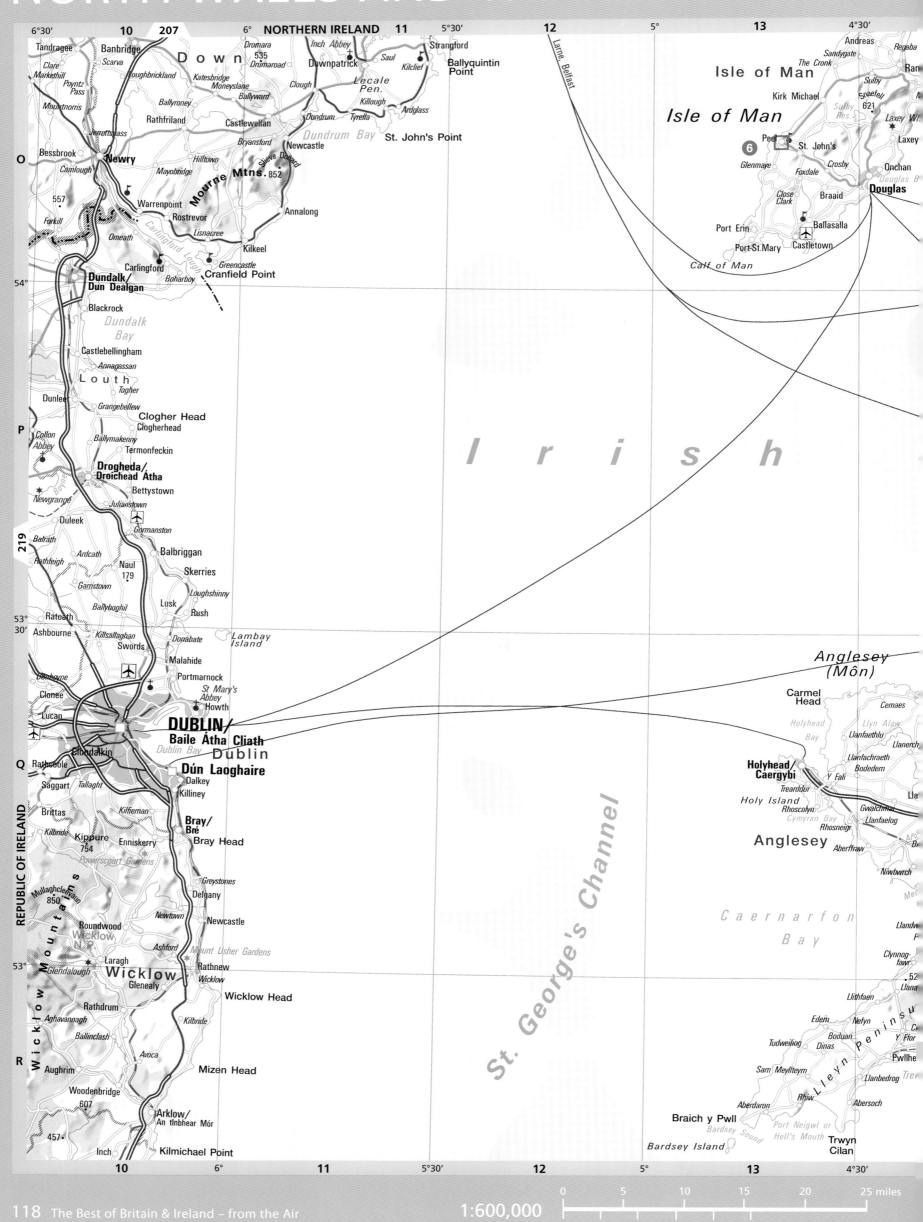

6°30' 10 6° 11 5°30' 12 5° 13 4°30'

Tandragee
Banbridge
Clare
Markethill
Scarva
Poyntz
Pass
Mountnorris
Bessbrook
Camlough
557
Forkill

Banbridge
Loughbrickland
Katesbridge
Moneyslane
Ballyward
Ballyroney
Rathfriland
Hilltown

Dromara
Drumaroad
Clough
Castlewellan
Bryansford
Newcastle

Inch Abbey
Downpatrick
Saul
Killough
Tyrella
Dundrum
Slieve Donard
Mourne Mtns. 852

Strangford
Kilclief
Ballyquintin
Point

D o w n

Lecale
Pen.
St. John's Point

Dundrum Bay

Isle of Man

Andreas
Sandygate
The Cronk
Kirk Michael Snaefell
621

Regaba
Ran
Sulby
Laxey Wh

O

Newry
Warrenpoint
Rostrevor
Lisnacree
Omeath
Mayobridge
Carlingford

Annalong

Glenmaye
Peel St. John's
Foxdale
Close
Clark
Braaid
Ballasalla

Laxey
Onchan
Douglas B

Douglas

Carlington
Lough

Kilkeel
Greencastle
Cranfield Point
Boharboy

Port Erin
Port St. Mary
Castletown

54° Dundalk/
Dún Dealgan

Blackrock

Calf of Man

Dundalk
Bay

Castlebellingham
Annagassan
Dunleer
Grangebellew
Togher

I r i s h

P Collon
Abbey
Ballymakenny
Termonfeckin

Clogher Head
Clogherhead

L o u t h

Drogheda/
Droichead Átha
Newgrange
Duleek

Bettystown
Julianstown
Gormanston

219 Balrath
Rathfeigh
Ardcath
Naul
179
Garristown
Ballyboghil

Balbriggan

Skerries

Loughshinny

Lusk
Rush

Ratoath
Ashbourne
Killsallaghan
Swords

Donabate
Lambay
Island

53°
30'

Batterstown
Clonee
Lucan

Malahide
Portmarnock
St Mary's
Abbey
Howth

Anglesey
(Môn)

Carmel
Head

Cemaes

DUBLIN/
Baile Átha Cliath
Dublin
Dún Laoghaire

Holyhead
Bay

Llyn Alaw

Llanfaethlu
Llanerch

Q Rathcoole
Saggart
Tallaght
Brittas
Kilbride
Kippure
754
Enniskerry

Clondalkin
Dublin Bay
Dalkey
Killiney

Bray/
Bré
Bray Head

Holyhead/
Caergybi
Trearddur
Holy Island
Rhoscolyn
Cymyran Bay

Y Fali
Rhosneigr

Llanfachraeth
Bodedern
Gwalchmai
Llanfaelog

REPUBLIC OF IRELAND

Powerscourt Gardens
Kilbride

Greystones
Delgany
Newcastle

Anglesey
Aberffraw

Niwbwrch

Mullaghcleevaun
850
Roundwood
Wicklow
N.P.

Newtown
Ashford
Mount Usher Gardens
Rathnew

Caernarfon
Bay

Llandw
52
Llana

53° Laragh
Glendalough

Wicklow
Glenealy

Wicklow
Wicklow Head

Llithfaen

Rathdrum
Aghavannagh
Ballinclash
Avoca

Kilbride

Clynnog-
fawr

Edern
Nefyn

W i c k l o w M o u n t a i n s

R Aughrim
Woodenbridge
607
457
Inch

Mizen Head

Arklow/
An tInbhear Mór

Kilmichael Point

St. G e o r g e ' s C h a n n e l

Tudweiliog
Dinas
Boduan
Ffor

Sarn Meyllteyrn

Aberdaron
Rhiw

Braich y Pwll
Bardsey Island

Bardsey Sound
Hell's Mouth
Port Neigwl or
Trwyn
Cilan

L l e y n P e n i n s u

Pwllhe
Llanbedrog
Tre
Abersoch

10 6° 11 5°30' 12 5° 13 4°30'

1:600,000

0 5 10 15 20 25 miles
0 5 10 15 20 25 km

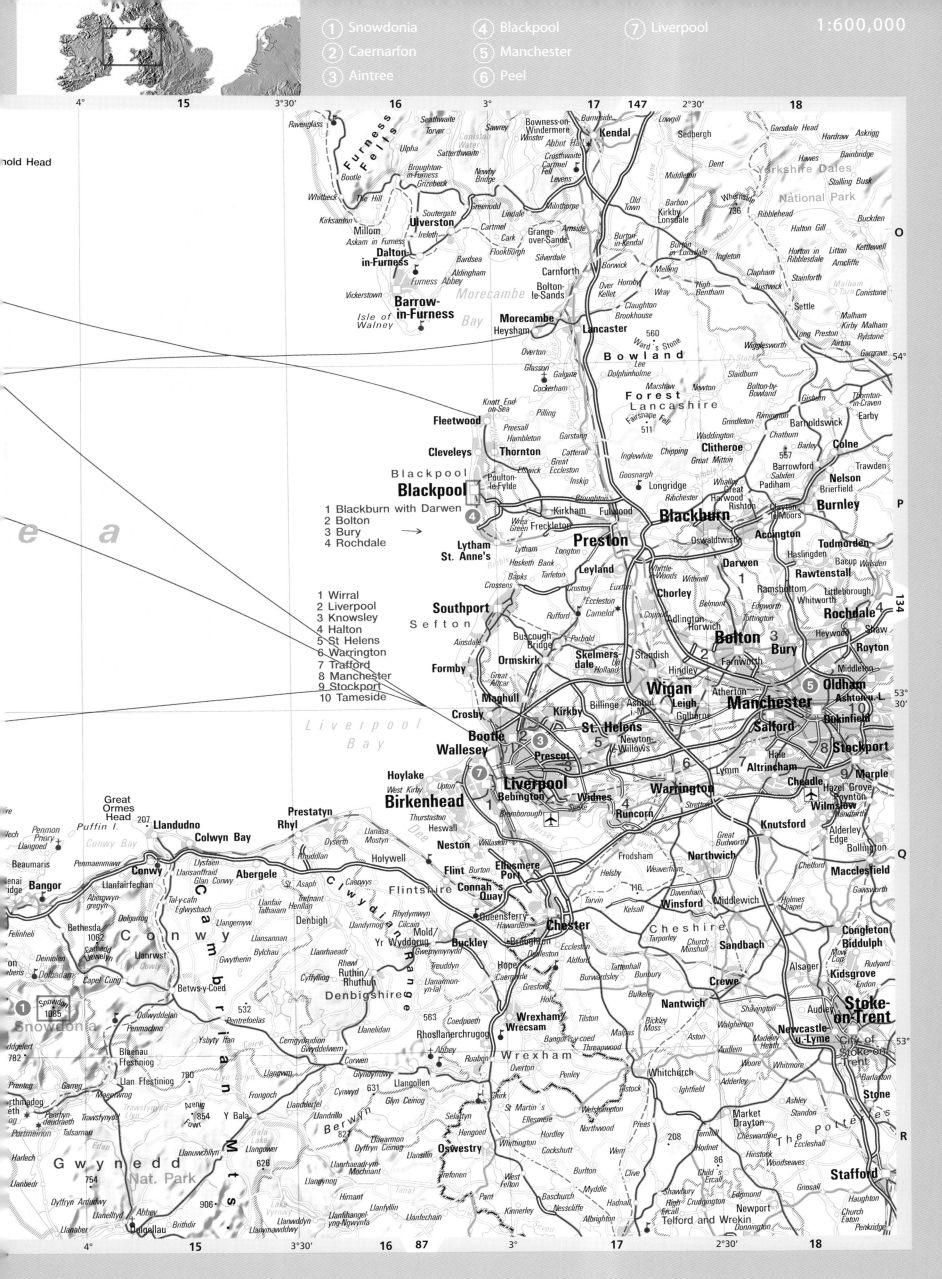

Snowdonia

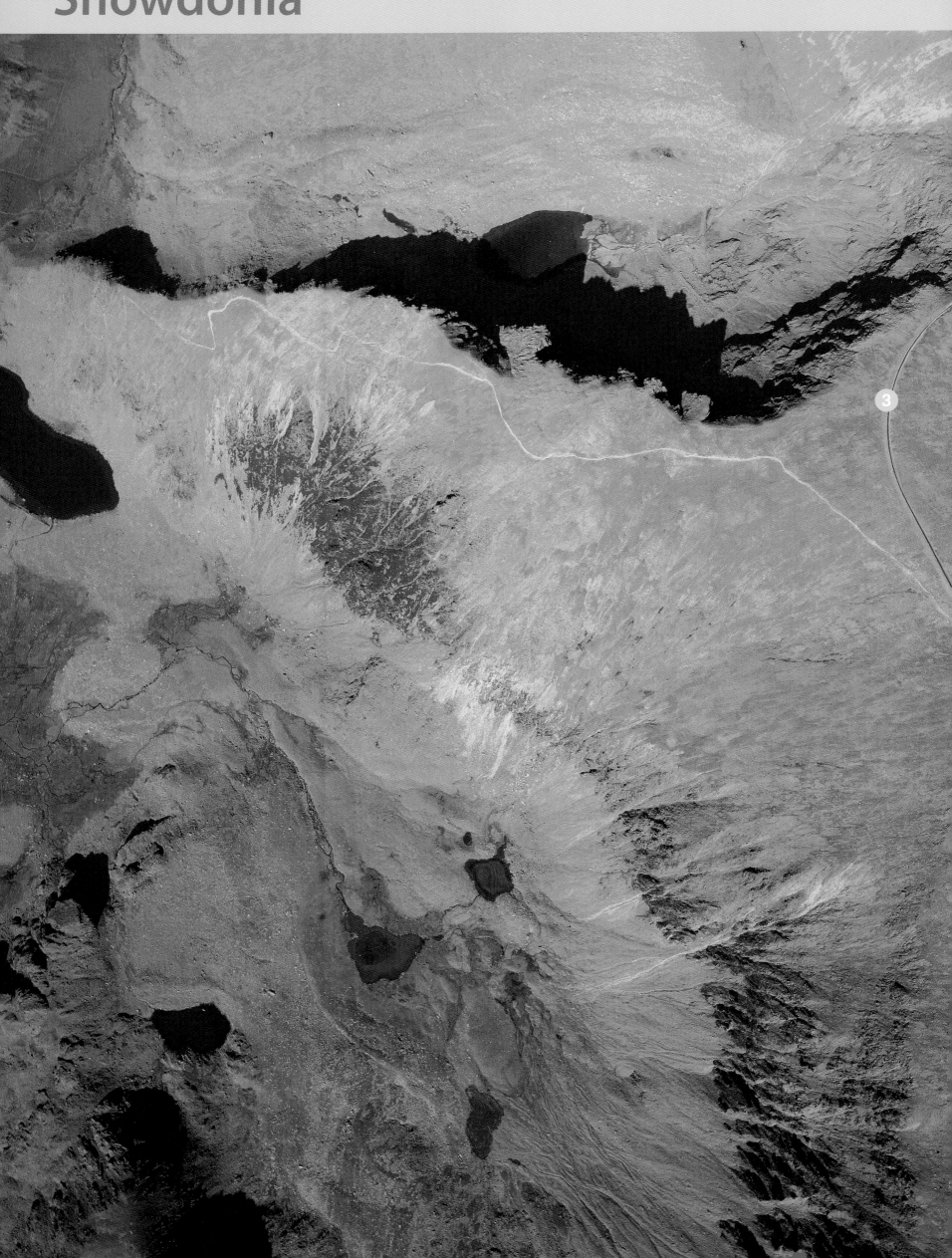

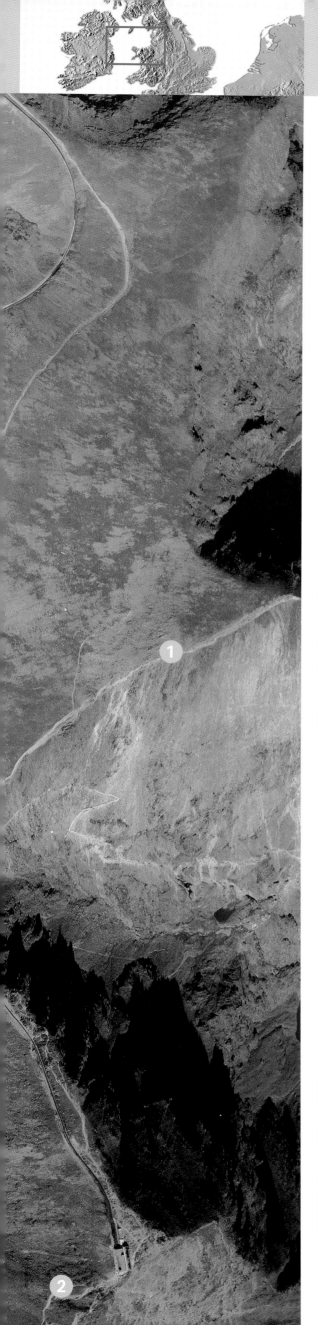

Snowdonia

The Snowdonia National Park is named after Mount Snowdon, at 1,085m (3,559ft) the highest peak in England and Wales. The park itself was established in 1951 and covers 2,170sq km (838sq miles). Formed mainly from glacial activity during the last ice age, the U-shaped valleys form a landscape of rugged beauty.

❶ Paths

The Snowdonia Upland Paths Partnership was launched to rebuild and repair eroded mountain footpaths throughout the park. The paths leading up to the summit are well-trodden but there are less well-known routes around the similarly spectacular and often quieter nearby peaks such as Crib y Ddysgl (1,065m / 3,493ft). Local guides are available to show visitors such pathways, but a reasonable level of fitness is required to explore them in a day.

Westerly winds often bring spectacular cloud formations to Snowdonia.

❷ Summit ▽

Over 350,000 visitors reach the summit of Snowdon every year, either on foot or by taking the mountain railway. The summit building was designed by the renowned architect Clough Williams Ellis in 1935 and has recently been refurbished. From the top of Snowdon visitors can see Anglesey, Pembrokeshire, the Isle of Man and even as far as Ireland. The Welsh name for the mountain – *Yr Wyddfa* – means 'the Tomb'. Legend tells that it is the burial place of the giant ogre Rhita, vanquished by King Arthur in the ancient kingdom of Gwynedd. The peak often appears higher than it really is because, unlike some mountain ranges, the ground rises from sea level to the summit in a short distance.

Some of the rolling stock is more than 100 years old.

❸ Snowdon Mountain Railway △

Opened in 1896, the Snowdon Mountain Railway runs for 6km (4.7 miles) from the base station at Llanberis to within 20m (66ft) of the summit. Most of the carriages are still in working order and run on a rack and pinion system that provides the necessary traction for the steep climb, but also acts as an effective brake on the descent. This is the only such system on any British railway due to the incline of the Snowdonia mountainscape. Each carriage can carry 54 passengers and a guard. When the service first began, the carriages were open to the elements, but were modified to include roofs in the 1950s. The average speed of the railway is 8km/h (5m/h).

The trigonometrical point at the summit of Snowdon.

Caernarfon

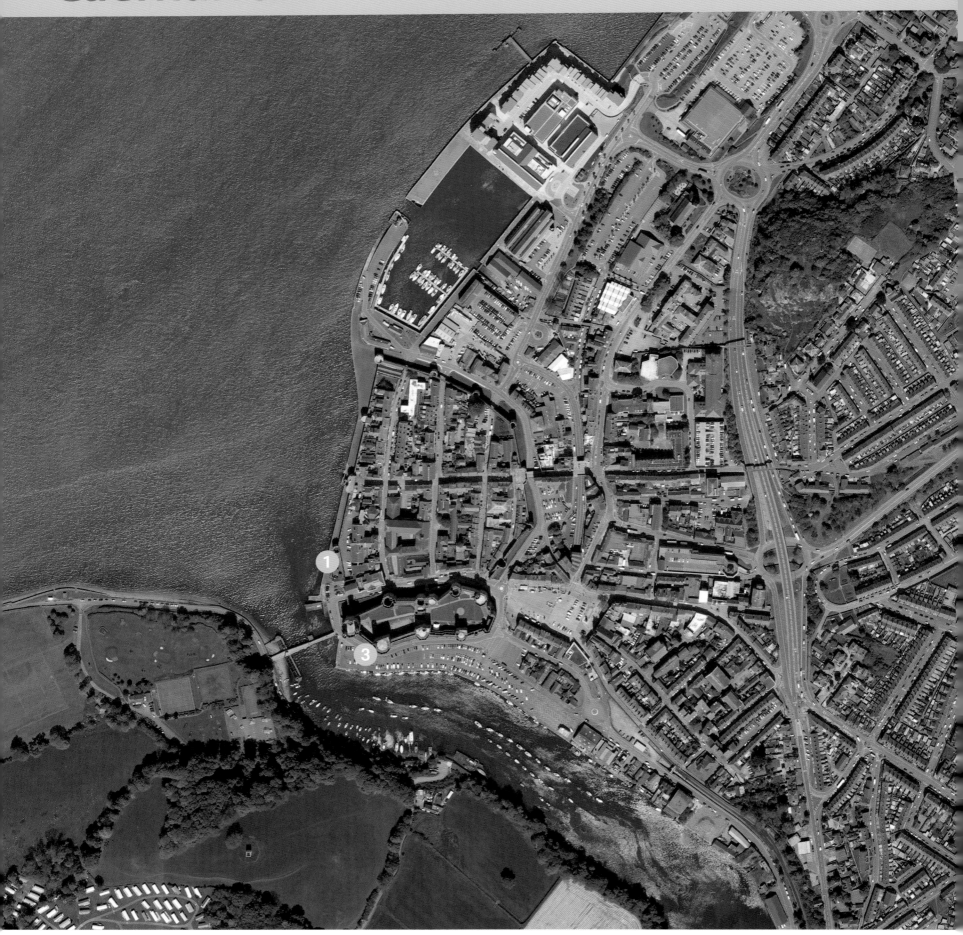

Caernarfon

Celts were already in the area of Caernarfon when the Romans settled this site on the Menai Strait, overlooking and controlling the sea route to Anglesey. When the Romans withdrew from Britain early in the 5th century, their fort was occupied by local chieftains, and there are remains of a 5th century Celtic church. Although the Normans did make brief forays, during which they built a small motte (fortified mound) on the present castle site, the area was controlled by Welsh princes, who built a manor there. The site was transformed by Edward I after his conquest of Wales. He built not only a castle that was to be an occasional royal residence and military strongpoint, but also laid out a carefully planned, walled town alongside it. The borough received its royal charter in 1284, and subsequently became the capital of North Wales. The port area along the walls of the castle was probably used from Roman times, but its main development was in the 19th century when it was used for shipping local slate.

1 Caernarfon Castle and Old Town ▽

The inspiration for the design and aesthetics of the walls of Caernarfon Castle came supposedly from the fortifications (dating from the 5th century onwards) of the great Byzantine city of Constantinople, which Edward I would have known from his crusading years. He was fortunate, too, in having James of St George as his master builder.

As a result of Edwards I's ambitions the castle's costs (over the 46 years that it took to build) exceeded those for any of his other Welsh fortresses. His castle-building programme had already started in 1283 at Conwy on the north coast and, after Caernarfon, Harlech was to be his next. The still substantial ruins of Segontium (see right) provided cut stone for parts of the castle, while extra stone was brought in by sea. A moat was created, and to the north the 740m (800yds) of town walls added further protection.

It was in the greatest of the towers, Eagle Tower, that Edward's son, the future Edward II, was born in 1284 and declared Prince of Wales. Formal investitures of the sovereign's eldest son as Prince of Wales have only taken place in the castle since 1911. During the Civil War it was besieged three times by the Parliamentarians, falling to them in 1646.

Unlike many other great fortresses, Caernarfon was not destroyed. Despite some 250 years of neglect it was not until the late 19th century that serious restoration started. It is still substantially intact and stands as a potent reminder of power projected over a subject people. The size of the King's Gate and the elegance and grandiose proportions of the Eagle Tower help set it apart from almost any other castle in Britain except Windsor. Few other castles in Europe would stand comparison. The castle is today notable as Wales' most prominent UNESCO World Heritage site.

2 Roman Segontium

Segontium Roman fort plays a significant role in both local history and legend, as it is connected to the legend of Magnus Maximus, who tried to usurp the title of Roman emperor. He appears as Macsen Wledig in the 'Dream of Macsen', part of the *Mabinogion*, the great collection of 11 Welsh legends; he supposedly dreams of a land of mountains across from an island, and a great city, full of multi-coloured towers. It is this story that, supposedly, helped to inspire Edward I's plans for Caernarfon Castle. The fort was built as an auxiliary fort in AD 77 by the Roman governor of Britain, Agricola, on a low hill south-east of the modern town centre, and had the longest continuous occupancy of any Roman fort in Wales. It would have held around 1,000 auxiliary troops (that is, not Roman citizen soldiers), who would have each signed on for 25 years' service. The unit was stationed here until Rome withdrew its forces from Wales in around AD 394.

The fort was the largest in the area, and also functioned as the administrative centre for north-west Wales. It was responsible for tax collection and mining activities. The sea approaches to Anglesey were covered from the observation point on Twt Hill to the north. The camp was originally protected by a wooden palisade and an external ditch, corresponding to Roman practice throughout the Empire. From AD 140 this was rebuilt in stone.

Excavations have revealed extensive rebuilding of the site. The foundations of a number of barracks (each containing 80 infantrymen) have been left exposed to give visitors a clearer idea of the layout. The two bathhouses are located to the south, across the modern road, in an area previously reserved for Roman officers and higher officials. East of the walls are the remains of a 3rd-century temple dedicated to the Roman god Mithras.

3 Museum of the Royal Welch Fusiliers

The museum of the Royal Welch Fusiliers Regiment is an unexpected bonus for the visitor to the castle. Like so many of Britain's infantry regiments, its history is a reflection of the tumultuous times during which the reach of the British Empire was worldwide, in countries and territories that were colonised and in those where the army merely attacked and withdrew. Wars with the French loom large in the exhibitions, including the 1808 defence of and subsequent retreat from Corunna in northern Spain, after the death of General Sir John Moore (the museum holds the keys of one of the town gates), and the invasion of the French island of Martinique in 1809. The latter, more successful, expedition is one of the battle honours on the Regiment's colours. The First World War also provides mementoes that are on display.

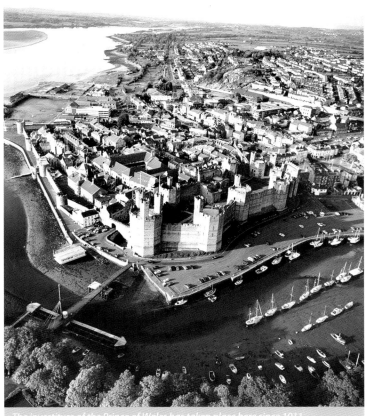

The investiture of the Prince of Wales has taken place here since 1911.

Aintree Racecourse

Aintree Racecourse near Liverpool is home to one of the world's most celebrated horse races, the Grand National steeplechase, watched on television each April by more than 10 million people in the UK alone – and upwards of 600 million people globally. There is much debate about the date of the very first race, which may have been in 1836. The first official Grand National was held on February 26, 1839, when the 5-1 favourite, Lottery, was the winner over a course including a ploughed field and a stone wall. The race consists of two circuits of the course and a total of 30 often hazardous jumps. The Grand National demands extraordinary stamina of the competing horses.

① Racecourse

The racecourse takes its name from the nearby Saxon village of Aintree. The word 'Aintree' is believed to mean 'a tree standing alone' – according to some authorities, the ancient oak tree that stood in Bull Bridge Lane, Aintree, until 2004, when its diseased state made it necessary to cut it down. Aintree racecourse was developed by Liverpool hotelier William Lynn, who leased ground from local landowner Lord Sefton. He erected a grandstand and laid out a course before holding the first official horse race at Aintree in 1829. This was a flat race rather than a steeplechase. Following the running of the first official steeplechase on the course in 1839, the Aintree steeplechase took the name 'Grand National' in 1847.

The modern race consists of two laps of a roughly triangular course, totalling 7.2km (4 miles 855yds). There are 16 fences, each jumped twice during the race apart from 'The Chair' and 'The Water Jump', which are jumped only once. The maximum number of runners allowed is 40.

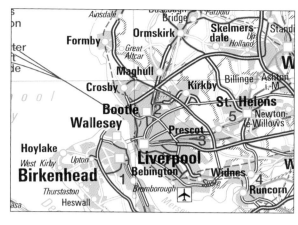

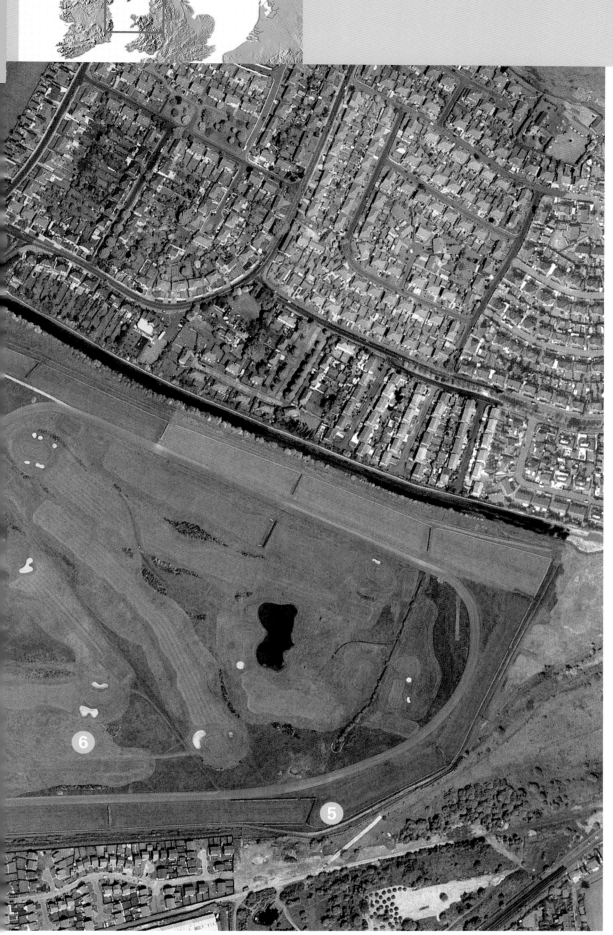

The Chair

The Chair is the course's deepest fence. Riders must time their jump perfectly to clear a ditch 1.83m (6ft) across before soaring over the fence itself, which stands 1.42m (4ft 8in) tall.

Mildmay course and motor racing track

In the mid-20th century Lord Sefton sold the land on which the course stood to a local family, the Tophams. Mrs Mirabel Topham laid out a new course named it after amateur jockey Lord Mildmay. The Mildmay course ran within the circuit of the Grand National course; around the perimeter of the Mildmay, Mrs Topham also established a motor racing circuit. The Mildmay course and the motor circuit opened in 1953.

The British motor racing Grand Prix was held at the Aintree circuit on five occasions between 1955 and 1962. Amid wild excitement at Aintree on July 16, 1955, British driver Stirling Moss won his first Grand Prix, driving a Mercedes-Benz. He beat his fellow Mercedes driver Juan Manuel Fangio by one-tenth of a second in front of a crowd estimated at 150,000.

Stands and winners' enclosure

The Queen Mother Stand, which commands a view of the finish line, stands in front of the Winners' Enclosure. Since 2006 the latter has been incorporated into the Parade Ring. The Princess Royal Stand nearby was completed in 1998. The two-tiered Earl of Derby and Lord Sefton Stands, completed in 2007, provide fine views of the entire course.

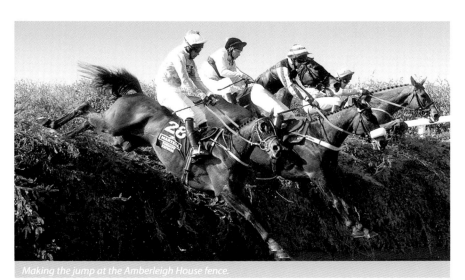
Making the jump at the Amberleigh House fence.

Becher's Brook

The most celebrated fence in the horse-racing world is 'Becher's Brook', the sixth and the 22nd jump on the course. Riders who succeed in clearing a fence 1.47m (4ft 10in) high must negotiate a drop of 2.07m (6ft 9in) to lower ground while also clearing a brook 61cm (2ft) across. The combination is named after Captain Martin Becher, who in the first steeplechase in 1839 fell from his mount 'Conrad' into the brook while leading the race.

Golf course

A nine-hole golf course is laid out on the land within the Grand National course, in full view of celebrated course features such as Canal Turn and Becher's Brook. It is the UK's longest nine-hole course, measuring a total of 6,056m (6,624 yd). Golfers must cope with a lake and stream, as well as a brook and a line of fir trees across the fairway of the third hole.

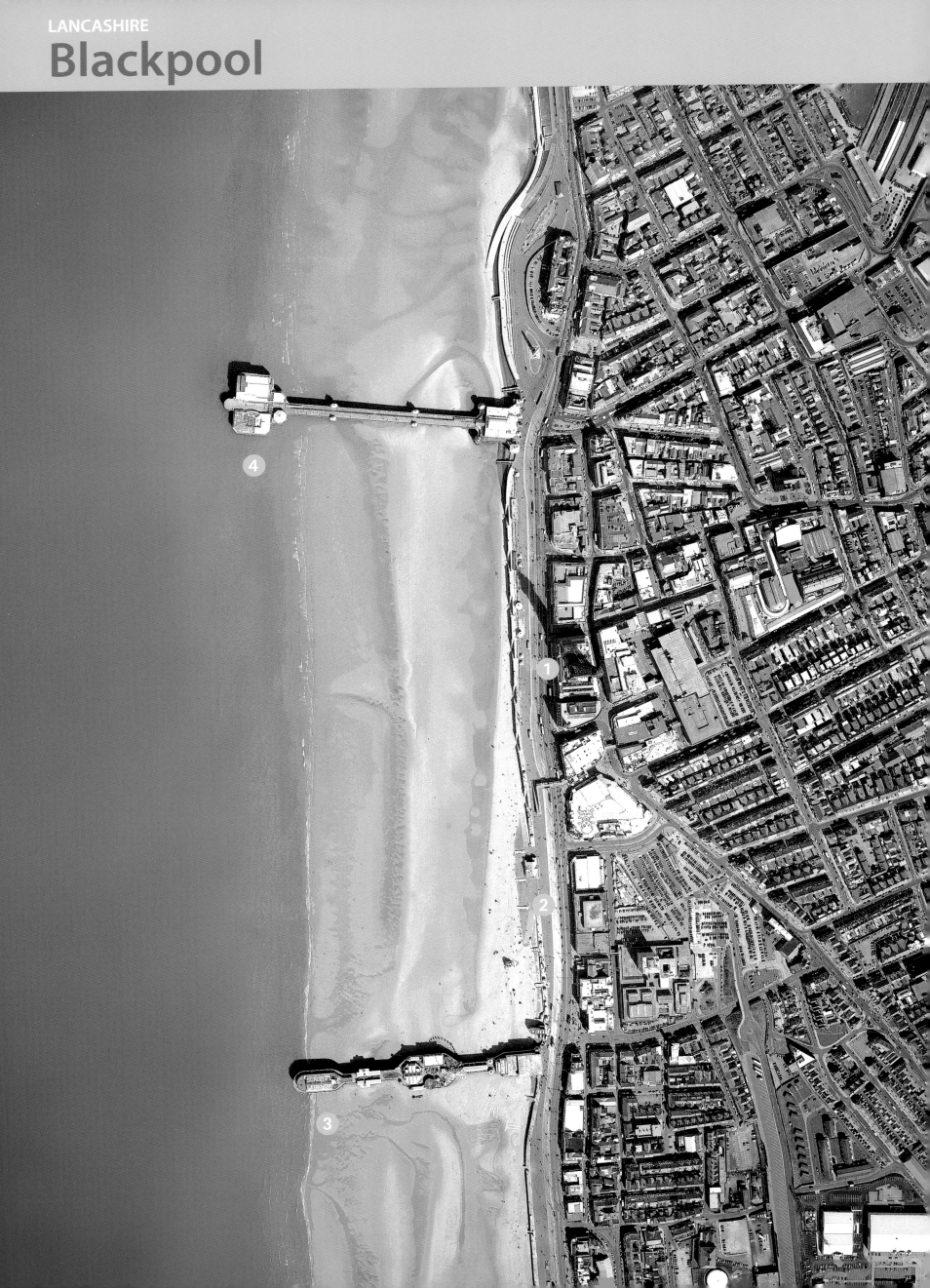

Blackpool

The seaside resort on Britain's northwest coast lies facing the waters of the Irish Sea. A fashionable resort for the wealthy during the 18th century, Blackpool rose to fame after the construction of the railway in 1846 and when the Lancashire mill towns started closing their factories for a week's holiday during the summer. Today's population of about 142,000 receives over 6 million visitors every year. Many come to see the Blackpool Illuminations in September and October, when the buildings and even the trams along the promenade are bright with designs picked out in neon, fibre optics and light-bulbs. All the traditional pleasures of the English seaside are found in abundance at Blackpool. The resort is most famous for its landmark tower, but it also has three piers; the North Pier and Central Pier are visible in this view (left and below).

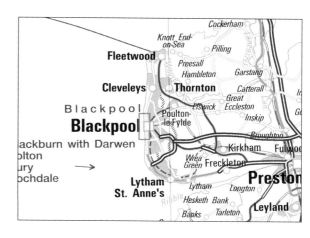

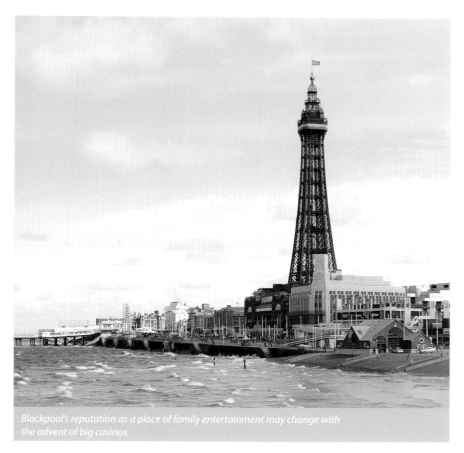

Blackpool's reputation as a place of family entertainment may change with the advent of big casinos.

① Blackpool Tower ◁

Blackpool Tower casts its long shadow across the front in the main picture. At 158m (519ft) high, including the 18.3m (60ft) flagpole, it is half the height of the Eiffel Tower in Paris, which inspired the then mayor of Blackpool, John Bickerstaffe, to build the signature landmark between 1891 to 1894. Constructed from 3,534 tonnes of steel and 358 tonnes of cast iron, it is protected by 9 tonnes of paint (usually red, except for its centenary year in 1994, when it was gold) and adorned with 10,000 light bulbs. The glass-floored 'Walk of Faith' at the top can be reached by lift. The complex of buildings at the foot of the tower includes the Tower Circus, inaugurated in 1904, and the Tower Ballroom. To the northeast are the Winter Gardens, now a conference centre housing venues whose exuberant designs reflect many places and eras, from Tudor England and Seville to Strauss's Vienna.

② Golden Mile

Blackpool has 11.6km (7.2 miles) of some of the best beaches in Britain. The central section of the seafront is called the Golden Mile. The tram is a picturesque means of transport along the promenade. This is the home of traditional English seaside delights such as the kiss-me-quick hat, the comic postcard and the fish-and-chip shop. It is also where the Royal National Lifeboat Institution (RNLI) has its station, just north of Central Pier. The first lifeboats were based at Blackpool in 1864. The leisure attractions along the Golden Mile include the Sea Life Centre, with an underwater tunnel from which visitors can get a close-up view of the sharks. Nearby is Louis Tussaud's waxworks, founded by a great-grandson of London's Madame Tussaud.

③ Central Pier

Built of cast iron with wooden decking, the Central Pier was the second of the three piers to be built; it was opened in May 1868. Its entertainments of music and dancing were more boisterous than those of the more decorous North Pier. Since 1990 the pier has been dominated by a Ferris wheel 32.7m (108ft) high – its shadow on the beach can be made out in the main picture, on the beach above the shadow of the pier. Today the pier is 340m (1,118ft) long. The Central Pier is still popular with visitors who come to see the end-of-the-pier shows. South of the Central Pier lies the South Pier and the South Shore, which includes the Pleasure Beach, with its permanent funfair and extravagant rollercoaster rides.

④ North Pier

The first pier at Blackpool was designed by master pier-builder Eugenius Birch. Construction began in 1862 and the pier was opened in 1863. It continued the line of Talbot Road, where Blackpool's first railway station had been constructed. The pier was later extended with a jetty that brought its length up to 503m (1,650ft). The pierhead was enlarged with two wings to accommodate an Indian-style pavilion, bandstand, restaurant and shops. The pavilion and a successor were both destroyed by fire and replaced by a 1,500-seat theatre. Today there is also a helipad, from which flights can be taken around the Tower and along the shore. Even today, the North Pier provides a quieter and more staid leisure environment than Blackpool's other two piers.

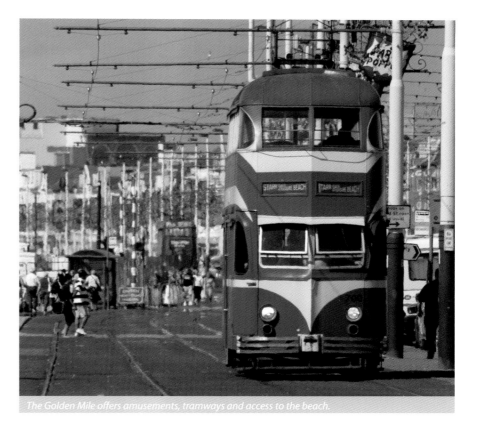

The Golden Mile offers amusements, tramways and access to the beach.

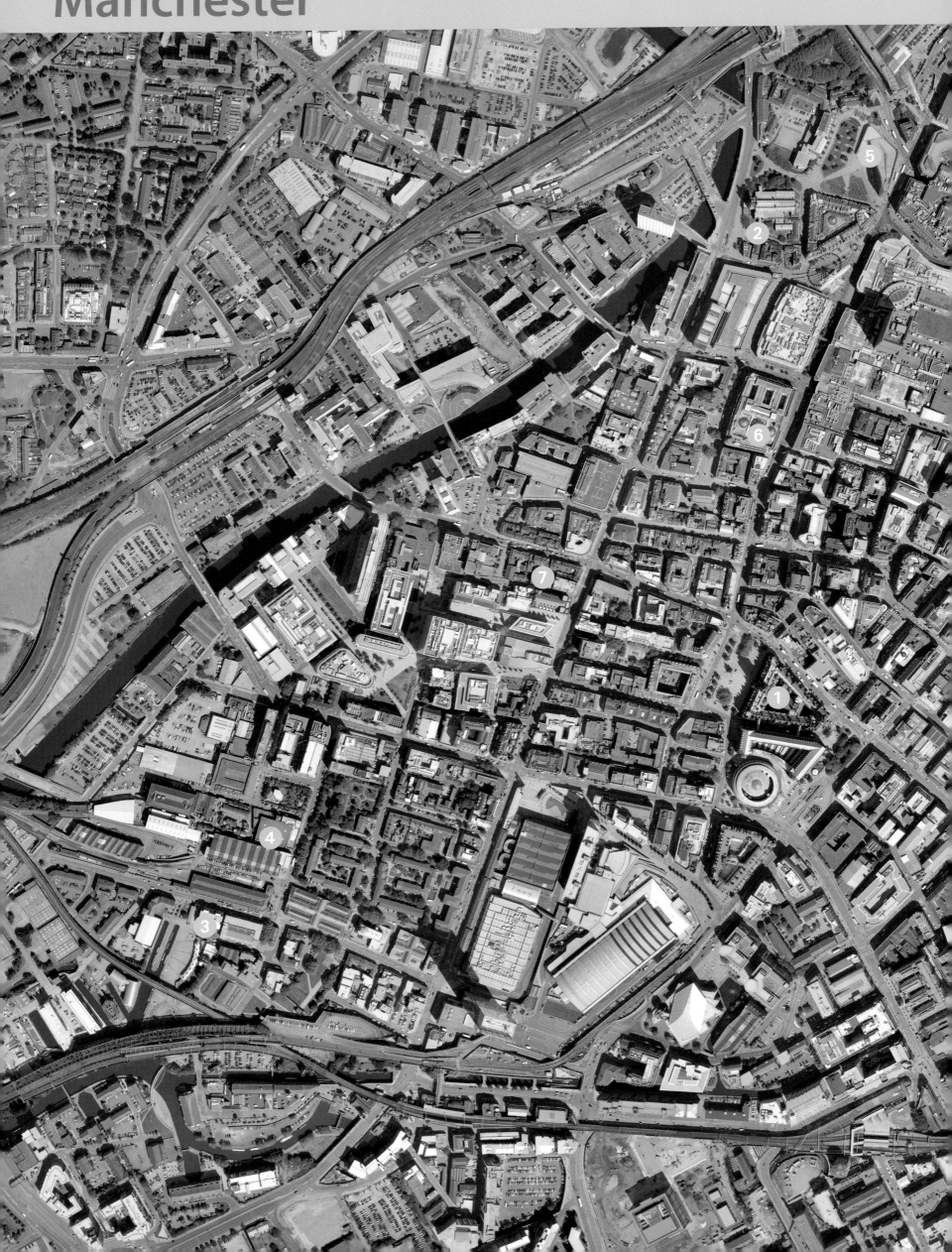

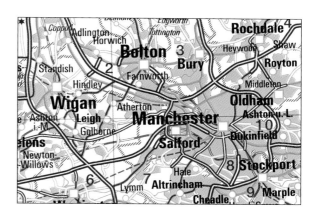

Manchester

Manchester's origins go back to Roman times, but it was during the Industrial Revolution and the development of the cotton industry in the 19th century that the city really prospered. The grand Victorian buildings of 'Cottonopolis', as the city came to be known, testify to the civic pride of that golden age. Today Manchester's industrial power has given way to a dynamic, modern city. The fortunes of the city's football teams – Manchester United at Old Trafford and Manchester City at the City of Manchester stadium – are followed by football fans throughout the world.

① Town Hall

Like many of Manchester's public buildings, the Town Hall overlooking Albert Square bears witness to the city's prosperity and civic pride during its 19th-century heyday. Following a competition for a new building to replace the neo-classical Town Hall on King Street, which had become too small, the present Town Hall was built from 1868 to 1877 in the Gothic Revival style fashionable at the time. The architect, Alfred Waterhouse, chose Spinkwell stone from Yorkshire to withstand the damp climate and atmospheric pollution. The sculptures adorning the elaborate façade beneath the 85m (280ft) bell tower represent important figures in Manchester's history. The series of 12 Pre-Raphaelite murals in the Great Hall are by Ford Madox Brown. They were completed in 1893 and depict major events in the history of the city. The mediaeval-style Albert Memorial in front of the main entrance was completed in 1865.

② The Cathedral

Standing on the site of a church mentioned in the Domesday Book and a later 13th-century building, the Cathedral and Collegiate Church of St Mary, St Denys and St George in Manchester was built in the Perpendicular Gothic style during the late 15th and early 16th centuries. Extensive re-facing and restoration work was undertaken in Victorian times and again following severe bomb damage in 1940 and 1996. The fine wooden furnishings date from the Middle Ages and include a remarkable pulpit, choir stalls, misericords and a carved nave roof supported by gilded angels playing musical instruments.

③ Castlefield Urban Heritage Park

The first Urban Heritage Park in the United Kingdom, set up in 1982 in the district of Castlefield in the heart of Manchester, captures the history of the city within a single location. Here a reconstructed stone gateway occupies the site of Mamucium, the Roman fort which gave the city its name. From the mid-18th century, Manchester's industrial developement was boosted by a network of waterways transporting coal and goods that linked to the Bridgewater Canal that terminated in Castlefield. The world's first passenger railway station also opened in this part of the city at Liverpool Road in 1830. In more recent years, the once derelict warehouses alongside the canals have been converted into fashionable restaurants, bars and residential complexes.

④ Museum of Science and Industry

Manchester's Museum of Science and Industry opened in its present premises in Castlefield in 1983. The site incorporates the former Liverpool Road Station, one of the termini of the Liverpool and Manchester Railway, the world's first passenger railway. The exhibits include extensive displays relating to transport, from railways to space travel, as well as sections focusing on telegraphy and telephony and the city's scientific and industrial heritage.

⑤ Urbis ▽

The redevelopment of Manchester city centre following the IRA bombing in 1996 resulted in a series of major building projects around Exchange Square and the creation of the Millennium Quarter. One of the most striking buildings bordering Cathedral Gardens is Urbis, a five-storey triangular building designed by the British architect Ian Simpson which opened as a cultural and exhibition space in 2002. As visitors ascend the building, each floor is smaller than the previous one, so that the lift linking them operates at an angle rather than vertically. Urbis has been taken over by the National Football Museum, which has relocated from Preston to Manchester. The top floor houses a fashionable restaurant.

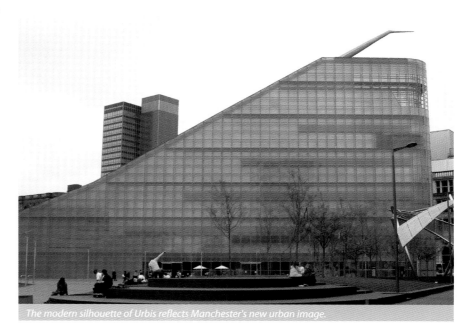

The modern silhouette of Urbis reflects Manchester's new urban image.

⑥ Royal Exchange

Seen from the outside, the third Royal Exchange building to occupy this city-centre site retains its dignified Victorian appearance despite the rebuilding, extensions, bombing and neglect from which it has periodically suffered since its completion in 1874. It was originally the trading arena for cotton and other commodities, but since this business ceased in 1968 it has been imaginatively converted into a theatre. The Great Hall now houses Britain's largest theatre in the round in a seven-sided glass and steel structure designed by Richard Negri. An ambitious programme of classic and contemporary drama is presented throughout the year.

⑦ The John Rylands University Library

Housed in a Victorian Gothic building on Deansgate, the library opened to the public in 1900. The building was commissioned by Enriqueta Rylands to house the 2nd Earl Spencer's collection of books, which she purchased in 1892 as a memorial to her husband. Designed by the architect Basil Champneys, the first-floor reading room was praised for its pleasant lighting thanks to its high, or clerestory, windows down both sides and the oriel windows in the alcoves, and for its tranquillity in spite of the building's location on a noisy main thoroughfare. Today it houses the university library's special collections, including mediaeval manuscripts, a Gutenberg Bible and the personal papers of writer Elizabeth Gaskell and scientist John Dalton.

Peel

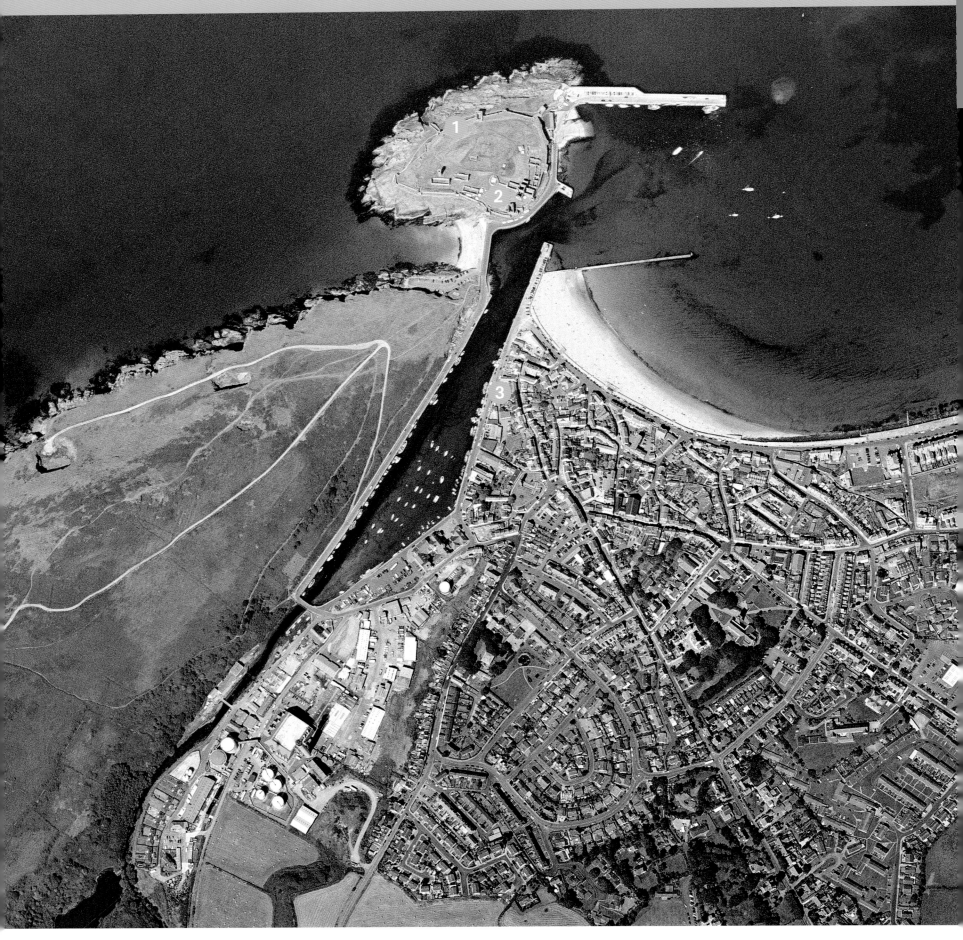

Peel

Peel is the most significant settlement and the only city on the west coast of the Isle of Man. It has a population of about 4,200. Enclosing the harbour is St Patrick's Isle, dominated by the extensive ruins of Peel Castle and by St German's Cathedral. The town's origins date from the 13th century, but Bronze Age remains have been found. St Patrick's Island was the site of a Celtic monastery from AD 550, and after the Viking invasions around AD 800 it became the capital of a Norwegian dependency that included the Hebrides.

● Peel Castle

Magnus Barefoot, the Viking chieftain who landed in 1098, built a wooden fort on St Patrick's Isle, the remains of which were found in the 1980s. Peel Castle probably owes its name to the 'peel tower' form of the castle keep, a type widely used in the Scottish borders, though a wooden defensive fence or 'paling' has also been suggested. The substantial but ruined red sandstone fortifications seen today are 15th-century curtain walls with 14th-century towers, though some structures pre-date this. Peel Castle was capital of the northern part of the island until the mid-1600s. Building re-started in the early 17th century, in response to perceived threats from the French, and several earlier buildings, including the residence of the Lords of Mann, were torn down to provide extra defences. Eventually the castle was abandoned in the 18th century and its buildings soon deteriorated.

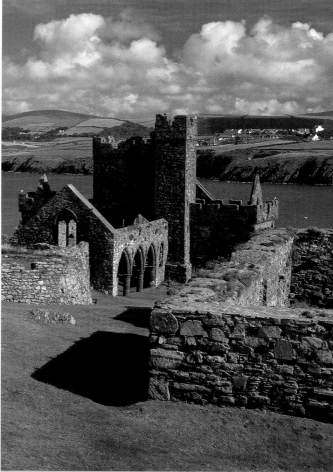

The ruined 13th century cathedral at Peel.

② St German's Cathedral

St German's dates from the 13th and 14th centuries, though the nave and transept may be even older. It is named after a follower of St Patrick, who is supposed to have settled here in AD 550, and was an integral part of the capital city for the Kingdom of Mann and the Isles. In the late 14th century it was crenellated for extra protection. The cathedral crypt was used as a prison by the bishop for sabbath-breakers, a sin that could involve fishing, farming or playing music on Sundays. The last Bishop was appointed in 1785, by which time the cathedral's fabric had already deteriorated, and in 1824 the roof collapsed in a heavy storm. This ruin is little changed today. Nearby is a 16m (50ft) round tower, also crenellated, that pre-dates the cathedral, and which would have been a belfry and lookout post, and the ruined 10th-century St Patrick's Church. This appears to have collapsed and been re-built in the 12th century, but continued in use as the parish church until 1884. Its present state is due to a fire in 1958.

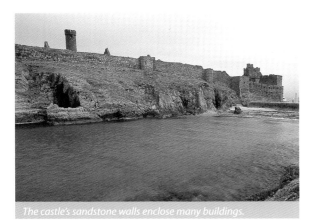

The castle's sandstone walls enclose many buildings.

③ House of Manannan

Built in 1997, this award-winning museum is located on the harbour, overlooking St Patrick's Isle, in the old Peel railway station that has been substantially modernised. It is named after the island's mythological sea god, and covers much of the Celtic and Viking history of the area. It charts the interaction of the pagan invaders and the early Christian missionaries, and the gradual conversion of the island to Christianity. Maritime traditions, from smuggling to fishing, are also reflected in the exhibits, including a full-size replica Viking longship.

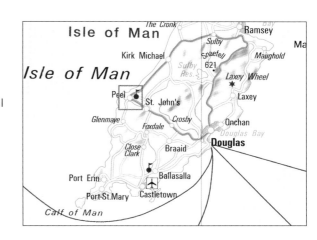

Overleaf: the seafront at Liverpool including the Royal Liver Building.

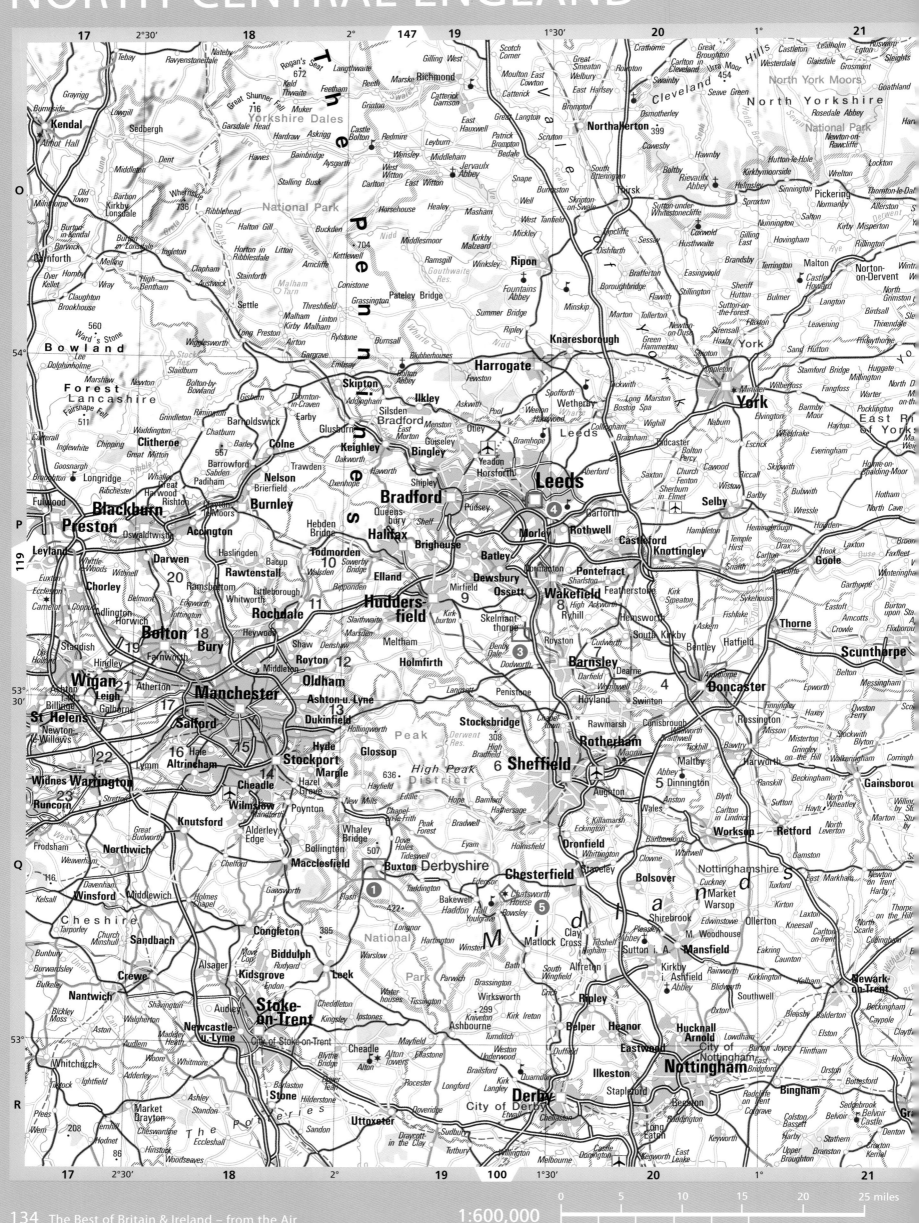

1:600,000

| 0 | 5 | 10 | 15 | 20 | 25 miles |
| 0 | 5 | 10 | 15 | 20 | 25 km |

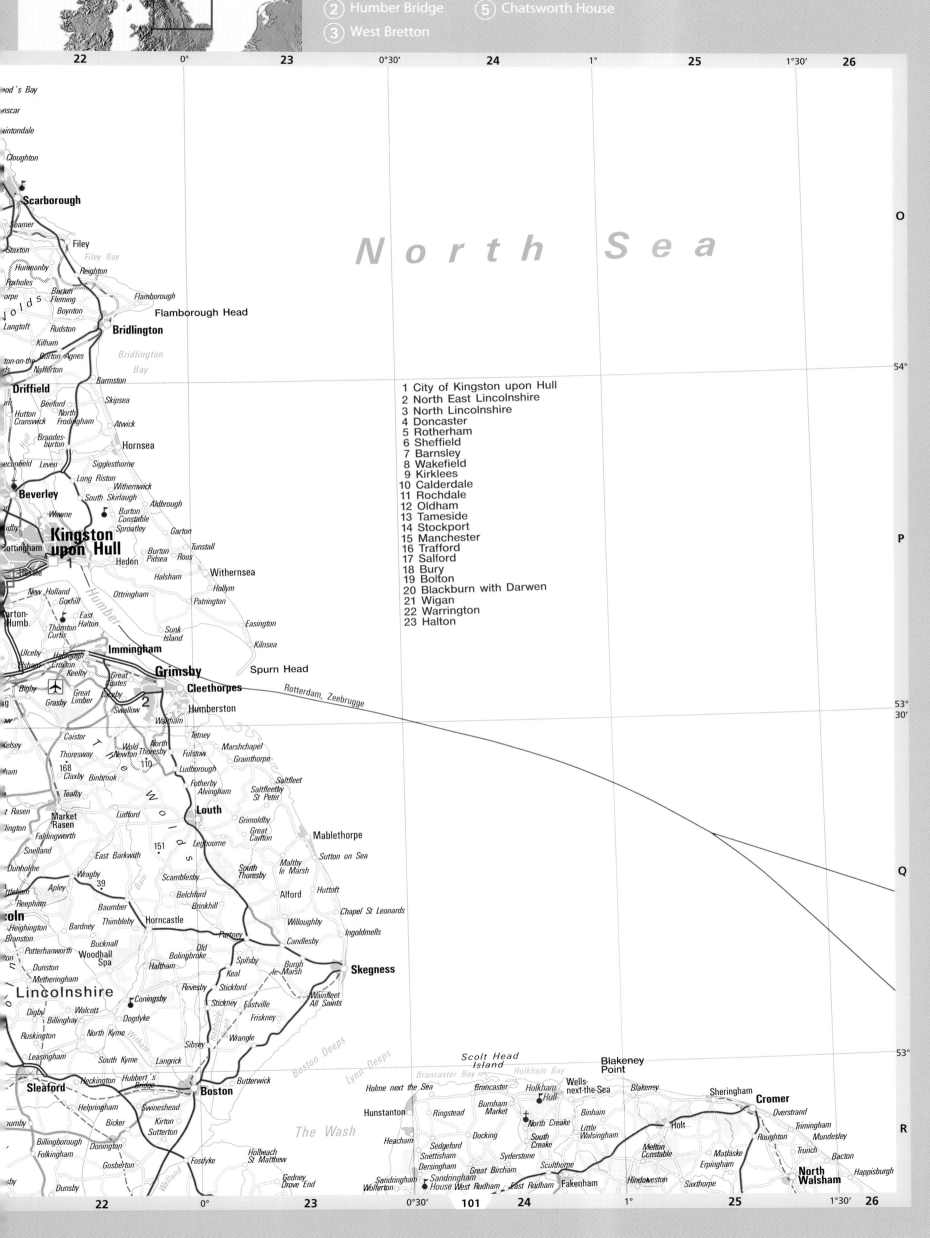

① Buxton
② Humber Bridge
③ West Bretton
④ Leeds
⑤ Chatsworth House

North Sea

O

54°

1 City of Kingston upon Hull
2 North East Lincolnshire
3 North Lincolnshire
4 Doncaster
5 Rotherham
6 Sheffield
7 Barnsley
8 Wakefield
9 Kirklees
10 Calderdale
11 Rochdale
12 Oldham
13 Tameside
14 Stockport
15 Manchester
16 Trafford
17 Salford
18 Bury
19 Bolton
20 Blackburn with Darwen
21 Wigan
22 Warrington
23 Halton

P

Scarborough
Seamer
Filey
Staxton
Hunmanby
Reighton
Foxholes
orpe
Burton
Fleming
Flamborough
Flamborough Head
Boynton
Langtoft
Rudston
Kilham
Bridlington
ton-on-the
Burton Agnes
Bridlington
Nafferton
Bay
Driffield
Barmston
Beeford
Skipsea
Hutton
North
Cranswick
Frodingham
Atwick
Brandes-
burton
Hornsea
econfield
Leven
Sigglesthorne
Long Riston
Withernwick
Beverley
South Skirlaugh
Aldbrough
Wawne
Burton
dby
Constable
Garton
Burton
Sproatley
Tunstall
Kingston
Pidsea
Roos
upon Hull
Hedon
ottingham
Tunstall
lessle
Halsham
Withernsea
New Holland
Ottringham
Hollym
Goxhill
Patrington
arton-
East
Humb.
Halton
Sunk
Easington
Thornton
Island
Curtis
Kilnsea
Ulceby
Habrough
Immingham
lsby
Croxton
Keelby
Grimsby
Spurn Head
Bigby
Great
Cleethorpes
Coates
Rotterdam, Zeebrugge
Great
Grasby
Limber
Humberston
Swallow
Waltham
Caistor
Tetney
Kelsey
North
Thoresby
Marshchapel
Thoresway
Wold
Fulstow
Grainthorpe
168
Newton Thoresby
110
Saltfleet
ham
Claxby
Binbrook
Ludborough
Fotherby
Saltfleetby
Tealby
Alvingham
St Peter
Rasen
Ludford
Louth
Market
Grimoldby
Rasen
Great
Faldingworth
Carlton
Mablethorpe
Snelland
East Barkwith
151
Sutton on Sea
Dunholme
Wragby
Scamblesby
South
Thoresby
ttleham
Apley
39
Malthy
le Marsh
Reepham
Baumber
Belchford
Alford
Huttoft
coln
Heighington
Thimbleby
Brinkhill
Chapel St Leonards
Bardney
Horncastle
Branston
Bucknall
Old
Willoughby
Ingoldmells
Potterhanworth
Woodhall
Bolingbroke
Candlesby
Dunston
Spa
Spilsby
Metheringham
Haltham
Keal
Burgh
le Marsh
Skegness
Lincolnshire
Revesby
Stickford
Wainfleet
Digby
Walcott
Coningsby
Stickney
Eastville
All Saints
Billinghay
Dogdyke
Friskney
Ruskington
North Kyme
Sibsey
Wrangle
Leasingham
South Kyme
Langrick
Boston Deeps
Sleaford
Heckington
Hubbert's
Butterwick
Bridge
Boston
Helpringham
Swineshead
Lynn Deeps
Bicker
Kirton
Billingborough
Sutterton
The Wash
umby
Donington
Gosberton
Fosdyke
Holbeach
St Matthew
sby
Dunsby
Gedney
Drove End

Q

53°
30'

53°

R

Scolt Head
Island
Blakeney
Point
Brancaster Bay
Holkham Bay
Sheringham
Holme next the Sea
Brancaster
Holkham
Wells-
Blakeney
Cromer
next-the-Sea
Overstrand
Hunstanton
Ringstead
Burnham
Hull
Binham
Holt
Trimingham
Market
Mundesley
Heacham
North Creake
Little
Melton
Roughton
Trunch
Sedgeford
Docking
South
Walsingham
Constable
Matlaske
Bacton
Snettisham
Creake
Syderstone
Erpingham
Dersingham
Great Bircham
Sculthorpe
Hindoveston
Saxthorpe
Happisburgh
Sandringham
Sandringham
East Rudham
North
Wolferton
House West Rudham
Fakenham
Walsham

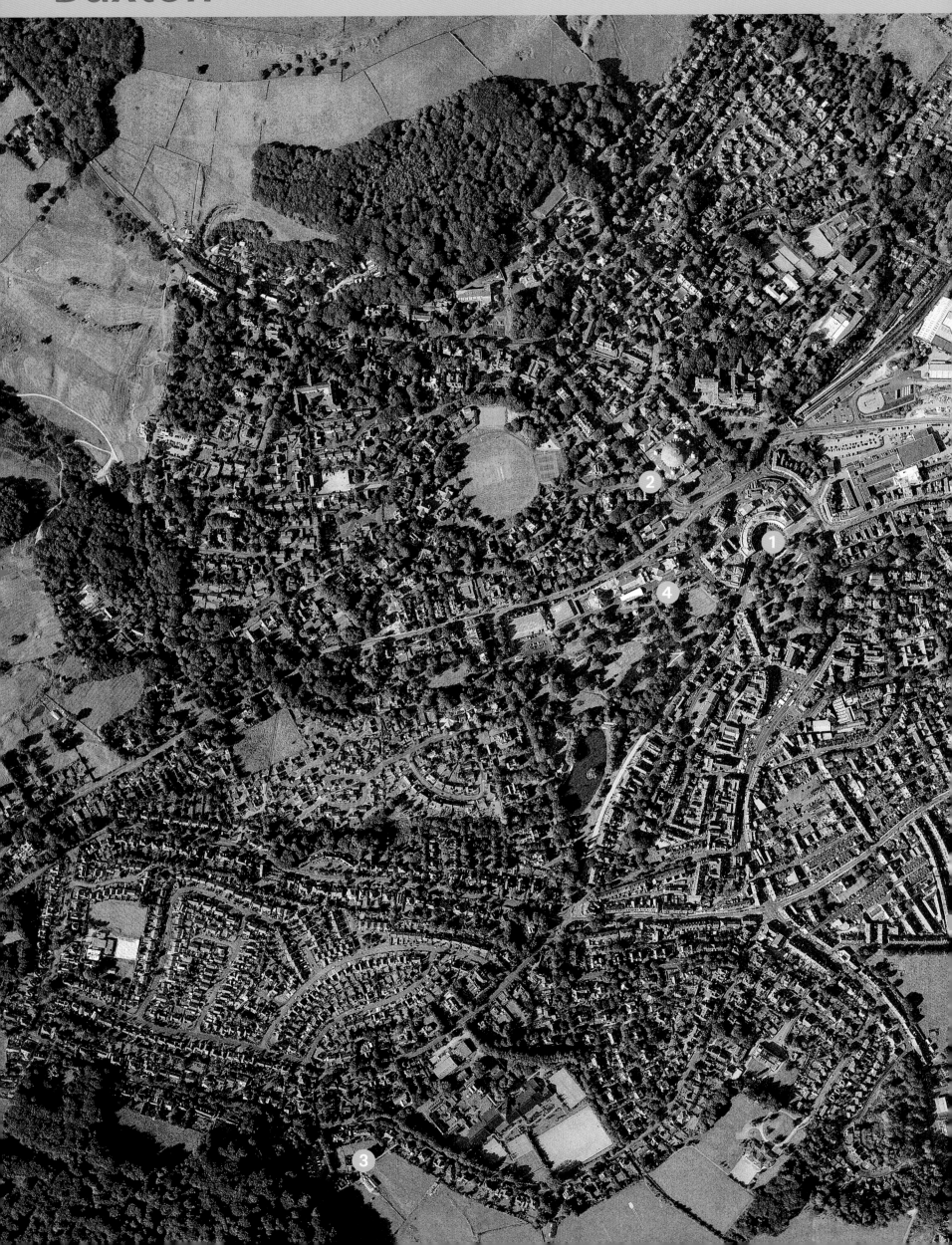

Buxton

Buxton in the Derbyshire Peak District, at more than 300m (984 ft), is the highest market town in England. Thanks to thermal springs providing a constant water temperature, it has been a spa town since Roman times. It benefited from the Georgian and Victorian obsession with 'taking the waters'. It has fine Georgian buildings, as well as the Victorian Pavilion Gardens and covered Winter Gardens. Buxton's importance as a tourist destination was enhanced by the opening of the Midland Line railway in 1863. The meticulously restored Edwardian Opera House is the focus of an opera festival every July. Tourists also come to Buxton for the annual 'well dressings' – a reminder of its pre-Christian past.

① The Crescent

The Dukes of Devonshire saw Buxton as a northern equivalent of Bath, catering for the newly rich industrial and commercial middle classes of Lancashire, and set out to create a city centre worthy of comparison. John Carr left the most enduring mark by designing the fine Crescent (modelled on the one in Bath) in 1784. Built of local sandstone, with nearly 400 windows, it was badly in need of restoration for many years, but work was finally put in hand in the late 1990s to secure the fabric for the future.

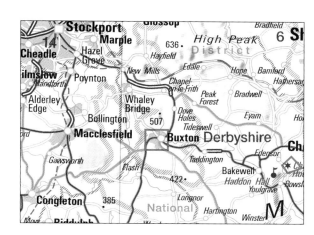

② The Devonshire Hospital

In 1790, John Carr was also commissioned by the 5th Duke of Devonshire to build the Great Stables and Riding School, with accommodation for more than a hundred horses. In 1858, two-thirds of the stables were converted into The Devonshire Hospital (later the Devonshire Royal Hospital). It was completed in 1881, with a clock tower and a soaring slate dome 48m (156ft) across the central courtyard. At the time it was the largest unsupported dome in the world. Today, the building is used as the campus for the University of Derby College, Buxton.

③ Poole's Cavern

Just outside Buxton, to the south, is one of the finest and most accessible underground limestone cavern systems in England. Probably created by the eroding action of flood waters, Poole's Cavern is some 650m (700yds) long, divided into a series of chambers such as the Roman Chamber and the Great Dome, some 12m (40ft) high. Stalactites and stalagmites hang from the ceilings or rise up from the cavern's floor. Several areas are dyed red, the result of the effects of iron oxide, while elsewhere the calcite formations owe their blue-grey colouring to manganese.

④ Opera House

In 1901, when the Gardens Commission decided to build a new theatre in Buxton, they turned to Frank Matcham, the architect for prestigious theatres such as London's Palladium and Coliseum. The site did not allow for anything so large, but the resulting building is an exquisite, finely proportioned, gold and filigree jewel. It was opened in 1903, and attracted some of the finest talent in theatre and music, including Gertrude Lawrence, Anna Pavlova and Gracie Fields. The advent of 'talkies' saw a gradual decline in live performances, and from 1945 until the late 1970s it was used mainly as a cinema. After substantial repairs, it was re-opened in 1979, in time for the first Opera Festival. Thanks to more local and national funding, the Opera House has now been restored to its former glory.

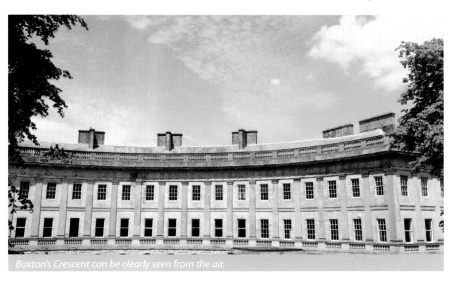
Buxton's Crescent can be clearly seen from the air.

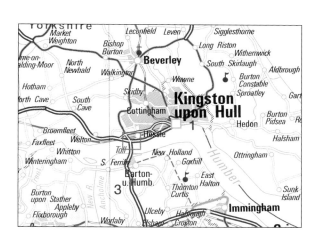

Humber Bridge (north bank)

Designed to cross the last major unbridged estuary in Britain, the Humber Bridge was opened by Queen Elizabeth II in 1981 having taken eight years to construct. Both Roman records and the Domesday Book show that a ferry was used to cross the Humber Estuary. In more recent times this journey took a minimum of 20 minutes, during which time a ferry would be exposed to the twin hazards of weather and tide. The bridge opened up both sides of the estuary to further economic and social development, and communities previously miles apart were now joined by road. More than six million vehicles cross the bridge every year.

① The Estuary

The brown appearance of the Humber Estuary is often thought to be a sign of pollution; however the colour derives from the river's natural turbidity as a large tidal estuary. The waters are heavily laden with sediment and support a wide range of wildlife. The enormous width of the river prevented economic development for many years. The ever-shifting bed of the river meant a tunnel could not be constructed easily and so the bridge was finally erected between Hessle on the north bank and Barton-upon-Humber on the south.

② Humber Bridge Country Park

The Country Park Local Reserve is located near to the northern approach of the bridge in a disused chalk quarry known locally as 'Little Switzerland'. The wildlife to be seen here includes many species of birds, great crested newts and the rare white letter hairstreak butterfly. The park also features the Phoenix Sculpture Trail and a black painted windmill, now minus its sails, that was used to crush the chalk in the old quarry.

③ Yorkshire Wolds Way

Beginning in the shadow of the bridge at Hessle, the Yorkshire Wolds Way is a national walking trail that extends for nearly 129km (80 miles) north to Filey in Cleveland. The first 5km (3 miles) of the path is alongside the estuary where walkers can see chalk pebbles on the foreshore left behind by the quarrying activities.

The Humber Bridge's two main cables each contain 14,948 wires.

④ The Bridge △

At the time of its completion and for 17 years thereafter the Humber Bridge was the largest single-span suspension bridge in the world. The suspension structure was chosen because the cost of constructing a tunnel was prohibitive and a single span bridge would not obstruct the flow of river traffic along the navigable estuary. The main central span of the bridge is 1,410m (4,626ft) in length, clearing the water by an average of 30m (100ft). About 480,000 tonnes of concrete were used in building the bridge together with 11,000 tonnes of steel wire in the main cables – long enough to stretch one and a half times around the world. The Humber Bridge was designed perfectly for its environment; it has the ability to bend inwards at the top by more than 3m (10ft) in high winds. The main support towers are 36mm (1.4in) further apart at the top than at the base, to allow for the curvature of the earth.

West Bretton

West Bretton

The village of West Bretton near Wakefield, West Yorkshire, is the site of the nationally renowned Yorkshire Sculpture Park, where works by Auguste Rodin, Barbara Hepworth, Elisabeth Frink and many others are displayed in an outdoor setting of 18th-century landscaped grounds. Adjacent to the park is the stately home, Bretton Hall, now part of the University of Leeds, and the Bretton Country Park, which houses an outdoor display of works by Henry Moore, one of the 20th century's most celebrated sculptors.

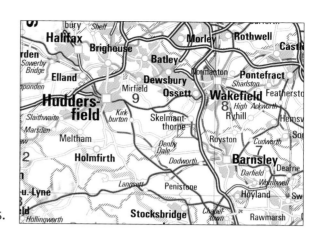

Modernist sculpture in the parkland at West Bretton.

① Yorkshire Sculpture Park ◁

After opening in 1977, the park gained a reputation for its pioneering work in exhibiting sculptures within the natural forms of its 105 hectare (260 acre) landscape grounds. Works on display from the park's collection are changed periodically. They include works by Jonathan Borofsky, Sol LeWitt, Edward Allington, David Nash and Richard Serra as well as Barbara Hepworth and Elisabeth Frink. Hepworth was renowned for her flowing, largely abstract sculptures in bronze, marble or wood, often showing the influence of natural shapes. Born locally in 1903, she reported that her youth in the West Yorkshire landscape 'disciplined me to the life of form and sculpture'. Frink produced mainly figurative sculptures in bronze: her works on display include the celebrated *Running Man*.

The park also puts on temporary exhibitions which have included works by such leading figures as Eduardo Paolozzi, Christo and Jeanne Claude, Anthony Caro and Richard Long.

With more than 300,000 visitors annually, the park has expanded with the acquisition of more land and a new visitor centre. This incorporates a glass concourse through woodland with views of the formal gardens; the upper level contains a balcony overlooking the display of Henry Moore works in Bretton Country Park next door.

② Display of Henry Moore works in Bretton Country Park

The monumental bronze sculptures of Henry Moore are at home in the setting of the 40 hectare (100 acre) Bretton Country Park. Moore was born in 1898 in the West Yorkshire town of Castleford and, like Barbara Hepworth, told of the influence of the local landscape on his artistic vision. He is best known for bronze and marble abstract forms and partly abstracted renderings of mother-and-child pairs or reclining figures. His reclining figures were influenced by the recumbent sacred sculptures of the Toltecs and Maya of ancient Mexico and Guatemala; these figures, thought to be images of the rain god and known as chacmools, were used for the display of human hearts extracted from sacrificial victims. The display of Moore's bronze sculptures at Bretton – on loan from the Henry Moore Foundation, the Tate Gallery and other sources – is changed periodically.

③ Bretton Hall

Located in a landscaped park with pleasure grounds and formal gardens, Bretton Hall was built in about 1720 to the designs of an amateur architect, Colonel James Moyser. The lakes and planting were laid out in the 1770s by the surveyor, Richard Woods, whose work is also to be seen at Lulworth Castle, Dorset, and Hatfield Priory, Essex. The fine camellia house was constructed in about 1817 by Jeffry Wyattville. The estate has a long and well documented history. Listed in the Domesday Book (1086) as Bretone, the land was held from at least the 13th century by the Dronsfield family. The Dronsfields intermarried with the Beaumonts of Whitley Hall and the Beaumonts occupied the estate from 1792 until 1948, when the house was sold to West Riding County Council. After some years as a teacher training college, the hall became part of Leeds University in 2000.

Some sculptures in the park can take on surprising forms such as Henry Moore's 'Large Totem Head' shown here.

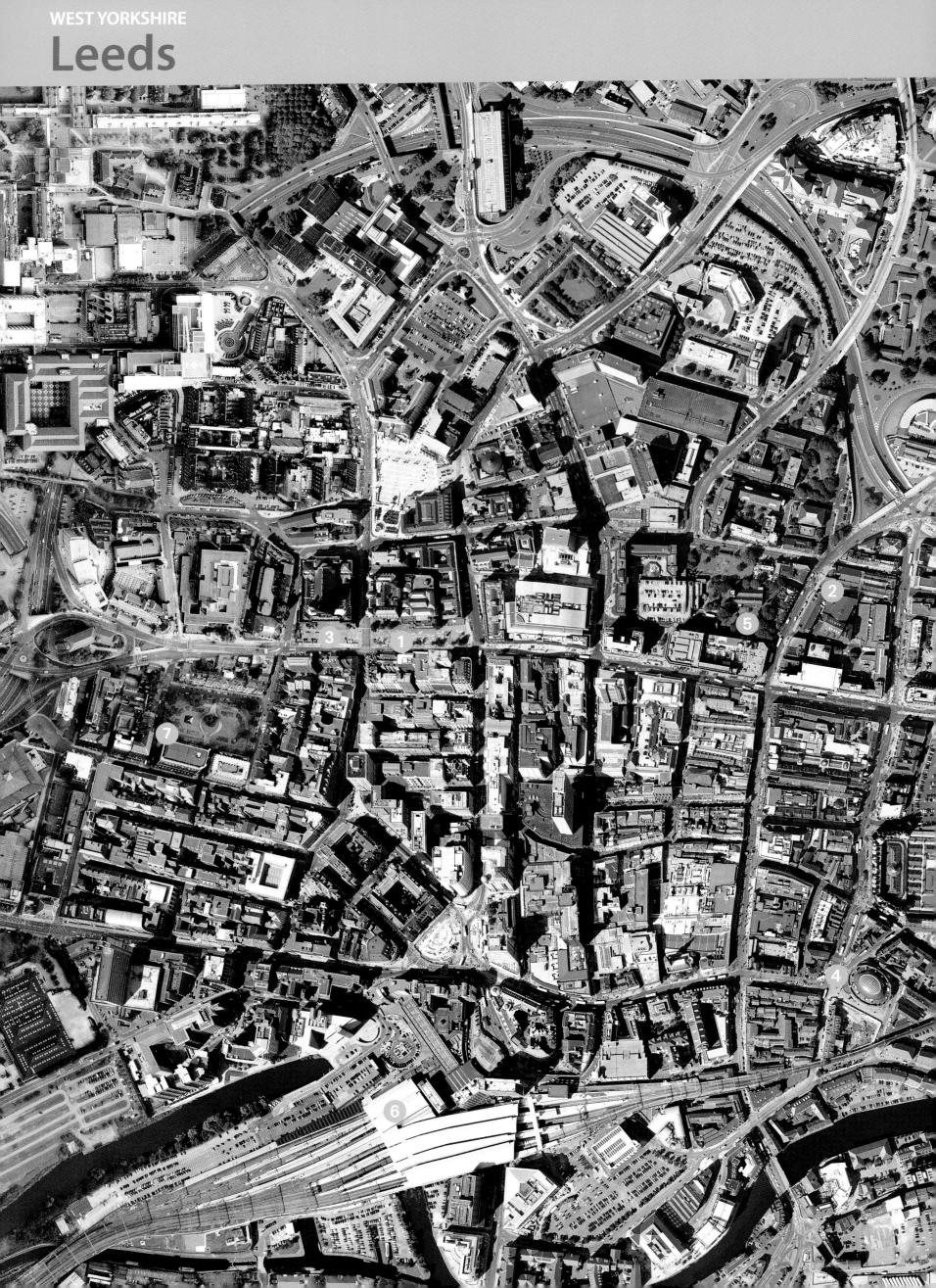

Leeds

The centre of Leeds contains a splendid Victorian Town Hall and Grand Theatre that stand as monuments to its great 19th-century prosperity, when it was celebrated as the industrial capital of Yorkshire. By the late 20th century Leeds had become a thriving multicultural city. It is home to people from more than 75 nationalities as well as a thriving centre for commerce, finance and the arts.

The domed roof of the 19th-century Corn Exchange.

① Leeds City Art Gallery

Established in 1888, the gallery's collection was designated as being of national importance by the government in 1997. It has the best collection of 20th-century British art outside London including drawings by Yorkshire sculptor Henry Moore and work by Francis Bacon as well as watercolours by J.M.W. Turner and John Sell Cotman. It also has a fine display of Pre-Raphaelite art and one of the country's leading collections of modern sculpture.

④ Corn Exchange △

Opened in 1864, the oval hall of the Corn Exchange was designed by Cuthbert Broderick, architect of Leeds's landmark town hall. A tribute to the Corn Exchange in the French capital Paris, the Leeds exchange was laid out beneath a glass dome roof that allowed plenty of light to fall on the trading floor, so that merchants could examine the corn samples in good lighting conditions. Broderick also designed the Leeds Mechanics Institute.

② The Grand Theatre

The Grand Theatre was built in 1878. It is widely regarded as a landmark of Victorian theatre construction, and was designed by architects George Corson and James Robertson Watson with seating for 2,600 people. Because two earlier theatres in Leeds had been destroyed by fire, the design for this gas-lit establishment included an elaborate water-sprinkler system using the gas pipes. Electric lighting and a new stage were added in 1898. Great theatre names including Lily Langtry, Sarah Bernhardt, Henry Irving and Ellen Terry had all appeared at the Grand in the late 19th and early 20th centuries. With a current capacity of 1,550 it attracts more than 240,000 theatregoers and opera-lovers each year. It closed in 2005 and re-opened in October 2006 following a £31 million renovation programme.

③ Leeds Town Hall

The City of Leeds's most celebrated and recognisable building was opened by Queen Victoria in 1858. The Town Hall was designed by a young architect, Cuthbert Broderick, whose plans for the building won a competition with a first prize of £200 in 1853.

Built of honey-coloured millstone grit and local sandstone, with a splendid colonnaded front, the hall was intended to be an expression of Leeds's civic pride. The main building was begun in 1853, with the tower and dome added in 1857. Initially the town hall – hailed by contemporaries as a municipal palace – contained the council chamber, the Lord Mayor's offices, the law courts as well as the police headquarters. Today, the Victoria Hall at the centre of the building is the premier venue for concerts in Leeds.

⑤ St John's Church

The Church of St John the Evangelist stands behind Allders department store on the Headrow, in a bustling part of Leeds city centre. Built between 1632 and 1634 by local wool merchant John Harrison in the Gothic Survival style, it contains original plasterwork, pews and pulpit – but its glory is probably the magnificent carved wooden screen, featuring vines and flowers together with human and animal heads. John Harrison was also a benefactor of Leeds Grammar School, providing land and some new buildings, and his name was given to one of the 'houses' within the school. He is buried in St John's, to the right of the altar.

In the 19th century the parish wanted to demolish the church to replace it with a modern building. However, local architect Richard Norman Shaw campaigned for its survival, supported by the eminent Victorian architect Sir George Gilbert Scott, and Norman Shaw was subsequently entrusted with the church's restoration. St John's Church is no longer in use for worship but is maintained by the Churches Conservation Trust and local volunteers.

⑥ City Station

Leeds City Station was established in 1938 by the merger of two existing rail terminals – the Leeds Wellington Station and the Leeds New Station, which were owned by different companies. Leeds City Station was rebuilt in 1967 and again in 2002. Its origin as two separate stations lives on in its present design with two concourses – the North and South. Much of the station is supported on a series of Victorian brick vaulted arches known as the Dark Arches, which today house the Granary Wharf shopping centre.

⑦ St Paul's House, Park Square

Originally built in 1878 by architect Thomas Ambler as a factory warehouse for the clothing manufacturer John Barron, St Paul's House is now a Grade-II listed office building. The building's generally plain lower floors are complemented by the extravagant decoration of its upper floors that suggest the influence of Moorish and Venetian architecture – in particular the Alhambra in Granada, Spain, and the Doge's Palace in Venice, Italy.

Overleaf: Chatsworth House, home to the Dukes of Devonshire.

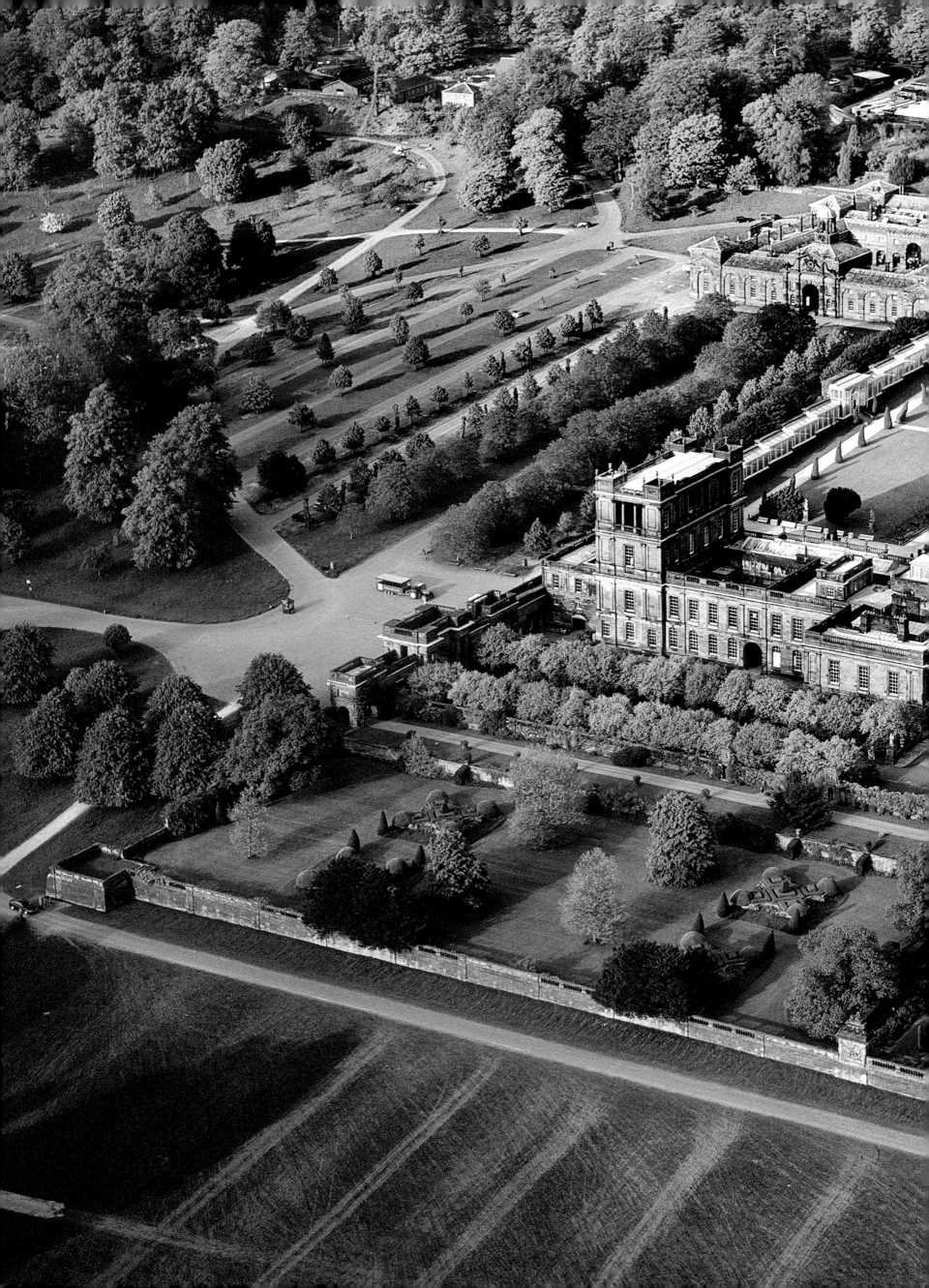

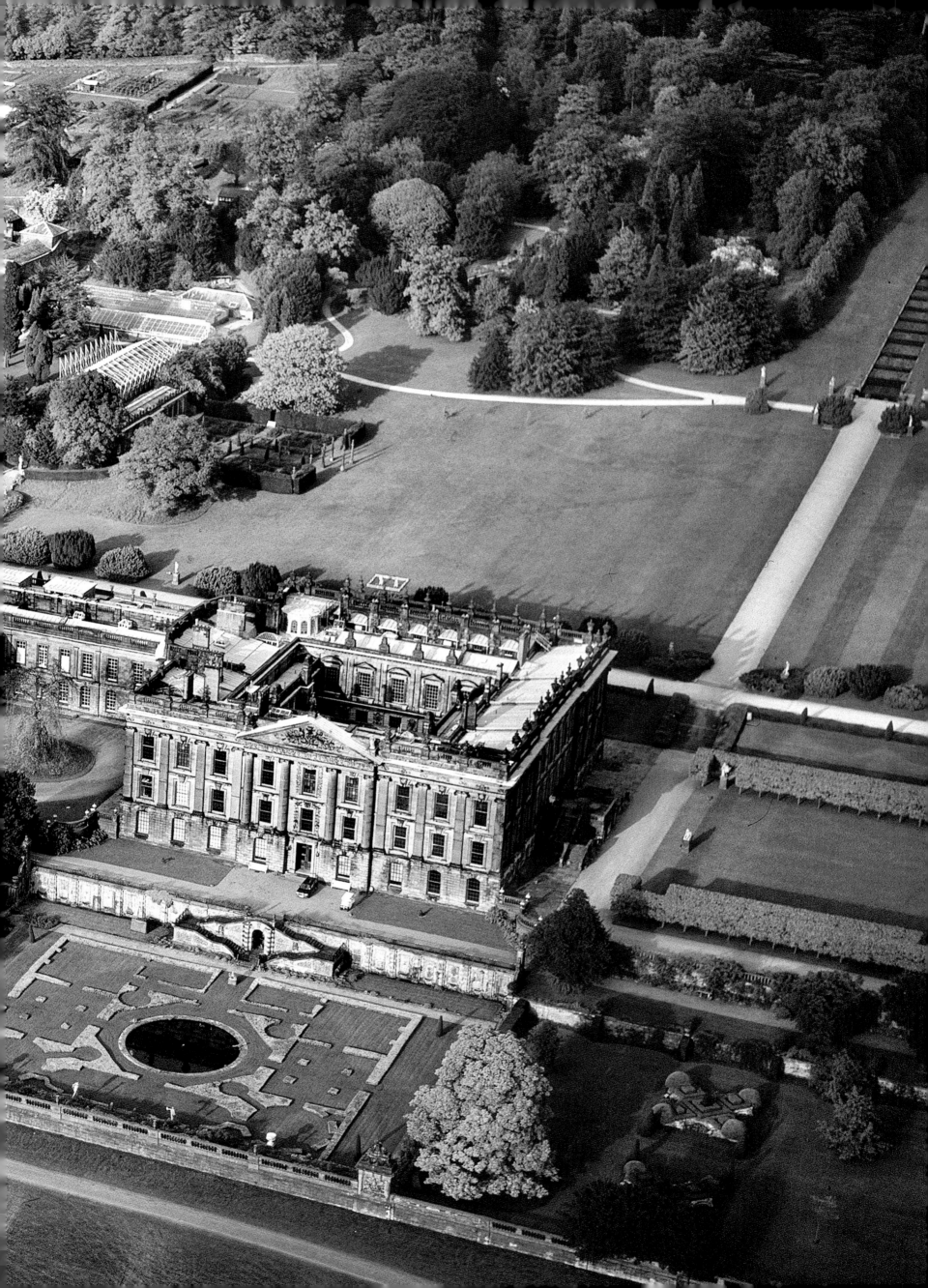

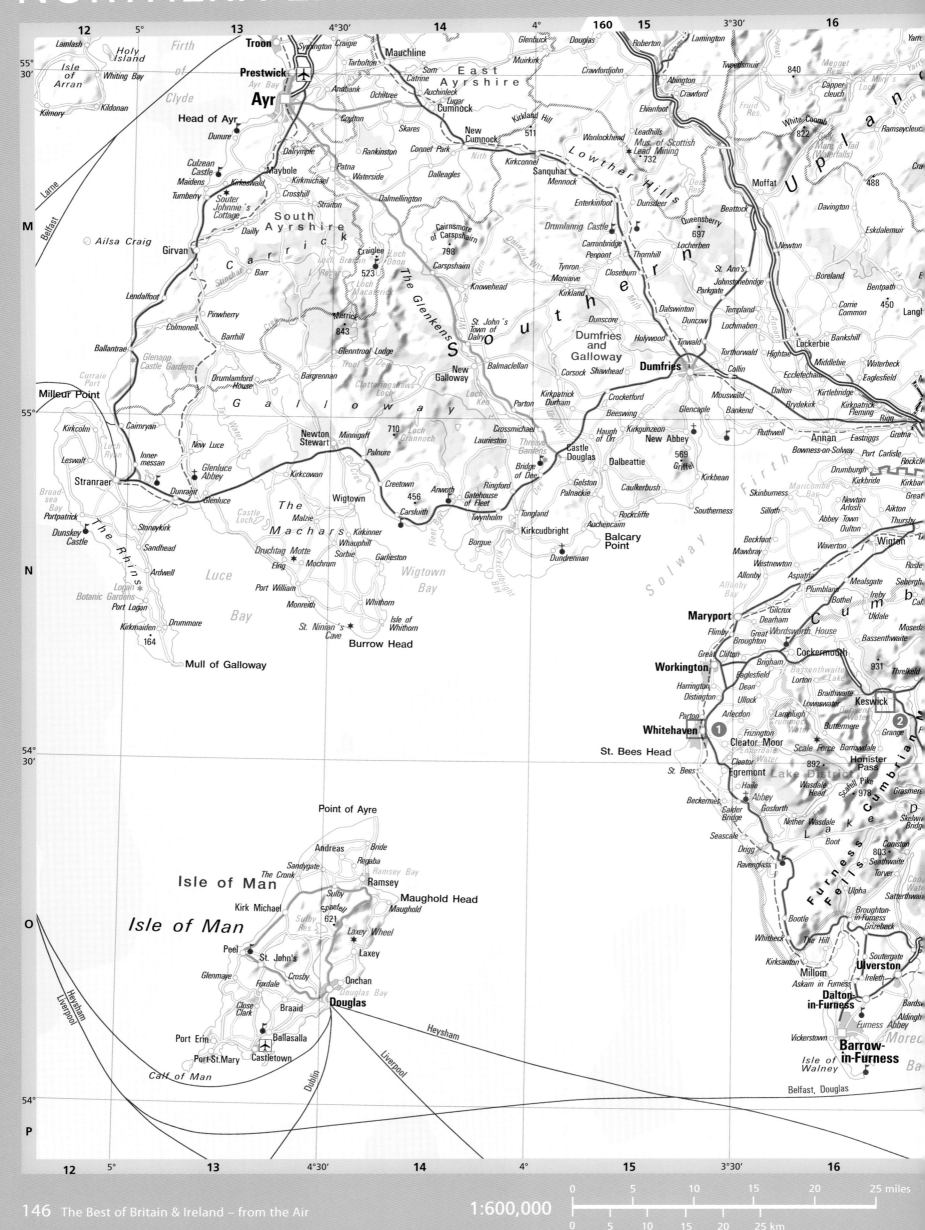

1:600,000

0	5	10	15	20	25 miles
0	5	10	15	20	25 km

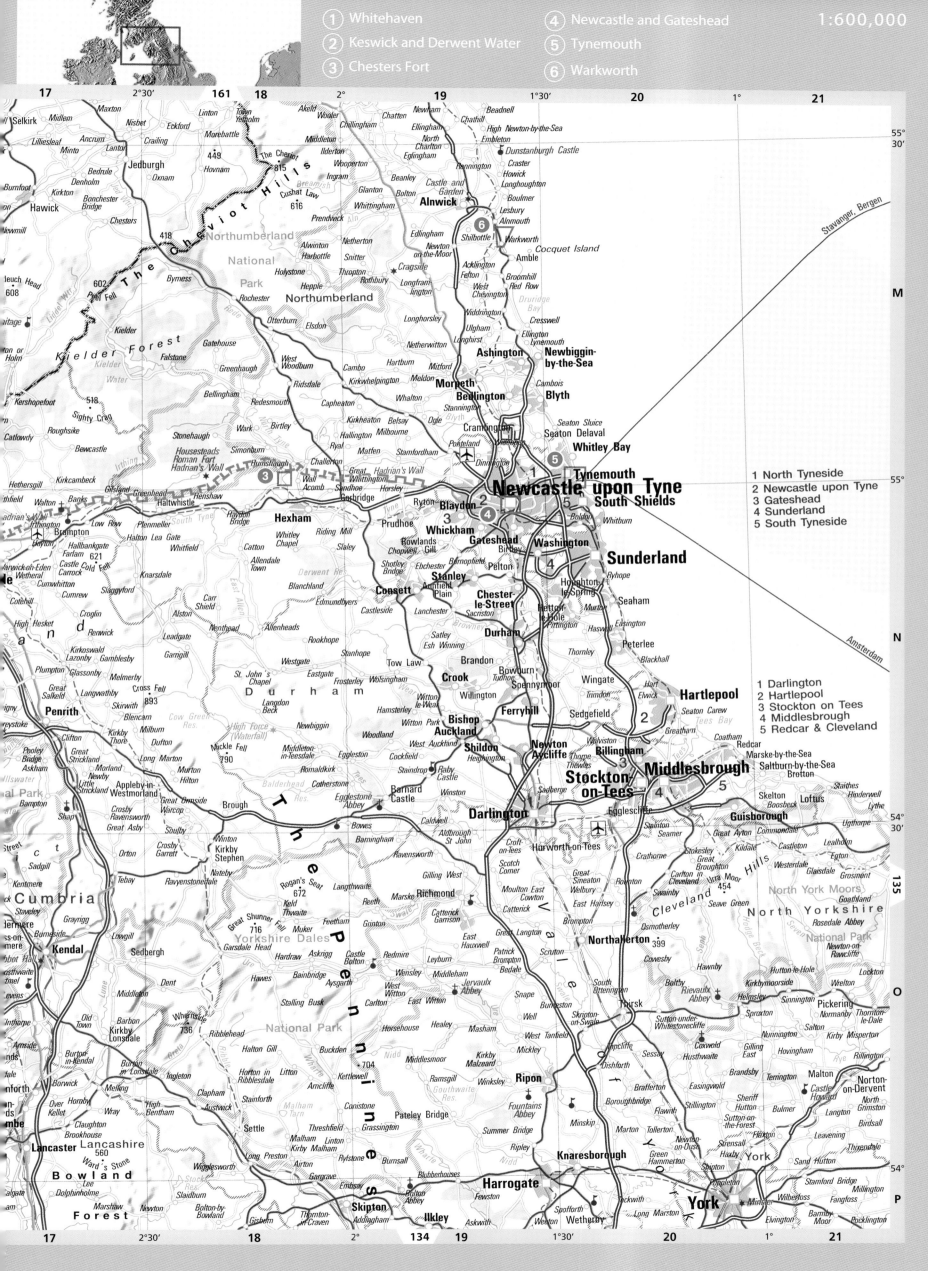

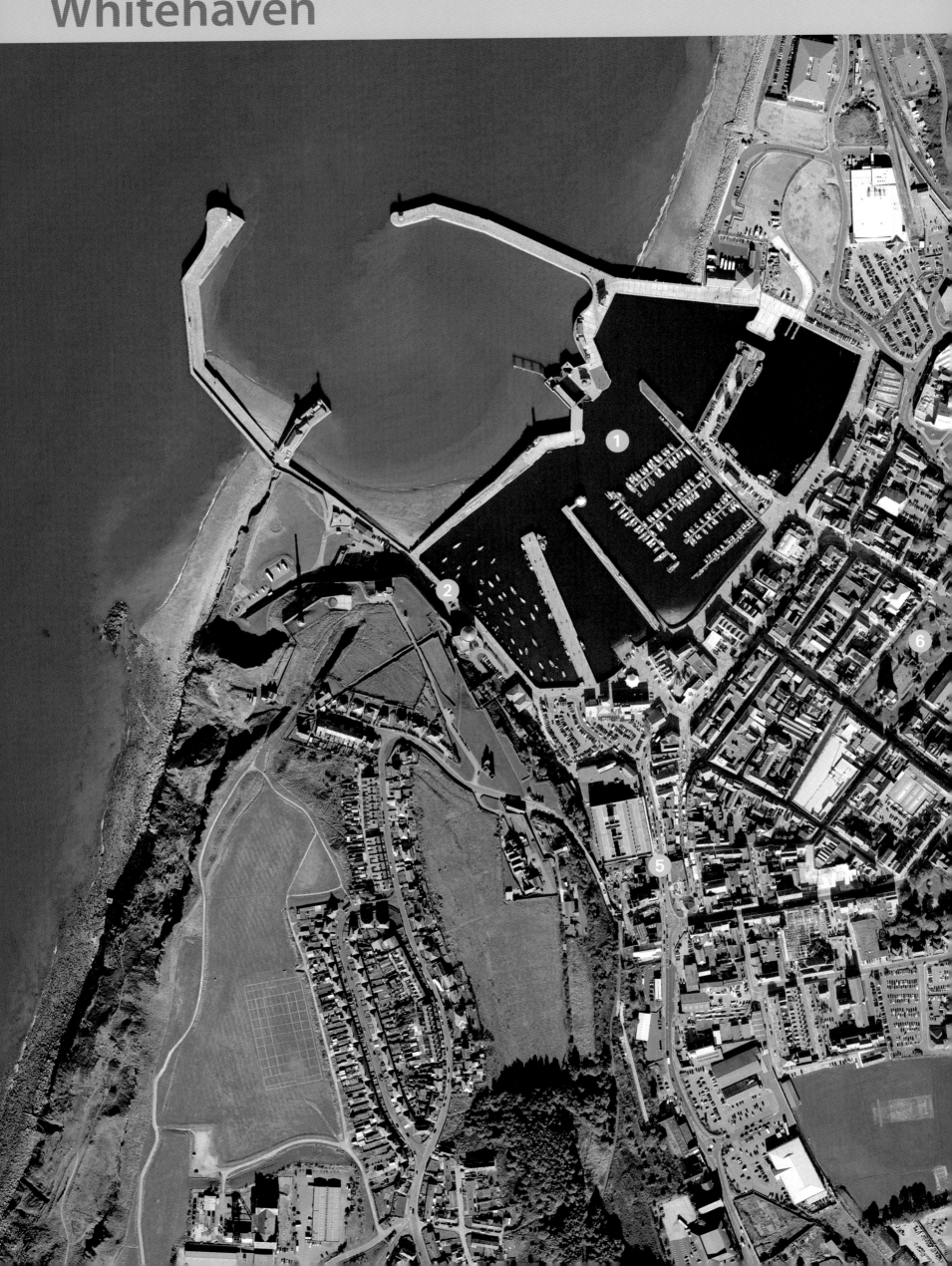

Whitehaven

In the 17th century, the elegant seaport of Whitehaven became one of the first towns to be laid out to a street plan since the Middle Ages. Its grid design was reputed to be the inspiration for the street plan of New York City. In Whitehaven's heyday, in the mid-18th century, the port grew rich exporting local Cumbrian coal, building ships and importing tobacco and rum from North America and the Caribbean. Today the town supports a small fishing fleet and its harbour and architecture have made it a popular holiday spot.

① Whitehaven Harbour ▷

Sir Christopher Lowther, Sheriff of Cumberland, bought the fishing village of Whitehaven in 1630 in order to develop a port from which to export salt from the salt pans located nearby. He built a stone pier in 1633 from which ships could load and unload their cargoes. On his death in 1644 the estate passed to his infant son John, who developed Whitehaven as a coal port. The harbour continued to expand over the next 60 years and by the mid-1700s, Whitehaven was Britain's third largest port, after London and Bristol. In the 19th century, trade dwindled because new larger ships could not navigate the shallow waters of the Solway Firth off Whitehaven and merchants turned to deep-water ports such as Liverpool and Glasgow. Today the Whitehaven Beacon, on the West Strand, houses a weather station and an exhibition celebrating the town's mining and merchant shipping past that can be visited.

② Statue of John Paul Jones

A statue at the end of the Old Quay commemorates a daring night raid carried out on Whitehaven in April 1778 by American naval hero John Paul Jones. Born in Scotland, Jones made a fortune in the West Indies but ran into trouble and subsequently settled in Virginia. During the American Revolution he played a prominent role in the American colonists' 'Continental Navy' that was based in France. In 1778 he was in command of the privateer *Ranger* and led a landing party ashore at Whitehaven. The landing party succeeded in spiking the port's defensive guns and setting fire to three ships in the harbour before they were discovered and had to retreat. This raid, the most recent invasion of the English mainland, is commemorated by a statue of John Paul Jones near Old Quay. It shows him spiking one of the cannons thereby rendering it useless.

③ Whitehaven Castle

In 1675 Sir John Lowther purchased a mansion called The Flatt. This house was destroyed by fire in 1769, after which the then Baronet, Sir James Lowther, rebuilt and renamed Whitehaven Castle. The Lowther family occupied the building until 1920, when it was sold. The castle reopened in 1926 as Whitehaven and West Cumberland Infirmary and remained so until the opening of a new hospital at Hensingham in 1964. The building is now privately owned.

④ St James's Church

Celebrated for its impressive Georgian interior, St James's Church was built in 1752. Its architect was a Whitehaven engineer, Carlisle Spedding, the designer of an early type of safety lamp for use in local coal mines. Two Italian craftsmen, Arture and Baggiotti, created the ceiling plasterwork, while the altarpiece was once in the Escorial monastery and palace outside Madrid before being brought to England. St James's has been the parish church of Whitehaven since the 1970s, when St Nicholas's Church burned down.

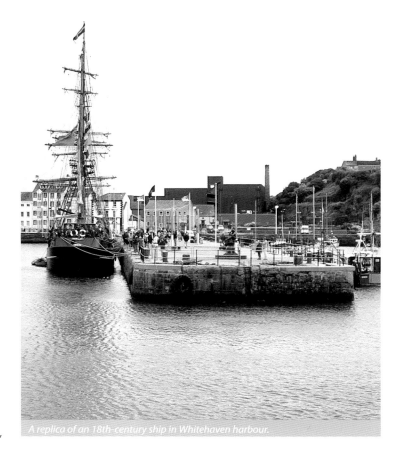

A replica of an 18th-century ship in Whitehaven harbour.

⑤ Market place and streets

The lord of the manor was granted the right to hold a market in Whitehaven in 1654. Most of the buildings surrounding the market place have been standing since the mid 1600s. Chapel Street, King Street and Roper Street were built in the 1640s near the site of the market place. Church Street was laid out in the 1660s and College Street, Duke Street, James Street, Lowther Street, New Street, Queen Street and Strand Street were all built in the 1680s. During this period, Whitehaven's population was growing quickly, up from around 1,000 in 1685 to about 3,000 in 1700. In the market place the market hall, opened in 1881, stands on the site of an earlier hall designed and built between 1814 and 1819 by Sir Robert Smirke.

⑥ St Nicholas's Church tower and graveyard

St Nicholas's Church was built in 1883, replacing an earlier church that was constructed in 1693. In August 1971, a major fire left only the tower standing and the building lost its status as the parish church of the area.

Records show that Mildred Gale, grandmother of the first American President, George Washington, was buried in St Nicholas's graveyard but the exact location of her grave still remains unknown.

Keswick and Derwent Water

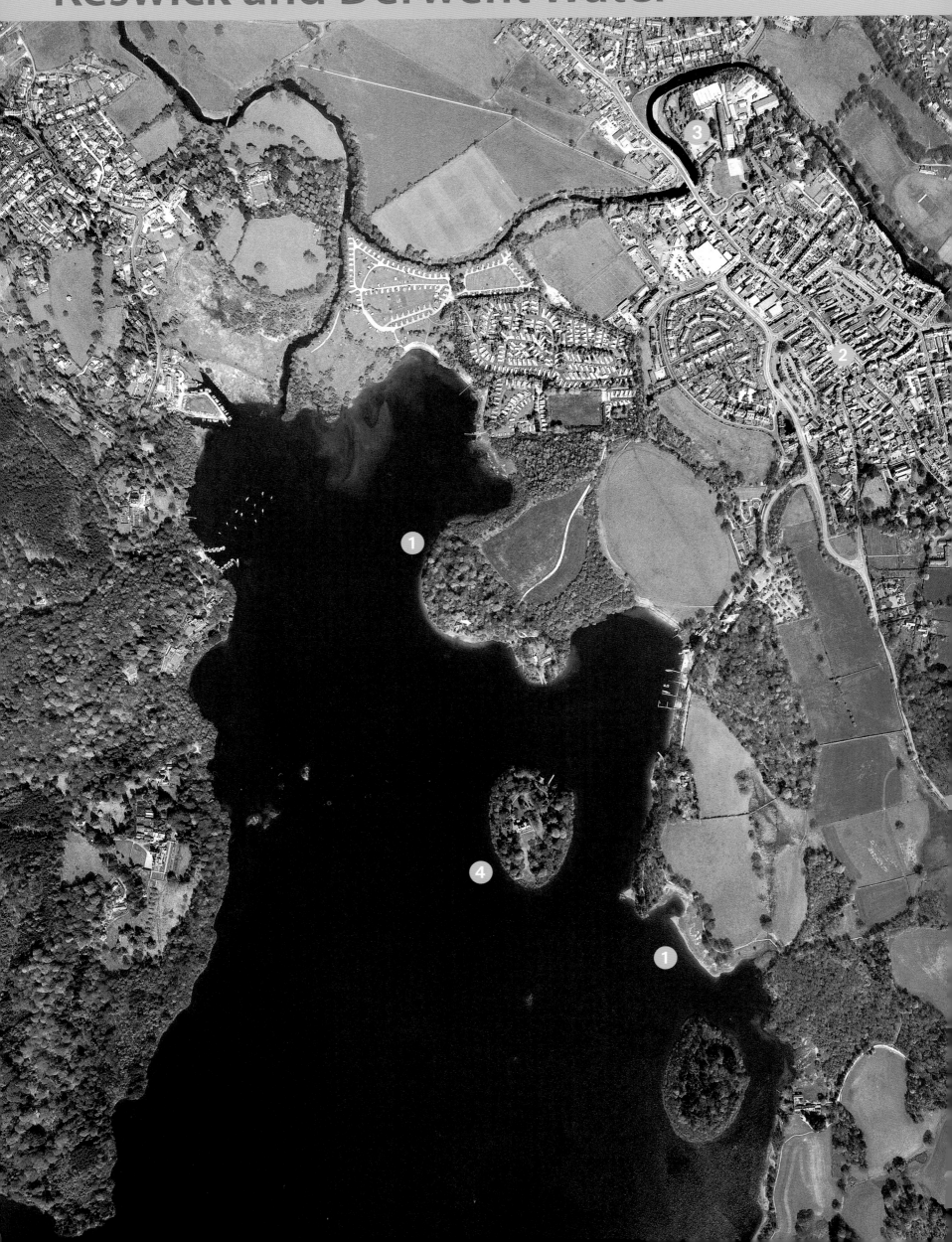

Keswick and Derwent Water

In Old English the name 'Keswick' means 'outlying cheese-producing farm', and at that time the gently sloping pastureland of this place would have made it ideal for dairy farming. Granted a charter to hold markets in 1276, the town of Keswick still has a market every Saturday. For 300 years it was also the world centre of pencil manufacturing, but a new chapter as a tourist destination began when the railway brought new visitors to the area in 1865. It is now the main centre from which walkers and boat enthusiasts set out to explore the northern Lake District.

② Keswick town centre

Keswick is still a small market town today, with a population of about 5,000 – not much more than it was a century ago. At its centre is a mediaeval marketplace, where stalls sell local produce every Saturday. North of the town runs the River Greta before it joins the River Derwent. On the northern bank lies Fitz Park, home of the Keswick Museum and Art Gallery. As the regional base for most outdoor activities, many of the town's shops are devoted to walking, camping and sailing gear.

Derwent Water is 5km (3.1 miles) long and a major tourist attraction. The picture shows a view towards Skiddaw, the 4th highest mountain in England.

① Derwent Water lakeside △

Keswick grew up near a lake, but did not become a lakeside town until tourism began in the 19th century. West of the town, on the low-lying ground around the River Derwent, are the fields that now serve as Keswick's main camping and caravanning grounds. West of the river is the marina of the Derwent Water Boat Club, south of which are the private houses of Fawepark and Lingholm, where Beatrix Potter spent many summers and in whose grounds she set her stories of Squirrel Nutkin. To the south of Keswick, the town is separated from Derwent Water by the crest of Hope Park and Crow Park, owned by the National Trust and with wonderful views across the lake to Newlands Valley and the fells. The parks' protected status has preserved Keswick lakeside from development and ensured continuous access to the public. South of Crow Park are the landing stages from which the Keswick Launch embarks on a six-stop, hour-long tour of the lake in summer. Next to the landing stages is Cockshott Wood, home to Theatre by the Lake – a new purpose-built theatre and year-round repertory company – that was opened in 1999.

③ Cumberland Pencil Works and Museum

The history of the pencil began in 1555 in Borrowdale, the valley south of Derwent Water, when shepherds discovered lumps of a black rock that they found useful for marking sheep. When this graphite was encased in a narrow cylinder of wood, the lead pencil was born. Until a process for making artificial pencil leads was developed in France in 1795, Borrowdale was the source of all the world's pencil graphite, and many of the pencils were actually made, by hand, in Keswick. In 1832 the first industrial-scale pencil factory opened in the town. The Cumberland Pencil Company was founded in 1916 and is now home to the Cumberland Pencil Works (still producing Derwent fine art pencils) and Museum, where visitors can see displays about the history of graphite mining and pencil making, as well as the world's longest pencil, measuring an enormous 7.91m (26ft) in length and weighing 446kg (985lb).

④ Derwent Isle

Derwent Isle, the only one of Derwent Water's four islands still to be inhabited, was originally owned by the monastery of Fountains Abbey in North Yorkshire. In 1778, the eccentric Joseph Pocklington built a house which is the core of the present-day house in the centre of the island. Only a chapel remains of the other buildings he built. The island was bequeathed to the National Trust in 1951.

Chesters Fort, Hadrian's Wall

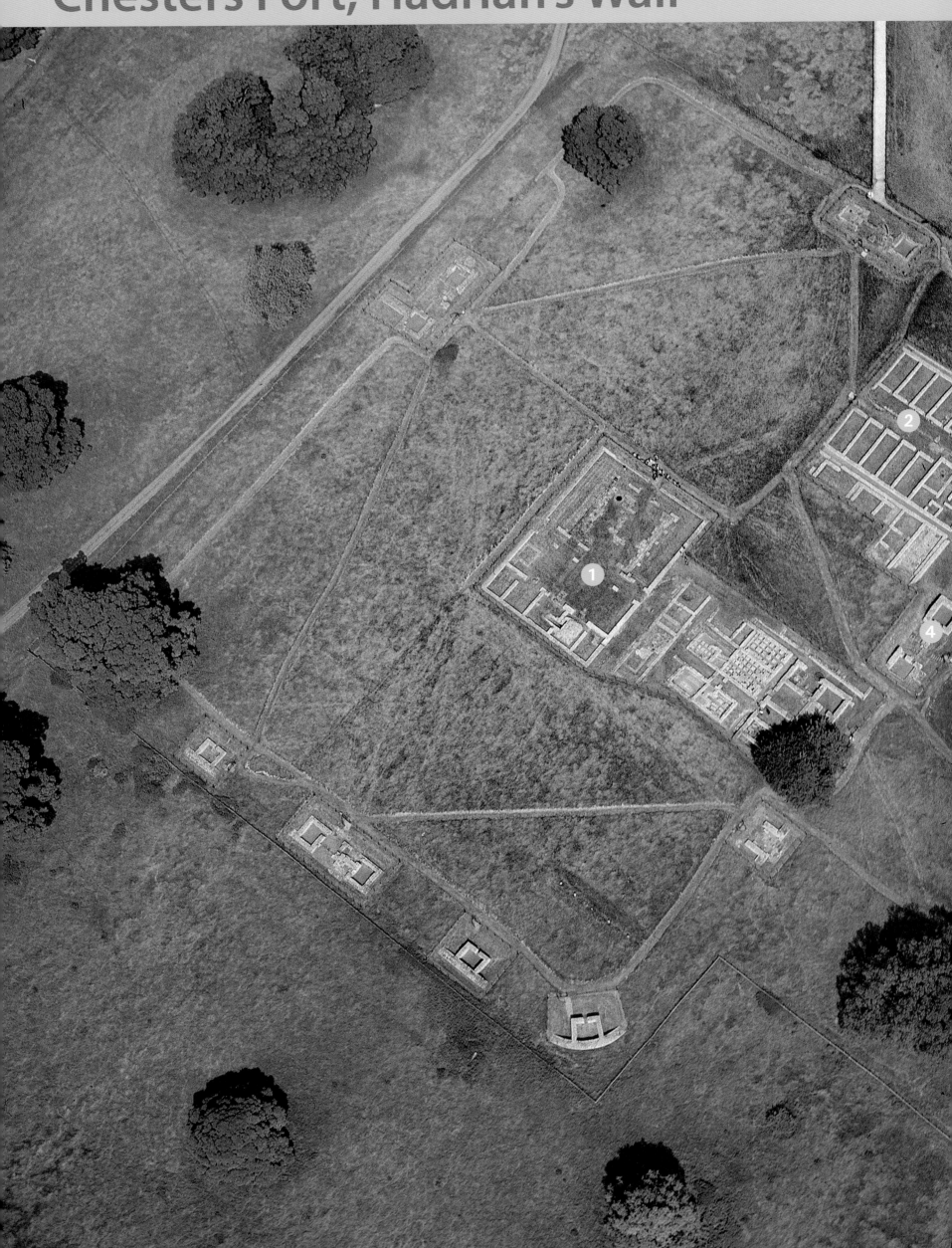

Chesters Fort, Hadrian's Wall

Hadrian's Wall is ancient Rome's most substantial legacy to Britain, stretching 117km (73 miles) from Wallsend on Tyneside to Bowness on the Solway Firth. Lying on the west bank of the River Tyne on Hadrian's Wall, between milecastles 27 and 28, Chesters Fort (Roman *Cilurnum*) is the best preserved Roman cavalry fort in Britain. Built around AD 123, the fort probably housed a reserve strike force to be deployed in case of trouble with the northern 'barbarian' Picts. The fort was designed for a unit of 500 mounted troops and their horses (though later it held legionaries), and contained a substantial *praetorium* (headquarters) with an open courtyard, barrack blocks and a bath complex between the fort and the river. Hadrian's Wall continued over the nearby river across a Roman bridge, of which very little remains today.

❶ The Praetorium

This building was the headquarters of the fort, and any visitor entering the fort would have walked into a courtyard colonnaded on three sides. Some of the paving (one carved with a phallus for good luck) and guttering is still visible. Beyond was a hall with a tribunal, or raised platform, from which the commander could address his troops. On the south side are five rooms that were used for administration, storage of the standards and the strong room, whose vaulted roof (second room from the right) still sits proud of the ground level.

❷ Barracks and Stables

Close to the North Gate are the remains of the main barrack blocks. The narrow rectangular rooms, probably divided by wooden partitions, were for the troopers, while the officers had more spacious accommodation at the end of the blocks. Remains of columns indicate the presence of broad, supported eaves, probably with rainwater gutters. Backing on to the south of the two rows of barracks is a third building that probably housed the horses.

❹ East Gate

There were six gates into the fort, four main ones in the centre of the walls and two smaller ones midway between the East and West Gates and the southern wall of the fort. The walls of the fort were originally some 1.5m (5ft) thick and 4.6m (15ft) high. The East Gate would, like the other main ones, have had two substantial square towers, and a double entrance. The extensive remains show clearly the original foundations dating from Hadrian's time. The north wall projects significantly beyond Hadrian's Wall, and in gates such as the North Gate, the original post holes for the gates can still be seen. With the angled corner towers, interval towers and battlements, the fort would have been a potent symbol of power on the northern edge of the Roman Empire.

❸ The Bath House Complex

Proximity to the river and fear of fire dictated the location of the bath complex outside the fort. It contains some of the most substantial remains on the site, with walls standing up to 3m (10ft) high and 0.9m (3ft) thick. It developed in different stages – first changing rooms and the main hot and cold rooms with a porch; larger changing rooms and more heated rooms were added later. There is significant buttressing along the latrine wall, though little of the interior survives apart from part of the sewer. The roof was probably made of tiles and tufa (a volcanic stone).

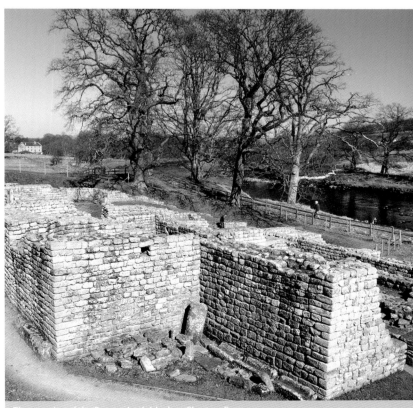
The remains of the Roman bath block at Chesters Fort.

Newcastle and Gateshead

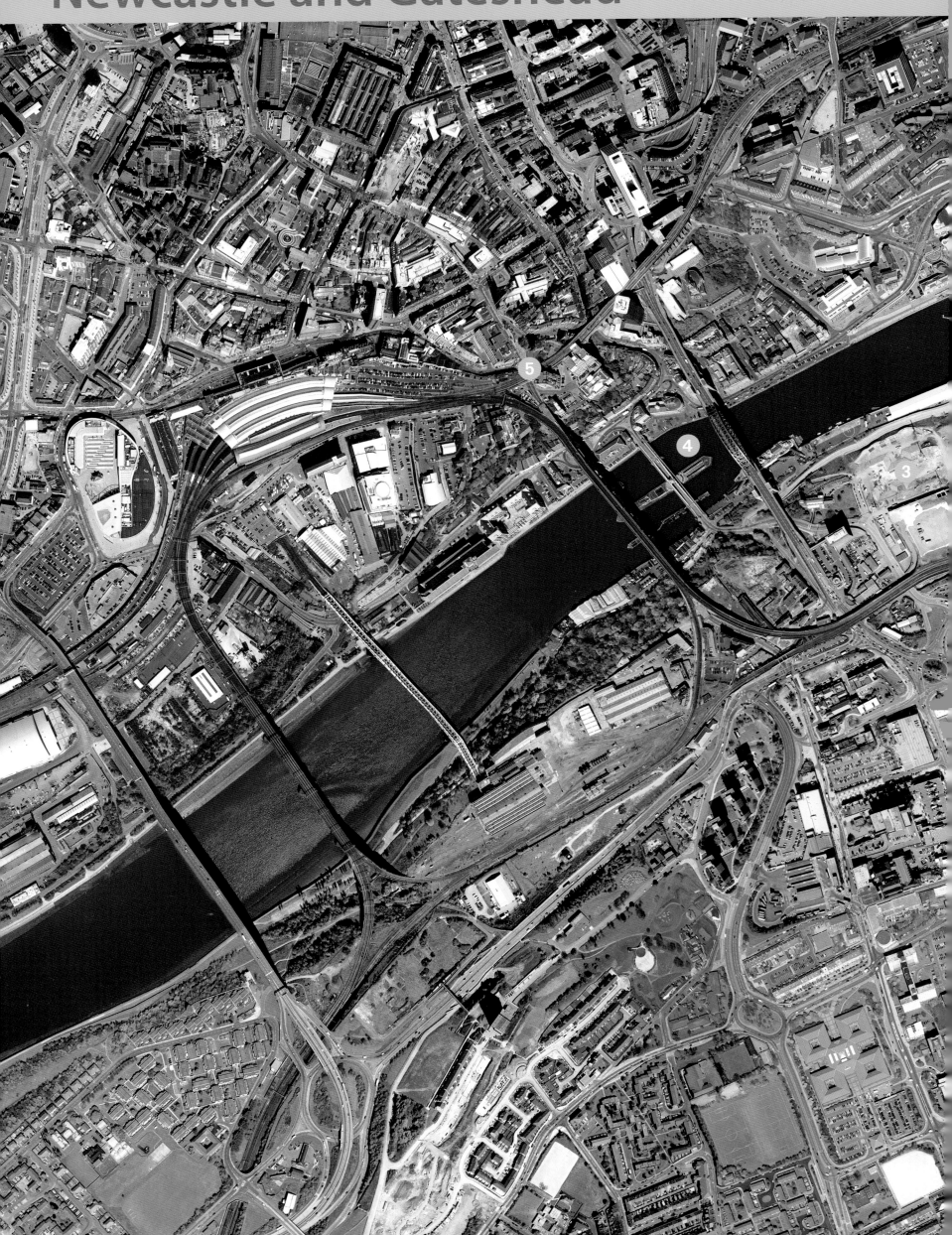

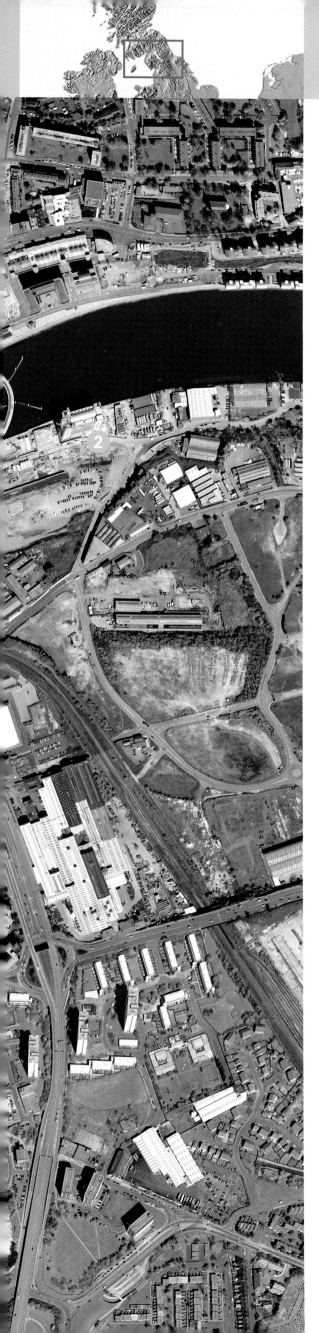

Newcastle and Gateshead

Lying inland from the North Sea on the banks of the River Tyne, Newcastle upon Tyne developed on the site of *Pons Aelius*, a Roman settlement at the end of Hadrian's Wall. Newcastle and Gateshead, a town on the south bank of the river, became renowned industrial centres in the 19th and early 20th centuries, famous for coalmining, iron and steel production and

shipbuilding. Newcastle's fine Victorian civic architecture is testament to the wealth generated by these industries. Today visitors and residents are attracted to Newcastle and Gateshead for their cultural centres, shops and nightlife.

① Millennium Bridge ▷

This remarkable pedestrian and bicycle bridge runs for 126m (413ft) across the River Tyne, linking Gateshead and the Quayside area of Newcastle. When ships need to pass, the bridge's roadway is tilted upwards on pivot mechanisms sited on both sides of the river, with a motion like that of a giant eyelid opening. The bridge was opened in 2001 and has won several awards for its ingenious design. The entire structure, designed by architects Wilkinson Eyre with engineers Gifford and Partners, was lifted into place in one piece after completion.

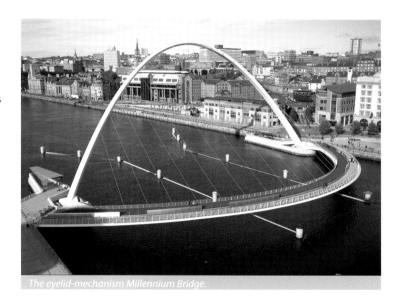
The eyelid-mechanism Millennium Bridge.

② Baltic Centre for Contemporary Art

Standing near the Millennium Bridge, on the river's south bank, the former Baltic Flour Mills in Gateshead was transformed into an international centre for visual arts in a £46 million project during the late 1990s. The Baltic Centre for Contemporary Art – which contains five art galleries, a cinema, artists' studios, a library-archive, media laboratories and restaurants – was opened in July 2002. The design for the art centre was produced by Ellis Williams Architects. The Baltic, which has no permanent art collection, commissions new contemporary artworks and appoints artists in residence. The original Baltic flour mills complex operated between 1950 and 1982 as a flour mill and animal-feed factory. The building converted into the Baltic Centre was the original mill silo.

③ Sage Centre ▽

The Sage Centre for music in Gateshead includes two concert halls, a rehearsal space, a 25-room music education centre, dining and bar spaces and a large concourse. Above the entire complex rises a curved steel roof containing 250 glass panels amid 3,000 stainless-steel sheets. From the concourse visitors can enjoy magnificent

The Sage Centre was opened in 2004.

views of the quayside and river area. Designed by Norman Foster and Partners, it is home to the Northern Sinfonia chamber orchestra. It opened in December 2004 after eight years of construction.

④ Bridges on the Tyne

When it was opened in 1928, the Tyne Bridge was the world's largest single-span bridge. However, it lost this record within five years to the Sydney Harbour Bridge. Immediately to the west is the Swing Bridge, constructed in 1876 on the spot where the Romans built the first bridge across the Tyne in the 2nd century AD. Next is the High-Level Bridge designed by Robert Stephenson and opened in 1849 by Queen Victoria.

⑤ Castle Keep and Black Gate

Newcastle takes its name from the 'new castle' built in 1080 by William the Conqueror's eldest son Robert Curthose (nickname meaning 'short stockings') when returning from a military raid in Scotland. Robert's original wooden motte and bailey castle was rebuilt in stone in 1172, during the reign of Henry II. The keep of this castle survives and can be visited today. The Black Gate was added in around 1250. The castle keep stands on the site of an original Roman fort, *Pons Aelius*, that was built in around AD 120.

Tynemouth

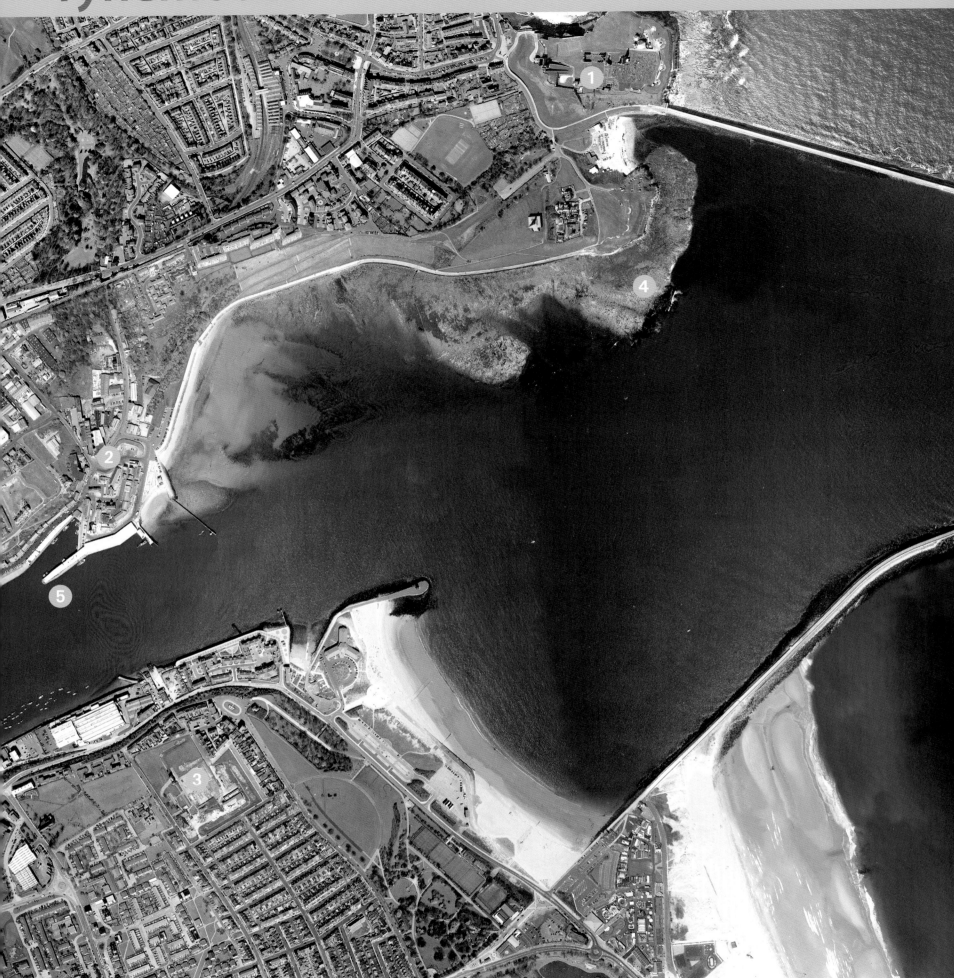

Tynemouth

The town of Tynemouth in North Tyneside lies on a promontory on the north side of the mouth of the River Tyne. To the south lies South Shields in South Tyneside. The mouth of the river is sheltered by two long piers, each of which has a lighthouse at its end to guide ships to safety. For centuries fish have been landed at the mouth of the Tyne estuary. The name 'Shields' itself derives from the word 'shiel' or 'shieling', meaning hut, and refers to the fishermen's huts that once stood on the shoreline. The strategic importance of Tynemouth is shown by the fortifications that have existed from Roman times right up to the 20th century. Three of the early kings of Northumbria are also represented by three crowns in the the borough of Tynemouth's coat of arms.

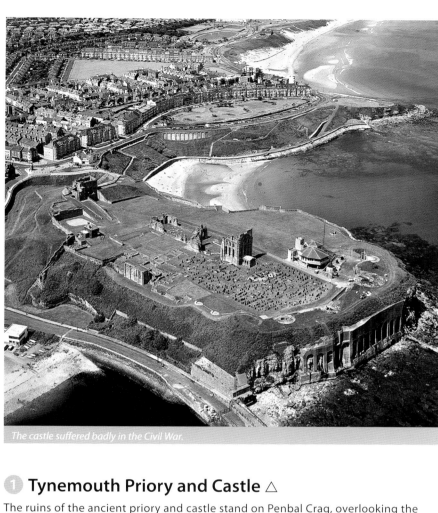

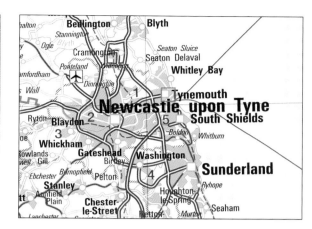

The castle suffered badly in the Civil War.

① Tynemouth Priory and Castle △

The ruins of the ancient priory and castle stand on Penbal Crag, overlooking the sheltered Prior's Haven. The priory is supposed to have been founded by Edwin, king of Northumbria, early in the 7th century and rebuilt by King Oswald in 634. St Oswin, king of Deira (part of what was to become Northumbria), was buried there in 651, which is why the priory is dedicated to St Mary and St Oswin. A Benedictine priory was built in 1090 and fortified soon afterwards. The castle keep and the walls and gatehouse which enclose the priory ruins were added during the 14th century. Henry VIII included the Spanish Battery, a gun emplacement manned by Spanish mercenaries, in the fortifications. Only the name survives, although a restored Second World War gun battery can be seen today. The castle was a Royalist stronghold in the Civil War; much of the Priory was destroyed when it fell to the Parliamentarians.

② Clifford's Fort

The ruins of Clifford's Fort, built in 1672 on the outbreak of the Third Dutch War to protect the mouth of the Tyne, can still be seen. The fort's cannons were directed seawards. There was also a lighthouse and a three-storey keep within the fort. In 1804, as a result of a drunken bet, companies of regular soldiers attacked the fort across the water from South Shields, but were repulsed by a Volunteer force. The fort continued as a battery until 1888, when it became a depot for Tyne Division, Royal Engineers (Volunteers) Submarine Miners. It again saw service as a coastal battery in the Second World War.

Roman Fort and Museum ▷

One of the finest Roman forts has been excavated and partially reconstructed in South Shields. The fort of Arbeia was constructed in AD 160 on the site of an Iron Age roundhouse. Its original cobbled parade ground can now be viewed by visitors. The fort soon became a supply base, equipped with granaries, to provision the 17 forts along Hadrian's Wall, which lies to the west. When the camp was burned down in 300, it was rebuilt with the addition of a fine house for the commanding officer. The house had two dining rooms, baths, kitchens, stables and central heating. Among the treasures recovered from the site are pieces of jewellery carved from jet.

④ Black Middens

These treacherous rocks, hidden at high tide, were once the cause of many shipwrecks in heavy seas. Ships were likely to run onto them as they tried to avoid Herd Sand, a shallow sandbank on the south side of the harbour. The schooner *Friendship* and the steamer *Stanley* were wrecked on the Black Middens on November 24, 1864, with the loss of 36 lives. This tragedy inspired the formation of the first Volunteer Life Brigade to assist in future rescue efforts from the landward side. The building of the piers was begun in 1854 and was only completed in 1895, when the North Pier was finished. Only two years later the North Pier was breached by a storm, and it was 14 years before its reconstruction was completed. The result is a tranquil harbour, which has made the rocks less deadly.

⑤ Fish Quay

The Fish Quay was already the site of a small fishing community as early as the 13th century. It developed to become the heart of an important fishing port. In the 19th century, the North Shields dockside was frequented by the famous fishwives of Cullercoats, a village a short way along the coast to the north. Less white fish is landed here nowadays, owing to the depletion of North Sea fish stocks. Tynemouth is still a major port for prawn and it is busiest in the prawn season, between September and March.

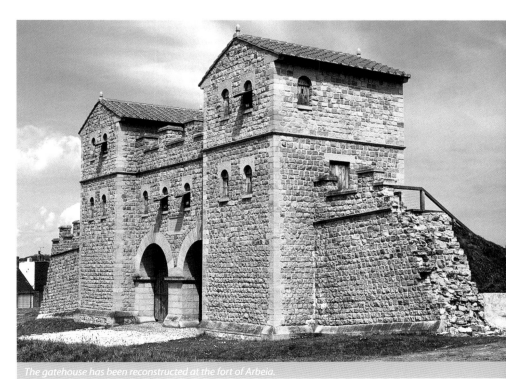

The gatehouse has been reconstructed at the fort of Arbeia.

Overleaf: the village and 14th-century castle at Warkworth.

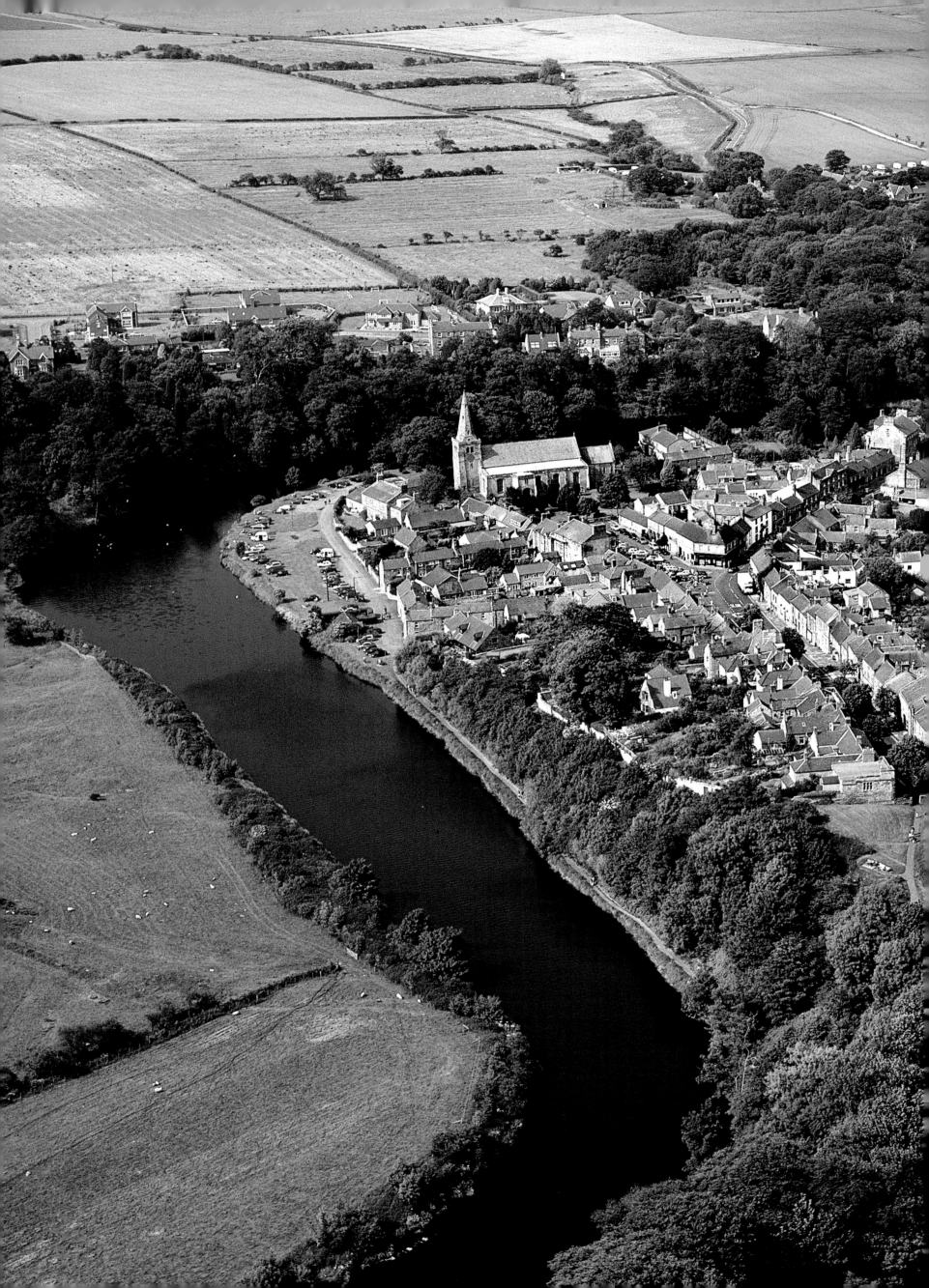

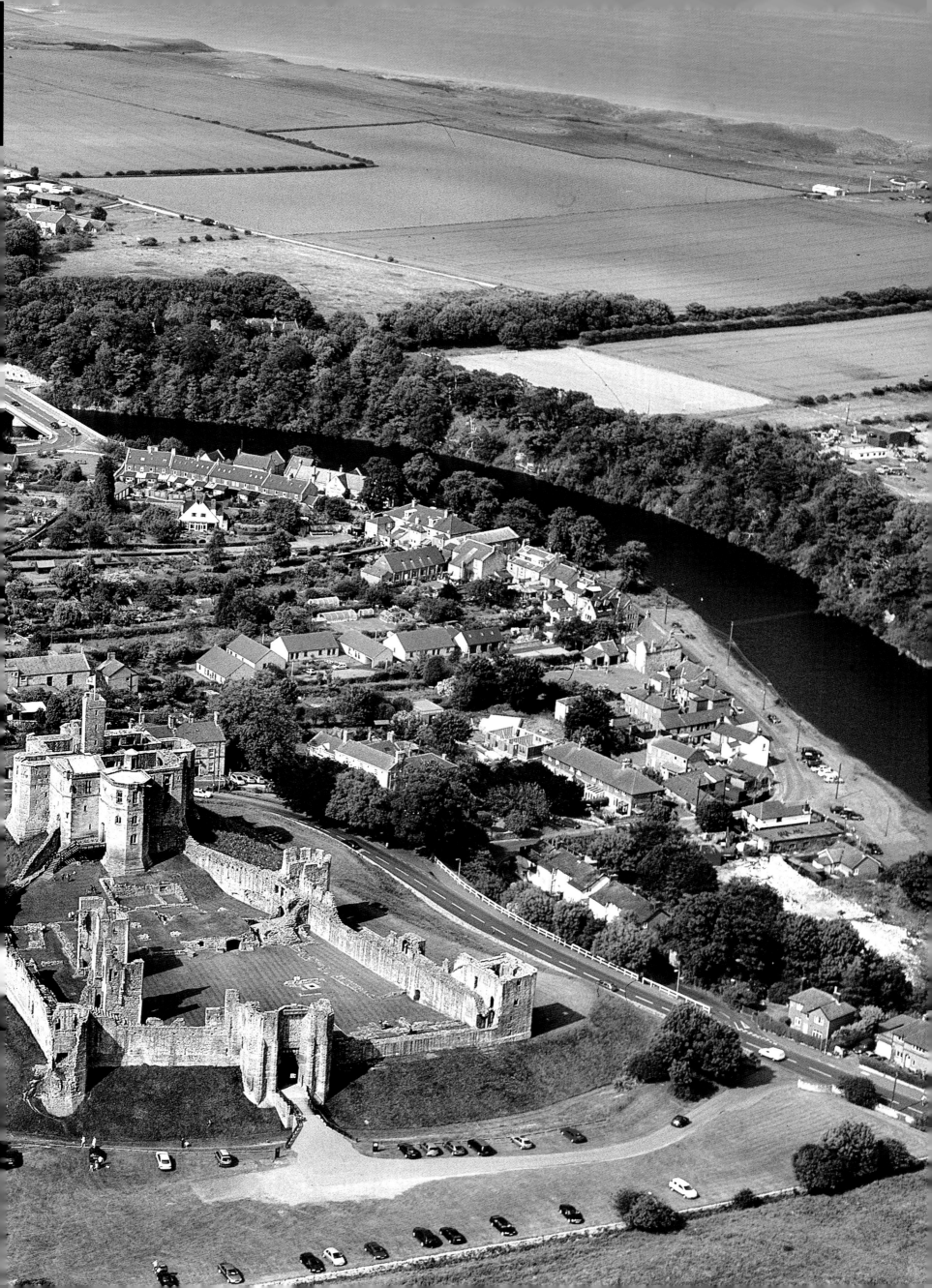

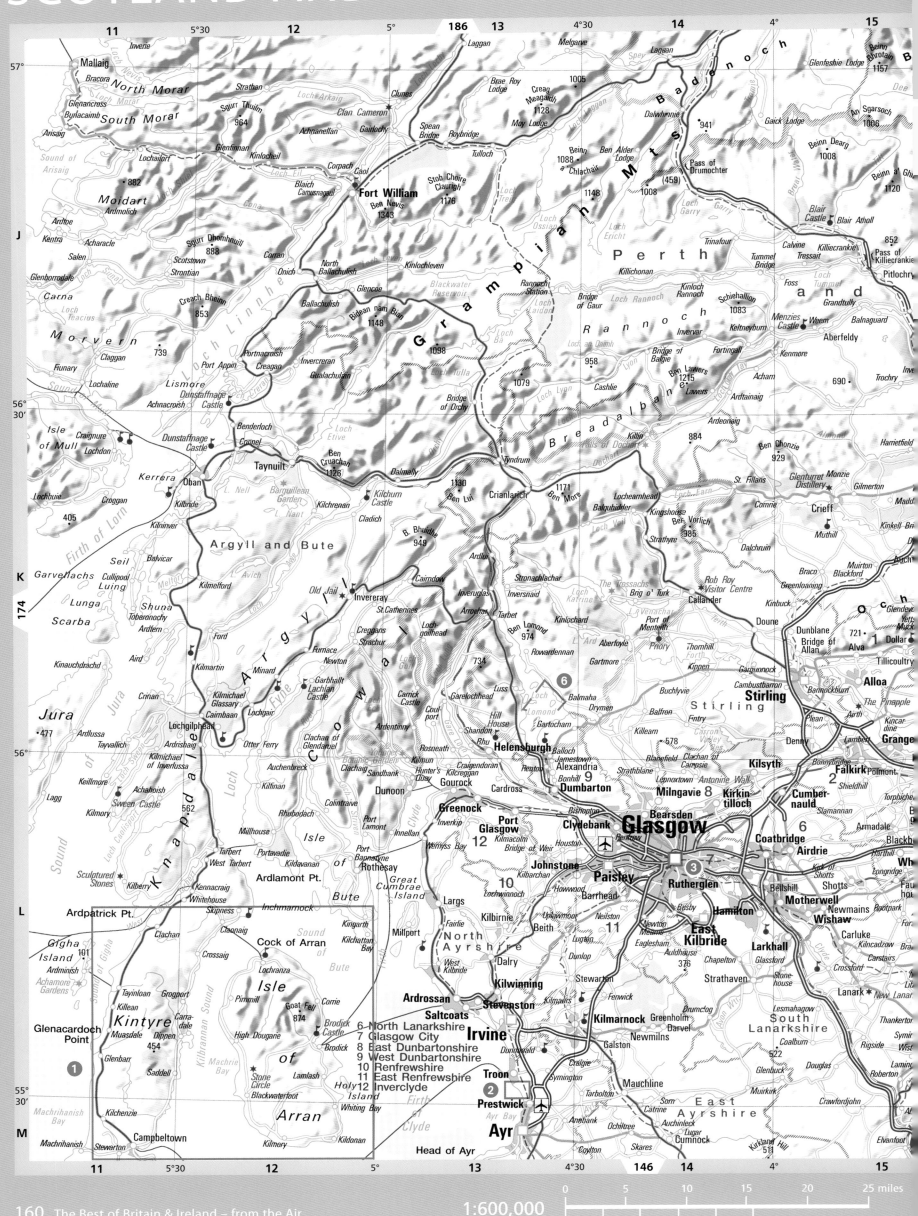

57°

11 5°30 12 5° **186** 13 4°30 14 4° 15

Invarie

Mallaig
Bracora *North Morar*
Glenancross Strathan
Burlacaimb *South Morar* Sgurr Thuilm
Arisaig 964
Moidart
Ardmolich
Ardtoe Glenfinnan Kinlocheil
Kentra Acharacle Scotstown 888
Salen Sgurr Dhomhnuill
Glenborrodale Strontian
Carna Creach Bheinn
853

Laggan
Melgarve
Laggan *Beinn a' Bhrotain* B
Clan Cameron Brae Roy Creag 1157
Lodge Meagaidh Glenfeshie Lodge
Achnanellan Gairlochy 1128
Clunes Moy Lodge Dalwhinnie *Badenoch* Gaick Lodge Any Sgarsoch
Spean Roybridge Ben Alder 941 1006
Bridge Tulloch 1088 Lodge Pass of
Corpach Caol a' Chlachair 1008 Drumochter Beinn Dearg
Fort William (459) 1008 1008
Ben Nevis 1148 Blair Beinn a' Ghlo
1343 Castle Blair Atholl 1120
Stob Choire *Grampian Mts* 852
Claurigh Trinafour Calvine Killiecrankie Pass of
1176 *Perth* Tummel Tressait Killiecrankie
North Kinlochleven Bridge Foss Pitlochry
Ballachulish Killichonan
Onich Glencoe Rannoch *and* Kinloch Schiehallion Grandtully
Ballachulish Station Rannoch 1083 Menzies Weem Balnaguard
Bidean nam Bian Blackwater Bridge *Rannoch* Invervar Castle Aberfeldy Kenmore
1148 Reservoir of Gaur 958 Bridge of Keltneyburn
Loch Balgie Fortingall Acharn 690
Ba 1079 Ben Lawers Ardtalnaig Trochry
1098 1215

J

Morvern 739
Port Appin Portnacroish
Creagan Invercreran *Grampian*
Lismore Gualachulain *Breadalbane* Lawers
Dunstaffnage Bridge Cashlie
Isle of Achnacroish Castle of Orchy Falls of Killin 884 Ben Chonzie
Mull Craignure Benderloch Loch Dochart 929
Lochdon Dunstaffnage Connel Etive St. Fillans Glenturret
Kerrera Castle Ben Cruachan Monzie Gilmerton
Lochbuie Taynuilt 1126 Dalmally Distillery
Croggan 1130 Crianlarich Ben More Balquhidder Comrie **Crieff**
Oban Kilchurn Ben Lui 1171 Lochearnhead Muthill Madd
405 Kilbride Castle B. Bhuidhe Ben Vorlich Dalchruin
Kilninver Kilchrenan 949 985 Kinkell Br
Seil Cladich Braco Auch
Garvellachs Balvicar *Argyll and Bute* Ardlui Strathyre Greenloaning
Cullipool Inveruglas Kinbuck Dunblane Yett:
Luing Old Jail Cairndow Inversnaid *The Trossachs* Callander Muck
Lunga Kilmelford Inveraray Arrochar Rob Roy 721 Dollar
Scarba St. Catherines Loch Tarbet Visitor Centre Bridge of Alva
174 Ford Creggans Katrine Brig o' Turk Allan Tillicoultry
Ben Lomond Port of Doune
Kinauchdrach Strachur 974 Kilmartin Menteith *Loch*
Jura Aird Minard Furnace Rowardennan Aberfoyle Priory Kippen
477 Garbhallt Newton 734 Gartmore Kingdom

K

Crnan Kilmichael Lachlan Thornhill
Glassary Castle Luss 578
Cairnbaan Lochgair Carrick Garelochhead Balmaha Drymen *Stirling* **Stirling**
Lochgilphead Castle Coulport Hill Balloch Bannockburn The Pineapple
Clachan of Ardentinny House Shandon Balmaha Gargunnock Denny Kincardine
Knapdale Glendaruel Rosneath Rhu Killearn Plean Grange
Otter Ferry **Helensburgh** Jamestown Blanefield Clachan of Airth
Auchenbreck Alexandria Strathblane Campsie **Kilsyth** **Falkirk**
562 Kilfinan Dunoon Bonhill Lennoxtown Antonine Wall Polmont
Colintraive *Dumbarton* **Milngavie** 8 Kirk Shieldhill
Rhubodach Kilcreggan Cardross tilloch **Cumber-** Torphiche
Millhouse Innellan Bishopton Bearsden **nauld** Armadale
Tarbert Portavadie Port **Greenock** Clydebank **Glasgow** Slamannan Blackb
West Tarbert Kildavanan Bannatyne Inverkip **Port** Renfrew 7 Wh
Isle **Glasgow** 12 Kilmacolm **Coatbridge** Longride
of Portnacroish Rothesay Bridge of Weir Houston 3 **Airdrie** Northill
Bute Ardlamont Pt. Wemyss Bay Kilbarchan Harthill
Kennacraig **Johnstone** **Rutherglen** Kirk of
Whitehouse Skipness *Great* 10 Howwood **Paisley** Bellshill Shotts Fau
Ardpatrick Pt. *Cumbrae* Largs Barrhead Newton Busby **Motherwell** hol
Island Lochwinnoch Mearns **Hamilton** **Wishaw** For
Inchmarnock Fairlie Neilston 11 **East** Newmains
Claonaig Millport Beith Uplawmoor Eaglesham **Kilbride** Carluke Kilncadzow
Clachan Kingarth *North* Kilbirnie Dunlop Auldhouse Larkhall Carstairs
Gigha Crossaig Kilchattan *Ayrshire* Dalry 376 Chapelton Glassford Stone- New Lanar
Island Cock of Arran Bay West Stewarton house **Lanark**
101 Lochranza Kilbride Fenwick Strathaven South
Ardminish *Isle* *of* **Kilwinning** Kilmaurs Drumclog *Lanarkshire* Symir
Achamore Tayinloan Grogport Pimmill Corrie **Ardrossan** Stewarton Greenholm Lesmahagow Rigside Wist
Gardens Goat Fell **Saltcoats** **Stevenston** **Kilmarnock** Darvel Newmilns Coalburn Thankerton
Killean 874 Brodick **Irvine** Galston 522 Douglas Lamin
Kintyre Carra- Castle Dundonald Craigie Glenbuck Crossford Roberton
dale Brodick Mauchline Som *East* Thankerton
Muasdale High Dougarie Dippen **Troon** Symington Tarbolton **Ayrshire** Crawfordjohn
454 *of* 2 Annbank Ochiltree Al
Glenbarr Stone **Prestwick** Mauchline Auchinleck
Saddell Circle Lamlash *Holy* Annbank Lugar Muirkirk Elvanfoot
1 Blackwaterfoot *Island* **Ayr** Coylton Skares Cumnock Kirkland 51

6 North Lanarkshire
7 Glasgow City
8 East Dunbartonshire
9 West Dunbartonshire
10 Renfrewshire
11 East Renfrewshire
12 Inverclyde

Glenacardoch
Point Machrie Whiting Bay Head of Ayr *Firth of Clyde*
Bay *Arran* Kildonan
Machrihanish Kilchenzie Kilmory
Bay Campbeltown
Machrihanish Stewarton

11 5°30 12 5° 13 4°30 **146** 14 4° 15

0 5 10 15 20 25 miles
0 5 10 15 20 25 km

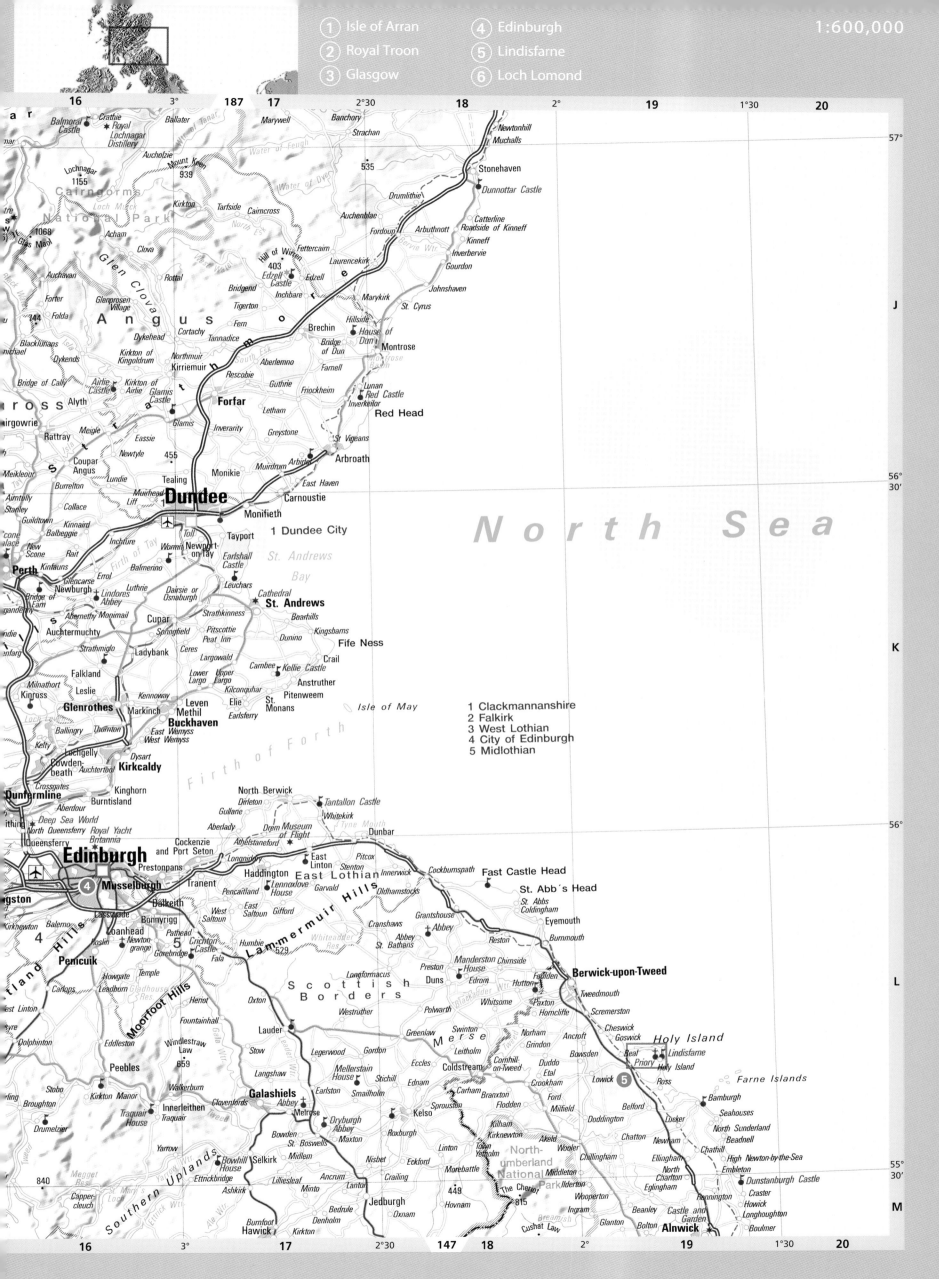

Isle of Arran

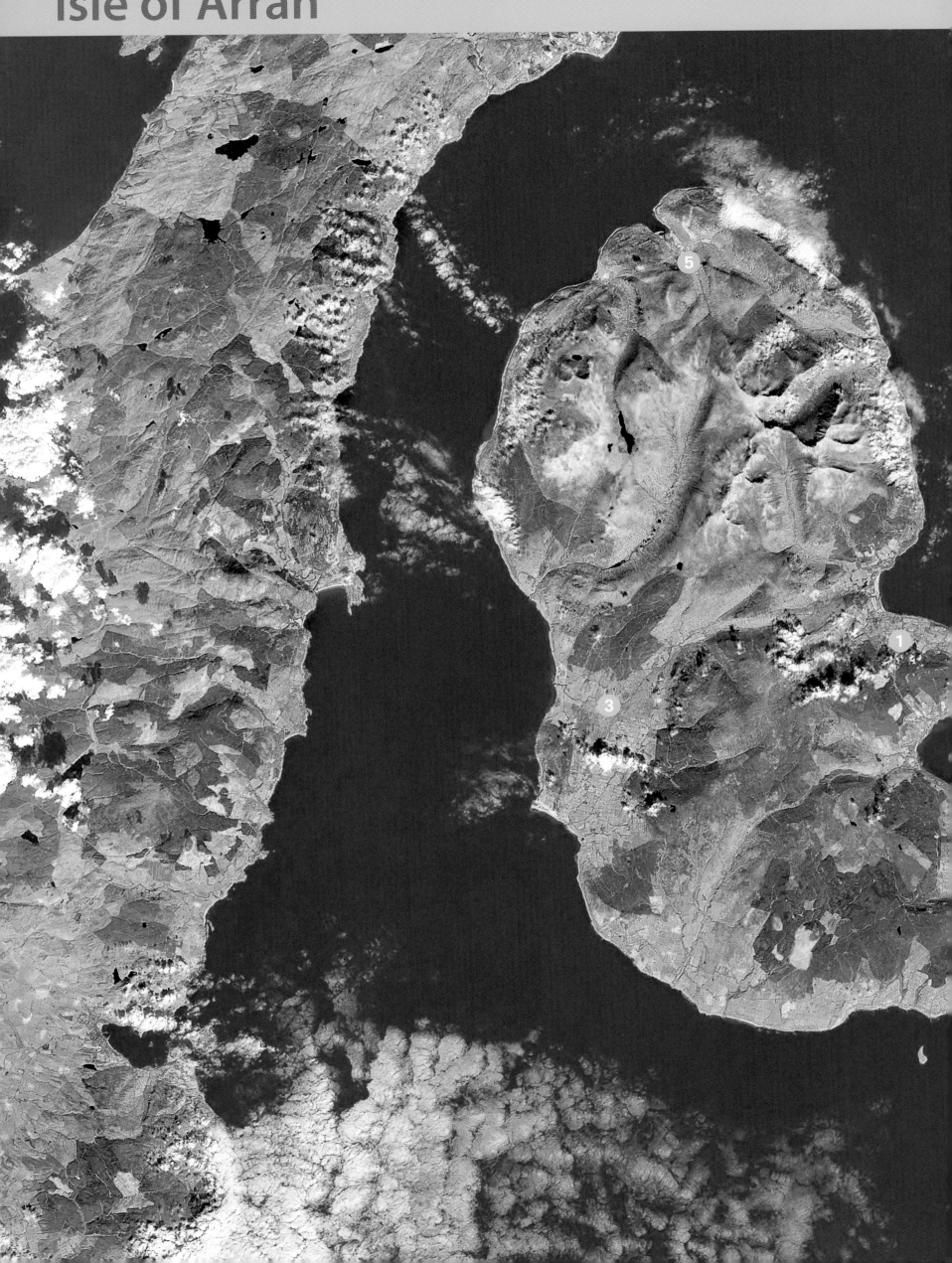

Isle of Arran

Arran is a mountainous island in the Firth of Clyde with an area of 432 sq km (167 sq miles) and a population of some 4,500. Its landscape of hills, streams, glens and lochs has been described as 'Scotland in miniature'. Its sheltered bays and sandy beaches make it a popular tourist destination. The most dramatic scenery is in the north: the top of Goat Fell looks over one of the best panoramic views in Scotland. Earlier settlers have left their mark on the island with stone circles and the remains of their huts and burial places. Across the water from Arran is the island of Bute which, despite a rocky coastline, has a fertile soil suitable for crop-growing and dairy farming.

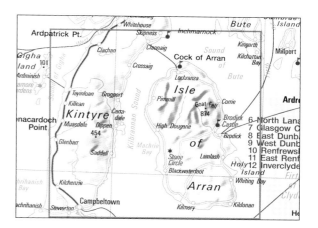

❶ Brodick ▽

Located on the east coat of Arran, Brodick is the island's main town, resort and port. A ferry service to Ardrossan links it with the mainland. The name derives from the Norse invaders who captured the site in the 9th century – Brodick means 'broad bay'.

The red sandstone bulk of Brodick Castle, the earliest part of which dates from the 13th century, commands the bay. Its defences were strengthened many times in the 16th and 17th centuries, but the biggest change came in the mid-19th century when it was transformed from a fortress into an opulent Victorian stately home. The Dukes of Hamilton were the owners of the castle from 1503, when James IV granted it to his cousin, Lord Hamilton later Earl of Arran, until 1957, when the Duchess of Montrose, the daughter of the 12th Duke died and it was bequeathed to the National Trust for Scotland.

Arran benefits from the Gulf Stream that gives it a mild climate – mild enough to grow palm trees in the castle's Edwardian-style garden. There is also an internationally famous collection of rhododendrons in the woodland garden, begun in 1923. Behind Brodick Castle rises Goat Fell, at 874m (2,866ft) the highest peak on Arran. Brodick village provides the island's main centre for shops and services and, behind the sandy beaches of the bay, protected by the dunes, is a fine 18-hole golf course in the classic Scottish links style. Just north of the village on the main road is the Arran Heritage Museum, where visitors can enjoy a picnic by the river before seeing demonstrations of horse-shoeing and other traditional crafts.

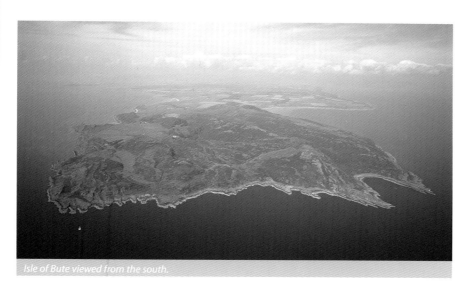
Isle of Bute viewed from the south.

❷ Isle of Bute △

Bute covers an area of 120 sq km (46 sq miles) and granite, red sandstone and slate are found on the island. The resort of Rothesay has sandy beaches, Winter Gardens and the ruins of a 13th-century castle that was destroyed by Oliver Cromwell. Mount Stuart, built in the late 19th century, lies south of Rothesay and is one of the seats of the Marquis of Bute. Its neo-Gothic architecture and art collection make it a popular excursion for visitors to the island. Tourism and agriculture are the backbone of the economy and there are ferry services connecting the island with the mainland and Arran. Bute is separated from the Cowal peninsula by a stretch of water called the Kyles of Bute. Cattle used to make the crossing by being forced to swim across the water.

❸ Standing Stones

Arran is well known for its fine collection of prehistoric standing stones. The most famous are the stone circles at Machrie, on the western side of the island, which include stone circles, single stones and hut circles dating from the Bronze Age around 2000 BC. Near Blackwaterfoot, also on the western side, are Bronze Age cairns. Just opposite the school in Brodick is a single standing stone by the side of the road. There is another stone in the forested area just south of the bridge over Glenrosa Water. Drumadoon Point is the site of an Iron Age fort.

Brodick Castle is surrounded by wonderful gardens and woodland walks.

❹ Lamlash Bay

Lamlash Bay on the east side of the island is a centre for yachting. It is protected by Holy Island, the site of a hermit's cell – St Molais's Cave – dating from the 6th century.

❺ Lochranza

Arran has a connection with Robert I (1274-1329), often known as Robert the Bruce who, after the uprising which ended in the execution of William Wallace, headed another rebellion against the English king, Edward I. He landed at Lochranza on what was called 'the loch of safe anchorage' from Ireland in 1306 and was crowned King of Scotland at Scone the same year. He sheltered in caverns near Blackwaterfoot, which are known as the King's Caves.

Royal Troon Golf Club

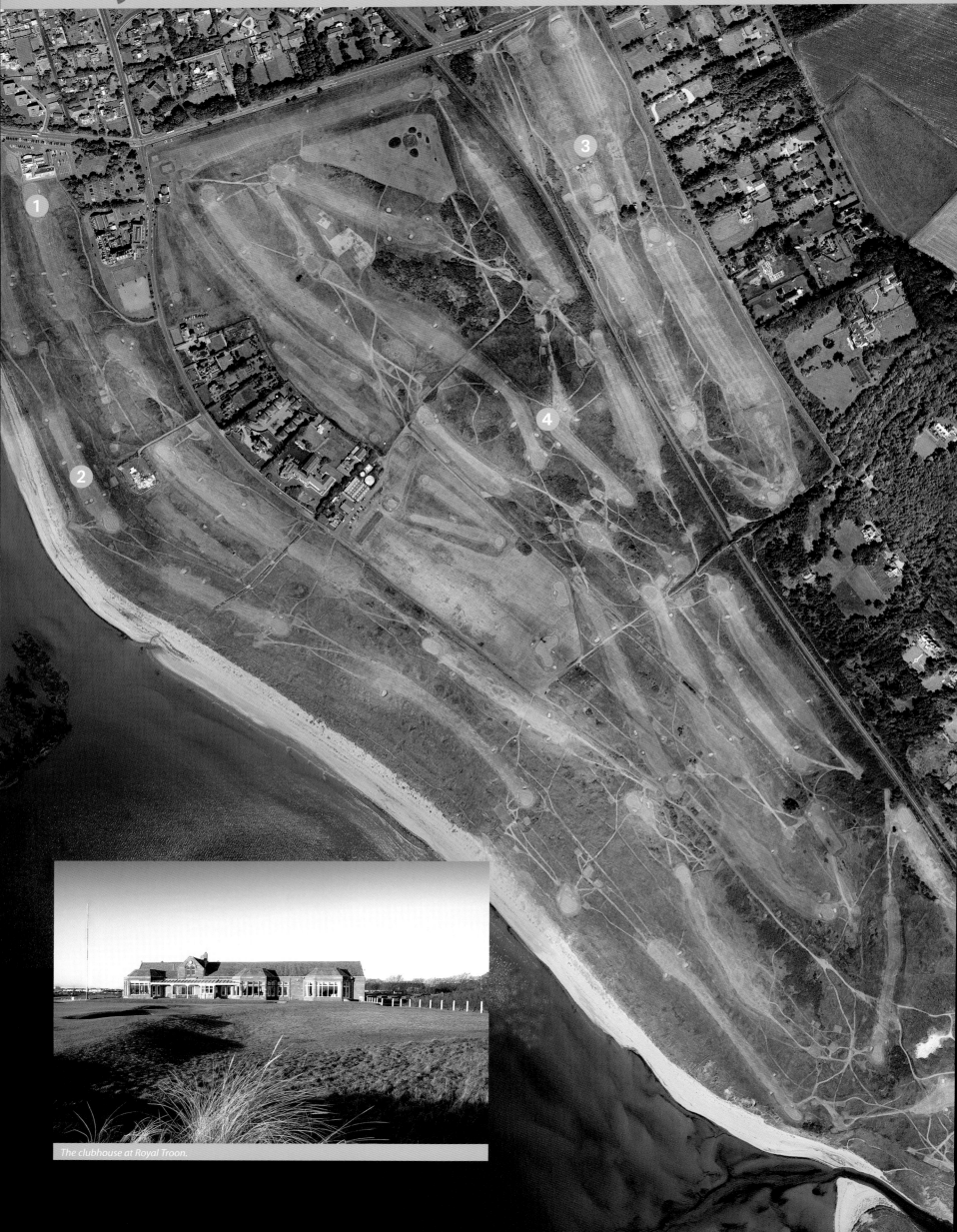

The clubhouse at Royal Troon.

Royal Troon Golf Club

Golfers rate the windswept, undulating Old Course at the Royal Troon Golf Club as one of the best in the world. The celebrated British Open Championship has been held on the course eight times. Famous professionals such as Seve Ballesteros, Nick Faldo and Ian Poulter have played here. The Club, which has two other courses, lies to the south of the Ayrshire coastal resort of Troon. The town was at one time a coal port and shipyard, and more recently a marina and a base for ferry operations to Northern Ireland.

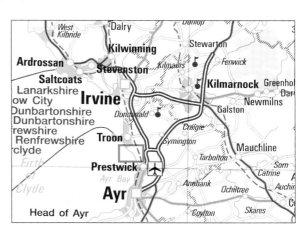

① Clubhouse

A group of 24 golf enthusiasts founded the Troon Golf Club on 16 March 1878. The first course, laid out by 1880, had just six holes but by 1888 an 18-hole course 1,950m (2,125yds) long had been completed. The first clubhouse was no more than a converted railway carriage, but this was replaced in the late 1870s with a small wooden building. The present clubhouse was begun in 1886, and the Smoke Room and the Dining Room were added in the early 20th century. In 1978, the Club's centenary year, Troon Golf Club received its royal charter.

The 8th hole is known as the Postage Stamp.

② Old Course

The Old Course measures 6,470m (7,079yds) of uneven country overlooking the waters of Ayr Bay; the prevailing northwesterly wind is a particular threat on the second half of the 18-hole course. The most celebrated hole is the par-3 eighth, known as the Postage Stamp because, when viewed from the tee, the green – only 7.5m (25ft) across at its widest point – looks no larger than a stamp. The Postage Stamp is also the shortest hole on any Open Championship course, measuring just 115m (126yds) in length.

The British Open Championship was first held on the Old Course in 1923. The Ladies British Open Amateur Championship was first held at Troon in 1904. Arnold Palmer won the Championship in 1962.

③ Par-3 Course

This course, consisting of nine holes, provides a series of challenges. It is mainly used by older and junior players and is 1,080m (1,191yds) in length.

④ Portland Course

The Portland, initially known as the Relief Course, was opened in June 1895 when Willie Fernie was the club's professional. In 1924, its name was changed to the Portland Course. The Portland is more sheltered than the Old Course and shorter, measuring about 5,751m (6,289yds). Running across moorland terrain with broom and gorse, it has five Par-3 holes and four more demanding Par-5s. In 1979, the qualifying rounds for the European Open Championship were held here.

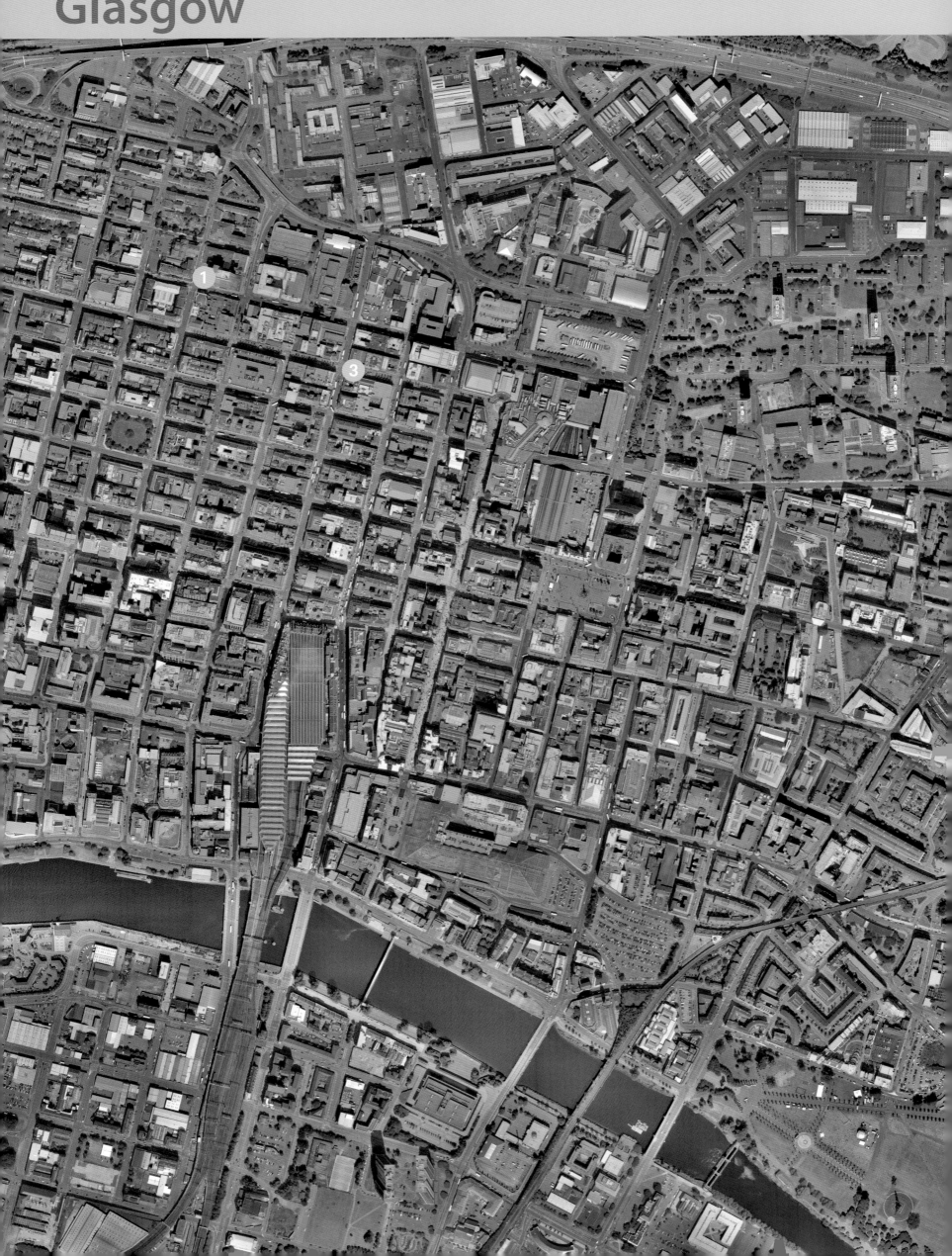

Glasgow

Glasgow has come a long way from its beginnings as a small fishing village on the River Clyde to its present-day position as the largest city in Scotland, a centre of culture, and winner of the 1990 European City of Culture award. Though little of the mediaeval city remains, the cityscape is coloured by its past as a centre for shipbuilding, textiles and the coal and steel industries. The 19th century brought poverty and overcrowding, but also grand public architecture, and art collections that were amassed by the wealthy. The city today has a reputation as a centre for entertainment and the arts.

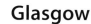

① Charles Rennie Mackintosh buildings ▽

A Glaswegian by birth, architect and artist Charles Rennie Mackintosh's early 20th century Art Nouveau buildings, furniture and interiors impart a minimalist elegance. He was involved in designing a chain of tea rooms as part of an unsuccessful campaign to fight drunkenness in the city. An outstanding example is the Willow Tea Rooms on Sauchiehall Street, with an opulent Salle de Luxe decorated in silver and white on the first floor. The Glasgow School of Art on Renfrew Street is perhaps his best-known larger building; it has an imposing exterior as well as many examples of his furniture inside its grand library. An overview of Mackintosh's unique and innovative style can be seen in the Mackintosh House at the Hunterian Art Gallery, part of the University of Glasgow.

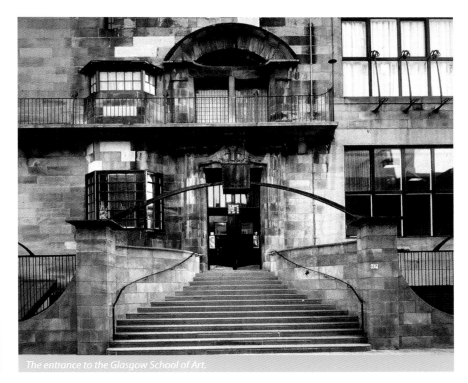
The entrance to the Glasgow School of Art.

② St Mungo's Cathedral ▷

Glasgow Cathedral is built on the site that is believed to have been that of a 6th-century church established by the city's founder and patron saint, St Kentigern – who was baptised as 'Mungo' or 'dear one'. The present cathedral was consecrated in 1197, and building was completed in the early 16th century to replace an earlier cathedral that was destroyed by fire.

In 1560, Archbishop James Beaton, Mary Queen of Scots' ambassador to France and one of her staunchest allies, fled to France to escape the Reformation, saving many relics and artefacts. Though the cathedral did not escape damage completely during the Reformation it was repaired by voluntary subscription in 1574, and has been restored over the centuries. The church was Catholic until the Reformation and then Episcopalian, becoming Presbyterian in 1689. Remarkable interior features include the Laigh Kirk (lower church), whose fine Gothic crypt holds St Mungo's tomb, and the 15th-century nave, which is divided by a stone choir screen.

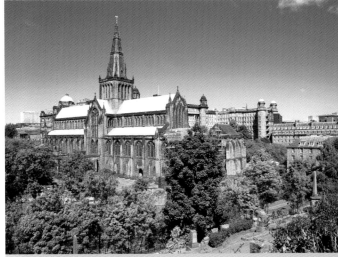
The Cathedral was rebuilt after a fire in the sixteenth century.

③ Sauchiehall Street

With a name derived from the Gaelic words for willow (saugh) and meadow (haugh), Sauchiehall Street has a long history as Glasgow's most popular and famous thoroughfare. Running from Buchanan Street to Charing Cross, it was originally a winding lane. In the 19th century it was widened and straightened to become the location for the finest city shops and, in later years, home to the Regal, La Scala and Gaumont cinemas, and the Locarno Ballroom. The few older businesses that remain include the Willow Tea Rooms, designed by Charles Rennie Mackintosh and the Watt Brothers department store.

④ Provand's Lordship

Provand's Lordship was built in 1471 as part of St Nicholas's Hospital, although its name comes from the 19th century when it was the home of the Lord of Provand. It is the oldest surviving house in Glasgow and a rare example of pre-Reformation domestic building. Unlike its contemporary near neighbour, St Mungo's Cathedral, it has a simple 'random rubble' exterior with no artistic pretensions. Mary, Queen of Scots is believed to have stayed there when visiting Glasgow in 1566, and over the years it has been a bishop's manse, an alehouse and a sweetshop. It is now a museum maintained by the City Council, who renovated the building in 1983 and subsequently restored the original St Nicholas physic garden behind the house. The three-storey museum has a fine collection of Scottish furniture and mediaeval artefacts.

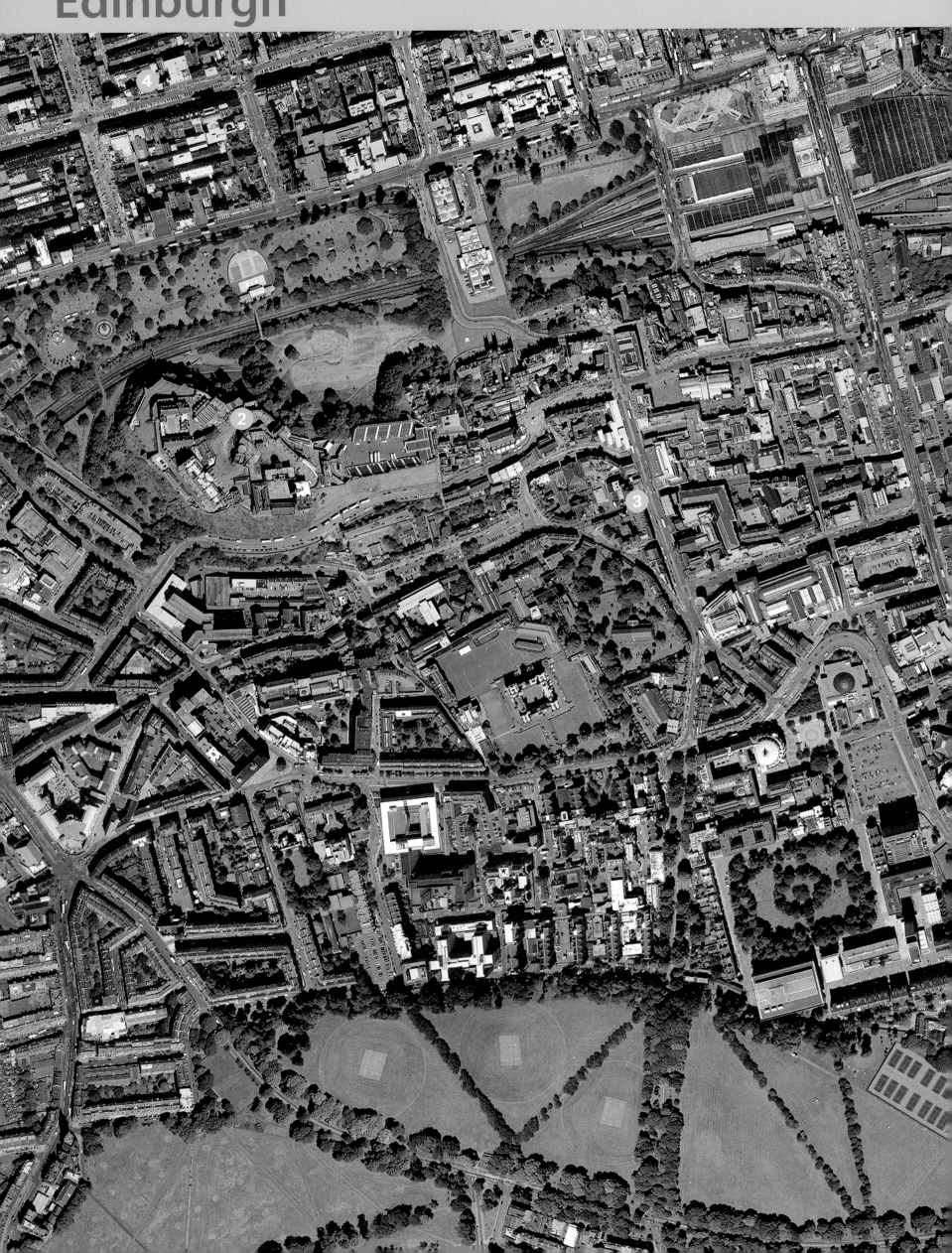

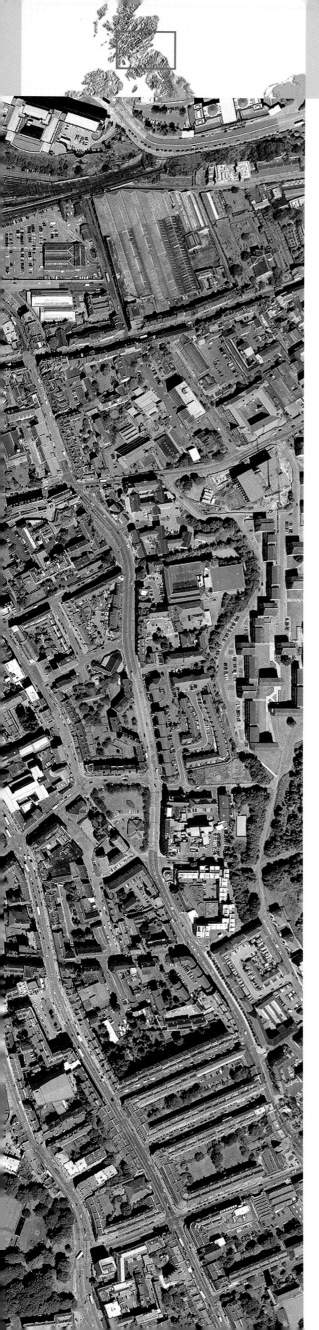

Edinburgh

The capital and second-largest city in Scotland, Edinburgh evolved in the Dark Ages around the nucleus of the naturally fortified Castle Rock to become the capital of the nation that unified Lowland Anglo-Saxons and Britons with the Celts of the Highlands and Islands. Its magnificent architectural heritage and distinguished intellectual history led to it being called the 'Athens of the North' and, along with its museums and world-renowned summer festival, the city continues to be a magnet for visitors today.

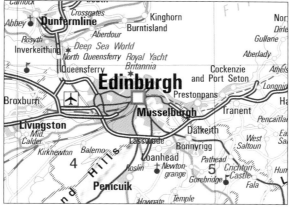

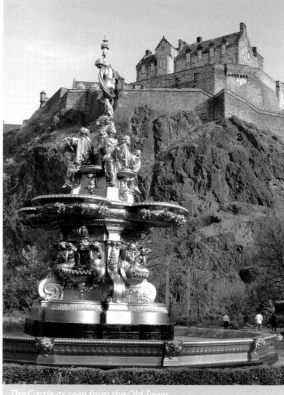

❶ Royal Mile

The Royal Mile is the straight road – made up of the High Street and its continuation, Canongate – that slopes down from the Castle at one end to the Royal Palace of Holyroodhouse at the other. The route as a whole forms the northern boundary of Edinburgh's Old Town. Part way along the High Street is St Giles's Cathedral, founded in the 12th century. The combination of royal power, military might and the city's cathedral made the Royal Mile the ceremonial and processional artery of Edinburgh during its centuries as the capital of an independent Scotland.

The Scottish Parliament ▽

Today's Scottish Parliament is descended from the Estates of Scotland, the Scottish national legislature from the early 13th century until its fusion with the English Parliament at Westminster following the Act of Union in 1707. A referendum in 1997 and the Scotland Act of 1998 permitted the formation of the *Pàrlamaid na h-Alba*, as it is known in Gaelic, which passes laws on 'devolved matters' such as education, health, agriculture and justice. The 129 members are elected for four years and meet in a bold new building designed by Catalan architect Enric Miralles.

The Castle as seen from the Old Town.

❷ Edinburgh Castle △

The great plug of volcanic rock that dominates the city of Edinburgh has been fortified since prehistoric times. The oldest surviving building on it is probably the 12th-century St Margaret's Chapel. James VI (later James I of England) was born in the castle in 1566. Between 1757 and 1814 thousands of prisoners of war were held in the castle. Those incarcerated were captured during the Seven Years War, the War of American Independence, the French Revolutionary Wars and the Napoleonic Wars.

❸ Old Town

To the east and south of the castle lies Edinburgh's Old Town. This is the mediaeval city that, alongside the markets and the famous multi-storeyed tenements, also included the Palace of Holyroodhouse, Parliament House (home of parliament in the 17th century), Edinburgh University and St Giles's Cathedral.

❹ New Town

As the Old Town became more crowded, suggestions were made to build a spacious new urban centre on the north side of the castle. James Craig laid out the master plan in 1766 and the individual buildings were constructed over the next 30 years by architects such as Robert Adam and William Chambers.

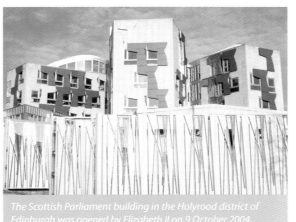

The Scottish Parliament building in the Holyrood district of Edinburgh was opened by Elizabeth II on 9 October 2004.

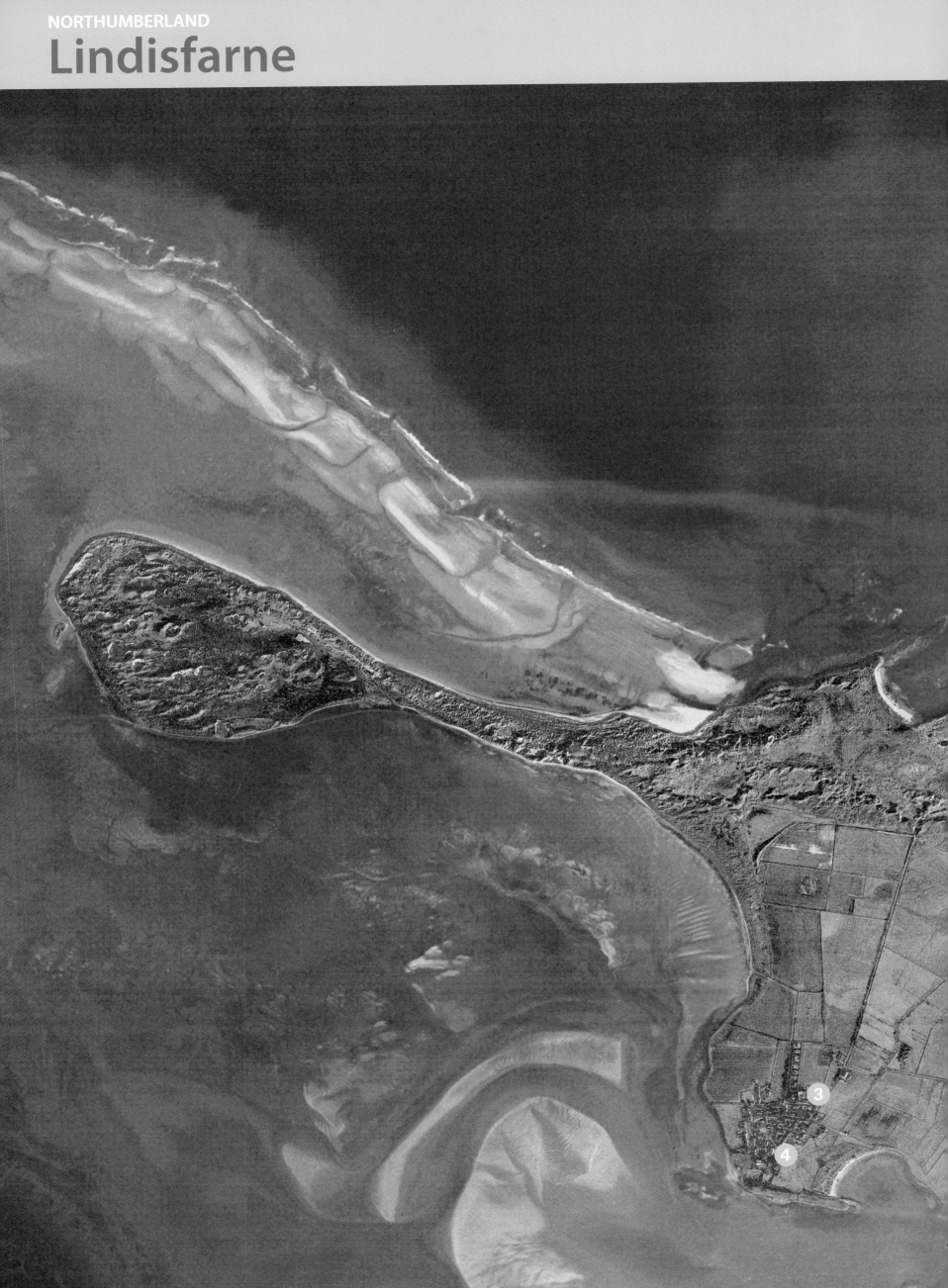

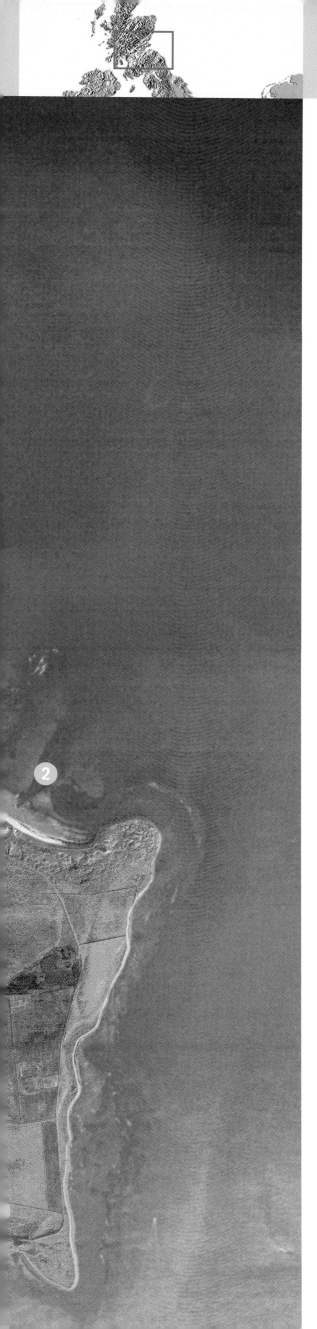

Lindisfarne

Also known as Holy Island, Lindisfarne is the largest of the Farne Islands off the coast of Northumberland. It is only an island part of the time: at low tide a causeway built on a sandy spit connects it to the mainland. Isolated, but not too remote, it was an ideal place to build a monastery and became not only a place of retreat, but one of the spiritual powerhouses of Dark Age Britain, from which missionaries spread out to convert the Anglo-Saxons on the mainland to Christianity.

1 Castle ▽

A timber and earth defensive structure was built on the island's most prominent outcrop of rock between 1548 and 1549, then rebuilt in stone in 1565 to 1571. It was held by Parliament during the Civil War, but the small garrison was finally removed in 1819, after which the castle was abandoned and became derelict. In 1901 it was bought by Edward Hudson, the owner of *Country Life* magazine, and he commissioned the architect Edwin Lutyens to renovate and redesign it as an intimate, domestically scaled retreat. The rooms are mostly small, with low, sometimes vaulted ceilings. The stonework is plain and massive, and the heavy, dark wooden furniture is largely 17th century, or in a similar style. A garden, laid out by the famous garden designer Gertrude Jekyll, is intended to be at its peak in high summer. In 1944 the castle was given to the National Trust, and today is open to the public.

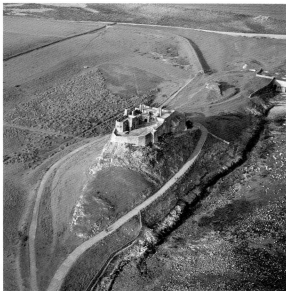

The castle was rebuilt by Edwin Lutyens in 1903.

2 Wildlife

The tidal sand flats around the island make it an important staging post for birds migrating north and south, particularly waders. Arctic and common terns are also seen, and among resident birds the eider duck, an emblem of St Cuthbert, is found here near the southern limit of its range. The dunes and marshes – which are concentrated on the northern shore, away from the main area of settlement – also support some rare plant life, including orchids such as the Northern Marsh Orchid, cord grass, eel grass, and marram grass. This area is now protected by English Nature as one of its National Nature Reserves.

3 Island History

The meaning of the island's original name, Lindisfarne, is uncertain, but most probably combines the Celtic words for stream or pool (perhaps referring to the nearby River Low or to the island's own small lake) and for land (*farran*). The first recorded mention of the island was in 635 when King Oswald of Northumbria granted Lindisfarne to St Aidan, the Irish monk who had come from Iona at Oswald's request to evangelise his people. The monastery Aidan founded became famous as the spiritual home of northern England's most beloved saint, Cuthbert, from 664 to 676. In the 8th century the cult of St Cuthbert made it a rich and sophisticated monastery and this drew the attention of the Vikings, who made the first recorded attack on the British Isles here in 793. Shortly afterwards the monastery was abandoned, and not re-established until the early 12th century; there is no record of the island being inhabited between those times. In the 1540s, Lindisfarne's position near the Scottish border, and the sheltered harbour on its southern side, made it an important English defence.

4 Priory

The ruins that can be seen today are of the mediaeval priory that work began on in around 1130. By the time it was completed in around 1200, it was home to a community of about a dozen monks. It was also at this time that the island was first called *Insula Sacra*, or Holy Island. The priory – built on the same site as the remains of the smaller 8th-century monastery – was an outpost of Durham Cathedral, and its church may have been designed as a miniature replica. The famous Lindisfarne Gospels, produced at this time, are preserved in the British Library in London. In the mid-14th century political tensions led to the fortification of the priory. War, bad harvests, and the Black Death cut its income severely and, by 1400, the much smaller community had abandoned some of the buildings, taking up residence in the prior's lodging. In 1537 the dissolution of the monasteries saw the priory closed, its buildings being used as storehouses. By the early 17th century the lead had been stripped from the roof.

Overleaf: a ribbon of islands stretches across Loch Lomond.

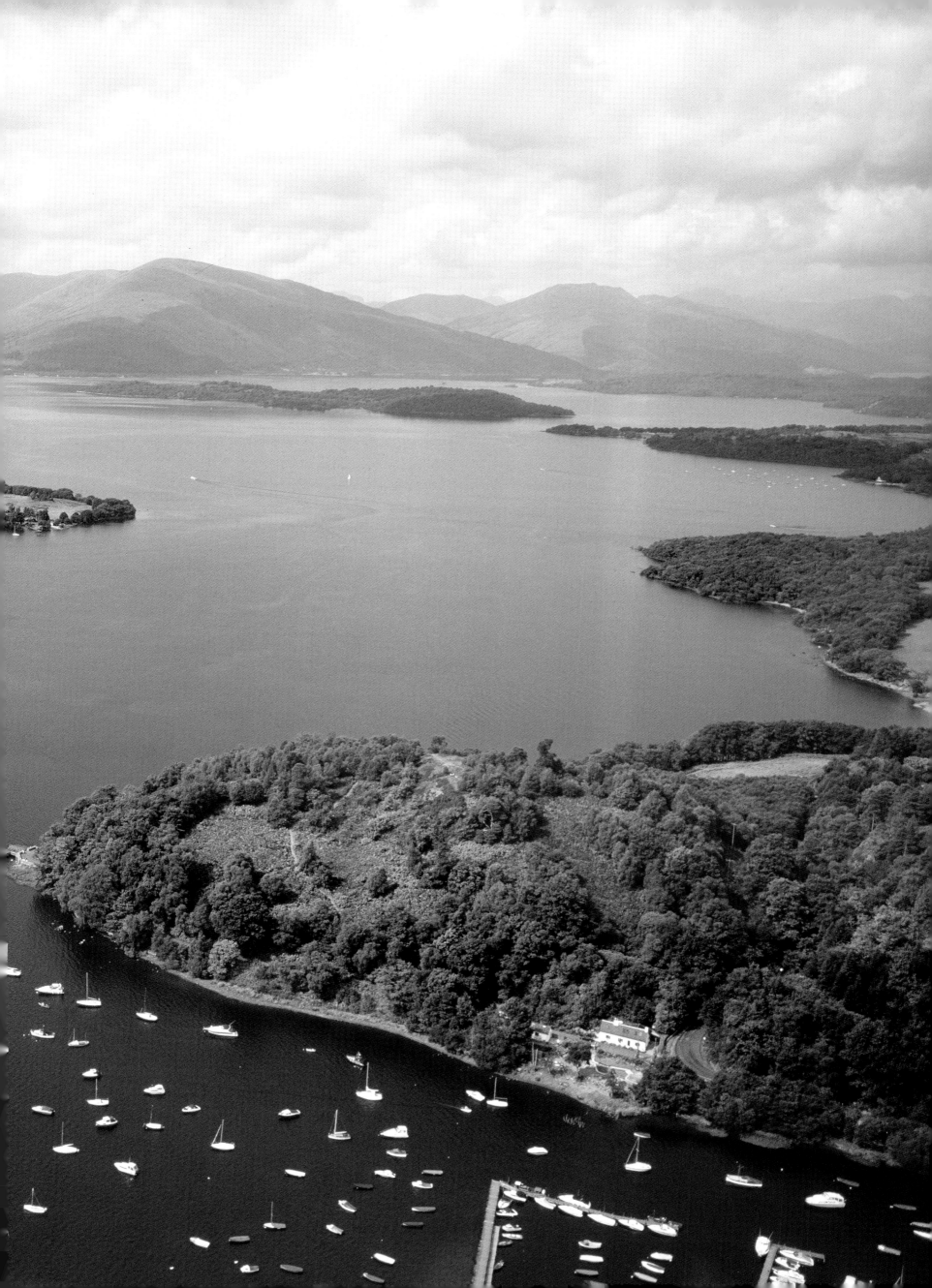

THE HEBRIDES

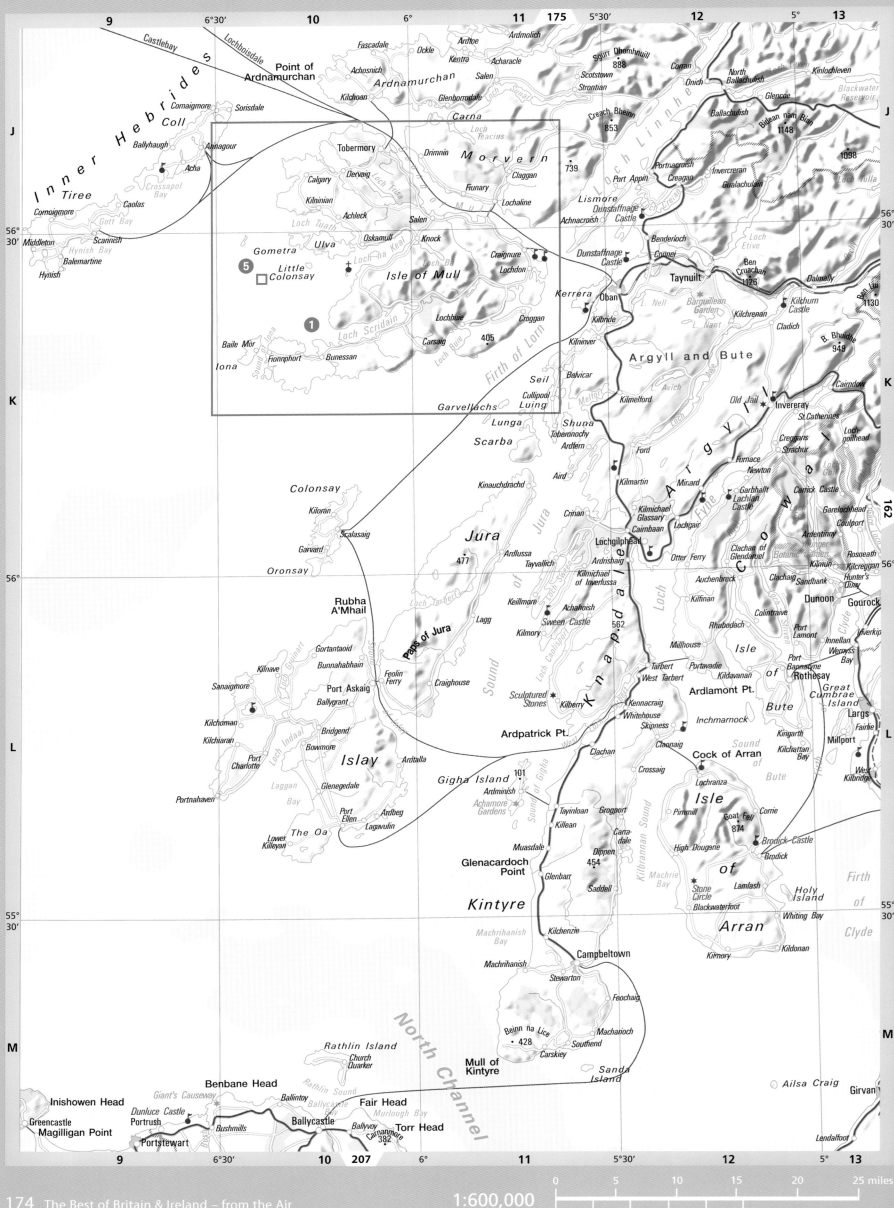

1:600,000

| 0 | 5 | 10 | 15 | 20 | 25 miles |
| 0 | 5 | 10 | 15 | 20 | 25 km |

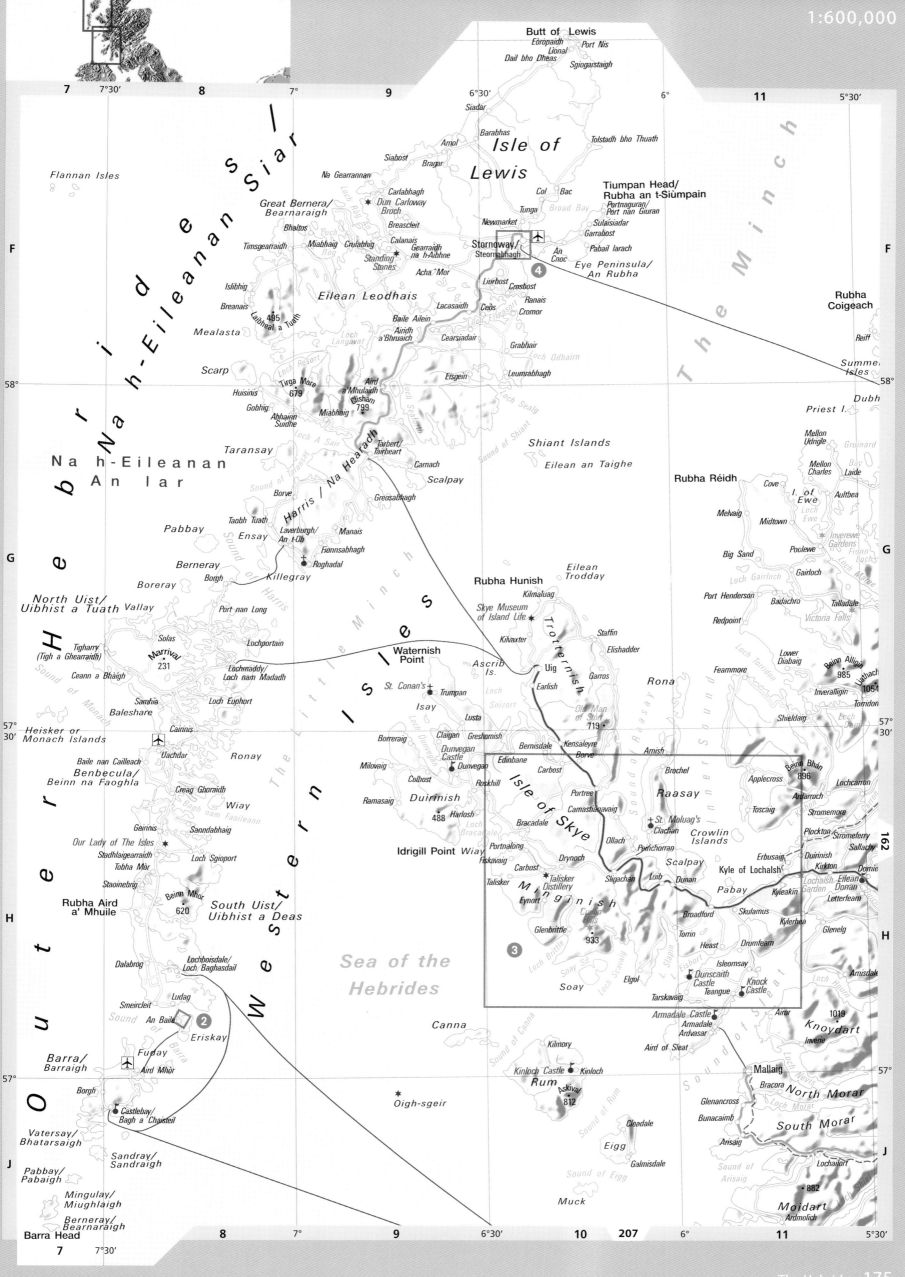

Butt of Lewis
Eòropaidh
Lional Port Nis
Dail bho Dheas
Sgiogarstaigh

Isle of
Lewis

Siadar
Barabhas Tolstadh bho Thuath
Arnol
Bragar

Na Gearrannan

Siabost

Tiumpan Head/
Rubha an t-Siùmpain
Portnaguran/
Port nan Giuran
Garrabost

Col Bac
Tunga

Great Bernera/
Bearnaraigh
Carlabhagh
Dùn Carloway
Broch

Breascleit
Calanais

Newmarket
Stornoway/
Steòrnabhagh
An Cnoc
Pabail Iarach

Eye Peninsula/
An Rubha

Flannan Isles

Bhaltos
Timsgearraidh Miabhaig Crulabhig
Standing
Stones
Gearraidh
na h-Aibhne
Acha´ Mor

Liùrbost
Crosbost
Ranais
Cromor

Islibhig
Breanais
Mealasta Laibheal a Tuath
485

Eilean Leodhais

Lacasaidh
Ceòs

Grabhair
Loch Odhairn

Rubha
Coigeach

Reiff

Scarp

Tirga More
679
a´Mhulaidh
Clisham
799
Miabhaig

Eisgein
Leumrabhagh

Summer
Isles

Huisinis
Gobhig Abhainn
Suidhe

Taransay
Aird
a´Mhulaidh

Shiant Islands
Eilean an Taighe

Dubh
Priest I.

Taobh Tuath Tarbert/
Tairbeart
Carnach
Scalpay

Mellon
Udrigle
Mellon
Charles Laide

Rubha Réidh
Cove I. of
Ewe Aultbea

Borve Harris / Na Hearadh
Greosabhagh

Pabbay Taobh Tuath
Ensay Laverburgh/
An t-Ob
Manais
Fionnsabhagh Roghadal

Melvaig
Midtown

Big Sand
Poolewe
Inverewe
Gardens

Berneray Borgh Killegray
North Uist/
Uibhist a Tuath
Boreray Valley

Rubha Hunish Eilean
Trodday

Skye Museum
of Island Life
Kilmaluag

Kilvaxter

Port Henderson
Badachro Talladale
Victoria Falls

Redpoint

Lower
Diabaig

Beinn Alligin
985 Liathach
1054

Tigharry
(Tigh a Ghearraidh)
Ceann a Bhàigh
Solas
Marrival
231
Lochportain
Lochmaddy/
Loch nam Madadh

Waternish
Point

Staffin
Elishadder
Garros

Fearnmore Inveralligin
Torridon

Shieldaig

Heisker or
Monach Islands
Samhla
Baleshare Loch Euphort
Cairinis

Ronay

St. Conan´s
Isay Trumpan
Ascrib
Is.
Uig
Earlish Trotternish

Old Man
of Storr
719

Rona

Baile nan Cailleach
Benbecula/
Beinn na Faoghla
Uachdar

Borreraig Greshornish
Claigan
Dunvegan
Castle
Dunvegan Bernisdale
Edinbane Kensaleyre
Borve
Carbost

Arnish

Brochel Applecross
Beinn Bhàn
896
Lochcarron

Creag Ghoraidh
Wiay Milovaig
Colbost
Roskhill

Portree

Raasay
Toscaig

Ardarroch
Stromemore

Plockton Stromeferry
Sallachy

Geirinis
Sanndabhaig Ramasaig
Duirinish
Harlosh
488

Camastianavaig
St. Moluag´s
Clachan

Crowlin
Islands

Erbusaig Duirinish
Kirkton
Kyle of Lochalsh
Lochalsh Garden Eilean
Donan
Domie

Our Lady of The Isles
Stadhlaigearraidh
Tobha Mòr Loch Sgioport
Portnalong Ollach
Bracadale Isle of Skye
Drynoch
Sligachan Ponchorran
Scalpay
Luib Dunan
Pabay Kyleakin Letterfearn

Staoinebrig Beinn Mhor
620 Idrigill Point Wiay
Fiskavaig
Carbost Talisker
Distillery
Eynort Minginish
Cuillin
Hills Broadford
Torrin Skulamus
Heast Drumfearn
Kylerhea Glenelg

Rubha Aird
a´ Mhuile
South Uist/
Uibhist a Deas
Talisker
Glenbrittle
933

Sea of the
Hebrides

Dalabrog Lochboisdale/
Loch Baghasdail

Soay Sd.
Elgol
L. Slapin Isleornsay
Dunscaith
Castle
Teangue
Knock
Castle Amisdale

Smeircleit Ludag
An Baile
Eriskay Soay
Tarskavaig

Armadale Castle
Armadale
Ardvasar Airor
1019
Invere

Knoydart

Barra/
Barraigh
Fuday
Aird Mhòr

Canna Aird of Sleat

Mallaig

Bracora North Morar

Borgh

Castlebay
Bagh a Chaisteil
Vatersay/
Bhatarsaigh Oigh-sgeir

Kilmory
Kinloch Castle Kinloch
Rum
Askival
812

Glenancross
Bunacaimb
South Morar

Pabbay/
Pabaigh
Sandray/
Sandraigh
Cleadale
Eigg Arisaig

Mingulay/
Miughlaigh
Berneray/
Bearnaraigh
Barra Head Muck
Galmisdale

882
Moidart
Ardmolich

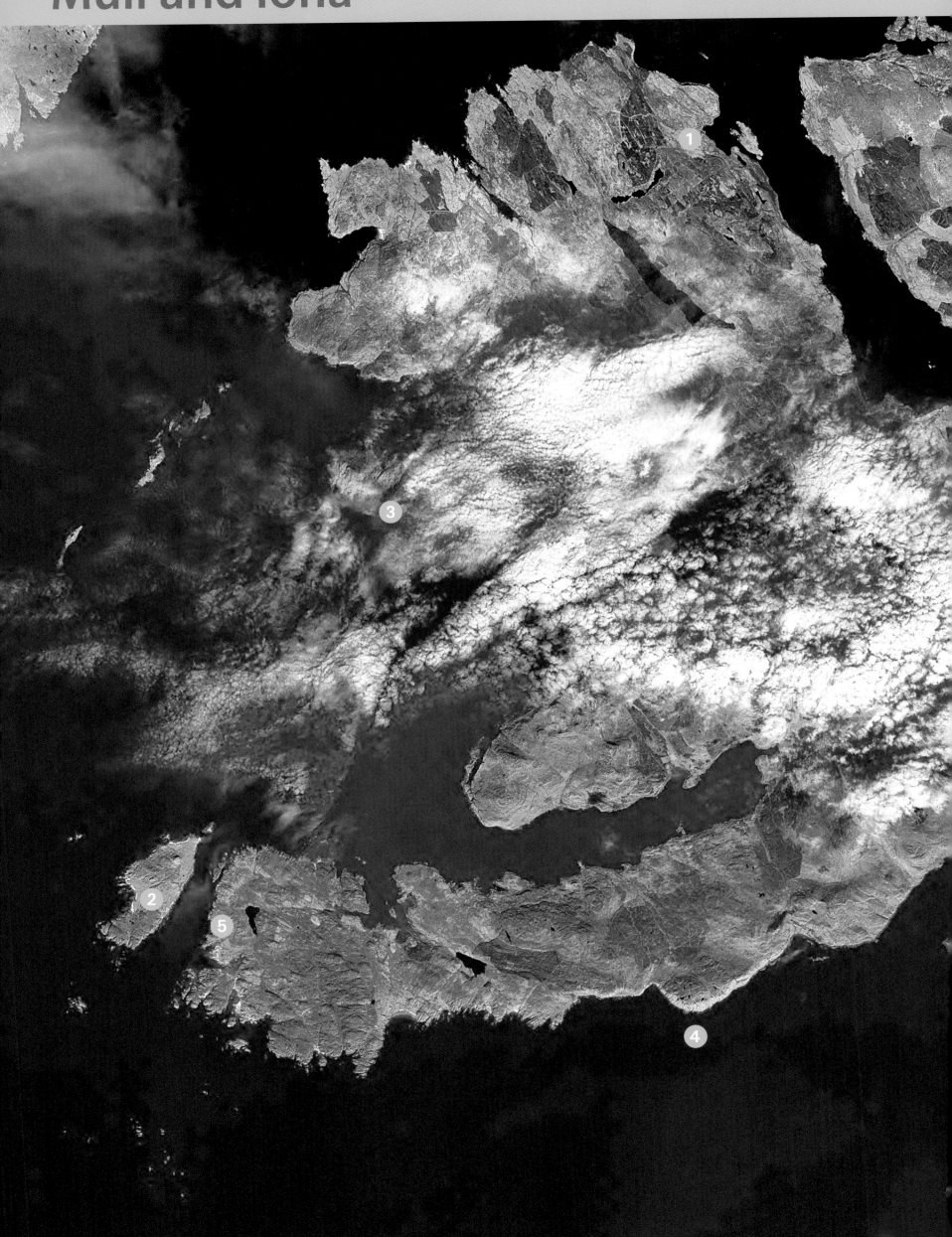

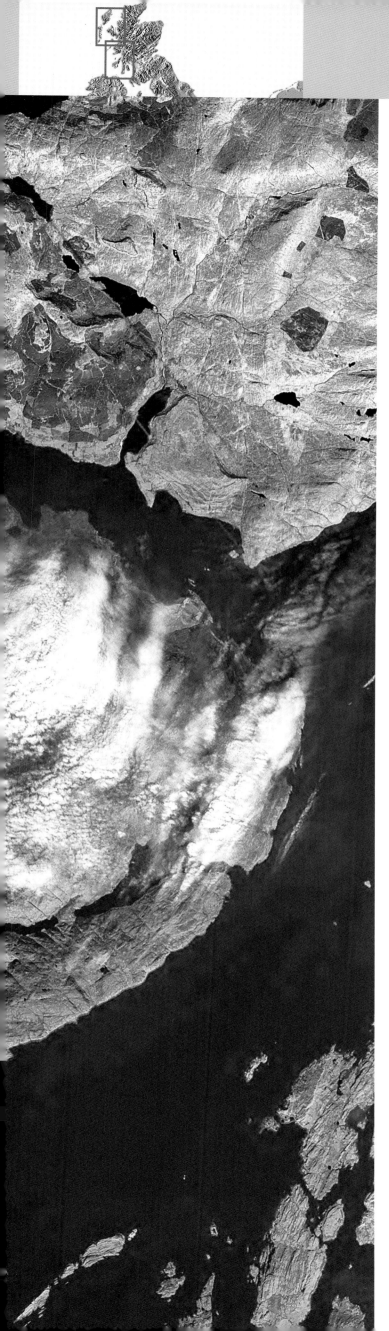

Mull and Iona

The tiny island of Iona, covering a mere 877 hectares (2,160 acres) in the Inner Hebrides, was the site of a monastery founded by St Columba in AD 563 as part of his mission to convert pagan Scotland to Christianity. It became an important Christian centre,

a place of learning and pilgrimage, and was also the burial place of 60 Scottish, Irish and Norwegian kings. By contrast, Iona's neighbour, the Isle of Mull, covers an area of 875 sq km (338 sq miles) – a beautiful landscape that includes mountains, waterfalls, forests, sea lochs and beaches. Mull has one of the best ferry services in the Scottish islands.

① Tobermory

Tobermory is the capital and fishing port of Mull, its harbour lined with brightly painted houses. A centre for yachting and diving, Tobermory played a small part in the rout of the Spanish Armada. A galleon, the *Florida*, took refuge in the bay in 1588 and was blown up by the local inhabitants. During the summer months, boat trips for viewing wildlife or sea fishing take place daily from the town. There are local walks and a museum, as well as a multimedia exhibition at the Hebridean Whale and Dolphin Trust.

Iona's beaches offer spectacular views.

② Iona △

The isle of Iona can be reached by ferry from Fionnphort on Mull. Its place is secured in history by the presence of St Columba who, paradoxically, went there as an act of self-imposed penance for causing a battle in his home in Ireland. Iona was the first place that he landed from which he was unable to see his homeland. He founded a community there which became famous for its scholarship and craftmanship: the early 9th-century manuscript of the *Book of Kells* – now in Trinity College, Dublin – bears witness to this. The community suffered attacks from Viking raiders, but survived as a Benedictine abbey until the Reformation. Restoration began again in 1899. The former British Labour party leader John Smith, who died unexpectedly of a heart attack in 1994, is buried on the island.

③ Ulva

The island of Ulva off the west coast of Mull can be reached from there by ferry. Ulva has had a procession of distinguished visitors over the past two centuries, including Samuel Johnson and his biographer and friend, James Boswell, who came there to inspect Ulva's caves and basalt cliffs in 1773. The missionary explorer, David Livingstone (1813-73) often referred to his ancestors who originally came from Ulva.

④ Carsaig Arches

The Carsaig Arches, on the southern coast of Mull, form a fitting climax to one of the most spectacular coastal walks in Britain. Created as a result of volcanic activity from long ago, the cliffs are a form of living geology with the two arches demonstrating the eroding power of the sea. One is a huge tunnel, the floor of which is covered in boulders that have been ground ever smoother as the ocean rolls over them. The other is a tower some 35m (114ft) high which is pierced by a keyhole-shaped arch. The paths on this coast are exposed and vertiginous but well worth visiting: colonies of kittiwakes and fulmars nest here in the spring and the cliffs are home to eagles and goats.

⑤ Fionnphort

Situated on the southwestern peninsula of Mull, known as the Ross of Mull, the village of Fionnphort is a busy ferry port serving Iona and the island of Staffa. Tourism plays an important part in the local economy together with fishing and agriculture. The distinctive pink and red granite quarried there has been exported worldwide.

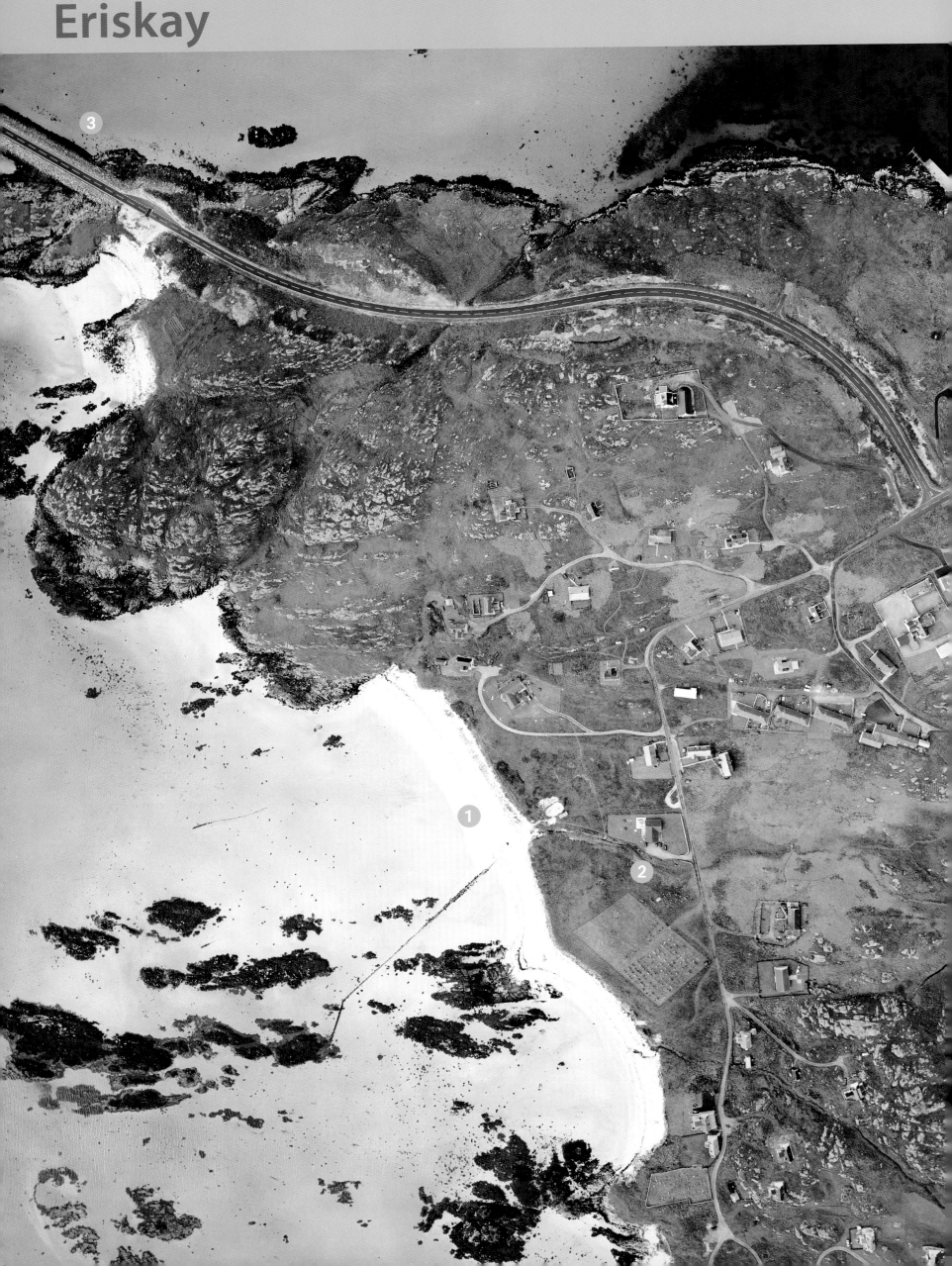

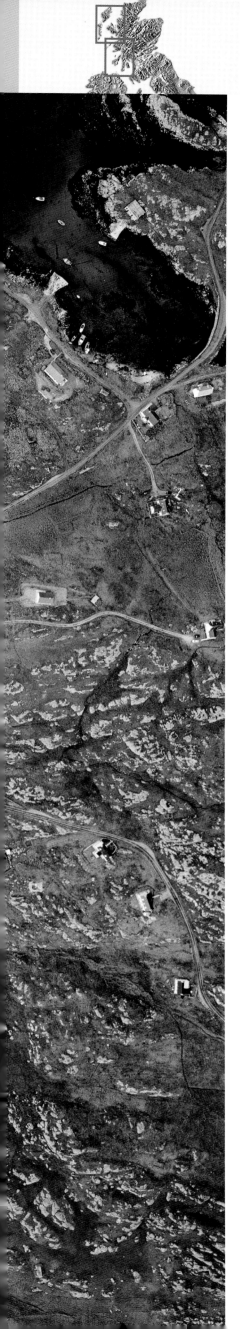

Eriskay

The island of Eriskay is located at the southern tip of South Uist, named after the Norse *Eirisgeidh* meaning 'Eric's Isle'. In Gaelic it is also referred to as *Eilean na h-Oige*, or the 'Isle of Youth'. Unfortunately, even though a causeway now links the island with the nearest mainland, the island's population has continued to decline since the 2001 census. The present population is now fewer than 180.

① Prince Charlie's Bay

In July 1745, Prince Charles Edward Stuart, better known as Bonnie Prince Charlie, landed on Eriskay in a small boat from the French ship *Du Teillay*. Now named *Coilleag a Phrionnsa*, which translates roughly as 'the prince's cockleshell strand', the white sand beach on which he landed features a white-striped pink sea bindweed not found anywhere else in the Hebridean islands. It is believed that seeds from this plant, gathered during his exile in France, fell from the Prince's handkerchief as he crossed the sands. From Eriskay he moved to the mainland and then south to England. His campaign ended with defeat at the bloody Battle of Culloden in 1746.

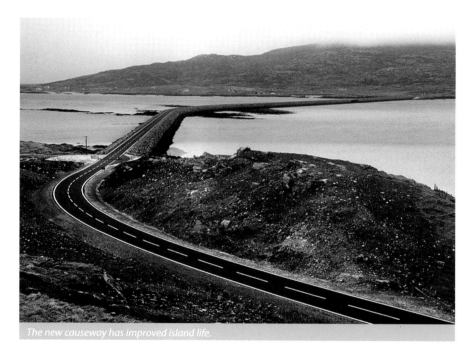

The new causeway has improved island life.

② Am Politician ▷

Eriskay's only public house, the Am Politician, is named after the SS *Politician* that struck rocks off the northeastern coast of the island in February 1941. En route to New York, the cargo contained 264,000 bottles of Scotch whisky. After the crew was saved, it is believed that over 2,000 cases were salvaged from the wreck before the authorities arrived. Compton Mackenzie's best-selling novel *Whisky Galore* was based on this story, as was the subsequent film made in 1949. Local rumours suggest that bottles can still be found from time to time, washed up on the shore or discovered in long-forgotten hiding places.

The sign of the only public house on Eriskay.

Ann Baile, a tiny settlement near Haunn.

③ The Causeway

At the time of its construction, between 2000 and 2001, the causeway linking Eriskay to South Uist was the largest civil engineering project in the United Kingdom. The geology of the local area helped to provide materials for the foundation and protective layering of the roadway – gneiss from the quarries of South Uist and Eriskay itself. The new road ended the isolation of the island community; it is the latest in a series of causeways built between the other Western islands linking all the way to North Uist with its many prehistoric sites 217km (135 miles) further north.

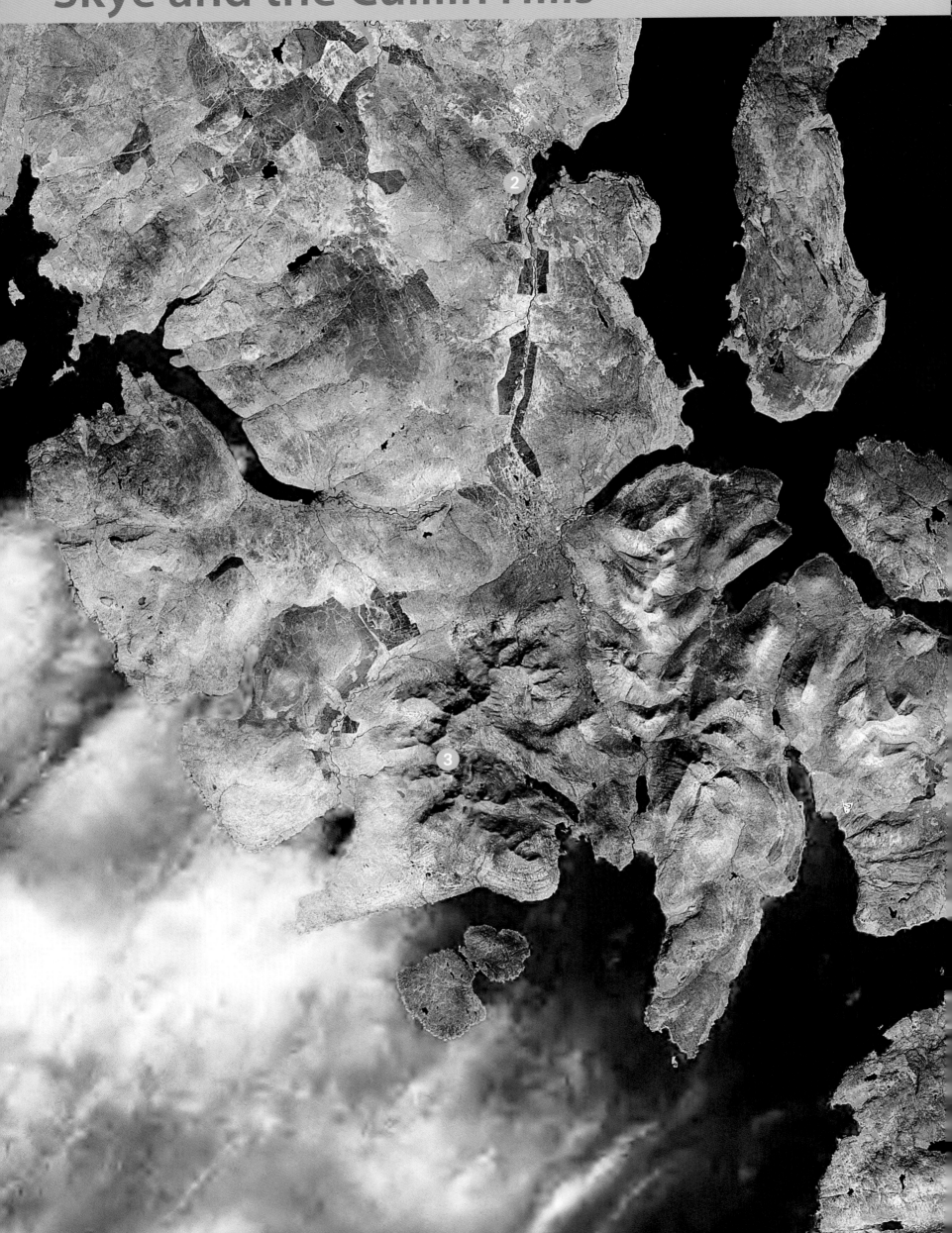

Skye and the Cuillins

Skye is the largest island in the Inner Hebrides with an area of 1,740sq km (672 sq miles). The coastline is deeply indented by many sea lochs and the central part of the island contains the Cuillin Hills which provide some of the best and the most dangerous climbing in the United Kingdom. The economy of the island is based on crofting, tourism, livestock and craft industries. The island briefly gave refuge to Bonnie Prince Charlie after the Battle of Culloden in 1746.

1 The Skye Bridge

Until 1995, Skye was linked to the mainland only by ferry. A privately funded toll bridge linking Kyleakin on Skye – formerly the main ferry port – with the Kyle of Lochalsh can now be crossed free of charge.

2 Portree

Portree is the capital of Skye, a harbour and an ideal centre for touring the island. The town hosts the annual Skye Agricultural Show and the Highland Games. The town's name derives from the Gaelic Port-an-Righ or 'King's Port' following a visit by James V of Scotland in 1540.

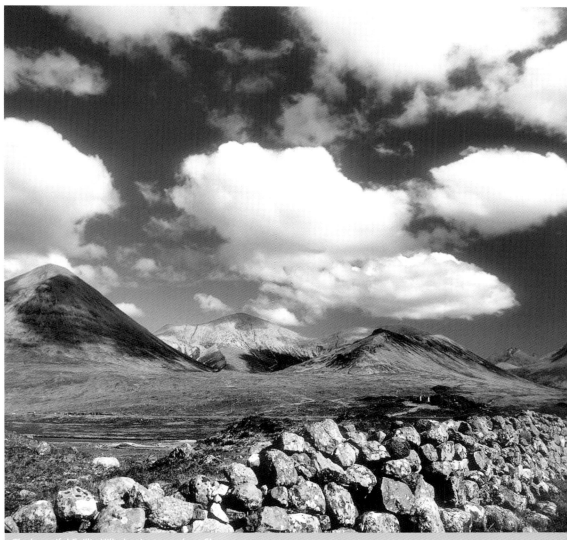

The beautiful Cuillin Hills dominate southern Skye.

3 The Cuillin Hills △

These are considered to be the most dramatic mountains in Britain, comprising the eastern Red Cuillin formed of red granite, and the main ridge, the Black Cuillin, formed of a dark, coarse rock known as gabbro. Sgurr Alasdair is the highest peak at 993m (3,257ft).

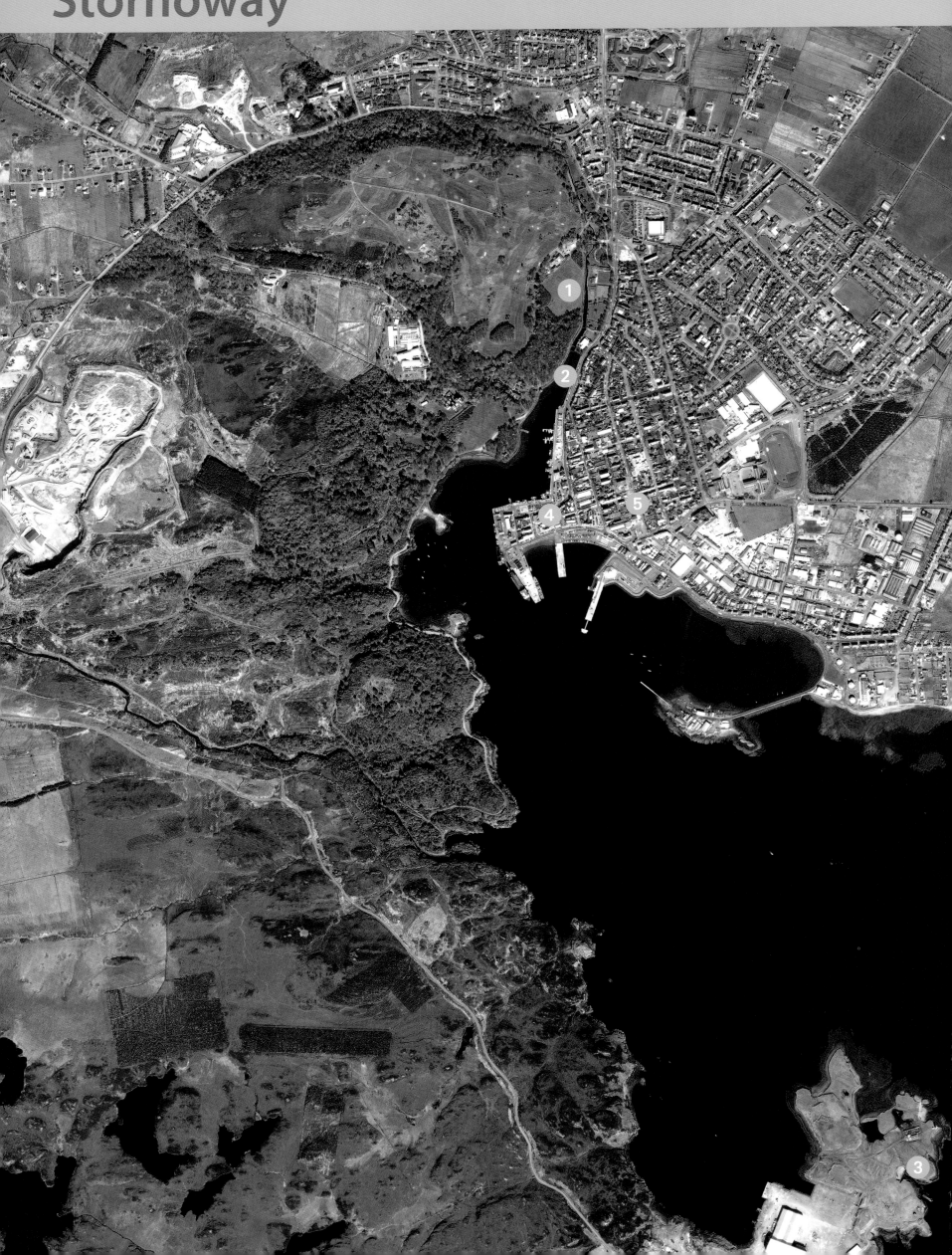

Stornoway, Outer Hebrides

With a population of some 9,000, Stornoway is the largest town on the isle of Lewis and Harris, and the unofficial capital of the Outer Hebrides. Renowned as a bastion of Gaelic culture and the Free Kirk tradition, it is also a fishing port, the centre of world-famous Harris tweed production and the commercial and services hub for the region. Stornoway makes an ideal base from which visitors can explore the distinctive peat moorland landscape of Lewis and Harris.

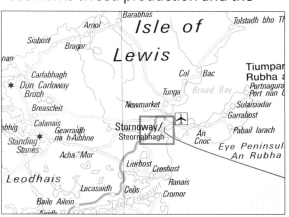

1 Lews Castle

In 1844, Sir James Matheson, the laird of Lewis, began constructing a mock-mediaeval castle as his residence, incorporating Seaforth Lodge, the home of previous lairds, on a site west of the town. The grounds were extensively landscaped, with conservatories growing tropical plants. The castle was sold along with the island to Lord Leverhulme in 1918, and castle and grounds were deeded to the people of Stornoway. It became the home of Lews Castle College until the 1990s. Possible future plans include development as a museum and hotel.

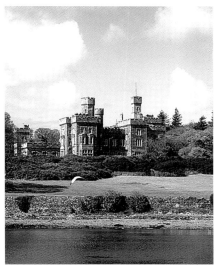

Lews Castle overlooks the harbour.

3 Arnish Point Lighthouse

Arnish Point marks the western side of the entrance to Stornoway Harbour, and its rocks, projecting into the harbour entrance, have been a danger to shipping for centuries. This was rectified in 1852 when an innovative hollow iron lighthouse, built by Alan Stevenson, began service on the point. The tower was automated in 1963.

2 Lewis Loom Centre

The Lewis Loom Centre, located near the centre of town on Bayhead, displays the techniques of weaving that have made Harris tweed famous around the world. There are examples of raw materials and yarns, and the looms are demonstrated by the expert proprietor. The building itself has a long history and was built as a weaver's workshop in 1799.

4 Stornoway Town Hall

Stornoway Town Hall stands in Cromwell Street on the town's waterfront, and its clock tower is a familiar sight to incoming ferry passengers. The first town hall was completed in 1905 and incorporated a library endowed by Andrew Carnegie, but was destroyed by fire in 1918. Its replacement opened in 1929. This building, in a turreted, baronial style, also housed a library until 1979.

5 Museum nan Eilean

The Museum nan Eilean was founded in 1983 and is the first museum in the Western Isles. In 1995, it moved from the Town Hall to a former secondary school in Francis Street that was specially redesigned. It holds documents and objects relating to the history of Lewis and the Western Isles.

Overleaf: the towering columnar basalt cliffs of Staffa.

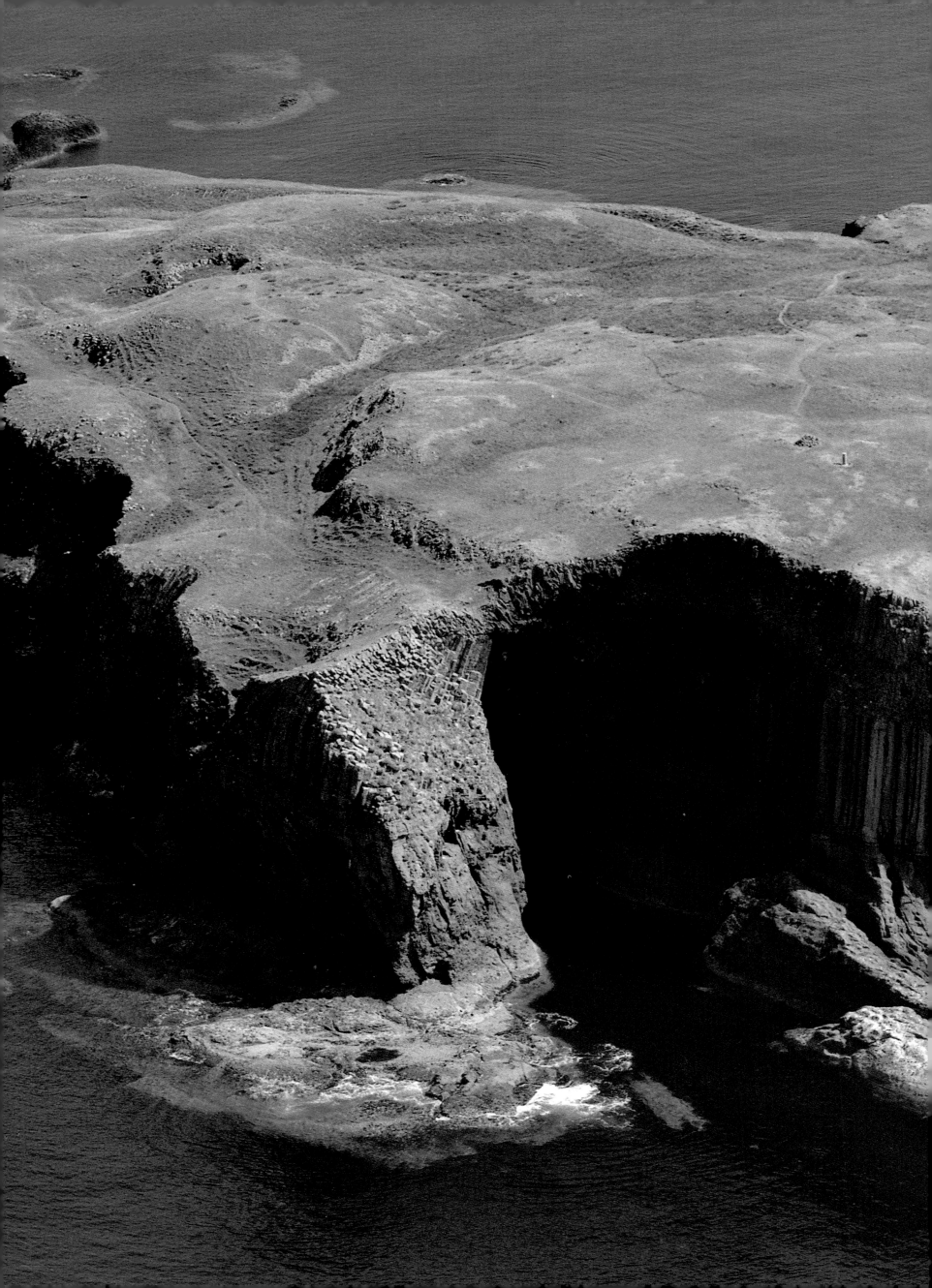

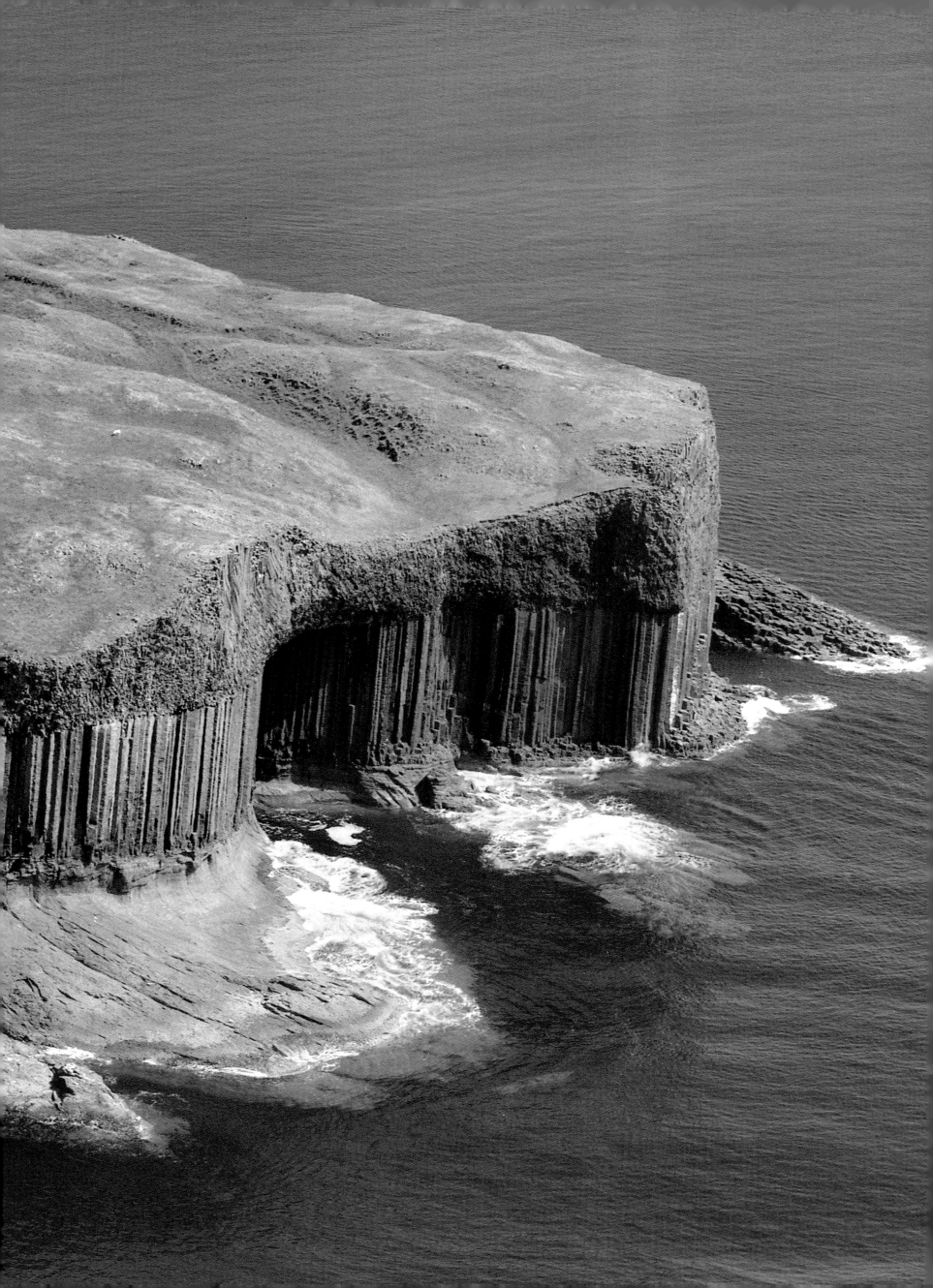

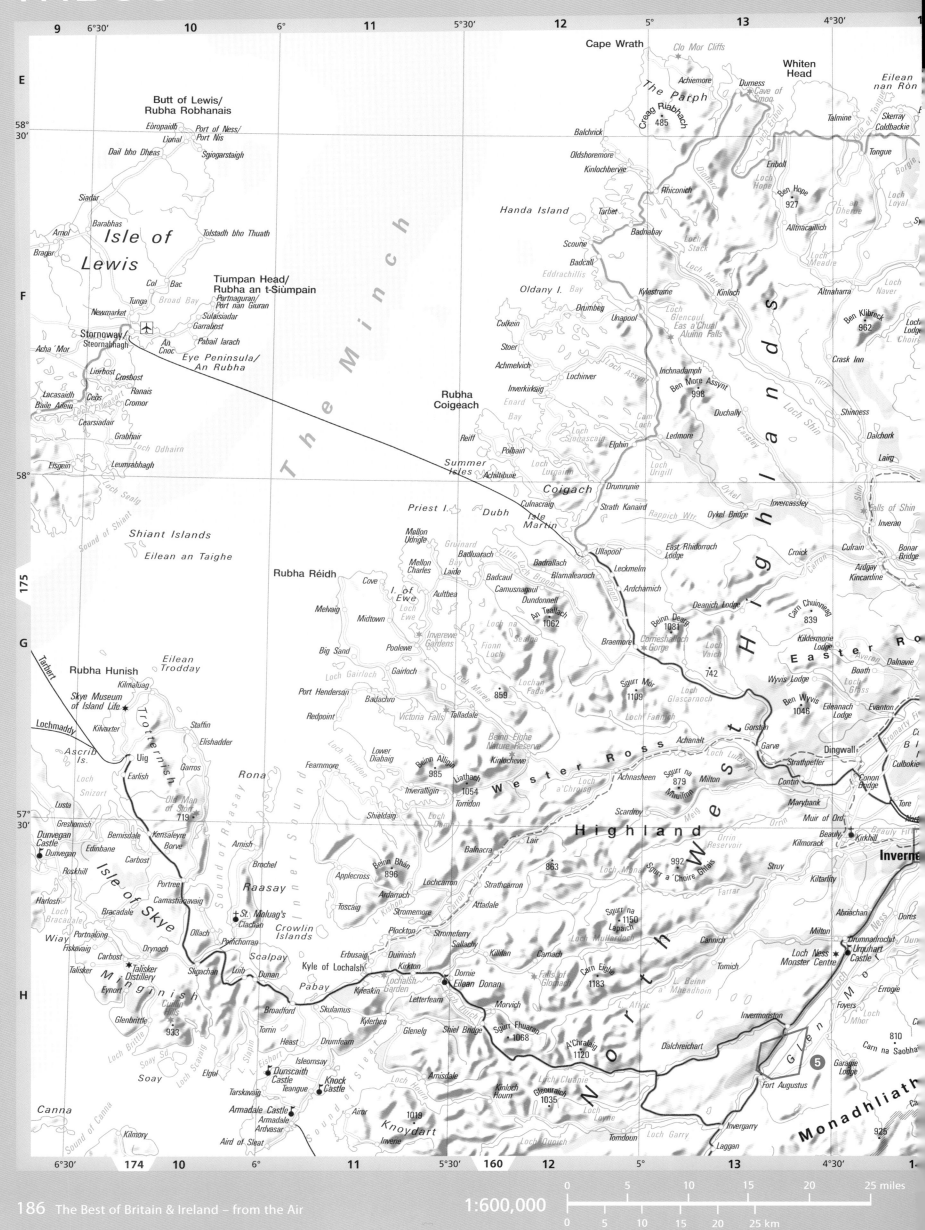

9 6°30' 10 6° 11 5°30' 12 5° 13 4°30'

E

Cape Wrath
Clo Mor Cliffs
Whiten Head
Eilean nan Ròn

Butt of Lewis/
Rubha Robhanais

The Parph
Achiemore
Durness
Cave of Smoo
Talmine
Skerray
Coldbackie

Eòropaidh
Lional
Port of Ness/
Port Nis

58°30'

Creag Riabhach
485

Balchrick

Kyle of Tongue
Tongue

Dail bho Dheas
Sgiogarstaigh

Oldshoremore
Kinlochbervie

Rhiconich
Loch Hope
Ben Hope
927
Loch Loyal

Siadar

Handa Island
Tarbet
Badnabay
Alltnacaillich

Loch an Dherue

Arnol
Barabhas
Isle of Lewis
Tolstadh bho Thuath

Scourie
Badcall
Loch Stack

Eriboll
Loch Eriboll
Loch Meadie

Bragar

Eddrachillis Bay

Altnaharra

Loch Naver

Col Bac

Oldany I.

Kylestrome
Kinloch

Ben Klibreck
962
Loch Choire

Tunga
Broad Bay

Tiumpan Head/
Rubha an t-Siùmpain

Drumbeg

Loch Glencoul
Eas a'Chual
Aluinn Falls

F

Newmarket
Partnaguran/
Port nan Giuran
Sulaisiadar
Garrabost

Culkein
Unapool

Crask Inn

Stornoway/
Steornabhagh
An Cnoc
Pabail Iarach

Stoer
Lochinver
Inchnadamph

Ben More Assynt
998

Loch Assynt

Acha Mòr
Eye Peninsula/
An Rubha

Achmelvich
Inverkirkaig

Duchally

Shinness

Liurbost
Crosbost

Ranais
Cromor

Reiff
Polbain

Rubha Coigeach

Enard Bay
Elphin
Ledmore

Cam Loch

Dalchork

Lacasaidh
Baile Ailein
Ceòs
Cearsiadair
Grabhair
Loch Odhairn

Achiltibuie
Summer Isles

Loch Sionascaig
Loch Urigill

Lairg
Loch Shin

Eisgein
Leumrabhagh
Loch Sealg

Priest I.
Dubh
Isle Martin

Coigach
Drumrunie

Falls of Shin
Inveran

Shiant Islands
Eilean an Taighe

Mellon Udrigle

Gruinard Bay

Culnacraig
Strath Kanaird
Rappich Wtr
Oykel Bridge
Invercassley
Loch Shin

Rubha Réidh

Mellon Charles
Laide
Badluarach

Ullapool
Leckmelm

East Rhidorroch Lodge

Croick

Culrain

Bonar Bridge

Cove
I. of Ewe
Aultbea

Badrallach
Camusnagaul

Ardcharnich

Deanich Lodge

Ardgay
Kincardine

175

Melvaig
Midtown

Loch Ewe

Badcaul
Dundonnell
An Teallach
1062

Beinn Dearg
Corrieshalloch Gorge

Carn Chuinneag
839

Kildermorie Lodge

Inverewe Gardens

Loch na Sealga

Braemore
Loch Vaich

Easter Ross

G

Rubha Hunish
Eilean Trodday

Big Sand
Poolewe

Fionn Loch

Sgurr Mòr
1109
Loch Glascarnoch

742

Boath
Dalnavie

Skye Museum
of Island Life

Kilmaluag
Staffin

Port Henderson
Gairloch

Loch Maree

Lochan Fada

Ben Wyvis
1046

Wyvis Lodge
Loch Glass

Averon

Tarbert
Lochmaddy

Kilvaxter
Elishadder

Badachro

Victoria Falls
Talladale

Loch Fannich

Gorston
Eileanach Lodge

Evanton

Ascrib Is.

Uig
Garros
Earlish

Beinn Eighe
Nature Reserve

Achnasheen
Achanalt
Loch Luichart

Garve
Strathpeffer
Dingwall

Trotternish
Rona

Fearnmore
Lower Diabaig

Beinn Alligin
985

Kinlochewe

Sgurr na
Muilinn
879
Milton

Conon Bridge

Culbokie

Loch Snizort

Lusta

Old Man of Storr
719

Liathach
1054
Torridon

Loch a'Chroisg
Achnashellach

Marybank
Muir of Ord

Tore

57°30'

Greshornish

Inveralligin

Loch Damh

Scardroy

Orrin Reservoir

Beauly

Dunvegan Castle
Bernisdale
Kensaleyre
Borve

Arnish
Brochel

Shieldaig

High land

Kilmorack
Kirkhill

Inverness

Edinbane
Dunvegan

Carbost

Applecross
Beinn Bhán
896

Lair

Balnacra

863

Sgurr a 'Choire Ghlais
992
Loch Monar

Kiltarlity

Roskhill

Portree
Camastianavaig

Raasay

Ardarroch
Lochcarron

Struy

Abriachan

Harlosh
Loch Bracadale

Bracadale

Ollach

Toscaig
Stromemore

Strathcarron
Attadale

Sgurr na
Lapaich
1150
Loch Mullardoch

Cannich
Tomich

Milton
Drumnadrochit

Urquhart Castle

Wiay
Fiskavaig
Portnalong

Drynoch

St. Maluag's
Clachan

Plockton
Stromeferry
Sallachy

Carnach

Carn Eige
1183

Loch Ness
Monster Centre

Talisker

Carbost
Talisker Distillery

Slipachan
Luib
Dunan

Crowlin Islands

Erbusaig
Duirinish
Kirkton

Killilan

Falls of Glomach

Loch Affric

Eynort

Scalpay
Pabay

Kyle of Lochalsh

Lochalsh Garden

Dornie
Eilean Donan

Morvich

L. Beinn a' Mheadhoin

Invermoriston

Foyers

Glenbrittle

Cuillin Hills
933

Isle of Skye

M g i n i s h

Broadford
Skulamus

Kyleakin
Kylerhea

Letterfearn

Glenelg
Shiel Bridge

Sgurr Fhuaran
1068

A'Chralaig
1120

Dalchreichart

Fort Augustus

Errogie
Loch Mhor

810
Carn na Saobhaidhe

Torrin
Heast

Drumfearn

Isleornsay

Arnisdale

Kinloch Hourn

Garragie Lodge

Soay Sd.

Elgol

Dunscaith Castle
Teangue
Knock Castle

Airor

1019

Gleouraich
1035

Loch Cluanie

Loch Loyne

Invergarry

925

Canna
Kilmory

Tarskavaig
Armadale Castle
Ardvasar

Sound of Sleat
Aird of Sleat
Inverie

Knoydart

Loch Garry
Tomdoun

Laggan

Monadhliath

6°30' 174 10 6° 11 5°30' 160 12 5° 13 4°30'

0 5 10 15 20 25 miles
0 5 10 15 20 25 km

1:600,000

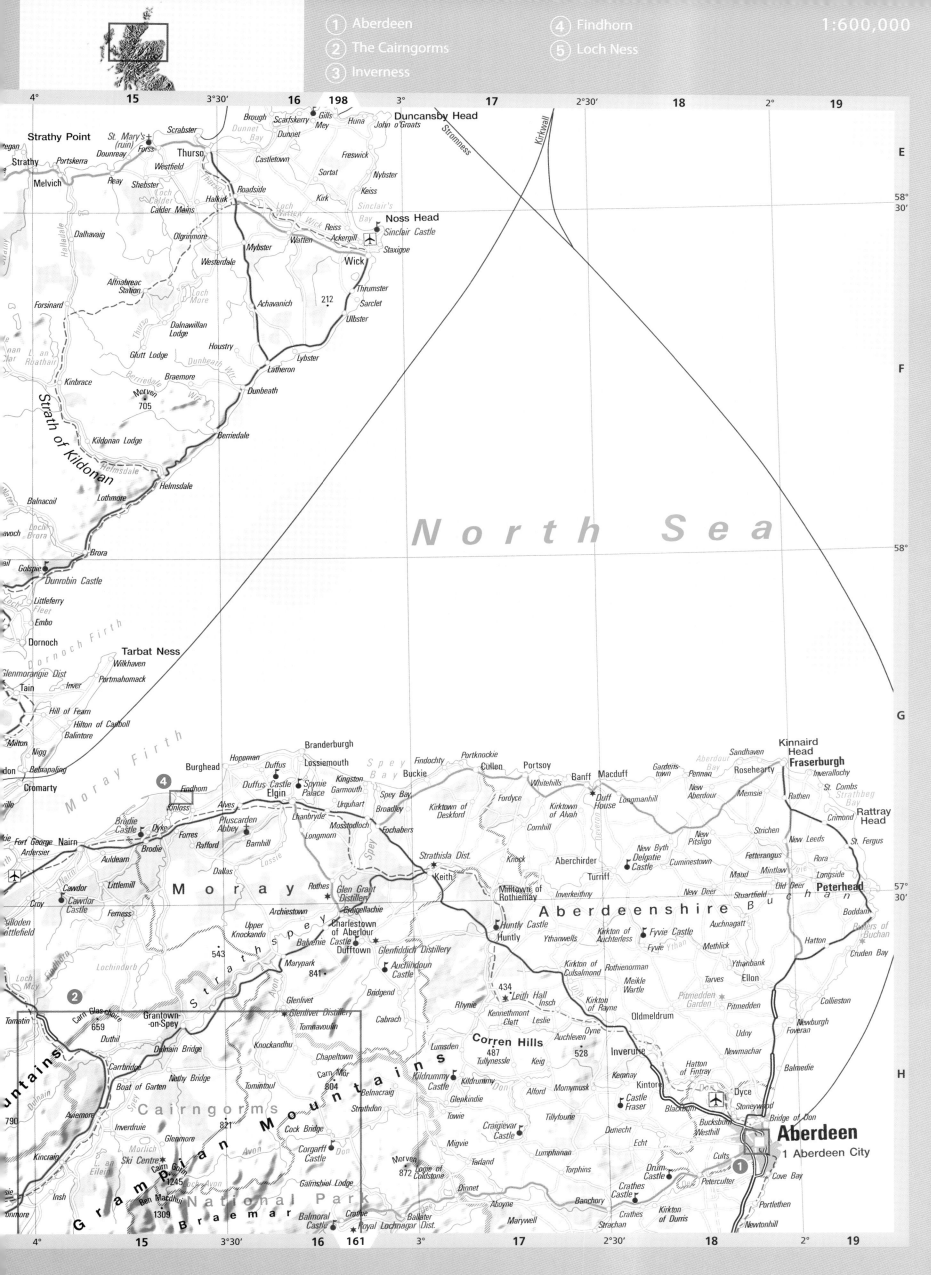

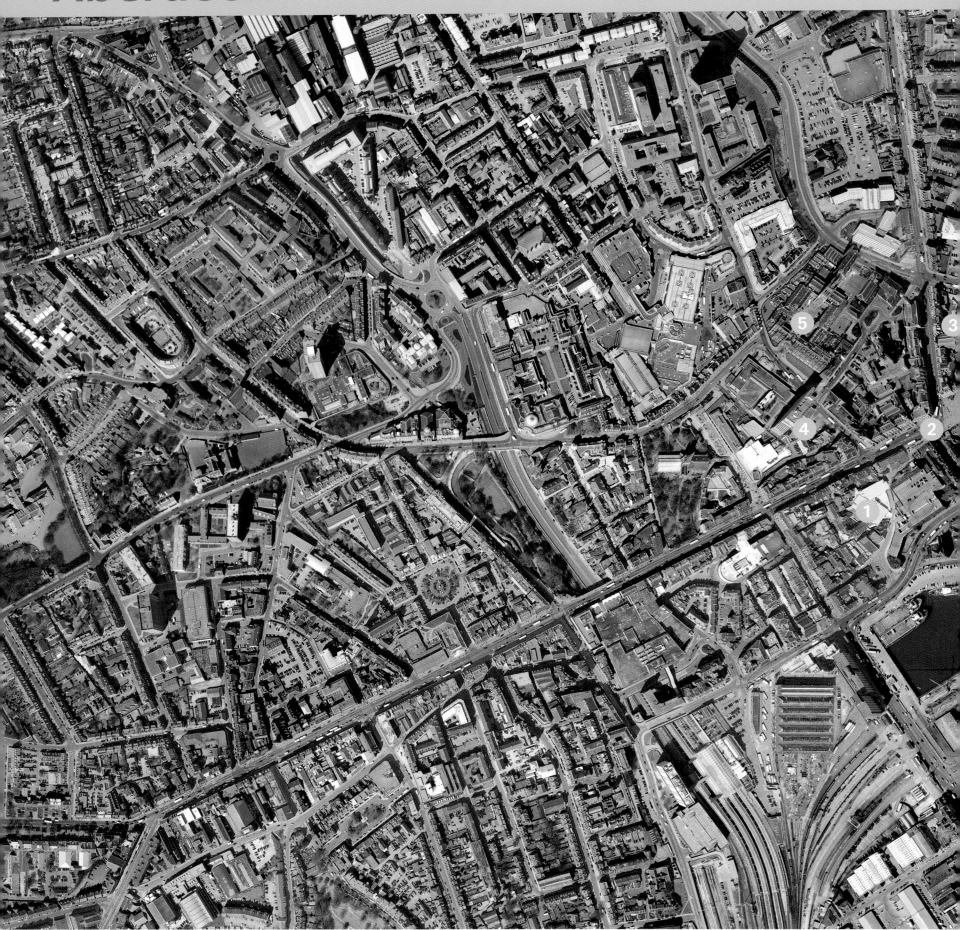

Aberdeen

Aberdeen is the capital of the Grampian Highlands, and is often known as the Granite City because of its dignified stone buildings, many of which date from the early 19th century and were designed by local architect Archibald Simpson (1790-1847). With an enduring connection to the sea, the city was once the point of departure for clipper ships trading in Chinese tea. Now, as a result of the discovery of North Sea oil in the 20th century, it is a prosperous city, the third largest in Scotland. The city has won the 'Britain in Bloom' award on many occasions.

① Aberdeen Maritime Museum

This award-winning museum is situated on the historic Shiprow, near the Aberdeen City docks. It is housed in a purpose-built structure, completed in 1997, which incorporates the 16th-century Provost Ross's House. The house was the museum's original home.

Considered to be one of the finest visitor attractions in Scotland, the museum offers a wonderful view of busy Aberdeen port, and provides a detailed history of sailing and shipbuilding in the city, as well as a unique exhibit on the offshore North Sea oil industry. With multimedia and interactive exhibits, the museum's high point is the model of the Murchison oil production platform, which stands 9m (29.5ft) high. The collections also feature exhibits on land transport as well as the maritime attractions.

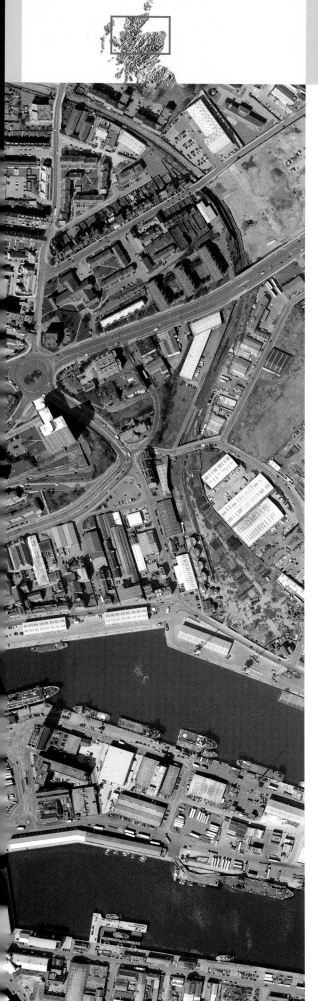

The 17th-century Tolbooth was built as a prison.

4 Provost Skene's House

First mentioned in 1545, the house was bought in 1669 by George Skene, a wealthy landowner who was provost from 1676 to 1685 and who virtually rebuilt it in contemporary style. One of the few remaining examples of 17th-century domestic architecture, it stood on Guestrow, a street dating from the 1450s now no longer in existence. Over the years the area became a less desirable part of the city, and Provost Skene's House fell into decay. It was saved from demolition in the 1950s and is now open as a museum of local history. Most notable in the house are the remarkable ceiling paintings, and a series of ten tempera panels of the life of Christ, which were discovered in 1951 when the council began restoration of the building. In 1993, all rooms were refurbished in various period styles.

5 Marischal College and Museum

Marischal College was founded in 1593 by the fourth Earl Marischal of Scotland on the site of a Franciscan priory disestablished during the Reformation in 1560. The existing college building, an ornate mid-19th century 'Tudor Gothic' edifice with a central tower, is the second largest granite building in the world. Once the city-centre site of the University of Aberdeen, most of the building was empty for some time but now houses offices; it is still also used for the university's ceremonial events. The Marischal Museum was founded in 1786, largely through donations of materials by former graduates and benefactors. It has significant collections of both Egyptian and Classical antiquities, non-Western artefacts and major exhibits on Scottish prehistory. The art collection is mostly of Scottish paintings from the 17th century onwards.

2 The Tolbooth △

The Tolbooth was built in the 1620s as a jail for criminals awaiting trial or punishment. Stone-built, with a clock tower and steeple, its small cells are connected by narrow winding staircases. Apparently, 17th-century jailers were somewhat lax in their duties: there are several stories of prisoners simply walking out of the Tolbooth. Today it is a museum of civic history, but also includes exhibits of mediaeval instruments of torture.

3 Cathedral Church of St Andrew

Situated in the centre of the city, St Andrew's has been a cathedral since 1814 and, as the Episcopal Church in the Diocese of Aberdeen and Orkney, serves the whole of northeastern Scotland. The 18th-century Gothic sandstone building was designed by Archibald Simpson, and an extension was built in the 1930s, though not completed until after the Second World War. It was later described by John Betjeman as 'Aberdeen's best modern building'. In 1784, Dr Samuel Seabury, of Connecticut, was consecrated Bishop for America by Bishop Kilgour of Aberdeen, extending the church's reach to the New World for the first time.

Aberdeen harbour's main activity is supporting the offshore oil industry.

The Cairngorms

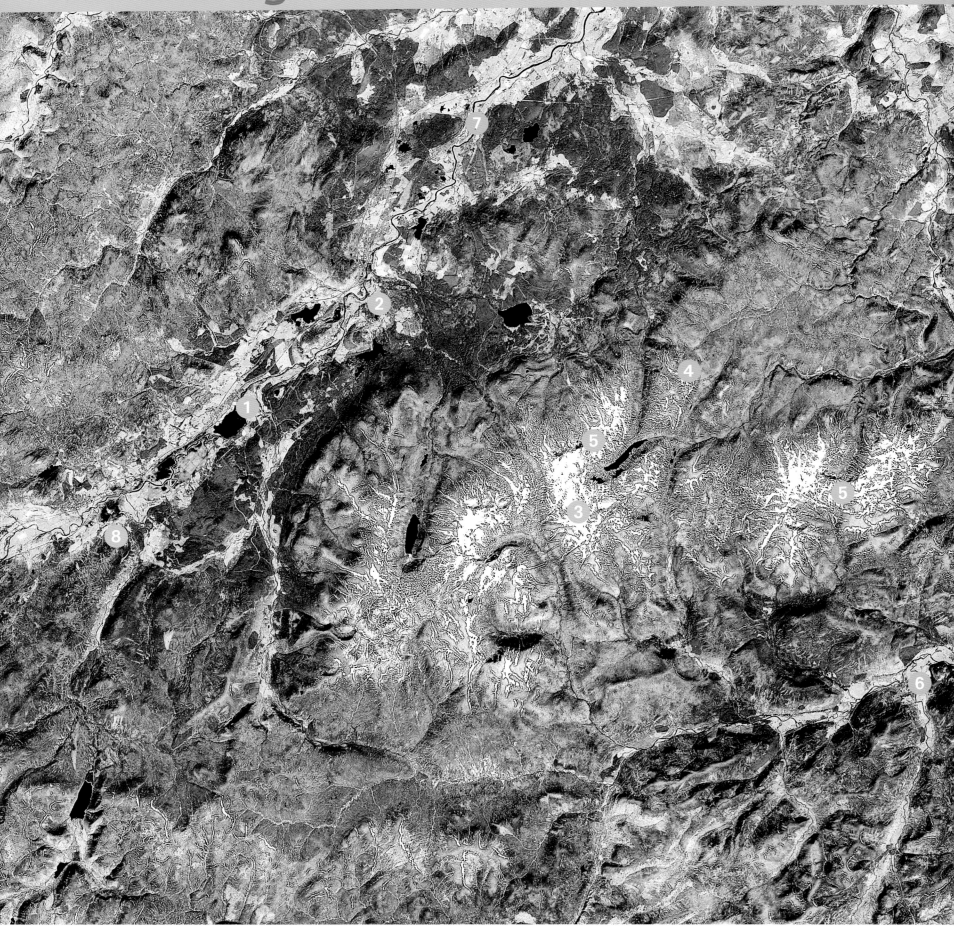

The Cairngorms

The Cairngorms are among the most rugged environments in the British Isles. Feared and seldom penetrated for centuries, in recent decades their mixture of sublime mountain beauty and inhospitable remoteness have made them a major attraction for climbers, walkers, and naturalists. In 2003 their unique value was recognised when the range was made one of Scotland's first two national parks. With a high winter snowfall and four of the five highest peaks in Britain, the area is a magnet for climbers and skiers. The landscape of the mountains is one of the most spectacular in Europe and is home to a range of wildlife including golden eagles, ptarmigans and wildcats.

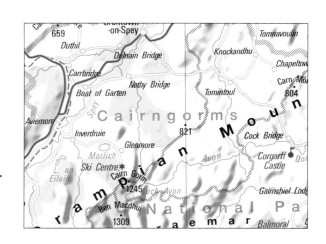

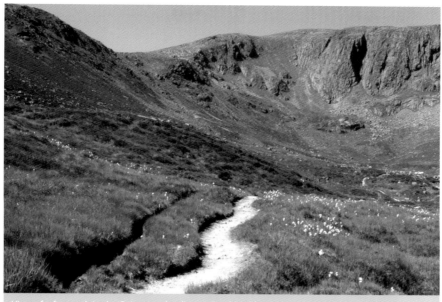

View of a footpath in the Cairngorms leading to Ben MacDhui, the second-highest peak in the United Kingdom.

① Transport and tourist infrastructure

The River Spey runs along the Cairngorms' northern flank, and in its valley lie the road and rail links that provide the major transport access routes to the mountains. Aviemore, some 16km (10 miles) northwest of the summit of Cairn Gorm, the main peak, serves as a base for walkers and climbers in summer and skiers and snowboarders in winter. Since the early 1960s winter sports have enjoyed increasing popularity here. The Cairn Gorm Ski Centre, Glenshee Ski Centre and Lecht Ski Centre operate a series of lifts servicing ski runs of widely varying difficulty. In 2001 a new funicular railway, with picture windows, was built to take passengers year-round to the Ptarmigan Restaurant with its northward-facing viewpoint at a height of 1,125m (3,700ft), about 120m (400ft) below Cairn Gorm's summit. Despite the protests which accompanied its construction it has helped the Cairngorms National Park Authority to pursue its policy of encouraging biodiversity and productive land management within the increasingly fragile natural environment.

② Aviemore

Together with Carrbridge and Grantown-on-Spey, Aviemore is one of the main ski resorts, lying in the foothills of the Cairngorms. Its transformation from a village into a winter sports centre took place in the 1960s with the construction of a large holiday complex. As well as catering to skiers, Aviemore also provides a good base for walkers.

③ Ben MacDhui

Ben MacDhui, at 1,309m (4,296ft), is the second-highest peak in Britain after Ben Nevis. Legends abound of eerie presences sensed by climbers who make the ascent to the summit, including one account, in 1925, of a professor from London University who ran down the mountain to escape the footsteps that he believed were pursuing him.

⑤ Mountain range

The Cairngorm range extends to the west of Braemar, with its boundaries formed by Glen Dee and Glen Geldie in the south, Glen Feshie and the River Spey in the west, Glen More in the north and Glen Avon in the east. To the south lie the Grampians. Four of the five highest mountains in Britain are in the Cairngorms; only the very highest, Ben Nevis, is not here. The range is named after one of its peaks, Cairn Gorm (1,245m / 4,084ft), although the highest summit of the group is Ben MacDhui (1,309m / 4,296 ft). Having been covered by glacial ice sheets for millions of years the Cairngorms have been worn down to a high plateau punctuated by a series of domed summits. Because of its height and latitude, this plateau forms the only arctic ecosystem in Britain, with patches of year-round snow and unusual, distinctive plant species that are more commonly found in Siberia.

⑥ Braemar

Braemar Castle was built by the second Earl of Mar in 1628. After the Jacobite Rising of 1715 it was garrisoned by English troops in order to control the Highlanders, and rebuilt some 30 years later. In the 19th century, Queen Victoria popularised Braemar as a holiday resort; the Royal family still attends the Royal Highland Games which are held in the town every September. Balmoral Castle, the Queen's favourite summer retreat, lies just a few miles to the north. The Highland Games include traditional sports such as tossing the caber and putting the shot, as well as Scottish dancing and bagpipe playing.

⑦ Grantown-on-Spey

Situated on the River Spey, Grantown is the creation of an 18th-century landowner, Sir James Grant, who planned and built the town as a centre for the linen industry.

④ Geology and wildlife

The rock of the highest part of the Cairngorms, including most of the high plateau over 900m (3,000ft), is predominantly granite, polished smooth by friction and pressure during the ice ages. It includes a special type of reddish-brown quartz known as Cairngorm quartz. At lower elevations, metamorphic rock such as schist is found. These rocks are more easily eroded, and so tend to form craggier features and steeper-sided valleys, giving rise to the deep north-south clefts that cut the Cairngorm range on both flanks. Typical plant species of the high tundra landscape include moss campion, starry saxifrage and snowbed or dwarf willow. The birds living here include golden eagles, osprey and the Scottish crossbill; the rivers contain rare freshwater mussels and lampreys as well as the trout and salmon for which the Dee and Spey are famous.

⑧ Ruthven Barracks

The stark walls of the ruins of Ruthven Barracks on the road south of Kingussie bear grim testimony to the unrest in the Highlands during the 18th century. The Jacobite Rising in 1715 was an attempt to restore the Stuarts to the throne and prompted a strong military response from the English. Ruthven was built between 1716 and 1718 to accommodate English troops sent to subdue the Scots; it was enlarged in 1734 by General George Wade, the architect of the military roads that crisscross Scotland. After their defeat at the battle of Culloden in 1746, which effectively brought the Jacobite challenge to an end, the Highlanders assembled at Ruthven to wait for their leader, Prince Charles Edward. When 'Bonnie Prince Charlie' failed to arrive, sending a message of farewell instead, his supporters blew up the barracks to stop them falling into English hands.

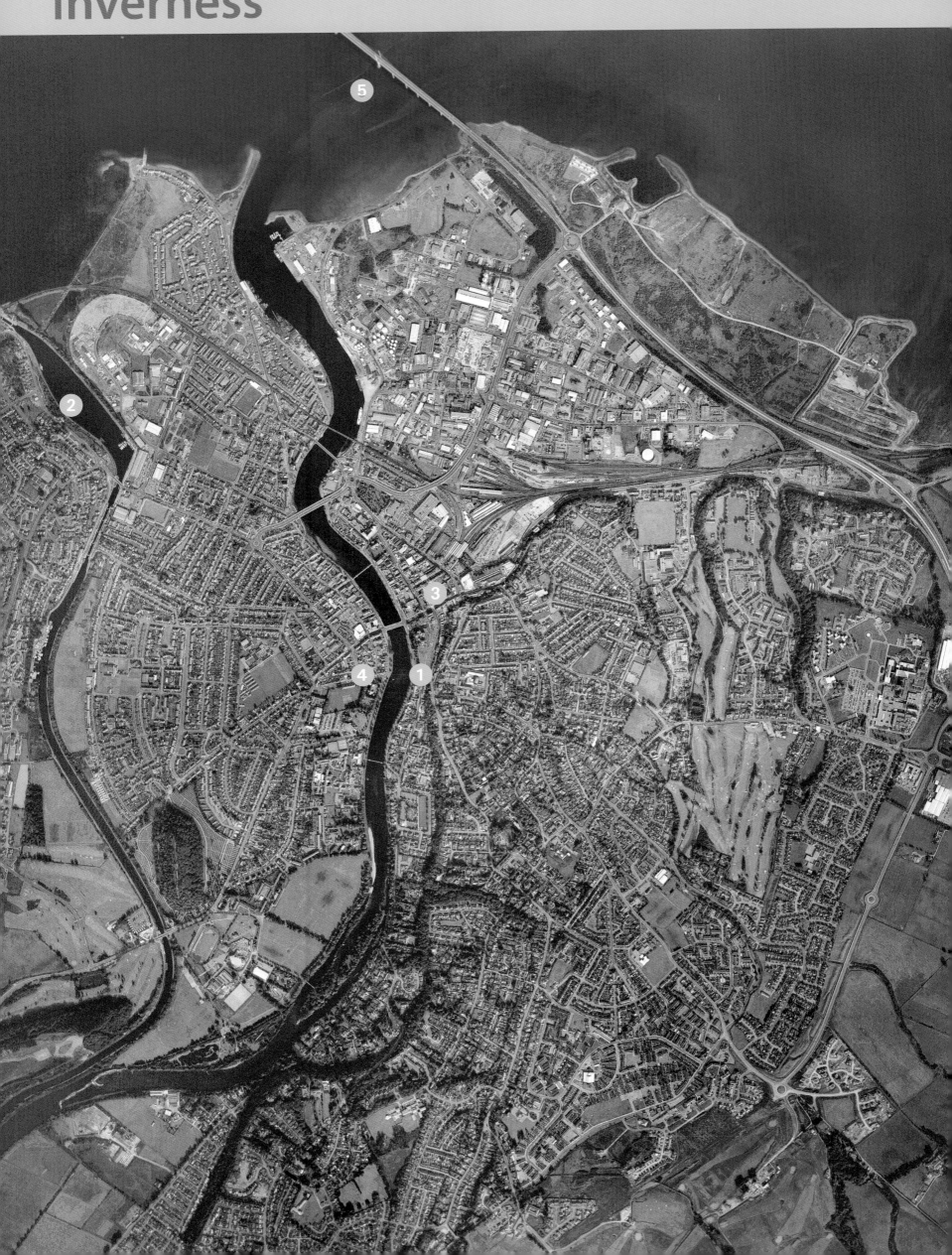

Inverness

Known as the 'Capital of the Highlands', the ancient town of Inverness (which means 'mouth of the Ness') was granted city status by Queen Elizabeth II in 2000 as part of the millennium celebrations. Its position near the sea at one end of the Great Glen has long made it a focal point for road, canal and rail networks, as well as the administrative centre for the Highlands, while its fine buildings and attractive riverside continue to draw visitors from far and wide.

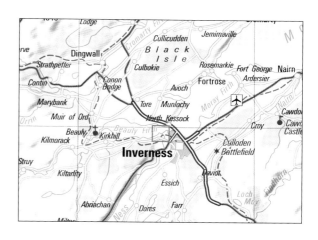

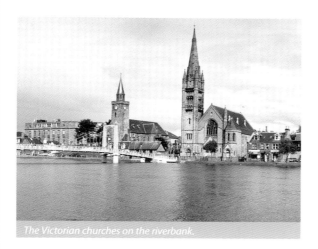

The Victorian churches on the riverbank.

1 Inverness Castle

The site of the current castle, occupying a commanding position beside the east bank of the River Ness, has been fortified for centuries. A succession of mediaeval wooden forts were sacked in the 14th and 15th centuries before the castle was rebuilt in stone in 1548. After withstanding a siege in the Civil War and being enlarged and strengthened in the 1720s, the original stone castle was finally blown up by retreating Jacobite forces in 1746.

The red sandstone castle seen today dates from 1835 and was designed by William Burn. Despite its fortified appearance, it was built for administration, serving as Invernesshire's county hall and court house, a function it still serves today for the Highland unitary authority. Next to it is the North Block, completed in 1848 in a similar style, which was originally the town prison but now houses court rooms.

2 Caledonian Canal ▽

Inverness is where the Caledonian Canal emerges into the sea at the Beauly Firth. Plans for a canal along the Great Glen between Inverness and Fort William had first been drawn up by James Watt in the 1770s, but it was finally constructed by engineers William Jessop and Thomas Telford, who worked together until Jessop's death in 1814. The canal was deepened further in the 1840s to its current depth of 5.5m (18ft). The best place to see it in Inverness is at the Muirtown basin, where boats can moor or turn around before entering or leaving the canal. Just south of it, the Muirtown locks are a series of four locks that raise the canal water some 10m (33ft) to the level of Loch Ness. The canal passes through western Inverness (walkers can follow the towpath, part of the 118km / 73 miles Great Glen Way footpath), and just south of the city it merges with the River Ness, 2.5km (1.5 miles) from the point where the river meets Loch Ness.

3 The Town House

Like the cathedral and the castle, the Town House is a Victorian creation, completed in 1882. It was designed by Inverness architects James Matthews and William Lawrie in a style that mixed red-brick municipal construction with gothic detailing, stained glass windows, and baronial turrets along the roofline. Inside, it is notable for its grand dividing staircase leading up to the formal Council Chamber, with its horseshoe-shaped table, and Committee Room. The Council Chamber is remarkable as the site of the only British government cabinet meeting ever held outside Westminster: Lloyd George held an emergency session here in 1921.

4 The Cathedral Church of Saint Andrew

On the west bank of the river, opposite the castle, stands St Andrew's Cathedral. Like the castle, it is mediaeval in appearance but was built during the 19th century renaissance of the city. The Episcopalian (Anglican) cathedral – the first new cathedral to be built in the United Kingdom since the Reformation – was the brainchild of Robert Eden, who became Bishop of Moray and Ross in 1851. He first proposed a new cathedral for Inverness in 1853. Construction began in 1866, and was completed in 1869. After a bout of fund-raising finally paid off the building costs, the cathedral was finally consecrated in 1874. It was designed by a member of the congregation, Alexander Ross, who had envisaged a rather larger building.

5 Kessock Bridge

East of Inverness, the Kessock Bridge carries the A9 from Perth over the strait separating the Beauly and Moray firths. Replacing an earlier ferry, the cable-stayed bridge, with a main span of 240m (787ft), was begun in 1976 and completed in 1982. It is credited with helping to revitalize the northern Highlands, to which it acts as a gateway. Its design, by the German engineer Hellmut Homberg, is based on that of a bridge across the Rhine at Düsseldorf. Since 2007, the 25th anniversary of its opening, the Kessock Bridge has featured on the obverse side of the £100 note issued by the Bank of Scotland.

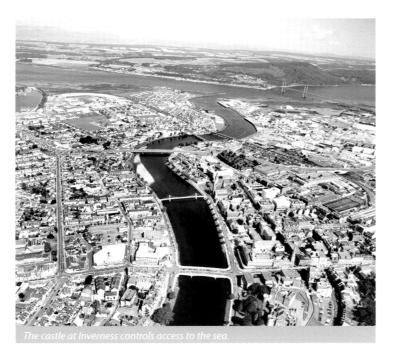

The castle at Inverness controls access to the sea.

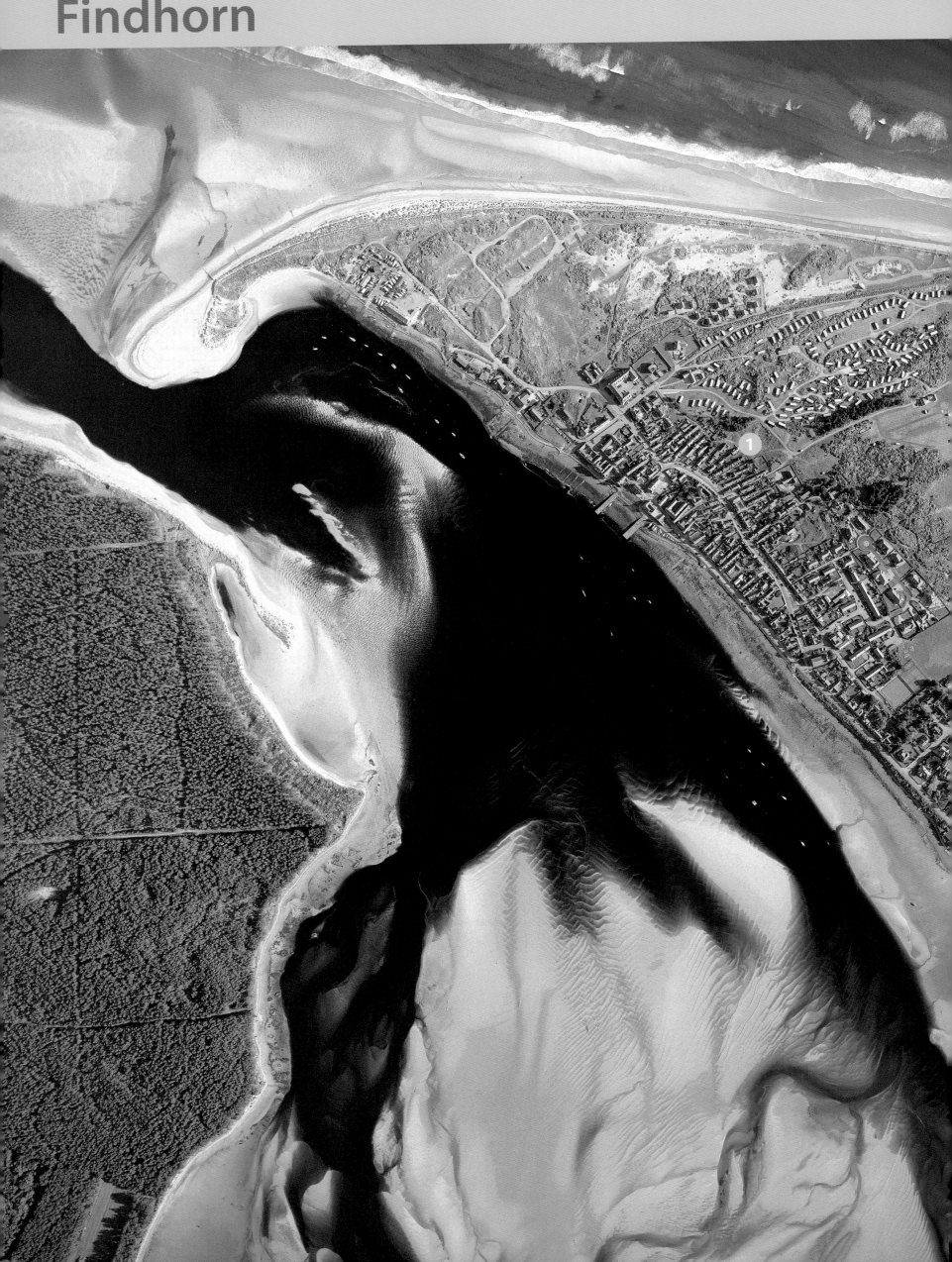

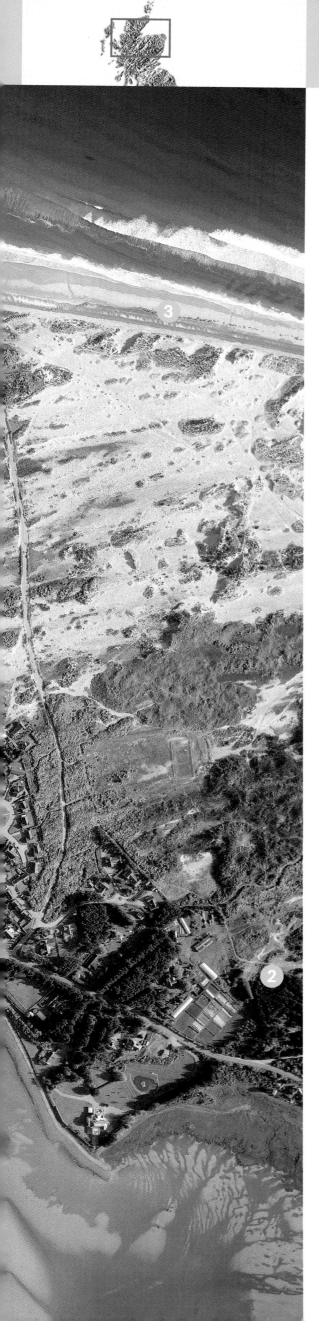

Findhorn

The village of Findhorn lies between the north-facing sea coast and the sheltered inlet of Findhorn Bay, where mudflats and dunes provide a haven for wildfowl and wading birds. Once a fishing port and shipbuilding base, Findhorn is today a well-known centre for sailing and watersports. Since the 1960s it has also been home to a spiritual community that runs courses in music, the visual arts and spiritual living that attract people from all over the world. At the southern end of Findhorn Bay, just outside the village of Kinloss, an RAF air base has been operational since 1939.

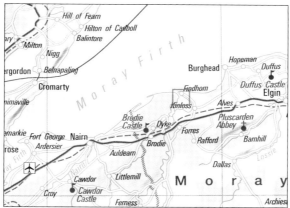

① Findhorn Heritage Centre

At the northern edge of Findhorn village, the Heritage Centre occupies two huts formerly used by salmon fishers. The first building recreates the conditions of a salmon fishery, while the second contains an exhibition of local history including a Bronze Age clay burial urn. There has been a settlement at Findhorn since at least 1189. Today's village is the third to have been built here: one was buried in sand dunes by 17th-century storms, while a second was destroyed by floods in 1701. The thriving port once had trading links with Scandinavian and Baltic settlements.

② Findhorn Foundation and Ecovillage ▽

The Findhorn Foundation charity, established in 1972, grew from the seeds of the Findhorn spiritual community that began in the village in 1962. In addition to offering many courses, the Foundation is today the hub of some 60 ecologically sustainable businesses. The community, which lies just to the south of Findhorn village, offers guided tours in the summer months. Community founders Eileen and Peter Caddy and Dorothy Maclean came to the area in 1957 to manage the Cluny Hill Hotel in the ancient royal town of Forres, 6.5km (4 miles) inland from Findhorn. In business they tried to follow the divine guidance that Eileen received in the form of an inner voice. The hotel was a success but the trio lost their jobs in 1962 and moved to a caravan site in Findhorn. Here in the dry, sandy coastal land they established a remarkable garden, again seeking to follow divine guidance in their planting and growing. Their astonishing results attracted like-minded individuals and a spiritual community was born. Permanent buildings were constructed and the community began educational work. The Findhorn community expanded and in 1975 it bought the Cluny Hill Hotel as an educational centre and in 1982 purchased the Findhorn Bay Caravan Park.

Findhorn gained an international reputation, in part through the publication of Eileen Caddy's guidance in the books *God Spoke to Me* and *Opening Doors Within*. She lived a long and inspiring life in the community and died in 2006. Peter Caddy left the community in 1979 but continued to visit regularly until his death in 1994. Dorothy Maclean, having lived in North America for a number of years and been actively involved in leading workshops around the world, has returned to Findhorn and lives in the community. In the late 1980s the community built an 'ecovillage' designed to be an ecologically, economically and spiritually sustainable place to live. The Findhorn Foundation is recognised as a United Nations non-governmental organisation and regularly sends representatives to UN Sustainable Development Committee meetings and various other UN conferences and workshops. In 2001, Findhorn Foundation College was established. In 2002, the Findhorn Foundation introduced a local currency called the Eko. There are approximately 20,000 Ekos in circulation.

The ecological footprint of the Findhorn Ecovillage is half the UK average.

③ Seashore habitats

The Findhorn Bay area is a nature reserve. At low tide large parts of the bay, which extends to just over 3km (2 miles) in width, are exposed mudflats providing a rich source of plankton. There is a hide where ornithologists flock to observe wildfowl and wading birds, and in winter to view visiting geese and duck. Botanists also visit to examine a wide range of lichens and fungi. To the north of the village, the North Shore extends for 11km (7 miles) of sand and dunes alongside Burghead Bay to the village of Burghead on a short headland. Grey and common seals live in the area and can be seen basking on the North Shore. In the Moray Firth, bottlenose dolphins, orcas, sperm and pilot whales as well as porpoises can be seen.

Overleaf: Loch Ness and Fort Augustus' Benedictine Abbey.

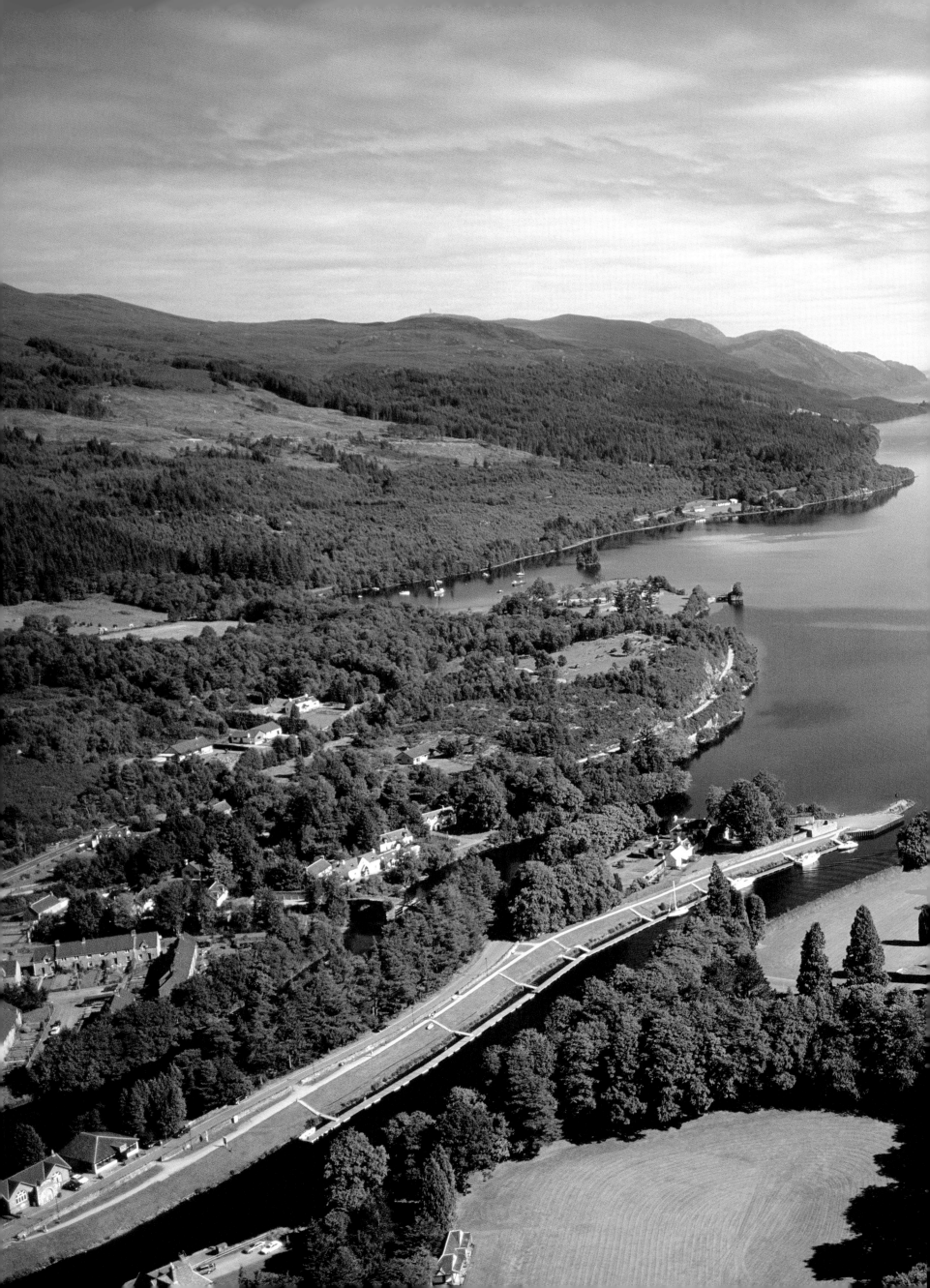

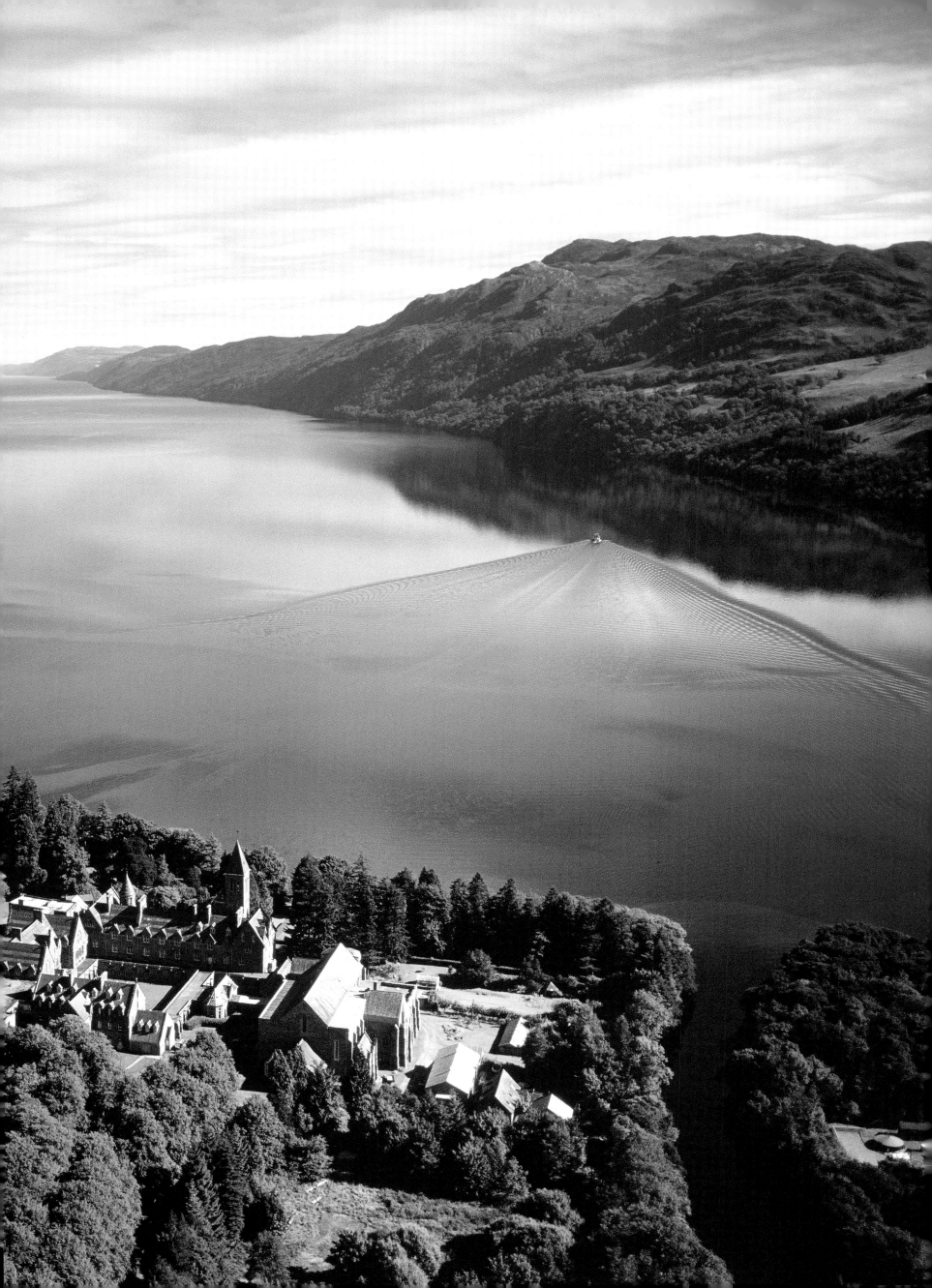

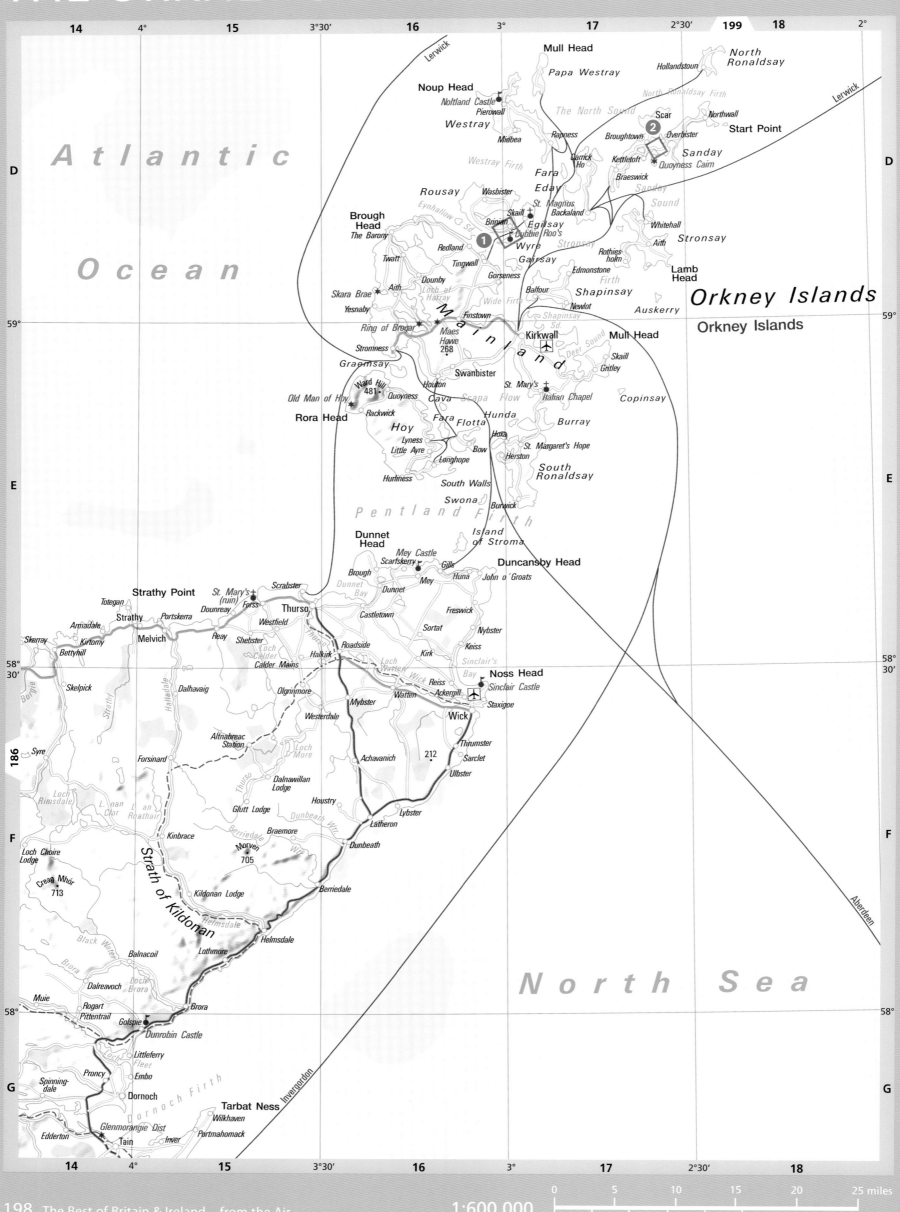

1:600,000

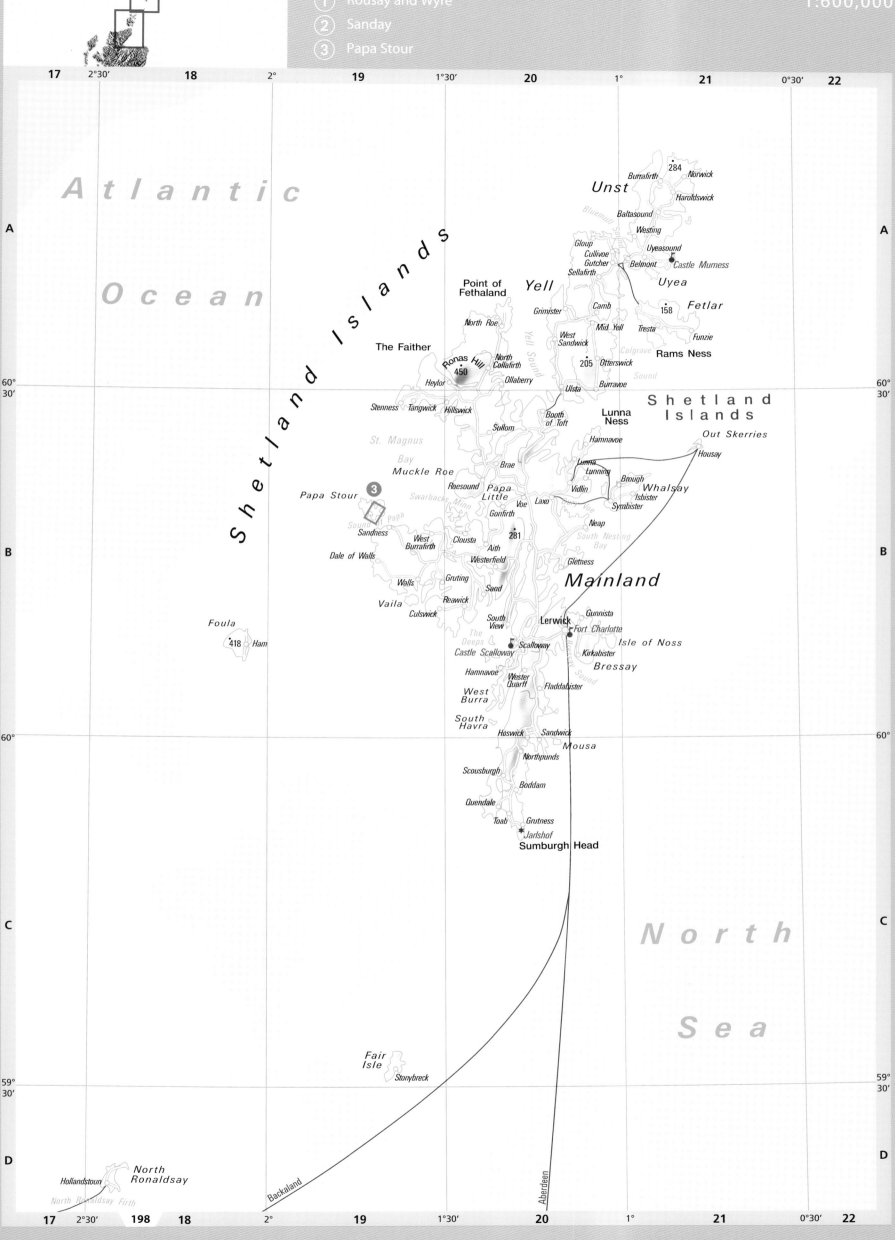

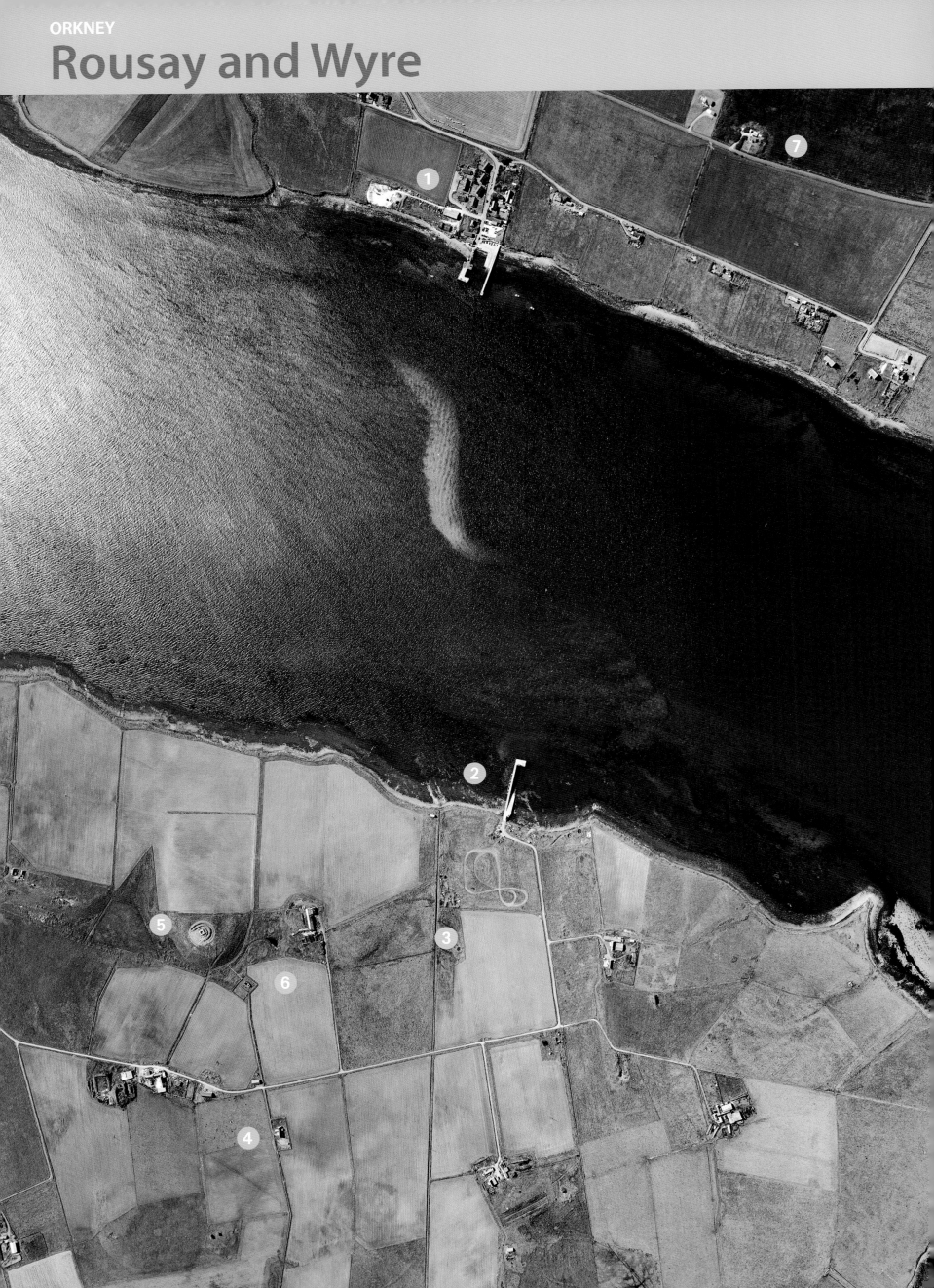

Rousay and Wyre

The islands of Rousay (upper half of main image) and Wyre (lower half), have sometimes been described as the 'Egypt of the North' because of the wealth of archaeological remains dating from the Stone Age and Iron Age to the Viking period that are preserved here. Together with Egilsay (further to the East, outside the camera angle) these islands reveal the unique heritage of the Orkney Islands. Situated a short distance from the northeastern coast of the Orkney mainland, Rousay is both the largest and the most hilly of the islands. Rousay has been designated a site of special scientific interest for its flora, birdlife, natural features and archaeology. The islands have experienced a drop in population from about 1,000 people in 1831 to fewer than 300 in the latest census in 2001.

3 The Bu

The island of Wyre (from the Old Norse *Vigr* meaning spearhead), features in Viking sagas as the domain of Kolbein Hruga, a powerful landowner from Norway and Viking chieftain. It is thought that the farm named The Bu stands on the site of Hruga's original dwelling. The Bu also gained more recent fame as a childhood home of the Scottish poet Edwin Muir (1887-1959). Muir is commemorated by the island in an exhibition at the nearby heritage centre.

1 Trumland, Rousay

Trumland is the main settlement on Rousay. Trumland House, located nearby, was home to General Sir Frederick William Traill-Burroughs, or 'The Little General', who became known as Orkney's worst landlord after he increased rents and evicted more than 200 people from their farms on Rousay. His actions contributed to the passing of the 1886 Crofters Act in parliament that subsequently protected smallholders from eviction and arbitrary rent increases. In the 1930s, Trumland House became home to Walter Grant, whose fortune helped bring archaeologists to the island to excavate all the sites that are now in the care of Historic Scotland. The Trumland visitors centre, near the pier, has a restaurant and provides tourist information.

2 MV *Eynhallow* ▽

A ferry connects Rousay and Wyre to the rest of the Orkney Islands and the mainland and is named after the uninhabited island that lies to the north of Rousay. Built in Bristol in 1987, the ferry can carry up to 95 passengers and nine cars. The MV *Eynhallow* begins and ends its round trip at Wyre. Visitors catching an early morning ferry can see Rousay, Wyre and Egilsay in a single day.

4 Wyre Heritage Centre

Originally built as a school and then converted into a community hall, the heritage centre at Wyre contains exhibitions on the history of island life and the poet Edwin Muir who was born on the island. There is also detailed information on the excavation of Cubbie Roo's Castle and its Norse links.

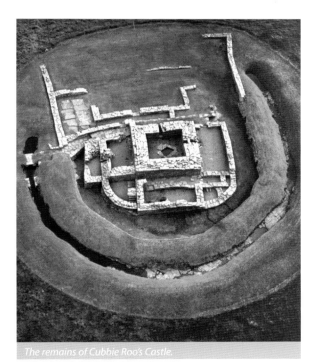
The remains of Cubbie Roo's Castle.

5 Cubbie Roo's Castle ◁

Cubbie Roo, a corruption of the name Kolbein Hruga, variously described as a Viking chieftain, tax collector and giant, played an influential role in the early development of Wyre. His castle, the oldest square keep in Scotland, was built in around 1145 and is mentioned in the Orkneyinga Saga of Norse legend as 'a fine stone fort…a really solid stronghold'. Excavated in the 1930s, it is a well-preserved site. The castle's tower has survived to a height of 15m (49ft) in places with walls approximately 1.7m (5.5ft) deep. A considerable height in its day, the archaeological site remains an impressive feature of the island. The castle is thought to have withstood at least one siege in 1231 when the assassins of Earl Haraldson, the last Norse Earl of Orkney took refuge there to escape the wrath of their victim's allies. With its stout defences the castle has been described as a 'very unhandy place to attack'.

6 St Mary's Chapel

The well-preserved St Mary's Chapel, close to the castle, was founded either by Cubbie Roo himself or by his son Bjarni Kolbeinsson, the Bishop of Orkney and a noted poet of the period. The chapel is accessible via the road and signposted from the castle.

7 Chambered Cairn

Chambered cairns are Neolithic burial sites and many can be found in Scotland, especially on the Orkney Islands. These tombs provide fascinating insights into Stone Age life through the human remains and possessions found. Many of the cairns discovered on Rousay and Wyre have multiple burial areas and archaeologists believe that groups of people were buried there.

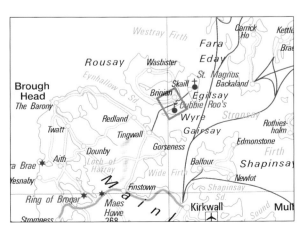

The MV Eynhallow at Rousay.

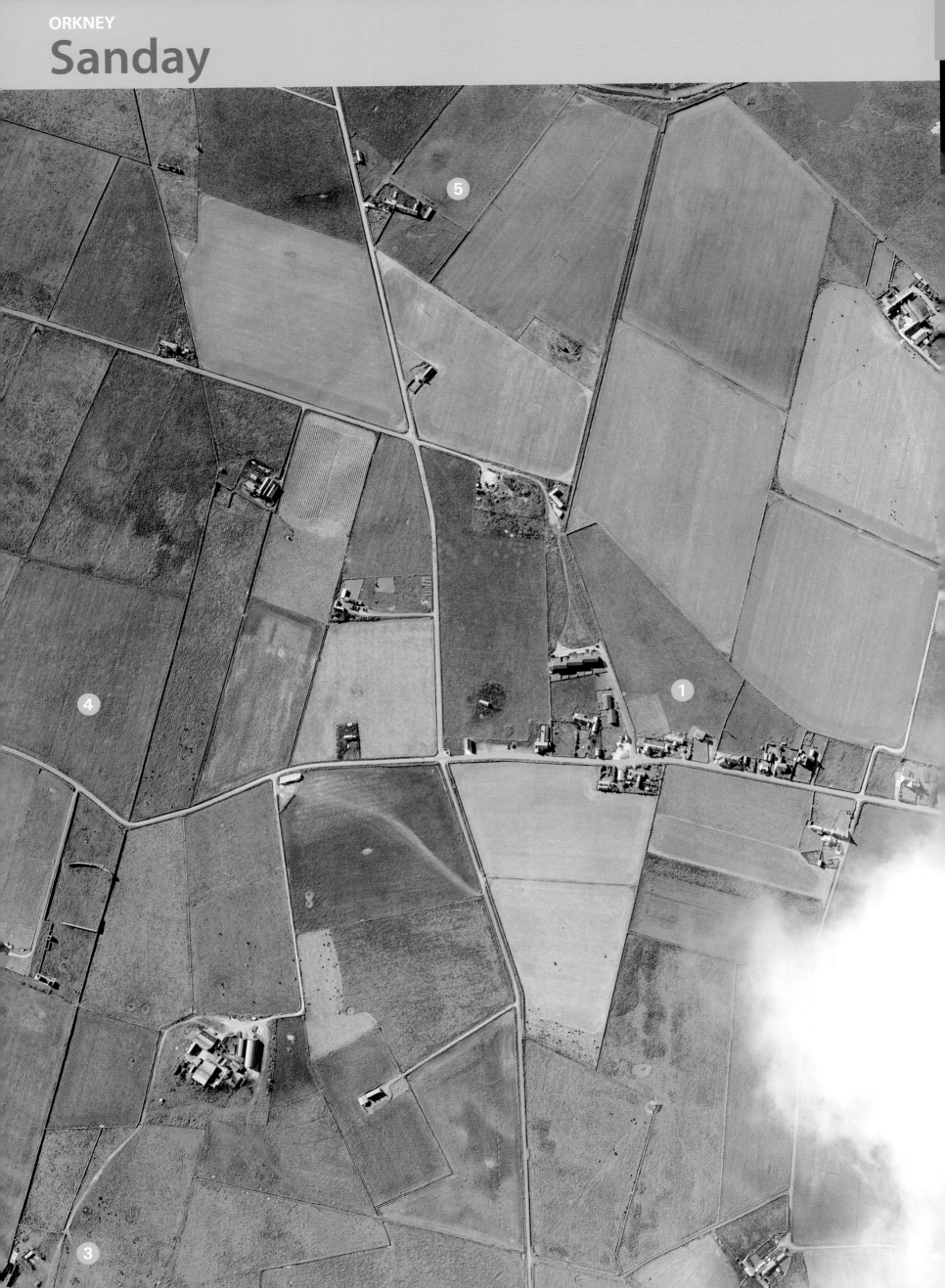

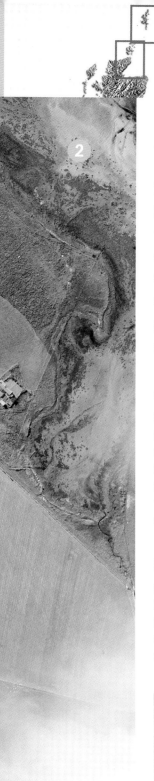

Sanday

Lying north-east of Kirkwall on the mainland and offering the best farmland in the Orkney Islands, Sanday is the largest of the North Isles of Orkney. Literally meaning 'sand island', Sanday is thought to have been underwater at one stage in prehistory, emerging to form the long coastline with many sweeping bays that can be seen today. Its white sandy beaches are a favourite with shell collectors and otter watchers alike. In 2009 the population of Sanday was around 500, having shrunk from a reported 2,000 people in 1883.

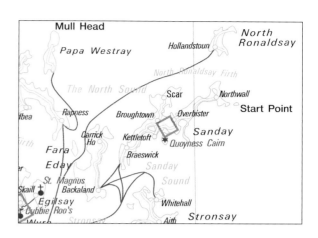

❶ Lady Village

Located in the centre of the island, the village of Lady is one of the main settlement areas on Sanday. The parish of Lady in the northeastern part of the island is bounded on all sides by sea. In the east its coast is deeply indented by the nearby Otterswick and Stywick bays. The National Gazetteer of Great Britain and Ireland in 1868 described the area of Lady as 'one-fourth…pasture or under cultivation, and the rest is either heath or waste.'

❷ Wildlife

Sanday is famed for its wildlife. Common and grey seals, known locally as selkies, are frequent visitors and can often be seen in Otterswick Bay during June. Otters, by contrast, are much more elusive creatures. Birds such as the Arctic tern, oystercatchers, redshanks and short-eared owls have all been spotted on the island.

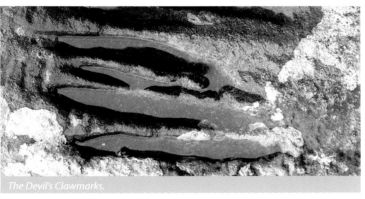

A view of Sanday looking south across the low-lying island.

The Devil's Clawmarks.

❸ Ladykirk ▽

Located off the main road to Kettletoft (outside the main image), Ladykirk is a ruined church of the village. A well-known feature of the building is the Devil's Clawmarks (see above), a strange set of unexplained grooves in a balustrade at the top of the church steps.

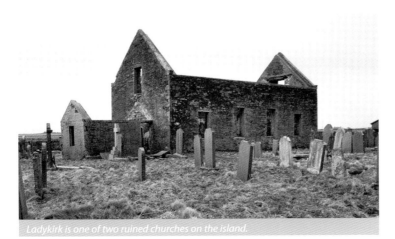

Ladykirk is one of two ruined churches on the island.

❹ Agriculture and Industry

The fertile soils of Sanday are derived from flagstone of the Old Red Sandstone Age dating from 40 million years ago. Improvements in farming occurred at the beginning of the 19th century as the kelp industry declined and landowners began to invest more in farming. A regular ferry link with Kirkwall on the Orkney mainland in 1836 saw a substantial increase in the area of land under cultivation for crops by 1860. Links to the mainland also led to an increase in the number of cattle kept, reaching 22,830 head in 1871 as well as 13,586 sheep. Innovations on the island were generally the result of individual enterprise, mainly from the tenant farmers – the sale of eggs, for example, became a valuable commodity in the Orkney economy.

Today, the main activities of Sanday include knitwear, beef cattle farming, lobster and crab fishing. Today there is also an electronics factory on the island.

❺ Myrtle Lane

In the 19th century, as the crofters of Sanday saw their fertile land increase in value, they faced the ever-present threat of eviction. Successive rises in rent made those who had improved their farms increasingly resentful of the landlords who made their tenants pay more in rent. A case in point was one John Grieve, who was given leave to settle on 18 acres of hill land at Myrtle Lane in 1847. He originally paid ten shillings a year for the uncultivated site, and saw his rent rise in three stages to seven pounds by 1889 – a more than tenfold increase. During that time he lost some of his hard-won land and, in its place, was given infertile fields to farm instead. However, the people of Sanday were, in general, more fortunate than those on Rousay who, twice in a lifetime, had to start from scratch, farming on a bare hillside.

Papa Stour

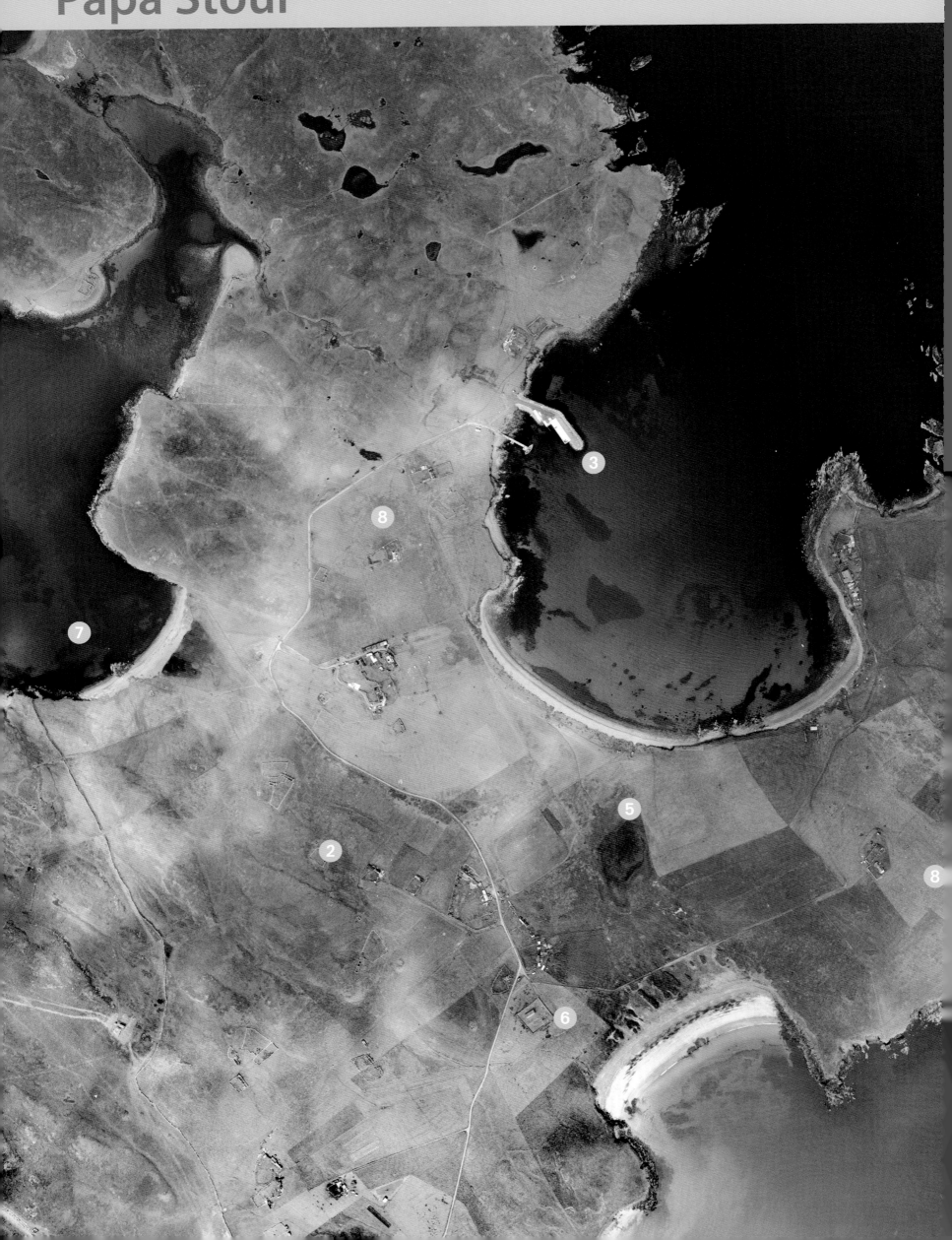

Papa Stour

On the western coast of Shetland at the southern tip of St Magnus Bay lies Papa Stour. The name derives from the Norse *papi* (priest) and *stòrr* which means large. The island was inhabited between the 6th and 7th centuries by a Celtic missionary community, although there is evidence of prehistoric settlement. It belonged to Norway until the late 15th century, when it was pledged to Scotland. In 1975 it was designated a site of special scientific interest for its wildlife and geology. Today the few remaining islanders are mainly crofters supplementing their income through fishing and tourism.

① Brei Holm

The first of many impressive sights on Papa Stour is seen when approaching the island by ferry. At Brei Holm a large tunnel has been eroded out of the rocks by the sea. The sea caves formed here are accessible but only by small boat and when weather conditions permit.

② Da Biggins

Archaeological excavations at the Da Biggins have unearthed the impressive foundations of a 13th-century Norse House. The remains of wooden floors suggest that this may have once been a significant building on the island and probably one of the oldest settlements in the area. Shetland's oldest document, a witness statement alleging slander, was signed here in 1299 at King Haakan's Royal Farm. The farm may well have been a *stofa*, or log-timbered house, imported from Norway. Archaeologists from St Andrews University carried out a survey of the area and a partial reconstruction was completed in 2008.

③ Housa Voe

Ferry services to the island arrive at Housa Voe pier after a 45 minute journey from West Burrafirth on the west mainland most days of the week. The passenger-only ferry carries cars very rarely because there is only one short road on Papa Stour and walking is the best way to see the landscape.

Gardie House near to the pier was once used by the Earl of Balcarres in the 19th century to confine his son, Edwin Lindsay. The young man, an officer in the Indian army, was punished for his refusal to fight in a duel and was subsequently imprisoned in the house for 26 years.

④ Maiden Stack

Maiden (or Frau) Stack is the tallest of the dramatic sea stacks on the approach to the island. Here, tradition says that a Norse lord imprisoned his only daughter in 1300 for refusing an arranged marriage. However, she was rescued from her confinement by a humble fisherman to whom she had given her heart and together they eloped to safety.

Papa Stour viewed from Mainland, the main island of the Shetlands.

⑤ Ting

Above the beach at Housa Voe is a circle of 46 stones thought to be where the Vikings held a local assembly. Here, Lord Thorvald Thoresson was accused of corruption as recorded in the oldest document found on the island dating from 1299; he subsequently fought and won a duel. At this time the island was the property of King Haakon of Norway.

⑥ The Church

The original church on the island is a listed building dating from the mid-19th century. A new window commissioned by the Reverend T G Reid was added in 1918. It features Christ calming the storm and was paid for by public subscription in memory of the six men of Papa Stour who died in the First World War. Services are still held in a nearby chapel. The old church, however, is no longer used because it has been declared unsafe.

A Robins Brae Mareel Shetland pony.

⑧ Miniature Shetland ponies ◁

Miniature Shetlands are mainly bred in a stud in the south-east of the island. They are exceptionally hardy, being able to weather the strong winds that sweep in from the Atlantic Ocean. Shetland ponies tend to graze on the east side of the island on grass and the kelp washed ashore on the nearby beaches. Such ponies have been used on the island for hundreds of years and are bred with a calm temperament.

⑨ SS *Highcliffe*

In February 1940 the 3,847 ton steamship SS *Highcliffe* sank off Forewick Holm to the southeast of Papa Stour. All 35 members of the crew were rescued safely by the local lifeboat. The wreck is one of the best-known scuba-diving attractions amongst the many sunken vessels in the area.

⑦ Wildlife

The wealth of marine life around Papa Stour has led to the waters being designated a Special Area of Conservation (SAC). The island is internationally recognised as an important area for terns that nest there in the summer breeding season. Puffins may also be found along the coast. Seals may be spotted in June and July and occasionally killer whales and porpoises can be seen swimming near the island.

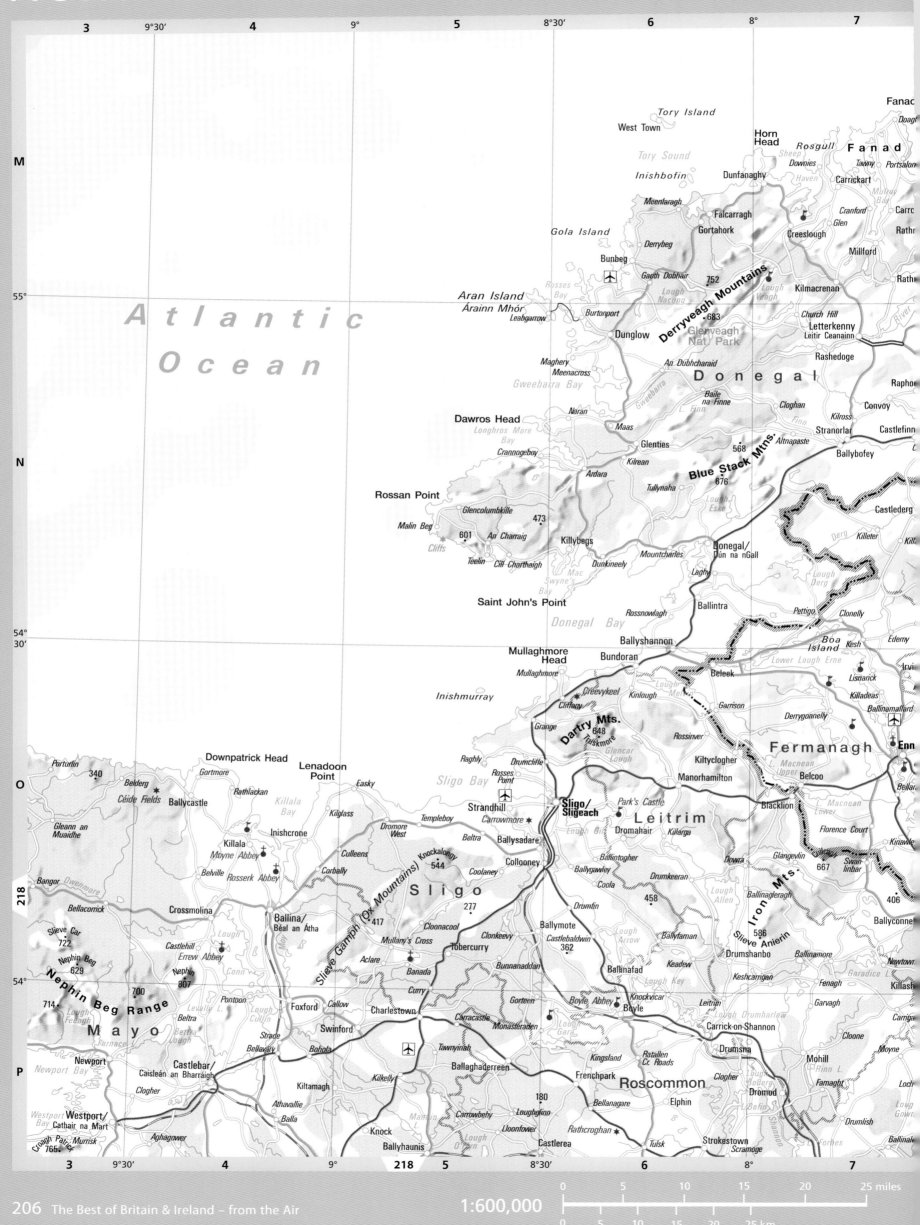

1:600,000

1 Belfast
2 Lisburn
3 Newry
4 Londonderry
5 Giant's Causeway

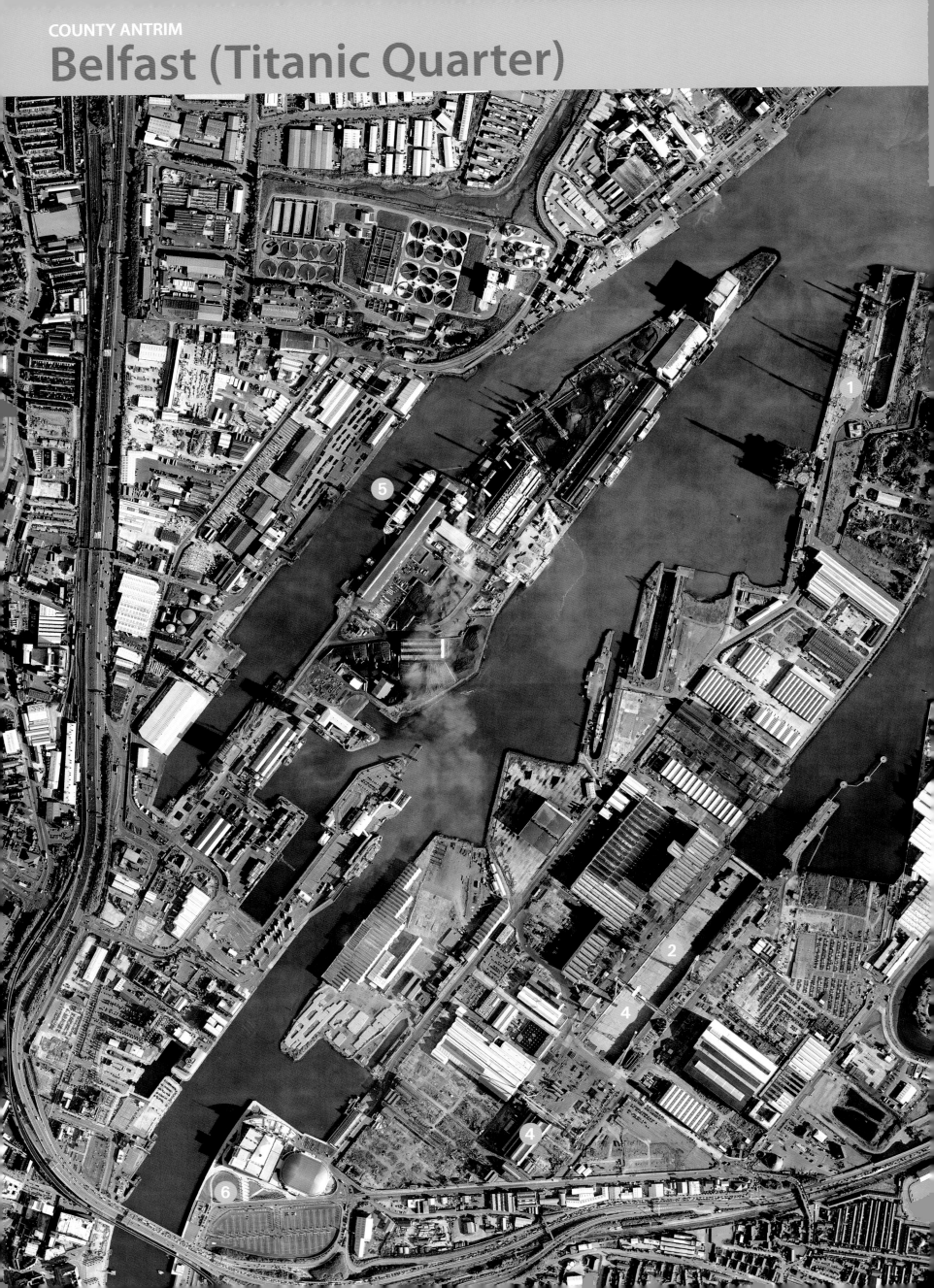

Belfast

Belfast has been the capital of Northern Ireland since the partitioning of Ireland in 1922. It is the province's largest city, with a population of about 270,000.

The Lagan is Belfast's most important river. It flows into Belfast Lough, where the docks, shown here, are located. Although Belfast was founded in 1603 by Scottish and English settlers, it was not until the 19th century that it grew significantly as a result of industrialisation. There were iron foundries, engineering works and whiskey distilleries and, although the cotton industry declined, the linen industry expanded. As a result, most of Belfast's grander buildings date from no earlier than the mid-19th and early 20th centuries. The city is the home of Queen's University, and the University of Ulster also has a campus here.

① The Titanic Quarter

The Titanic Quarter was formed when a channel was dug to bypass a bend in the Lagan River in the mid-1840s. Originally called Dargan Island, it was renamed in honour of Queen Victoria in 1849 but has been known as the Titanic Quarter since 2000. The shipyard of Harland & Wolff was founded here by Robert Hickson in 1853 and became the first yard in Ireland to build iron ships. In 1854, Edward James Harland bought the yard, and in 1861 Gustav Wilhelm Wolff became his partner. The company has since re-located and the old site is now the focus of the bold new mixed-use Titanic Quarter development.

② Harland & Wolff

The company built many great ships, including more than 70 for the White Star Line in the late 19th and early 20th century. Among these were the ill-fated *Titanic*, and her sister ships the *Britannic*, sunk in 1916 during the First World War, and *Olympic*, which continued in service from 1911 to 1935. The last cruise liner built by the company was the *Canberra* in 1960. The company was nationalised for a period but is now back in private hands, though with a much-reduced workforce of roughly 500. Today the yard's order books are filled mostly with ferries, oil tankers and floating drilling rigs. The company has also diversified into other areas such as offshore construction and bridge-building.

③ Bombardier-Shorts

Belfast is home to the aircraft plant of Bombardier-Shorts, a subsidiary of the Canadian company Bombardier. Shorts (also known as Short Brothers), has been located in Belfast since 1948 and was acquired by Bombardier in 1989. In 2008 the company celebrated its centenary with exhibitions, aircraft displays and special events.

④ Samson and Goliath

Two enormous gantry cranes, 'Samson' and 'Goliath', tower over Harland & Wolff's yard and are visible from most parts of Belfast. Their span is 140m (459ft) and they can lift 840 tonnes each – 1,600 tonnes in combination.

One of the *Titanic's* propellers weighing 38 tons.

⑤ The docks △

The first record of a ship being built in Belfast dates from 1636. The vessel was constructed by a group of Presbyterian clergymen. Shipbuilding began in earnest when William Ritchie, a Scot, founded a shipyard in July 1791. His first ship was the 300-tonne *Hibernia*. Before long, his brother Hugh had launched a second shipyard in partnership with Alexander McLaine. Their yard was the first in Ireland to build a steamboat – the *Belfast*. In December 1838 a third yard, Thompson and Kirwan, opened and, in 1851, they moved to the newly created Queen's Island.

⑥ Odyssey Arena ◁

Next to the Abercorn Basin is the Odyssey Arena, the largest indoor sports and entertainment venue in Ireland, which opened in December 2000. It can seat as many as 1,000 spectators and accommodate a huge variety of sporting events – boxing, running, basketball, tennis and motorcycling. It can also be converted into an ice-rink. On the same site is W5, an interactive science and technology centre, with an IMAX giant-screen cinema, shops and restaurants.

⑦ George Best Belfast City Airport

George Best Belfast City Airport is in the heart of Belfast and right next to the docks. Flights go to destinations in Britain and the Isle of Man, and to Cork in the Republic of Ireland. Its runway is 1.83km (1.14 miles) long. Despite being subject to strict pollution controls, the airport handles 2 million passengers annually.

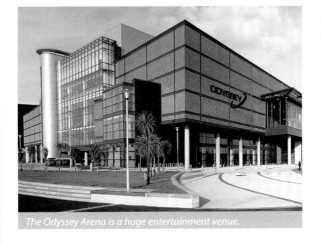

The Odyssey Arena is a huge entertainment venue.

Lisburn

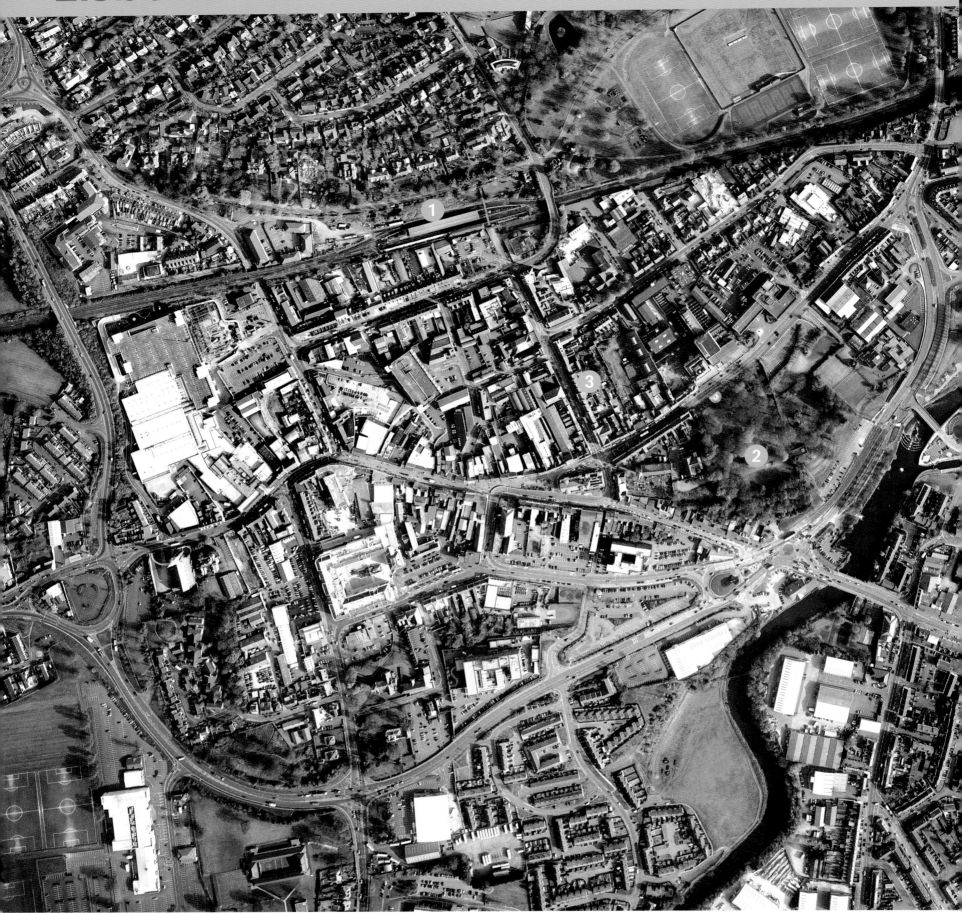

Lisburn

In 2002, Lisburn was granted city status as part of the Golden Jubilee celebrations marking the 50th anniversary of the accession of Queen Elizabeth II to the throne. With a population of about 116,000, it lies southwest of Belfast on the River Lagan in County Antrim. Many important government agencies have their headquarters here, including the Belfast Region of the Police Service of Northern Ireland (PSNI), and the British Army in Northern Ireland at Thiepval Barracks.

In 1698 Louis Crommelin, a Huguenot (French Protestant), was appointed Overseer of the Royal Linen Manufacture in Ireland. He not only invested £10,000 of his own money but also shared his knowledge and experience of the manufacturing process. Subsequently, the city became a centre of the Irish linen industry, and attracted a French community. Though flax had already been grown and spun in Ireland, the Huguenots possessed many secrets of the manufacture of linen which were unknown to the local people. Irish linen soon became to a byword for quality with a worldwide reputation.

② Castle Gardens

The Castle Gardens form part of the city's Historic Quarter. In 1707 the castle and the town burned down in a great fire. Only the castle's entrance gateway survives. Currently the gardens have been redeveloped using funding from the National Lottery Fund and in 2010 were granted the prestigious Green Flag award for the third consecutive year as one of the outstanding public green spaces in the United Kingdom. The improvements in the park include the restoration of the war memorial, the 17th-century garden terraces and the Wallace Monument which is dedicated to a benefactor of the town, Sir Richard Wallace.

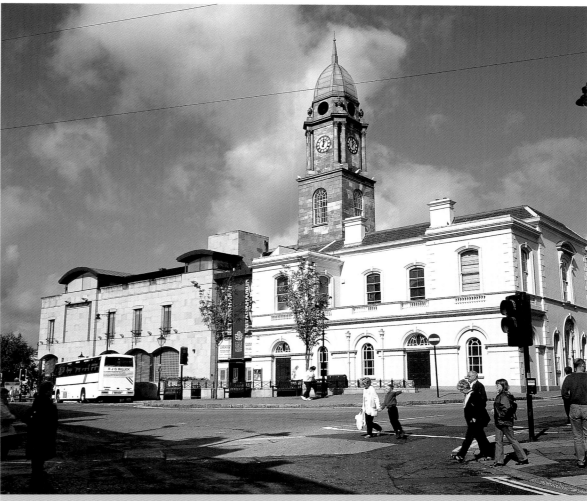

The Irish Linen Centre and Lisburn Museum houses three collections providing insights into the development of the industry. On display are artefacts, paintings by local artists and a photographic collection.

① Railway station

The first rail service from Lisburn was opened in August 1839, when an 11-km (7-mile) stretch of track between Lisburn and Belfast was inaugurated with 3,000 people travelling on that day alone. This was the first rail service in Northern Ireland (it had been preceded in the south by a service from Dublin to Kingstown (present-day Dun Laoghire) in December 1834). The railway station that can be seen today in Lisburn dates from 1890. Today the railway network in Northern Ireland is much reduced from its heyday in the mid-20th century.

③ Historic Quarter △

The oldest part of Lisburn has been designated as the Historic Quarter. It contains many ancient buildings that survived the city's great fire of 1707, and others that were built shortly afterwards. It is now the subject of municipal regeneration and development plans. Among the features to be found in the Historic Quarter are the railway station and market square as well as the County Antrim Infirmary, founded in 1767 by Act of Parliament and supported by private subscription. There is also a building that was the city's French Church in the 18th century, used by the Huguenot families engaged in the linen trade. It later became the courthouse, and then, with the adjoining building, became the town hall. It continued to be used for civic purposes until 2001. The Lisburn Museum and the Irish Linen Centre share a building dating from the 18th and 19th centuries.

④ Lagan Valley Island

This island was formed when the Lagan Navigation (waterway) was constructed in the middle of the 18th century. A section of canal was built to cut off the bend in the river here. It became known as Vitriol Island because a chemical works producing bleach for the linen industry was set up on the island. Later, a linen spinning-mill was built there and linen thread was produced on the island until 1983. The canal was subsequently filled in and has only been restored in recent times, so that Lagan Valley Island has once again become an island. The island is now home to a major complex of buildings that house the City Council offices, conference facilities and an arts centre. It is built on the site of a derelict linen mill and is surrounded by gardens. The arts centre has an extensive programme of classes and workshops. There is also a sculpture trail on the island.

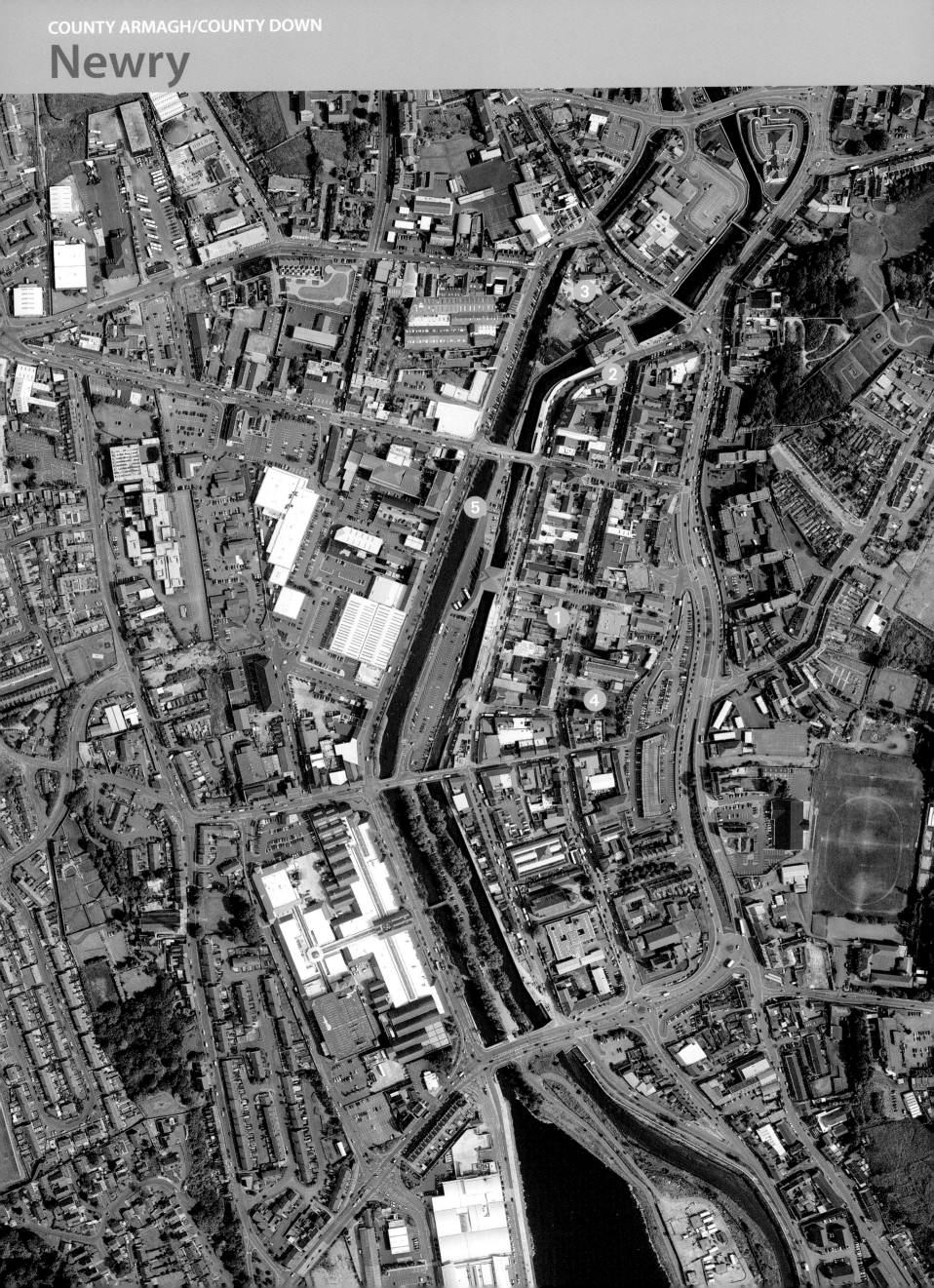

Newry

Lying partly in County Armagh and partly in County Down, this historic market town once stood at the head of the now disused Newry Canal. Newry retains its long-established reputation as a centre for trade and shopping and attracts visitors to nearby areas of outstanding natural beauty – the Mountains of Mourne and the Ring of Gullion. In 2002, Newry was granted the status of a city in celebration of the Golden Jubilee of Queen Elizabeth II's reign.

2 Newry Town Hall ▽

Designed by William Batt in the Classical style, Newry Town Hall was built in 1893. It stands on a three-arched bridge across the River Clanrye, which divides County Armagh and County Down – a location chosen following disputes between the people of the two counties over who was entitled to lay claim to the town hall building. The crest of the Newry Town Commissioners, bearing the date 1891, adorns the front of the building.

1 Historic town

Newry's original Irish name, *An iu(bh)ir C(h)inn Tra(ha)* ('The Yew at the Head of the Strand') derives from a story that St Patrick planted a yew tree here, at the head of the strand of Carlingford Lough, in the 5th century. St Patrick is also reputed to have established a monastery, which is said to have burned down – together with the yew tree – in 1162. A few years previously, in 1157, Maurice McLoughlin, the King of Ireland, founded a Cistercian monastery at Newry. After the dissolution of the monasteries in the 16th century, King Edward VI granted the monastery to Sir Nicholas Bagenal, Marshall of the King's Army in Ireland, who established a garrison there. The building which later became McCann Bakery on Abbey Way, closed in 1996. The building, known as Bagenal's Castle, has been redeveloped and now forms part of the Newry and Mourne Museum.

Sir Nicholas Bagenal developed a significant part of the town and also built the Parish Church of St Patrick, Ireland's first Protestant church, in 1578. A 16th-century map shows 'Bagenal's Castle' – thought to be the former Abbot's House – on the east side of the new area of town that he laid out within ditches and earth banks. Several two-storey houses are depicted, together with a tree stump, perhaps representing St Patrick's yew tree. In 1575 Bagenal played host to an important visitor: Sir Henry Sidney, the Lord Deputy of Ireland, who approved of the 'well planted' town. In 1689 Newry was burned almost to the ground by the forces of James II, during the campaign in Ireland to regain his throne from William and Mary. Only the rebuilt castle and six houses survived the flames. But the town's fortunes soon revived. By the mid-1700s Newry was Ulster's most prosperous port, its trade greatly stimulated by the construction of the Newry Canal. The coming of the railways in 1849 brought further development, by which time the population of the town had increased to nearly 16,000.

3 Newry and Mourne Museum

The museum, opened in 1986, contains diverse collections and includes exhibitions relating to Newry's prehistoric past, the coming of the Cistercians and the building of the monastery, the development of the town, the building and use of the Newry canal and local working life and folk traditions. Early 18th-century architectural features from Newry's Upper North Street were rescued during redevelopment work in that part of town in the 1960s and placed on display in the museum. An exhibition about 'Bagenal's Castle', the building used as a garrison by Sir Nicholas Bagenal, attracts many visitors. There is also an oral history project which captures the experiences of local people.

Newry's classical town hall sits in both Armagh and Down counties.

4 Cathedral of St Patrick and St Colman

The cathedral was designed by the Newry-born architect Thomas J. Duff. Construction started in 1823 and lasted for six years; the cathedral was built using local granite. It was the first Catholic cathedral to be built in Ireland since the Reformation in the 16th century. The cathedral was dedicated in May 1829, shortly after the passing of the Emancipation Act that allowed Catholics to sit as members in the Westminster Parliament. Two transepts were added in 1888 and a bell-tower was built in 1891; the nave was lengthened by 12m (40ft) and a new sanctuary area created between 1904 and 1909. Craftsmen from Italy worked for five years to install the marble and mosaics in the cathedral's interior.

5 Newry Canal

The canal was built using 15 locks across 28km (18 miles) of difficult country that rose to a height of 23m (78ft) above sea level. Work began in 1731 under the supervision of engineer Richard Cassels, a German immigrant. The commissioners replaced him with the Englishman Thomas Steers three years later. Opened in March 1742, the canal provided a route for transporting coal from the Tyrone coalfields to the Irish Sea and connected Newry to Whitecoat Point, 2km (about a mile) south of Portadown on the River Bann. The Newry canal connects Lough Neagh and the Lower Bann, which drain into the Atlantic, with the Upper Bann and Carlingford Lough, which also drain into the Atlantic. The Newry canal was the first man-made waterway connecting two rivers separated by a ridge in Britain, and is known as a summit level canal. Barges on the canal carried cargoes including coal, grain, flax seed and linen cloth. But as the railways spread, fewer goods were carried by water and the last working journey on the canal was in 1936. Today, the route of the canal can be followed on the south bank, starting by the Town Hall. Close to Steenson's Bridge section lies Goragh Wood, which was Newry's main railway station and, as the last stopping place before the Irish Republic, a customs point.

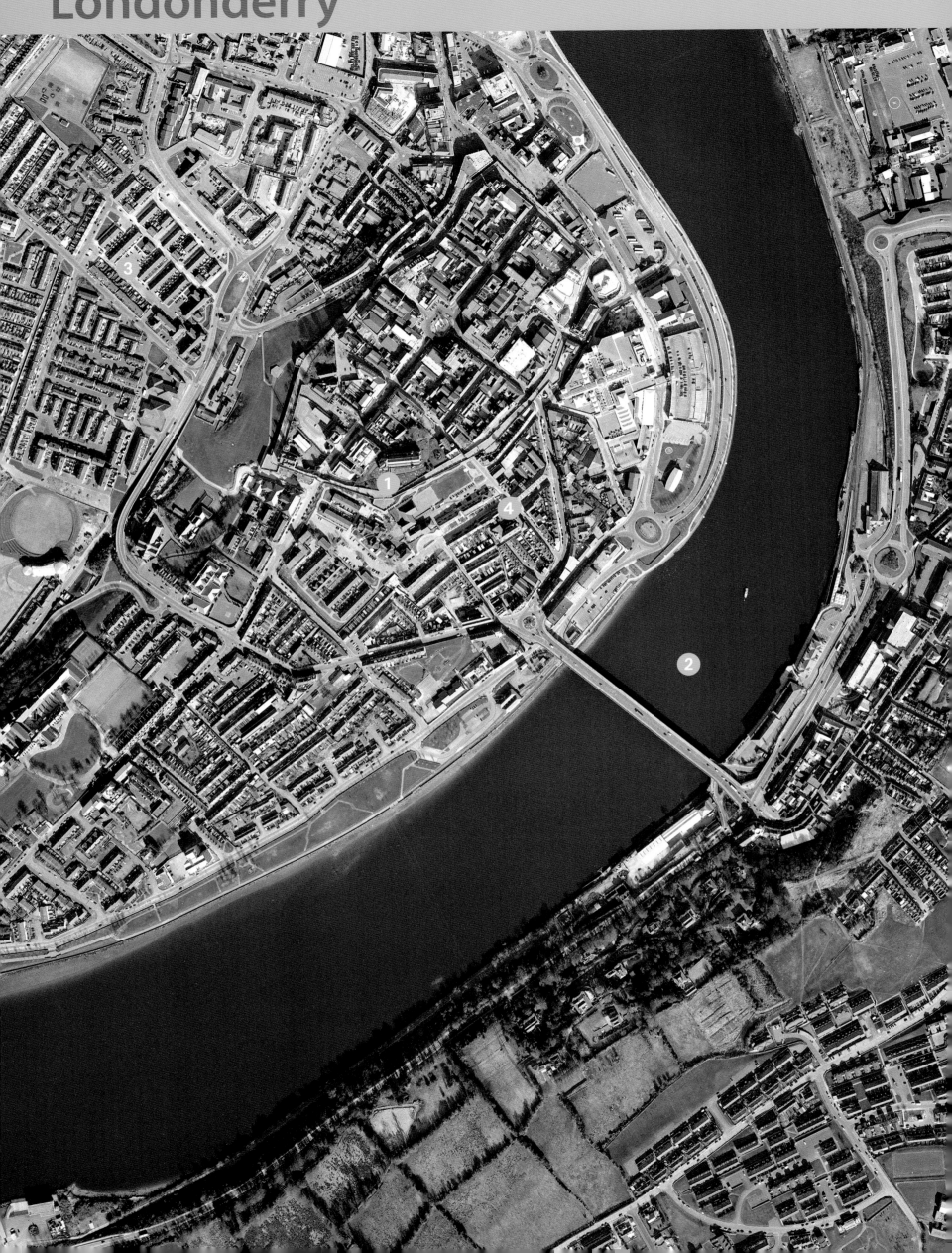

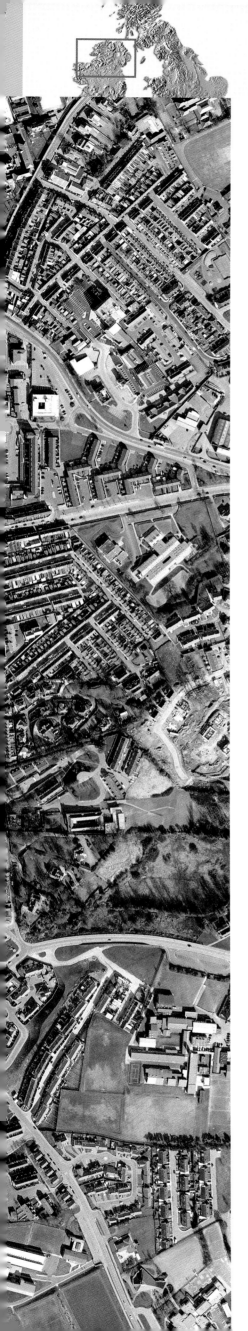

Londonderry

Sitting astride the River Foyle, Londonderry – or Derry – is Northern Ireland's second largest city, after Belfast. The original 17th-century settlement, on the west bank, is the only fortified city in Ireland whose defensive walls survive intact. The city withstood a siege by the forces of James II in 1689. Between the 1960s and 1990s the city, in particular the Bogside area, was a flashpoint for the sectarian violence known as 'the Troubles'.

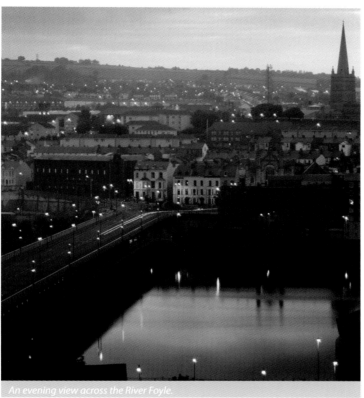

An evening view across the River Foyle.

① City walls

Visitors can walk the ramparts of the city's 17th-century walls, which are 5.4m (18ft) thick and 2km (1.2 miles) in circumference and still have the air of impregnability. The original black cannon remain in place. In 1987, sculptor Antony Gormley, creator of the celebrated *Angel of the North* in Gateshead, designed and installed three pairs of figures standing back-to-back with outstretched arms on the walls.

The walled city was built in the early 17th century as part of King James I's policy for the 'Plantation of Ulster', in which the region was colonised by Protestant English and Scottish migrants. The new settlement, designed and constructed under a charter of 1613 granted to the City of London, was named 'Londonderry'. Its elegant layout, with four main streets leading out from a central point to the four gates – Butcher's Gate, Shipquay Gate, Ferryquay Gate and Bishop's Gate – has survived to this day.

After the city's foundation, it grew slowly, and by the 1680s had around 2,000 inhabitants. During the English Civil War, Londonderry supported the Parliamentarians: in 1649 it survived a siege by a troop of Scottish royalists. Then, on April 18, 1689 James II arrived at Londonderry and demanded the city's surrender. But the people of Londonderry refused to accede to his demand and the celebrated slogan 'No Surrender' was born. The Siege of Derry lasted 105 days and cost thousands of lives, both within the city and among the besiegers. Finally, in late July 1689, a relief ship, the *Mountjoy*, brought the siege to an end.

② River Foyle

Craigavon Bridge connects the old walled city of Londonderry on the west bank to the modern development on the east bank of the River Foyle. The bridge was built in 1933, replacing an earlier steel bridge (Carlisle Bridge), which had been erected in 1863. Carlisle Bridge was itself a replacement for Londonderry's first bridge, made of wood and built in 1790 around 90m (300ft) north of the present bridge in the Bridge Street area.

③ Bogside

The traditionally Roman Catholic Bogside area was at the centre of the Irish 'Troubles'. In 1968 riots erupted there following a civil rights march. In August 1969 there was further violence when the police attempted to disperse Catholic residents who were protesting at a Loyalist Apprentice Boys parade along the city walls. Known as the 'Battle of the Bogside', these events have been identified by some as the start of 'the Troubles'. In January 1972 British soldiers shot 26 protesters and bystanders during a civil rights march. Thirteen men, seven of them teenagers, died immediately and another died later of the injuries he sustained in what has become known as 'Bloody Sunday'.

④ St Columb's Cathedral

The Gothic Cathedral of St Columb was built in 1633 as part of the city's 17th-century development by the master builders of the City of London. In its porch visitors can read the inscription: 'If stones could speake then London's prayse should sounde Who built this church and cittie from the grounde'.

Memorials and relics relating to the Siege of 1689 were later installed in the Cathedral. The keys to the city gates that were locked against James II's army are displayed in the chapter house, while in the Cathedral there is a memorial to Colonel Baker, the city governor who died on the siege's 74th day, and to Captain Browning, who was killed as the *Mountjoy*, an armed merchant ship, broke through the boom across the River Foyle to lift the siege. The Cathedral's stained-glass windows celebrate scenes from the siege.

St Columb's was the first Protestant cathedral built in Ireland following the Reformation. The Honourable Irish Company, formed in London under King James I's 1613 charter to build Londonderry, sent a silver-plate chalice and paten that is still used in the Cathedral on special occasions.

Overleaf: the polygonal columns of the Giant's Causeway, County Antrim.

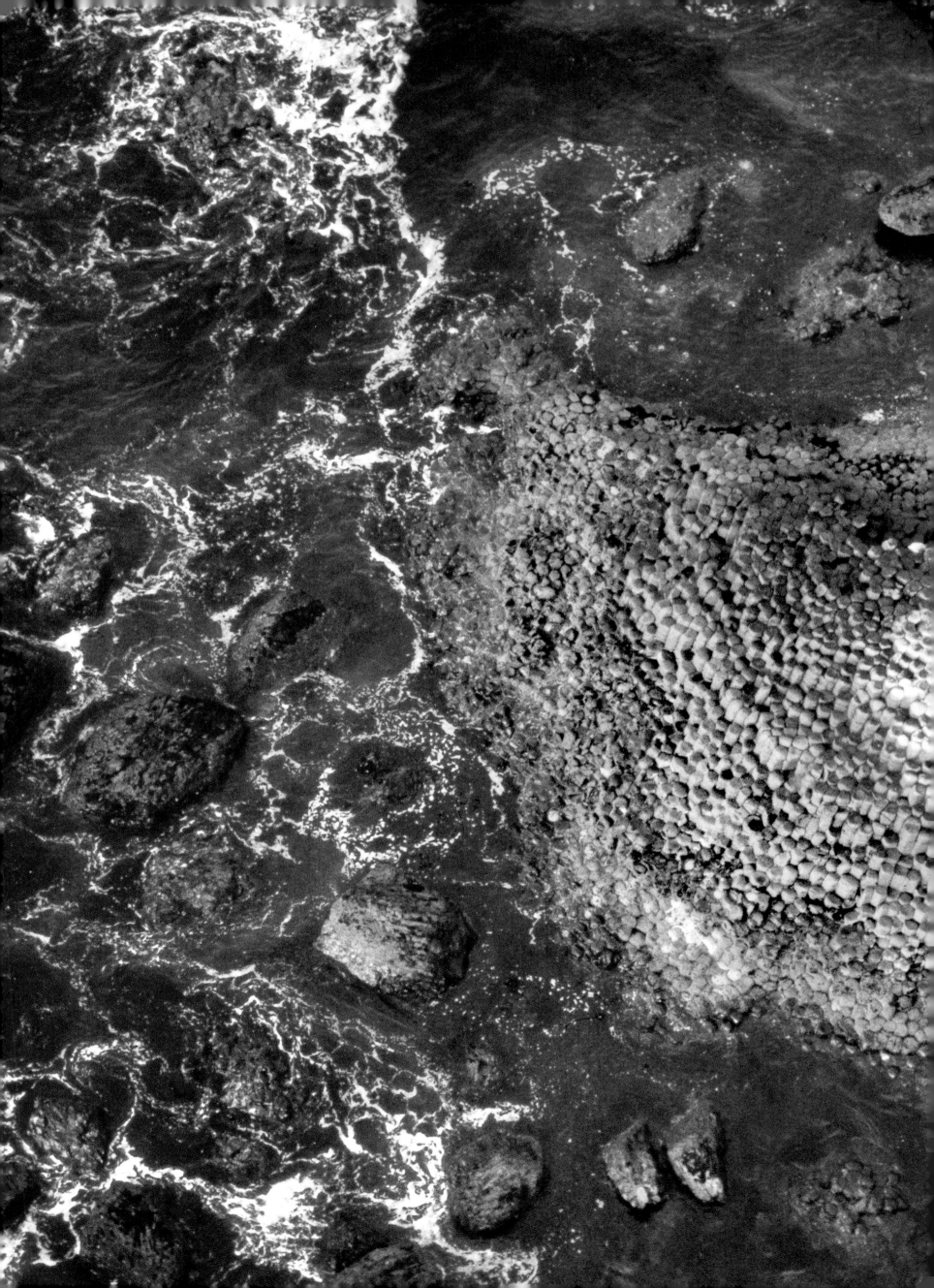

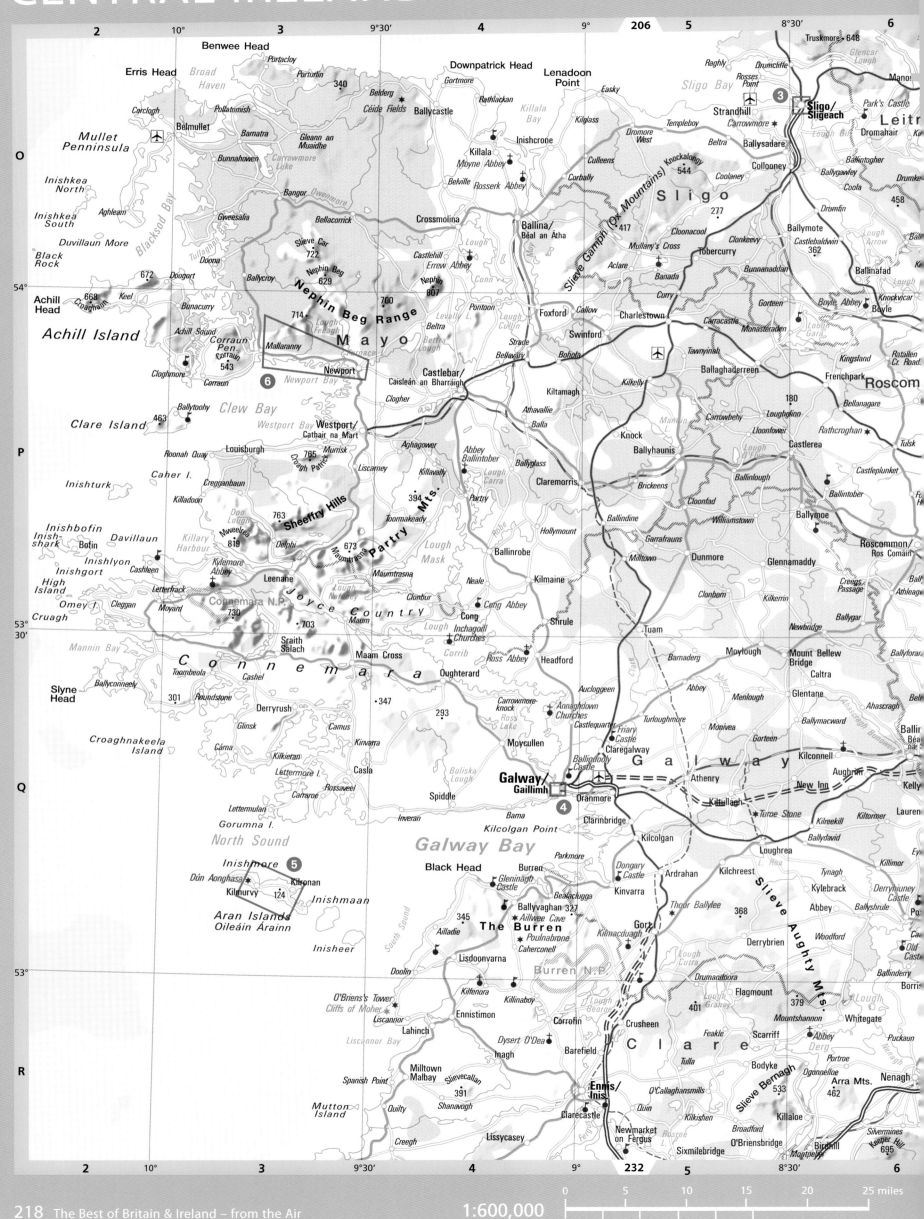

1:600,000

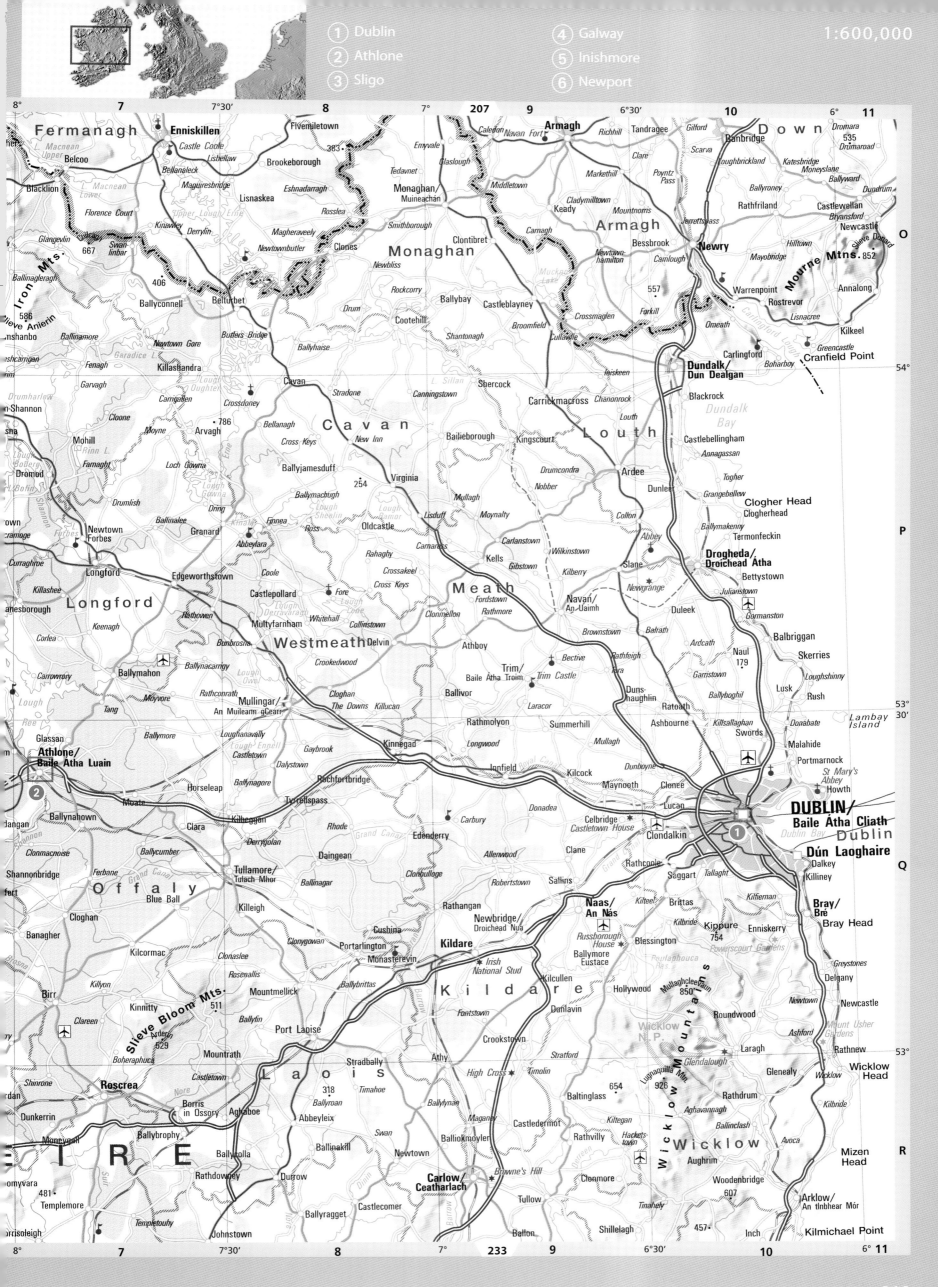

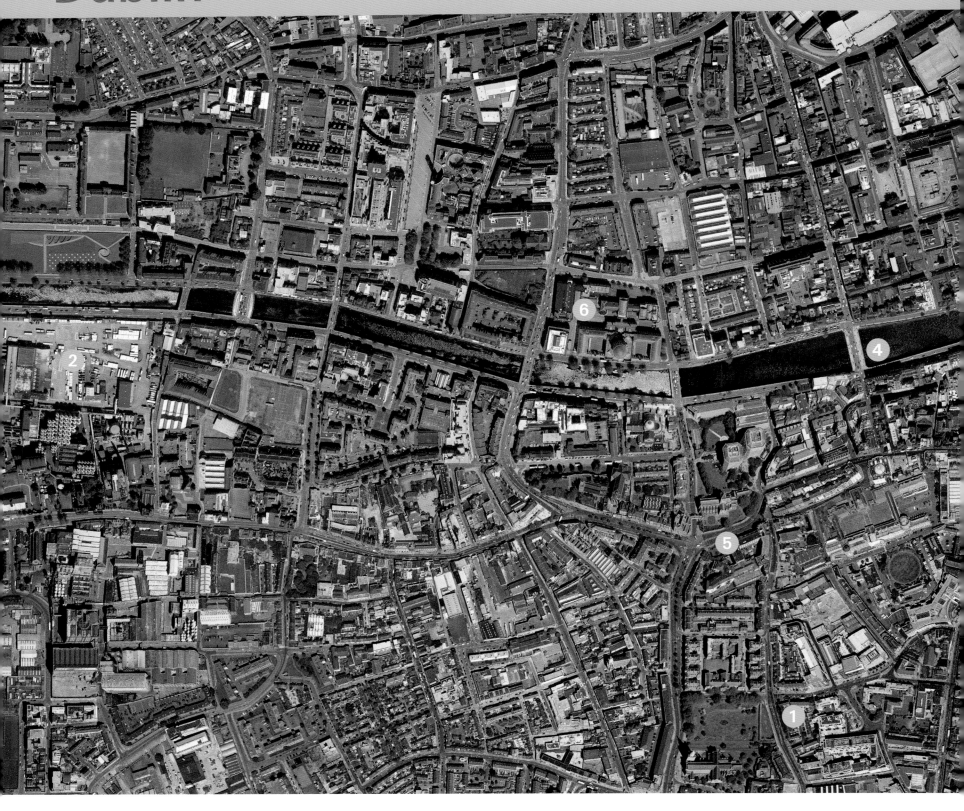

Dublin

Ireland's capital city takes its name from the 9th-century word for 'Black pool', or *dubh linn*, that formed at the meeting of the River Poddle and the River Liffey. Founded by the Vikings in 841, the fortified settlement became a trading centre. Its chequered past is one of unrest and change. The Great Famine of 1845-49 brought destitution to Dublin and Ireland. As a result thousands of people fled the countryside for the capital. An estimated one million people starved to death during that time; the same number emigrated to North America and Australia. Nonetheless, throughout its history Dublin has remained a vibrant cultural centre, and has produced some of the world's most influential writers, most famously James Joyce, whose *Ulysses* immortalises much of the city. During the 1990s an influx of high-technology industries to the city and its immediate surroundings transformed Dublin into a sophisticated European metropolis.

① Dublin Castle

Situated on high ground, Dublin Castle occupies a commanding defensive position. The Plantagenet king, Henry II, came to Dublin in 1171 to receive the submission of the Irish chieftains after his troops had taken the city, and the old Viking fortifications were strengthened. Henry's son, John, was responsible for the construction of the stone castle which was begun in 1204 and completed by 1230. As the seat of English colonial administration, the castle was at various times the parliament building, the official residence for royal representatives and a prison. Now it is largely used to entertain heads of state and as the location for European Union summit meetings. In 1684, most of the mediaeval building was destroyed by fire; only the Record Tower remains. Most of the building, with its imposing Great Gate and palatial state apartments, dates from the Georgian period.

② Guinness Brewery and Guinness Storehouse

Ireland's most famous export started life in 1759 at the St James's Gate Brewery, when Arthur Guinness began producing a beer made from roasted barley. By 1838, the brewery was the largest in Ireland. The Guinness Storehouse, in a renovated fermentation building, provides an extensive audio-visual history of the brewery as well as a bar on the top floor. Guinness is now part of Diageo PLC.

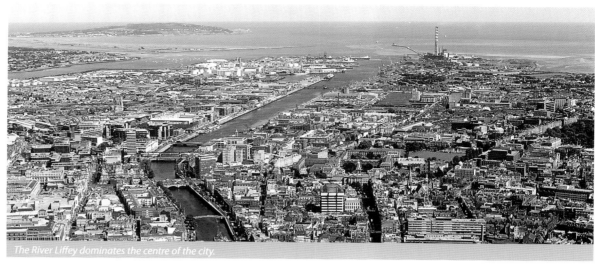

The River Liffey dominates the centre of the city.

③ Trinity College

Founded by a royal charter of Elizabeth I in 1592 on the site of the former All Hallows monastery, Trinity College is the oldest university in Ireland; it first admitted women as students in 1904. It remains a thriving seat of learning whose graduates include Jonathan Swift, Oliver Goldsmith, Bram Stoker, Oscar Wilde and Samuel Beckett. Trinity College Library's Long Room, which is over 65m (213ft) long and dates from 1712, houses an outstanding collection of Irish manuscripts, including the Book of Kells. Other interesting campus buildings are the 30m (100ft)-high campanile and the 18th-century printing house, with its impressive Doric temple front.

④ River Liffey △

Also referred to as 'Anna Livia', from its Irish name *An Life*, the River Liffey divides the city into north and south. The mouth of the river provided a landing-place for the ships of the 9th-century Viking invaders. It is spanned by many bridges, from the pedestrian 'Ha'penny Bridge' – originally a toll bridge, and the unofficial symbol of Dublin – to the starkly minimalist James Joyce bridge.

⑤ Christ Church Cathedral

Originally founded in the 11th century by the first Bishop of Dublin, the present structure dates from 1172 when the first Anglo-Norman archbishop, John Comyn, started a new building. The Romanesque cathedral was completed in 1240, and in the 15th century an extended choir was added. The south nave wall collapsed in 1562, with the the temporary repair lasting until the 1870s. An overhaul of the entire building from 1871 to 1878 by the architect George Street was paid for by a Dublin whisky distiller. The massive Romanesque crypt was restored in the 1990s.

⑥ Georgian Cityscape

Georgian buildings like the Bank of Ireland, City Hall, Four Courts, and Leinster House remain as evidence of Dublin's 18th-century architectural glory. At a more domestic level, the Georgian legacy endures in the many gracious terraces, spacious streets and squares that characterise much of the central area. Particularly interesting are the variety of Georgian doors, windows and fanlights, which managed to escape the strict building regulations of the period.

⑦ Spire of Dublin (the Monument of Light)

At 120m (393ft) high, the Spire of Dublin is the tallest structure in the city centre. It was completed in 2003, and was built to replace Nelson's Pillar, a 19th-century monument that was blown up by the IRA in 1966. The swaying stainless steel 'needle' is 3m (9ft) wide at its base and 15cm (5in) wide at its top, where it is illuminated by 1,200 small lights.

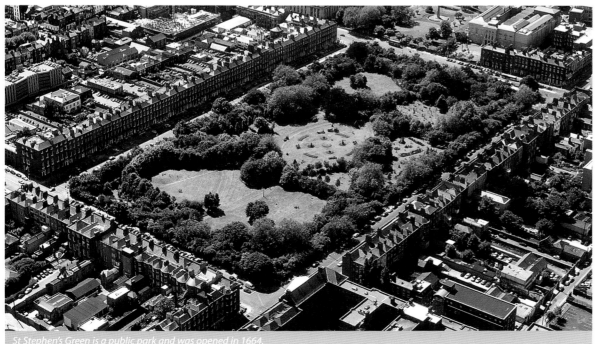

St Stephen's Green is a public park and was opened in 1664.

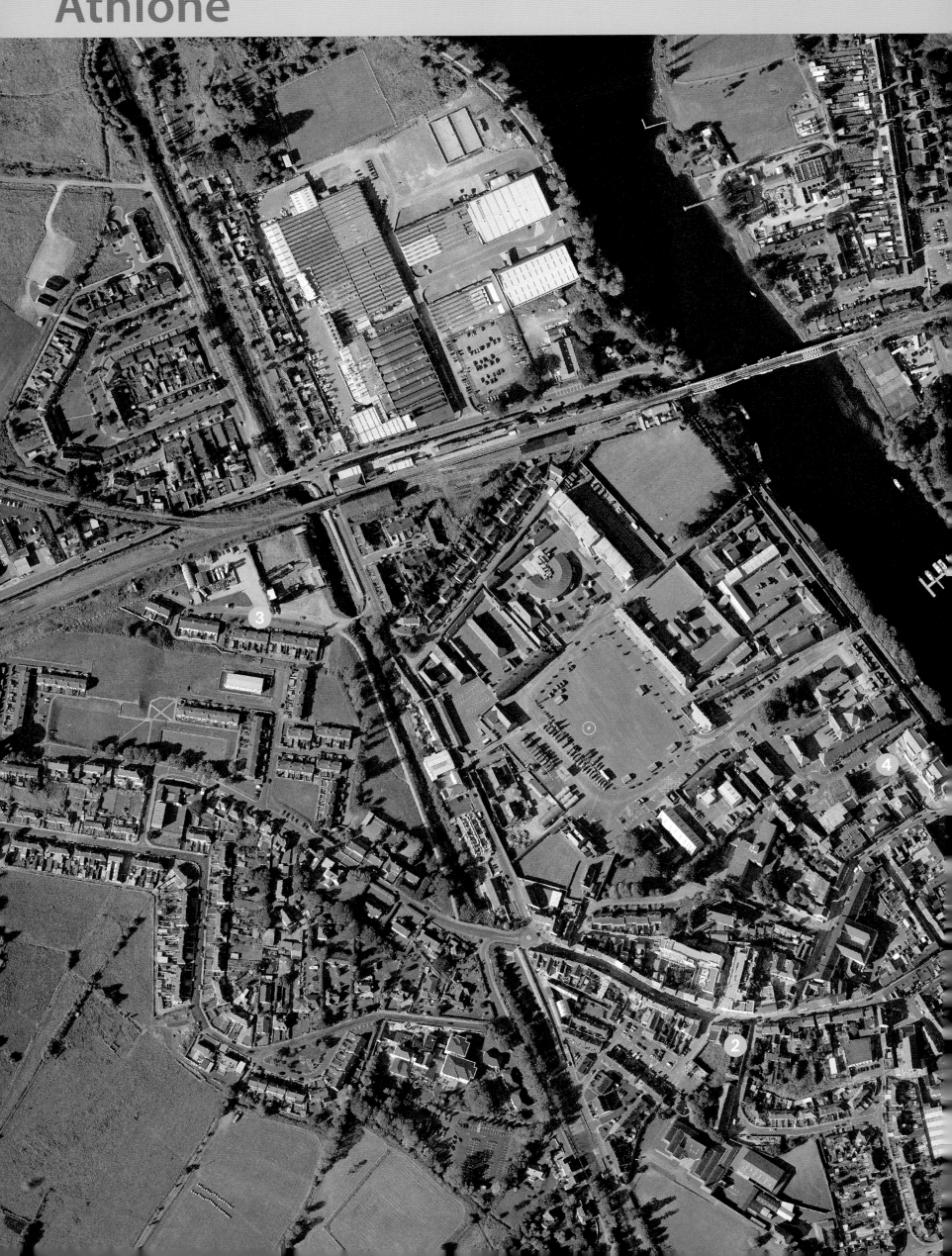

Athlone

Athlone's position as a crossing point on the River Shannon has characterised its history in terms of economic development and strategic significance. The first recorded bridge – a wooden structure – was built by the King of Connaught in 1120 and was quickly supplemented by a protective wooden castle in 1129. Frequently a place of battle for control of the crossing, the town is perhaps best known for the siege of 1691 by William III's army when the Irish armies retreated to Athlone following their defeat by the English army at the Battle of the Boyne in 1690.

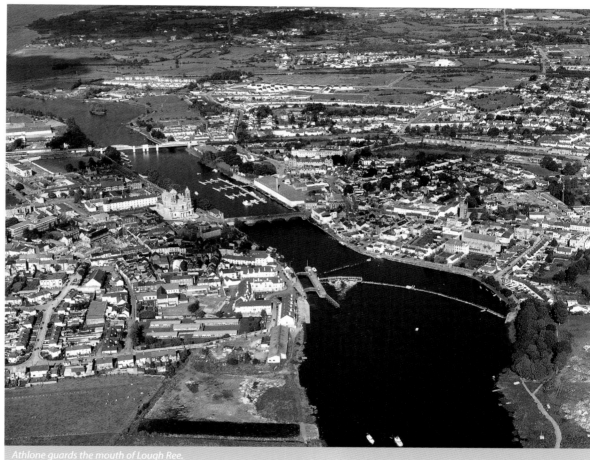

Athlone guards the mouth of Lough Ree.

① Athlone Castle

On the west bank of the Shannon, the castle has always been the town's first line of defence. The current structure has been rebuilt and remodelled several times since its first construction in 1129 by the Normans on the site of an earlier wooden fort. The drum-shaped towers date from the 13th century. It was badly damaged in the siege of 1691, in no little part due to the 12,000 cannon balls that were fired by the advancing English forces.

② Connaught Street

A well-known street of Old Athlone, Connaught Street once contained many of the town's major businesses. Even today some of the most interesting and curious shop fronts still survive, the most unusual of which is the doorway of the Noggin Inn. Connaught Street has been immortalised by the poet Desmond Egan and the author John Broderick, who both lived on the street.

③ The Batteries

After the outbreak of war with France in 1793 and the attempted invasion at Bantry Bay in 1796, eight batteries were built on the western edge of Athlone. Only part of one remains but the name refers to the whole area – the first location of the Athlone Golf Club.

④ St Peter and St Paul's Church

Located at St Peter's Square, the impressive St Peter and St Paul's Church is often mistaken for a cathedral because of its monumental size. A priory of the same name had stood on the site since before the 13th century, but the first St Peter's Church was not built until the end of the 18th century. Enlarged in 1809, St Peter's served as the parish church until the Church of St Peter and St Paul was completed in 1837.

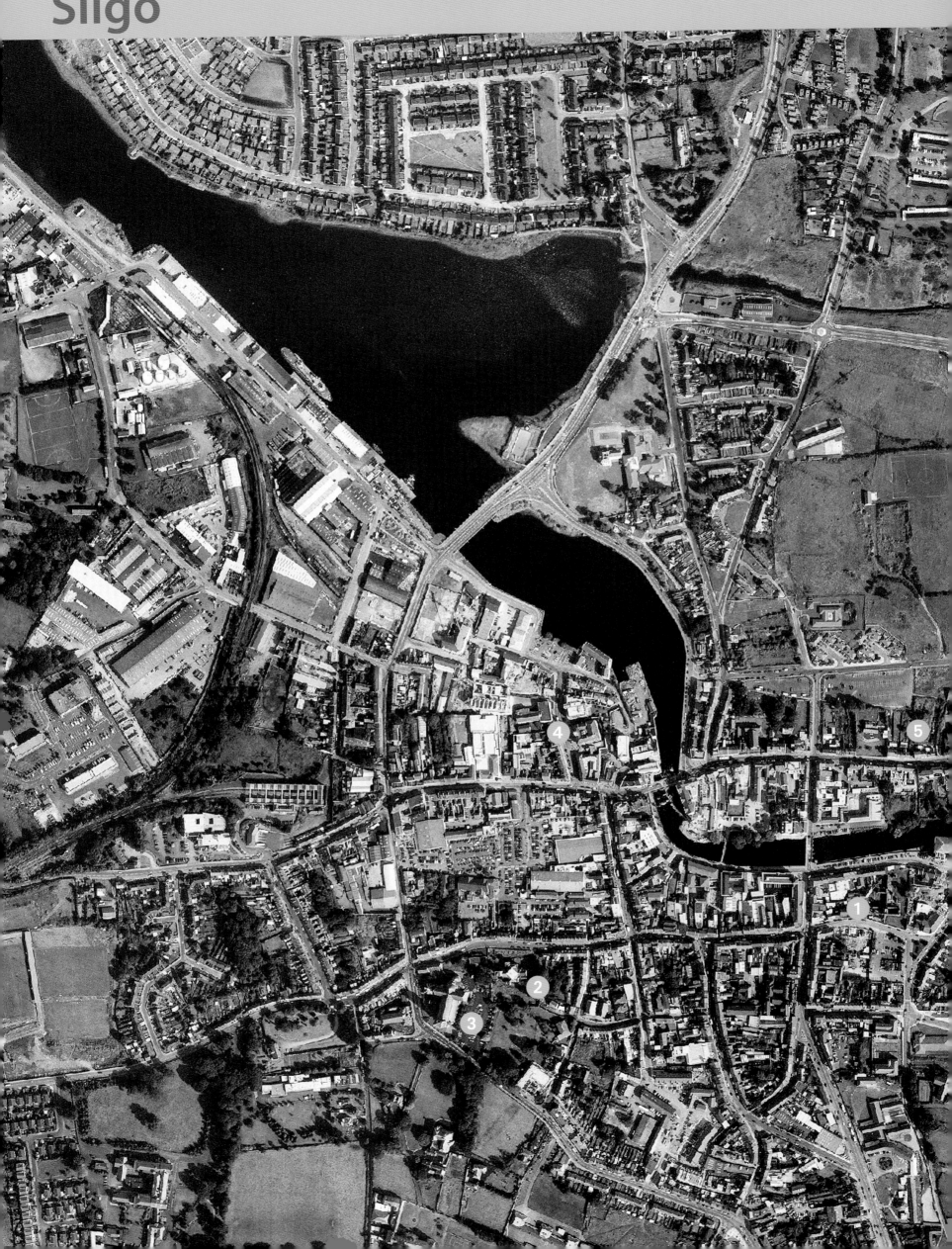

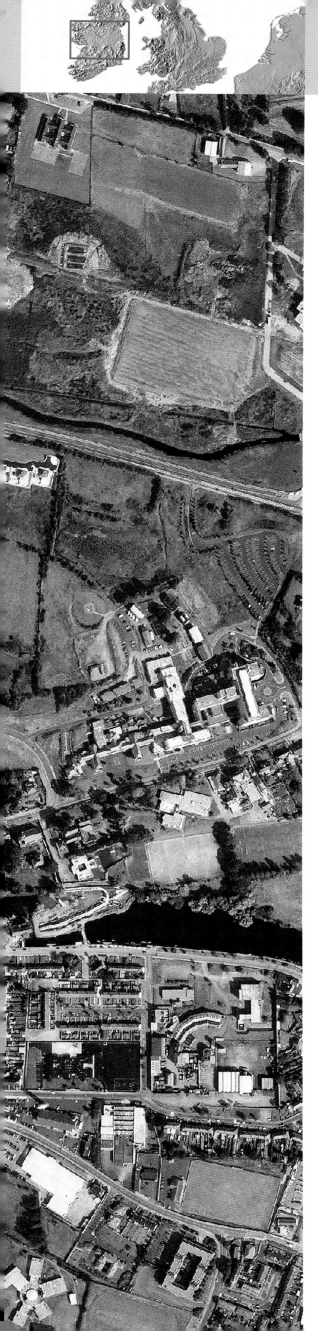

Sligo

Located on Sligo Bay at the mouth of the River Garavogue and close to the picturesque inlet of Lough Gill, Sligo thrives as a port, a salmon-fishing base and a holiday destination. The town and bay derive their name, which means 'the Place of Shells', from the large numbers of shellfish found along the coast and in the river. These plentiful natural resources made the area an attractive place to settle in ancient times, and at nearby Carrowmore there is a group of megalithic monuments, parts of which are believed to date from the 4th millennium BC.

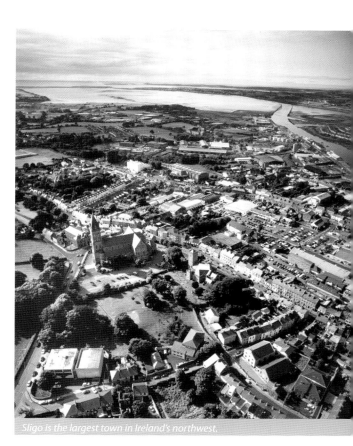
Sligo is the largest town in Ireland's northwest.

① Sligo Abbey

Sligo Abbey was founded as a Dominican friary in around 1252 by Anglo-Norman Maurice Fitzgerald. The building's actual name is the Convent of the Holy Cross, although it is commonly referred to as Sligo Abbey. The abbey has had a troubled history including destruction by fire and attacks in the 1595 Tyrone War and the 1641 Ulster Rising. The Dominicans remained until 1760, when they moved to the Holy Cross Priory. There are six 13th-century lancet windows in the choir, as well as a carved 15th-century stone altar. There is also a 1624 monument in the choir to Sir Donagh O'Connor, Lord of Sligo.

② Cathedral of St Mary the Virgin and St John the Baptist

A much-modified Georgian building, Sligo's Protestant cathedral in John Street was designed by German architect Richard Cassels in 1730, and constructed on the site of a 13th-century almshouse and a 17th-century mortuary built by Sir Roger Jones of Banada, Governor of Sligo. The grave slab from Sir Roger's tomb can be seen in the church's west wall. The glass and fittings date from the Victorian period. Near the pulpit a brass plaque commemorates Susan Mary Yeats, who came from a wealthy Sligo family and was the mother of the poet William Butler Yeats and the painter Jack Yeats. Her father, William Pollexfen, lies buried close to the church's main gate. Also in the graveyard is the family plot of the Thornleys, whose daughter Catherine was the mother of Bram Stoker, the author of *Dracula*.

③ The Cathedral of the Immaculate Conception

Designed by English architect George Goldie in the Romanesque style, Sligo's Roman Catholic Cathedral was built by Laurence Gillooly, Bishop of Elphin, and dedicated in 1874 by the Archbishop of Dublin, Cardinal Cullen. The cathedral's main entrance faces away from the town – a requirement of the Protestant landowner who sold the land on condition that, if used for a Catholic Church, the church's doors must face away from the town. The peal of nine bells is struck rather than rung because of fears that their loud ringing might cause the spire to crumble.

④ Sligo Town Hall

Built in the Italian Renaissance style to designs by Dublin architect William Hague, the town hall was constructed between 1865 and 1872 using limestone dressed with contrasting County Donegal rock. It stands on the site of a 17th-century stone fort. The statue in front of the Town Hall celebrates a former Lord Mayor of Sligo.

⑤ The Niland Collection

Situated in a former schoolhouse dating from 1862, the Niland Collection has a permanent display of paintings by Jack Butler Yeats, brother of the poet William Butler Yeats. Both brothers had strong Sligo connections – Jack was educated there and William spent many childhood holidays in the town. William is buried in the graveyard of the Protestant church at Drumcliffe, as he had asked in a poem in his final collection. His grave is marked with the epitaph he wrote: 'Cast a cold eye on life, on death. Horseman, pass by!'

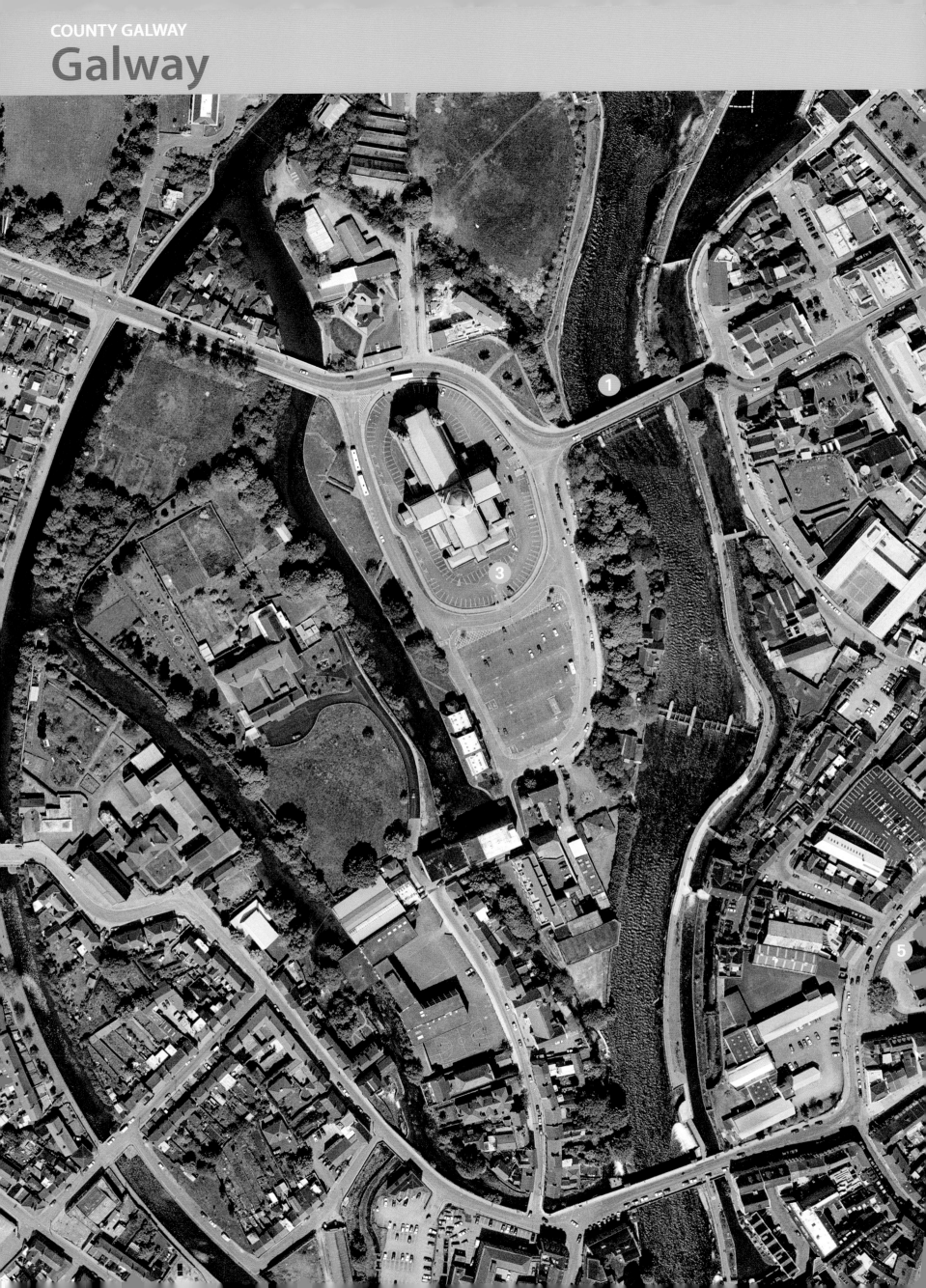

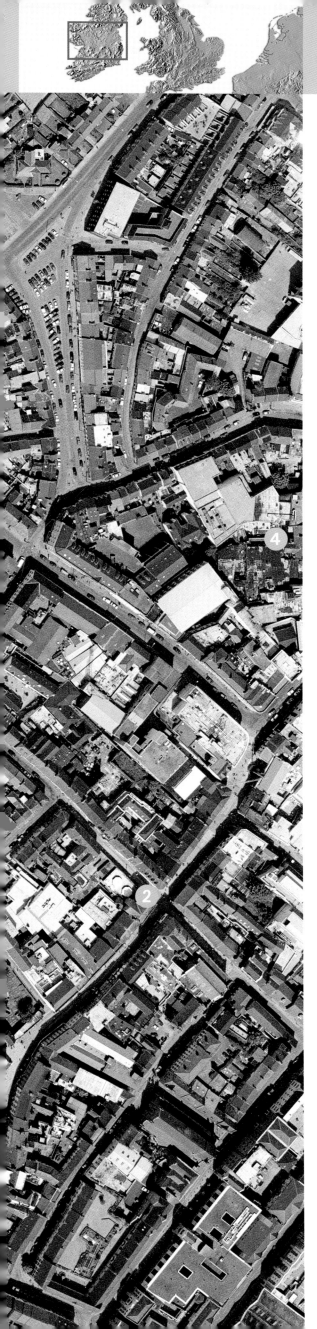

Galway

From its roots as a small fishing village named after the mythical princess Galvia, who it was said drowned there, Galway evolved into a bustling mediaeval port, made wealthy through importing wine and exporting wool. It prospered after gaining a Royal Charter in 1396. In the 14th and 15th centuries it was dominated by 14 powerful merchant families, giving the city its enduring nickname of 'City of the Tribes'. In recent years Galway has benefitted from the development of the computing industry, and is now one of the fastest-growing cities in Europe. Present-day Galway is noted for its young population, its internationally-renowned arts festival and for the Galway Races, which draw huge crowds from all over Ireland and beyond.

1 Salmon Weir Bridge

Completed in 1819, the Salmon Weir Bridge is made up of an elegant series of stone arches. The weir is upstream from the bridge and is the largest in the country, with a flow of 4 million gallons per second at full strength. The bridge is so-called because hundreds of spawning salmon pass under it in the spring as they make their way up the River Corrib against the current to lay their eggs. Downstream, salmon traps are set in what is known as Queen's Gap.

2 Lynch's Castle and Window

Built in the early 17th century for the Lynch family, one of the powerful merchant 'tribes' of Galway, this impressive building has an ornate façade. The Lynch Memorial Window, in the wall adjacent to St Nicholas's Church, commemorates the alleged hanging – the first lynching – by James Lynch FithStephen of his own son for the murder of a Spaniard.

3 Galway Cathedral

The largest building in the city, Galway Cathedral has a copper dome, 44m (145ft) high, which is visible for miles around. Officially known as the Cathedral of Our Lady Assumed into Heaven and St Nicholas, the cathedral was built between 1958 and 1965, on the site of the former city jail. The cathedral is built from local limestone, in a style blending Renaissance architecture with mediaeval influences, with opulent green Connemara marble floors, stained glass windows and mosaics.

4 Galway's Mediaeval Walls

In the 13th-century Galway was fortified by the Normans, who built walls around the thriving port to protect its increasing wealth from the native Irish. Many of the latter were forced to live outside the walls, where they settled on the west bank of the River Corrib to form a Gaelic-speaking fishing community, which was still in evidence in the 1950s. Only a few remnants of the original mediaeval town walls remain today, since most have either decayed or were destroyed by Cromwellian forces in the 1650s. Remnants of the wall can be seen near the Eyre Square Centre, and the Spanish Arch which was built in 1584 to protect the estuary of the River Corrib. First known as *Ceann an Bhalla* or the 'Head of the Wall', the Spanish Arch acquired its name in the 18th century in reference to the Spanish traders who unloaded their ships there.

5 St Nicholas's Church

Dating from 1320, the Anglo-Norman St Nicholas's Church is the oldest surviving building in Galway, and one of the best-preserved mediaeval churches in Ireland. St Nicholas – the original Santa Claus – is the patron saint of both children and sailors, and legend has it that in 1477 Christopher Columbus visited the church. The building was enlarged in 1486, and again in the 1500s. There is a private chapel for the Lynch family and, although some monuments were defaced by Parliamentarian forces when Cromwell captured the city in 1652, many interesting carvings of mermaids, animals, angels and some fearsome gargoyles can still be seen.

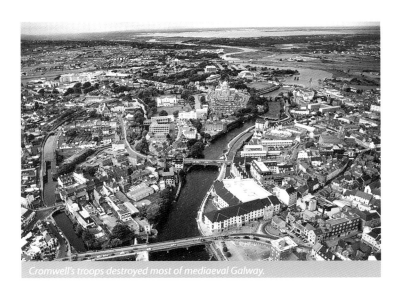

Cromwell's troops destroyed most of mediaeval Galway.

Galway, County Galway **227**

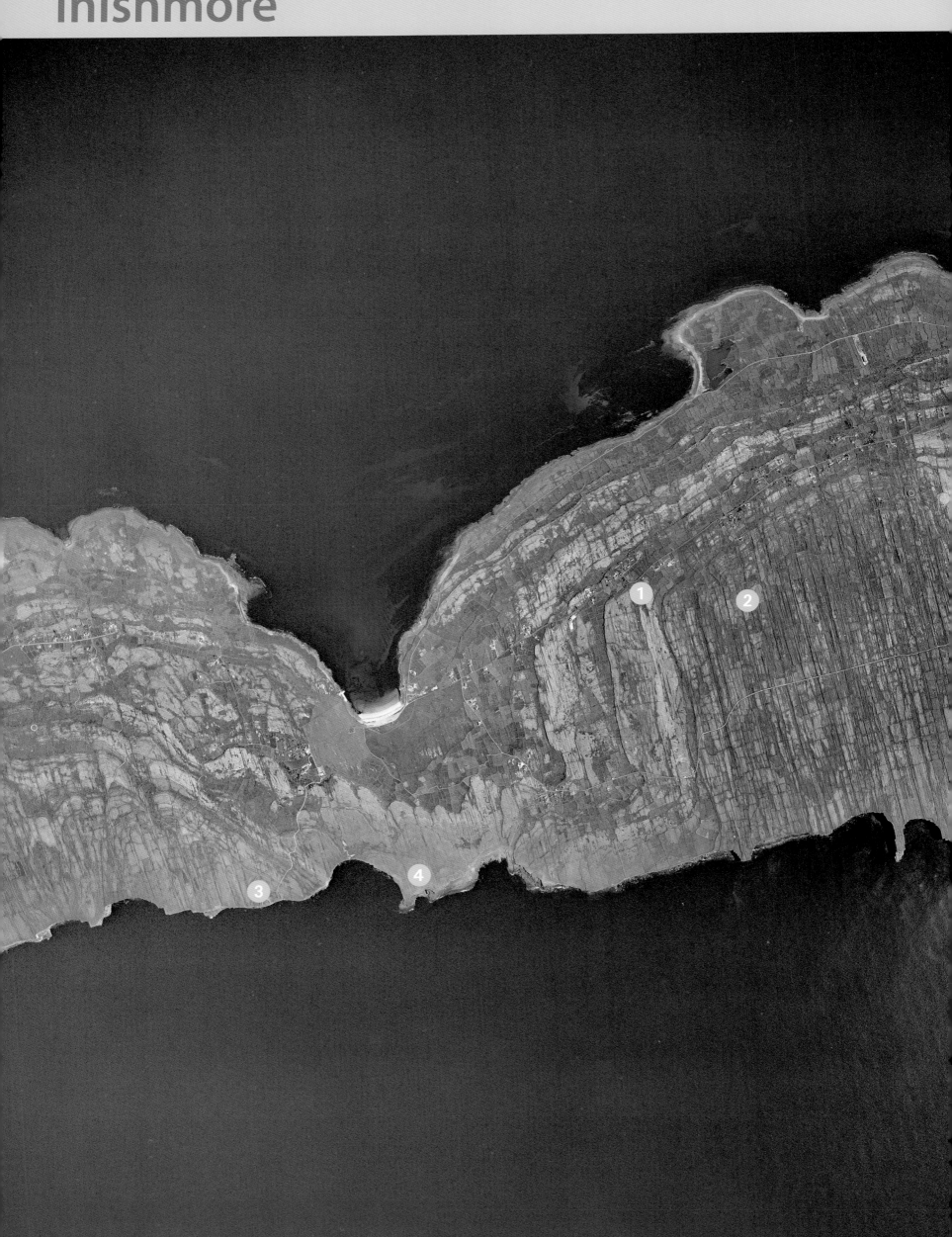

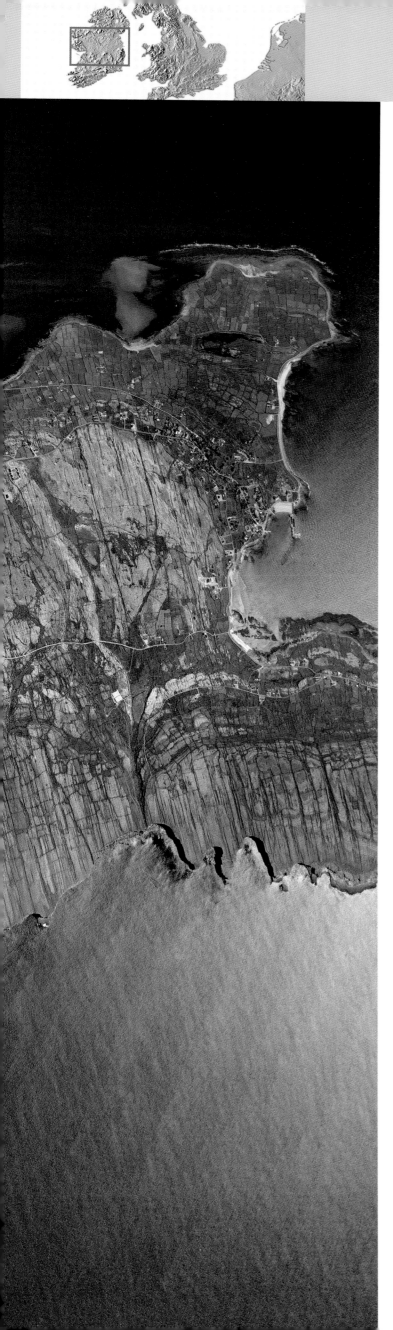

Inishmore

On the east coast of Ireland, in Galway Bay, on the very edge of Western Europe, the Aran Islands lie stark against the full force of the Atlantic Ocean. Inishmore, the largest, elongated island, has a population of 850 and is well-known for its spectacular jagged limestone cliff scenery and prehistoric sites. The economy of the island relies heavily on tourism. The community there is still predominantly Gaelic-speaking.

① Dún Eochla

One of the great stone forts of the island, Dún Eochla, stands near the highest point on the island. Its massive circular walls, terraces and stairways are well-preserved and heaps of stones inside the fort mark the remains of huts. Nearby, the name 'EIRE', outlined in stone, was one of a series of coastal markers placed around the country during the Second World War.

② Teampall an Cheathrair Álainn

The 15th-century church at Teampall an Cheathrair Álainn is dedicated to the 'four beautiful saints' – Fursey, Conal, Brendan and Berchan – who are all supposedly buried on Inishmore. A holy well nearby inspired J.M. Synge's play *The Well of the Saints*.

④ Worm Hole

Located close to the village of Gort na gCapall, the Worm, or Serpent Hole, is a perfectly rectangular shaped pool of unidentifiable origin. It is connected to the ocean by an underwater channel.

③ Dún Aonghasa ▽

The triple-walled clifftop fort at Dún Aonghasa is known as one of the finest prehistoric monuments in Western Europe. Standing almost 90m (300ft) above sea level, it has a defensive structure known as *chevaux de frise*, literally bands of stone standing on edge, that were placed to deter attackers. Dún Aonghasa is perched on the edge of a sheer cliff that falls immediately away into the sea. Theories have abounded as to whether it was deliberately constructed in this way or simply that the full ring of the fort has eroded over time. It is believed that it was built by the prehistoric tribe Fir Bolg whose chief, Aonghus, is a hero of mediaeval literary legend.

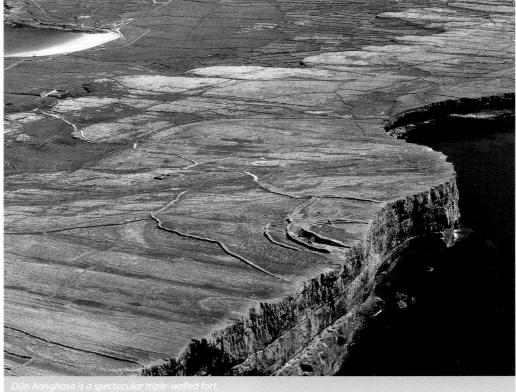

Dún Aonghasa is a spectacular triple-walled fort.

Overleaf: the Irish coast at Newport stretching westwards to Achill Island.

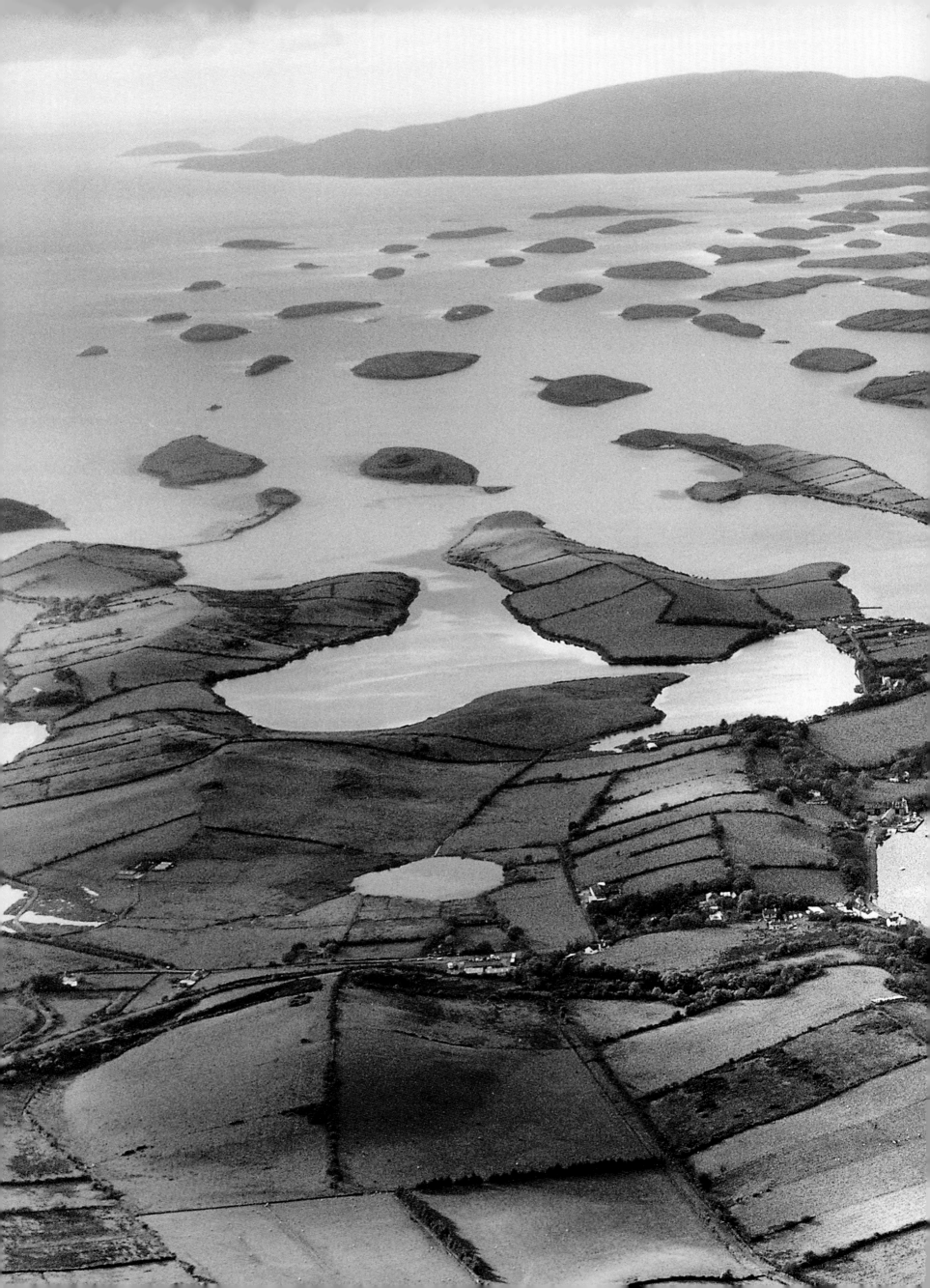

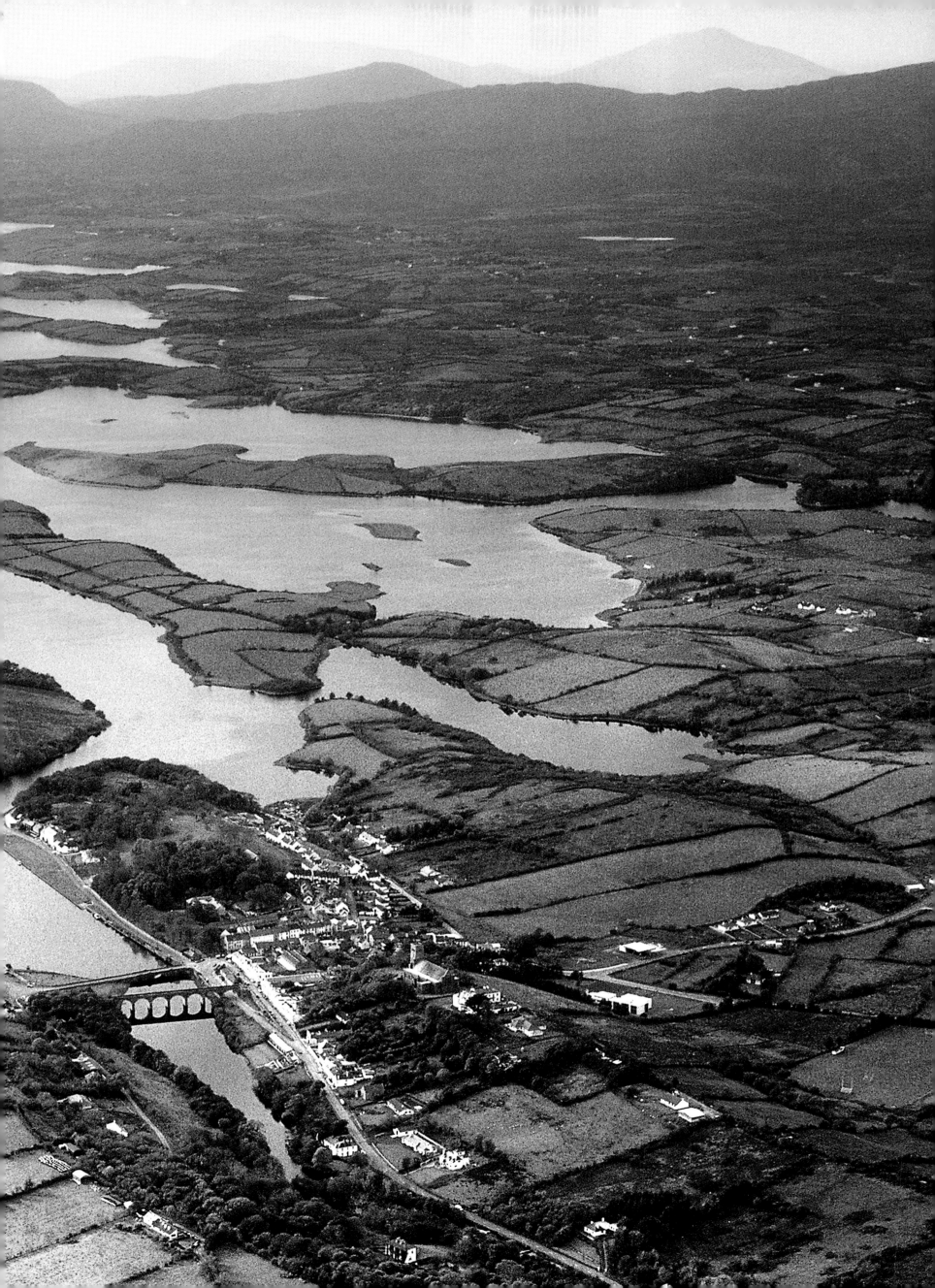

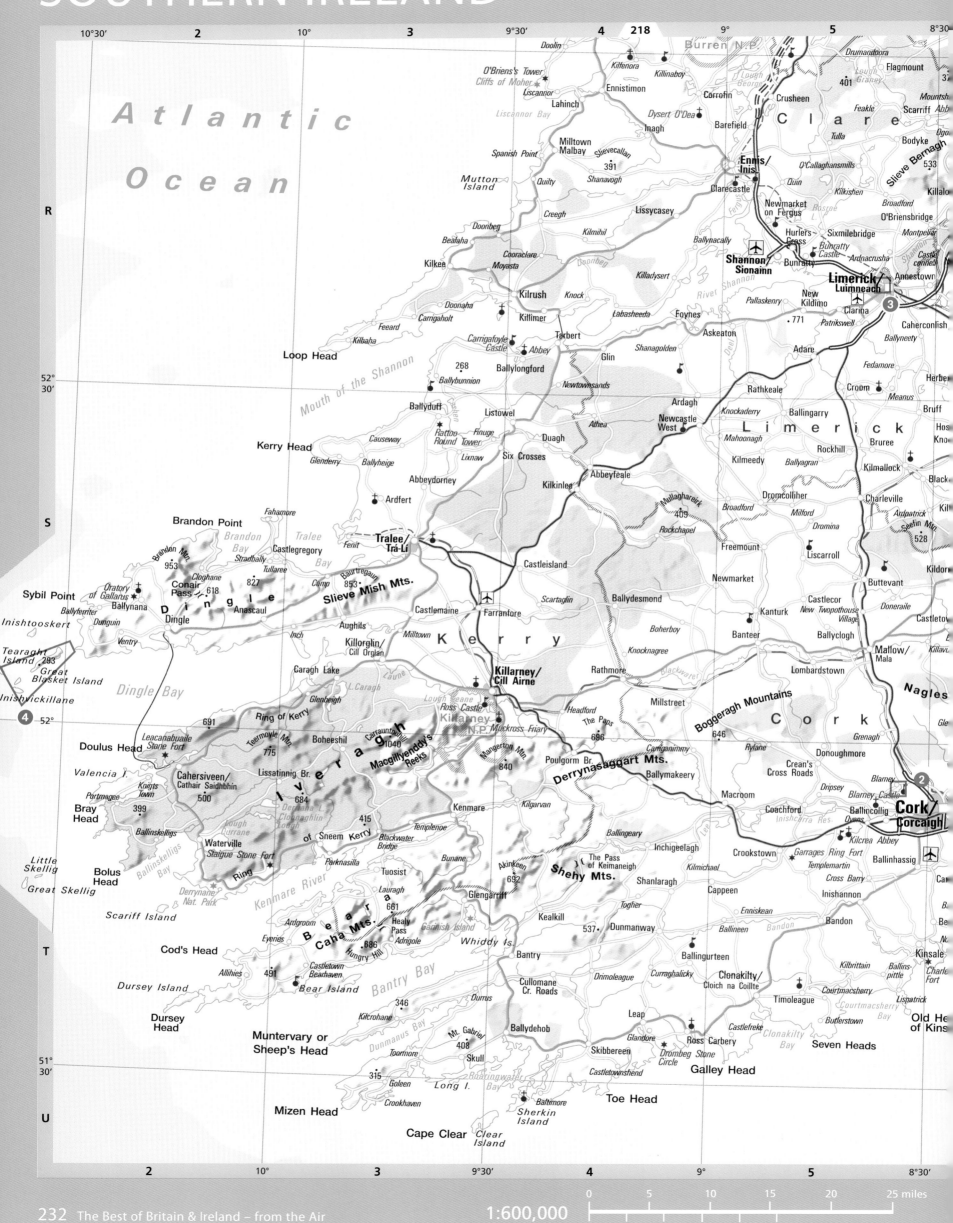

1:600,000

EIRE

Laois

Tipperary

Kilkenny

Carlow

Wexford

Wicklow

Waterford

Irish Sea

Borrisokane, Ballinderry, Ballingarry, Boheraphuca, Mountrath, Stradbally, Crookstown, Stratford, High Cross, Timolin, Laragh, Glendalough

Roscrea, Shinrone, Castletown, Ballyroan, Timahoe, Athy, Wicklow Mts P

Cloghjordan, Borris in Ossory, Aghaboe, Abbeyleix, Ballylynan, Maganey, Castledermot, Rathvilly, Kiltegan, Hacketstown, 654, 926, Rathdrum

Dunkerrin, Ballybrophy, Durrow, Ballinakill, Newtown, Balliokmoyler, Aghavannagh, Ballinclash

Nenagh, Moneygall, Rathdowney, Carlow/Ceatharlach, Browne's Hill, Tullow, Clonmore, Shillelagh, 457, Aughrim, Avoca, Woodenbridge, 607, Arklow/An tInbhear Mór

Toomyvara, 481, Templemore, Johnstown, Ballyragget, Castlecomer, Ballon, Leighlinbridge, Fennagh, Inch, Kilmichael Point

Keeper Hill 695, 543, Borrisoleigh, Urlingford, Freshford, Three-castles, 336, Dunmore Cave, Whitehall, Bagenalstown, Myshall, 423, Carnew, Courtown

Silvermines Mts, Dolla, Upperchurch, Thurles/Durlas, Gortnahoe, 335, Kilkenny/Cill Chainnigh, Gowran, Borris, Mount Leinster 796, Bunclody, Camolin, Riverchapel

Rear Cross, Milestone, Ballycahill, Littleton, Kilcooley Abbey, Kilmanagh, Bennettsbridge, Dungarvan, Graiguenamanagh, Thomastown, Kiltealy, Ballindaggan, Monamolin, Ballygarrett

New Pallas Green, Doon, Cappagh White, Ballagh, Horse, Ballingarry, Abbey, Callan, Kells, Kells Priory, Jerpoint Abbey, Enniscorthy/Inis Córthaidh, Oulart, Cahore Point

Donohill, Dundrum, Rock of Cashel, Golden, Cashel, Killenaule, Ballinure, Cloneen, Mullinahone, Knocktopher, Kilmaganny, Ballyhale, Inistioge, St Mullin's Churches & Abbey, Ballywilliam, Rathnure, Clonroche, Oilgate, Kilmuckridge

Tipperary, Bansha, Newinn, Rosegreen, Fethard, Donaghmore Church, Ninemilehouse, Slievenamon 722, Ahenny, Tullaghought, Clonegal, Ballaghkeen, Blackwater

Glen of Aherlow, Lisvarrinane, Galbally, Flanders, Galtymore Mtn 919, Galty Mts, Cahir, Cahir Castle, Kilsheelan, Carrick-on-Suir/Carraig na Siúire, Fiddown, Mullinavat, Glenmore, New Ross/Ros Mhic Thriúin, Adamstown, Camaross, Glynn, Castlebridge, Curracloe, The Wexford Wildfowl Reserve, North Bay, Wexford or

kanevin, Mitchelstown Caves, Ballylooby, Ardfinnan, Clonmel/Cluain Meala, Comeragh Mts, Ballymacarbry, Newcastle, Knockanaffrin 792, Clonea, Portlaw, Glenmore, John F. Kennedy Memorial Forest Park, Gusserane, Wellingtonbridge, Piercetown, Rosslare, Wexford/Loch Garman, Wexford Harbour

Mitchelstown, 304, Ballyporeen, Clogheen, Monavullagh Mts, Knockmealdown Mts 795, Waterford/Port Láirge, Dunbrody Abbey, Arthurstown, Duncannon, Carrick, Duncormick, Rathmacknee Castle, Bridgetown, Rosslare Harbour/Calafort Ros Láir, Tagoat

Kilworth, Araglin, Ballynamult, 595, Waterford, Passage East, Fethard, Bastardstown, Tacumshane Windmill, Churchtown, Carnsore Point

Fermoy, Duag, Knockmealdown, Cappoquin, Kilmacthomas, Kill, Tramore, Dunmore East, Ballyteige Bay, Kilmore Quay, Saltee Islands

Rathcormack, Ballyduff, Lismore, Lemybrien, Stradbally, Bunmahon, Annestown, Fennor, Browstown Head, Churchtown, Hook Head

Ballynoe, Tallow, Aglish, Dungarvan/Dún Garbhán, Ballynacourty, Dungarvan Harbour, Clonea Bay

watergrasshill, Ballincurrig, 205, Dungourney, Kinsalebeg, Youghal/Eochaill, Ardmore, Ringville, Helvick Head, 302, Clashmore

Midleton, Killeagh, Killeagh, Castlemartyr, Ballymacoda, Knockadoon Head

Great Island, Cobh/An Cóbh, Ladysbridge, Cloyne, Garryvoe, Whitegate, Gyleen, Ballycotton, Ballycotton Bay, Power Head

bert's ead

Le Havre, Roscoff, Cherbourg

Swansea

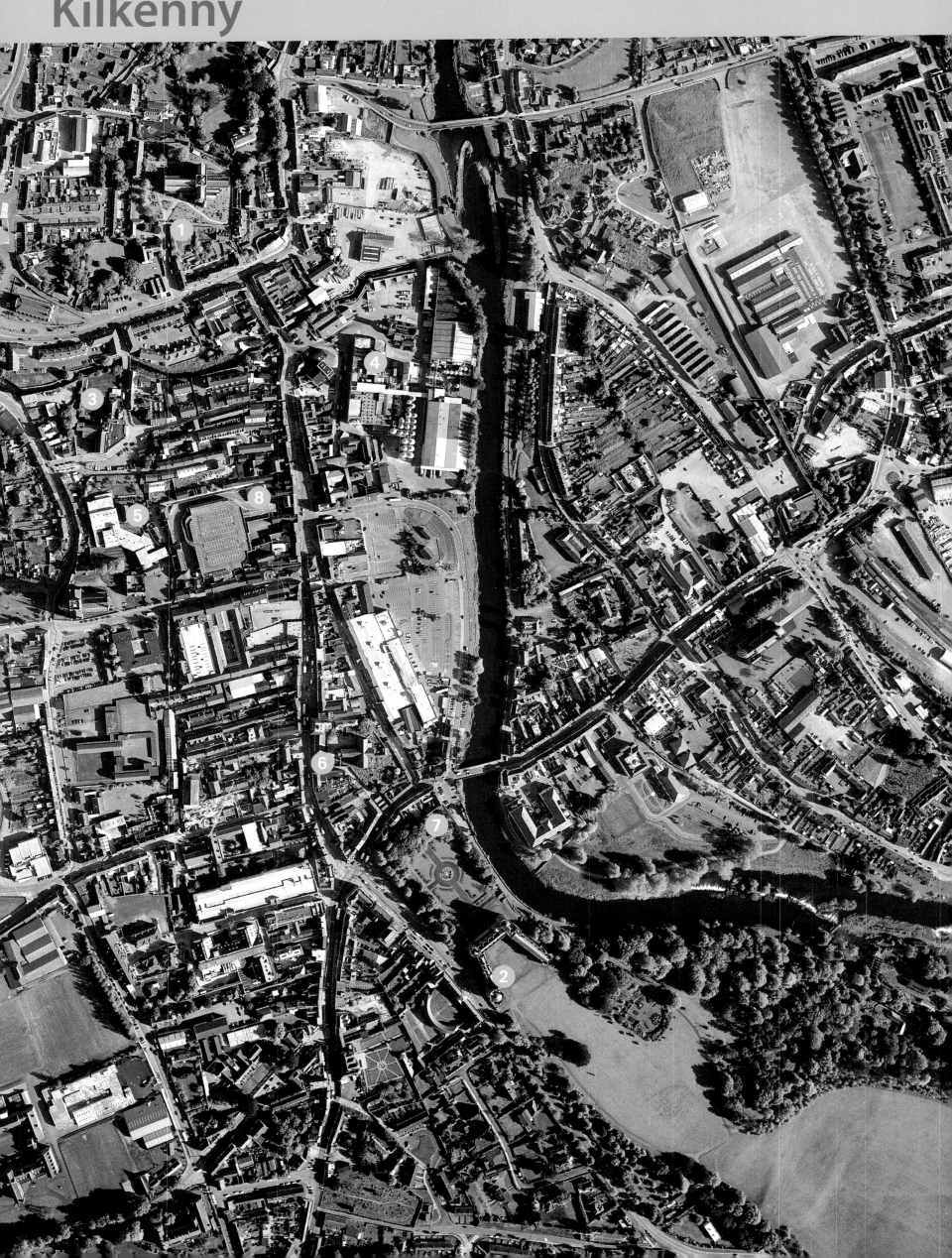

Kilkenny

Home to many Irish parliaments between 1293 and 1408, Kilkenny is today renowned for its numerous well-preserved mediaeval buildings, and is a popular tourist destination. It is known as 'the Marble City' because of its distinctive locally-quarried limestone which resembles marble. Kilkenny has been a brewing centre since the late 17th century, and is the site of Ireland's oldest brewery (Sullivan's) as well as the birthplace of the well-known Kilkenny and Smithwick's ales. With a population of roughly 22,000, Kilkenny is the Republic of Ireland's smallest city.

1 St Canice's Cathedral

Kilkenny takes its name – in Irish, *Cill Chainnigh* meaning 'Church of Canice' – from the saint who founded a monastic settlement here in the 6th century and who is celebrated in the splendid St Canice's Cathedral. This was begun in the 1190s, under Bishop Felix O'Deleaney, on the site of the monastery. Built of limestone in the early Gothic style, it was largely complete by 1280. The cathedral still has its original 13th-century baptismal font, together with one of the finest collections of carved stone memorials found in Ireland.

The cathedral was badly damaged in 1650 by Oliver Cromwell's Parliamentarian forces who used it as a stable; restoration work was carried out in the 19th century. To the south of the cathedral stands a 9th-century round tower, 30m (100ft) high, that was probably used as a refuge and watchtower.

2 Kilkenny Castle ◁

This imposing building occupies a 30m (100ft) hill in the southern end of the city, looking down on the River Nore. The present building has three of the four original towers that date from when the first stone castle was built on the site by William Marshall, Earl of Pembroke, in 1192. This stone building replaced an earlier wooden fortress built in 1172 by the Norman knight, Richard de Clare, known as 'Strongbow'. James Butler, 3rd Earl of Ormonde, bought the castle in 1391 when he was Lord Lieutenant of Ireland. The building was restored in the 19th century, and in May 1922 it was occupied by Irish Republican forces, who were defeated after a two-day siege. The castle remained the home of the Butler family until 1935 and, in 1967, Arthur Butler, 23rd Earl of Ormonde, handed over control of the castle to a restoration committee. The castle opened to the public in 1976.

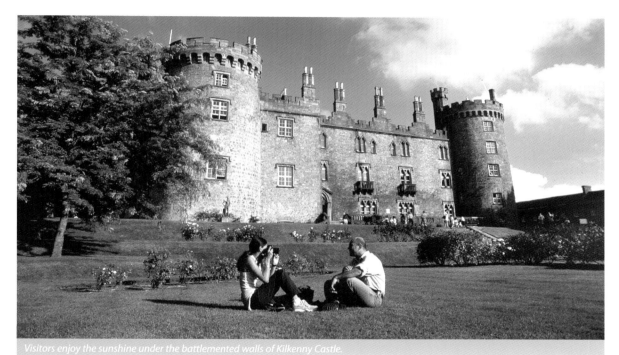

Visitors enjoy the sunshine under the battlemented walls of Kilkenny Castle.

3 Holy Trinity Church, or The Black Abbey

The 'Convent of the One and Undivided Trinity' was founded by the Earl of Pembroke in 1225 for the Dominican friars. Located outside the walls of the city, it became known as the Black Abbey because of the dark habits worn by the friars. In 1349, during the Black Death, eight friars died in a single day. The abbey was confiscated by the Crown in the early 1540s, and used as a courthouse until the end of the 17th century. In the late 18th century it was partially restored and in the mid-19th century became Holy Trinity Church. Visitors can view the original 13th-century nave, a 14th-century transept and the 15th-century stained glass windows. Close by, on Abbey Street, is Black Freren gate, the only surviving part of the entrance gates in the mediaeval city walls.

4 St Francis's Abbey

Kilkenny's Franciscan abbey was founded in the 1230s by Richard Marshall, Earl of Pembroke, and quickly expanded and grew in importance. It was repressed in 1540 during the dissolution of the monasteries, but the friars remained in residence until 1550, when they were forced to leave by John Bale, Bishop of Ossory. They briefly returned under the Catholic Queen Mary I (1553-58) but were expelled once more following the accession of her half-sister, the Protestant Queen Elizabeth I. The monastery was re-dedicated following the accession of James I in 1603, but the buildings were little more than ruins. The Franciscan community survived but dwindled, and the abbey's last Franciscan friar, Father Philip Forristal, died in 1829. It was in the abbey grounds that Richard Cole and John Smithwick started a brewery in the early 18th century.

6 The Tholsel

Built in 1761, on the site of Kilkenny's mediaeval courthouse and guildhall, the Tholsel takes its name from the Old English words toll (tax) and sael (hall). Today it is used for art exhibitions and street theatre performances in the arcade that was once a covered marketplace.

7 Shee Alms House

The alms house was built by Sir Richard Shee, a powerful Kilkenny lawyer, in 1582 'to accommodate twelve poor persons'. The Shees lost their possessions at the time of Oliver Cromwell in the mid-17th century but finally regained control of the Alms House in 1756. The last known inmates were resident in 1830. Since 1978, it has belonged to Kilkenny Corporation and has been carefully restored.

5 The Maltings

The present building on James Street probably dates from around 1810. It served as an extension of Sullivan's Brewery, which was founded here in 1702. During much of the 20th century the brewery was operated by Smithwick's, who bought it in 1910. The massive kiln and parts of the waterwheel still survive although the main brewery buildings were demolished by the Kilkenny Corporation to make way for the Market Cross Shopping Centre. The Maltings is now a commercial property.

8 Rothe House

In 1594, the wealthy Kilkenny merchant John Rothe built a fine house on Parliament Street (at that time called the Coal Market) for his wife, Rose Archer. Its three buildings stand around cobbled courtyards, which contain a well dating from 1604. The restored building contains a kitchen, bakery, brew house and reception room, with a collection of period costumes. It is now the headquarters of the Kilkenny Archaeological Society and the Heritage Council of Ireland.

Blarney

North-west of the City of Cork lies the village of Blarney, whose name is derived from the Irish *An blarna* which means 'the plain'. Best-known for the castle and, within its battlements, the Blarney Stone, the village has also entered the English lexicon through a comment made by Elizabeth I during the Reformation. The monarch's response to the elaborate excuses made by the owner of the castle (when asked to give up his property as a sign of loyalty to the Crown) was that it was all 'Blarney', later defined as 'pleasant talk, intending to deceive without offending'.

① Blarney House

The picturesque Blarney House was built in Scottish baronial style to the south of the castle and completed in 1874 by the Colthurst family, whose descendants reside in the property to this day. Recently restored, it is open to visitors in the summer months. The house has a collection of early furniture, tapestries and works of arts and there are also extensive gardens, forests and parklands.

② The Rock Close

The previous owners of the castle, the Jeffreyes family, planned a garden area consisting of a collection of boulders and rocks arranged around a possible prehistoric Druid site. The Rock Close, as it is known, remains an eerie place to visit after nightfall. A dolmen or ancient burial place shaped in the form of a tomb with a large flat stone laid on uprights has survived in the area.

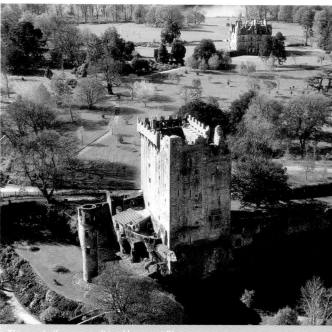

The castle (foreground) and house at Blarney.

③ The Blarney Stone

Tradition dictates that kissing the Blarney Stone bestows eloquence upon a person. The stone is believed to be half of the Stone of Scone, originally used in the coronation of Scottish kings and presented to Cormac McCarthy by Robert the Bruce in gratitude for his support at the Battle of Bannockburn in 1314. Situated high in the battlements of the castle, the stone can only be reached by bending backwards with the support of others until, hanging upside down, the stone can be kissed.

④ The Woollen Mills

Destroyed by fire in 1869, the factory was back in operation again by 1871 and employed as many as 700 people by 1950. The mill closed in 1975. In 1988 the building was converted into a store with pub, restaurant and hotel.

⑤ Blarney Castle △

The existing keep structure of Blarney Castle was built by Dermot McCarthy, King of Munster, in 1446. However, this is the third castle to stand on this site. The first structure was a 10th-century wooden castle which was replaced by a stronger stone building in 1210. At 26m (86ft) high, the surviving keep is the sole remnant of a much larger fortress that was able to withstand long sieges. The tower walls were broken by the cannon fire of Cromwell's general Lord Broghill. The building remained under the control of the McCarthy family until it was forfeited by Donagh McCarthy, because of his support for James II at the Battle of the Boyne in 1690. It was subsequently sold to the Governor of Cork, Sir James St John Jeffreyes. The castle stands in 139ha (344 acres) of land currently managed by the Trustees of the Blarney Castle Estate.

Blarney, County Cork **237**

Limerick

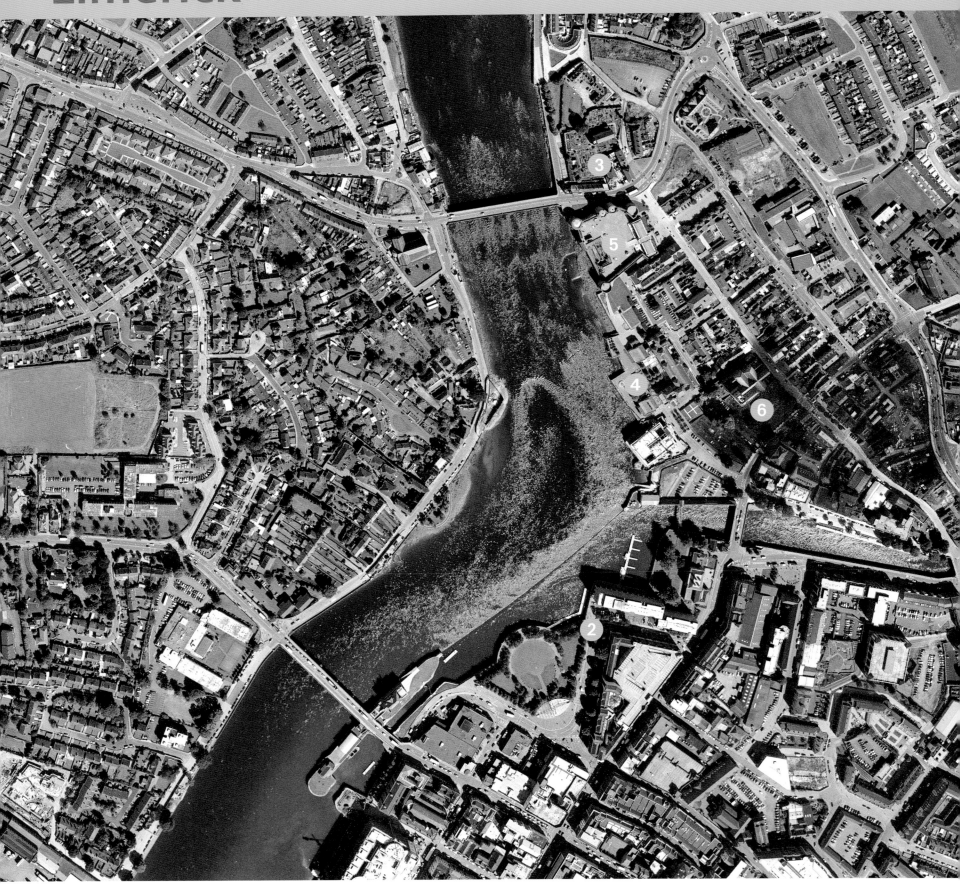

Limerick

Situated at the head of the River Shannon estuary, Limerick has been a major seaport since the Vikings sacked the early native settlement and founded a town in 812. After the Irish hero Brian Boru drove out the Vikings in 967, Limerick first became a mediaeval stronghold and later, in 1769, an elegant Georgian new town. As part of the Irish economic revival of the 1990s, Limerick established itself as a centre for high-tech industries, while also sustaining its reputation as a popular tourist destination. A short distance from the city is Shannon Airport where the first transatlantic flights to Ireland landed in 1945.

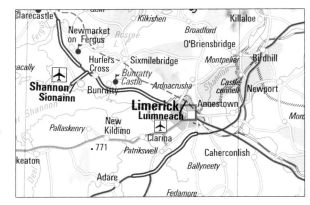

① John's Square and Georgian architecture

This was the first of the Georgian developments in Limerick, begun in the 1750s in advance of the planning and laying out of the main Georgian part of the city, Newton Pery. The elegant houses of John's Square are built in local limestone.

The symmetrically designed terrace at numbers 1 to 6, Pery Square, is claimed by some authorities as the finest Georgian architecture in the whole of Ireland. A great deal of the original marbling, woodwork and plasterwork can still be seen. Gable entrances adorn numbers 1 and 6. Number 2 has been restored by the Limerick Civic Trust and is now open to the public.

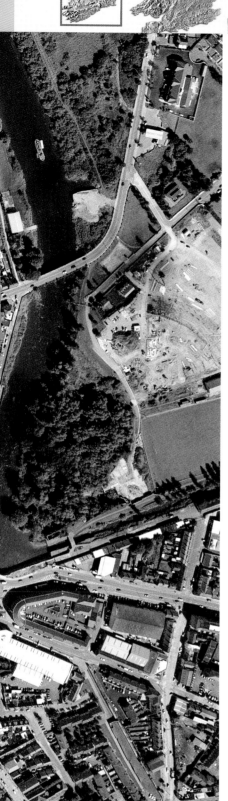

③ Bishop's Palace

The Bishop's Palace was built in the late 17th century. With a five-bay classical façade, this building exhibits a form of the Palladian architectural style adapted for the Irish climate. It was once the palace of the Protestant Bishop of Limerick, but is now the headquarters of the Limerick Civic Trust. It stands across the road from King John's Castle.

④ Limerick Civic Offices

This modern development stands on the site of the city jail and courthouse, it was built for the Limerick Corporation and the City Council after the former city jail was demolished in 1988. It was the first building in Limerick to follow a new policy of orientating new constructions towards the river. Visitors can tour the gallery within the building.

⑤ King John's Castle

The Vikings built their first stronghold here as early as 922. Their settlement was established on an island beside a ford across the Shannon. After Brian Boru and his brother King Mahon of Thomond defeated the invaders, the island settlement became the capital of the kings of Thomond. In the 12th century an Anglo-Norman army took the town and named the spot King's Island. King John, 'Lord of Ireland', ordered the construction of fortifications and King John's Castle was built in around 1200. The castle's curtain walls and D-shaped towers on its north face were unique for the period.

The castle was besieged and overpowered by Oliver Cromwell when he captured Limerick in 1651. It was besieged twice more by the 'Williamite' forces fighting in support of William and Mary from 1690. The Treaty of Limerick, ending the second of the sieges and bringing to an end that phase of the struggle between 'Williamites' and 'Jacobites' (supporters of the exiled James II), was signed in October 1691 on a stone that is now mounted as the 'Treaty Stone' on the opposite bank of the river beside Thompson Bridge.

Visitors can walk the battlements, enjoying views of the River Shannon and the city, and examine excavations of Viking and other houses that occupied the site before the castle was built.

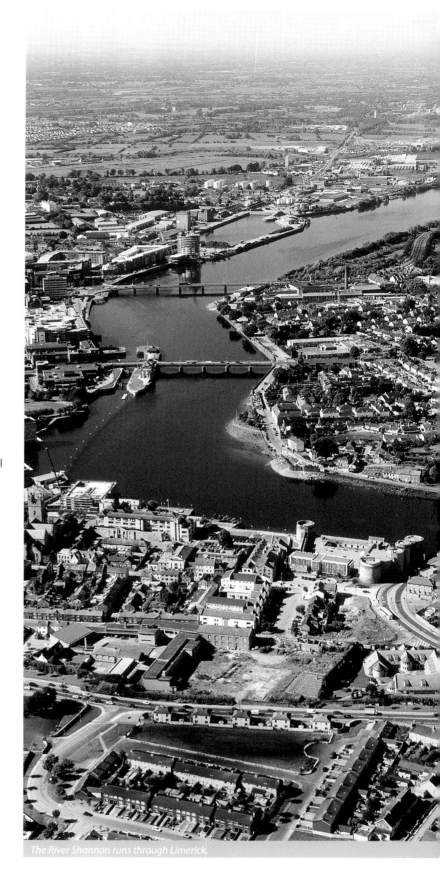

The River Shannon runs through Limerick.

② Custom House and Hunt Museum

Limerick's Palladian-style Custom House was built between 1765 and 1769 by the Italian architect Daviso de Arcort (also known as Davis Ducart), who was also the designer of a number of Irish country houses. The Custom House was the administrative headquarters of the Revenue, and the site of a post office when the new Penny Post was introduced in the 1840s. Today it is the home of the Hunt Collection, a miscellany of around 2,000 objects brought together by John and Gertrude Hunt after their marriage in 1933. The diverse collection contains mediaeval statues, crucifixes and jewellery, ancient Egyptian pieces, ancient Greek and Roman items, the personal seal of King Charles I and a bronze horse by Leonardo da Vinci. Pieces of Irish interest include some Neolithic flints, Bronze Age gold and an 8th-century AD Antrim bronze cross with five bosses each in the form of a truncated pyramid.

⑥ St Mary's Cathedral

Founded in 1168 and completed nearly 30 years later, the Cathedral of St Mary the Blessed Virgin combines Gothic and Romanesque architectural styles. It was built on the site of a palace that had been donated by Donal Mor O'Brien, King of Munster. Parts of the palace structure are believed to be incorporated into the cathedral's structure. Experts suggest that the cathedral's Romanesque West Door was once the palace entrance; marks in the wall around the door are said to have been made by soldiers who sharpened their swords and crossbows there during the sieges of the city. The site of King Donal Mor's palace had previously been the Viking meeting house.

The West Door is now used only on ceremonial occasions: a new bishop knocks and is admitted by this entrance during his installation. Within the cathedral, visitors can see beautifully sculptured 15th-century oak misericords (with carvings on the underside of the seats). After Oliver Cromwell's troops captured the city in 1651, they used the cathedral as a stable. The choir today wears scarlet cassocks as a mark of its royal origins.

Overleaf: Great Blasket Island off the Dingle Peninsula.

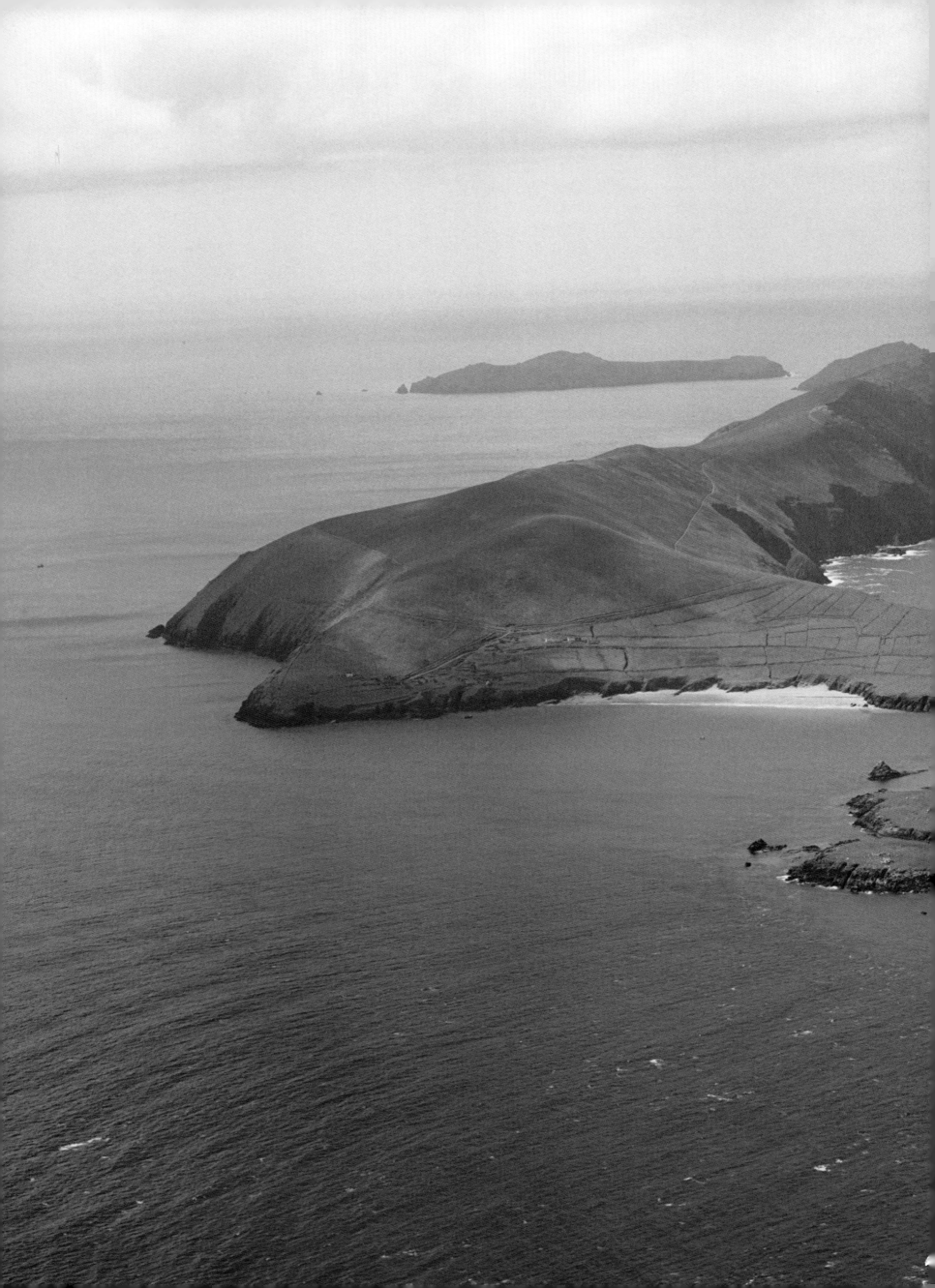

Index to place names

Applecross Highland GB 175 H 11

Appledore Devon GB 52/53 U 14

Appledore Kent GB 71 U 24

Araglin Cork IRL 232/233 S 6

Arbirlot Angus GB 161 J 18

Arbroath Angus GB 161 J 18

Arbuthnott Aberdeenshire GB 161 J 18

Archiestown Moray GB 187 H 16

Ardagh Limerick IRL 232 S 4

Ardara Donegal IRL 206 N 6

Ardarroch Highland GB 175 H 11

Ardbeg Argyll and Bute GB 174 L 10

Ardcath Meath IRL 219 P 10

Ardcharnich Highland GB 186 G 12

Ardee Louth IRL 219 P 9

Ardentinny Argyll and Bute GB 160 K 13

Ardeonaig Stirling GB 160 K 14

Ardersier Highland GB 186/187 G 14

Ardfern Argyll and Bute GB 174 K 11

Ardfert Kerry IRL 232 S 3

Ardfinnan Tipperary IRL 233 S 7

Ardgay Highland GB 186/187 G 14

Ardglass Down GB 207 O 11

Ardgroom Cork IRL 232 T 3

Ardleigh Essex GB 71 T 24

Ardley Oxfordshire GB 70 T 20

Ardlui Argyll and Bute GB 160 K 13

Ardlussa Argyll and Bute GB 174 K 11

Ardminish Argyll and Bute GB 174 L 11

Ardmolich Highland GB 174 J 11

Ardmore Waterford IRL 233 T 7

Ardnacrusha Limerick IRL 232 R 5

Ardpatrick Limerick IRL 232 S 5

Ardrahan Galway IRL 218 Q 5

Ardress Armagh GB 207 O 9

Ardrishaig Argyll and Bute GB 160 K 12

Ardrossan North Ayrshire GB 160 L 13

Ardstraw Tyrone GB 207 N 8

Ardtainaig Perth and Kinross GB 160 J 14

Ardtalla Argyll and Bute GB 174 L 10

Ardtoe Highland GB 174 J 11

Ardvasar Highland GB 175 H 11

Ardwell Dumfries und Galloway GB 146 N 13

Arinagour Argyll and Bute GB 174 J 9

Arisaig Highland GB 175 J 11

Arklow An tInbhear Mór Wicklow IRL 233 R 10

Arlecdon Cumbria GB 146 N 16

Arlosh Cumbria GB 146 N 16

Armadale West Lothian GB 160/161 L 15

Armadale Highland GB 175 H 11

Armadale Highland GB 186/187 E 14

Armagh Armagh GB 207 O 9

Armitage Staffordshire GB 100 R 19

Armoy Antrim GB 207 M 10

Armthorpe Doncaster GB 134 P 20

Arncliffe North Yorkshire GB 147 O 18

Arnisdale Highland GB 175 H 11

Arnish Highland GB 175 H 10

Arnol Na h-Eileanan an Iar GB 175 F 9

Arnold Nottinghamshire GB 134 Q 20

Arnside Cumbria GB 146/147 O 17

Arrington Cambridgeshire GB 100/101 S 22

Arrochar Argyll and Bute GB 160 K 13

Arthurstown Wexford IRL 233 S 9

Artigarvan Tyrone GB 207 N 8

Arundel West Sussex GB 70/71 V 21

Arvagh Cavan IRL 219 P 7

Ascot Windsor & Maidenhead GB 70/71 U 21

Ash Kent GB 71 U 23

Ash Mill Devon GB 53 V 15

Ashbourne Derbyshire GB 134 Q 19

Ashbourne Meath IRL 219 Q 10

Ashburton Devon GB 53 V 15

Ashbury Oxfordshire GB 70 T 19

Ashby-de-la-Zouch Leicestershire GB 100 R 20

Ashford Wicklow IRL 219 Q 10

Ashford Devon GB 52/53 U 14

Ashford Kent GB 71 U 24

Ashill Norfolk GB 101 R 24

Ashington Northumberland GB 147 M 19

Ashkirk Scottish Borders GB 146/147 M 17

Ashley Staffordshire GB 100 R 18

Ashley Devon GB 53 V 15

Ashton Devon GB 53 V 15

Ashton Keynes Wiltshire GB 70 T 19

Ashton under Hill Worcestershire GB 100 S 19

Ashton-under-Lyne Tameside GB 134 Q 18

Ashwell Rutland GB 100 R 21

Ashwell Hertfordshire GB 100/101 S 22

Ashwellthorpe Norfolk GB 101 R 25

Askam in Furness Cumbria GB 146 O 16

Askeaton Limerick IRL 232 R 5

Askern Doncaster GB 134 P 20

Askham Cumbria GB 146/147 N 17

Askrigg North Yorkshire GB 147 O 18

Askwith North Yorkshire GB 134 P 19

Aspatria Cumbria GB 146 N 16

Assington Suffolk GB 101 S 24

Aston Cheshire GB 119 Q 17

Aston Abbots Buckinghamshire GB 70/71 T 21

Aston Clinton Buckinghamshire GB 70/71 T 21

Astwood Bank Worcestershire GB 100 S 19

Athavallie Mayo IRL 218 P 4

Athboy Meath IRL 219 P 9

Athea Limerick IRL 232 S 4

Athelstaneford East Lothian GB 161 L 17

Athenry Galway IRL 218 Q 5

Atherstone Warwickshire GB 100 R 19

Atherton Wigan GB 134 P 18

Athleague Roscommon IRL 218/219 P 6

Athlone Baile Átha Luain Westmeath IRL 219 Q 7

Athy Kildare IRL 219 Q 8

Attadale Highland GB 186 H 12

Attleborough Norfolk GB 101 R 25

Attlebridge Norfolk GB 101 R 25

Atwick East Riding of Yorkshire GB 135 P 22

Atworth Wiltshire GB 70 U 18

Auchavan Angus GB 161 J 16

Auchenblae Aberdeenshire GB 161 J 18

Auchenbreck Argyll and Bute GB 160 L 12

Auchencairn Dumfries und Galloway GB 146 N 15

Auchengray South Lanarkshire GB 160/161 L 15

Auchinleck East Ayrshire GB 146 M 14

Auchleven Aberdeenshire GB 187 H 17

Auchnagatt Aberdeenshire GB 187 H 18

Aucholzie Aberdeenshire GB 161 J 16

Auchterarder Perth and Kinross GB 160/161 K 15

Auchtermuchty Fife GB 161 K 16

Auchtertool Fife GB 161 K 16

Aucloggeen Galway IRL 218 Q 5

Audlem Cheshire GB 119 R 17

Audley Staffordshire GB 134 Q 18

Augher Tyrone GB 207 O 8

Aughils Kerry IRL 232 S 3

Aughnacloy Tyrone GB 207 O 9

Aughrim Galway IRL 218/219 Q 6

Aughrim Wicklow IRL 233 R 10

Aughton Rotherham GB 134 Q 20

Auldearn Highland GB 187 G 15

Auldhouse South Lanarkshire GB 160 L 14

Aultbea Highland GB 186 G 11

Aust South Gloucestershire GB 87 T 17

Austwick North Yorkshire GB 147 O 18

Avebury Wiltshire GB 70 U 19

Avening Gloucestershire GB 70 T 18

Aviemore Highland GB 187 H 15

Avoca Wicklow IRL 233 R 10

Avoch Highland GB 186/187 G 14

Avonmouth Bristol GB 87 T 17

Avonwick Devon GB 53 W 15

Axbridge Somerset GB 53 U 17

Axminster Devon GB 53 V 17

Aylesbury Buckinghamshire GB 70/71 T 21

Aylesham Kent GB 71 U 25

Aylsham Norfolk GB 101 R 25

Ayr South Ayrshire GB 146 M 13

Aysgarth North Yorkshire GB 147 O 19

Ayton North Yorkshire GB 135 O 22

B

Bac Na h-Eileanan an Iar GB 186 F 10

Backaland Orkney Islands GB 198 D 17

Backwell North Somerset GB 53 U 17

Bacton Norfolk GB 101 R 25

Bacup Lancashire GB 134 P 18

Badachro Highland GB 186 G 11

Badby Northhamptonshire GB 100 S 20

Badcall Highland GB 186 F 12

Badcaul Highland GB 186 G 12

Badluarach Highland GB 186 G 12

Badminton South Gloucestershire GB 70 T 18

Badnabay Highland GB 186 F 12

Badrallach Highland GB 186 G 12

Bagenalstown Carlow IRL 233 R 9

Bagh a'Chaisteil Castlebay Na h-Eileanan an Iar GB 175 J 8

Bagshot Surrey GB 70/71 U 21

Baile Ailein Na h-Eileanan an Iar GB 175 F 9

Baile Mòr Argyll and Bute GB 174 K 10

Baile na Finne Donegal IRL 206 N 6

Baile nan Cailleach Na h-Eileanan an Iar GB 175 H 8

Bailieborough Cavan IRL 219 P 9

Bainbridge North Yorkshire GB 147 O 18

Bainton East Riding of Yorkshire GB 134/135 P 21

Bakewell Derbyshire GB 134 Q 19

Balbeggie Perth and Kinross GB 161 K 16

Balblair Highland GB 186/187 G 14

Balbriggan Dublin IRL 219 P 10

Balchrick Highland GB 186 E 12

Balcombe West Sussex GB 71 U 22

Balderton Nottinghamshire GB 134/135 Q 21

Balemartine Argyll and Bute GB 174 K 9

Balerno Edinburgh GB 161 L 16

Balfour Orkney Islands GB 198 D 17

Balfron Stirling GB 160 K 14

Balintore Highland GB 187 G 15

Balla Mayo IRL 218 P 4

Ballachulish Highland GB 160 J 12

Ballagh Tipperary IRL 233 R 7

Ballaghaderreen Roscommon IRL 218 P 5

Ballaghkeen Wexford IRL 233 S 10

Ballantrae South Ayrshire GB 146 M 12

Ballasalla Isle of Man GB 146 O 13

Ballater Aberdeenshire GB 187 H 16

Ballina Béal an Átha Mayo IRL 206 O 4

Ballinafad Sligo IRL 206 O 6

Ballinagar Offaly IRL 219 Q 8

Ballinagleragh Leitrim IRL 206 O 6

Ballinakill Laois IRL 233 R 8

Ballinalee Longford IRL 219 P 7

Ballinamallard Fermanagh GB 206 O 7

Ballinamore Leitrim IRL 206 O 7

Ballinasloe Béal Átha na Sluaighe Galway IRL 218/219 Q 6

Ballinclash Wicklow IRL 233 R 10

Ballincollig Cork IRL 232 T 5

Ballincurrig Cork IRL 232/233 T 6

Ballindaggan Wexford IRL 233 R 9

Ballinderry Antrim GB 207 N 10

Ballinderry Tipperary IRL 218/219 Q 6

Ballindine Mayo IRL 218 P 5

Ballineen Cork IRL 232 T 5

Ballingarry Tipperary IRL 218/219 Q 6

Ballingarry Limerick IRL 232 S 5

Ballingarry Tipperary IRL 233 R 7

Ballingeary Cork IRL 232 T 4

Ballingry Fife GB 161 K 16

Ballingurteen Cork IRL 232 T 4

Ballinhassig Cork IRL 232 T 5

Ballinlough Roscommon IRL 218 P 5

Ballinluig Perth and Kinross GB 160/161 J 15

Ballinrobe Mayo IRL 218 P 4

Ballinskelligs Kerry IRL 70 T 2

Ballinspittle Cork IRL 232 T 5

Ballintober Roscommon IRL 218/219 P 6

Ballintogher Sligo IRL 206 O 6

Ballintoy Antrim GB 207 M 10

Ballintra Donegal IRL 206 N 6

Ballinure Tipperary IRL 233 R 7

Balliokmoyler Laois IRL 233 R 9

Ballivor Meath IRL 219 P 9

Balloch West Dunbartonshire GB 160 K 13

Ballon Carlow IRL 233 R 9

Ballyagran Limerick IRL 232 S 5

Ballybay Monaghan IRL 207 O 9

Ballybofey Donegal IRL 206 N 7

Ballyboghil Dublin IRL 219 P 10

Ballybrittas Laois IRL 219 Q 8

Ballybrophy Laois IRL 233 R 7

Ballybunnion Kerry IRL 232 R 3

Ballycahill Tipperary IRL 233 R 7

Ballycarry Antrim GB 207 N 11

Ballycastle Mayo IRL 206 O 4

Ballycastle Antrim GB 207 M 10

Ballyclare Antrim GB 207 N 10

Ballyclerahan Tipperary IRL 233 S 7

Ballyclogh Cork IRL 232 S 5

Ballycolla Laois IRL 233 R 8

Ballyconneely Galway IRL 218 Q 2

Ballyconnell Cavan IRL 206 O 7

Ballycotton Cork IRL 232/233 T 6

Ballycroy Mayo IRL 218 O 3

Ballycumber Offaly IRL 219 Q 7

Ballydangan Offaly IRL **218/219** Q 6

Ballydavid Galway IRL **218/219** Q 6

Ballydehob Cork IRL **232** T 4

Ballydesmond Cork IRL **232** S 4

Ballyduff Kerry IRL **232** S 3

Ballyduff Waterford IRL **232/233** S 6

Ballyfarnan Roscommon IRL **206** O 6

Ballyfeard Cork IRL **232/233** T 6

Ballyferriter Kerry IRL **232** S 2

Ballyfin Laois IRL **219** Q 8

Ballyforan Offaly IRL **218/219** Q 6

Ballygalley Antrim GB **207** N 11

Ballygar Galway IRL **218/219** P 6

Ballygarrett Wexford IRL **233** R 10

Ballygawley Sligo IRL **206** O 6

Ballygawley Tyrone GB **207** O 8

Ballyglass Mayo IRL **218** P 4

Ballygorman Donegal IRL **207** M 8

Ballygowan Down GB **207** O 11

Ballygrant Argyll and Bute GB **174** L 10

Ballyhaise Cavan IRL **207** O 8

Ballyhalbert Down GB **207** O 12

Ballyhale Kilkenny IRL **233** S 8

Ballyhaugh Argyll and Bute GB **174** J 9

Ballyhaunis Mayo IRL **218** P 5

Ballyheige Kerry IRL **232** S 3

Ballyhooly Cork IRL **232/233** S 6

Ballyjamesduff Cavan IRL **219** P 8

Ballykelly Londonderry GB **207** M 8

Ballylanders Limerick IRL **232/233** S 6

Ballyliffin Donegal IRL **207** M 8

Ballylongford Kerry IRL **232** R 3

Ballylooby Tipperary IRL **233** S 7

Ballylynan Laois IRL **233** R 8

Ballymacarbry Waterford IRL **233** S 7

Ballymachugh Cavan IRL **219** P 8

Ballymacoda Cork IRL **233** T 7

Ballymacward Galway IRL **218/219** Q 6

Ballymahon Longford IRL **219** P 7

Ballymakeery Cork IRL **232** T 4

Ballymakenny Louth IRL **219** P 10

Ballymena Antrim GB **207** N 10

Ballymoe Galway IRL **218/219** P 6

Ballymoney Antrim GB **207** M 9

Ballymore Westmeath IRL **219** Q 7

Ballymore Eustace Kildare IRL **219** Q 9

Ballymote Sligo IRL **206** O 5

Ballymurray Roscommon IRL **218/219** P 6

Ballynabragget Down GB **207** O 10

Ballynacally Clare IRL **232** R 4

Ballynacarrigy Westmeath IRL **219** P 7

Ballynacourty Waterford IRL **233** S 7

Ballynagore Westmeath IRL **219** Q 8

Ballynahinch Down GB **207** O 11

Ballynahown Westmeath IRL **219** Q 7

Ballynamallaght Tyrone GB **207** N 8

Ballynamult Waterford IRL **233** S 7

Ballynana Kerry IRL **232** S 2

Ballyneety Limerick IRL **232** R 5

Ballynoe Cork IRL **232/233** S 6

Ballynure Antrim GB **207** N 11

Ballyporeen Tipperary IRL **232/233** S 6

Ballyragget Kilkenny IRL **233** R 8

Ballyroan Laois IRL **233** R 8

Ballyronan Londonderry GB **207** N 9

Ballyroney Down GB **207** O 10

Ballysadare Sligo IRL **206** O 5

Ballyshannon Donegal IRL **206** N 6

Ballyshrule Galway IRL **218/219** Q 6

Ballytoohy Mayo IRL **218** P 3

Ballyvaghan Clare IRL **218** Q 4

Ballyvoy Antrim GB **207** M 10

Ballywalter Down GB **146** N 12

Ballyward Down GB **207** O 10

Ballywilliam Wexford IRL **233** S 9

Balmaclellan Dumfries und Galloway GB **146** M 14

Balmaha Stirling GB **160** K 13

Balmedie Aberdeenshire GB **187** H 18

Balmerino Fife GB **161** K 16

Balnacoil Highland GB **186/187** F 14

Balnacra Highland GB **186** H 12

Balnaguard Perth and Kinross GB **160/161** J 15

Balquhidder Stirling GB **160** K 14

Balrath Meath IRL **219** P 10

Balsham Cambridgeshire GB **101** S 23

Baltasound Shetland Islands GB **199** A 21

Baltimore Cork IRL **232** U 4

Baltinglass Wicklow IRL **233** R 9

Baltonsborough Somerset GB **53** U 17

Balvicar Argyll and Bute GB **174** K 11

Bamburgh Northumberland GB **161** L 19

Bamford Derbyshire GB **134** Q 19

Bampton Cumbria GB **146/147** N 17

Bampton Devon GB **53** V 16

Bampton Oxfordshire GB **70** T 19

Banada Sligo IRL **206** O 5

Banagher Offaly IRL **219** Q 7

Banbridge Down GB **207** O 10

Banbury Oxfordshire GB **100** S 20

Banchory Aberdeenshire GB **187** H 17

Bandon Cork IRL **232** T 5

Banff Aberdeenshire GB **187** G 17

Bangor Gwynedd GB **118/119** Q 14

Bangor Down GB **207** N 11

Bangor Mayo IRL **218** O 3

Bangor-is-y-coed Wrexham GB **119** Q 17

Bankend Dumfries und Galloway GB **146** M 15

Bankfoot Perth and Kinross GB **160/161** K 15

Banks Lancashire GB **119** P 17

Banks Cumbria GB **146/147** N 17

Bankshill Dumfries und Galloway GB **146** M 16

Bannockburn Stirling GB **160/161** K 15

Bansha Tipperary IRL **232/233** S 6

Banstead Surrey GB **71** U 22

Banteer Cork IRL **232** S 5

Bantry Cork IRL **232** T 4

Barabhas Na h-Eileanan an Iar GB **186** F 10

Barbon Cumbria GB **146/147** O 17

Bardney Lincolnshire GB **135** Q 22

Bardsea Cumbria GB **146** O 16

Barefield Clare IRL **232** R 5

Barford Warwickshire GB **100** S 19

Bargoed Caerphilly GB **87** T 16

Bargrennan Dumfries und Galloway GB **146** M 13

Barham Kent GB **71** U 25

Barking Greater London GB **71** T 23

Barkston Lincolnshire GB **100** R 21

Barkway Hertfordshire GB **71** T 23

Barlaston Staffordshire GB **100** R 18

Barlborough Derbyshire GB **134** Q 20

Barlby North Yorkshire GB **134** P 20

Barlestone Leicestershire GB **100** R 20

Barley Hertfordshire GB **101** S 23

Barley Lancashire GB **134** P 18

Barmby Moor East Riding of Yorkshire GB **134/135** P 21

Barmouth Gwynedd GB **86** R 14

Barmston East Riding of Yorkshire GB **135** O 22

Barna Galway IRL **218** Q 4

Barnaderg Galway IRL **218** Q 5

Barnard Castle Durham GB **147** N 19

Barnatra Mayo IRL **218** O 3

Barnet Greater London GB **71** T 22

Barnham Suffolk GB **101** S 24

Barnham Broom Norfolk GB **101** R 25

Barnhill Moray GB **187** G 16

Barningham Suffolk GB **101** S 24

Barningham Durham GB **147** O 19

Barnoldswick Lancashire GB **134** P 18

Barnsley Barnsley GB **134** P 20

Barnsley Gloucestershire GB **70** T 19

Barnstaple Devon GB **52/53** U 14

Barr South Ayrshire GB **146** M 13

Barrhead East Renfrewshire GB **160** L 14

Barrhill South Ayrshire GB **146** M 13

Barrow Suffolk GB **101** S 24

Barrowford Lancashire GB **134** P 18

Barrow-in-Furness Cumbria GB **146** O 16

Barry Vale of Glamorgan GB **53** U 16

Bartlow Cambridgeshire GB **101** S 23

Barton-le-Clay Bedfordshire GB **71** T 22

Barton-upon-Humber North Lincolnshire GB **135** P 22

Baschurch Shropshire GB **119** R 17

Basildon Essex GB **71** T 23

Basingstoke Hampshire GB **70** U 20

Bassenthwaite Cumbria GB **146** N 16

Bassingham Lincolnshire GB **134/135** Q 21

Bastardstown Wexford IRL **233** S 9

Baston Lincolnshire GB **100/101** R 22

Bastwick Norfolk GB **101** R 26

Bath Derbyshire GB **134** Q 19

Bath Bath & NE Somerset GB **70** U 18

Bathgate West Lothian GB **160/161** L 15

Batley Kirklees GB **134** P 19

Battle East Sussex GB **71** V 23

Battlesbridge Essex GB **71** T 24

Baumber Lincolnshire GB **135** Q 22

Bawburgh Norfolk GB **101** R 25

Bawdeswell Norfolk GB **101** R 25

Bawdsey Suffolk GB **101** S 25

Bawtry Doncaster GB **134** Q 20

Baydon Wiltshire GB **70** U 19

Bayston Hill Shropshire GB **87** R 17

Beachampton Buckinghamshire GB **100** S 21

Beaconsfield Buckinghamshire GB **70/71** T 21

Beadnell Northumberland GB **161** L 19

Beal Northumberland GB **161** L 19

Bealaclugga Clare IRL **218** Q 4

Bealaha Clare IRL **232** R 3

Beaminster Dorset GB **53** V 17

Beanley Northumberland GB **147** M 19

Beare Green Surrey GB **71** U 22

Bearley Warwickshire GB **100** S 19

Bearsden East Dunbartonshire GB **160** L 14

Beattock Dumfries und Galloway GB **146** M 16

Beaulieu Hampshire GB **70** V 20

Beauly Highland GB **186** H 14

Beaumaris Anglesey GB **118/119** Q 14

Beauworth Hampshire GB **70** U 20

Bebington Wirral GB **119** Q 16

Beccles Suffolk GB **101** S 26

Beck Row Suffolk GB **101** S 23

Beckermet Cumbria GB **146** O 15

Beckfoot Cumbria GB **146** N 16

Beckingham Lincolnshire GB **134/135** Q 21

Beckingham Nottinghamshire GB **134/135** Q 21

Beckington Somerset GB **70** U 18

Bective Meath IRL **219** P 9

Bedale North Yorkshire GB **147** O 19

Beddgelert Gwynedd GB **118/119** Q 14

Beddingham East Sussex GB **71** V 23

Bedford Bedfordshire GB **100/101** S 22

Bedlington Northumberland GB **147** M 19

Bedrule Scottish Borders GB **146/147** M 17

Bedwas Caerphilly GB **87** T 16

Bedworth Warwickshire GB **100** S 20

Bedwyn Wiltshire GB **70** U 19

Beeford East Riding of Yorkshire GB **135** P 22

Beeston Nottinghamshire GB **100** R 20

Beeswing Dumfries und Galloway GB **146** M 15

Beguildy Powys GB **87** S 16

Beith North Ayrshire GB **160** L 13

Belbroughton Worcestershire GB **87** S 18

Belchford Lincolnshire GB **135** Q 22

Belcoo Fermanagh GB **206** O 7

Belderg Mayo IRL **218** O 3

Beleek Fermanagh GB **206** O 6

Belfast Antrim GB **207** N 11

Belford Northumberland GB **161** L 19

Belgooly Cork IRL **232/233** T 6

Bellacorrick Mayo IRL **218** O 3

Bellaghy Londonderry GB **207** N 9

Bellanagare Roscommon IRL **218/219** P 6

Bellanagh Cavan IRL **219** P 8

Bellanaleck Fermanagh GB **206** O 7

Bellavary Mayo IRL **218** P 4

Belleaneeny Offaly IRL **218/219** Q 6

Bellingham Northumberland GB **147** M 18

Bellshill North Lanarkshire GB **160** L 14

Belmont Blackburn with Darwen GB **119** P 17

Belmont Shetland Islands GB **199** A 21

Belmullet Mayo IRL **218** O 3

Belnacraig Aberdeenshire GB **187** H 16

Belnapaling Highland GB **186/187** G 14

Belper Derbyshire GB **134** Q 20

Belsay Northumberland GB **147** M 19

Belton Norfolk GB **101** R 26

Belton North Lincolnshire GB **134/135** P 21

Beltra Sligo IRL **206** O 5

Beltra Mayo IRL **218** P 4

Belturbet Cavan IRL **207** O 8

Belville Mayo IRL **206** O 4

Belvoir Leicestershire GB **100** R 21

Bembridge Isle of Wight GB **70** V 20

Ben Alder Lodge Highland GB **160** J 14

Benburb Tyrone GB **207** O 9

Benderloch Argyll and Bute GB **160** K 12

Benllech Anglesey GB **118/119** Q 14

Bennettsbridge Kilkenny IRL **233** R 8

Benson Oxfordshire GB **70** T 20

Bentley Doncaster GB **134** P 20

Bentley Hampshire GB **70/71** U 21

Bentpath Dumfries und Galloway GB **146** M 16

Benville Dorset GB **53** V 17

Benwick Cambridgeshire GB **100/101** S 22

Beragh Tyrone GB **207** N 8

Bere Alston Devon GB **52/53** W 14

Bere Ferrers Devon GB **52/53** W 14

Bere Regis Dorset GB **70** V 18

Berkeley Gloucestershire GB **70** T 18

Berkhamsted Hertfordshire GB **70/71** T 21

Bernisdale Highland GB **175** H 10

Berriedale Highland GB **187** F 15

Berrynarbor Devon GB **52/53** U 14

Berwick-upon-Tweed Northumberland GB **161** L 18

Bessbrook Armagh GB **207** O 10

Bethersden Kent GB **71** U 24

Bethesda Gwynedd GB **118/119** Q 14

Bettyhill Highland GB **186/187** E 14

Bettystown Meath IRL **219** P 10

Betws-y-Coed Conwy GB **119** Q 15

Beulah Ceredigion GB **86** S 14

Beulah Powys GB **86/87** S 15

Beverley East Riding of Yorkshire GB **135** P 22

Bewcastle Cumbria GB **146/147** M 17

Bewdley Worcestershire GB **87** S 18

Bexhill East Sussex GB **71** V 23

Beyton Suffolk GB **101** S 24

Bhaltos Na h-Eileanan an Iar GB **175** F 9

Bibury Gloucestershire GB **70** T 19

Bicester Oxfordshire GB **70** T 20

Bicker Lincolnshire GB **100/101** R 22

Bickington Devon GB **53** V 15

Bickley Moss Cheshire GB **119** Q 17

Biddenden Kent GB **71** U 24

Biddulph Staffordshire GB **134** Q 18

Bideford Devon GB **52/53** U 14

Bidford-on-Avon Warwickshire GB **100** S 19

Big Sand Highland GB **186** G 11

Bigbury-on-Sea Devon GB **53** W 15

Bigby Lincolnshire GB **135** P 22

Biggar South Lanarkshire GB **160/161** L 15

Biggin Hill Greater London GB **71** U 23

Biggleswade Bedfordshire GB **100/101** S 22

Bildeston Suffolk GB **101** S 24

Billericay Essex GB **71** T 23

Billesdon Leicestershire GB **100** R 21

Billingborough Lincolnshire GB **100/101** R 22

Billinge St Helens GB **119** Q 17

Billingham Stockton-on-Tees GB **147** N 20

Billinghay Lincolnshire GB **135** Q 22

Billingshurst West Sussex GB **71** U 22

Billingsley Shropshire GB **87** S 18

Binbrook Lincolnshire GB **135** Q 22

Bingham Nottinghamshire GB **100** R 21

Bingley Bradford GB **134** P 19

Binham Norfolk GB **101** R 24

Birdhill Tipperary IRL **232/233** R 6

Birdlip Gloucestershire GB **70** T 18

Birdsall North Yorkshire GB **134** O 21

Birkenhead Wirral GB **119** Q 16

Birmingham Birmingham GB **100** S 19

Birr Offaly IRL **219** Q 7

Birtley Northumberland GB **147** M 18

Birtley Gateshead GB **147** N 19

Bishampton Worcestershire GB **87** S 18

Bishop Auckland Durham GB **147** N 19

Bishop Burton East Riding of Yorkshire GB **134/135** P 21

Bishop´s Castle Shropshire GB **87** R 16

Bishop´s Waltham Hampshire GB **70** V 20

Bishops Cannings Wiltshire GB **70** U 19

Bishop's Cleeve Gloucestershire GB **70** T 18

Bishops Lydeard Somerset GB **53** U 16

Bishop's Stortford Hertfordshire GB **71** T 23

Bishop's Tawton Devon GB **52/53** U 14

Bishopston Swansea GB **86** T 14

Bishopton Renfrewshire GB **160** L 13

Bisley Gloucestershire GB **70** T 18

Bisley Surrey GB **70/71** U 21

Bittadon Devon GB **52/53** U 14

Bitterley Shropshire GB **87** S 17

Blackburn Blackburn with Darwen GB **134** P 18

Blackburn West Lothian GB **160/161** L 15

Blackburn Aberdeen City GB **187** H 18

Blackford Cumbria GB **146/147** N 17

Blackford Perth and Kinross GB **160/161** K 15

Blackhall Durham GB **147** N 20

Blacklunans Perth and Kinross GB **161** J 16

Blacklion Cavan IRL **206** O 7

Blackmill Bridgend GB **86/87** T 15

Blackpool Blackpool GB **119** P 16

Blackpool Limerick IRL **232** S 5

Blackrock Louth IRL **219** P 10

Blackthorn Oxfordshire GB **70** T 20

Blackwater Wexford IRL **233** S 10

Blackwater Bridge Kerry IRL **232** T 3

Blackwaterfoot North Ayrshire GB **160** L 12

Blackwatertown Armagh GB **207** O 9

Bladon Oxfordshire GB **70** T 20

Blaenau Ffestiniog Gwynedd GB **119** Q 15

Blaenavon Torfaen GB **87** T 16

Blagdon North Somerset GB **53** U 17

Blaich Highland GB **160** J 12

Blaina Blaenau Gwent GB **87** T 16

Blair Atholl Perth and Kinross GB **160/161** J 15

Blairgowrie Perth and Kinross GB **161** J 16

Blakemere Herefordshire GB **87** S 17

Blakeney Norfolk GB **101** R 25

Blakeney Gloucestershire GB **70** T 18

Blakesley Northhamptonshire GB **100** S 20

Blanchland Northumberland GB **147** N 18

Blandford Forum Dorset GB **70** V 18

Blanefield Stirling GB **160** L 14

Blarnalearoch Highland GB **186** G 12

Blarney Cork IRL **232** T 5

Blaydon Gateshead GB **147** N 19

Bleadon North Somerset GB **53** U 17

Bleasby Nottinghamshire GB **134/135** Q 21

Bledington Oxfordshire GB **70** T 19

Blencarn Cumbria GB **146/147** N 17

Blessington Wicklow IRL **219** Q 9

Blewbury Oxfordshire GB **70** T 20

Blidworth Nottinghamshire GB **134** Q 20

Blisworth Northhamptonshire GB **100** S 21

Blockley Gloucestershire GB **70** T 19

Blofield Norfolk GB **101** R 25

Bloxham Oxfordshire GB **100** S 20

Blubberhouses North Yorkshire GB **134** P 19

Blue Ball Offaly IRL **219** Q 7

Bluntisham Cambridgeshire GB **101** S 23

Blyth Nottinghamshire GB **134** Q 20

Blyth Northumberland GB **147** M 20

Blythburgh Suffolk GB **101** S 26

Blythe Bridge Staffordshire GB **100** R 18

Blyton Lincolnshire GB **134/135** Q 21

Bo´ness Falkirk GB **160/161** K 15

Boarhills Fife GB **161** K 17

Boat of Garten Highland GB **187** H 15

Boath Highland GB **186/187** G 14

Bocking Churchstreet Essex GB **71** T 24

Boddam Aberdeenshire GB **187** H 19

Boddam Shetland Islands GB **199** C 20

Bodedern Anglesey GB **118** Q 13

Bodiam East Sussex GB **71** U 24

Bodmin Cornwall GB **52** W 13

Boduan Gwynedd GB **118** R 13

Bodyke Clare IRL **232** R 5

Bofin Mayo IRL **218** P 2

Bognor Regis West Sussex GB **70/71** V 21

Boharboy Louth IRL **207** O 10

Boheeshil Kerry IRL **232** T 3

Boheraphuca Offaly IRL **219** Q 7

Boherboy Cork IRL **232** S 4

Bohola Mayo IRL **218** P 4

Boldon South Tyneside GB **147** N 20

Boldre Hampshire GB **70** V 19

Bollington Cheshire GB **134** Q 18

Bolsover Derbyshire GB **134** Q 20

Boltby North Yorkshire GB **147** O 20

Bolton Bolton GB **134** P 18

Bolton Northumberland GB **147** M 19

Bolton Abbey North Yorkshire GB **134** P 19

Bolton Percy North Yorkshire GB **134** P 20

Bolton-by-Bowland Lancashire GB **134** P 18

Bolton-le-Sands Lancashire GB **146/147** O 17

Bolventor Cornwall GB **52** V 13

Bonar Bridge Highland GB **186/187** G 14

Boncath Pembrokeshire GB **86** S 13

Bonchester Bridge Scottish Borders GB **146/147** M 17

Bonhill West Dunbartonshire GB **160** L 13

Bonnington Kent GB **71** U 24

Bonnybridge Falkirk GB **160/161** L 15

Bonnyrigg Midlothian GB **161** L 16

Bont-goch or Elerch Ceredigion GB **86/87** S 15

Bonvilston Vale of Glamorgan GB **53** U 16

Boosbeck Redcar & Cleveland GB **147** N 21

Boot Cumbria GB **146** O 16

Booth of Toft Shetland Islands GB **199** B 20

Bootle Salford GB **119** Q 17

Bootle Cumbria GB **146** O 16

Borehamwood Hertfordshire GB **71** T 22

Boreland Dumfries und Galloway GB **146** M 16

Borgh Na h-Eileanan an Iar GB **175** G 8

Borgh Na h-Eileanan an Iar GB **175** J 7

Borgue Dumfries und Galloway GE **146** N 14

Boroughbridge North Yorkshire GB **147** O 20

Borreraig Highland GB **175** H 9

Borris Carlow IRL **233** R 9

Borris in Ossory Laois IRL **233** R 7

Borrisokane Tipperary IRL **232/233** R 6

Borrisoleigh Tipperary IRL **233** R 7

Borrowdale Cumbria GB **146** N 16

Borth Ceredigion GB **86** S 14

Borve Na h-Eileanan an Iar GB **175** G 8

Borve Highland GB **175** H 10

Borwick Lancashire GB **146/147** O 17

Bosbury Herefordshire GB **87** S 18

Boscastle Cornwall GB **52** V 13

Bosherston Pembrokeshire GB **86** T 13

Boston Lincolnshire GB **100/101** R 22

Boston Spa Leeds GB **134** P 20

Botesdale Suffolk GB **101** S 25

Bothel Cumbria GB **146** N 16

Botley Hampshire GB **70** V 20

Bottesford Leicestershire GB **100** R 21

Bottisham Cambridgeshire GB **101** S 23

Boulmer Northumberland GB **147** M 19

Bourne Lincolnshire GB **100/101** R 22

Bournemouth Bournemouth GB **70** V 19

Bourton Dorset GB **70** U 18

Bourton-on-the-Water Gloucestershire GB **70** T 19

Bovey Tracey Devon GB **53** V 15

Bovingdon Hertfordshire GB **70/71** T 21

Bow Orkney Islands GB **198** E 16

Bow Devon GB **53** V 15

Bowburn Durham GB **147** N 19

Bowden Scottish Borders GB **161** L 17

Bowes Durham GB **147** N 19

Bowmore Argyll and Bute GB **174** L 10

Bowness-on-Solway Cumbria GB **146** N 16

Bowness-on-Windermere Cumbria GB **146/147** O 17

Bowsden Northumberland GB **161** L 19

Box Wiltshire GB **70** U 18

Boxford Suffolk GB **101** S 24

Boyle Roscommon IRL **218/219** P 6

Boynton East Riding of Yorkshire GB **135** O 22

Boyton Cornwall GB **52/53** V 14

Bozeat Northhamptonshire GB **100** S 21

Braaid Isle of Man GB **146** O 13

Brabourne Lees Kent GB **71** U 25

Bracadale Highland GB **175** H 10

Brackley Buckinghamshire GB **100** S 20

Brackley Northhamptonshire GB **100** S 20

Bracknell Bracknell Forest GB **70/71** U 21

Braco Perth and Kinross GB **160/161** K 15

Bracora Highland GB **175** J 11

Bradford Bradford GB **134** P 19

Bradford Abbas Dorset GB **53** V 17

Bradford-on-Avon Wiltshire GB **70** U 18

Bradninch Devon GB **53** V 16

Bradwell Derbyshire GB **134** Q 19

Bradwell Waterside Essex GB **71** T 24

Bradworthy Devon GB **52/53** V 14

Brae Shetland Islands GB **199** B 20

Brae Roy Lodge Highland GB **160** J 13

Braehead South Lanarkshire GB **160/161** L 15

Braemar Aberdeenshire GB **161** H 16

Braemore Highland GB **186** G 12

Braemore Highland GB **187** F 15

Braeswick Orkney Islands GB **198** D 17

Brafferton North Yorkshire GB **147** O 20

Bragar Na h-Eileanan an Iar GB **175** F 9

Brailsford Derbyshire GB **100** R 19

Braintree Essex GB **71** T 24

Braishfield Hampshire GB **70** U 20

Braithwaite Cumbria GB **146** N 16

Braithwell Doncaster GB **134** Q 20

Bramdean Hampshire GB **70** U 20

Bramfield Suffolk GB **101** S 26

Bramford Suffolk GB **101** S 25

Bramham Leeds GB **134** P 20

Bramhope Leeds GB **134** P 19

Bramley Hampshire GB **70** U 20

Brampton Cambridgeshire GB **100/101** S 22

Brampton Suffolk GB **101** S 26

Brampton Cumbria GB **146/147** N 17

Bramshaw Hampshire GB **70** V 19

Brancaster Norfolk GB **101** R 24

Branderburgh Moray GB **187** G 16

Brandesburton East Riding of Yorkshire GB **135** P 22

Brandon Suffolk GB **101** S 24

Brandon Durham GB **147** N 19

Brandsby North Yorkshire GB **147** O 20

Branscombe Devon GB **53** V 16

Bransgore Hampshire GB **70** V 19

Branston Leicestershire GB **100** R 21

Branston Lincolnshire GB **135** Q 22

Branxton Northumberland GB **161** L 18

Brassington Derbyshire GB **134** Q 19

Bratton Clovelly Devon GB **52/53** V 14

Bratton Fleming Devon GB **53** U 15

Braughing Hertfordshire GB **71** T 23

Braunston Northhamptonshire GB **100** S 20

Braunton Devon GB **52/53** U 14

Bray Bré Wicklow IRL **219** Q 10

Brayford Devon GB **53** U 15

Breage Cornwall GB **52** W 12

Breamore Hampshire GB **70** V 19

Brean Somerset GB **53** U 16

Breanais Na h-Eileanan an Iar GB **176** F 8

Breascleit Na h-Eileanan an Iar GB **175** F 9

Brechfa Carmarthenshire GB **86** T 14

Brechin Angus GB **161** J 18

Brecon Aberhonddu Powys GB **87** T 16

Brede East Sussex GB **71** V 24

Bredgar Kent GB **71** U 24

Bredon Worcestershire GB **87** S 18

Breedon on the Hill Leicestershire GB **100** R 20

Brendon Devon GB **53** U 15

Brent Pelham Hertfordshire GB **71** T 23

Brentwood Essex GB **71** T 23

Brewood Staffordshire GB **100** R 18

Brickeens Mayo IRL **218** P 5

Bride Isle of Man GB **146** O 14

Bridestowe Devon GB **52/53** V 14

Bridge Kent GB **71** U 25

Bridge End Donegal IRL **207** M 8

Bridge of Allan Stirling GB **160/161** K 15

Bridge of Balgie Perth and Kinross GB **160** J 14

Bridge of Cally Perth and Kinross GB **161** J 16

Bridge of Dee Dumfries und Galloway GB **146** N 15

Bridge of Don Aberdeen City GB **187** H 18

Bridge of Dun Angus GB **161** J 18

Bridge of Earn Perth and Kinross GB **161** K 16

Bridge of Gaur Perth and Kinross GB **160** J 14

Bridge of Weir Renfrewshire GB **160** L 13

Bridgend Angus GB **161** J 18

Bridgend Argyll and Bute GB **174** L 10

Bridgend Moray GB **187** H 16

Bridgend Peny-y-Bont Ar Ogwr Bridgend GB **53** U 15

Bridgerule Devon GB **52/53** V 14

Bridgetown Wexford IRL **233** S 9

Bridgnorth Shropshire GB **100** R 18

Bridgwater Somerset GB **53** U 16

Bridlington East Riding of Yorkshire GB **135** O 22

Bridport Dorset GB **53** V 17

Brierfield Lancashire GB **134** P 18

Brig o' Turk Stirling GB **160** K 14

Brigg North Lincolnshire GB **135** P 22

Brigham Cumbria GB **146** N 16

Brighouse Calderdale GB **134** P 19

Brighstone Isle of Wight GB **70** V 20

Brightlingsea Essex GB **71** T 25

Brighton Cornwall GB **52** W 13

Brighton Brighton & Hove GB **71** V 22

Brigstock Northhamptonshire GB **100** S 21

Brill Buckinghamshire GB **70** T 20

Brinian Orkney Islands GB **198** D 17

Brinkhill Lincolnshire GB **135** Q 23

Brinkley Cambridgeshire GB **101** S 23

Brinklow Warwickshire GB **100** S 20

Brinkworth Wiltshire GB **70** T 19

Bristol Bristol GB **53** U 17

Brithdir Gwynedd GB **119** R 15

Briton Ferry Neath Port Talbot GB **86/87** T 15

Brittas Dublin IRL **219** Q 10

Brixham Torbay GB **53** W 15

Brixworth Northhamptonshire GB **100** S 21

Brize Norton Oxfordshire GB **70** T 19

Broad Chalke Wiltshire GB **70** U 19

Broad Haven Pembrokeshire GB **86** T 12

Broad Hinton Wiltshire GB **70** U 19

Broadclyst Devon GB **53** V 16

Broadford Highland GB **175** H 11

Broadford Clare IRL **232** R 5

Broadford Limerick IRL **232** S 5

Broadhembury Devon GB **53** V 16

Broadley Moray GB **187** G 16

Broadmayne Dorset GB **70** V 18

Broadstairs Kent GB **71** U 25

Broadway Worcestershire GB **100** S 19

Broadway Somerset GB **53** V 17

Broadwindsor Dorset GB **53** V 17

Brochel Highland GB **175** H 10

Brockenhurst Hampshire GB **70** V 19

Brodick North Ayrshire GB **160** L 12

Brodie Moray GB **187** G 15

Bromborough Wirral GB **119** Q 16

Bromfield Shropshire GB **87** S 17

Bromham Bedfordshire GB **100** S 21

Bromham Wiltshire GB **70** U 18

Bromley Greater London GB **71** U 22

Brompton North Yorkshire GB **134** O 21

Brompton North Yorkshire GB **147** O 19

Brompton North Yorkshire GB **147** O 20

Brompton Ralph Somerset GB **53** U 16

Brompton Regis Somerset GB **53** U 15

Bromsgrove Worcestershire GB **87** S 18

Bromyard Herefordshire GB **87** S 17

Brook Isle of Wight GB **70** V 20

Brooke Norfolk GB **101** R 25

Brookeborough Fermanagh GB **207** O 8

Brookhouse Lancashire GB **146/147** O 17

Brookland Kent GB **71** V 24

Broom Warwickshire GB **100** S 19

Broomfield Monaghan IRL **207** O 9

Broomfleet East Riding of Yorkshire GB **134/135** P 21

Broomhill Northumberland GB **147** M 19

Brora Highland GB **187** F 15

Broseley Shropshire GB **100** R 18

Brotton Redcar & Cleveland GB **147** N 21

Brough Cumbria GB **147** N 18

Brough Highland GB **198** E 16

Brough Shetland Islands GB **199** B 21

Broughshane Antrim GB **207** N 10

Broughton Northhamptonshire GB **100** S 21

Broughton Lancashire GB **119** P 17

Broughton Flintshire GB **119** Q 17

Broughton Scottish Borders GB **161** L 16

Broughton Hampshire GB **70** U 19

Broughton Astley Leicestershire GB **100** R 20

Broughton Poggs Oxfordshire GB **70** T 19

Broughton-in-Furness Cumbria GB **146** O 16

Broughtown Orkney Islands GB **198** D 17

Brownhills Walsall GB **100** R 19

Brownston Devon GB **53** W 15

Brownstown Meath IRL **219** P 9

Broxburn West Lothian GB **161** L 16

Bruff Limerick IRL **232** S 5

Brundall Norfolk GB **101** R 25

Brundish Suffolk GB **101** S 25

Bruree Limerick IRL **232** S 5

Bruton Somerset GB **70** U 18

Bryansford Down GB **207** O 11

Brydekirk Dumfries und Galloway GB **146** M 16

Brynamman Carmarthenshire GB **86/87** T 15

Brynmawr Blaenau Gwent GB **87** T 16

Brynsiencyn Anglesey GB **118/119** Q 14

Bubwith East Riding of Yorkshire GB **134/135** P 21

Buchlyvie Stirling GB **160** K 14

Buckden North Yorkshire GB **147** O 18

Buckfastleigh Devon GB **53** W 15

Buckhaven Fife GB **161** K 16

Buckie Moray GB **187** G 17

Buckingham Buckinghamshire GB **100** S 21

Buckland Oxfordshire GB **70** T 19

Buckland Hertfordshire GB **71** T 22

Buckland Brewer Devon GB **52/53** V 14

Bucklers Hard Hampshire GB **70** V 20

Buckley Flintshire GB **119** Q 16

Bucknall Lincolnshire GB **135** Q 22

Bucknell Shropshire GB **87** S 17

Bucksburn Aberdeen City GB **187** H 18

Bude Cornwall GB **52** V 13

Budleigh Salterton Devon GB **53** V 16

Bugbrooke Northhamptonshire GB **100** S 20

Bugle Cornwall GB **52** W 13

Builth Wells Llanfair-ym-Muallt Powys GB **87** S 16

Bulford Wiltshire GB **70** U 19

Bulkeley Cheshire GB **119** Q 17

Bulmer North Yorkshire GB **134** O 21

Bunacaimb Highland GB **175** J 11

Bunacurry Mayo IRL **218** P 3

Bunane Kerry IRL **232** T 3

Bunbeg Donegal IRL **206** M 6

Bunbrosna Westmeath IRL **219** P 8

Bunbury Cheshire GB **119** Q 17

Bunclody Wexford IRL **233** R 9

Buncrana Donegal IRL **207** M 8

Bundoran Donegal IRL **206** O 6

Bunessan Argyll and Bute GB **174** K 10

Bungay Suffolk GB **101** S 25

Bunmahon Waterford IRL **233** S 8

Bunnahabhain Argyll and Bute GB **174** L 10

Bunnahowen Mayo IRL **218** O 3

Bunnanaddan Sligo IRL **206** O 5

Bunratty Clare IRL **232** R 5

Buntingford Hertfordshire GB **71** T 22

Burbage Wiltshire GB **70** U 19

Bures Essex GB **71** T 24

Burford Oxfordshire GB **70** T 19

Burgess Hill West Sussex GB **71** V 22

Burgh Castle Norfolk GB **101** R 26

Burgh le Marsh Lincolnshire GB **135** Q 23

Burghead Moray GB **187** G 15

Burley Hampshire GB **70** V 19

Burley Gate Herefordshire GB **87** S 17

Burlton Shropshire GB **119** R 17

Burmington Warwickshire GB **100** S 19

Burneside Cumbria GB **146/147** O 17

Burneston North Yorkshire GB **147** O 19

Burnfoot Scottish Borders GB **146/147** M 17

Burnfoot Donegal IRL **207** M 8

Burnham Market Norfolk GB **101** R 24

Burnham-on-Crouch Essex GB **71** T 24

Burnham-on-Sea Somerset GB **53** U 16

Burnley Lancashire GB **134** P 18

Burnmouth Scottish Borders GB **161** L 18

Burnopfield Durham GB **147** N 19

Burnsall North Yorkshire GB **147** O 19

Burntisland Fife GB **161** K 16

Burrafirth Shetland Islands GB **199** A 21

Burravoe Shetland Islands GB **199** A 20

Burrelton Perth and Kinross GB **161** J 16

Burren Clare IRL **218** Q 4

Burry Port Carmarthenshire GB **86** T 14

Burton Cheshire GB **119** Q 16

Burton Agnes East Riding of Yorkshire GB **135** O 22

Burton Bradstock Dorset GB **53** V 17

Burton Constable East Riding of Yorkshire GB **135** P 22

Burton Fleming East Riding of Yorkshire GB **135** O 22

Burton in Lonsdale North Yorkshire GB **146/147** O 17

Burton Joyce Nottinghamshire GB **100** R 20

Burton Latimer Northhamptonshire GB 100 S 21

Burton Pidsea East Riding of Yorkshire GB 135 P 22

Burton upon Stather North Lincolnshire GB 134/135 P 21

Burton-in-Kendal Cumbria GB 146/147 O 17

Burtonport Donegal IRL 206 N 6

Burton-upon-Trent Staffordshire GB 100 R 19

Burwardsley Cheshire GB 119 Q 17

Burwash East Sussex GB 71 U 23

Burwell Cambridgeshire GB 101 S 23

Burwick Orkney Islands GB 198 E 17

Bury Bury GB 134 P 18

Bury St. Edmunds Suffolk GB 101 S 24

Busby East Renfrewshire GB 160 L 14

Buscough Bridge Lancashire GB 119 P 17

Bushey Hertfordshire GB 71 T 22

Bushmills Antrim GB 207 M 9

Butleigh Somerset GB 53 U 17

Butlers Bridge Cavan IRL 207 O 8

Butlerstown Cork IRL 232 T 5

Butley Suffolk GB 101 S 25

Buttermere Cumbria GB 146 N 16

Butterwick Lincolnshire GB 101 R 23

Buttevant Cork IRL 232 S 5

Buxton Norfolk GB 101 R 25

Buxton Derbyshire GB 134 Q 19

Byfield Northhamptonshire GB 100 S 20

Byfleet Surrey GB 71 U 22

Bylchau Conwy GB 119 Q 15

Byrness Northumberland GB 147 M 18

C

Cabrach Moray GB 187 H 16

Cadbury Devon GB 53 V 15

Cadnam Hampshire GB 70 V 19

Caerdydd Cardiff Cardiff GB 53 U 16

Caerfyrddin Carmarthenshire GB 86 T 14

Caergwrle Flintshire GB 119 Q 16

Caergybi Holyhead Anglesey GB 118 Q 13

Caerleon Newport GB 87 T 17

Caernarfon Gwynedd GB 118/119 Q 14

Caerphilly Caerphilly GB 87 T 16

Caersws Powys GB 87 S 16

Caerwent Monmouthshire GB 87 T 17

Caerwys Flintshire GB 119 Q 16

Caherconell Clare IRL 218 Q 4

Caherconlish Limerick IRL 232/233 R 6

Cahersiveen Cathair Saidhbhín Kerry IRL 70 T 2

Cahir Tipperary IRL 233 S 7

Cairinis Na h-Eileanan an Iar GB 175 H 8

Cairnbaan Argyll and Bute GB 160 K 12

Cairncross Angus GB 161 J 18

Cairndow Argyll and Bute GB 160 K 13

Cairnryan Dumfries und Galloway GB 146 N 12

Caister-on-Sea Norfolk GB 101 R 26

Caistor Lincolnshire GB 135 Q 22

Calanais Na h-Eileanan an Iar GB 175 F 9

Calbourne Isle of Wight GB 70 V 20

Caldbeck Cumbria GB 146 N 16

Calder Bridge Cumbria GB 146 O 16

Calder Mains Highland GB 198 E 15

Caldicot Monmouthshire GB 87 T 17

Caldwell North Yorkshire GB 147 N 19

Caledon Tyrone GB 207 O 9

Calgary Argyll and Bute GB 174 J 10

Callan Kilkenny IRL 233 R 8

Callander Stirling GB 160 K 14

Callington Cornwall GB 52/53 V 14

Callow Mayo IRL 218 P 4

Calne Wiltshire GB 70 U 18

Calshot Hampshire GB 70 V 20

Calthwaite Cumbria GB 146/147 N 17

Caltra Galway IRL 218/219 Q 6

Calvine Perth and Kinross GB 160/161 J 15

Camaross Wexford IRL 233 S 9

Camastianavaig Highland GB 175 H 10

Camb Shetland Islands GB 199 A 20

Camber East Sussex GB 71 V 24

Camberley Surrey GB 70/71 U 21

Cambo Northumberland GB 147 M 19

Cambois Northumberland GB 147 M 19

Camborne Cornwall GB 52 W 12

Cambridge Cambridgeshire GB 101 S 23

Cambustbarron Stirling GB 160/161 K 15

Camelford Cornwall GB 52 V 13

Camlough Armagh GB 207 O 10

Camolin Wexford IRL 233 R 10

Camp Kerry IRL 232 S 3

Campbeltown Argyll and Bute GB 174 M 11

Camus Galway IRL 218 Q 3

Camusnagaul Highland GB 160 J 12

Camusnagaul Highland GB 186 G 12

Candlesby Lincolnshire GB 135 Q 23

Canewdon Essex GB 71 T 24

Cannich Highland GB 186 H 13

Canningstown Cavan IRL 219 P 8

Cannington Somerset GB 53 U 16

Cannock Staffordshire GB 100 R 18

Canonbie Dumfries und Galloway GB 146/147 M 17

Canterbury Kent GB 71 U 25

Cantley Norfolk GB 101 R 26

Canvey Thurrock GB 71 T 24

Caol Highland GB 160 J 12

Caolas Argyll and Bute GB 174 J 9

Capel Surrey GB 71 U 22

Capel Curig Conwy GB 119 Q 15

Capel St Mary Suffolk GB 101 S 25

Capheaton Northumberland GB 147 M 19

Cappagh White Tipperary IRL 232/233 R 6

Cappamore Limerick IRL 232/233 R 6

Cappoquin Waterford IRL 233 S 7

Capthorne Surrey GB 71 U 22

Caputh Perth and Kinross GB 161 J 16

Caragh Lake Kerry IRL 232 S 3

Carbost Highland GB 175 H 10

Carbury Kildare IRL 219 Q 9

Cardiff Caerdydd Cardiff GB 53 U 16

Cardigan Aberteifi Ceredigion GB 86 S 13

Cardington Bedfordshire GB 100/101 S 22

Cardington Shropshire GB 87 R 17

Cardross Argyll and Bute GB 160 L 13

Carew Pembrokeshire GB 86 T 13

Carham Scottish Borders GB 161 L 18

Cark Cumbria GB 146/147 O 17

Carlabhagh Na h-Eileanan an Iar GB 175 F 9

Carlanstown Meath IRL 219 P 9

Carlingcott Bath & NE Somerset GB 70 U 18

Carlingford Louth IRL 207 O 10

Carlisle Cumbria GB 146/147 N 17

Carlops Scottish Borders GB 161 L 16

Carlow Ceatharlach Carlow IRL 233 R 9

Carlton North Yorkshire GB 134 P 20

Carlton North Yorkshire GB 147 O 19

Carlton in Cleveland North Yorkshire GB 147 O 20

Carlton in Lindrick Nottinghamshire GB 134 Q 20

Carlton-on-Trent Nottinghamshire GB 134/135 Q 21

Carluke South Lanarkshire GB 160/161 L 15

Carmarthen/ Carmarthenshire GB 86 T 14

Cárna Galway IRL 218 Q 3

Carnach Na h-Eileanan an Iar GB 175 G 9

Carnach Highland GB 186 H 12

Carnagh Armagh GB 207 O 9

Carnaross Meath IRL 219 P 9

Carnbee Fife GB 161 K 17

Carncastle Antrim GB 207 N 11

Carndonagh Donegal IRL 207 M 8

Carnew Wicklow IRL 233 R 9

Carnforth Lancashire GB 146/147 O 17

Carnlough Antrim GB 207 N 10

Carno Powys GB 86/87 R 15

Carnock Fife GB 160/161 K 15

Carnoustie Angus GB 161 K 17

Carnteel Tyrone GB 207 O 9

Carnwath South Lanarkshire GB 160/161 L 15

Carracastle Mayo IRL 218 P 5

Carradale Argyll and Bute GB 160 L 12

Carraroe Galway IRL 218 Q 3

Carrbridge Highland GB 187 H 15

Carrick Wexford IRL 233 S 9

Carrick Castle Argyll and Bute GB 160 K 13

Carrick Ho Orkney Islands GB 198 D 17

Carrickart Donegal IRL 206 M 7

Carrickfergus Antrim GB 207 N 11

Carrickmacross Monaghan IRL 219 P 9

Carrickmore Tyrone GB 207 N 8

Carrick-on-Shannon Leitrim IRL 218/219 P 6

Carrick-on-Suir Carraig na Siúre Tipperary IRL 233 S 8

Carrigaholt Clare IRL 232 R 3

Carrigahorig Tipperary IRL 218/219 Q 6

Carrigaline Cork IRL 232/233 T 6

Carrigallen Leitrim IRL 219 P 7

Carriganimmy Cork IRL 232 T 4

Carronbridge Dumfries und Galloway GB 146 M 15

Carrowbehy Roscommon IRL 218 P 5

Carrowdore Down GB 207 N 11

Carrowkeel Donegal IRL 206 M 7

Carrowmoreknock Galway IRL 218 Q 4

Carrowrory Longford IRL 219 P 7

Carryduff Down GB 207 N 11

Carsaig Argyll and Bute GB 174 K 11

Carskiey Argyll and Bute GB 174 M 11

Carsluith Dumfries und Galloway GB 146 N 14

Carspshairn Dumfries und Galloway GB 146 M 14

Carstairs South Lanarkshire GB 160/161 L 15

Carterton Oxfordshire GB 70 T 19

Cartmel Cumbria GB 146/147 O 17

Cartmel Fell Cumbria GB 146/147 O 17

Cas-Gwent Chepstow Monmouthshire GB 87 T 17

Cashel Galway IRL 218 Q 3

Cashel Tipperary IRL 233 R 7

Cashleen Galway IRL 218 P 2

Cashlie Perth and Kinross GB 160 J 14

Casla Galway IRL 218 Q 3

Casnewydd Newport Newport GB 87 T 17

Castle Acre Norfolk GB 101 R 24

Castle Bolton North Yorkshire GB 147 O 19

Castle Bytham Lincolnshire GB 100 R 21

Castle Carrock Cumbria GB 146/147 N 17

Castle Cary Somerset GB 53 U 17

Castle Donington Leicestershire GB 100 R 20

Castle Douglas Dumfries und Galloway GB 146 N 15

Castle Frome Herefordshire GB 87 S 18

Castlebaldwin Sligo IRL 206 O 6

Castlebar Caisleán an Bharráigh Mayo IRL 218 P 4

Castlebay Bagh a´Chaisteil Na h-Eileanan an Iar GB 175 J 8

Castlebellingham Louth IRL 219 P 10

Castleblayney Monaghan IRL 207 O 9

Castlebridge Wexford IRL 233 S 10

Castlecaulfield Tyrone GB 207 N 9

Castlecomer Kilkenny IRL 233 R 8

Castleconnell Limerick IRL 232/233 R 6

Castlecor Cork IRL 232 S 5

Castlederg Tyrone GB 206 N 7

Castledermot Kildare IRL 233 R 9

Castlefinn Donegal IRL 206 N 7

Castleford Wakefield GB 134 P 20

Castlefreke Cork IRL 232 T 5

Castlegregory Kerry IRL 232 S 2

Castlehill Mayo IRL 206 O 4

Castleisland Kerry IRL 232 S 4

Castlemaine Kerry IRL 232 S 3

Castlemartin Pembrokeshire GB 86 T 12

Castlemartyr Cork IRL 232/233 T 6

Castleplunket Roscommon IRL 218/219 P 6

Castlepollard Westmeath IRL 219 P 8

Castlequarter Galway IRL 218 Q 4

Castlerea Roscommon IRL 218 P 5

Castleside Durham GB 147 N 19

Castleton North Yorkshire GB 147 O 21

Castletown Isle of Man GB 146 O 13

Castletown Highland GB 198 E 16

Castletown Westmeath IRL 219 Q 8

Castletown Laois IRL 233 R 8

Castletown Bearhaven Cork IRL 232 T 3

Castletownroche Cork IRL 232 S 5

Castletownshend Cork IRL 232 T 4

Castlewellan Down GB 207 O 11

Caston Norfolk GB 101 R 24

Caterham Surrey GB 71 U 22

Catfield Norfolk GB 101 R 26

Catlowdy Cumbria GB 146/147 M 17

Catrine East Ayrshire GB 146 M 14

Catterall Lancashire GB 119 P 17

Catterick North Yorkshire GB **147** O 19

Catterick Garrison North Yorkshire GB **147** O 19

Catterline Aberdeenshire GB **161** J 18

Catton Northumberland GB **147** N 18

Caulkerbush Dumfries und Galloway GB **146** N 15

Caunton Nottinghamshire GB **134/135** Q 21

Causeway Kerry IRL **232** S 3

Cavan Cavan IRL **219** P 8

Cavendish Suffolk GB **101** S 24

Cavenham Suffolk GB **101** S 24

Cawdor Highland GB **187** G 15

Cawood North Yorkshire GB **134** P 20

Cawston Norfolk GB **101** R 25

Caypole Lincolnshire GB **134/135** Q 21

Ceann a Bhàigh Na h-Eileanan an Iar GB **175** G 8

Cearsiadair Na h-Eileanan an Iar GB **175** F 9

Celbridge Kildare IRL **219** Q 9

Cemaes Anglesey GB **118/119** Q 14

Cemmaes Powys GB **86/87** R 15

Ceòs Na h-Eileanan an Iar GB **186** F 10

Ceres Fife GB **161** K 17

Cerne Abbas Dorset GB **70** V 18

Cerrigydrudion Conwy GB **119** Q 15

Chacewater Cornwall GB **52** W 12

Chaddesley Corbett Worcestershire GB **87** S 18

Chagford Devon GB **53** V 15

Chale Isle of Wight GB **70** V 20

Chalfont St. Giles Buckinghamshire GB **70/71** T 21

Challacombe Devon GB **53** U 15

Challerton Northumberland GB **147** M 18

Chanonrock Louth IRL **219** P 9

Chapel St Leonards Lincolnshire GB **135** Q 23

Chapel-en-le-Frith Derbyshire GB **134** Q 19

Chapelton South Lanarkshire GB **160** L 14

Chapeltown Sheffield GB **134** Q 20

Chapeltown Moray GB **187** H 16

Chapmans Well Devon GB **52/53** V 14

Chard Somerset GB **53** V 17

Chardstock Devon GB **53** V 17

Charing Kent GB **71** U 24

Charlbury Oxfordshire GB **70** T 20

Charlestown Mayo IRL **218** P 5

Charlestown of Aberlour Moray GB **187** H 16

Charleville Cork IRL **232** S 5

Charlton Wiltshire GB **70** T 18

Charlton Horethorne Somerset GB **70** U 18

Charlton-on-Otmoor Oxfordshire GB **70** T 20

Charlwood Surrey GB **71** U 22

Charmouth Dorset GB **53** V 17

Charwelton Northhamptonshire GB **100** S 20

Chatburn Lancashire GB **134** P 18

Chatham Medway GB **71** U 24

Chathill Northumberland GB **161** L 19

Chatteris Cambridgeshire GB **101** S 23

Chatton Northumberland GB **161** L 19

Chawleigh Devon GB **53** V 15

Cheadle Staffordshire GB **100** R 19

Cheadle Stockport GB **134** Q 18

Chedburgh Suffolk GB **101** S 24

Cheddar Somerset GB **53** U 17

Cheddleton Staffordshire GB **134** Q 18

Chelford Cheshire GB **134** Q 18

Chellaston Derby GB **100** R 20

Chelmsford Essex GB **71** T 23

Cheltenham Gloucestershire GB **70** T 18

Chepstow Cas-Gwent Monmouthshire GB **87** T 17

Cherhill Wiltshire GB **70** U 19

Cheriton Hampshire GB **70** U 20

Cheriton Bishop Devon GB **53** V 15

Cheriton Fitzpaine Devon GB **53** V 15

Chertsey Surrey GB **70/71** U 21

Chesham Buckinghamshire GB **70/71** T 21

Cheshunt Hertfordshire GB **71** T 22

Chester Cheshire GB **119** Q 17

Chesterfield Derbyshire GB **134** Q 20

Chester-le-Street Durham GB **147** N 19

Chesters Scottish Borders GB **146/147** M 17

Cheswardine Shropshire GB **100** R 18

Cheswick Northumberland GB **161** L 19

Chevington Northumberland GB **147** M 19

Chew Magna Bath & NE Somerset GB **53** U 17

Chewton Mendip Somerset GB **53** U 17

Chichester West Sussex GB **70/71** V 21

Chickerell Dorset GB **53** V 17

Chiddingfold Surrey GB **70/71** U 21

Chigwell Essex GB **71** T 23

Chilbolton Hampshire GB **70** U 20

Child's Ercall Shropshire GB **119** R 17

Chilham Kent GB **71** U 24

Chillaton Devon GB **52/53** V 14

Chillingham Northumberland GB **161** L 19

Chinnor Oxfordshire GB **70/71** T 21

Chippenham Cambridgeshire GB **101** S 23

Chippenham Wiltshire GB **70** U 18

Chipping Lancashire GB **119** P 17

Chipping Campden Gloucestershire GB **100** S 19

Chipping Ongar Essex GB **71** T 23

Chipping Sodbury South Gloucestershire GB **70** T 18

Chipping-Norton Oxfordshire GB **70** T 19

Chirbury Shropshire GB **87** R 16

Chirk Wrexham GB **119** R 16

Chirnside Scottish Borders GB **161** L 18

Chiseldon Swindon GB **70** T 19

Chitterne Wiltshire GB **70** U 18

Chittlehampton Devon GB **53** U 15

Chobham Surrey GB **70/71** U 21

Cholderton Wiltshire GB **70** U 19

Cholsey Oxfordshire GB **70** T 20

Chopwell Gateshead GB **147** N 19

Chorley Lancashire GB **119** P 17

Chorleywood Hertfordshire GB **70/71** T 21

Chrickhowell Powys GB **87** T 16

Christchurch Cambridgeshire GB **101** R 23

Christchurch Bournemouth GB **70** V 19

Chudleigh Devon GB **53** V 15

Chulmleigh Devon GB **53** V 15

Church Eaton Staffordshire GB **100** R 18

Church Fenton North Yorkshire GB **134** P 20

Church Hill Donegal IRL **206** N 7

Church Minshull Cheshire GB **119** Q 17

Church Quarker Antrim GB **207** M 10

Church Stoke Powys GB **87** R 16

Church Stretton Shropshire GB **87** R 17

Churchdown Gloucestershire GB **70** T 18

Churchingford Somerset GB **53** V 16

Churchtown Wexford IRL **233** S 10

Churchtown Wexford IRL **233** S 9

Churston Ferrers Devon GB **53** W 15

Chwilog Gwynedd GB **118/119** R 14

Cilcain Flintshire GB **119** Q 16

Cilcennin Ceredigion GB **86** S 14

Cilfynydd Rhondda Cynon Taff GB **87** T 16

Cilgerran Pembrokeshire GB **86** S 13

Cill Charthaigh Donegal IRL **206** N 5

Cilycwm Carmarthenshire GB **86/87** S 15

Cinderford Gloucestershire GB **70** T 18

Cirencester Gloucestershire GB **70** T 19

City of London Greater London GB **71** U 22

Clabby Fermanagh GB **207** O 8

Clachaig Argyll and Bute GB **160** L 12

Clachan Argyll and Bute GB **174** L 11

Clachan Highland GB **175** H 10

Clachan of Campsie East Dunbartonshire GB **160** L 14

Clachan of Glendaruel Argyll and Bute GB **160** K 12

Clacton-on-Sea Essex GB **71** T 25

Cladich Argyll and Bute GB **160** K 12

Clady Donegal IRL **206** N 7

Cladymilltown Armagh GB **207** O 9

Claggan Highland GB **174** J 11

Claigan Highland GB **175** H 9

Clanabogan Tyrone GB **207** N 8

Clane Kildare IRL **219** Q 9

Clanfield Oxfordshire GB **70** T 19

Clanfield Hampshire GB **70** V 20

Claonaig Argyll and Bute GB **160** L 12

Clapham North Yorkshire GB **147** O 18

Clara Offaly IRL **219** Q 7

Clarbeston Pembrokeshire GB **86** T 13

Clare Suffolk GB **101** S 24

Clare Armagh GB **207** O 10

Clarecastle Clare IRL **232** R 5

Clareen Offaly IRL **219** Q 7

Claregalway Galway IRL **218** Q 5

Claremorris Mayo IRL **218** P 4

Clarina Limerick IRL **232** R 5

Clarinbridge Galway IRL **218** Q 5

Clashmore Waterford IRL **233** S 7

Clatt Aberdeenshire GB **187** H 17

Claudy Londonderry GB **207** N 8

Claughton Lancashire GB **146/147** O 17

Claverdon Warwickshire GB **100** S 19

Claverley Shropshire GB **100** R 18

Clawton Devon GB **52/53** V 14

Claxby Lincolnshire GB **135** Q 22

Clay Cross Derbyshire GB **134** Q 20

Claydon Suffolk GB **101** S 25

Claythorpe Lincolnshire GB **134/135** Q 21

Clayton-le-Moors Lancashire GB **134** P 18

Cleadale Highland GB **175** J 10

Cleator Cumbria GB **146** O 15

Cleator Moor Cumbria GB **146** N 15

Clee St Margaret Shropshire GB **87** S 17

Cleethorpes North East Lincolnshire GB **135** P 22

Cleggan Galway IRL **218** P 2

Cleobury Mortimer Shropshire GB **87** S 18

Clevedon North Somerset GB **53** U 17

Cleveleys Blackpool GB **119** P 16

Cliddesden Hampshire GB **70** U 20

Cliffe Medway GB **71** U 24

Cliffony Sligo IRL **206** O 6

Clifford Herefordshire GB **87** S 16

Clifton Cumbria GB **146/147** N 17

Clifton upon Teme Worcestershire GB **87** S 18

Clipston Northhamptonshire GB **100** S 21

Clitheroe Lancashire GB **134** P 18

Clive Shropshire GB **119** R 17

Clogh Antrim GB **207** N 10

Cloghan Donegal IRL **206** N 7

Cloghan Westmeath IRL **219** P 8

Cloghan Offaly IRL **219** Q 7

Cloghane Kerry IRL **232** S 2

Clogheen Tipperary IRL **233** S 7

Clogher Tyrone GB **207** O 8

Clogher Mayo IRL **218** P 4

Clogher Roscommon IRL **218/219** P 6

Clogherhead Louth IRL **219** P 10

Cloghjordan Tipperary IRL **232/233** R 6

Cloghmore Mayo IRL **218** P 3

Cloghy Down GB **207** O 12

Clonakilty Cloich na Coillte Cork IRL **232** T 5

Clonaslee Laois IRL **219** Q 7

Clonbern Galway IRL **218** P 5

Clonbulloge Offaly IRL **219** Q 8

Clonbur Galway IRL **218** P 4

Clondalkin Dublin IRL **219** Q 10

Clonea Waterford IRL **233** S 8

Clonee Meath IRL **219** Q 10

Cloneen Tipperary IRL **233** S 7

Clonegall Carlow IRL **233** R 9

Clonelly Fermanagh GB **206** N 7

Clones Monaghan IRL **207** O 8

Clonfert Galway IRL **218/219** Q 6

Clonkeevy Sligo IRL **206** O 5

Clonmacnoise Offaly IRL **219** Q 7

Clonmany Donegal IRL **207** M 8

Clonmel Cluain Meala Tipperary IRL **233** S 7

Clonmellon Westmeath IRL **219** P 8

Clonmore Carlow IRL **233** R 9

Clonroche Wexford IRL **233** S 9

Clontibret Monaghan IRL **207** O 9

Clonygowan Offaly IRL **219** Q 8

Cloonacool Sligo IRL **206** O 5

Cloone Leitrim IRL **219** P 7

Cloonfad Roscommon IRL **218** P 5

Clophill Bedfordshire GB **100/101** S 22

Close Clark Isle of Man GB **146** O 13

Closeburn Dumfries und Galloway GB **146** M 15

Clough Down GB **207** O 11

Cloughton North Yorkshire GB **135** O 22

Clousta Shetland Islands GB **199** B 20

Clova Angus GB **161** J 16

Clovelly Devon GB **52/53** V 14

Clovenfords Scottish Borders GB **161** L 17

Clowne Derbyshire GB **134** Q 20

Clows Top Worcestershire GB **87** S 18

Cloyne Cork IRL **232/233** T 6

Clun Shropshire GB **87** S 16

Clunes Highland GB **160** J 13

Clungunford Shropshire GB **87** S 17

Clutton Bath & NE Somerset GB **53** U 17

Clydach Swansea GB **86/87** T 15

Clydebank Renfrewshire GB **160** L 14

Clynnogfawr Gwynedd GB **118/119** Q 14

Clyro Powys GB **87** S 16

Coachford Cork IRL **232** T 5

Coad's Cornwall GB **52/53** V 14

Coagh Tyrone GB **207** N 9

Coalburn South Lanarkshire GB **160/161** L 15

Coalisland Tyrone GB **207** N 9

Coalville Leicestershire GB **100** R 20

Coatbridge North Lanarkshire GB **160** L 14

Coatham Redcar & Cleveland GB **147** N 20

Cobh An Cóbh Cork IRL **232/233** T 6

Cobham Surrey GB **71** U 22

Cock Bridge Aberdeenshire GB **187** H 16

Cockburnspath East Lothian GB **161** L 18

Cockenzie and Port Seton East Lothian GB **161** L 17

Cockerham Lancashire GB **119** P 17

Cockermouth Cumbria GB **146** N 16

Cockfield Suffolk GB **101** S 24

Cockfield Durham GB **147** N 19

Cocking West Sussex GB **70/71** V 21

Cockley Cley Norfolk GB **101** R 24

Cockshutt Shropshire GB **119** R 17

Coddenham Suffolk GB **101** S 25

Codsall Staffordshire GB **100** R 18

Coedpoeth Wrexham GB **119** Q 16

Coggeshall Essex GB **71** T 24

Coignafearn Lodge Highland GB **186** H 14

Col Na h-Eileanan an Iar GB **186** F 10

Colbost Highland GB **175** H 9

Colchester Essex GB **71** T 24

Cold Ashton South Gloucestershire GB **70** U 18

Cold Norton Essex GB **71** T 24

Coldbackie Highland GB **186/187** E 14

Coldingham Scottish Borders GB **161** L 18

Coldstream Scottish Borders GB **161** L 18

Coleford Gloucestershire GB **87** T 17

Coleraine Londonderry GB **207** M 9

Coleshill Warwickshire GB **100** R 19

Colintraive Argyll and Bute GB **160** L 12

Collace Perth and Kinross GB **161** K 16

Collieston Aberdeenshire GB **187** H 19

Collin Dumfries und Galloway GB **146** M 15

Collingbourne Kingston Wiltshire GB **70** U 19

Collingham Leeds GB **134** P 20

Collingham Nottinghamshire GB **134/135** Q 21

Collinstown Westmeath IRL **219** P 8

Collon Louth IRL **219** P 9

Collooney Sligo IRL **206** O 5

Colmonell South Ayrshire GB **146** M 13

Colne Lancashire GB **134** P 18

Colsterworth Lincolnshire GB **100** R 21

Colston Bassett Nottinghamshire GB **100** R 21

Coltishall Norfolk GB **101** R 25

Colwyn Bay Conwy GB **119** Q 15

Colyford Devon GB **53** V 16

Combe Martin Devon GB **52/53** U 14

Combe St. Nicholas Somerset GB **53** V 17

Comber Down GB **207** N 11

Comberton Cambridgeshire GB **101** S 23

Commondale North Yorkshire GB **147** O 21

Compton West Sussex GB **70/71** V 21

Comrie Perth and Kinross GB **160/161** K 15

Cong Galway IRL **218** P 4

Congleton Cheshire GB **134** Q 18

Congresbury North Somerset GB **53** U 17

Coningsby Lincolnshire GB **135** Q 22

Conisbrough Doncaster GB **134** Q 20

Coniston Cumbria GB **146** O 16

Conistone North Yorkshire GB **147** O 18

Conna Cork IRL **232/233** S 6

Connah´s Flintshire GB **119** Q 16

Connel Argyll and Bute GB **160** K 12

Connel Park East Ayrshire GB **146** M 14

Conon Bridge Highland GB **186/187** G 14

Consett Durham GB **147** N 19

Contin Highland GB **186** G 13

Convoy Donegal IRL **206** N 7

Conwy Conwy GB **119** Q 15

Cookham Windsor & Maidenhead GB **70/71** T 21

Cookstown Tyrone GB **207** N 9

Coola Sligo IRL **206** O 6

Coolaney Sligo IRL **206** O 5

Coole Westmeath IRL **219** P 8

Coombe Cornwall GB **52** V 13

Coombe Bradley Wiltshire GB **70** U 19

Cooraclare Clare IRL **232** R 4

Cootehill Cavan IRL **207** O 8

Copdock Suffolk GB **101** S 25

Copplestone Devon GB **53** V 15

Coppull Lancashire GB **119** P 17

Copthorne West Sussex GB **71** U 22

Corbally Sligo IRL **206** O 4

Corbridge Northumberland GB **147** N 18

Corby Northhamptonshire GB **100** S 21

Corby Glen Lincolnshire GB **100** R 21

Corclogh Mayo IRL **218** O 2

Corfe Somerset GB **53** V 16

Corfe Castle Dorset GB **70** V 18

Cork Corcaigh Cork IRL **232/233** T 6

Corlea Longford IRL **219** P 7

Cornoigmore Argyll and Bute GB **174** J 9

Corner North Yorkshire GB **147** O 19

Cornhill Aberdeenshire GB **187** G 17

Cornhill-on-Tweed Northumberland GB **161** L 18

Corpach Highland GB **160** J 12

Corran Highland GB **160** J 12

Corraun Mayo IRL **218** P 3

Corrie North Ayrshire GB **160** L 12

Corrie Common Dumfries und Galloway GB **146** M 16

Corringham Lincolnshire GB **134/135** Q 21

Corris Gwynedd GB **86/87** R 15

Corrofin Clare IRL **232** R 4

Corsham Wiltshire GB **70** U 18

Corsock Dumfries und Galloway GB **146** M 15

Cortachy Angus GB **161** J 18

Corton Suffolk GB **101** R 26

Corwen Denbighshire GB **119** R 16

Coryton Thurrock GB **71** T 24

Cossington Somerset GB **53** U 17

Costessey Norfolk GB **101** R 25

Cotehill Cumbria GB **146/147** N 17

Cotgrave Nottinghamshire GB **100** R 20

Cotherstone Durham GB **147** N 19

Cotleigh Devon GB **53** V 16

Cottenham Cambridgeshire GB **101** S 23

Cottered Hertfordshire GB **71** T 22

Cottingham Northhamptonshire GB **100** R 21

Cottingham Kingston upon Hull GB **135** P 22

Coulport Argyll and Bute GB **160** K 13

Coulter South Lanarkshire GB **160/161** L 15

Countesthorpe Leicestershire GB **100** R 20

Countisbury Devon GB **53** U 15

Coupar Angus Perth and Kinross GB **161** J 16

Courtmacsherry Cork IRL **232** T 5

Courtown Wexford IRL **233** R 10

Cove Highland GB **186** G 11

Cove Bay Aberdeen City GB **187** H 18

Coventry Coventry GB **100** S 19

Coverack Cornwall GB **52** W 12

Cowbit Lincolnshire GB **100/101** R 22

Cowbridge Vale of Glamorgan GB **53** U 16

Cowdenbeath Fife GB **161** K 16

Cowesby North Yorkshire GB **147** O 20

Cowfold West Sussex GB **71** V 22

Coxwold North Yorkshire GB **147** O 20

Coylton South Ayrshire GB **146** M 14

Cradley Herefordshire GB **87** S 18

Crai Powys GB **86/87** T 15

Craigavon Down GB **207** O 10

Craigellachie Moray GB **187** H 16

Craigendoran Argyll and Bute GB **160** L 13

Craighouse Argyll and Bute GB **174** L 11

Craigie South Ayrshire GB **160** L 13

Craignure Argyll and Bute GB **174** K 11

Craik Scottish Borders GB **146** M 16

Crail Fife GB **161** K 17

Crailing Scottish Borders GB **161** L 18

Cramlington Northumberland GB **147** M 19

Cranagh Tyrone GB **207** N 8

Cranborne Dorset GB **70** V 19

Cranbrook Kent GB **71** U 24

Cranfield Bedfordshire GB **100** S 21

Cranford Donegal IRL **206** M 7

Cranford St Andrew Northhamptonshire GB **100** S 21

Cranleigh Surrey GB **70/71** U 21

Crannogeboy Donegal IRL **206** N 5

Cranshaws Scottish Borders GB **161** L 17

Crask Inn Highland GB **186** F 13

Craster Northumberland GB **147** M 19

Crathes Aberdeenshire GB **187** H 18

Crathie Aberdeenshire GB **187** H 16

Crathorne North Yorkshire GB **147** O 20

Craven Arms Shropshire GB **87** S 17

Crawford South Lanarkshire GB **146** M 15

Crawfordjohn South Lanarkshire GB **160/161** L 15

Crawley Hampshire GB **70** U 20

Crawley West Sussex GB **71** U 22

Creag Ghoraidh Na h-Eileanan an Iar GB **175** H 8

Crean's Cross Roads Cork IRL **232** T 5

Crediton Devon GB **53** V 15

Creegh Clare IRL **232** R 4

Creegs Passage Galway IRL **218/219** P 6

Creeslough Donegal IRL **206** M 7

Creetown Dumfries und Galloway GB **146** N 14

Creggan Tyrone GB **207** N 8

Cregganbaun Mayo IRL **218** P 3

Creggans Argyll and Bute GB **160** K 12

Cressage Shropshire GB **87** R 17

Cresswell Northumberland GB **147** M 19

Crewe Cheshire GB **134** Q 18

Crewkerne Somerset GB **53** V 17

Crianlarich Stirling GB **160** K 13

Cribyn Ceredigion GB **86** S 14

Criccieth Gwynedd GB **118/119** R 14

Crich Derbyshire GB **134** Q 20

Crick Northhamptonshire GB **100** S 20

Cricklade Wiltshire GB **70** T 19

Crieff Perth and Kinross GB **160/161** K 15

Crimond Aberdeenshire GB **187** G 19

Crinan Argyll and Bute GB **174** K 11

Crocketford Dumfries und Galloway GB **146** M 15

Crockham Hill Kent GB **71** U 23

Croft-on-Tees North Yorkshire GB **147** O 19

Croggan Argyll and Bute GB **174** K 11

Croglin Cumbria GB **146/147** N 17

Croick Highland GB **186** G 13

Cromarty Highland GB **186/187** G 14

Cromer Norfolk GB **101** R 25

Cromor Na h-Eileanan an Iar GB **186** F 10

Crook Durham GB **147** N 19

Crookedwood Westmeath IRL **219** P 8

Crookham Northumberland GB **161** L 18

Crookhaven Cork IRL **232** U 3

Crookstown Kildare IRL **219** Q 9

Crookstown Cork IRL **232** T 5

Croom Limerick IRL **232** R 5

Cropredy Oxfordshire GB **100** S 20

Crosbost Na h-Eileanan an Iar GB **186** F 10

Crosby Salford GB **119** Q 16

Crosby Isle of Man GB **146** O 13

Crosby Cumbria GB **147** O 18

Crosby Ravensworth Cumbria GB **146/147** N 17

Crosby-on-Eden Cumbria GB **146/147** N 17

Cross Barry Cork IRL **232** T 5

Cross Hands Carmarthenshire GB **86** T 14

Cross Keys Cavan IRL **219** P 8

Cross Keys Meath IRL **219** P 8

Crossaig Argyll and Bute GB **160** L 12

Crossakeel Meath IRL **219** P 8

Crossdoney Cavan IRL **219** P 8

Crossens Sefton GB **119** P 17

Crossford South Lanarkshire GB **160/161** L 15

Crossgar Down GB **207** O 11

Crossgates Fife GB **161** K 16

Crossgates Powys GB **87** S 16

Crosshaven Cork IRL **232/233** T 6

Crosshill South Ayrshire GB **146** M 13

Crossmaglen Armagh GB **207** O 9

Crossmichael Dumfries und Galloway GB **146** N 15

Crossmolina Mayo IRL **206** O 4

Crosthwaite Cumbria GB **146/147** O 17

Croston Lancashire GB **119** P 17

Croughton Oxfordshire GB **70** T 20

Crowan Cornwall GB **52** W 12

Crowborough East Sussex GB **71** U 23

Crowland Lincolnshire GB **100/101** R 22

Crowlas Cornwall GB **52** W 12

Crowle North Lincolnshire GB **134/135** P 21

Crowle Worcestershire GB **87** S 18

Croxton North Lincolnshire GB **135** P 22

Croxton Kerrial Leicestershire GB **100** R 21

Croy Highland GB **186** H 14

Croyde Devon GB **52/53** U 14

Croydon Greater London GB **71** U 22

Cruden Bay Aberdeenshire GB **187** H 19

Crudgington Shropshire GB **119** R 17

Crudgington Telford and Wrekin GB **87** R 17

Crudwell Wiltshire GB **70** T 18

Crulabhig Na h-Eileanan an Iar GB **175** F 9

Crumlin Antrim GB **207** N 10

Crusheen Clare IRL **232** R 5

Crymych Pembrokeshire GB **86** T 13

Crynant Neath Port Talbot GB **86/87** T 15

Cubert Cornwall GB **52** W 12

Cuckfield West Sussex GB **71** U 22

Cuckney Nottinghamshire GB **134** Q 20

Cudworth Barnsley GB **134** P 20

Culbokie Highland GB **186/187** G 14

Culdaff Donegal IRL **207** M 8

Culford Suffolk GB **101** S 24

Culkein Highland GB **186** F 12

Cullaville Armagh GB **207** O 9

Culleens Sligo IRL **206** O 5

Cullen Moray GB **187** G 17

Cullicudden Highland GB **186/187** G 14

Cullipool Argyll and Bute GB **174** K 11

Cullivoe Shetland Islands GB **199** A 20

Cullomane Cross Roads Cork IRL **232** T 4

Cullompton Devon GB **53** V 16

Cullybackey Antrim GB **207** N 10

Culmington Shropshire GB **87** S 17

Culmstock Devon GB **53** V 16

Culnacraig Highland GB **186** G 12

Culrain Highland GB **186/187** G 14

Culross Fife GB **160/161** K 15

Culswick Shetland Islands GB **199** B 19

Cults Aberdeen City GB **187** H 18

Culworth Northhamptonshire GB **100** S 20

Cumbernauld North Lanarkshire GB **160/161** L 15

Cuminestown Aberdeenshire GB **187** G 18

Cumnock East Ayrshire GB **146** M 14

Cumnor Oxfordshire GB **70** T 20

Cumrew Cumbria GB **146/147** N 17

Cumwhitton Cumbria GB **146/147** N 17

Cupar Fife GB **161** K 16

Curracloe Wexford IRL **233** S 10

Curraghalicky Cork IRL **232** T 4

Curraghroe Roscommon IRL **218/219** P 6

Curry Sligo IRL **218** P 5

Cushendall Antrim GB **207** M 10

Cushendun Antrim GB **207** M 10

Cushina Offaly IRL **219** Q 8

Cwmbran Torfaen GB **87** T 16

Cwmffrwd Carmarthenshire GB **86** T 14

Cyffylliog Denbighshire GB **119** Q 16

Cymmer Neath Port Talbot GB **86/87** T 15

Cynghordy Carmarthenshire GB **86/87** S 15

Cynwyd Denbighshire GB **119** R 16

Cynwyl Elfed Carmarthenshire GB **86** T 14

D

Dacre Cumbria GB **146/147** N 17

Dagenham Greater London GB **71** T 23

Daglingworth Gloucestershire GB **70** T 18

Dagnall Buckinghamshire GB **70/71** T 21

Dail bho Dheas Na h-Eileanan an Iar GB **186** F 10

Dailly South Ayrshire GB **146** M 13

Daingean Offaly IRL **219** Q 8

Dairsie or Osnaburgh Fife GB **161** K 17

Dalabrog Na h-Eileanan an Iar GB **175** H 8

Dalbeattie Dumfries und Galloway GB **146** N 15

Dalchork Highland GB **186/187** F 14

Dalchreichart Highland GB **186** H 13

Dalchruin Perth and Kinross GB **160** K 14

Dale Pembrokeshire GB **86** T 12

Dale of Walls Shetland Islands GB **199** B 19

Dalhavaig Highland GB **187** F 15

Dalkeith Midlothian GB **161** L 16

Dalkey Dublin IRL **219** Q 10

Dallas Moray GB **187** G 16

Dalleagles East Ayrshire GB **146** M 14

Dalmally Argyll and Bute GB **160** K 13

Dalmellington East Ayrshire GB **146** M 14

Dalnavie Highland GB **186/187** G 14

Dalnawillan Lodge Highland GB **187** F 15

Dalreavoch Highland GB **186/187** F 14

Dalry North Ayrshire GB **160** L 13

Dalrymple East Ayrshire GB **146** M 13

Dalston Cumbria GB **146/147** N 17

Dalswinton Dumfries und Galloway GB **146** M 15

Dalton Dumfries und Galloway GB **146** M 16

Dalton-in-Furness Cumbria GB **146** O 16

Dalwhinnie Highland GB **160** J 14

Dalwood Devon GB **53** V 16

Dalystown Westmeath IRL **219** Q 8

Damerham Hampshire GB **70** V 19

Danbury Essex GB **71** T 24

Darenth Kent GB **71** U 23

Darfield Barnsley GB **134** P 20

Darlington Darlington GB **147** N 19

Dartford Kent GB **71** U 23

Dartington Devon GB **53** W 15

Dartmeet Devon GB **53** V 15

Dartmouth Devon GB **53** W 15

Darvel East Ayrshire GB **160** L 14

Darwen Blackburn with Darwen GB **134** P 18

Davenham Cheshire GB **119** Q 17

Daventry Northhamptonshire GB **100** S 20

Davidstow Cornwall GB **52** V 13

Davington Dumfries und Galloway GB **146** M 16

Daviot Highland GB **187** H 14

Dawley Shropshire GB **100** R 18

Dawley Telford and Wrekin GB **100** R 18

Dawlish Devon GB **53** V 16

Deal Kent GB **71** U 25

Deanich Lodge Highland GB **186** G 13

Dearham Cumbria GB **146** N 16

Debenham Suffolk GB **101** S 25

Deddington Oxfordshire GB **70** T 20

Deeping St Nicholas Lincolnshire GB **100/101** R 22

Defford Worcestershire GB **87** S 18

Deiniolen Gwynedd GB **118/119** Q 14

Delabole Cornwall GB **52** V 13

Delgany Wicklow IRL **219** Q 10

Delphi Mayo IRL **218** P 3

Delvin Westmeath IRL **219** P 8

Denbigh Denbighshire GB **119** Q 16

Denby Dale Kirklees GB **134** P 19

Denholm Scottish Borders GB **146/147** M 17

Denny Falkirk GB **160/161** K 15

Denshaw Oldham GB **134** P 18

Dent Cumbria GB **147** O 18

Denton Lincolnshire GB **100** R 21

Denton Norfolk GB **101** S 25

Derby Derby GB **100** R 20

Dereham Norfolk GB **101** R 24

Derrybeg Donegal IRL **206** M 6

Derrybrien Galway IRL **218** Q 5

Derrygolan Westmeath IRL **219** Q 8

Derrygonnelly Fermanagh GB **206** O 7

Derrykeighan Antrim GB **207** M 10

Derrylin Fermanagh GB **206** O 7

Derryrush Galway IRL **218** Q 3

Dersingham Norfolk GB **101** R 24

Dervaig Argyll and Bute GB **174** J 10

Dervock Antrim GB **207** M 10

Desborough Northhamptonshire GB **100** S 21

Desertmartin Londonderry GB **207** N 9

Desford Leicestershire GB **100** R 20

Devil´s Bridge Ceredigion GB **86/87** S 15

Devizes Wiltshire GB **70** U 19

Dewsbury Kirklees GB **134** P 19

Dickleburgh Norfolk GB **101** S 25

Didcot Oxfordshire GB **70** T 20

Digby Lincolnshire GB **135** Q 22

Dinas Gwynedd GB **118** R 13

Dinas Cross Pembrokeshire GB **86** S 13

Dinas Mawddwy Gwynedd GB **86/87** R 15

Dinas Powys Vale of Glamorgan GB **53** U 16

Dingle Kerry IRL **232** S 2

Dingwall Highland GB **186/187** G 14

Dinnet Aberdeenshire GB **187** H 17

Dinnington Rotherham GB **134** Q 20

Dinnington Newcastle upon Tyne GB **147** M 19

Dinton Wiltshire GB **70** U 19

Dippen Argyll and Bute GB **174** L 11

Dirleton East Lothian GB **161** K 17

Dishforth North Yorkshire GB **147** O 20

Diss Norfolk GB **101** S 25

Distington Cumbria GB **146** N 15

Ditchling East Sussex GB **71** V 22

Ditton Priors Shropshire GB **87** R 17

Doagh Antrim GB **207** N 10

Doagh Beg Donegal IRL **206** M 7

Dobwalls Cornwall GB **52** W 13

Doc Penfro Pembroke Dock Pembrokeshire GB **86** T 13

Docking Norfolk GB **101** R 24

Dockray Cumbria GB **146/147** N 17

Doddington Cambridgeshire GB **101** S 23

Doddington Northumberland GB **161** L 19

Doddington Kent GB **71** U 24

Dodleston Cheshire GB **119** Q 17

Dodworth Barnsley GB **134** P 19

Dogdyke Lincolnshire GB **135** Q 22

Dolanog Powys GB **87** R 16

Dolfor Powys GB **87** S 16

Dolgarrog Conwy GB **119** Q 15

Dolgellau Gwynedd GB **119** R 15

Dolla Tipperary IRL **232/233** R 6

Dollar Clackmannanshire GB **160/161** K 15

Dolphinholme Lancashire GB **119** P 17

Dolphinton South Lanarkshire GB **161** L 16

Dolton Devon GB **52/53** V 14

Dolwyddelan Conwy GB **119** Q 15

Donabate Dublin IRL **219** Q 10

Donadea Kildare IRL **219** Q 9

Donaghadee Down GB **207** N 11

Donagh Dún na nGall Donegal IRL **206** N 6

Doneraile Cork IRL **232** S 5

Donington Lincolnshire GB **100/101** R 22

Donnington Shropshire GB **100** R 18

Donnington Telford and Wrekin GB **100** R 18

Donohill Tipperary IRL **232/233** R 6

Donoughmore Cork IRL **232** T 5

Doogort Mayo IRL **218** O 2

Doolin Clare IRL **218** Q 4

Doon Limerick IRL **232/233** R 6

Doona Mayo IRL **218** O 3

Doonaha Clare IRL **232** R 3

Doonbeg Clare IRL **232** R 3

Dorchester Oxfordshire GB **70** T 20

Dorchester Dorset GB **70** V 18

Dores Highland GB **186** H 14

Dorking Surrey GB **71** U 22

Dornie Highland GB **186** H 12

Dornoch Highland GB **186/187** G 14

Dorstone Herefordshire GB **87** S 16

Douglas Isle of Man GB **146** O 14

Douglas South Lanarkshire GB **160/161** L 15

Dounby Orkney Islands GB **198** D 16

Doune Stirling GB **160** K 14

Dounreay Highland GB **198** E 15

Dove Holes Derbyshire GB **134** Q 19

Dover Kent GB **71** U 25

Doveridge Derbyshire GB **100** R 19

Downderry Cornwall GB **52/53** W 14

Downham Market Norfolk GB **101** R 23

Downhill Londonderry GB **207** M 9

Downies Donegal IRL **206** M 7

Downpatrick Down GB **207** O 11

Downton Wiltshire GB **70** V 19

Dowra Leitrim IRL **206** O 6

Draperstown Londonderry GB **207** N 9

Drax North Yorkshire GB **134/135** P 21

Draycott Somerset GB **53** U 17

Draycott in the Clay Staffordshire GB **100** R 19

Drem East Lothian GB **161** K 17

Driffield East Riding of Yorkshire GB **135** P 22

Drigg Cumbria GB **146** O 16

Drimnin Highland GB **174** J 11

Drimoleague Cork IRL **232** T 4

Dring Longford IRL **219** P 7

Dripsey Cork IRL **232** T 5

Drogheda Droichead Átha Louth IRL **219** P 10

Droitwich Spa Worcestershire GB **87** S 18

Dromahair Leitrim IRL **206** O 6

Dromara Down GB **207** O 11

Dromcolliher Limerick IRL **232** S 5

Dromina Cork IRL **232** S 5

Dromod Leitrim IRL **219** P 7

Dromore Down GB **207** O 10

Dromore Tyrone GB **207** O 8

Dromore West Sligo IRL **206** O 5

Dronfield Derbyshire GB **134** Q 20

Drum Monaghan IRL **207** O 8

Drumandoora Clare IRL **218** Q 5

Drumaroad Down GB **207** O 11

Drumbeg Highland GB **186** F 12

Drumburgh Cumbria GB **146** N 16

Drumcliffe Sligo IRL **206** O 5

Drumclog South Lanarkshire GB **160** L 14

Drumcondra Meath IRL **219** P 9

Drumelzier Scottish Borders GB **161** L 16

Drumfearn Highland GB **175** H 11

Drumfin Sligo IRL **206** O 6

Drumfree Donegal IRL **207** M 8

Drumkeeran Leitrim IRL **206** O 6

Drumlamford House South Ayrshire GB **146** M 13

Drumlish Longford IRL **219** P 7

Drumlithie Aberdeenshire GB **161** J 18

Drummore Dumfries und Galloway GB **146** N 13

Drumnadrochit Highland GB **186** H 14

Drumquin Tyrone GB **207** N 8

Drumrunie Highland GB **186** G 12

Drumshanbo Leitrim IRL **206** O 6

Drumsna Leitrim IRL **219** P 6

Drymen Stirling GB **160** K 14

Drynoch Highland GB **175** H 10

Duagh Kerry IRL **232** S 4

Dublin Baile Átha Cliath Dublin IRL **219** Q 10

Duchally Highland GB **186** F 13

Ducklington Oxfordshire GB **70** T 20

Duddington Northhamptonshire GB **100** R 21

Duddo Northumberland GB **161** L 18

Dudley Dudley GB **100** R 18

Duffield Derbyshire GB **100** R 20

Dufftown Moray GB **187** H 16

Duffus Moray GB **187** G 16

Dufton Cumbria GB **147** N 18

Duirinish Highland GB **175** H 11

Dukinfield Tameside GB **134** Q 18

Duleek Meath IRL **219** P 10

Dulford Devon GB **53** V 16

Dullingham Cambridgeshire GB **101** S 23

Dulnain Bridge Highland GB **187** H 15

Dulverton Somerset GB **53** U 15

Dumbarton West Dunbartonshire GB **160** L 13

Dumfries Dumfries und Galloway GB **146** M 15

Dún Laoghaire Dublin IRL **219** Q 10

Dunan Highland GB **175** H 10

Dunbar East Lothian GB **161** K 17

Dunbeath Highland GB **187** F 16

Dunblane Stirling GB **160/161** K 15

Dunboyne Meath IRL **219** Q 10

Duncannon Wexford IRL **233** S 9

Dunchurch Warwickshire GB **100** S 20

Duncormick Wexford IRL **233** S 9

Duncow Dumfries und Galloway GB **146** M 15

Duncton West Sussex GB **70/71** V 21

Dundalk Dun Dealgan Louth IRL **207** O 10

Dundee Dundee City GB **161** K 17

Dundonald South Ayrshire GB **160** L 13

Dundonald Down GB **207** N 11

Dundonnell Highland GB **186** G 12

Dundrennan Dumfries und Galloway GB **146** N 15

Dundrod Antrim GB **207** N 10

Dundrum Down GB **207** O 11

Dundrum Tipperary IRL **232/233** R 6

Dunecht Aberdeenshire GB **187** H 18

Dunfanaghy Donegal IRL **206** M 7

Dunfermline Fife GB **161** K 16

Dungannon Tyrone GB **207** O 9

Dungarvan Kilkenny IRL **233** R 8

Dungarvan Dún Garbhán Waterford IRL **233** S 7

Dungiven Londonderry GB **207** N 9

Dunglow Donegal IRL **206** N 6

Dungourney Cork IRL **232/233** T 6

Dunguin Kerry IRL **232** S 2

Dunholme Lincolnshire GB **135** Q 22

Dunino Fife GB **161** K 17

Dunkeld Perth and Kinross GB **160/161** J 15

Dunkerrin Offaly IRL **233** R 7

Dunkeswell Devon GB **53** V 16

Dunkineely Donegal IRL **206** N 6

Dunlavin Wicklow IRL **219** Q 9

Dunleer Louth IRL **219** P 10

Dunlop East Ayrshire GB **160** L 13

Dunloy Antrim GB **207** N 10

Dunmanway Cork IRL **232** T 4

Dunmore Galway IRL **218** P 5

Dunmore East Waterford IRL **233** S 9

Dunmurry Antrim GB **207** N 10

Dunnamanagh Tyrone GB **207** N 8

Dunnet Highland GB **198** E 16

Dunning Perth and Kinross GB **160/161** K 15

Dunoon Argyll and Bute GB **160** L 13

Dunragit Dumfries und Galloway GB **146** N 13

Duns Scottish Borders GB **161** L 18

Dunsby Lincolnshire GB **100/101** R 22

Dunscore Dumfries und Galloway GB **146** M 15

Dunsford Devon GB **53** V 15

Dunshaughlin Meath IRL **219** P 9

Dunstable Bedfordshire GB **70/71** T 21

Dunster Somerset GB **53** U 16

Dunston Lincolnshire GB **135** Q 22

Dunsyre South Lanarkshire GB **161** L 16

Duntish Dorset GB **70** V 18

Dunure South Ayrshire GB **146** M 13

Dunvegan Highland GB **175** H 9

Dunwich Suffolk GB **101** S 26

Durham Durham GB **147** N 19

Durisdeer Dumfries und Galloway GB **146** M 15

Durness Highland GB **186** E 13

Durrington Wiltshire GB **70** U 19

Durrow Laois IRL **233** R 8

Durrus Cork IRL **232** T 3

Dursley Gloucestershire GB **70** T 18

Durweston Dorset GB **70** V 18

Duthil Highland GB **187** H 15

Duxford Cambridgeshire GB **101** S 23

Dyce Aberdeen City GB **187** H 18

Dyffryn Ardudwy Gwynedd GB **86** R 14

Dyke Moray GB **187** G 15

Dykehead Angus GB **161** J 16

Dykends Angus GB **161** J 16

Dylife Powys GB **86/87** R 15

Dymchurch Kent GB **71** U 24

Dymock Gloucestershire GB **70** T 18

Dysart Fife GB **161** K 16

Dyserth Denbighshire GB **119** Q 16

E

Eaglesfield Dumfries und Galloway GB **146** M 16

Eaglesfield Dean Cumbria GB **146** N 16

Eaglesham East Renfrewshire GB **160** L 14

Eakring Nottinghamshire GB **134** Q 20

Earby Lancashire GB **134** P 18

Eardisley Herefordshire GB **87** S 17

Earith Cambridgeshire GB **101** S 23

Earl Shilton Leicestershire GB **100** R 20

Earl Soham Suffolk GB **101** S 25

Earl Stonham Suffolk GB **101** S 25

Earlish Highland GB **186** G 10

Earls Barton Northhamptonshire GB **100** S 21

Earls Colne Essex GB **71** T 24

Earlsferry Fife GB **161** K 17

Earlston Scottish Borders GB **161** L 17

Easington East Riding of Yorkshire GB **135** P 23

Easington Durham GB **147** N 20

Easingwold North Yorkshire GB **147** O 20

Easky Sligo IRL **206** O 5

Eassie Angus GB **161** J 16

East Barkwith Lincolnshire GB **135** Q 22

East Bergholt Suffolk GB **71** T 24

East Brent Somerset GB **53** U 17

East Bridgford Nottinghamshire GB **100** R 21

East Challow Oxfordshire GB **70** T 20

East Chinnock Somerset GB **53** V 17

East Cowes Isle of Wight GB **70** V 20

East Cowton North Yorkshire GB **147** O 19

East Croachy Highland GB **186** H 14

East Dean East Sussex GB **71** V 23

East Grinstead West Sussex GB **71** U 23

East Haddon Northhamptonshire GB **100** S 20

East Halton North Lincolnshire GB **135** P 22

East Hanney Oxfordshire GB **70** T 20

East Harling Norfolk GB **101** S 24

East Harlsey North Yorkshire GB **147** O 20

East Hauxwell North Yorkshire GB **147** O 19

East Hoathly East Sussex GB **71** V 23

East Ilsey West Berkshire GB **70** T 20

East Kilbride South Lanarkshire GB **160** L 14

East Knoyle Wiltshire GB **70** U 18

East Leake Nottinghamshire GB **100** R 20

East Linton East Lothian GB **161** L 17

East Markham Nottinghamshire GB **134/135** Q 21

East Meon Hampshire GB **70** V 20

East Morton Bradford GB **134** P 19

East Norton Leicestershire GB **100** R 21

East Portlemouth Devon GB **53** W 15

East Raynham Norfolk GB **101** R 24

East Rhidorroch Lodge Highland GB **186** G 13

East Rudham Norfolk GB **101** R 24

East Saltoun East Lothian GB **161** L 17

East Wemyss Fife GB **161** K 16

East Wittering West Sussex GB **70/71** V 21

East Witton North Yorkshire GB **147** O 19

East Wretham Norfolk GB **101** S 24

Eastbourne East Sussex GB **71** V 23

Eastchurch Kent GB **71** U 24

Eastgate Durham GB **147** N 18

Eastleigh Hampshire GB **70** V 20

Eastnor Herefordshire GB **87** S 18

Eastoft North Lincolnshire GB **134/135** P 21

Easton Dorset GB **70** V 18

Easton on the Hill Northhamptonshire GB **100/101** R 22

Eastry Kent GB **71** U 25

Eastville Lincolnshire GB **135** Q 23

Eastwood Nottinghamshire GB **100** R 20

Ebbw Vale Blaenau Gwent GB **87** T 16

Ebchester Durham GB **147** N 19

Ecclefechan Dumfries und Galloway GB **146** M 16

Eccles Scottish Borders GB **161** L 18

Eccleshall Staffordshire GB **100** R 18

Eccleston Lancashire GB **119** P 17

Eccleston Cheshire GB **119** Q 17

Echt Aberdeenshire GB **187** H 18

Eckford Scottish Borders GB **161** L 18

Eckington Derbyshire GB **134** Q 20

Edale Derbyshire GB **134** Q 19

Edderton Highland GB **186/187** G 14

Eddleston Scottish Borders GB **161** L 16

Edenbridge Kent GB **71** U 23

Edenderry Offaly IRL **219** Q 8

Edenham Lincolnshire GB **100/101** R 22

Edensor Derbyshire GB **134** Q 19

Edern Gwynedd GB **118** R 13

Ederny Fermanagh GB **206** N 7

Edgeworthstown Longford IRL **219** P 7

Edgmond Shropshire GB **100** R 18

Edgmond Telford and Wrekin GB **100** R 18

Edgworth Blackburn with Darwen GB **134** P 18

Edinbane Highland GB **175** H 10

Edinburgh Edinburgh GB **161** L 16

Edington Wiltshire GB **70** U 18

Edington Burtle Somerset GB **53** U 17

Edlingham Northumberland GB **147** M 19

Edmonstone Orkney Islands GB **198** D 17

Edmundbyers Durham GB **147** N 19

Ednam Scottish Borders GB **161** L 18

Edrom Scottish Borders GB **161** L 18

Edwinstowe Nottinghamshire GB **134** Q 20

Edzell Angus GB **161** J 18

Egglescliffe Stockton-on-Tees GB **147** N 20

Eggleston Durham GB **147** N 19

Egham Surrey GB **70/71** U 21

Eglingham Northumberland GB **147** M 19

Eglinton Londonderry GB **207** M 8

Egloskerry Cornwall GB **52/53** V 14

Eglwys Fach Ceredigion GB **86/87** R 15

Eglwysbach Conwy GB **119** Q 15

Eglwyswrw Pembrokeshire GB **86** S 13

Egremont Cumbria GB **146** O 15

Egton North Yorkshire GB **134** O 21

Eileanach Highland GB **186/187** G 14

Eisgein Na h-Eileanan an Iar GB **175** F 9

Elan Village Powys GB **86/87** S 15

Elgin Moray GB **187** G 16

Elgol Highland GB **175** H 10

Elham Kent GB **71** U 25

Elie Fife GB **161** K 17

Elishadder Highland GB **186** G 10

Elland Calderdale GB **134** P 19

Ellastone Staffordshire GB **100** R 19

Ellesmere Shropshire GB **119** R 17

Ellesmere Port Cheshire GB **119** Q 17

Ellingham Northumberland GB **161** L 19

Ellington Northumberland GB **147** M 19

Ellon Aberdeenshire GB **187** H 18

Elmdon Essex GB **101** S 23

Elmswell Suffolk GB **101** S 24

Elphin Highland GB **186** F 12

Elphin Roscommon IRL **218/219** P 6

Elrig Dumfries und Galloway GB **146** N 13

Elsdon Northumberland GB **147** M 18

Elsenham Essex GB **71** T 23

Elsham North Lincolnshire GB **135** P 22

Elsrickle South Lanarkshire GB **160/161** L 15

Elstead Surrey GB **70/71** U 21

Elston Nottinghamshire GB **134/135** Q 21

Elstree Hertfordshire GB **71** T 22

Elswick Lancashire GB **119** P 17

Elsworth Cambridgeshire GB **100/101** S 22

Eltisley Cambridgeshire GB **100/101** S 22

Elton Northhamptonshire GB **100/101** R 22

Elvanfoot South Lanarkshire GB **146** M 15

Elveden Suffolk GB **101** S 24

Elvington York GB **134/135** P 21

Elwick Hartlepool GB **147** N 20

Ely Cambridgeshire GB **101** S 23

Embleton Northumberland GB **161** L 19

Embo Highland GB **187** G 15

Embsay North Yorkshire GB **134** P 19

Emly Tipperary IRL **232/233** S 6

Emmoo Roscommon IRL **218/219** P 6

Emneth Norfolk GB **101** R 23

Empingham Rutland GB **100** R 21

Emsworth Hampshire GB **70/71** V 21

Emyvale Monaghan IRL **207** O 9

Endon Staffordshire GB **134** Q 18

Enfield Greater London GB **71** T 22

Ennis Inis Clare IRL **232** R 5

Enniscorthy Inis Córthaidh Wexford IRL **233** R 9

Enniskean Cork IRL **232** T 5

Enniskerry Wicklow IRL **219** Q 10

Enniskillen Fermanagh GB **206** O 7

Ennistimon Clare IRL **232** R 4

Enochdhu Perth and Kinross GB **160/161** J 15

Enstone Oxfordshire GB **70** T 20

Enterkinfoot Dumfries und Galloway GB **146** M 15

Eòropaidh Na h-Eileanan an Iar GB **186** E 10

Epping Essex GB **71** T 23

Epsom Greater London GB **71** U 22

Epworth North Lincolnshire GB **134/135** P 21

Erbusaig Highland GB **175** H 11

Eriboll Highland GB **186** F 13

Ermington Devon GB **53** W 15

Erpingham Norfolk GB **101** R 25

Errogie Highland GB **186** H 14

Errol Perth and Kinross GB **161** K 16

Escrick North Yorkshire GB **134** P 20

Esh Winning Durham GB **147** N 19

Esher Surrey GB **71** U 22

Eshnadarragh Fermanagh GB **207** O 8

Eskdalemuir Dumfries und Galloway GB **146** M 16

Essendine Rutland GB **100/101** R 22

Essich Highland GB **186** H 14

Etal Northumberland GB **161** L 18

Eton Windsor & Maidenhead GB **70/71** U 21

Ettington Warwickshire GB **100** S 19

Ettrickbridge Scottish Borders GB **161** L 17

Etwall Derbyshire GB **100** R 19

Euxton Lancashire GB **119** P 17

Evanton Highland GB **186/187** G 14

Evercreech Somerset GB **53** U 17

Everdon Northamptonshire GB **100** S 20

Everingham East Riding of Yorkshire GB **134/135** P 21

Everleigh Wiltshire GB **70** U 19

Eversden Cambridgeshire GB **100/101** S 22

Evershot Dorset GB **53** V 17

Evesham Worcestershire GB **100** S 19

Ewes Dumfries und Galloway GB **146** M 16

Ewhurst Surrey GB **71** U 22

Exbourne Devon GB **53** V 15

Exbury Hampshire GB **70** V 20

Exeter Devon GB **53** V 15

Exford Somerset GB **53** U 15

Exminster Devon GB **53** V 15

Exmouth Devon GB **53** V 16

Exton Somerset GB **53** U 15

Eyam Derbyshire GB **134** Q 19

Eye Peterborough GB **100/101** R 22

Eye Suffolk GB **101** S 25

Eyemouth Scottish Borders GB **161** L 18

Eyeries Cork IRL **232** T 3

Eynort Highland GB **175** H 10

Eynsford Kent GB **71** U 23

Eynsham Oxfordshire GB **70** T 20

Eyrecourt Galway IRL **218/219** Q 6

F

Fahamore Kerry IRL **232** S 2

Fahan Donegal IRL **207** M 8

Fairbourne Gwynedd GB **86** R 14

Fairford Gloucestershire GB **70** T 19

Fairlie North Ayrshire GB **160** L 13

Fairlight East Sussex GB **71** V 24

Fakenham Norfolk GB **101** R 24

Fala Midlothian GB **161** L 17

Falcarragh Donegal IRL **206** M 6

Faldingworth Lincolnshire GB **135** Q 22

Falfield South Gloucestershire GB **70** T 18

Falkirk Falkirk GB **160/161** L 15

Falkland Fife GB **161** K 16

Falmer East Sussex GB **71** V 22

Falmouth Cornwall GB **52** W 12

Falstone Northumberland GB **147** M 18

Fangfoss East Riding of Yorkshire GB **134/135** P 21

Farcet Cambridgeshire GB **100/101** R 22

Fareham Hampshire GB **70** V 20

Faringdon Oxfordshire GB **70** T 19

Farlam Cumbria GB **146/147** N 17

Farnaght Leitrim IRL **219** P 7

Farnborough Hampshire GB **70/71** U 21

Farnell Angus GB **161** J 18

Farnham Surrey GB **70/71** U 21

Farningham Kent GB **71** U 23

Farnworth Bolton GB **134** P 18

Farr Highland GB **186** H 14

Farranfore Kerry IRL **232** S 3

Farringdon Hampshire GB **70/71** U 21

Farthinghoe Northhamptonshire GB **100** S 20

Fascadale Highland GB **174** J 10

Fauldhouse West Lothian GB **160/161** L 15

Faversham Kent GB **71** U 24

Fawley Hampshire GB **70** V 20

Faxfleet East Riding of Yorkshire GB **134/135** P 21

Fazeley Staffordshire GB **100** R 19

Feakle Clare IRL **232** R 5

Fearnmore Highland GB **186** G 11

Featherstone Wakefield GB **134** P 20

Feckenham Worcestershire GB **100** S 19

Fedamore Limerick IRL **232** R 5

Feeard Clare IRL **232** R 3

Feeny Londonderry IRL **207** N 8

Feetham North Yorkshire GB **147** O 18

Felixstowe Suffolk GB **71** T 25

Felton Northumberland GB **147** M 19

Feltwell Norfolk GB **101** S 24

Fenagh Leitrim IRL **206** O 7

Fenit Kerry IRL **232** S 3

Fennagh Carlow IRL **233** R 9

Fennor Waterford IRL **233** S 8

Fenwick East Ayrshire GB **160** L 14

Feochaig Argyll and Bute GB **174** M 11

Feolin Ferry Argyll and Bute GB **174** L 10

Ferbane Offaly IRL **219** Q 7

Fermoy Cork IRL **232/233** S 6

Fern Angus GB **161** J 18

Ferndown Dorset GB **70** V 19

Ferness Highland GB **187** H 15

Fernhurst West Sussex GB **70/71** U 21

Ferns Wexford IRL **233** R 9

Ferryhill Durham GB **147** N 19

Fethard Tipperary IRL **233** S 7

Fethard Wexford IRL **233** S 9

Fetterangus Aberdeenshire GB **187** G 18

Fettercairn Aberdeenshire GB **161** J 18

Fewston North Yorkshire GB **134** P 19

Ffarmers Carmarthenshire GB **86/87** S 15

Ffostrasol Ceredigion GB **86** S 14

Fiddown Kilkenny IRL **233** S 8

Filby Norfolk GB **101** R 26

Filey North Yorkshire GB **135** O 22

Fillongley Warwickshire GB **100** S 19

Fincham Norfolk GB **101** R 23

Finchingfield Essex GB **71** T 23

Findhorn Moray GB **187** G 15

Findochty Moray GB **187** G 17

Findon West Sussex GB **71** V 22

Finedon Northhamptonshire GB **100** S 21

Finnea Westmeath IRL **219** P 8

Finningham Suffolk GB **101** S 25

Finningley Doncaster GB **134/135** Q 21

Finstown Orkney Islands GB **198** D 16

Fintona Tyrone GB **207** O 8

Fintry Stirling GB **160** K 14

Finuge Kerry IRL **232** S 3

Finvoy Antrim GB **207** M 10

Fionnphort Argyll and Bute GB **174** K 10

Fionnsabhagh Na h-Eileanan an Iar GB **175** G 9

Fishbourne Isle of Wight GB **70** V 20

Fishguard Abergwaun Pembrokeshire GB **86** T 13

Fishlake Doncaster GB **134** P 20

Fiskavaig Highland GB **175** H 10

Fittleworth West Sussex GB **70/71** V 21

Fiunary Highland GB **174** J 11

Fivemiletown Fermanagh GB **207** O 8

Fladdabister Shetland Islands GB **199** B 20

Flagmount Clare IRL **232** R 5

Flamborough East Riding of Yorkshire GB **135** O 22

Flash Staffordshire GB **134** Q 19

Flawith North Yorkshire GB **147** O 20

Flaxton North Yorkshire GB **134** O 21

Fleet Hampshire GB **70/71** U 21

Fleetwood Lancashire GB **119** P 16

Flimby Cumbria GB **146** N 15

Flimwell East Sussex GB **71** U 23

Flint Flintshire GB **119** Q 16

Flintham Nottinghamshire GB **100** R 21

Flitwick Bedfordshire GB **71** T 22

Flixborough North Lincolnshire GB **134/135** P 21

Flodden Northumberland GB **161** L 18

Flookburgh Cumbria GB **146** O 16

Florence Court Fermanagh GB **206** O 7

Fobbing Thurrock GB **71** T 23

Fochabers Moray GB **187** G 16

Folda Angus GB **161** J 16

Folkestone Kent GB **71** U 25

Folkingham Lincolnshire GB **100/101** R 22

Fontstown Kildare IRL **219** Q 9

Ford Argyll and Bute GB **160** K 12

Ford Northumberland GB **161** L 18

Ford End Essex GB **71** T 23

Fordham Cambridgeshire GB **101** S 23

Fordingbridge Hampshire GB **70** V 19

Fordoun Aberdeenshire GB **161** J 18

Fordstown Meath IRL **219** P 9

Fordyce Aberdeenshire GB **187** G 17

Fore Westmeath IRL **219** P 8

Forest Row East Sussex GB **71** U 23

Forfar Angus GB **161** J 18

Forgandenny Perth and Kinross GB **160/161** K 15

Forkill Armagh GB **207** O 10

Formby Sefton GB **119** P 16

Forres Moray GB **187** G 15

Forsinard Highland GB **187** F 15

Forss Highland GB **198** E 15

Fort Augustus Highland GB **186** H 13

Fort George Highland GB **186/187** G 14

Fort William Highland GB **160** J 12

Forter Angus GB **161** J 16

Forteviot Perth and Kinross GB **160/161** K 15

Forth South Lanarkshire GB **160/161** L 15

Fortingall Perth and Kinross GB **160** J 14

Fortrose Highland GB **186/187** G 14

Fortuneswell Dorset GB **70** V 18

Fosdyke Lincolnshire GB **100/101** R 22

Foss Perth and Kinross GB **160/161** J 15

Fotherby Lincolnshire GB **135** Q 22

Foulden Scottish Borders GB **161** L 18

Foulsham Norfolk GB **101** R 25

Fountainhall Scottish Borders GB **161** L 17

Four Mile House Roscommon IRL **218/219** P 6

Foveran Aberdeenshire GB **187** H 18

Fowey Cornwall GB **52** W 13

Fownhope Herefordshire GB **87** S 17

Foxdale Isle of Man GB **146** O 13

Foxford Mayo IRL **218** P 4

Foxholes North Yorkshire GB **135** O 22

Foyers Highland GB **186** H 14

Foynes Limerick IRL **232** R 4

Framlingham Suffolk GB **101** S 25

Frampton Dorset GB **53** V 17

Frampton on Severn Gloucestershire GB **70** T 18

Fraserburgh Aberdeenshire GB **187** G 19

Freckleton Lancashire GB **119** P 17

Freemount Cork IRL **232** S 5

Frenchpark Roscommon IRL **218/219** P 6

Frensham Surrey GB **70/71** U 21

Freshford Kilkenny IRL **233** R 8

Freshwater Isle of Wight GB **70** V 19

Fressingfield Suffolk GB **101** S 25

Freswick Highland GB **198** E 16

Friday Bridge Cambridgeshire GB **101** R 23

Fridaythorpe East Riding of Yorkshire GB **134** O 21

Frinton-on-Sea Essex GB **71** T 25

Friockheim Angus GB **161** J 18

Frisby on the Wreake Leicestershire GB **100** R 21

Friskney Lincolnshire GB **135** Q 23

Frizington Cumbria GB **146** N 16

Frodsham Cheshire GB **119** Q 17

Frome Somerset GB **70** U 18

Frongoch Gwynedd GB **119** R 15

Frosterley Durham GB **147** N 19

Froxfield Wiltshire GB **70** U 19

Fulbourn Cambridgeshire GB **101** S 23

Fulstow Lincolnshire GB **135** Q 23

Fulwood Lancashire GB **119** P 17

Funzie Shetland Islands GB **199** A 21

Furnace Argyll and Bute GB **160** K 12

Fyfield Essex GB **71** T 23

Fyvie Aberdeenshire GB **187** H 18

G

Gabwell Devon GB **53** V 15

Gaick Lodge Highland GB **160** J 14

Gainsborough Lincolnshire GB **134/135** Q 21

Gairloch Highland GB **186** G 11

Gairlochy Highland GB **160** J 12

Gairnshiel Lodge Aberdeenshire GB **187** H 16

Gaitsgill Cumbria GB **146/147** N 17

Galashiels Scottish Borders GB **161** L 17

Galbally Limerick IRL **232/233** S 6

Galgate Lancashire GB **119** P 17

Galmisdale Highland GB **175** J 10

Galston East Ayrshire GB **160** L 14

Galway Gaillimh Galway IRL **218** Q 4

Gamblesby Cumbria GB **146/147** N 17

Gamlingay Cambridgeshire GB **100/101** S 22

Gamston Nottinghamshire GB **134/135** Q 21

Gaoth Dobhair Donegal IRL **206** M 6

Garagie Lodge Highland GB **186** H 14

Garbhallt Argyll and Bute GB **160** K 12

Garboldisham Norfolk GB **101** S 24

Gardenstown Aberdeenshire GB **187** G 18

Garelochhead Argyll and Bute GB **160** K 13

Garforth Leeds GB **134** P 20

Gargrave North Yorkshire GB **134** P 18

Gargunnock Stirling GB **160** K 14

Garlieston Dumfries und Galloway GB **146** N 14

Garmouth Moray GB **187** G 16

Garrabost Na h-Eileanan an Iar GB **186** F 10

Garrafrauns Galway IRL **218** P 5

Garras Cornwall GB **52** W 12

Garreg Gwynedd GB **118/119** R 14

Garrett Cumbria GB **147** O 18

Garrigill Cumbria GB **147** N 18

Garrison Fermanagh GB **206** O 6

Garristown Dublin IRL **219** P 10

Garros Highland GB **186** G 10

Garryvoe Cork IRL **232/233** T 6

Garsdale Head Cumbria GB **147** O 18

Garstang Lancashire GB **119** P 17

Garth Powys GB **86/87** S 15

Garthmyl Powys GB **87** R 16

Garthorpe North Lincolnshire GB **134/135** P 21

Gartmore Stirling GB **160** K 14

Gartocharn West Dunbartonshire GB **160** K 13

Garton East Riding of Yorkshire GB **135** P 22

Garton-on-the-Wolds East Riding of Yorkshire GB **135** O 22

Garvagh Londonderry GB **207** N 9

Garvagh Leitrim IRL **219** P 7

Garvaghy Tyrone GB **207** O 8

Garvald East Lothian GB **161** L 17

Garvard Argyll and Bute GB **174** K 10

Garve Highland GB **186** G 13

Gatehouse Northumberland GB **147** M 18

Gatehouse of Fleet Dumfries und Galloway GB **146** N 14

Gateshead Gateshead GB **147** N 19

Gawsworth Cheshire GB **134** Q 18

Gaybrook Westmeath IRL **219** Q 8

Gaydon Warwickshire GB **100** S 20

Gayton Norfolk GB **101** R 24

Gearraidh na h-Aibhne Na h-Eileanan an Iar GB **175** F 9

Geddington Northhamptonshire GB **100** S 21

Gedney Drove End Lincolnshire GB **101** R 23

Gedney Hill Lincolnshire GB **100/101** R 22

Geirinis Na h-Eileanan an Iar GB **175** H 8

Gelston Dumfries und Galloway GB **146** N 15

Georgeham Devon GB **52/53** U 14

Gerrards Cross Buckinghamshire GB **70/71** T 21

Gibstown Meath IRL **219** P 9

Gifford East Lothian GB **161** L 17

Gilcrux Cumbria GB **146** N 16

Gilford Down GB **207** O 10

Gill Durham GB **147** N 19

Gilling East North Yorkshire GB **147** O 20

Gilling West North Yorkshire GB **147** O 19

Gillingham Norfolk GB **101** S 26

Gillingham Dorset GB **70** U 18

Gillingham Medway GB **71** U 24

Gills Highland GB **198** E 16

Gilmerton Perth and Kinross GB **160/161** K 15

Gilmorton Leicestershire GB **100** S 20

Gilsland Cumbria GB **146/147** N 17

Gilwern Monmouthshire GB **87** T 16

Girvan South Ayrshire GB **146** M 13

Gisburn Lancashire GB **134** P 18

Gladestry Powys GB **87** S 16

Glaisdale North Yorkshire GB **134** O 21

Glamis Angus GB **161** J 16

Glanaman Carmarthenshire GB **86/87** T 15

Glandore Cork IRL **232** T 4

Glangevlin Cavan IRL **206** O 7

Glanton Northumberland GB **147** M 19

Glanworth Cork IRL **232/233** S 6

Glasgow Glasgow City GB **160** L 14

Glaslough Monaghan IRL **207** O 9

Glassan Westmeath IRL **219** Q 7

Glassford South Lanarkshire GB **160** L 14

Glasson Lancashire GB **119** P 17

Glassonby Cumbria GB **146/147** N 17

Glastonbury Somerset GB **53** U 17

Gleann an Muaidhe Mayo IRL **218** O 3

Glebe Londonderry GB **207** M 9

Glemsford Suffolk GB **101** S 24

Glen Donegal IRL **206** M 7

Glenancross Highland GB **175** J 11

Glenariff Antrim GB **207** M 10

Glenarm Antrim GB **207** N 11

Glenavy Antrim GB **207** N 10

Glenbarr Argyll and Bute GB **174** L 11

Glenbeigh Kerry IRL **232** S 3

Glenborrodale Highland GB **174** J 11

Glenbrittle Highland GB **175** H 10

Glenbuck East Ayrshire GB **160/161** L 15

Glencaple Dumfries und Galloway GB **146** M 15

Glencarse Perth and Kinross GB **161** K 16

Glencoe Highland GB **160** J 12

Glencolumbkille Donegal IRL **206** N 5

Glenderry Kerry IRL **232** S 3

Glendevon Perth and Kinross GB **160/161** K 15

Glenealy Wicklow IRL **233** R 10

Gleneely Donegal IRL **207** M 8

Glenegedale Argyll and Bute GB **174** L 10

Glenelg Highland GB **175** H 11

Glenfarg Perth and Kinross GB **161** K 16

Glenfeshie Lodge Highland GB **160** H 15

Glenfinnan Highland GB **160** J 12

Glengarriff Cork IRL **232** T 3

Glenkindie Aberdeenshire GB **187** H 17

Glenlivet Moray GB **187** H 16

Glenluce Dumfries und Galloway GB **146** N 13

Glenmaye Isle of Man GB **146** O 13

Glenmore Highland GB **187** H 15

Glenmore Kilkenny IRL **233** S 8

Glennamaddy Galway IRL **218** P 5

Glenntrool Lodge Dumfries und Galloway GB **146** M 14

Glenprosen Village Angus GB **161** J 16

Glenrothes Fife GB **161** K 16

Glentane Galway IRL **218/219** Q 6

Glentham Lincolnshire GB **134/135** Q 21

Glenties Donegal IRL **206** N 6

Glenville Cork IRL **232/233** S 6

Gletness Shetland Islands GB **199** B 20

Glin Limerick IRL **232** R 4

Glinsk Galway IRL **218** Q 3

Glossop Derbyshire GB **134** Q 19

Gloucester Gloucestershire GB **70** T 18

Gloup Shetland Islands GB **199** A 20

Glusburn Bradford GB **134** P 19

Glutt Lodge Highland GB **187** F 15

Glyn Ceiriog Wrexham GB **119** R 16

Glynde East Sussex GB **71** V 23

Glyndyfrdwy Denbighshire GB **119** R 16

Glynn Antrim GB **207** N 11

Glynn Wexford IRL **233** S 9

Glynneath Neath Port Talbot GB **86/87** T 15

Gnosall Staffordshire GB **100** R 18

Goathland North Yorkshire GB **134** O 21

Gobhig Na h-Eileanan an Iar GB **175** G 8

Godalming Surrey GB **70/71** U 21

Godmanchester Cambridgeshire GB **100/101** S 22

Godshill Isle of Wight GB **70** V 20

Godstone Surrey GB **71** U 22

Goginan Ceredigion GB **86/87** S 15

Golborne Wigan GB **119** Q 17

Goldcliff Newport GB **87** T 17

Golden Tipperary IRL **233** R 7

Goldhanger Essex GB **71** T 24

Goleen Cork IRL **232** U 3

Golspie Highland GB **187** G 15

Gonfirth Shetland Islands GB **199** B 20

Goodrich Herefordshire GB **87** T 17

Goodwick Pembrokeshire GB **86** S 13

Goole East Riding of Yorkshire GB **134/135** P 21

Goonhavern Cornwall GB **52** W 12

Goosnargh Lancashire GB **119** P 17

Gordon Scottish Borders GB **161** L 17

Gorebridge Midlothian GB **161** L 16

Gorey Wexford IRL **233** R 10

Gorey Channel Islands GB **66** Y 18

Goring Oxfordshire GB **70** T 20

Gormanston Meath IRL **219** P 10

Gorran Haven Cornwall GB **52** W 13

Gorseinon Swansea GB **86** T 14

Gorseness Orkney Islands GB **198** D 17

Gorstan Highland GB **186** G 13

Gort Galway IRL **218** Q 5

Gortahork Donegal IRL **206** M 6

Gortantaoid Argyll and Bute GB **174** L 10

Gorteen Sligo IRL **218** P 5

Gorteen Galway IRL **218** Q 5

Gortin Tyrone GB **207** N 8

Gortmore Mayo IRL **206** O 4

Gortnahoo Tipperary IRL **233** R 7

Gosberton Lincolnshire GB **100/101** R 22

Gosforth Cumbria GB **146** O 16

Gosport Hampshire GB **70** V 20

Goswick Northumberland GB **161** L 19

Goudhurst Kent GB **71** U 23

Gourdon Aberdeenshire GB **161** J 18

Gourock Inverclyde GB **160** L 13

Gowran Kilkenny IRL **233** R 8

Goxhill North Lincolnshire GB **135** P 22

Grabhair Na h-Eileanan an Iar GB **186** F 10

Graiguenamanagh Kilkenny IRL **233** R 9

Grain Medway GB **71** U 24

Grainthorpe Lincolnshire GB **135** Q 23

Grampound Cornwall GB **52** W 13

Granard Longford IRL **219** P 7

Grandtully Perth and Kinross GB **160/161** J 15

Grange Cumbria GB **146** N 16

Grange Sligo IRL **206** O 5

Grangebellew Louth IRL **219** P 10

Grangemouth Falkirk GB **160/161** K 15

Grange-over-Sands Cumbria GB **146/147** O 17

Grantham Lincolnshire GB **100** R 21

Grantown-on-Spey Highland GB **187** H 15

Grantshouse Scottish Borders GB **161** L 18

Grasby Lincolnshire GB **135** P 22

Grasmere Cumbria GB **146** O 16

Grassington North Yorkshire GB **147** O 19

Gravesend Kent GB **71** U 23

Grayrigg Cumbria GB **146/147** O 17

Grays Thurrock GB **71** U 23

Great Altcar Lancashire GB **119** P 16

Great Asby Cumbria GB **146/147** N 17

Great Ayton North Yorkshire GB **147** O 20

Great Baddow Essex GB **71** T 23

Great Bardfield Essex GB **71** T 23

Great Barford Bedfordshire GB **100/101** S 22

Great Bircham Norfolk GB **101** R 24

Great Brickhill Buckinghamshire GB **70/71** T 21

Great Broughton Cumbria GB **146** N 16

Great Broughton North Yorkshire GB **147** O 20

Great Budworth Cheshire GB **134** Q 18

Great Carlton Lincolnshire GB **135** Q 23

Great Chesterford Essex GB **101** S 23

Great Clifton Cumbria GB **146** N 16

Great Coates North East Lincolnshire GB **135** P 22

Great Dalby Leicestershire GB **100** R 21

Great Dunmow Essex GB **71** T 23

Great Eccleston Lancashire GB **119** P 17

Great Gidding Cambridgeshire GB **100/101** S 22

Great Glen Leicestershire GB **100** R 20

Great Grandsen Cambridgeshire GB **100/101** S 22

Great Hampden Buckinghamshire GB **70/71** T 21

Great Harrowden Northhamptonshire GB **100** S 21

Great Harwood Lancashire GB **134** P 18

Great Langton North Yorkshire GB **147** O 19

Great Leighs Essex GB **71** T 23

Great Limber Lincolnshire GB **135** P 22

Great Malvern Worcestershire GB **87** S 18

Great Massingham Norfolk GB **101** R 24

Great Missenden Buckinghamshire GB **70/71** T 21

Great Mitton Lancashire GB **134** P 18

Great Oakley Essex GB **71** T 25

Great Offley Hertfordshire GB **71** T 22

Great Ormside Cumbria GB **147** N 18

Great Orton Cumbria GB **146** N 16

Great Ponton Lincolnshire GB **100** R 21

Great Rissington Gloucestershire GB **70** T 19

Great Ryburgh Norfolk GB **101** R 24

Great Salkeld Cumbria GB **146/147** N 17

Great Sampford Essex GB **71** T 23

Great Shefford West Berkshire GB **70** U 20

Great Shelford Cambridgeshire GB **101** S 23

Great Smeaton North Yorkshire GB **147** O 20

Great Staughton Cambridgeshire GB **100/101** S 22

Great Strickland Cumbria GB **146/147** N 17

Great Tew Oxfordshire GB **70** T 20

Great Torrington Devon GB **52/53** V 14

Great Wakering Essex GB **71** T 24

Great Waltham Essex GB **71** T 23

Great Whittington Northumberland GB **147** M 19

Great Witley Worcestershire GB **87** S 18

Great Wolford Gloucestershire GB **70** T 19

Great Yarmouth Norfolk GB **101** R 26

Great Yeldham Essex GB **101** S 24

Greatham Hartlepool GB **147** N 20

Green Cornwall GB **52/53** V 14

Green Hammerton North Yorkshire GB **147** O 20

Greencastle Donegal IRL **207** M 9

Greencastle Tyrone GB **207** N 8

Greencastle Down GB **207** O 10

Greenhaugh Northumberland GB **147** M 18

Greenhead Northumberland GB **146/147** N 17

Greenholm East Ayrshire GB **160** L 14

Greenisland Antrim GB **207** N 11

Greenlaw Scottish Borders GB **161** L 18

Greenloaning Perth and Kinross GB **160/161** K 15

Greenock Inverclyde GB **160** L 13

Greenodd Cumbria GB **146** O 16

Greetham Rutland GB **100** R 21

Grenagh Cork IRL **232** S 5

Greosabhagh Na h-Eileanan an Iar GB **175** G 9

Gresford Wrexham GB **119** Q 17

Greshornish Highland GB **175** H 10

Gretna Dumfries und Galloway GB **146** N 16

Gretton Northhamptonshire GB **100** R 21

Greyabbey Down GB **207** N 11

Greystoke Cumbria GB **146/147** N 17

Greystone Angus GB **161** J 18

Greystone Tyrone GB **207** O 9

Greystones Wicklow IRL **219** Q 10

Grimister Shetland Islands GB **199** A 20

Grimoldby Lincolnshire GB **135** Q 23

Grimsby North East Lincolnshire GB **135** P 22

Grimston Norfolk GB **101** R 24

Grindleton Lancashire GB **134** P 18

Grindon Northumberland GB **161** L 18

Gringley on the Hill Nottinghamshire GB **134/135** Q 21

Grinton North Yorkshire GB **147** O 19

Gritley Orkney Islands GB **198** E 17

Grizebeck Cumbria GB **146** O 16

Groby Leicestershire GB **100** R 20

Grogport Argyll and Bute GB **160** L 12

Grosmont North Yorkshire GB **134** O 21

Grove Cheshire GB **134** Q 18

Grove Kent GB **71** U 25

Grundisburgh Suffolk GB **101** S 25

Gruting Shetland Islands GB **199** B 20

Grutness Shetland Islands GB **199** C 20

Gualachulain Highland GB **160** J 12

Guildford Surrey GB **70/71** U 21

Guildtown Perth and Kinross GB **161** K 16

Guilsfield Powys GB **87** R 16

Guisborough Redcar & Cleveland GB **147** N 20

Guiseley Leeds GB **134** P 19

Guist Norfolk GB **101** R 24

Guiting Power Gloucestershire GB **70** T 19

Gulladuff Londonderry GB **207** N 9

Gullane East Lothian GB **161** K 17

Gunnislake Cornwall GB **52/53** V 14

Gunnista Shetland Islands GB **199** B 20

Gusserane Wexford IRL **233** S 9

Gutcher Shetland Islands GB **199** A 20

Guthrie Angus GB **161** J 18

Guyhirn Cambridgeshire GB **101** R 23

Gwalchmai Anglesey GB **118/119** Q 14

Gweek Cornwall GB **52** W 12

Gweesalia Mayo IRL **218** O 3

Gwernymynydd Flintshire GB **119** Q 16

Gwyddelwern Denbighshire GB **119** Q 16

Gwytherin Conwy GB **119** Q 15

Gyleen Cork IRL **232/233** T 6

H

Habrough North East Lincolnshire GB **135** P 22

Hacketstown Carlow IRL **233** R 9

Hackness North Yorkshire GB **135** O 21

Haddenham Cambridgeshire GB **101** S 23

Haddenham Buckinghamshire GB **70/71** T 21

Haddington East Lothian GB **161** L 17

Haddiscoe Norfolk GB **101** R 26

Hadleigh Suffolk GB **101** S 24

Hadleigh Southend-on-Sea GB **71** T 24

Hadnall Shropshire GB **119** R 17

Hagley Herefordshire GB **87** S 17

Hagley Worcestershire GB **87** S 18

Haile Cumbria GB **146** O 16

Hailsham East Sussex GB **71** V 23

Hale Trafford GB **134** Q 18

Hales Norfolk GB **101** R 26

Halesowen Dudley GB **87** S 18

Halesworth Suffolk GB **101** S 26

Halford Warwickshire GB **100** S 19

Halifax Calderdale GB **134** P 19

Halkirk Highland GB **198** E 16

Halland East Sussex GB **71** V 23

Hallaton Leicestershire GB **100** R 21

Hallbankgate Cumbria GB **146/147** N 17

Hallington Northumberland GB **147** M 18

Hallsands Devon GB **53** W 15

Halsham East Riding of Yorkshire GB **135** P 22

Halstead Essex GB **71** T 24

Haltham Lincolnshire GB **135** Q 22

Halton Gill North Yorkshire GB **147** O 18

Halton Lea Gate Northumberland GB **146/147** N 17

Haltwhistle Northumberland GB **147** N 18

Halvergate Norfolk GB **101** R 26

Halwell Devon GB **53** W 15

Halwill Devon GB **52/53** V 14

Ham Shetland Islands GB **199** B 18

Hamble le Rice Hampshire GB **70** V 20

Hambledon Hampshire GB **70** V 20

Hambleton Lancashire GB **119** P 17

Hambleton North Yorkshire GB **134** P 20

Hamilton South Lanarkshire GB **160** L 14

Hamnavoe Shetland Islands GB **199** B 20

Hamnavoe Shetland Islands GB **199** B 20

Hamsterley Durham GB **147** N 19

Hamstreet Kent GB **71** U 24

Handforth Cheshire GB **134** Q 18

Hanslope Milton Keynes GB **100** S 21

Happisburgh Norfolk GB **101** R 26

Harbottle Northumberland GB **147** M 18

Harbury Warwickshire GB **100** S 20

Harby Leicestershire GB **100** R 21

Harby Nottinghamshire GB **100** R 21

Hardraw North Yorkshire GB **147** O 18

Harewood Leeds GB **134** P 19

Harlech Gwynedd GB **86** R 14

Harleston Norfolk GB **101** S 25

Harlosh Highland GB **175** H 9

Harlow Essex GB **71** T 23

Harmston Lincolnshire GB **134/135** Q 21

Haroldswick Shetland Islands GB **199** A 21

Harpenden Hertfordshire GB **71** T 22

Harpley Norfolk GB **101** R 24

Harrietfield Perth and Kinross GB **160/161** K 15

Harrietsham Kent GB **71** U 24

Harrington Cumbria GB **146** N 15

Harringworth Northhamptonshire GB **100** R 21

Harrogate North Yorkshire GB **134** P 19

Harrold Bedfordshire GB **100** S 21

Harrow Greater London GB **71** T 22

Hart Hartlepool GB **147** N 20

Hartburn Northumberland GB **147** M 19

Hartest Suffolk GB **101** S 24

Hartfield East Sussex GB **71** U 23

Hartford Cambridgeshire GB **100/101** S 22

Harthill West Lothian GB **160/161** L 15

Hartington Derbyshire GB **134** Q 19

Hartland Devon GB **52/53** V 14

Hartlepool Hartlepool GB **147** N 20

Hartley Whitney Hampshire GB **70/71** U 21

Hartpury Gloucestershire GB **70** T 18

Harvington Worcestershire GB **100** S 19

Harwel Oxfordshire GB **70** T 20

Harwich Essex GB **71** T 25

Harwood Dale North Yorkshire GB **134** O 21

Harworth Nottinghamshire GB **134** Q 20

Haslemere Surrey GB **70/71** U 21

Haslingden Lancashire GB **134** P 18

Hastings East Sussex GB **71** V 24

Haswell Durham GB **147** N 20

Hatch Beauchamp Somerset GB **53** V 17

Hatfield Doncaster GB **134** P 20

Hatfield Hertfordshire GB **71** T 22

Hatfield Herefordshire GB **87** S 17

Hatfield Broad Oak Essex GB **71** T 23

Hatfield Peverel Essex GB **71** T 24

Hatherleigh Devon GB **52/53** V 14

Hathern Leicestershire GB **100** R 20

Hatherop Gloucestershire GB **70** T 19

Hathersage Derbyshire GB **134** Q 19

Hatton Warwickshire GB **100** S 19

Hatton Aberdeenshire GB **187** H 19

Hatton of Fintray Aberdeenshire GB **187** H 18

Haugh of Urr Dumfries und Galloway GB **146** N 15

Haughton Staffordshire GB **100** R 18

Havant Hampshire GB **70** V 20

Haverfordwet Hwlffordd Pembrokeshire GB **86** T 13

Haverhill Essex GB **101** S 23

Haverhill Suffolk GB **101** S 23

Hawarden Flintshire GB **119** Q 16

Hawes North Yorkshire GB **147** O 18

Hawick Scottish Borders GB **146/147** M 17

Hawkhurst Kent GB **71** U 24

Hawkinge Kent GB **71** U 25

Hawkshead Cumbria GB **146/147** O 17

Hawnby North Yorkshire GB **147** O 20

Haworth Bradford GB **134** P 19

Hawsker North Yorkshire GB **134** O 21

Haxby York GB **147** O 20

Haxey North Lincolnshire GB **134/135** Q 21

Haydon Bridge Northumberland GB **147** N 18

Hayfield Derbyshire GB **134** Q 19

Hayle Cornwall GB **52** W 12

Hay-on-Wye Powys GB **87** S 16

Hayton East Riding of Yorkshire GB **134/135** P 21

Hayton Nottinghamshire GB **134/135** Q 21

Hayton Cumbria GB **146/147** N 17

Haywards Heath West Sussex GB **71** U 22

Hazel Grove Stockport GB **134** Q 18

Hazelbury Bryan Dorset GB **70** V 18

Hazlemere Buckinghamshire GB **70/71** T 21

Heacham Norfolk GB **101** R 23

Headcorn Kent GB **71** U 24

Headford Galway IRL **218** Q 4

Headford Kerry IRL **232** S 4

Healey North Yorkshire GB **147** O 19

Heanor Derbyshire GB **134** Q 20

Heast Highland GB **175** H 11

Heath End West Berkshire GB **70** U 20

Heathfield East Sussex GB **71** V 23

Hebden Bridge Calderdale GB **134** P 18

Heckington Lincolnshire GB **100/101** R 22

Hedge End Hampshire GB **70** V 20

Hedon East Riding of Yorkshire GB **135** P 22

Heighington Lincolnshire GB **135** Q 22

Heighington Durham GB **147** N 19

Helensburgh Argyll and Bute GB **160** K 13

Hellingly East Sussex GB **71** V 23

Helmdon Northhamptonshire GB **100** S 20

Helmsdale Highland GB **187** F 15

Helmsley North Yorkshire GB **147** O 20

Helpringham Lincolnshire GB **100/101** R 22

Helpston Peterborough GB **100/101** R 22

Helsby Cheshire GB **119** Q 17

Helston Cornwall GB **52** W 12

Hemel Hempstead Hertfordshire GB **71** T 22

Hemingbrough North Yorkshire GB **134/135** P 21

Hempnall Norfolk GB **101** S 25

Hemsby Norfolk GB **101** R 26

Hemsworth Wakefield GB **134** P 20

Hemyock Devon GB **53** V 16

Henfield West Sussex GB **71** V 22

Hengoed Shropshire GB **119** R 16

Henley-in-Arden Warwickshire GB **100** S 19

Henley-on-Thames Oxfordshire GB **70/71** T 21

Henllan Conwy GB **119** Q 16

Henshaw Northumberland GB **147** N 18

Henstridge Somerset GB **70** V 18

Hepple Northumberland GB **147** M 18

Herbertstown Limerick IRL **232/233** R 6

Hereford Herefordshire GB **87** S 17

Heriot Scottish Borders GB **161** L 17

Hermitage West Berkshire GB **70** U 20

Herne Bay Kent GB **71** U 25

Herriard Hampshire GB **70** U 20

Herstmonceux East Sussex GB **71** V 23

Herston Orkney Islands GB **198** E 16

Hertford Hertfordshire GB **71** T 22

Hesketh Bank Lancashire GB **119** P 17

Hessle Kingston upon Hull GB **135** P 22

Heswall Wirral GB **119** Q 16

Hethersett Norfolk GB **101** R 25

Hethersgill Cumbria GB **146/147** M 17

Hetton-le-Hole Sunderland GB **147** N 20

Heveningham Suffolk GB **101** S 25

Hexham Northumberland GB **147** N 18

Heylor Shetland Islands GB **199** A 20

Heytesbury Wiltshire GB **70** U 18

Heywood Rochdale GB **134** P 18

Hibaldstow North Lincolnshire GB **134/135** P 21

Hickling Norfolk GB **101** R 26

High Ackworth Wakefield GB **134** P 20

High Bentham North Yorkshire GB **146/147** O 17

High Bradfield Sheffield GB **134** Q 19

High Dougarie North Ayrshire GB **160** L 12

High Ercall Shropshire GB **119** R 17

High Ercall Telford and Wrekin GB **119** R 17

High Ham Somerset GB **53** U 17

High Hesket Cumbria GB **146/147** N 17

High Newton-by-the-Sea Northumberland GB **161** L 19

High Roding Essex GB **71** T 23

High Wycombe Buckinghamshire GB **70/71** T 21

Higham Derbyshire GB **134** Q 20

Higham Ferrers Northhamptonshire GB **100** S 21

Highampton Devon GB **52/53** V 14

Highbridge Somerset GB **53** U 17

Highclere Hampshire GB **70** U 20

Higher Town Isles of Scilly GB **52** X 10

Highley Shropshire GB **87** S 18

Hightae Dumfries und Galloway GB **146** M 16

Highworth Swindon GB **70** T 19

Hilborough Norfolk GB **101** R 24

Hildenborough Kent GB **71** U 23

Hilderstone Staffordshire GB **100** R 18

Hilgay Norfolk GB **101** R 23

Hill South Gloucestershire GB **87** T 17

Hill of Fearn Highland GB **187** G 15

Hillington Norfolk GB **101** R 24

Hillsborough Down GB **207** O 10

Hillside Angus GB **161** J 17

Hillswick Shetland Islands GB **199** B 19

Hilltown Down GB **207** O 10

Hilmarton Wiltshire GB **70** U 19

Hilton Cumbria GB **147** N 18

Hilton of Cadboll Highland GB **187** G 15

Hinckley Leicestershire GB **100** R 20

Hinderwell North Yorkshire GB **147** N 21

Hindhead Hampshire GB **70/71** U 21

Hindley Wigan GB **119** P 17

Hindolveston Norfolk GB **101** R 25

Hindon Wiltshire GB **70** U 18

Hingham Norfolk GB **101** R 24

Hinstock Shropshire GB **100** R 18

Hintlesham Suffolk GB **101** S 25

Hirnant Powys GB **119** R 16

Hirwaun Rhondda Cynon Taff GB **86/87** T 15

Histon Cambridgeshire GB **101** S 23

Hitcham Suffolk GB **101** S 24

Hitchin Hertfordshire GB **71** T 22

Hockley Essex GB **71** T 24

Hockley Heath Warwickshire GB **100** S 19

Hockliffe Bedfordshire GB **70/71** T 21

Hockwold cum Wilton Norfolk GB **101** S 24

Hoddesdon Hertfordshire GB **71** T 22

Hodnet Shropshire GB **119** R 17

Holbeach Lincolnshire GB **101** R 23

Holbeach St Johns Lincolnshire GB **100/101** R 22

Holbeach St Matthew Lincolnshire GB **101** R 23

Holbrook Suffolk GB **71** T 25

Holcombe Rogus Devon GB **53** V 16

Holford Somerset GB **53** U 16

Hollandstoun Orkney Islands GB **198** D 18

Hollesley Suffolk GB **101** S 25

Hollingbourne Kent GB **71** U 24

Hollingworth Derbyshire GB **134** Q 19

Hollym East Riding of Yorkshire GB **135** P 23

Hollymount Mayo IRL **218** P 4

Hollywood Wicklow IRL **219** Q 9

Holme Cambridgeshire GB **100/101** S 22

Holme next the Sea Norfolk GB **101** R 24

Holme-on-Spalding-Moor East Riding of Yorkshire GB **134/135** P 21

Holmes Chapel Cheshire GB **134** Q 18

Holmfirth Kirklees GB **134** P 19

Holmsfield Derbyshire GB **134** Q 19

Holsworthy Devon GB **52/53** V 14

Holsworthy Beacon Devon GB **52/53** V 14

Holt Norfolk GB **101** R 25

Holt Wrexham GB **119** Q 17

Holt Heath Worcestershire GB **87** S 18

Holy Island Northumberland GB **161** L 19

Holycross Tipperary IRL **233** R 7

Holyhead Caergybi Anglesey GB **118** Q 13

Holystone Northumberland GB **147** M 18

Holywell Flintshire GB **119** Q 16

Holywell Dorset GB **53** V 17

Holywood Dumfries und Galloway GB **146** M 15

Holywood Down GB **207** N 11

Honing Norfolk GB **101** R 25

Honingham Norfolk GB **101** R 25

Honington Lincolnshire GB **100** R 21

Honiton Devon GB **53** V 16

Hoo St Werburgh Medway GB **71** U 24

Hook East Riding of Yorkshire GB **134/135** P 21

Hook Hampshire GB **70/71** U 21

Hook Norton Oxfordshire GB **70** T 20

Hope Flintshire GB **119** Q 16

Hope Derbyshire GB **134** Q 19

Hope Bowdler Shropshire GB **87** R 17

Hope under Dinmore Herefordshire GB **87** S 17

Hopeman Moray GB **187** G 16

Hopton-on-Sea Norfolk GB **101** R 26

Hordley Shropshire GB **119** R 17

Horley Surrey GB **71** U 22

Hornby Lancashire GB **146/147** O 17

Horncastle Lincolnshire GB **135** Q 22

Horncliffe Northumberland GB **161** L 18

Horndean Hampshire GB **70** V 20

Horningsham Wiltshire GB **70** U 18

Hornsea East Riding of Yorkshire GB **135** P 22

Horrabridge Devon GB **52/53** V 14

Horse Tipperary IRL **233** R 7

Horsehouse North Yorkshire GB **147** O 19

Horseleap Offaly IRL **219** Q 7

Horsey Norfolk GB **101** R 26

Horsforth Leeds GB **134** P 19

Horsham West Sussex GB **71** U 22

Horsham St Faith Norfolk GB **101** R 25

Horsley Northumberland GB **147** N 19

Horsley Gloucestershire GB **70** T 18

Horsted Keynes West Sussex GB **71** U 22

Horton Dorset GB **70** V 19

Horton in Ribblesdale North Yorkshire GB **147** O 18

Horwich Bolton GB **119** P 17

Hospital Limerick IRL **232/233** S 6

Hoswick Shetland Islands GB **199** B 20

Hotham East Riding of Yorkshire GB **134/135** P 21

Houghton-le-Spring Sunderland GB **147** N 20

Hourn Highland GB **186** H 12

Housay Shetland Islands GB **199** B 21

Houston Renfrewshire GB **160** L 13

Houstry Highland GB **187** F 16

Houton Orkney Islands GB **198** E 16

Hove Brighton & Hove GB **71** V 22

Hovingham North Yorkshire GB **134** O 21

Hovnam Scottish Borders GB **147** M 18

Howden East Riding of Yorkshire GB **134/135** P 21

Howgate Midlothian GB **161** L 16

Howick Northumberland GB **147** M 19

Howth Dublin IRL **219** Q 10

Howwood Renfrewshire GB **160** L 13

Hoxa Orkney Islands GB **198** E 17

Hoxne Suffolk GB **101** S 25

Hoylake Wirral GB **119** Q 16

Hoyland Barnsley GB **134** Q 20

Hoyland Barnsley GB **134** Q 20

Hubbert´s Bridge Lincolnshire GB **100/101** R 22

Hucknall Nottinghamshire GB **134** Q 20

Huddersfield Kirklees GB **134** P 19

Huggate East Riding of Yorkshire GB **134/135** P 21

Hugh Town Isles of Scilly GB **52** X 10

Huish Champflower Somerset GB **53** U 16

Huisinis Na h-Eileanan an Iar GB **175** G 8

Hullavington Wiltshire GB **70** T 18

Hulwer Street Suffolk GB **101** S 26

Humberston North East Lincolnshire GB **135** P 22

Humbie East Lothian GB **161** L 17

Humshaugh Northumberland GB **147** M 18

Huna Highland GB **198** E 16

Hundon Suffolk GB **101** S 24

Hungerford West Berkshire GB **70** U 19

Hunmanby North Yorkshire GB **135** O 22

Hunstanton Norfolk GB **101** R 23

Hunter's Quay Argyll and Bute GB **160** L 13

Huntingdon Cambridgeshire GB **100/101** S 22

Huntley Gloucestershire GB **70** T 18

Huntly Aberdeenshire GB **187** H 17

Hurlers Cross Clare IRL **232** R 5

Hurliness Orkney Islands GB **198** E 16

Hurn Dorset GB **70** V 19

Hursley Hampshire GB **70** U 20

Hurst Green East Sussex GB **71** U 23

Hurstbourne Priors Hampshire GB **70** U 20

Hurstbourne Tarrant Hampshire GB **70** U 20

Hurstpierpoint West Sussex GB **71** V 22

Hurworth-on-Tees Durham GB **147** O 20

Husbands Bosworth Leicestershire GB **100** S 20

Husthwaite North Yorkshire GB **147** O 20

Huttoft Lincolnshire GB **135** Q 23

Hutton Scottish Borders GB **161** L 18

Hutton Cranswick East Riding of Yorkshire GB **135** P 22

Hutton-le-Hole North Yorkshire GB **134** O 21

Hwlffordd Haverfordwet Pembrokeshire GB **86** T 13

Hyde Derbyshire GB **134** Q 18

Hynish Argyll and Bute GB **174** K 9

Hythe Hampshire GB **70** V 20

Hythe Kent GB **71** U 25

I

Ibsley Hampshire GB **70** V 19

Ibstock Leicestershire GB **100** R 20

Icklingham Suffolk GB **101** S 24

Ide Devon GB **53** V 15

Ideford Devon GB **53** V 15

Idminston Wiltshire GB **70** U 19

Ightfield Shropshire GB **119** R 17

Ightham Kent GB **71** U 23

Ilchester Somerset GB **53** V 17

Ilderton Northumberland GB **147** M 19

Ilfracombe Devon GB **52/53** U 14

Ilkeston Derbyshire GB **100** R 20

Ilkley Bradford GB **134** P 19

Ilmington Warwickshire GB **100** S 19

Ilminster Somerset GB **53** V 17

Immingham North East Lincolnshire GB **135** P 22

Inagh Clare IRL **232** R 4

Inch Kerry IRL **232** S 3

Inch Wexford IRL **233** R 10

Inchbare Angus GB **161** J 18

Inchigeelagh Cork IRL **232** T 4

Inchnadamph Highland GB **186** F 13

Inchture Perth and Kinross GB **161** K 16

Ingatestone Essex GB **71** T 23

Ingham Suffolk GB **101** S 24

Ingleton North Yorkshire GB **147** O 18

Inglewhite Lancashire GB **119** P 17

Ingoldmells Lincolnshire GB **135** Q 23

Ingoldsby Lincolnshire GB **100** R 21

Ingram Northumberland GB **147** M 19

Inishannon Cork IRL **232** T 5

Inishcrone Sligo IRL **206** O 4

Iniskeen Monaghan IRL **219** P 9

Inistioge Kilkenny IRL **233** S 8

Inkberrow Worcestershire GB **100** S 19

Innellan Argyll and Bute GB **160** L 13

Innerleithen Scottish Borders GB **161** L 16

Innermessan Dumfries und Galloway GB **146** N 13

Innerwick East Lothian GB **161** L 18

Innfield Meath IRL **219** Q 9

Insch Aberdeenshire GB **187** H 17

Insh Highland GB **187** H 15

Inskip Lancashire GB **119** P 17

Instow Devon GB **52/53** U 14

Inver Perth and Kinross GB **160/161** J 15

Inver Highland GB **187** G 15

Inveralligin Highland GB **186** G 11

Inverallochy Aberdeenshire GB **187** G 19

Inveran Highland GB **186/187** G 14

Inveran Galway IRL **218** Q 4

Inverarity Angus GB **161** J 18

Inverbervie Aberdeenshire GB **161** J 18

Invercassley Highland GB **186** G 13

Inverdruie Highland GB **187** H 15

Invereray Argyll and Bute GB **160** K 12

Inverey Aberdeenshire GB **160/161** J 15

Invergarry Highland GB **186** H 13

Invergordon Highland GB **186/187** G 14

Inverie Highland GB **175** H 11

Inverkeilor Angus GB **161** J 18

Inverkeithing Fife GB **161** K 16

Inverkeithny Aberdeenshire GB **187** G 17

Inverkip Inverclyde GB **160** L 13

Inverkirkaig Highland GB **186** F 12

Invermoriston Highland GB **186** H 13

Inverness Highland GB **186** H 14

Inversnaid Stirling GB **160** K 13

Inveruglas Argyll and Bute GB **160** K 13

Inverurie Aberdeenshire GB **187** H 18

Invervar Perth and Kinross GB **160** J 14

Ipplepen Devon GB **53** W 15

Ipstones Staffordshire GB **134** Q 19

Ipswich Suffolk GB **101** S 25

Ireby Cumbria GB **146** N 16

Ireleth Cumbria GB **146** O 16

Iron Acton South Gloucestershire GB **70** T 18

Ironbridge Shropshire GB **100** R 18

Ironbridge Telford and Wrekin GB **100** R 18

Irthington Cumbria GB **146/147** N 17

Irthlingborough Northhamptonshire GB **100** S 21

Irvine North Ayrshire GB **160** L 13

Irvinestown Tyrone GB **206** O 7

Isbister Shetland Islands GB **199** B 21

Island Medway GB **71** U 24

Isle of Whithorn Dumfries und Galloway GB **146** N 14

Isleham Cambridgeshire GB **101** S 23

Isleornsay Highland GB **175** H 11

Islibhig Na h-Eileanan an Iar GB **175** F 8

Iver Buckinghamshire GB **70/71** T 21

Ivinghoe Buckinghamshire GB **70/71** T 21

Ivybridge Devon GB **53** W 15

Iwade Kent GB **71** U 24

Iwerne Minster Dorset GB **70** V 18

Ixworth Suffolk GB **101** S 24

J

Jamestown West Dunbartonshire GB **160** L 13

Jedburgh Scottish Borders GB **146/147** M 17

Jemimaville Highland GB **186/187** G 14

Jerrettspass Armagh GB **207** O 10

John o´Groats Highland GB **198** E 16

Johnshaven Aberdeenshire GB **161** J 18

Johnston Pembrokeshire GB **86** T 13

Johnstone Renfrewshire GB **160** L 14

Johnstonebridge Dumfries und Galloway GB **146** M 16

Johnstown Kilkenny IRL **233** R 7

Julianstown Meath IRL **219** P 10

K

Kanturk Cork IRL **232** S 5

Katesbridge Down GB **207** O 10

Keadew Roscommon IRL **206** O 6

Keady Armagh GB **207** O 9

Keal Lincolnshire GB **135** Q 23

Kealkill Cork IRL **232** T 4

Keel Mayo IRL **218** P 2

Keelby Lincolnshire GB **135** P 22

Keenagh Longford IRL **219** P 7

Kegworth Leicestershire GB **100** R 20

Keig Aberdeenshire GB **187** H 17

Keighley Bradford GB **134** P 19

Keillmore Argyll and Bute GB **174** L 11

Keiss Highland GB **198** E 16

Keith Moray GB **187** G 17

Keld North Yorkshire GB **147** O 18

Kelham Nottinghamshire GB **134/135** Q 21

Kells Antrim GB **207** N 10

Kells Meath IRL **219** P 9

Kells Kilkenny IRL **233** R 8

Kellys Grove Galway IRL **218/219** Q 6

Kelmscott Oxfordshire GB **70** T 19

Kelsall Cheshire GB **119** Q 17

Kelso Scottish Borders GB **161** L 18

Keltneyburn Perth and Kinross GB **160** J 14

Kelty Fife GB **161** K 16

Kelvedon Essex GB **71** T 24

Kemble Gloucestershire GB **70** T 19

Kemnay Aberdeenshire GB **187** H 18

Kempsey Worcestershire GB **87** S 18

Kempston Bedfordshire GB **100** S 21

Kemsing Kent GB **71** U 23

Kendal Cumbria GB **146/147** O 17

Kenfig Bridgend GB **86/87** T 15

Kenilworth Warwickshire GB **100** S 19

Kenmare Kerry IRL **232** T 3

Kenmore Perth and Kinross GB **160/161** J 15

Kennacraig Argyll and Bute GB **160** L 12

Kennethmont Aberdeenshire GB **187** H 17

Kenninghall Norfolk GB **101** S 25

Kennoway Fife GB **161** K 16

Kensaleyre Highland GB **175** H 10

Kentford Suffolk GB **101** S 24

Kentisbury Devon GB **53** U 15

Kenton Devon GB **53** V 16

Kentmere Cumbria GB **146/147** O 17

Kentra Highland GB **174** J 11

Kerry Powys GB **87** S 16

Kershopefoot Cumbria GB **146/147** M 17

Kesh Fermanagh GB **206** N 7

Keshcarrigan Leitrim IRL **206** O 7

Kessingland Suffolk GB **101** S 26

Keswick Cumbria GB **146** N 16

Kettering Northhamptonshire GB **100** S 21

Kettletoft Orkney Islands GB **198** D 17

Kettlewell North Yorkshire GB **147** O 18

Ketton Rutland GB **100** R 21

Keynsham Bath & NE Somerset GB **53** U 17

Keyworth Nottinghamshire GB **100** R 20

Kibworth Harcourt Leicestershire GB **100** R 21

Kidderminster Worcestershire GB **87** S 18

Kidlington Oxfordshire GB **70** T 20

Kidsgrove Staffordshire GB **134** Q 18

Kidwelly Carmarthenshire GB **86** T 14

Kielder Northumberland GB **146/147** M 17

Kilbaha Clare IRL **232** R 3

Kilbarchan Renfrewshire GB **160** L 13

Kilbeggan Westmeath IRL **219** Q 8

Kilberry Argyll and Bute GB **174** L 11

Kilberry Meath IRL **219** P 9

Kilbirnie North Ayrshire GB **160** L 13

Kilbride Argyll and Bute GB **160** K 12

Kilbride Wicklow IRL **219** Q 10

Kilbride Wicklow IRL **233** R 10

Kilbrittain Cork IRL **232** T 5

Kilchattan Bay Argyll and Bute GB **160** L 12

Kilchenzie Argyll and Bute GB **174** M 11

Kilchiaran Argyll and Bute GB **174** L 10

Kilchoan Highland GB **174** J 10

Kilchoman Argyll and Bute GB **174** L 10

Kilchreest Galway IRL **218** Q 5

Kilchrenan Argyll and Bute GB **160** K 12

Kilclief Down GB **207** O 11

Kilcock Meath IRL **219** Q 9

Kilcolgan Galway IRL **218** Q 5

Kilconnell Galway IRL **218/219** Q 6

Kilconquhar Fife GB **161** K 17

Kilcormac Offaly IRL **219** Q 7

Kilcreggan Argyll and Bute GB **160** L 13

Kilcrohane Cork IRL **232** T 3

Kilcullen Kildare IRL **219** Q 9

Kildale North Yorkshire GB **147** O 20

Kildare Kildare IRL **219** Q 9

Kildary Highland GB **186/187** G 14

Kildavanan Argyll and Bute GB **160** L 12

Kildermorie Lodge Highland GB **186/187** G 14

Kildonan North Ayrshire GB **174** M 12

Kildonan Lodge Highland GB **187** F 15

Kildorrery Cork IRL **232/233** S 6

Kildrummy Aberdeenshire GB **187** H 17

Kilfenora Clare IRL **232** R 4

Kilfiernan Dublin IRL **219** Q 10

Kilfinan Argyll and Bute GB **160** L 12

Kilfinnane Limerick IRL **232/233** S 6

Kilgarvan Kerry IRL **232** T 4

Kilgetty Pembrokeshire GB **86** T 13

Kilglass Sligo IRL **206** O 4

Kilham East Riding of Yorkshire GB **135** C 22

Kilham Northumberland GB **161** L 18

Kilkee Clare IRL **232** R 3

Kilkeel Down GB **207** O 11

Kilkelly Mayo IRL **218** P 5

Kilkenny Cill Chainnigh Kilkenny IRL **233** R 8

Kilkerrin Galway IRL **218** P 5

Kilkhampton Cornwall GB **52/53** V 14

Kilkieran Galway IRL **218** Q 3

Kilkinlea Limerick IRL **232** S 4

Kilkishen Clare IRL **232** R 5

Kill Waterford IRL **233** S 8

Killadeas Fermanagh GB **206** O 7

Killadoon Mayo IRL **218** P 3

Killadysert Clare IRL **232** R 4

Killala Mayo IRL **206** O 4

Killaloe Clare IRL **232/233** R 6

Killamarsh Derbyshire GB **134** Q 20

Killarga Leitrim IRL **206** O 6

Killarney Cill Áirne Kerry IRL **232** S 3

Killashandra Cavan IRL **206** O 7

Killashee Longford IRL **219** P 7

Killavally Mayo IRL **218** P 4

Killavullen Cork IRL **232** S 5

Killead Antrim GB **207** N 10

Killeagh Cork IRL **232/233** T 6

Killean Argyll and Bute GB **174** L 11

Killearn Stirling GB **160** K 14

Killeigh Offaly IRL **219** Q 8

Killen Tyrone GB **206** N 7

Killenaule Tipperary IRL **233** R 7

Killeter Tyrone GB **206** N 7

Killichonan Perth and Kinross GB **160** J 14

Killiecrankie Perth and Kinross GB **160/161** J 15

Killilan Highland GB **186** H 12

Killimer Clare IRL **232** R 4

Killimor Galway IRL **218/219** Q 6

Killin Stirling GB **160** K 14

Killinaboy Clare IRL **232** R 4

Killiney Dublin IRL **219** Q 10

Killorglin Cill Orglan Kerry IRL **232** S 3

Killough Down GB **207** O 11

Killsallaghan Dublin IRL **219** Q 10

Killucan Westmeath IRL **219** P 8

Killybegs Donegal IRL **206** N 6

Killyleagh Down GB **207** O 11

Killyon Offaly IRL **219** Q 7

Kilmacolm Inverclyde GB **160** L 13

Kilmacrenan Donegal IRL **206** M 7

Kilmacthomas Waterford IRL **233** S 8

Kilmaganny Kilkenny IRL **233** S 8

Kilmaine Mayo IRL **218** P 4

Kilmallock Limerick IRL **232** S 5

Kilmaluag Highland GB **186** G 10

Kilmanagh Kilkenny IRL **233** R 8

Kilmarnock East Ayrshire GB **160** L 14

Kilmartin Argyll and Bute GB **160** K 12

Kilmaurs East Ayrshire GB **160** L 13

Kilmeedy Limerick IRL **232** S 5

Kilmelford Argyll and Bute GB **160** K 12

Kilmichael Cork IRL **232** T 4

Kilmichael Glassary Argyll and Bute GB **160** K 12

Kilmichael of Inverlussa Argyll and Bute GB **174** L 11

Kilmihil Clare IRL **232** R 4

Kilmorack Highland GB **186** H 13

Kilmore Quay Wexford IRL **233** S 9

Kilmory Argyll and Bute GB **174** L 11

Kilmory North Ayrshire GB **174** M 12

Kilmory Highland GB **175** H 10

Kilmuckridge Wexford IRL **233** R 10

Kilmun Argyll and Bute GB **160** L 13

Kilmurvy Galway IRL **218** Q 3

Kilnave Argyll and Bute GB **174** L 10

Kilncadzow South Lanarkshire GB **160/161** L 15

Kilninian Argyll and Bute GB **174** J 10

Kilninver Argyll and Bute GB **174** K 11

Kilnsea East Riding of Yorkshire GB **135** P 23

Kiloran Argyll and Bute GB **174** K 10

Kilrea Londonderry GB **207** N 9

Kilreekill Galway IRL **218/219** Q 6

Kilronan Galway IRL **218** Q 3

Kilross Donegal IRL **206** N 7

Kilrush Clare IRL **232** R 4

Kilsby Northhamptonshire GB **100** S 20

Kilsheelan Tipperary IRL **233** S 7

Kilskeery Fermanagh GB **206** O 7

Kilsyth North Lanarkshire GB **160** L 14

Kiltamagh Mayo IRL **218** P 4

Kiltarlity Highland GB **186** H 14

Kiltealy Wexford IRL **233** R 9

Kilteel Kildare IRL **219** Q 9

Kiltegan Wicklow IRL **233** R 9

Kiltoom Offaly IRL **218/219** Q 6

Kiltormer Galway IRL **218/219** Q 6

Kiltullagh Galway IRL **218** Q 5

Kiltyclogher Leitrim IRL **206** O 6

Kilvaxter Highland GB **186** G 10

Kilwaughter Antrim GB **207** N 11

Kilwinning North Ayrshire GB **160** L 13

Kilworth Cork IRL **232/233** S 6

Kimbolton Cambridgeshire GB **100/101** S 22

Kimmendge Dorset GB **70** V 18

Kimpton Hertfordshire GB **71** T 22

Kinauchdrachd Argyll and Bute GB **174** K 11

Kinawley Fermanagh GB **206** O 7

Kinbrace Highland GB **187** F 15

Kinbuck Stirling GB **160/161** K 15

Kincardine Fife GB **186/187** G 14

Kincardine Highland GB **186/187** G 14

Kincraig Highland GB **187** H 15

Kineton Warwickshire GB **100** S 19

Kinfauns Perth and Kinross GB **161** K 16

King´s Bromley Staffordshire GB **100** R 19

King´s Cliffe Northhamptonshire GB **100** R 21

King´s Lynn Norfolk GB **101** R 23

Kingarth Argyll and Bute GB **160** L 12

Kinghorn Fife GB **161** K 16

Kings Caple Herefordshire GB **87** T 17

Kings Langley Hertfordshire GB **71** T 22

King's Somborne Hampshire GB **70** U 20

Kings Sutton Northhamptonshire GB **100** S 20

Kingsbarns Fife GB **161** K 17

Kingsbridge Devon GB **53** W 15

Kingsbury Warwickshire GB **100** R 19

Kingsbury Episcopi Somerset GB **53** V 17

Kingsclere Hampshire GB **70** U 20

Kingscourt Cavan IRL **219** P 9

Kingshouse Stirling GB **160** K 14

Kingskerswell Devon GB **53** V 15

Kingsland Roscommon IRL **218/219** P 6

Kingsland Herefordshire GB **87** S 17

Kingsley Staffordshire GB **134** Q 19

Kingsteignton Devon GB **53** V 15

Kingston Moray GB **187** G 16

Kingston Devon GB **53** W 15

Kingston Bagpuize Oxfordshire GB **70** T 20

Kingston upon Thames Greater London GB **71** U 22

Kingstone Herefordshire GB **87** S 17

Kingston-upon-Hull Kingston upon Hull GB **135** P 22

Kingswear Devon GB **53** W 15

Kingswood Bristol GB **53** U 17

Kington Herefordshire GB **87** S 16

Kingussie Highland GB **187** H 14

Kinkell Bridge Perth and Kinross GB **160/161** K 15

Kinloch Highland GB **175** H 10

Kinloch Highland GB **186** F 13

Kinloch Highland GB **186** H 12

Kinloch Rannoch Perth and Kinross GB **160** J 14

Kinlochard Stirling GB **160** K 14

Kinlochbervie Highland GB **186** F 12

Kinlocheil Highland GB **160** J 12

Kinlochewe Highland GB **186** G 12

Kinlochleven Highland GB **160** J 13

Kinloss Moray GB **187** G 15

Kinlough Leitrim IRL **206** O 6

Kinnaird Perth and Kinross GB **161** K 16

Kinneff Aberdeenshire GB **161** J 18

Kinnegad Westmeath IRL **219** Q 8

Kinnerley Shropshire GB **119** R 17

Kinnitty Offaly IRL **219** Q 7

Kinross Perth and Kinross GB **161** K 16

Kinsale Cork IRL **232** T 5

Kinsalebeg Waterford IRL **233** T 7

Kintbury West Berkshire GB **70** U 20

Kintore Aberdeenshire GB **187** H 18

Kinvarra Galway IRL **218** Q 3

Kinvarra Galway IRL **218** Q 5

Kinver Staffordshire GB **87** S 18

Kippen Stirling GB **160** K 14

Kirby Grindalythe North Yorkshire GB **134** O 21

Kirby Malham North Yorkshire GB **147** O 18

Kirby Misperton North Yorkshire GB **134** O 21

Kircubbin Down GB **207** O 11

Kirk Derbyshire GB **100** R 19

Kirk North Yorkshire GB **134** P 20

Kirk Highland GB **198** E 16

Kirk Ireton Derbyshire GB **134** Q 19

Kirk Michael Isle of Man GB **146** O 13

Kirk of Shotts North Lanarkshire GB **160/161** L 15

Kirkabister Shetland Islands GB **199** B 20

Kirkbampton Cumbria GB **146** N 16

Kirkbean Dumfries und Galloway GB **146** N 15

Kirkbride Cumbria GB **146** N 16

Kirkburn East Riding of Yorkshire GB **135** P 22

Kirkburton Kirklees GB **134** P 19

Kirkby Knowsley GB **119** Q 17

Kirkby Cumbria GB **147** O 18

Kirkby in Ashfield Nottinghamshire GB **134** Q 20

Kirkby Lonsdale Cumbria GB **146/147** O 17

Kirkby Malzeard North Yorkshire GB **147** O 19

Kirkby Thore Cumbria GB **146/147** N 17

Kirkbymoorside North Yorkshire GB **134** O 21

Kirkcaldy Fife GB **161** K 16

Kirkcambeck Cumbria GB **146/147** M 17

Kirkcolm Dumfries und Galloway GB **146** N 12

Kirkconnel Dumfries und Galloway GB **146** M 15

Kirkcowan Dumfries und Galloway GB **146** N 13

Kirkcudbright Dumfries und Galloway GB **146** N 14

Kirkgunzeon Dumfries und Galloway GB **146** N 15

Kirkham Lancashire GB **119** P 17

Kirkheaton Northumberland GB **147** M 19

Kirkhill Highland GB **186** H 14

Kirkinner Dumfries und Galloway GB **146** N 14

Kirkintilloch East Dunbartonshire GB **160** L 14

Kirkland Dumfries und Galloway GB **146** M 15

Kirklington Nottinghamshire GB **134/135** Q 21

Kirkmaiden Dumfries und Galloway GB **146** N 13

Kirkmichael South Ayrshire GB **146** M 13

Kirkmichael Perth and Kinross GB **161** J 16

Kirknewton West Lothian GB **161** L 16

Kirknewton Northumberland GB **161** L 18

Kirkoswald South Ayrshire GB **146** M 13

Kirkoswald Cumbria GB **146/147** N 17

Kirkpatrick Durham Dumfries und Galloway GB **146** M 15

Kirkpatrick-Fleming Dumfries und Galloway GB **146** M 16

Kirksanton Cumbria GB **146** O 16

Kirkton Scottish Borders GB **146/147** M 17

Kirkton Angus GB **161** J 18

Kirkton Highland GB **175** H 11

Kirkton Aberdeenshire GB **187** H 18

Kirkton Manor Scottish Borders GB **161** L 16

Kirkton of Airlie Angus GB **161** J 16

Kirkton of Alvah Aberdeenshire GB **187** G 17

Kirkton of Auchterless Aberdeenshire GB **187** H 17

Kirkton of Culsalmond Aberdeenshire GB **187** H 17

Kirkton of Durris Aberdeenshire GB **187** G 17

Kirkton of Kingoldrum Angus GB 161 J 16

Kirktown of Deskford Moray GB 187 G 17

Kirkwall Orkney Islands GB 198 E 17

Kirkwhelpington Northumberland GB 147 M 19

Kirriemuir Angus GB 161 J 16

Kirtlebridge Dumfries und Galloway GB 146 M 16

Kirtlington Oxfordshire GB 70 T 20

Kirtomy Highland GB 186/187 E 14

Kirton Lincolnshire GB 100/101 R 22

Kirton Nottinghamshire GB 134/135 Q 21

Kirton in Lindsey North Lincolnshire GB 134/135 Q 21

Knaresborough North Yorkshire GB 147 O 20

Knarsdale Northumberland GB 146/147 N 17

Knebworth Hertfordshire GB 71 T 22

Kneesall Nottinghamshire GB 134/135 Q 21

Knighton Powys GB 87 S 16

Knigts Town Kerry IRL 70 T 2

Kniveton Derbyshire GB 134 Q 19

Knock Argyll and Bute GB 174 K 11

Knock Moray GB 187 G 17

Knock Mayo IRL 218 P 5

Knock Clare IRL 232 R 4

Knockaderry Limerick IRL 232 S 5

Knockandhu Moray GB 187 H 16

Knockanevin Cork IRL 232/233 S 6

Knocklong Limerick IRL 232/233 S 6

Knocknagree Cork IRL 232 S 4

Knocktopher Kilkenny IRL 233 S 8

Knockvicar Roscommon IRL 218/219 P 6

Knossington Rutland GB 100 R 21

Knott End-on-Sea Lancashire GB 119 P 17

Knottingley Wakefield GB 134 P 20

Knowehead Dumfries und Galloway GB 146 M 14

Knowle Solihull GB 100 S 19

Knucklas Powys GB 87 S 16

Knutsford Cheshire GB 134 Q 18

Kyle of Lochalsh Highland GB 175 H 11

Kyleakin Highland GB 175 H 11

Kylebrack Galway IRL 218/219 Q 6

Kylerhea Highland GB 175 H 11

Kylestrome Highland GB 186 F 12

L

Labasheeda Clare IRL 232 R 4

Lacasaidh Na h-Eileanan an Iar GB 175 F 9

Laceby North East Lincolnshire GB 135 P 22

Lack Fermanagh GB 206 N 7

Lacock Wiltshire GB 70 U 18

Ladybank Fife GB 161 K 16

Ladysbridge Cork IRL 232/233 T 6

Lagavulin Argyll and Bute GB 174 L 10

Lagg Argyll and Bute GB 174 L 11

Laggan Highland GB 160 H 13

Laggan Highland GB 160 H 14

Laghy Donegal IRL 206 N 6

Lagney Corner Tyrone GB 207 O 9

Lahinch Clare IRL 232 R 4

Laide Highland GB 186 G 11

Lair Highland GB 186 H 12

Lairg Highland GB 186/187 F 14

Lakenheath Suffolk GB 101 S 24

Lamberhurst Kent GB 71 U 23

Lambert Falkirk GB 160/161 K 15

Lambourn West Berkshire GB 70 T 19

Lamington South Lanarkshire GB 160/161 L 15

Lamlash North Ayrshire GB 160 L 12

Lamonby Cumbria GB 146/147 N 17

Lampeter Ceredigion GB 86 S 14

Lamplugh Cumbria GB 146 N 16

Lamport Northhamptonshire GB 100 S 21

Lanark South Lanarkshire GB 160/161 L 15

Lancaster Lancashire GB 146/147 O 17

Lanchester Durham GB 147 N 19

Lane End Buckinghamshire GB 70/71 T 21

Lanesborough Longford IRL 218/219 P 6

Langdale End North Yorkshire GB 134 O 21

Langdon Beck Durham GB 147 N 18

Langford Devon GB 53 V 16

Langford Budville Somerset GB 53 U 16

Langholm Dumfries und Galloway GB 146/147 M 17

Langley Derbyshire GB 100 R 19

Langley Essex GB 71 T 23

Langport Somerset GB 53 U 17

Langrick Lincolnshire GB 135 Q 22

Langsett Barnsley GB 134 P 19

Langshaw Scottish Borders GB 161 L 17

Langthwaite North Yorkshire GB 147 O 19

Langtoft East Riding of Yorkshire GB 135 O 22

Langton North Yorkshire GB 134 O 21

Langwathby Cumbria GB 146/147 N 17

Lanivet Cornwall GB 52 W 13

Lanreath Cornwall GB 52 W 13

Lanton Scottish Borders GB 146/147 M 17

Lapford Devon GB 53 V 15

Laracor Meath IRL 219 P 9

Laragh Wicklow IRL 219 Q 10

Largowald Fife GB 161 K 17

Largs North Ayrshire GB 160 L 13

Larkhall South Lanarkshire GB 160/161 L 15

Larne Antrim GB 207 N 11

Lasham Hampshire GB 70 U 20

Lasswade Midlothian GB 161 L 16

Latheron Highland GB 187 F 16

Lauder Scottish Borders GB 161 L 17

Laugharne Carmarthenshire GB 86 T 14

Launceston Cornwall GB 52/53 V 14

Lauragh Kerry IRL 232 T 3

Laurencekirk Aberdeenshire GB 161 J 18

Laurencetown Galway IRL 218/219 Q 6

Laurieston Dumfries und Galloway GB 146 N 14

Lavendon Milton Keynes GB 100 S 21

Lavenham Suffolk GB 101 S 24

Lawers Perth and Kinross GB 160 J 14

Laxey Isle of Man GB 146 O 14

Laxfield Suffolk GB 101 S 25

Laxo Shetland Islands GB 199 B 20

Laxton East Riding of Yorkshire GB 134/135 P 21

Laxton Nottinghamshire GB 134/135 Q 21

Layer de la Haye Essex GB 71 T 24

Lazonby Cumbria GB 146/147 N 17

Lea Herefordshire GB 70 T 18

Leabgarrow Donegal IRL 206 N 5

Leadburn Scottish Borders GB 161 L 16

Leaden Roding Essex GB 71 T 23

Leadenham Lincolnshire GB 134/135 Q 21

Leadgate Cumbria GB 147 N 18

Leadhills South Lanarkshire GB 146 M 15

Leafield Oxfordshire GB 70 T 19

Lealholm North Yorkshire GB 147 O 21

Leap Cork IRL 232 T 4

Leasingham Lincolnshire GB 135 Q 22

Leatherhead Surrey GB 71 U 22

Leavening North Yorkshire GB 134 O 21

Lecarrow Roscommon IRL 218/219 P 6

Lechlade Gloucestershire GB 70 T 19

Leckmelm Highland GB 186 G 12

Leconfield East Riding of Yorkshire GB 135 P 22

Ledbury Herefordshire GB 87 S 18

Ledmore Highland GB 186 F 13

Lee Lancashire GB 119 P 17

Leebotwood Shropshire GB 87 R 17

Leeds Leeds GB 134 P 19

Leeds Kent GB 71 U 24

Leedstown Cornwall GB 52 W 12

Leek Staffordshire GB 134 Q 18

Leenane Galway IRL 218 P 3

Lee-on-the-Solent Hampshire GB 70 V 20

Legbourne Lincolnshire GB 135 Q 23

Legerwood Scottish Borders GB 161 L 17

Leicester Leicester GB 100 R 20

Leigh Wigan GB 119 Q 17

Leigh Surrey GB 71 U 22

Leigh Kent GB 71 U 23

Leighlinbridge Carlow IRL 233 R 9

Leighterton Gloucestershire GB 70 T 18

Leighton Buzzard Bedfordshire GB 70/71 T 21

Leintwardine Herefordshire GB 87 S 17

Leiston Suffolk GB 101 S 26

Leitholm Scottish Borders GB 161 L 18

Leitrim Leitrim IRL 218/219 P 6

Lemybrien Waterford IRL 233 S 7

Lendalfoot South Ayrshire GB 146 M 13

Lenham Kent GB 71 U 24

Lennoxtown East Dunbartonshire GB 160 L 14

Leominster Herefordshire GB 87 S 17

Leperstown Waterford IRL 233 S 8

Lerryn Cornwall GB 52 W 13

Lerwick Shetland Islands GB 199 B 20

Lesbury Northumberland GB 147 M 19

Leslie Fife GB 161 K 16

Leslie Aberdeenshire GB 187 H 17

Lesmahagow South Lanarkshire GB 160/161 L 15

Leswalt Dumfries und Galloway GB 146 N 12

Letchworth Garden City Hertfordshire GB 71 T 22

Letham Angus GB 161 J 18

Letterfearn Highland GB 175 H 11

Letterfrack Galway IRL 218 P 3

Letterkenny Leitir Ceanainn Donegal IRL 206 N 7

Lettermulan Galway IRL 218 Q 3

Letterston Pembrokeshire GB 86 T 13

Leuchars Fife GB 161 K 17

Leumrabhagh Na h-Eileanan an Iar GB 186 F 10

Leven East Riding of Yorkshire GB 135 P 22

Leven Fife GB 161 K 17

Levens Cumbria GB 146/147 O 17

Leverburgh An t-Ob Na h-Eileanan an Iar GB 175 G 8

Lewannick Cornwall GB 52/53 V 14

Lewes East Sussex GB 71 V 23

Lewtrenchard Devon GB 52/53 V 14

Leyburn North Yorkshire GB 147 O 19

Leyland Lancashire GB 119 P 17

Leysdown on Sea Kent GB 71 U 24

Lhanbryde Moray GB 187 G 16

Libberton South Lanarkshire GB 160/161 L 15

Lichfield Staffordshire GB 100 R 19

Lidgate Suffolk GB 101 S 24

Liff Angus GB 161 K 16

Lifford Donegal IRL 207 N 8

Lifton Devon GB 52/53 V 14

Lilliesleaf Scottish Borders GB 161 L 17

Limavady Londonderry GB 207 M 9

Limerick Luimneach Limerick IRL 232 R 5

Lincoln Lincolnshire GB 134/135 Q 21

Lindale Cumbria GB 146/147 O 17

Lingen Herefordshire GB 87 S 17

Lingfield Surrey GB 71 U 23

Linlithgow West Lothian GB 160/161 L 15

Linton Cambridgeshire GB 101 S 23

Linton North Yorkshire GB 147 O 18

Linton Scottish Borders GB 161 L 18

Linton Kent GB 71 U 24

Lional Na h-Eileanan an Iar GB 186 F 10

Liphook West Sussex GB 70/71 U 21

Lisbellaw Fermanagh GB 206 O 7

Lisburn Antrim GB 207 N 10

Liscannor Clare IRL 232 R 4

Liscarney Mayo IRL 218 P 3

Liscarroll Cork IRL 232 S 5

Lisdoonvarna Clare IRL 218 Q 4

Lisduff Cavan IRL 219 P 8

Liskeard Cornwall GB 52/53 W 14

Lismore Waterford IRL 233 S 7

Lisnacree Down GB 207 O 10

Lisnarick Fermanagh GB 206 O 7

Lisnaskea Fermanagh GB 207 O 8

Lispatrick Cork IRL 232 T 5

Liss Hampshire GB 70/71 U 21

Lissatinnig Br. Kerry IRL 232 T 3

Lissycasey Clare IRL 232 R 4

Listowel Kerry IRL 232 S 4

Lisvarrinane Tipperary IRL 232/233 S 6

Litcham Norfolk GB 101 R 24

Little Ayre Orkney Islands GB 198 E 16

Little Berkhamsted Hertfordshire GB 71 T 22

Little Bytham Lincolnshire GB 100/101 R 22

Little Compton Warwickshire GB 70 T 19

Little Downham Cambridgeshire GB 101 S 23

Little Missenden Buckinghamshire GB 70/71 T 21

Little Strickland Cumbria GB 146/147 N 17

Little Walsingham Norfolk GB 101 R 24

Little Waltham Essex GB 71 T 23

Littleborough Rochdale GB 134 P 18

Littleferry Highland GB 186/187 G 14

Littlehampton West Sussex GB 70/71 V 21

Littlemill Highland GB 187 G 15

Littleport Cambridgeshire GB **101** S 23

Littleton Tipperary IRL **233** R 7

Litton North Yorkshire GB **147** O 18

Litton Cheney Dorset GB **53** V 17

Liurbost Na h-Eileanan an Iar GB **186** F 10

Liverpool Liverpool GB **119** Q 17

Livingston West Lothian GB **161** L 16

Lixnaw Kerry IRL **232** S 3

Lizard Cornwall GB **52** X 12

Llan Ffestiniog Gwynedd GB **119** R 15

Llanaber Gwynedd GB **118/119** R 14

Llanaelhaearn Gwynedd GB **118/119** R 14

Llanarmon Dyffryn Ceiriog Wrexham GB **119** R 16

Llanarmon-yn-Ial Denbighshire GB **119** Q 16

Llanarth Ceredigion GB **86** S 14

Llanasa Flintshire GB **119** Q 16

Llanbadarn Fynydd Powys GB **87** S 16

Llanbedr Gwynedd GB **86** R 14

Llanbedrog Gwynedd GB **118/119** R 14

Llanberis Gwynedd GB **118/119** Q 14

Llanbister Powys GB **87** S 16

Llanboidy Carmarthenshire GB **86** T 13

Llanbrynmair Powys GB **86/87** R 15

Llanddarog Carmarthenshire GB **86** T 14

Llandderfel Gwynedd GB **119** R 15

Llanddewi Brefi Ceredigion GB **86/87** S 15

Llanddewi Ystradenni Powys GB **87** S 16

Llandefaelog Powys GB **87** T 16

Llandeilo Carmarthenshire GB **86/87** T 15

Llandinam Powys GB **87** S 16

Llandovery Llanymddyfi Carmarthenshire GB **86/87** T 15

Llandrillo Denbighshire GB **119** R 16

Llandrindod Powys GB **87** S 16

Llandudno Conwy GB **119** Q 15

Llandwrog Gwynedd GB **118/119** Q 14

Llandybie Carmarthenshire GB **86/87** T 15

Llandyfaelog Carmarthenshire GB **86** T 14

Llandyrnog Denbighshire GB **119** Q 16

Llandyssil Powys GB **119** R 16

Llandysul Ceredigion GB **86** S 14

Llanegryn Gwynedd GB **86** R 14

Llanelidan Denbighshire GB **119** Q 16

Llanelltyd Gwynedd GB **119** R 15

Llanerchymedd Anglesey GB **118/119** Q 14

Llanfachraeth Anglesey GB **118** Q 13

Llanfaelog Anglesey GB **118/119** Q 14

Llanfaethlu Anglesey GB **118** Q 13

Llanfair Clydogau Ceredigion GB **86** S 14

Llanfair Talhaiarn Conwy GB **119** Q 15

Llanfair-Caereinion Powys GB **87** R 16

Llanfairfechan Conwy GB **119** Q 15

Llanfair-ym-Muallt Builth Wells Powys GB **87** S 16

Llanfechain Powys GB **119** R 16

Llanfihangel Nant Bran Powys GB **86/87** T 15

Llanfihangel-nant-Melan Powys GB **87** S 16

Llanfihangel-yng-Ngwynfa Powys GB **87** R 16

Llanfihangel-y-pennant Gwynedd GB **86/87** R 15

Llanfrynach Powys GB **87** T 16

Llanfyllin Powys GB **119** R 16

Llanfynydd Carmarthenshire GB **86** T 14

Llanfyrnach Pembrokeshire GB **86** T 13

Llangadfan Powys GB **87** R 16

Llangadog Carmarthenshire GB **86/87** T 15

Llangain Carmarthenshire GB **86** T 14

Llangefni Anglesey GB **118/119** Q 14

Llangeler Carmarthenshire GB **86** S 14

Llangennech Carmarthenshire GB **86** T 14

Llangernyw Conwy GB **119** Q 15

Llangoed Anglesey GB **118/119** Q 14

Llangollen Denbighshire GB **119** R 16

Llangors Powys GB **87** T 16

Llangower Gwynedd GB **119** R 15

Llangranog Ceredigion GB **86** S 14

Llangunllo Powys GB **87** S 16

Llangunnor Carmarthenshire GB **86** T 14

Llangurig Powys GB **86/87** S 15

Llangwm Conwy GB **119** R 15

Llangybi Ceredigion GB **86** S 14

Llangynidr Powys GB **87** T 16

Llangynin Carmarthenshire GB **86** T 13

Llangynog Powys GB **119** R 16

Llanharry Rhondda Cynon Taff GB **87** T 16

Llanidloes Powys GB **86/87** S 15

Llanilar Ceredigion GB **86** S 14

Llanllugan Powys GB **87** R 16

Llanmadoc Swansea GB **86** T 14

Llannon Carmarthenshire GB **86** T 14

Llanon Ceredigion GB **86** S 14

Llanpumsaint Carmarthenshire GB **86** T 14

Llanrhaeadr Denbighshire GB **119** Q 16

Llanrhaeadr-ym-Mochnant Powys GB **119** R 16

Llanrhain Pembrokeshire GB **86** T 12

Llanrhidian Swansea GB **86** T 14

Llanrhystud Ceredigion GB **86** S 14

Llanrug Gwynedd GB **118/119** Q 14

Llanrwst Conwy GB **119** Q 15

Llansanffraid Glan Conwy Conwy GB **119** Q 15

Llansannan Conwy GB **119** Q 15

Llansilin Powys GB **119** R 16

Llansteffan Carmarthenshire GB **86** T 14

Llanthony Monmouthshire GB **87** T 16

Llantrisant Rhondda Cynon Taff GB **87** T 16

Llantrisant Monmouthshire GB **87** T 17

Llantwit Major Vale of Glamorgan GB **53** U 16

Llanuwchllyn Gwynedd GB **119** R 15

Llanvihangel Gobion Monmouthshire GB **87** T 17

Llanwddyn Powys GB **119** R 16

Llanwenog Ceredigion GB **86** S 14

Llanwnog Powys GB **87** R 16

Llanwrda Carmarthenshire GB **86/87** T 15

Llanwrin Powys GB **86/87** R 15

Llanwrthwl Powys GB **87** S 16

Llanwrtyd Wells Powys GB **86/87** S 15

Llanybydder Carmarthenshire GB **86** S 14

Llanycefn Pembrokeshire GB **86** T 13

Llanychaer Pembrokeshire GB **86** T 13

Llanymawddwy Gwynedd GB **86/87** R 15

Llanymddyfi Llandovery Carmarthenshire GB **86/87** T 15

Llawhaden Pembrokeshire GB **86** T 13

Lledrod Ceredigion GB **86** S 14

Llithfaen Gwynedd GB **118/119** R 14

Lloonfower Roscommon IRL **218** P 5

Llwyndafydd Ceredigion GB **86** S 14

Llwyngwril Gwynedd GB **86** R 14

Llysfaen Conwy GB **119** Q 15

Llyswen Powys GB **87** S 16

Loanhead Midlothian GB **161** L 16

Loch Baghasdail Lochboisdale Na h-Eileanan an Iar GB **175** H 8

Loch Choire Lodge Highland GB **186/187** F 14

Loch Euphort Na h-Eileanan an Iar GB **175** G 8

Loch Gowna Cavan IRL **219** P 7

Loch nam Madadh Lochmaddy Na h-Eileanan an Iar GB **175** G 8

Loch Sgioport Na h-Eileanan an Iar GB **175** H 8

Lochailort Highland GB **175** J 11

Lochaline Highland GB **174** J 11

Lochboisdale Loch Baghasdail Na h-Eileanan an Iar GB **175** H 8

Lochbuie Argyll and Bute GB **174** K 11

Lochcarron Highland GB **186** H 12

Lochdon Argyll and Bute GB **174** K 11

Lochearnhead Stirling GB **160** K 14

Locherben Dumfries und Galloway GB **146** M 15

Lochgair Argyll and Bute GB **160** K 12

Lochgelly Fife GB **161** K 16

Lochgilphead Argyll and Bute GB **160** K 12

Lochgoilhead Argyll and Bute GB **160** K 13

Lochinver Highland GB **186** F 12

Lochmaben Dumfries und Galloway GB **146** M 16

Lochmaddy Loch nam Madadh Na h-Eileanan an Iar GB **175** G 8

Lochportain Na h-Eileanan an Iar GB **175** G 8

Lochranza North Ayrshire GB **160** L 12

Lochwinnoch Renfrewshire GB **160** L 13

Lockerbie Dumfries und Galloway GB **146** M 16

Lockton North Yorkshire GB **134** O 21

Loddiswell Devon GB **53** W 15

Loddon Norfolk GB **101** R 25

Loftus Redcar & Cleveland GB **147** N 21

Logie of Coldstone Aberdeenshire GB **187** H 17

Login Carmarthenshire GB **86** T 13

Lombardstown Cork IRL **232** S 5

Lon. Colney Hertfordshire GB **71** T 22

London Greater London GB **71** T 22

Londonderry Londonderry GB **207** N 8

Long Buckby Northhamptonshire GB **100** S 20

Long Compton Warwickshire GB **70** T 19

Long Crendon Buckinghamshire GB **70** T 20

Long Eaton Derbyshire GB **100** R 20

Long Marston Warwickshire GB **100** S 19

Long Marston North Yorkshire GB **134** P 20

Long Marton Cumbria GB **146/147** N 17

Long Melford Suffolk GB **101** S 24

Long Preston North Yorkshire GB **147** O 18

Long Riston East Riding of Yorkshire GB **135** P 22

Long Stratton Norfolk GB **101** S 25

Long Sutton Lincolnshire GB **101** R 23

Long Sutton Somerset GB **53** U 17

Longbridge Deverill Wiltshire GB **70** U 18

Longdon Worcestershire GB **87** S 18

Longford Derbyshire GB **100** R 19

Longford Longford IRL **219** P 7

Longformacus Scottish Borders GB **161** L 18

Longframlington Northumberland GB **147** M 19

Longhirst Northumberland GB **147** M 19

Longhope Orkney Islands GB **198** E 16

Longhorsley Northumberland GB **147** M 19

Longhoughton Northumberland GB **147** M 19

Longmanhill Aberdeenshire GB **187** G 18

Longmorn Moray GB **187** G 16

Longney Gloucestershire GB **70** T 18

Longniddry East Lothian GB **161** L 17

Longnor Staffordshire GB **134** Q 19

Longridge Lancashire GB **119** P 17

Longridge West Lothian GB **160/161** L 15

Longside Aberdeenshire GB **187** G 19

Longton Lancashire GB **119** P 17

Longtown Cumbria GB **146/147** M 17

Longtown Herefordshire GB **87** T 17

Longwood Meath IRL **219** Q 9

Looe Cornwall GB **52/53** W 14

Loose Kent GB **71** U 24

Lorton Cumbria GB **146** N 16

Lossiemouth Moray GB **187** G 16

Lostwithiel Cornwall GB **52** W 13

Lothmore Highland GB **187** F 15

Loughanavally Offaly IRL **219** Q 7

Loughborough Leicestershire GB **100** R 20

Loughbrickland Down GB **207** O 10

Loughglinn Roscommon IRL **218** P 5

Loughrea Galway IRL **218** Q 5

Loughshinny Dublin IRL **219** P 10

Louisburgh Mayo IRL **218** P 3

Louth Lincolnshire GB **135** Q 23

Louth Louth IRL **219** P 9

Low Row Cumbria GB **146/147** N 17

Lowdham Nottinghamshire GB **134** Q 20

Lower Antrim GB **207** N 10

Lower Diabaig Highland GB **186** G 11

Lower Heyford Oxfordshire GB **70** T 20

Lower Higham Kent GB **71** U 23

Lower Killeyan Argyll and Bute GB **174** L 10

Lower Largo Fife GB **161** K 17

Lowestoft Suffolk GB **101** S 26

Loweswater Cumbria GB **146** N 16

Lowgill Cumbria GB **146/147** O 17
Lowick Northumberland GB **161** L 19
Lucan Dublin IRL **219** Q 10
Luccombe Somerset GB **53** U 15
Lucker Northumberland GB **161** L 19
Ludag Na h-Eileanan an Iar GB **175** H 8
Ludborough Lincolnshire GB **135** Q 22
Ludford Lincolnshire GB **135** Q 22
Ludgershall Wiltshire GB **70** U 19
Ludham Norfolk GB **101** R 26
Ludlow Shropshire GB **87** S 17
Lugar East Ayrshire GB **146** M 14
Lugton East Ayrshire GB **160** L 13
Luib Highland GB **175** H 10
Lumphanan Aberdeenshire GB **187** H 17
Lumsden Aberdeenshire GB **187** H 17
Lunan Angus GB **161** J 18
Lund East Riding of Yorkshire GB **134/135** P 21
Lundie Angus GB **161** J 16
Lunna Shetland Islands GB **199** B 20
Lunning Shetland Islands GB **199** B 20
Lurgan Down GB **207** O 10
Lusk Dublin IRL **219** P 10
Luss Argyll and Bute GB **160** K 13
Lusta Highland GB **175** G 9
Lustleigh Devon GB **53** V 15
Luthrie Fife GB **161** K 16
Luton Luton GB **71** T 22
Lutterworth Leicestershire GB **100** S 20
Lutton Northhamptonshire GB **100/101** S 22
Lutton Lincolnshire GB **101** R 23
Lutton Devon GB **53** W 15
Luxborough Somerset GB **53** U 16
Lybster Highland GB **187** F 16
Lydbury North Shropshire GB **87** S 17
Lydd Kent GB **71** V 24
Lydford Devon GB **52/53** V 14
Lydford Somerset GB **53** U 17
Lydham Shropshire GB **87** R 17
Lydlinch Dorset GB **70** V 18
Lydney Gloucestershire GB **87** T 17
Lyminge Kent GB **71** U 25
Lymington Hampshire GB **70** V 19
Lymm Warrington GB **134** Q 18
Lympne Kent GB **71** U 25
Lympstone Devon GB **53** V 16
Lyndhurst Hampshire GB **70** V 19
Lyneham Wiltshire GB **70** T 19
Lynemouth Northumberland GB **147** M 19
Lyness Orkney Islands GB **198** E 16
Lyng Norfolk GB **101** R 25
Lyng Somerset GB **53** U 17
Lynmouth Devon GB **53** U 15
Lynton Devon GB **53** U 15
Lytchett Matravers Dorset GB **70** V 18
Lytchett Minster Dorset GB **70** V 18

Lytham Lancashire GB **119** P 17
Lytham St. Anne's Lancashire GB **119** P 16
Lythe North Yorkshire GB **147** N 21

M

Maam Cross Galway IRL **218** Q 3
Maas Donegal IRL **206** N 6
Mablethorpe Lincolnshire GB **135** Q 23
Macclesfield Cheshire GB **134** Q 18
Macduff Aberdeenshire GB **187** G 17
Macharioch Argyll and Bute GB **174** M 11
Machrihanish Argyll and Bute GB **174** M 11
Machynlleth Powys GB **86/87** R 15
Macosquin Londonderry GB **207** M 9
Macroom Cork IRL **232** T 5
Madderty Perth and Kinross GB **160/161** K 15
Madeley Heath Staffordshire GB **134** Q 18
Madley Herefordshire GB **87** S 17
Maenclochog Pembrokeshire GB **86** T 13
Maentwrog Gwynedd GB **119** R 15
Maesteg Bridgend GB **86/87** T 15
Maganey Kildare IRL **233** R 9
Maghera Londonderry GB **207** N 9
Magherafelt Londonderry GB **207** N 9
Magheraveely Fermanagh GB **207** O 8
Maghull Sefton GB **119** P 17
Magor Monmouthshire GB **87** T 17
Maguiresbridge Fermanagh GB **207** O 8
Mahoonagh Limerick IRL **232** S 5
Maiden Bradley Wiltshire GB **70** U 18
Maiden Newton Dorset GB **53** V 17
Maidenhead Windsor & Maidenhead GB **70/71** T 21
Maidens South Ayrshire GB **146** M 13
Maidstone Kent GB **71** U 24
Malahide Dublin IRL **219** Q 10
Maldon Essex GB **71** T 24
Malham North Yorkshire GB **147** O 18
Malin Donegal IRL **207** M 8
Malin Beg Donegal IRL **206** N 5
Mallaig Highland GB **175** H 11
Mallaranny Mayo IRL **218** P 3
Mallow Mala Cork IRL **232** S 5
Mallwyd Gwynedd GB **119** R 15
Malmesbury Wiltshire GB **70** T 18
Malpas Cheshire GB **119** Q 17
Maltby Rotherham GB **134** Q 20
Maltby le Marsh Lincolnshire GB **135** Q 23
Malton North Yorkshire GB **134** O 21
Malzie Dumfries und Galloway GB **146** N 13
Manaccan Cornwall GB **52** W 12

Manafon Powys GB **87** R 16
Manais Na h-Eileanan an Iar GB **175** G 9
Manchester Manchester GB **134** Q 18
Manea Cambridgeshire GB **101** S 23
Mangotsfield Bristol GB **53** U 17
Manningtree Essex GB **71** T 25
Manorbier Pembrokeshire GB **86** T 13
Manorhamilton Leitrim IRL **206** O 6
Mansfield Nottinghamshire GB **134** Q 20
Mansfield Woodhouse Nottinghamshire GB **134** Q 20
Mantor Rutland GB **100** R 21
Marazion Cornwall GB **52** W 12
March Cambridgeshire GB **101** R 23
Marden Kent GB **71** U 24
Maresfield East Sussex GB **71** V 23
Margam Neath Port Talbot GB **86/87** T 15
Margate Kent GB **71** U 25
Marham Norfolk GB **101** R 24
Marhamchurch Cornwall GB **52** V 13
Marholm Peterborough GB **100/101** R 22
Mark Somerset GB **53** U 17
Market Bosworth Leicestershire GB **100** R 20
Market Deeping Lincolnshire GB **100/101** R 22
Market Drayton Shropshire GB **100** R 18
Market Harborough Leicestershire GB **100** R 21
Market Lavington Wiltshire GB **70** U 19
Market Rasen Lincolnshire GB **135** Q 22
Market Warsop Nottinghamshire GB **134** Q 20
Market Weighton East Riding of Yorkshire GB **134/135** P 21
Markethill Armagh GB **207** O 9
Markinch Fife GB **161** K 16
Marks Tey Essex GB **71** T 24
Marksbury Bath & NE Somerset GB **53** U 17
Marlborough Wiltshire GB **70** U 19
Marloes Pembrokeshire GB **86** T 12
Marlow Buckinghamshire GB **70/71** T 21
Marple Stockport GB **134** Q 18
Marsden Kirklees GB **134** P 19
Marsh Gibbon Buckinghamshire GB **70** T 20
Marshalstown Wexford IRL **233** R 9
Marshaw Lancashire GB **119** P 17
Marshchapel Lincolnshire GB **135** Q 23
Marshfield South Gloucestershire GB **70** U 18
Marshwood Dorset GB **53** V 17
Marske North Yorkshire GB **147** O 19
Marske-by-the-Sea Redcar & Cleveland GB **147** N 20

Marston Magna Somerset GB **53** U 17
Martham Norfolk GB **101** R 26
Martin Hampshire GB **70** V 19
Martinhoe Devon GB **53** U 15
Martlesham Suffolk GB **101** S 25
Martley Worcestershire GB **87** S 18
Martock Somerset GB **53** V 17
Marton Lincolnshire GB **134/135** Q 21
Marton North Yorkshire GB **147** O 20
Marwood Devon GB **52/53** U 14
Mary Tavy Devon GB **52/53** V 14
Marybank Highland GB **186** G 13
Marykirk Aberdeenshire GB **161** J 18
Marypark Moray GB **187** H 16
Maryport Cumbria GB **146** N 15
Marywell Aberdeenshire GB **187** H 17
Masham North Yorkshire GB **147** O 19
Matfen Northumberland GB **147** M 19
Mathry Pembrokeshire GB **86** T 12
Matlaske Norfolk GB **101** R 25
Matlock Derbyshire GB **134** Q 19
Mauchline East Ayrshire GB **160** L 14
Maud Aberdeenshire GB **187** G 18
Maughold Isle of Man GB **146** O 14
Maum Galway IRL **218** P 3
Maumtrasna Mayo IRL **218** P 3
Mawbray Cumbria GB **146** N 16
Mawnan Cornwall GB **52** W 12
Maxton Scottish Borders GB **161** L 17
Maybole South Ayrshire GB **146** M 13
Mayfield Staffordshire GB **134** Q 19
Mayfield East Sussex GB **71** U 23
Maynooth Kildare IRL **219** Q 9
Mayobridge Down GB **207** O 10
Mealsgate Cumbria GB **146** N 16
Meanus Limerick IRL **232** R 5
Meare Somerset GB **53** U 17
Mearns East Renfrewshire GB **160** L 14
Mears Ashby Northhamptonshire GB **100** S 21
Measham Leicestershire GB **100** R 19
Medbourne Leicestershire GB **100** R 21
Medstead Hampshire GB **70** U 20
Meenlaragh Donegal IRL **206** M 6
Meidrim Carmarthenshire GB **86** T 13
Meifod Powys GB **87** R 16
Meigle Perth and Kinross GB **161** J 16
Meikle Aberdeenshire GB **187** H 18
Meikleour Perth and Kinross GB **161** J 16
Melbourn Cambridgeshire GB **101** S 23
Melbourne Derbyshire GB **100** R 20
Meldon Northumberland GB **147** M 19

Meldreth Cambridgeshire GB **101** S 23
Melgarve Highland GB **160** H 13
Melin-y-ddol Powys GB **87** R 16
Melksham Wiltshire GB **70** U 18
Melling Lancashire GB **146/147** O 17
Mellis Suffolk GB **101** S 25
Mellon Charles Highland GB **186** G 11
Mellon Udrigle Highland GB **186** G 11
Mells Somerset GB **70** U 18
Melmerby Cumbria GB **146/147** N 17
Melrose Scottish Borders GB **161** L 17
Meltham Kirklees GB **134** P 19
Melton Constable Norfolk GB **101** R 25
Melton Mowbray Leicestershire GB **100** R 21
Melvaig Highland GB **186** G 11
Melvich Highland GB **198** E 15
Memsie Aberdeenshire GB **187** G 18
Menai Bridge Anglesey GB **118/119** Q 14
Mendlesham Suffolk GB **101** S 25
Menlough Galway IRL **218** Q 5
Mennock Dumfries und Galloway GB **146** M 15
Menston Bradford GB **134** P 19
Mentmore Buckinghamshire GB **70/71** T 21
Meonstoke Hampshire GB **70** V 20
Meopham Kent GB **71** U 23
Mepal Cambridgeshire GB **101** S 23
Mere Wiltshire GB **70** U 18
Mereworth Kent GB **71** U 23
Meriden Solihull GB **100** S 19
Merriott Somerset GB **53** V 17
Merthyr Cynog Powys GB **87** S 16
Merthyr Tydfil Merthyr Tydfil GB **87** T 16
Merton Devon GB **52/53** V 14
Merton Greater London GB **71** U 22
Meshaw Devon GB **53** V 15
Messingham North Lincolnshire GB **134/135** P 21
Metfield Suffolk GB **101** S 25
Metheringham Lincolnshire GB **135** Q 22
Methil Fife GB **161** K 16
Methlick Aberdeenshire GB **187** H 18
Methven Perth and Kinross GB **160/161** K 15
Methwold Norfolk GB **101** R 24
Mevagissey Cornwall GB **52** W 13
Mey Highland GB **198** E 16
Miabhaig Na h-Eileanan an Iar GB **175** F 9
Miabhaig Na h-Eileanan an Iar GB **175** G 9
Michaelchurch Escley Herefordshire GB **87** T 16
Mickleton Gloucestershire GB **100** S 19
Mickley North Yorkshire GB **147** O 19

Mid Calder West Lothian GB **161** L 16

Mid Yell Shetland Islands GB **199** A 20

Midbea Orkney Islands GB **198** D 17

Middle Barton Oxfordshire GB **70** T 20

Middle Tysoe Warwickshire GB **100** S 19

Middle Wallop Hampshire GB **70** U 19

Middlebie Dumfries und Galloway GB **146** M 16

Middleham North Yorkshire GB **147** O 19

Middlesbrough Middlesbrough GB **147** N 20

Middlesmoor North Yorkshire GB **147** O 19

Middleton Norfolk GB **101** R 23

Middleton Oldham GB **134** P 18

Middleton Cumbria GB **146/147** O 17

Middleton Northumberland GB **161** L 18

Middleton Argyll and Bute GB **174** K 9

Middleton Cheney Northhamptonshire GB **100** S 20

Middleton-in-Teesdale Durham GB **147** N 18

Middleton-on-the-Wolds East Riding of Yorkshire GB **134/135** P 21

Middletown Armagh GB **207** O 9

Middletown Powys GB **87** R 16

Middlewich Cheshire GB **134** Q 18

Midhurst West Sussex GB **70/71** V 21

Midlem Scottish Borders GB **161** L 17

Midleton Cork IRL **232/233** T 6

Midsomer Norton Bath & NE Somerset GB **70** U 18

Midtown Highland GB **186** G 11

Migvie Aberdeenshire GB **187** H 17

Milborne Port Somerset GB **70** V 18

Milbourne Northumberland GB **147** M 19

Milburn Cumbria GB **146/147** N 17

Mildenhall Suffolk GB **101** S 24

Milestone Tipperary IRL **232/233** R 6

Milfield Northumberland GB **161** L 18

Milford Cork IRL **232** S 5

Milford Haven Aberdaugleddau Pembrokeshire GB **86** T 12

Milford on Sea Hampshire GB **70** V 19

Millbrook Cornwall GB **52/53** W 14

Millford Donegal IRL **206** M 7

Millhouse Argyll and Bute GB **160** L 12

Millington East Riding of Yorkshire GB **134/135** P 21

Millisle Down GB **207** N 11

Millom Cumbria GB **146** O 16

Millport North Ayrshire GB **160** L 13

Mills Antrim GB **207** N 10

Millstreet Cork IRL **232** S 4

Milltown Dumfries und Galloway GB **146** M 16

Milltown Galway IRL **218** P 5

Milltown Kerry IRL **232** S 3

Milltown Malbay Clare IRL **232** R 4

Milltown of Rothiemay Aberdeenshire GB **187** G 17

Milnathort Perth and Kinross GB **161** K 16

Milngavie East Dunbartonshire GB **160** L 14

Milnthorpe Cumbria GB **146/147** O 17

Milovaig Highland GB **175** H 9

Milton Highland GB **186** G 13

Milton Highland GB **186** H 13

Milton Highland GB **186/187** G 14

Milton Abbas Dorset GB **70** V 18

Milton Abbot Devon GB **52/53** V 14

Milton Bryan Bedfordshire GB **70/71** T 21

Milton Ernest Bedfordshire GB **100** S 21

Milton Keynes Milton Keynes GB **100** S 21

Minard Argyll and Bute GB **160** K 12

Minchinhampton Gloucestershire GB **70** T 18

Minehead Somerset GB **53** U 16

Minety Wiltshire GB **70** T 19

Minnigaff Dumfries und Galloway GB **146** N 14

Minskip North Yorkshire GB **147** O 20

Minstead Hampshire GB **70** V 19

Minster Kent GB **71** U 24

Minster Kent GB **71** U 25

Minsterley Shropshire GB **87** R 17

Mintlaw Aberdeenshire GB **187** G 18

Minto Scottish Borders GB **146/147** M 17

Mirfield Kirklees GB **134** P 19

Misson Nottinghamshire GB **134/135** Q 21

Misterton Nottinghamshire GB **134/135** Q 21

Mistley Essex GB **71** T 25

Mitcheldean Gloucestershire GB **70** T 18

Mitchelstown Cork IRL **232/233** S 6

Mitford Northumberland GB **147** M 19

Moate Westmeath IRL **219** Q 7

Mochrum Dumfries und Galloway GB **146** N 13

Modbury Devon GB **53** W 15

Moelfre Anglesey GB **118/119** Q 14

Moffat Dumfries und Galloway GB **146** M 16

Mohill Leitrim IRL **219** P 7

Moira Down GB **207** O 10

Mold Yr Wyddgrug Flintshire GB **119** Q 16

Monaghan Muineachán Monaghan IRL **207** O 9

Monamolin Wexford IRL **233** R 10

Monasteraden Sligo IRL **218** P 5

Monasterevin Kildare IRL **219** Q 8

Moneygall Offaly IRL **233** R 7

Moneymore Londonderry GB **207** N 9

Moneyslane Down GB **207** O 10

Moniaive Dumfries und Galloway GB **146** M 15

Monimail Fife GB **161** K 16

Monivea Galway IRL **218** Q 5

Monkland Herefordshire GB **87** S 17

Monksilver Somerset GB **53** U 16

Monmouth Trefynwy Monmouthshire GB **87** T 17

Monreith Dumfries und Galloway GB **146** N 13

Montacute Somerset GB **53** V 17

Montain Ash Rhondda Cynon Taff GB **87** T 16

Montgomery Powys GB **119** R 16

Montpelier Limerick IRL **232** R 5

Montrose Angus GB **161** J 18

Monzie Perth and Kinross GB **160/161** K 15

Moorfields Antrim GB **207** N 10

Moorlinch Somerset GB **53** U 17

Morchard Bishop Devon GB **53** V 15

Mordiford Herefordshire GB **87** S 17

Morebath Devon GB **53** U 16

Morebattle Scottish Borders GB **161** L 18

Morecambe Lancashire GB **146/147** O 17

Moreton Dorset GB **70** V 18

Moreton Essex GB **71** T 23

Moretonhampstead Devon GB **53** V 15

Morland Cumbria GB **146/147** N 17

Morley Leeds GB **134** P 19

Mornymusk Aberdeenshire GB **187** H 17

Moroe Limerick IRL **232/233** R 6

Morpeth Northumberland GB **147** M 19

Mortehoe Devon GB **52/53** U 14

Mortimer´s Cross Herefordshire GB **87** S 17

Morton Lincolnshire GB **100/101** R 22

Morvich Highland GB **186** H 12

Morville Shropshire GB **100** R 18

Morwenstow Cornwall GB **52** V 13

Mosedale Cumbria GB **146** N 16

Mosstodloch Moray GB **187** G 16

Mostyn Flintshire GB **119** Q 16

Motherwell North Lanarkshire GB **160/161** L 15

Moulton Northhamptonshire GB **100** S 21

Moulton Lincolnshire GB **100/101** R 22

Moulton Suffolk GB **101** S 24

Moulton North Yorkshire GB **147** O 19

Mount Bellew Bridge Galway IRL **218** Q 5

Mountcharles Donegal IRL **206** N 6

Mountfield Tyrone GB **207** N 8

Mountmellick Laois IRL **219** Q 8

Mountnorris Armagh GB **207** O 10

Mountrath Laois IRL **219** Q 8

Mountshannon Clare IRL **232/233** R 6

Mountsorrel Leicestershire GB **100** R 20

Mousehole Cornwall GB **52** W 11

Mouswald Dumfries und Galloway GB **146** M 16

Moville Donegal IRL **207** M 8

Mow Cop Cheshire GB **134** Q 18

Moy Armagh GB **207** O 9

Moy Lodge Highland GB **160** J 13

Moyard Galway IRL **218** P 2

Moyasta Clare IRL **232** R 3

Moycullen Galway IRL **218** Q 4

Moylgrove Pembrokeshire GB **86** S 13

Moylough Galway IRL **218** Q 5

Moynalty Meath IRL **219** P 9

Moyne Longford IRL **219** P 7

Moyvore Westmeath IRL **219** P 7

Muasdale Argyll and Bute GB **174** L 11

Much Hadham Hertfordshire GB **71** T 23

Much Marcle Herefordshire GB **70** T 18

Much Wenlock Shropshire GB **87** R 17

Muchalls Aberdeenshire GB **161** H 18

Muff Donegal IRL **207** M 8

Muie Highland GB **186/187** F 14

Muir of Ord Highland GB **186/187** G 14

Muirdrum Angus GB **161** J 18

Muirhead Angus GB **161** K 16

Muirkirk East Ayrshire GB **160** L 14

Muirton Perth and Kinross GB **160/161** K 15

Muker North Yorkshire GB **147** O 18

Mullagh Cavan IRL **219** P 9

Mullagh Meath IRL **219** Q 9

Mullaghboy Antrim GB **207** N 11

Mullaghmore Sligo IRL **206** O 6

Mullany's Cross Sligo IRL **206** O 5

Mullinahone Tipperary IRL **233** R 8

Mullinavat Kilkenny IRL **233** S 8

Mullingar An Muileann gCearr Westmeath IRL **219** P 8

Mullion Cornwall GB **52** W 12

Multyfarnham Westmeath IRL **219** P 8

Mundesley Norfolk GB **101** R 25

Mundford Norfolk GB **101** R 24

Munlochy Highland GB **186/187** G 14

Murrisk Mayo IRL **218** P 3

Murrow Cambridgeshire GB **101** R 23

Murton Cumbria GB **147** N 18

Murton Durham GB **147** N 20

Musbury Devon GB **53** V 16

Musselburgh East Lothian GB **161** L 16

Muthill Perth and Kinross GB **160/161** K 15

Mybster Highland GB **187** F 16

Myddfai Carmarthenshire GB **86/87** T 15

Myddle Shropshire GB **119** R 17

Mydroilyn Ceredigion GB **86** S 14

Myshall Carlow IRL **233** R 9

N

Na Gearrannan Na h-Eileanan an Iar GB **175** F 9

Naas An Nás Kildare IRL **219** Q 9

Naburn York GB **134** P 20

Nacton Suffolk GB **101** S 25

Nafferton East Riding of Yorkshire GB **135** O 22

Nailsea North Somerset GB **53** U 17

Nailsworth Gloucestershire GB **70** T 18

Nairn Highland GB **187** G 15

Nant y-moel Bridgend GB **86/87** T 15

Nantmel Powys GB **87** S 16

Nantwich Cheshire GB **119** Q 17

Nantyffyllon Bridgend GB **86/87** T 15

Naran Donegal IRL **206** N 6

Narberth Pembrokeshire GB **86** T 13

Narborough Leicestershire GB **100** R 20

Narborough Norfolk GB **101** R 24

Naseby Northhamptonshire GB **100** S 21

Nateby Cumbria GB **147** O 18

Naul Dublin IRL **219** P 10

Navan An Uaimh Meath IRL **219** P 9

Navenby Lincolnshire GB **134/135** Q 21

Nazeing Essex GB **71** T 23

Neale Mayo IRL **218** P 4

Neap Shetland Islands GB **199** B 20

Neath Neath Port Talbot GB **86/87** T 15

Necton Norfolk GB **101** R 24

Needham Market Suffolk GB **101** S 25

Nefyn Gwynedd GB **118** R 13

Neilston East Renfrewshire GB **160** L 14

Nelson Lancashire GB **134** P 18

Nenagh Tipperary IRL **232/233** R 6

Nenthead Cumbria GB **147** N 18

Nesscliffe Shropshire GB **119** R 17

Neston Cheshire GB **119** Q 16

Nether Stowey Somerset GB **53** U 16

Nether Wasdale Cumbria GB **146** O 16

Netheravon Wiltshire GB **70** U 19

Netherton Northumberland GB **147** M 19

Netherwitton Northumberland GB **147** M 19

Nethy Bridge Highland GB **187** H 15

Nettlebed Oxfordshire GB **70/71** T 21

Nettleham Lincolnshire GB **135** Q 22

New Abbey Dumfries und Galloway GB **146** N 15

New Aberdour Aberdeenshire GB **187** G 18

New Addington Greater London GB **71** U 22

New Alresford Hampshire GB **70** U 20

New Buckenham Norfolk GB **101** S 25

New Buildings Londonderry GB **207** N 8

New Byth Aberdeenshire GB **187** G 18

New Cumnock East Ayrshire GB **146** M 14

New Deer Aberdeenshire GB **187** G 18

New Galloway Dumfries und Galloway GB **146** M 14

New Holland North Lincolnshire GB **135** P 22

New Inn Galway IRL **218/219** Q 6

New Inn Cavan IRL **219** P 8

New Kildimo Limerick IRL **232** R 5

New Leeds Aberdeenshire GB **187** G 18

New Luce Dumfries und Galloway GB **146** N 13

New Mills Derbyshire GB **134** Q 19

New Milton Hampshire GB **70** V 19

New Pallas Green Limerick IRL **232/233** R 6

New Pitsligo Aberdeenshire GB **187** G 18

New Quay Ceredigion GB **86** S 14

New Radnor Powys GB **87** S 16

New Romney Kent GB **71** V 24

New Ross Ross Mhic Thriúin Wexford IRL **233** S 9

New Scone Perth and Kinross GB **161** K 16

New Twopothouse Village Cork IRL **232** S 5

Newark-on-Trent Nottinghamshire GB **134/135** Q 21

Newbiggin Durham GB **147** N 18

Newbiggin-by-the-Sea Northumberland GB **147** M 20

Newbigging South Lanarkshire GB **160/161** L 15

Newbliss Monaghan IRL **207** O 8

Newbridge Galway IRL **218/219** P 6

Newbridge Droichead Nua Kildare IRL **219** Q 9

Newbridge Caerphilly GB **87** T 16

Newbridge on-Wye Powys GB **87** S 16

Newburgh Fife GB **161** K 16

Newburgh Aberdeenshire GB **187** H 19

Newbury West Berkshire GB **70** U 20

Newby Cumbria GB **146/147** N 17

Newby Bridge Cumbria GB **146/147** O 17

Newcastle Down GB **207** O 11

Newcastle Wicklow IRL **219** Q 10

Newcastle Tipperary IRL **233** S 7

Newcastle Shropshire GB **87** S 16

Newcastle Emlyn Carmarthenshire GB **86** S 14

Newcastle upon Tyne Newcastle upon Tyne GB **147** N 19

Newcastle West Limerick IRL **232** S 4

Newcastleton or Copshaw Holm Scottish Borders GB **146/147** M 17

Newcastle-under-Lyme Staffordshire GB **134** Q 18

Newchurch Powys GB **87** S 16

Newent Gloucestershire GB **70** T 18

Newham Northumberland GB **161** L 19

Newhaven East Sussex GB **71** V 23

Newick East Sussex GB **71** V 22

Newington Kent GB **71** U 24

Newinn Tipperary IRL **233** S 7

Newlot Orkney Islands GB **198** D 17

Newlyn Cornwall GB **52** W 11

Newmachar Aberdeenshire GB **187** H 18

Newmains North Lanarkshire GB **160/161** L 15

Newmarket Suffolk GB **101** S 23

Newmarket Na h-Eileanan an Iar GB **186** F 10

Newmarket Cork IRL **232** S 4

Newmarket on Fergus Clare IRL **232** R 5

Newmill Scottish Borders GB **146/147** M 17

Newmilns East Ayrshire GB **160** L 14

Newport Shropshire GB **100** R 18

Newport Telford and Wrekin GB **100** R 18

Newport Mayo IRL **218** P 3

Newport Tipperary IRL **232/233** R 6

Newport Isle of Wight GB **70** V 20

Newport Essex GB **71** T 23

Newport Pembrokeshire GB **86** S 13

Newport Casnewydd Newport GB **87** T 17

Newport Pagnell Milton Keynes GB **100** S 21

Newport Trench Tyrone GB **207** N 9

Newport-on-Tay Fife GB **161** K 17

Newquay Cornwall GB **52** W 12

Newry Down GB **207** O 10

Newton Lancashire GB **134** P 18

Newton Dumfries und Galloway GB **146** M 16

Newton Cumbria GB **146** N 16

Newton Argyll and Bute GB **160** K 12

Newton East Renfrewshire GB **160** L 14

Newton Pembrokeshire GB **86** T 12

Newton Abbot Devon GB **53** V 15

Newton Aycliffe Durham GB **147** N 19

Newton Ferrers Devon GB **52/53** W 14

Newton Flotman Norfolk GB **101** R 25

Newton on Trent Lincolnshire GB **134/135** Q 21

Newton on-the-Moor Northumberland GB **147** M 19

Newton Poppleford Devon GB **53** V 16

Newton Reigny Cumbria GB **146/147** N 17

Newton Stewart Dumfries und Galloway GB **146** N 13

Newton Tracey Devon GB **52/53** U 14

Newtongrange Midlothian GB **161** L 16

Newtonhill Aberdeenshire GB **161** H 18

Newton-le-Willows St Helens GB **119** Q 17

Newtonmore Highland GB **187** H 14

Newton-on-Ouse North Yorkshire GB **147** O 20

Newton-on-Rawcliffe North Yorkshire GB **134** O 21

Newtown Wicklow IRL **219** Q 10

Newtown Laois IRL **233** R 8

Newtown Y Drenewydd Powys GB **87** R 16

Newtown Cunningham Donegal IRL **206** N 7

Newtown Forbes Longford IRL **219** P 7

Newtown Gore Leitrim IRL **206** O 7

Newtownabbey Antrim GB **207** N 11

Newtownards Down GB **207** N 11

Newtownbutler Fermanagh GB **207** O 8

Newtown-Crommelin Antrim GB **207** M 10

Newtownhamilton Armagh GB **207** O 9

Newtownsands Kerry IRL **232** R 4

Newtownstewart Tyrone GB **207** N 8

Newtyle Angus GB **161** J 16

Neyland Pembrokeshire GB **86** T 13

Nigg Highland GB **186/187** G 14

Ninemilehouse Tipperary IRL **233** S 8

Ninfield East Sussex GB **71** V 23

Nisbet Scottish Borders GB **161** L 17

Niwbwrch Anglesey GB **118/119** Q 14

Nobber Meath IRL **219** P 9

Nohaval Cork IRL **232/233** T 6

Nolton Pembrokeshire GB **86** T 12

Norham Northumberland GB **161** L 18

Normanby North Yorkshire GB **134** O 21

Normanton Wakefield GB **134** P 20

North Ballachulish Highland GB **160** J 12

North Berwick East Lothian GB **161** K 17

North Brentor Devon GB **52/53** V 14

North Cave East Riding of Yorkshire GB **134/135** P 21

North Cerney Gloucestershire GB **70** T 19

North Charlton Northumberland GB **161** L 19

North Collafirth Shetland Islands GB **199** A 20

North Crawley Milton Keynes GB **100** S 21

North Creake Norfolk GB **101** R 24

North Curry Somerset GB **53** U 17

North Dalton East Riding of Yorkshire GB **134/135** P 21

North Elmham Norfolk GB **101** R 24

North Frodingham East Riding of Yorkshire GB **135** P 22

North Grimston North Yorkshire GB **134** O 21

North Hill Cornwall GB **52/53** V 14

North Hykeham Lincolnshire GB **134/135** Q 21

North Kessock Highland GB **186/187** G 14

North Kilworth Leicestershire GB **100** S 20

North Kyme Lincolnshire GB **135** Q 22

North Leverton Nottinghamshire GB **134/135** Q 21

North Luffenham Rutland GB **100** R 21

North Marston Buckinghamshire GB **70/71** T 21

North Molton Devon GB **53** U 15

North Newbald East Riding of Yorkshire GB **134/135** P 21

North Nibley Gloucestershire GB **70** T 18

North Petherton Somerset GB **53** U 16

North Queensferry Fife GB **161** K 16

North Roe Shetland Islands GB **199** A 20

North Scarle Lincolnshire GB **134/135** Q 21

North Sunderland Northumberland GB **161** L 19

North Tamerton Cornwall GB **52/53** V 14

North Tawton Devon GB **53** V 15

North Thoresby Lincolnshire GB **135** Q 22

North Walsham Norfolk GB **101** R 25

North Wheatley Nottinghamshire GB **134/135** Q 21

North Wootton Somerset GB **53** U 17

Northallerton North Yorkshire GB **147** O 20

Northam Devon GB **52/53** U 14

Northampton Northhamptonshire GB **100** S 21

Northchapel West Sussex GB **70/71** U 21

Northiam East Sussex GB **71** V 24

Northleach Gloucestershire GB **70** T 19

Northleigh Devon GB **53** V 16

Northlew Devon GB **52/53** V 14

Northmuir Angus GB **161** J 16

Northpunds Shetland Islands GB **199** C 20

Northwall Orkney Islands GB **198** D 18

Northwich Cheshire GB **119** Q 17

Northwold Norfolk GB **101** R 24

Northwood Shropshire GB **119** R 17

Norton Gloucestershire GB **70** T 18

Norton Oxfordshire GB **70** T 20

Norton Powys GB **87** S 16

Norton Fitzwarren Somerset GB **53** U 16

Norton St. Philip Somerset GB **70** U 18

Norton-on-Dervent North Yorkshire GB **134** O 21

Norwich Norfolk GB **101** R 25

Norwick Shetland Islands GB **199** A 21

Nottingham Nottingham GB **100** R 20

Nuneaton Warwickshire GB **100** R 20

Nunney Somerset GB **70** U 18

Nunnington North Yorkshire GB **147** O 20

Nybster Highland GB **198** E 16

O

Oadby Leicestershire GB **100** R 20

Oakford Devon GB **53** V 15

Oakham Rutland GB **100** R 21

Oakington Cambridgeshire GB **101** S 23

Oakley Buckinghamshire GB **70** T 20

Oakworth Bradford GB **134** P 19

Oban Argyll and Bute GB **160** K 12

O'Briensbridge Clare IRL **232** R 5

O'Callaghansmills Clare IRL **232** R 5

Ochiltree East Ayrshire GB **146** M 14

Ockle Highland GB **174** J 11

Ockley Surrey GB **71** U 22

Odiham Hampshire GB **70/71** U 21

of Rayne Aberdeenshire GB **187** H 18

Offord D´Arcy Cambridgeshire GB **100/101** S 22

Offton Suffolk GB **101** S 25

Ogle Northumberland GB **147** M 19

Ogonnelloe Clare IRL **232/233** R 6

Oilgate Wexford IRL **233** S 9

Okehampton Devon GB **52/53** V 14

Old Bolingbroke Lincolnshire GB **135** Q 23

Old Deer Aberdeenshire GB **187** G 18

Old Fletton Peterborough GB **100/101** R 22

Old Town Cumbria GB **146/147** O 17

Old Town Isles of Scilly GB **52** X 10

Oldcastle Meath IRL **219** P 8

Oldham Oldham GB **134** P 18

Oldhamstocks East Lothian GB **161** L 18

Oldland South Gloucestershire GB **70** U 18

Oldmeldrum Aberdeenshire GB **187** H 18

Oldshoremore Highland GB **186** F 12

Olgrinmore Highland GB **187** F 15

Ollaberry Shetland Islands GB **199** A 20

Ollach Highland GB **175** H 10

Ollerton Nottinghamshire GB **134** Q 20

Olney Milton Keynes GB **100** S 21

Omagh Tyrone GB **207** N 8

Ombersley Worcestershire GB **87** S 18

Omeath Louth IRL **207** O 10

Onchan Isle of Man GB **146** O 14

Onich Highland GB **160** J 12

Oranmore Galway IRL **218** Q 5

Orford Suffolk GB **101** S 26

Orleton Herefordshire GB **87** S 17

Ormesby St Margaret Norfolk GB **101** R 26

Ormskirk Lancashire GB **119** P 17

Orpington Greater London GB **71** U 23

Orsett Thurrock GB **71** T 23

Orston Nottinghamshire GB **100** R 21

Orton Cumbria GB **146/147** O 17

Orwell Cambridgeshire GB **101** S 23

Osbournby Lincolnshire GB **100/101** R 22

Oskamull Argyll and Bute GB **174** K 10

Osmington Dorset GB **70** V 18

Osmotherley North Yorkshire GB **147** O 20

Ossett Wakefield GB **134** P 19

Oswaldtwistle Lancashire GB **134** P 18

Oswestry Shropshire GB **119** R 16

Othery Somerset GB **53** U 17

Otley Suffolk GB **101** S 25

Otley Leeds GB **134** P 19

Otter Ferry Argyll and Bute GB **160** K 12

Otterburn Northumberland GB **147** M 18

Otterswick Shetland Islands GB **199** A 20

Otterton Devon GB **53** V 16

Ottery St Mary Devon GB **53** V 16

Ottringham East Riding of Yorkshire GB **135** P 22

Oughterard Galway IRL **218** Q 4

Oulart Wexford IRL **233** R 10

Oulton Cumbria GB **146** N 16

Oundle Northhamptonshire GB **100/101** S 22

Outwell Norfolk GB **101** R 23

Outwood Surrey GB **71** U 22

Ovens Cork IRL **232** T 5

Over Kellet Lancashire GB **146/147** O 17

Overbister Orkney Islands GB **198** D 17

Overseal Derbyshire GB **100** R 19

Overstrand Norfolk GB **101** R 25

Overton Wrexham GB **119** R 17

Overton Lancashire GB **146/147** O 17

Overton Hampshire GB **70** U 20

Owston Ferry North Lincolnshire GB **134/135** Q 21

Oxborough Norfolk GB **101** R 24

Oxenhope Bradford GB **134** P 19

Oxford Oxfordshire GB **70** T 20

Oxnam Scottish Borders GB **147** M 18

Oxted Surrey GB **71** U 23

Oxton Nottinghamshire GB **134** Q 20

Oxton Scottish Borders GB **161** L 17

Oykel Bridge Highland GB **186** G 13

Oyne Aberdeenshire GB **187** H 17

P

Pabail Iarach Na h-Eileanan an Iar GB **186** F 10

Padbury Buckinghamshire GB **70/71** T 21

Paddock Wood Kent GB **71** U 23

Padiham Lancashire GB **134** P 18

Padstow Cornwall GB **52** V 13

Pagham West Sussex GB **70/71** V 21

Paignton Torbay GB **53** W 15

Pailton Warwickshire GB **100** S 20

Painscastle Powys GB **87** S 16

Painswick Gloucestershire GB **70** T 18

Paisley Renfrewshire GB **160** L 14

Pallas Green Limerick IRL **232/233** R 6

Pallaskenry Limerick IRL **232** R 5

Palnackie Dumfries und Galloway GB **146** N 15

Palnure Dumfries und Galloway GB **146** N 14

Pandy Monmouthshire GB **87** T 17

Pangbourne West Berkshire GB **70** U 20

Pant Shropshire GB **87** R 16

Pant Glas Gwynedd GB **118/119** Q 14

Papworth Everard Cambridgeshire GB **100/101** S 22

Parbold Lancashire GB **119** P 17

Park Londonderry GB **207** N 8

Parkend Gloucestershire GB **87** T 17

Parkgate Dumfries und Galloway GB **146** M 15

Parknasilla Kerry IRL **232** T 3

Parracombe Devon GB **53** U 15

Partney Lincolnshire GB **135** Q 23

Parton Dumfries und Galloway GB **146** M 14

Parton Cumbria GB **146** N 15

Partry Mayo IRL **218** P 4

Parwich Derbyshire GB **134** Q 19

Passage East Waterford IRL **233** S 9

Passage West Cork IRL **232/233** T 6

Pateley Bridge North Yorkshire GB **147** O 19

Path of Condie Perth and Kinross GB **160/161** K 15

Pathhead Midlothian GB **161** L 17

Patna East Ayrshire GB **146** M 14

Patrick North Yorkshire GB **147** O 19

Patrikswell Limerick IRL **232** R 5

Patrington East Riding of Yorkshire GB **135** P 23

Patterdale Cumbria GB **146/147** N 17

Paxton Scottish Borders GB **161** L 18

Peacehaven East Sussex GB **71** V 23

Peak Forest Derbyshire GB **134** Q 19

Peakirk Peterborough GB **100/101** R 22

Peasenhall Suffolk GB **101** S 25

Peasmarsh East Sussex GB **71** V 24

Peat Inn Fife GB **161** K 17

Peebles Scottish Borders GB **161** L 16

Peel Isle of Man GB **146** O 13

Peinchorran Highland GB **175** H 10

Pelton Durham GB **147** N 19

Pembrey Carmarthenshire GB **86** T 14

Pembridge Herefordshire GB **87** S 17

Pembroke Pembrokeshire GB **86** T 13

Pembroke Dock Doc Penfro Pembrokeshire GB **86** T 13

Penarth Vale of Glamorgan GB **53** U 16

Pencaitland East Lothian GB **161** L 17

Pencoed Bridgend GB **86/87** T 15

Pendeen Cornwall GB **52** W 11

Penderyn Rhondda Cynon Taff GB **86/87** T 15

Pendine Carmarthenshire GB **86** T 13

Penicuik Midlothian GB **161** L 16

Penistone Barnsley GB **134** P 19

Penkridge Staffordshire GB **100** R 18

Penley Wrexham GB **119** R 17

Penmachno Conwy GB **119** Q 15

Penmaenmawr Conwy GB **119** Q 15

Pennal Gwynedd GB **86/87** R 15

Pennan Aberdeenshire GB **187** G 18

Penpont Dumfries und Galloway GB **146** M 15

Penrhyn-deudraeth Gwynedd GB **118/119** R 14

Penrith Cumbria GB **146/147** N 17

Penruddock Cumbria GB **146/147** N 17

Penryn Cornwall GB **52** W 12

Pensford Bath & NE Somerset GB **53** U 17

Penshurst Kent GB **71** U 23

Pensilva Cornwall GB **52/53** W 14

Pentraeth Anglesey GB **118/119** Q 14

Pentrefoelas Conwy GB **119** Q 15

Penybont Powys GB **87** S 16

Penygroes Gwynedd GB **118/119** Q 14

Peny-y-Bont Ar Ogwr Bridgend Bridgend GB **53** U 15

Penzance Cornwall GB **52** W 11

Perranporth Cornwall GB **52** W 12

Pershore Worcestershire GB **87** S 18

Perth Perth and Kinross GB **161** K 16

Peterborough Peterborough GB **100/101** R 22

Peterculter Aberdeenshire GB **187** H 18

Peterhead Aberdeenshire GB **187** G 19

Peterlee Durham GB **147** N 20

Petersfield Hampshire GB **70/71** V 21

Peterstow Herefordshire GB **87** T 17

Petham Kent GB **71** U 25

Petworth West Sussex GB **70/71** V 21

Pevensey East Sussex GB **71** V 23

Pewsey Wiltshire GB **70** U 19

Pickering North Yorkshire GB **134** O 21

Piddletrenthide Dorset GB **70** V 18

Piercetown Wexford IRL **233** S 10

Pierowall Orkney Islands GB **198** D 17

Pilling Lancashire GB **119** P 17

Pilton Somerset GB **53** U 17

Pinchbeck Lincolnshire GB **100/101** R 22

Pinchbeck West Lincolnshire GB **100/101** R 22

Pinwherry South Ayrshire GB **146** M 13

Pirbright Surrey GB **70/71** U 21

Pirnmill North Ayrshire GB **160** L 12

Pitcox East Lothian GB **161** L 17

Pitenweem Fife GB **161** K 17

Pitlochry Perth and Kinross GB **160/161** J 15

Pitmedden Aberdeenshire GB **187** H 18

Pitscottie Fife GB **161** K 17

Pittentrail Highland GB **186/187** G 14

Pittington Durham GB **147** N 19

Plean Stirling GB **160/161** K 15

Pleasley Nottinghamshire GB **134** Q 20

Plenmeller Northumberland GB **147** N 18

Plockton Highland GB **175** H 11

Pluckley Kent GB **71** U 24

Plumbland Cumbria GB **146** N 16

Plumbridge Tyrone GB **207** N 8

Plumpton Cumbria GB **146/147** N 17

Plymouth Plymouth GB **52/53** W 14

Plympton Plymouth GB **52/53** W 14

Pocklington East Riding of Yorkshire GB **134/135** P 21

Point Donegal IRL **207** M 8

Polbain Highland GB **186** F 12

Polbathic Cornwall GB **52/53** W 14

Polegate East Sussex GB **71** V 23

Polesworth Warwickshire GB **100** R 19

Pollatomish Mayo IRL **218** O 3

Polmont Falkirk GB **160/161** L 15

Polperro Cornwall GB **52** W 13

Polruan Cornwall GB **52** W 13

Polwarth Scottish Borders GB **161** L 18

Polzeath Cornwall GB **52** V 13

Pomeroy Tyrone GB **207** N 9

Pontardawe Neath Port Talbot GB **86/87** T 15

Pontardulais Swansea GB **86** T 14

Pontefract Wakefield GB **134** P 20

Ponteland Northumberland GB **147** M 19

Ponterwyd Ceredigion GB **86/87** S 15

Pontesbury Shropshire GB **87** R 17

Pontllanfraith Caerphilly GB **87** T 16

Pontoon Mayo IRL **218** P 4

Pontrhydfendigaid Ceredigion GB **86/87** S 15

Pontrilas Herefordshire GB **87** T 17

Pontsticill Powys GB **87** T 16

Pontyates Carmarthenshire GB **86** T 14

Pontycymer Bridgend GB **86/87** T 15

Pontypool Torfaen GB **87** T 16

Pontypridd Rhondda Cynon Taff GB **87** T 16

Pool North Yorkshire GB **134** P 19

Poole Poole GB **70** V 19

Poolewe Highland GB **186** G 11

Pooley Bridge Cumbria GB **146/147** N 17

Poppleton York GB **134** P 20

Porlock Somerset GB **53** U 15

Port Bannatyne Argyll and Bute GB **160** L 12

Port Carlisle Cumbria GB **146** N 16

Port Charlotte Argyll and Bute GB **174** L 10

Port Ellen Argyll and Bute GB **174** L 10

Port Erin Isle of Man GB **146** O 13

Port Glasgow Inverclyde GB **160** L 13

Port Henderson Highland GB **186** G 11

Port Isaac Cornwall GB **52** V 13

Port Lamont Argyll and Bute GB **160** L 12

Port Laoise Laois IRL **219** Q 8

Port Logan Dumfries und Galloway GB **146** N 13

Port nan Giuran Portnaguran Na h-Eileanan an Iar GB **186** F 10

Port nan Long Na h-Eileanan an Iar GB **175** G 8

Port Nis Port of Ness Na h-Eileanan an Iar GB **186** E 10

Port of Menteith Stirling GB **160** K 14

Port of Ness Port Nis Na h-Eileanan an Iar GB **186** E 10

Port Talbot Neath Port Talbot GB **86/87** T 15

Port William Dumfries und Galloway GB **146** N 13

Portacloy Mayo IRL **218** O 3

Portadown Armagh GB **207** O 10

Portaferry Down GB **207** O 11

Portaleen Donegal IRL **207** M 8

Portarlington Offaly IRL **219** Q 8

Portavadie Argyll and Bute GB **160** L 12

Portesham Dorset GB **53** V 17

Port Eynon Swansea GB **86** T 14

Portglenone Antrim GB **207** N 10

Porth Rhondda Cynon Taff GB **87** T 16

Porthcawl Bridgend GB **53** U 15

Porthleven Cornwall GB **52** W 12

Porthmadog Gwynedd GB **118/119** R 14

Porthmeor Cornwall GB **52** W 11

Portishead North Somerset GB **53** U 17

Portknockie Moray GB **187** G 17

Portlaw Waterford IRL **233** S 8

Portlethen Aberdeenshire GB **187** H 18

Portmagee Kerry IRL **70** T 2

Portmahomack Highland GB **187** G 15

Portmarnock Dublin IRL **219** Q 10

Portnaguran Port nan Giuran Na h-Eileanan an Iar GB **186** F 10

Portnahaven Argyll and Bute GB **174** L 9

Portnalong Highland GB **175** H 10

Portpatrick Dumfries und Galloway GB **146** N 12

Portreath Cornwall GB **52** W 12

Portree Highland GB **175** H 10

Portroe Tipperary IRL **232/233** R 6

Portrush Antrim GB **207** M 9

Portsalon Donegal IRL **206** M 7

Portscatho Cornwall GB **52** W 13

Portskerra Highland GB **198** E 15

Portslade-by-Sea Brighton & Hove GB **71** V 22

Portsmouth Portsmouth GB **70** V 20

Portsoy Aberdeenshire GB **187** G 17

Port St. Mary Isle of Man GB **146** O 13

Portstewart Londonderry GB **207** M 9

Portumna Galway IRL **218/219** Q 6

Porturlin Mayo IRL **218** O 3

Potterhanworth Lincolnshire GB **135** Q 22

Potters Bar Hertfordshire GB **71** T 22

Potton Bedfordshire GB **100/101** S 22

Poulgorm Br. Kerry IRL **232** T 4

Poulton Gloucestershire GB **70** T 19

Poulton-le-Fylde Lancashire GB **119** P 17

Poundstock Cornwall GB **52** V 13

Powerstock Dorset GB **53** V 17

Powick Worcestershire GB **87** S 18

Poynton Cheshire GB **134** Q 18

Poyntz Pass Armagh GB **207** O 10

Prees Shropshire GB **119** R 17

Preesall Lancashire GB **119** P 17

Prendwick Northumberland GB **147** M 19

Prenteg Gwynedd GB **118/119** R 14

Prescot Knowsley GB **119** Q 17

Prestatyn Denbighshire GB **119** Q 16

Presteigne Powys GB **87** S 17

Preston Rutland GB **100** R 21

Preston Lancashire GB **119** P 17

Preston Scottish Borders GB **161** L 18

Preston Dorset GB **70** V 18

Preston Candover Hampshire GB **70** U 20

Prestonpans East Lothian GB **161** L 17

Prestwick South Ayrshire GB **146** M 13

Prickwillow Cambridgeshire GB **101** S 23

Princes Risborough Buckinghamshire GB **70/71** T 21

Princethorpe Warwickshire GB **100** S 20

Princetown Devon GB **52/53** V 14

Priors Marston Warwickshire GB **100** S 20

Probus Cornwall GB **52** W 13

Proncy Highland GB **186/187** G 14

Prudhoe Northumberland GB **147** N 19

Puckaun Tipperary IRL **232/233** R 6

Puckeridge Hertfordshire GB **71** T 23

Puddletown Dorset GB **70** V 18

Pudsey Leeds GB **134** P 19

Pulborough West Sussex GB **70/71** V 21

Pulham Norfolk GB **101** S 25

Pumsaint Carmarthenshire GB **86/87** S 15

Puncheston Pembrokeshire GB **86** T 13

Purfleet Thurrock GB **71** U 23

Puriton Somerset GB **53** U 17

Purley Greater London GB **71** U 22

Purton Wiltshire GB **70** T 19

Puttenham Surrey GB **70/71** U 21

Pwllheli Gwynedd GB **118/119** R 14

Pyle Bridgend GB **86/87** T 15

Q

Quainton Buckinghamshire GB **70/71** T 21

Quantoxhead Somerset GB **53** U 16

Quarndon Derbyshire GB **100** R 20

Quay Flintshire GB **119** Q 16

Queenborough Kent GB **71** U 24

Queensbury Bradford GB **134** P 19

Queensferry Flintshire GB **119** Q 16

Queensferry Edinburgh GB **161** L 16

Quendale Shetland Islands GB **199** C 20

Quendon Essex GB **71** T 23

Quigley's Donegal IRL **207** M 8

Quilty Clare IRL **232** R 4

Quin Clare IRL **232** R 5

Quorn Leicestershire GB **100** R 20

Quoyness Orkney Islands GB **198** E 16

R

Rackenford Devon GB **53** V 15

Rackwick Orkney Islands GB **198** E 16

Radcliffe on Trent Nottinghamshire GB **100** R 20

Radlett Hertfordshire GB **71** T 22

Radstock Bath & NE Somerset GB **70** U 18

Rafford Moray GB **187** G 15

Raghly Sligo IRL **206** O 5

Raglan Monmouthshire GB **87** T 17

Rahaghy Meath IRL **219** P 8

Rainham Greater London GB **71** T 23

Rainworth Nottinghamshire GB **134** Q 20

Rait Perth and Kinross GB **161** K 16

Ramasaig Highland GB **175** H 9

Rame Cornwall GB **52** W 12

Rame Cornwall GB **52/53** W 14

Ramsbottom Bury GB **134** P 18

Ramsbury Wiltshire GB **70** U 19

Ramsey Cambridgeshire GB **100/101** S 22

Ramsey Isle of Man GB **146** O 14

Ramsey Essex GB **71** T 25

Ramseycleuch Scottish Borders GB **146** M 16

Ramsgate Kent GB **71** U 25

Ramsgill North Yorkshire GB **147** O 19

Ranais Na h-Eileanan an Iar GB **186** F 10

Randalstown Antrim GB **207** N 10

Rankinston East Ayrshire GB **146** M 14

Rannoch Station Perth and Kinross GB **160** J 13

Ranskill Nottinghamshire GB **134** Q 20

Raphoe Donegal IRL **206** N 7

Rapness Orkney Islands GB **198** D 17

Rasharkin Antrim GB **207** N 10

Rashedoge Donegal IRL **206** N 7

Ratallen Cross Roads Roscommon IRL **218/219** P 6

Rathangan Kildare IRL **219** Q 9

Rathconrath Westmeath IRL **219** P 7

Rathcoole Dublin IRL **219** Q 10

Rathcormack Cork IRL **232/233** S 6

Rathdowney Laois IRL **233** R 7

Rathdrum Wicklow IRL **233** R 10

Rathen Aberdeenshire GB **187** G 18

Rathfeigh Meath IRL **219** P 10

Rathfriland Down GB **207** O 10

Rathkeale Limerick IRL **232** R 5

Rathlackan Mayo IRL **206** O 4

Rathmelton Donegal IRL **206** M 7

Rathmolyon Meath IRL **219** Q 9

Rathmore Meath IRL **219** P 9

Rathmore Kerry IRL **232** S 4

Rathmullan Donegal IRL **206** M 7

Rathnew Wicklow IRL **233** R 10

Rathnure Wexford IRL **233** S 9

Rathowen Westmeath IRL **219** P 7

Rathvilly Carlow IRL **233** R 9

Ratoath Meath IRL **219** P 10

Rattlesden Suffolk GB **101** S 24

Rattray Perth and Kinross GB **161** J 16

Raunds Northhamptonshire GB **100** S 21

Ravenglass Cumbria GB **146** O 16

Ravenscar North Yorkshire GB **135** O 22

Ravensworth North Yorkshire GB **147** O 19

Ravyenstonedale Cumbria GB **147** O 18

Rawcliffe East Riding of Yorkshire GB **134/135** P 21

Rawmarsh Rotherham GB **134** Q 20

Rawtenstall Lancashire GB **134** P 18

Rayleigh Essex GB **71** T 24

Reading Reading GB **70/71** U 21

Rear Cross Tipperary IRL **232/233** R 6

Rearsby Leicestershire GB **100** R 20

Reawick Shetland Islands GB **199** B 20

Reay Highland GB **198** E 15

Reculver Kent GB **71** U 25

Red Roses Carmarthenshire GB **86** T 13

Red Row Northumberland GB **147** M 19

Redcar Redcar & Cleveland GB **147** N 20

Redditch Worcestershire GB **100** S 19

Redesmouth Northumberland GB **147** M 18

Redgrave Suffolk GB **101** S 25

Redhill Surrey GB **71** U 22

Redland Orkney Islands GB **198** D 16

Redlynch Wiltshire GB **70** V 19

Redmire North Yorkshire GB **147** O 19

Redpoint Highland GB **186** G 11

Redruth Cornwall GB **52** W 12

Redwick Newport GB **87** T 17

Reedham Norfolk GB **101** R 26

Reepham Norfolk GB **101** R 25

Reepham Lincolnshire GB **135** Q 22

Reeth North Yorkshire GB **147** O 19

Regaba Isle of Man GB **146** O 14

Reiff Highland GB **186** F 12

Reigate Surrey GB **71** U 22

Reighton North Yorkshire GB **135** O 22

Reiss Highland GB **187** F 16

Rendlesham Suffolk GB **101** S 25

Renfrew Renfrewshire GB **160** L 14

Renhold Bedfordshire GB **100/101** S 22

Rennington Northumberland GB **147** M 19

Renton West Dunbartonshire GB **160** L 13

Renwick Cumbria GB **146/147** N 17

Rescobie Angus GB **161** J 18

Resolven Neath Port Talbot GB **86/87** T 15

Reston Scottish Borders GB **161** L 18

Retford Nottinghamshire GB **134/135** Q 21

Rettendon Essex GB **71** T 24

Revesby Lincolnshire GB **135** Q 22

Reynoldston Swansea GB **86** T 14

Rhaeadr Gwy Rhayader Powys GB **86/87** S 15

Rhandirmwyn Carmarthenshire GB **86/87** S 15

Rhayader Rhaeadr Gwy Powys GB **86/87** S 15

Rhewl Denbighshire GB **119** Q 16

Rhiconich Highland GB **186** F 13

Rhiw Gwynedd GB **118** R 13

Rhode Offaly IRL **219** Q 8

Rhondda Rhondda Cynon Taff GB **87** T 16

Rhoose Vale of Glamorgan GB **53** U 16

Rhos Carmarthenshire GB **86** T 14

Rhoscolyn Anglesey GB **118** Q 13

Rhosllanerchrugog Wrexham GB **119** Q 16

Rhosneigr Anglesey GB **118** Q 13

Rhossili Swansea GB **86** T 14

Rhostryfan Gwynedd GB **118/119** Q 14

Rhu Argyll and Bute GB **160** K 13

Rhubodach Argyll and Bute GB **160** L 12

Rhuddlan Denbighshire GB **119** Q 16

Rhuthun Ruthin Denbighshire GB **119** Q 16

Rhydcymerau Carmarthenshire GB **86** S 14

Rhydymwyn Flintshire GB **119** Q 16

Rhyl Denbighshire GB **119** Q 16

Rhymney Caerphilly GB **87** T 16

Rhynie Aberdeenshire GB **187** H 17

Ribblehead North Yorkshire GB **147** O 18

Ribchester Lancashire GB **119** P 17

Riccall North Yorkshire GB **134** P 20

Richhill Armagh GB **207** O 9

Richmond North Yorkshire GB **147** O 19

Richmond Greater London GB **71** U 22

Rickmansworth Hertfordshire GB **70/71** T 21

Ridgewell Essex GB **101** S 24

Ridgmont Bedfordshire GB **100** S 21

Riding Mill Northumberland GB **147** N 19

Ridsdale Northumberland GB **147** M 18

Rigg Dumfries und Galloway GB **146** N 16

Rigside South Lanarkshire GB **160/161** L 15

Rillington North Yorkshire GB **134** O 21

Rimington Lancashire GB **134** P 18

Ringaskiddy Cork IRL **232/233** T 6

Ringford Dumfries und Galloway GB **146** N 14

Ringmer East Sussex GB **71** V 23

Ringsend Londonderry GB **207** M 9

Ringstead Norfolk GB **101** R 24

Ringville Waterford IRL **233** S 7

Ringwood Hampshire GB **70** V 19

Ripley Derbyshire GB **134** Q 20

Ripley North Yorkshire GB **147** O 19

Ripley Surrey GB **70/71** U 21

Ripon North Yorkshire GB **147** O 19

Ripponden Calderdale GB **134** P 19

Risca Caerphilly GB **87** T 16

Rishton Lancashire GB **134** P 18

Riverchapel Wexford IRL **233** R 10

Roade Northhamptonshire GB **100** S 21

Roadside Highland GB **198** E 16

Roadside of Kinneff Aberdeenshire GB **161** J 18

Roberton Scottish Borders GB **146/147** M 17

Roberton South Lanarkshire GB **160/161** L 15

Robertsbridge East Sussex GB **71** V 23

Robertstown Kildare IRL **219** Q 9

Robin Hood´s Bay North Yorkshire GB **135** O 21

Roborough Devon GB **52/53** V 14

Rocester Staffordshire GB **100** R 19

Roch Pembrokeshire GB **86** T 12

Rochdale Rochdale GB **134** P 18

Rochester Northumberland GB **147** M 18

Rochester Medway GB **71** U 23

Rochford Essex GB **71** T 24

Rochfortbridge Westmeath IRL **219** Q 8

Rock Cornwall GB **52** V 13

Rockbeare Devon GB **53** V 16

Rockchapel Cork IRL **232** S 4

Rockcliffe Dumfries und Galloway GB **146** N 15

Rockcliffe Cumbria GB **146** N 16

Rockcorry Monaghan IRL **207** O 8

Rockhill Limerick IRL **232** S 5

Rockingham Northhamptonshire GB **100** R 21

Rodington Shropshire GB **119** R 17

Rodington Telford and Wrekin GB **87** R 17

Roesound Shetland Islands GB **199** B 20

Rogart Highland GB **186/187** F 14

Roghadal Na h-Eileanan an Iar GB **175** G 9

Rolvenden Kent GB **71** U 24

Romaldkirk Durham GB **147** N 18

Romsey Hampshire GB **70** V 19

Rookhope Durham GB **147** N 18

Rooks Bridge Somerset GB **53** U 17

Roonah Quay Mayo IRL **218** P 3

Roos East Riding of Yorkshire GB **135** P 22

Rootpark South Lanarkshire GB **160/161** L 15

Ropley Hampshire GB **70** U 20

Ropsley Lincolnshire GB **100** R 21

Rora Aberdeenshire GB **187** G 19

Roscommon Ros Comáin Roscommon IRL **218/219** P 6

Roscrea Tipperary IRL **233** R 7

Rosedale Abbey North Yorkshire GB **134** O 21

Rosegreen Tipperary IRL **233** S 7

Rosehearty Aberdeenshire GB **187** G 18

Rosemarkie Highland GB **186/187** G 14

Rosenallis Laois IRL **219** Q 8

Roskhill Highland GB **175** H 9

Rosley Cumbria GB **146** N 16

Roslin Midlothian GB **161** L 16

Rosneath Argyll and Bute GB **160** K 13

Ross Northumberland GB **161** L 19

Ross Meath IRL **219** P 8

Ross Carbery Cork IRL **232** T 4

Rossaveel Galway IRL **218** Q 3

Rosses Point Sligo IRL **206** O 5

Rossington Doncaster GB **134** Q 20

Rossinver Leitrim IRL **206** O 6

Rosslare Wexford IRL **233** S 10

Rosslare Harbour Calafort Ros Láir Wexford IRL **233** S 10

Rosslea Fermanagh GB **207** O 8

Rossnowlagh Donegal IRL **206** N 6

Ross-on-Wye Herefordshire GB **87** T 17

Rostrevor Down GB **207** O 10

Rosyth Fife GB **161** K 16

Rothbury Northumberland GB **147** M 19

Rotherfield East Sussex GB **71** U 23

Rotherham Rotherham GB **134** Q 20

Rothes Moray GB **187** G 16

Rothesay Argyll and Bute GB **160** L 12

Rothienorman Aberdeenshire GB **187** H 18

Rothiesholm Orkney Islands GB **198** D 17

Rothwell Northhamptonshire GB **100** S 21

Rothwell Leeds GB **134** P 20

Rottal Angus GB **161** J 16

Rottingdean Brighton & Hove GB **71** V 22

Roughsike Cumbria GB **146/147** M 17

Roughton Norfolk GB **101** R 25

Roundstone Galway IRL **218** Q 3

Roundwood Wicklow IRL **219** Q 10

Rounton North Yorkshire GB **147** O 20

Rousdon Devon GB **53** V 16

Rousky Tyrone GB **207** N 8

Rowanburn Dumfries und Galloway GB **146/147** M 17

Rowardennan Stirling GB **160** K 13

Rowlands Gateshead GB **147** N 19

Rowsley Derbyshire GB **134** Q 19

Roxburgh Scottish Borders GB **161** L 18

Roxton Bedfordshire GB **100/101** S 22

Roxwell Essex GB **71** T 23

Royal Leamington Spa Warwickshire GB **100** S 19

Royal Tunbridge Wells Kent GB **71** U 23

Roybridge Highland GB **160** J 13

Royston Hertfordshire GB **100/101** S 22

Royston Barnsley GB **134** P 20

Royton Oldham GB **134** P 18

Ruabon Wrexham GB **119** R 16

Ruan Minor Cornwall GB **52** X 12

Ruddington Nottinghamshire GB **100** R 20

Rudgwick West Sussex GB **71** U 22

Rudston East Riding of Yorkshire GB **135** O 22

Rudyard Staffordshire GB **134** Q 18

Rufford Lancashire GB **119** P 17

Rugby Warwickshire GB **100** S 20

Rugeley Staffordshire GB **100** R 19

Rumbling Bridge Perth and Kinross GB **160/161** K 15

Rumburgh Suffolk GB **101** S 25

Runcorn Halton GB **119** Q 17

Rush Dublin IRL **219** P 10

Rushden Northhamptonshire GB **100** S 21

Ruskington Lincolnshire GB **135** Q 22

Ruswarp North Yorkshire GB **134** O 21

Rutherglen South Lanarkshire GB **160** L 14

Ruthin Rhuthun Denbighshire GB **119** Q 16

Ruthwell Dumfries und Galloway GB **146** N 16

Ryal Northumberland GB **147** M 18

Ryde Isle of Wight GB **70** V 20

Rye East Sussex GB **71** V 24

Ryhill Wakefield GB **134** P 20

Ryhope Sunderland GB **147** N 20

Rylane Cork IRL **232** T 5

Rylstone North Yorkshire GB **147** O 18

Ryton Gateshead GB **147** N 19

S

Sabden Lancashire GB **134** P 18

Sacriston Durham GB **147** N 19

Sadberge Durham GB **147** N 20

Saddell Argyll and Bute GB **174** L 11

Sadgill Cumbria GB **146/147** O 17

Saffron Walden Essex GB **101** S 23

Saggart Dublin IRL **219** Q 10

Saintfield Down GB **207** O 11

Salcombe Devon GB **53** W 15

Salcott Essex GB **71** T 24

Salen Argyll and Bute GB **174** J 11

Salen Highland GB **174** J 11

Salford Trafford GB **134** Q 18

Salfords Surrey GB **71** U 22

Saline Fife GB **160/161** K 15

Salisbury Wiltshire GB **70** U 19

Sallachy Highland GB **186** H 12

Sallins Kildare IRL **219** Q 9

Saltash Cornwall GB **52/53** W 14

Saltburn-by-the-Sea Redcar & Cleveland GB **147** N 21

Saltcoats North Ayrshire GB **160** L 13

Saltdean East Sussex GB **71** V 22

Saltfleet Lincolnshire GB **135** Q 23

Saltfleetby St Peter Lincolnshire GB **135** Q 23

Saltford Bath & NE Somerset GB **70** U 18

Salton North Yorkshire GB **134** O 21

Samhia Na h-Eileanan an Iar GB **175** G 8

Sampford Peverell Devon GB **53** V 16

Sanaigmore Argyll and Bute GB **174** L 10

Sand Shetland Islands GB **199** B 20

Sand Hutton North Yorkshire GB **134** O 21

Sandbach Cheshire GB **134** Q 18

Sandbank Argyll and Bute GB **160** L 13

Sandford North Somerset GB **53** U 17

Sandhaven Aberdeenshire GB **187** G 18

Sandhead Dumfries und Galloway GB **146** N 13

Sandhoe Northumberland GB **147** N 18

Sandhurst Hampshire GB **70/71** U 21

Sandness Shetland Islands GB **199** B 19

Sandon Staffordshire GB **100** R 18

Sandown Isle of Wight GB **70** V 20

Sandplace Cornwall GB **52/53** W 14

Sandringham Norfolk GB **101** R 24

Sandwell Sandwell GB **87** S 18

Sandwich Kent GB **71** U 25

Sandwick Shetland Islands GB **199** B 20

Sandy Bedfordshire GB **100/101** S 22

Sandygate Isle of Man GB **146** O 13

Sanndabhaig Na h-Eileanan an Iar GB **175** H 8

Sanquhar Dumfries und Galloway GB **146** M 15

Sarclet Highland GB **187** F 16

Sarn Meyllteyrn Gwynedd GB **118** R 13

Sarnesfield Herefordshire GB **87** S 17

Sarre Kent GB **71** U 25

Satley Durham GB **147** N 19

Satterthwaite Cumbria GB **146** O 16

Saul Down GB **207** O 11

Saundersfoot Pembrokeshire GB **86** T 13

Sawbridgeworth Hertfordshire GB **71** T 23

Sawrey Cumbria GB **146/147** O 17

Sawston Cambridgeshire GB **101** S 23

Sawtry Cambridgeshire GB **100/101** S 22

Saxby Leicestershire GB **100** R 21

Saxelbye Leicestershire GB **100** R 21

Saxilby Lincolnshire GB **134/135** Q 21

Saxmundham Suffolk GB **101** S 25

Saxthorpe Norfolk GB **101** R 25

Saxton North Yorkshire GB **134** P 20

Scalasaig Argyll and Bute GB **174** K 10

Scalby North Yorkshire GB **135** O 22

Scaleby Hill Cumbria GB **146/147** N 17

Scalford Leicestershire GB **100** R 21

Scalloway Shetland Islands GB **199** B 20

Scamblesby Lincolnshire GB **135** Q 22

Scar Orkney Islands GB **198** D 17

Scarborough North Yorkshire GB **135** O 22

Scardroy Highland GB **186** G 12

Scarfskerry Highland GB **198** E 16

Scarinish Argyll and Bute GB **174** K 9

Scarriff Clare IRL **232** R 5

Scartaglin Kerry IRL **232** S 4

Scarva Down GB **207** O 10

Scawby North Lincolnshire GB **134/135** P 21

Scole Norfolk GB **101** S 25

Scotch North Yorkshire GB **147** O 19

Scotstown Highland GB **174** J 11

Scotter Lincolnshire GB **134/135** Q 21

Scourie Highland GB **186** F 12

Scousburgh Shetland Islands GB **199** C 20

Scrabster Highland GB **198** E 15

Scramoge Roscommon IRL **218/219** P 6

Scremerston Northumberland GB **161** L 19

Scruton North Yorkshire GB **147** O 19

Sculthorpe Norfolk GB **101** R 24

Scunthorpe North Lincolnshire GB **134/135** P 21

Sea Palling Norfolk GB **101** R 26

Seaford East Sussex GB **71** V 23

Seaham Durham GB **147** N 20

Seahouses Northumberland GB **161** L 19

Seamer North Yorkshire GB **135** O 22

Seamer North Yorkshire GB **147** O 20

Seascale Cumbria GB **146** O 16

Seathwaite Cumbria GB **146** O 16

Seaton Devon GB **53** V 16

Seaton Carew Hartlepool GB **147** N 20

Seaton Delaval Northumberland GB **147** M 19

Seaton Sluice Northumberland GB **147** M 20

Seatown Dorset GB **53** V 17

Seave Green North Yorkshire GB **147** O 20

Seaview Isle of Wight GB **70** V 20

Sebergham Cumbria GB **146** N 16

Sedbergh Cumbria GB **146/147** O 17

Sedgebrook Lincolnshire GB **100** R 21

Sedgefield Durham GB **147** N 20

Sedgeford Norfolk GB **101** R 24

Sedgley Dudley GB **100** R 18

Seend Wiltshire GB **70** U 18

Selattyn Shropshire GB **119** R 16

Selborne Hampshire GB **70/71** U 21

Selby North Yorkshire GB **134** P 20

Selkirk Scottish Borders GB **161** L 17

Sellafirth Shetland Islands GB **199** A 20

Selsey West Sussex GB **70/71** V 21

Senghenydd Caerphilly GB **87** T 16

Sennen Cornwall GB **52** W 11

Sennybridge Powys GB **86/87** T 15

Seskinore Tyrone GB **207** N 8

Sessay North Yorkshire GB **147** O 20

Settle North Yorkshire GB **147** O 18

Seven Sisters Neath Port Talbot GB **86/87** T 15

Sevenoaks Kent GB **71** U 23

Sgiogarstaigh Na h-Eileanan an Iar GB **186** F 10

Shaftesbury Dorset GB **70** U 18

Shalbourne Wiltshire GB **70** U 19

Shalfleet Isle of Wight GB **70** V 20

Shanagolden Limerick IRL **232** R 4

Shanavogh Clare IRL **232** R 4

Shandon Argyll and Bute GB **160** K 13

Shanklin Isle of Wight GB **70** V 20

Shanlaragh Cork IRL **232** T 4

Shannon Sionainn Clare IRL **232** R 5

Shannonbridge Offaly IRL **218/219** Q 6

Shantonagh Monaghan IRL **207** O 9

Shap Cumbria GB **146/147** N 17

Shapwick Somerset GB **53** U 17

Sharlston Wakefield GB **134** P 20

Sharnbrook Bedfordshire GB **100** S 21

Sharpness Gloucestershire GB **70** T 18

Shavington Cheshire GB **134** Q 18

Shaw Oldham GB **134** P 18

Shawbury Shropshire GB **119** R 17

Shawhead Dumfries und Galloway GB **146** M 15

Shebbear Devon GB **52/53** V 14

Shebster Highland GB **198** E 15

Shedfield Hampshire GB **70** V 20

Sheepwash Devon GB **52/53** V 14

Sheerness Kent GB **71** U 24

Sheffield Sheffield GB **134** Q 20

Shefford Bedfordshire GB **100/101** S 22

Sheldwich Kent GB **71** U 24

Shelf Calderdale GB **134** P 19

Shelve Shropshire GB **87** R 17

Shenley Hertfordshire GB **71** T 22

Sheperdswell Kent GB **71** U 25

Shepreth Cambridgeshire GB **101** S 23

Shepshed Leicestershire GB **100** R 20

Shepton Mallet Somerset GB **53** U 17

Sherborne Dorset GB **53** V 17

Sherborne St. John Hampshire GB **70** U 20

Sherburn North Yorkshire GB **135** O 21

Sherburn in Elmet North Yorkshire GB **134** P 20

Shercock Cavan IRL **219** P 9

Sherfield on Loddon Hampshire GB **70** U 20

Sheriff Hutton North Yorkshire GB **147** O 20

Sheriffhales Shropshire GB **100** R 18

Sheringham Norfolk GB **101** R 25

Sherington Milton Keynes GB **100** S 21

Sherston Wiltshire GB **70** T 18

Shiel Bridge Highland GB **186** H 12

Shieldaig Highland GB **186** G 11

Shieldhill Falkirk GB **160/161** L 15

Shifnal Shropshire GB **100** R 18

Shilbottle Northumberland GB **147** M 19

Shildon Durham GB **147** N 19

Shillelagh Wicklow IRL **233** R 9

Shillingstone Dorset GB **70** V 18

Shillington Bedfordshire GB **71** T 22

Shinness Highland GB **186/187** F 14

Shinrone Offaly IRL **233** R 7

Shipbourne Kent GB **71** U 23

Shipdham Norfolk GB **101** R 24

Shipley Bradford GB **134** P 19

Shipston-on-Stour Warwickshire GB **100** S 19

Shipton North Yorkshire GB **147** O 20

Shipton-under-Wychwood Oxfordshire GB **70** T 19

Shirebrook Derbyshire GB **134** Q 20

Shirenewton Monmouthshire GB **87** T 17

Shobdon Herefordshire GB **87** S 17

Shoreham-by-Sea West Sussex GB **71** V 22

Shorwell Isle of Wight GB **70** V 20

Shotley Bridge Durham GB **147** N 19

Shotley Gate Suffolk GB **71** T 25

Shotts North Lanarkshire GB **160/161** L 15

Shrewsbury Shropshire GB **87** R 17

Shrewton Wiltshire GB **70** U 19

Shrivenham Oxfordshire GB **70** T 19

Shrule Galway IRL **218** P 4

Siabost Na h-Eileanan an Iar GB **175** F 9

Siadar Na h-Eileanan an Iar GB **186** F 10

Sible Hedingham Essex GB **71** T 24

Sibsey Lincolnshire GB **135** Q 23

Sidbury Devon GB **53** V 16

Sidmouth Devon GB **53** V 16

Sigglesthorne East Riding of Yorkshire GB **135** P 22

Sileby Leicestershire GB **100** R 20

Silloth Cumbria GB **146** N 16

Silsden Bradford GB **134** P 19

Silverdale Lancashire GB **146/147** O 17

Silvermines Tipperary IRL **232/233** R 6

Silverstone Northhamptonshire GB **100** S 20

Silverton Devon GB **53** V 16

Simonburn Northumberland GB **147** M 18

Simonsbath Somerset GB **53** U 15

Singleton West Sussex GB **70/71** V 21

Sinnington North Yorkshire GB **134** O 21

Sion Mills Tyrone GB **207** N 8

Sittingbourne Kent GB **71** U 24

Six Crosses Kerry IRL **232** S 3

Sixmilebridge Clare IRL **232** R 5

Sixmilecross Tyrone GB **207** N 8

Sixpenny Handley Dorset GB **70** V 19

Skaill Orkney Islands GB **198** D 17

Skaill Orkney Islands GB **198** E 17

Skares East Ayrshire GB **146** M 14

Skegness Lincolnshire GB **135** Q 23

Skelmantthorpe Wakefield GB **134** P 19

Skelmersdale Lancashire GB **119** P 17

Skelpick Highland GB **186/187** F 14

Skelton Redcar & Cleveland GB **147** N 21

Skelwith Bridge Cumbria GB **146** O 16

Skerray Highland GB **186/187** E 14

Skerries Dublin IRL **219** P 10

Skewen Neath Port Talbot GB **86/87** T 15

Skibbereen Cork IRL **232** T 4

Skidby East Riding of Yorkshire GB **135** P 22

Skillington Lincolnshire GB **100** R 21

Skinburness Cumbria GB **146** N 16

Skipness Argyll and Bute GB **160** L 12

Skipsea East Riding of Yorkshire GB **135** P 22

Skipton North Yorkshire GB **134** P 18

Skipwith North Yorkshire GB **134/135** P 21

Skirling Scottish Borders GB **161** L 16

Skirwith Cumbria GB **146/147** N 17

Skripton-on-Swale North Yorkshire GB **147** O 20

Skulamus Highland GB **175** H 11

Skull Cork IRL **232** T 3

Slaggyford Northumberland GB **146/147** N 17

Slaidburn Lancashire GB **134** P 18

Slaithwaite Kirklees GB **134** P 19

Slaley Northumberland GB **147** N 18

Slamannan Falkirk GB **160/161** L 15

Slane Meath IRL **219** P 9

Slapton Devon GB **53** W 15

Sleaford Lincolnshire GB **100/101** R 22

Sledmere East Riding of Yorkshire GB **134** O 21

Sleights North Yorkshire GB **134** O 21

Sligachan Highland GB **175** H 10

Sligo Sligeach Sligo IRL **206** O 6

Slindon West Sussex GB **70/71** V 21

Slough Slough GB **70/71** T 21

Smailholm Scottish Borders GB **161** L 17

Smallburgh Norfolk GB **101** R 25

Smeaton North Yorkshire GB **134** P 20

Smeeth Kent GB **71** U 24

Smeircleit Na h-Eileanan an Iar GB **175** H 8

Smithborough Monaghan IRL **207** O 8

Smithfield Cumbria GB **146/147** N 17

Snainton North Yorkshire GB **134** O 21

Snaith East Riding of Yorkshire GB **134** P 20

Snape Suffolk GB **101** S 25

Snape North Yorkshire GB **147** O 19

Sneem Kerry IRL **232** T 3

Snelland Lincolnshire GB **135** Q 22

Snettisham Norfolk GB **101** R 24

Snitter Northumberland GB **147** M 19

Snodland Kent GB **71** U 23

Snoulham Norfolk GB **101** R 23

Soham Cambridgeshire GB **101** S 23

Solas Na h-Eileanan an Iar GB **175** G 8

Solihull Solihull GB **100** S 19

Solva Pembrokeshire GB **86** T 12

Somersham Cambridgeshire GB **101** S 23

Somerton Norfolk GB **101** R 26

Somerton Somerset GB **53** U 17

Somerton Oxfordshire GB **70** T 20

Sopley Dorset GB **70** V 19

Sorbie Dumfries und Galloway GB **146** N 14

Sorisdale Argyll and Bute GB **174** J 10

Sorn East Ayrshire GB **160** L 14

Sortat Highland GB **198** E 16

Soulby Cumbria GB **147** N 18

Sourton Devon GB **52/53** V 14

Soutergate Cumbria GB **146** O 16

South Benfleet Essex GB **71** T 24

South Brent Devon GB **53** W 15

South Cave East Riding of Yorkshire GB **134/135** P 21

South Creake Norfolk GB **101** R 24

South Ferriby North Lincolnshire GB **134/135** P 21

South Harting West Sussex GB **70/71** V 21

South Hayling Hampshire GB **70/71** V 21

South Kelsey Lincolnshire GB **135** Q 22

South Kirkby Wakefield GB **134** P 20

South Kyme Lincolnshire GB **135** Q 22

South Littleton Worcestershire GB **100** S 19

South Molton Devon GB **53** V 15

South Otterington North Yorkshire GB **147** O 20

South Oxhey Hertfordshire GB **71** T 22

South Petherton Somerset GB **53** V 17

South Shields South Tyneside GB **147** N 20

South Skirlaugh East Riding of Yorkshire GB **135** P 22

South Thoresby Lincolnshire GB **135** Q 23

South View Shetland Islands GB **199** B 20

South Wingfield Derbyshire GB **134** Q 20

South Woodham Ferrers Essex GB **71** T 24

South Wootton Norfolk GB **101** R 23

South Zeal Devon GB **53** V 15

Southam Warwickshire GB **100** S 20

Southampton Southampton GB **70** V 20

Southborough Kent GB **71** U 23

Southend Argyll and Bute GB **174** M 11

Southend-on-Sea Southend-on-Sea GB **71** T 24

Southerness Dumfries und Galloway GB **146** N 15

Southery Norfolk GB **101** R 23

Southminster Essex GB **71** T 24

Southport Sefton GB **119** P 16

Southwell Nottinghamshire GB **134/135** Q 21

Southwick West Sussex GB **71** V 22

Southwold Suffolk GB **101** S 26

Sowerby Bridge Calderdale GB **134** P 19

Spalding Lincolnshire GB 100/101 R 22

Spaldwick Cambridgeshire GB 100/101 S 22

Spanish Point Clare IRL 232 R 4

Sparkford Somerset GB 53 U 17

Spean Bridge Highland GB 160 J 13

Speke Liverpool GB 119 Q 17

Spennymoor Durham GB 147 N 19

Spetchley Worcestershire GB 87 S 18

Spetisbury Dorset GB 70 V 18

Spey Bay Moray GB 187 G 16

Spiddle Galway IRL 218 Q 4

Spilsby Lincolnshire GB 135 Q 23

Spinningdale Highland GB 186/187 G 14

Spittal Pembrokeshire GB 86 T 13

Spittal of Glenshee Perth and Kinross GB 161 J 16

Spofforth North Yorkshire GB 134 P 20

Spratton Northhamptonshire GB 100 S 21

Spreyton Devon GB 53 V 15

Spridlington Lincolnshire GB 135 Q 22

Springfield Fife GB 161 K 16

Sproatley East Riding of Yorkshire GB 135 P 22

Sprouston Scottish Borders GB 161 L 18

Sprowston Norfolk GB 101 R 25

Sproxton North Yorkshire GB 147 O 20

Sraith Salach Galway IRL 218 Q 3

St. Abbs Scottish Borders GB 161 L 18

St. Agnes Cornwall GB 52 W 12

St. Albans Hertfordshire GB 71 T 22

St. Andrews Fife GB 161 K 17

St. Ann's Dumfries und Galloway GB 146 M 16

St. Arvans Monmouthshire GB 87 T 17

St. Asaph Denbighshire GB 119 Q 16

St. Aubin Channel Islands GB 66 Y 18

St. Austell Cornwall GB 52 W 13

St. Bees Cumbria GB 146 O 15

St. Blazey Cornwall GB 52 W 13

St. Boswells Scottish Borders GB 161 L 17

St. Brelade Channel Islands GB 66 Y 18

St. Briavels Gloucestershire GB 87 T 17

St. Bride´s Major Vale of Glamorgan GB 53 U 15

St. Buryan Cornwall GB 52 W 11

St. Catherines Argyll and Bute GB 160 K 12

St. Clears Carmarthenshire GB 86 T 14

St. Clément Channel Islands GB 66 Y 18

St. Clether Cornwall GB 52 V 13

St. Columb Major Cornwall GB 52 W 13

St. Combs Aberdeenshire GB 187 G 19

St. Cyrus Aberdeenshire GB 161 J 18

St. David's Pembrokeshire GB 86 T 12

St. Dennis Cornwall GB 52 W 13

St. Dogmaels Pembrokeshire GB 86 S 13

St. Donats Vale of Glamorgan GB 53 U 15

St. Fergus Aberdeenshire GB 187 G 19

St. Fillans Perth and Kinross GB 160 K 14

St. Gennys Cornwall GB 52 V 13

St. Harmon Powys GB 86/87 S 15

St. Helens St Helens GB 119 Q 17

St. Helens Isle of Wight GB 70 V 20

St. Helier Channel Islands GB 66 Y 18

St. Issey Cornwall GB 52 W 13

St. Ive Cornwall GB 52/53 W 14

St. Ives Cambridgeshire GB 100/101 S 22

St. Ives Cornwall GB 52 W 12

St. John Channel Islands GB 66 Y 18

St. John´s Chapel Durham GB 147 N 18

St. John´s Town of Dalry Dumfries und Galloway GB 146 M 14

St. John's Isle of Man GB 146 O 13

St. Johnstown Donegal IRL 207 N 8

St. Just Cornwall GB 52 W 11

St. Keverne Cornwall GB 52 W 12

St. Margaret's at Cliffe Kent GB 71 U 25

St. Margaret's Hope Orkney Islands GB 198 E 17

St. Martin Channel Islands GB 66 Y 17

St. Martin Channel Islands GB 66 Y 18

St. Martin´s Shropshire GB 119 R 16

St. Mary's Orkney Islands GB 198 E 17

St. Mary's Bay Kent GB 71 U 24

St. Mawes Cornwall GB 52 W 13

St. Mellion Cornwall GB 52/53 W 14

St. Mellons Cardiff GB 87 T 16

St. Merryn Cornwall GB 52 V 12

St. Minver Cornwall GB 52 V 13

St. Monans Fife GB 161 K 17

St. Mullin's Carlow IRL 233 S 9

St. Neot Cornwall GB 52 W 13

St. Neots Cambridgeshire GB 100/101 S 22

St. Nicholas Pembrokeshire GB 86 T 12

St. Osyth Essex GB 71 T 25

St. Peter Channel Islands GB 66 Y 18

St. Peter Port Channel Islands GB 66 Y 17

St. Sampson Channel Islands GB 66 Y 17

St. Stephen Cornwall GB 52 W 13

St. Teath Cornwall GB 52 V 13

St. Vigeans Angus GB 161 J 18

St. Weonards Herefordshire GB 87 T 17

Stadhampton Oxfordshire GB 70 T 20

Stadhlaigearraidh Na h-Eileanan an Iar GB 175 H 8

Staffin Highland GB 186 G 10

Stafford Staffordshire GB 100 R 18

Stagsden Bedfordshire GB 100 S 21

Staindrop Durham GB 147 N 19

Staines Surrey GB 71 U 22

Stainforth North Yorkshire GB 147 O 18

Stainton Stockton-on-Tees GB 147 O 20

Staintondale North Yorkshire GB 135 O 22

Staithes North Yorkshire GB 147 N 21

Stalbridge Dorset GB 70 V 18

Stalham Norfolk GB 101 R 26

Stalling Busk North Yorkshire GB 147 O 18

Stamford Lincolnshire GB 100/101 R 22

Stamford Bridge East Riding of Yorkshire GB 134/135 P 21

Stamfordham Northumberland GB 147 M 19

Standish Wigan GB 119 P 17

Standlake Oxfordshire GB 70 T 20

Standon Staffordshire GB 100 R 18

Standon Hertfordshire GB 71 T 23

Stanford-le-Hope Thurrock GB 71 U 23

Stanhope Durham GB 147 N 18

Stanley Durham GB 147 N 19

Stanley Perth and Kinross GB 161 K 16

Stannington Northumberland GB 147 M 19

Stansted Mountfitchet Essex GB 71 T 23

Stanton Suffolk GB 101 S 24

Stanton Harcourt Oxfordshire GB 70 T 20

Stanton St John Oxfordshire GB 70 T 20

Stanway Gloucestershire GB 70 T 19

Staoinebrig Na h-Eileanan an Iar GB 175 H 8

Staple Fitzpaine Somerset GB 53 V 16

Stapleford Nottinghamshire GB 100 R 20

Stapleford Wiltshire GB 70 U 19

Staplehurst Kent GB 71 U 24

Starcross Devon GB 53 V 16

Stathern Leicestershire GB 100 R 21

Staunton Gloucestershire GB 70 T 18

Staunton-on-Wye Herefordshire GB 87 S 17

Staveley Derbyshire GB 134 Q 20

Staveley Cumbria GB 146/147 O 17

Staverton Gloucestershire GB 70 T 18

Staxigoe Highland GB 187 F 16

Staxton North Yorkshire GB 135 O 22

Ste. Anne Channel Islands GB 66 X 18

Stebbing Essex GB 71 T 23

Steeple Bumpstead Essex GB 101 S 23

Steeple Claydon Buckinghamshire GB 70/71 T 21

Steeple Morden Cambridgeshire GB 100/101 S 22

Stenton East Lothian GB 161 L 17

Steornabhagh Stornoway Na h-Eileanan an Iar GB 186 F 10

Stephen Cumbria GB 147 O 18

Stevenage Hertfordshire GB 71 T 22

Stevenston North Ayrshire GB 160 L 13

Steventon Oxfordshire GB 70 T 20

Stevning West Sussex GB 71 V 22

Stewarton East Ayrshire GB 160 L 14

Stewarton Argyll and Bute GB 174 M 11

Stewartstown Tyrone GB 207 N 9

Stewkley Buckinghamshire GB 70/71 T 21

Stibb Cross Devon GB 52/53 V 14

Stichill Scottish Borders GB 161 L 18

Sticker Cornwall GB 52 W 13

Stickford Lincolnshire GB 135 Q 23

Stickney Lincolnshire GB 135 Q 23

Stillington North Yorkshire GB 147 O 20

Stilton Cambridgeshire GB 100/101 S 22

Stirling Stirling GB 160/161 K 15

Stobo Scottish Borders GB 161 L 16

Stock Essex GB 71 T 23

Stockbridge Hampshire GB 70 U 20

Stockland Devon GB 53 V 16

Stockland Bristol Somerset GB 53 U 16

Stockport Stockport GB 134 Q 18

Stocksbridge Sheffield GB 134 Q 19

Stockton Wiltshire GB 70 U 18

Stockton-on-Tees Stockton-on-Tees GB 147 N 20

Stockwith Nottinghamshire GB 134/135 Q 21

Stoer Highland GB 186 F 12

Stoke Medway GB 71 U 24

Stoke Albany Northhamptonshire GB 100 S 21

Stoke Ferry Norfolk GB 101 R 24

Stoke Fleming Devon GB 53 W 15

Stoke Golding Leicestershire GB 100 R 20

Stoke Hammond Buckinghamshire GB 70/71 T 21

Stoke Prior Worcestershire GB 87 S 18

Stoke-by-Nayland Suffolk GB 71 T 24

Stokenchurch Buckinghamshire GB 70/71 T 21

Stoke-on-Trent Stoke-on-Trent GB 134 Q 18

Stokesley North Yorkshire GB 147 O 20

Stone Staffordshire GB 100 R 18

Stone Gloucestershire GB 70 T 18

Stone Buckinghamshire GB 70/71 T 21

Stonehaugh Northumberland GB 147 M 18

Stonehaven Aberdeenshire GB 161 J 18

Stonehouse South Lanarkshire GB 160/161 L 15

Stonehouse Gloucestershire GB 70 T 18

Stoneleigh Warwickshire GB 100 S 19

Stoneykirk Dumfries und Galloway GB 146 N 13

Stoneywood Aberdeen City GB 187 H 18

Stonor Oxfordshire GB 70/71 T 21

Stony Stratford Milton Keynes GB 100 S 21

Stonybreck Shetland Islands GB 199 C 19

Stornoway Steornabhagh Na h-Eileanan an Iar GB 186 F 10

Storrington West Sussex GB 71 V 22

Stotfold Bedfordshire GB 100/101 S 22

Stourbridge Dudley GB 87 S 18

Stourport-on-Severn Worcestershire GB 87 S 18

Stourton Wiltshire GB 70 U 18

Stow Scottish Borders GB 161 L 17

Stowmarket Suffolk GB 101 S 24

Stow-on-the-Wold Gloucestershire GB 70 T 19

Strabane Tyrone GB 207 N 8

Strachan Aberdeenshire GB 187 H 17

Strachur Argyll and Bute GB 160 K 12

Stradbally Kerry IRL 232 S 2

Stradbally Laois IRL 233 R 8

Stradbally Waterford IRL 233 S 8

Stradbroke Suffolk GB 101 S 25

Strade Mayo IRL 218 P 4

Stradone Cavan IRL 219 P 8

Straiton South Ayrshire GB 146 M 13

Strandhill Sligo IRL 206 O 5

Strangford Down GB 207 O 11

Stranocum Antrim GB 207 M 10

Stranorlar Donegal IRL 206 N 7

Stranraer Dumfries und Galloway GB 146 N 12

Stratfield Mortimer West Berkshire GB 70 U 20

Stratford Wicklow IRL 219 Q 9

Stratford St. Mary Essex GB 71 T 24

Stratford-upon-Avon Warwickshire GB 100 S 19

Strath Kanaird Highland GB **186** G 12

Strathan Highland GB **160** J 12

Strathaven South Lanarkshire GB **160** L 14

Strathblane Stirling GB **160** L 14

Strathcarron Highland GB **186** H 12

Strathdon Aberdeenshire GB **187** H 16

Strathkinness Fife GB **161** K 17

Strathmiglo Fife GB **161** K 16

Strathpeffer Highland GB **186** G 13

Strathy Highland GB **198** E 15

Strathyre Stirling GB **160** K 14

Stratton Cornwall GB **52** V 13

Stratton Audley Oxfordshire GB **70** T 20

Streatley Bedfordshire GB **71** T 22

Street Somerset GB **53** U 17

Strensall York GB **147** O 20

Strete Devon GB **53** W 15

Stretham Cambridgeshire GB **101** S 23

Stretton Rutland GB **100** R 21

Stretton Warrington GB **119** Q 17

Stretton Sugwas Herefordshire GB **87** S 17

Strichen Aberdeenshire GB **187** G 18

Strokestown Roscommon IRL **218/219** P 6

Stromeferry Highland GB **175** H 11

Stromemore Highland GB **175** H 11

Stromness Orkney Islands GB **198** E 16

Stronachlachar Stirling GB **160** K 13

Strontian Highland GB **174** J 11

Strood Medway GB **71** U 23

Stroud Gloucestershire GB **70** T 18

Struy Highland GB **186** H 13

Stuartfield Aberdeenshire GB **187** H 18

Studland Dorset GB **70** V 19

Studley Warwickshire GB **100** S 19

Sturminster Newton Dorset GB **70** V 18

Sturry Kent GB **71** U 25

Sturton by Stow Lincolnshire GB **134/135** Q 21

Sudbury Derbyshire GB **100** R 19

Sudbury Suffolk GB **101** S 24

Sulaisiadar Na h-Eileanan an Iar GB **186** F 10

Sulby Isle of Man GB **146** O 14

Sullom Shetland Islands GB **199** B 20

Sully Vale of Glamorgan GB **53** U 16

Summer Bridge North Yorkshire GB **147** O 19

Summerhill Meath IRL **219** Q 9

Sunbury Surrey GB **71** U 22

Sunderland Sunderland GB **147** N 20

Sunk Island East Riding of Yorkshire GB **135** P 22

Sunningdale Windsor & Maidenhead GB **70/71** U 21

Sutterton Lincolnshire GB **100/101** R 22

Sutton Cambridgeshire GB **101** S 23

Sutton Nottinghamshire GB **134/135** Q 21

Sutton West Sussex GB **70/71** V 21

Sutton Greater London GB **71** U 22

Sutton Bridge Lincolnshire GB **101** R 23

Sutton Coldfield Birmingham GB **100** R 19

Sutton in Ashfield Nottinghamshire GB **134** Q 20

Sutton on Sea Lincolnshire GB **135** Q 23

Sutton Scotney Hampshire GB **70** U 20

Sutton St James Lincolnshire GB **101** R 23

Sutton Valence Kent GB **71** U 24

Sutton Wick Bath & NE Somerset GB **53** U 17

Sutton-on--the-Forest North Yorkshire GB **147** O 20

Sutton-under-Whitestonecliffe North Yorkshire GB **147** O 20

Swadlincote Derbyshire GB **100** R 19

Swaffham Norfolk GB **101** R 24

Swainby North Yorkshire GB **147** O 20

Swainshill Herefordshire GB **87** S 17

Swalcliffe Oxfordshire GB **100** S 20

Swallow North East Lincolnshire GB **135** P 22

Swallowcliffe Wiltshire GB **70** U 18

Swan Laois IRL **233** R 8

Swanage Dorset GB **70** V 19

Swanbister Orkney Islands GB **198** E 16

Swanley Kent GB **71** U 23

Swanlinbar Cavan IRL **206** O 7

Swansea Abertawe Swansea GB **86/87** T 15

Swanton Morley Norfolk GB **101** R 24

Swardeston Norfolk GB **101** R 25

Swarragh Londonderry GB **207** N 9

Swavesey Cambridgeshire GB **101** S 23

Sway Hampshire GB **70** V 19

Swayfield Lincolnshire GB **100** R 21

Swimbridge Devon GB **53** U 15

Swindon Swindon GB **70** T 19

Swineshead Lincolnshire GB **100/101** R 22

Swineshead Bedfordshire GB **100/101** S 22

Swinford Leicestershire GB **100** S 20

Swinford Mayo IRL **218** P 5

Swinton Scottish Borders GB **161** L 18

Swords Dublin IRL **219** Q 10

Syderstone Norfolk GB **101** R 24

Sykehouse Doncaster GB **134** P 20

Symbister Shetland Islands GB **199** B 20

Symington South Ayrshire GB **160** L 13

Symington South Lanarkshire GB **160/161** L 15

Syre Highland GB **186/187** F 14

Syresham Northamptonshire GB **100** S 20

Syston Leicestershire GB **100** R 20

T

Tadcaster North Yorkshire GB **134** P 20

Taddington Derbyshire GB **134** Q 19

Tadworth Surrey GB **71** U 22

Taghmon Wexford IRL **233** S 9

Tagoat Wexford IRL **233** S 10

Tain Highland GB **186/187** G 14

Tairbeart Tarbert Na h-Eileanan an Iar GB **175** G 9

Takeley Essex GB **71** T 23

Talaton Devon GB **53** V 16

Talgarth Powys GB **87** T 16

Talisker Highland GB **175** H 10

Talladale Highland GB **186** G 11

Tallaght Dublin IRL **219** Q 10

Talley Carmarthenshire GB **86/87** T 15

Tallow Waterford IRL **232/233** S 6

Talmine Highland GB **186/187** E 14

Talsarnau Gwynedd GB **118/119** R 14

Talwrn Anglesey GB **118/119** Q 14

Tal-y-bont Ceredigion GB **86/87** S 15

Tal-y-cafn Conwy GB **119** Q 15

Talysarn Gwynedd GB **118/119** Q 14

Tamerton Foliot Plymouth GB **52/53** W 14

Tamworth Staffordshire GB **100** R 19

Tandragee Armagh GB **207** O 10

Tang Westmeath IRL **219** P 7

Tangwick Shetland Islands GB **199** B 19

Tannadice Angus GB **161** J 18

Taobh Tuath Na h-Eileanan an Iar GB **175** G 8

Tara Meath IRL **219** P 9

Tarbert Argyll and Bute GB **160** L 12

Tarbert Tairbeart Na h-Eileanan an Iar GB **175** G 9

Tarbert Kerry IRL **232** R 4

Tarbet Argyll and Bute GB **160** K 13

Tarbet Highland GB **186** F 12

Tarbolton South Ayrshire GB **160** L 14

Tarfside Angus GB **161** J 18

Tarland Aberdeenshire GB **187** H 17

Tarleton Lancashire GB **119** P 17

Tarporley Cheshire GB **119** Q 17

Tarskavaig Highland GB **175** H 11

Tarves Aberdeenshire GB **187** H 18

Tarvin Cheshire GB **119** Q 17

Tattenhall Cheshire GB **119** Q 17

Taunton Somerset GB **53** U 16

Tavernspite Pembrokeshire GB **86** T 13

Tavistock Devon GB **52/53** V 14

Tawny Donegal IRL **206** M 7

Tawnyinah Mayo IRL **218** P 5

Tayinloan Argyll and Bute GB **174** L 11

Taynuilt Argyll and Bute GB **160** K 12

Tayport Fife GB **161** K 17

Tayvallich Argyll and Bute GB **174** K 11

Tealby Lincolnshire GB **135** Q 22

Teangue Highland GB **175** H 11

Tebay Cumbria GB **146/147** O 17

Tedavnet Monaghan IRL **207** O 8

Tedburn St. Mary Devon GB **53** V 15

Teelin Donegal IRL **206** N 5

Teignmouth Devon GB **53** V 16

Telford Shropshire GB **100** R 18

Telford Telford and Wrekin GB **100** R 18

Templand Dumfries und Galloway GB **146** M 16

Temple Midlothian GB **161** L 16

Temple Hirst North Yorkshire GB **134** P 20

Templeboy Sligo IRL **206** O 5

Templecombe Somerset GB **70** V 18

Templemartin Cork IRL **232** T 5

Templemore Tipperary IRL **233** R 7

Templenoe Kerry IRL **232** T 3

Templepatrick Antrim GB **207** N 10

Templeton Pembrokeshire GB **86** T 13

Templetouhy Tipperary IRL **233** R 7

Tempo Fermanagh GB **207** O 8

Tenbury Wells Worcestershire GB **87** S 17

Tenby Pembrokeshire GB **86** T 13

Tenterden Kent GB **71** U 24

Terling Essex GB **71** T 24

Termonfeckin Louth IRL **219** P 10

Ternhill Shropshire GB **119** R 17

Terrington North Yorkshire GB **134** O 21

Terrington St Clement Norfolk GB **101** R 23

Tetbury Gloucestershire GB **70** T 18

Tetney Lincolnshire GB **135** Q 22

Tetsworth Oxfordshire GB **70** T 20

Teviothead Scottish Borders GB **146/147** M 17

Tewkesbury Gloucestershire GB **70** T 18

Teynham Kent GB **71** U 24

Thame Oxfordshire GB **70/71** T 21

Thankerton South Lanarkshire GB **160/161** L 15

Thatcham West Berkshire GB **70** U 20

Thaxted Essex GB **71** T 23

The Barony Orkney Islands GB **198** D 16

The Cronk Isle of Man GB **146** O 13

The Downs Westmeath IRL **219** P 8

The Drones Antrim GB **207** M 10

The Hill Cumbria GB **146** O 16

The Loup Londonderry GB **207** N 9

The Mumbles Swansea GB **86** T 14

The Sheddings Antrim GB **207** N 10

The Temple Down GB **207** O 11

Theale West Berkshire GB **70** U 20

Therfield Hertfordshire GB **100/101** S 22

Thetford Norfolk GB **101** S 24

Thimbleby Lincolnshire GB **135** Q 22

Thirsk North Yorkshire GB **147** O 20

Thixendale North Yorkshire GB **134** O 21

Thomastown Kilkenny IRL **233** R 8

Thompson Norfolk GB **101** R 24

Thoresway Lincolnshire GB **135** Q 22

Thornbury South Gloucestershire GB **87** T 17

Thornby Northhamptonshire GB **100** S 20

Thorncombe Dorset GB **53** V 17

Thorndon Suffolk GB **101** S 25

Thorne Doncaster GB **134/135** P 21

Thorney Peterborough GB **100/101** R 22

Thornhill Dumfries und Galloway GB **146** M 15

Thornhill Stirling GB **160** K 14

Thornley Durham GB **147** N 20

Thornton Lancashire GB **119** P 17

Thornton Fife GB **161** K 16

Thornton Curtis North Lincolnshire GB **135** P 22

Thornton-in-Craven North Yorkshire GB **134** P 18

Thornton-le-Dale North Yorkshire GB **134** O 21

Thorpe on the Hill Lincolnshire GB **134/135** Q 21

Thorpe Thewles Stockton-on-Tees GB **147** N 20

Thorpe-le-Soken Essex GB **71** T 25

Thorpeness Suffolk GB **101** S 26

Thorrington Essex GB **71** T 25

Thorverton Devon GB **53** V 15

Thrapston Northhamptonshire GB **100** S 21

Threapwood Cheshire GB **119** R 17

Threecastles Kilkenny IRL **233** R 8

Threlkeld Cumbria GB **146** N 16

Threshfield North Yorkshire GB **147** O 18

Thropton Northumberland GB **147** M 19

Thrumster Highland GB **187** F 16

Thruxton Hampshire GB **70** U 19

Thurlby Lincolnshire GB **100/101** R 22

Thurles Durlas Tipperary IRL **233** R 7

Thurlestone Devon GB **53** W 15

Thurlow Suffolk GB **101** S 23

Thursby Cumbria GB **146** N 16

Thurso Highland GB **198** E 15

Thurstaston Wirral GB **119** Q 16

Thwaite North Yorkshire GB **147** O 18

Tibbermore Perth and Kinross GB **160/161** K 15

Tibberton Gloucestershire GB **70** T 18

Tibshelf Derbyshire GB **134** Q 20

Ticehurst East Sussex GB **71** U 23

Tickhill Doncaster GB **134** Q 20

Tideswell Derbyshire GB **134** Q 19

Tidworth Wiltshire GB **70** U 19

Tigerton Angus GB **161** J 18

Tigh a Ghearraidh Tigharry Na h-Eileanan an Iar GB **175** G 7

Tigharry Tigh a Ghearraidh Na h-Eileanan an Iar GB **175** G 7

Tigley Devon GB **53** W 15

Tilbury Thurrock GB **71** U 23

Tildarg Antrim GB **207** N 10

Tillicoultry Clackmannanshire GB **160/161** K 15

Tillingham Essex GB **71** T 24

Tillyfourie Aberdeenshire GB **187** H 17

Tilshead Wiltshire GB **70** U 19

Tilstock Shropshire GB **119** R 17

Tilston Cheshire GB **119** Q 17

Timahoe Laois IRL **233** R 8

Timberscombe Somerset GB **53** U 15

Timoleague Cork IRL **232** T 5

Timolin Kildare IRL **233** R 9

Timsgearraidh Na h-Eileanan an Iar GB **175** F 8

Tinahely Wicklow IRL **233** R 10

Tingewick Buckinghamshire GB **70** T 20

Tingwall Orkney Islands GB **198** D 16

Tintagel Cornwall GB **52** V 13

Tintern Monmouthshire GB **87** T 17

Tinwald Dumfries und Galloway GB **146** M 15

Tipperary Tipperary IRL **232/233** S 6

Tiptree Essex GB **71** T 24

Tirabad Powys GB **86/87** S 15

Tissington Derbyshire GB **134** Q 19

Tiverton Devon GB **53** V 15

Toab Shetland Islands GB **199** C 20

Tobercurry Sligo IRL **206** O 5

Tobermore Londonderry GB **207** N 9

Tobermory Argyll and Bute GB **174** J 10

Toberonochy Argyll and Bute GB **174** K 11

Tobha Mòr Na h-Eileanan an Iar GB **175** H 8

Tockwith North Yorkshire GB **134** P 20

Todmorden Calderdale GB **134** P 18

Togher Louth IRL **219** P 10

Togher Cork IRL **232** T 4

Tollerton North Yorkshire GB **147** O 20

Tollesbury Essex GB **71** T 24

Tolleshunt D'Arcy Essex GB **71** T 24

Tolstadh bho Thuath Na h-Eileanan an Iar GB **186** F 10

Tomatin Highland GB **187** H 14

Tomdoun Highland GB **186** H 12

Tomich Highland GB **186** H 13

Tomintoul Moray GB **187** H 16

Tomnavoulin Moray GB **187** H 16

Tonbridge Kent GB **71** U 23

Tondu Bridgend GB **86/87** T 15

Tongham Surrey GB **70/71** U 21

Tongland Dumfries und Galloway GB **146** N 14

Tongue Highland GB **186/187** F 14

Tonyrefail Rhondda Cynon Taff GB **87** T 16

Toombeola Galway IRL **218** Q 3

Toome Antrim GB **207** N 10

Toomyvara Tipperary IRL **232/233** R 6

Toormakeady Mayo IRL **218** P 4

Toormore Cork IRL **232** T 3

Topcliffe North Yorkshire GB **147** O 20

Topsham Devon GB **53** V 16

Torcross Devon GB **53** W 15

Tore Highland GB **186/187** G 14

Tormarton South Gloucestershire GB **70** U 18

Torphichen West Lothian GB **160/161** L 15

Torphins Aberdeenshire GB **187** H 17

Torpoint Cornwall GB **52/53** W 14

Torquay Torbay GB **53** W 16

Torridon Highland GB **186** G 12

Torrin Highland GB **175** H 11

Torthorwald Dumfries und Galloway GB **146** M 15

Torver Cumbria GB **146** O 16

Toscaig Highland GB **175** H 11

Totegan Highland GB **186/187** E 14

Totland Isle of Wight GB **70** V 19

Totnes Devon GB **53** W 15

Tottington Bury GB **134** P 18

Totton Hampshire GB **70** V 20

Tow Law Durham GB **147** N 19

Towcester Northhamptonshire GB **100** S 20

Towie Aberdeenshire GB **187** H 17

Town Yetholm Scottish Borders GB **161** L 18

Tralee Trá-Lí Kerry IRL **232** S 3

Tramore Waterford IRL **233** S 8

Tranent East Lothian GB **161** L 17

Trapp Carmarthenshire GB **86/87** T 15

Traquair Scottish Borders GB **161** L 16

Trawden Lancashire GB **134** P 18

Trawsfynydd Gwynedd GB **119** R 15

Trearddur Anglesey GB **118** Q 13

Treburley Cornwall GB **52/53** V 14

Trecastle Powys GB **86/87** T 15

Tredegar Blaenau Gwent GB **87** T 16

Treen Cornwall GB **52** W 11

Trefeglwys Powys GB **86/87** R 15

Treffgarne Pembrokeshire GB **86** T 13

Trefnant Denbighshire GB **119** Q 16

Trefonen Shropshire GB **119** R 16

Trefynwy Monmouth Monmouthshire GB **87** T 17

Tregaron Ceredigion GB **86/87** S 15

Tregonetha Cornwall GB **52** W 13

Tregony Cornwall GB **52** W 13

Tregynon Powys GB **87** R 16

Treherbert Rhondda Cynon Taff GB **86/87** T 15

Trelech Carmarthenshire GB **86** T 14

Treleddydfawr Pembrokeshire GB **86** T 12

Trelleck Monmouthshire GB **87** T 17

Trenance Cornwall GB **52** W 12

Tressait Perth and Kinross GB **160/161** J 15

Tresta Shetland Islands GB **199** A 21

Treuddyn Flintshire GB **119** Q 16

Trillick Tyrone GB **207** O 8

Trim Baile Atha Troim Meath IRL **219** P 9

Trimdon Durham GB **147** N 20

Trimingham Norfolk GB **101** R 25

Trinafour Perth and Kinross GB **160** J 14

Tring Hertfordshire GB **70/71** T 21

Trinity Channel Islands GB **66** Y 18

Trochry Perth and Kinross GB **160/161** J 15

Troon South Ayrshire GB **160** L 13

Troutbeck Bridge Cumbria GB **146/147** O 17

Trowbridge Wiltshire GB **70** U 18

Trull Somerset GB **53** V 16

Trumpan Highland GB **175** G 9

Trumpington Cambridgeshire GB **101** S 23

Trunch Norfolk GB **101** R 25

Truro Cornwall GB **52** W 12

Tuam Galway IRL **218** P 5

Tuddenham Suffolk GB **101** S 24

Tuddenham St Martin Suffolk GB **101** S 25

Tudhoe Durham GB **147** N 19

Tudweiliog Gwynedd GB **118** R 13

Tulla Clare IRL **232** R 5

Tullaghought Kilkenny IRL **233** S 8

Tullamore Tulach Mhor Offaly IRL **219** Q 8

Tullaroe Kerry IRL **232** S 3

Tulloch Highland GB **160** J 13

Tullow Carlow IRL **233** R 9

Tullynessle Aberdeenshire GB **187** H 17

Tulsk Roscommon IRL **218/219** P 6

Tumble Carmarthenshire GB **86** T 14

Tummel Bridge Perth and Kinross GB **160/161** J 15

Tunga Na h-Eileanan an Iar GB **186** F 10

Tunstall Suffolk GB **101** S 25

Tunstall East Riding of Yorkshire GB **135** P 23

Tuosist Kerry IRL **232** T 3

Turloughmore Galway IRL **218** Q 5

Turnberry South Ayrshire GB **146** M 13

Turnditch Derbyshire GB **134** Q 19

Turriff Aberdeenshire GB **187** G 18

Turvey Bedfordshire GB **100** S 21

Tutbury Staffordshire GB **100** R 19

Tuxford Nottinghamshire GB **134/135** Q 21

Twatt Orkney Islands GB **198** D 16

Tweedmouth Northumberland GB **161** L 19

Tweedsmuir Scottish Borders GB **161** L 16

Two Bridges Devon GB **53** V 15

Twycross Leicestershire GB **100** R 19

Twyford Leicestershire GB **100** R 21

Twyford Hampshire GB **70** U 20

Twyford Wokingham GB **70/71** U 21

Twynholm Dumfries und Galloway GB **146** N 14

Tydd St Giles Cambridgeshire GB **101** R 23

Tydd St Mary Lincolnshire GB **101** R 23

Tynagh Galway IRL **218/219** Q 6

Tyndrum Stirling GB **160** K 13

Tynemouth North Tyneside GB **147** M 20

Tynron Dumfries und Galloway GB **146** M 15

Tyrella Down GB **207** O 11

Tyrrellspass Westmeath IRL **219** Q 8

Tywyn Gwynedd GB **86** R 14

U

Uachdar Na h-Eileanan an Iar GB **175** H 8

Uckfield East Sussex GB **71** V 23

Udny Aberdeenshire GB **187** H 18

Uffculme Devon GB **53** V 16

Uffington Oxfordshire GB **70** T 19

Ufford Peterborough GB **100/101** R 22

Ufford Suffolk GB **101** S 25

Ugthorpe North Yorkshire GB **147** O 21

Uig Highland GB **186** G 10

Ulbster Highland GB **187** F 16

Ulceby North Lincolnshire GB **135** P 22

Uldale Cumbria GB **146** N 16

Uley Gloucestershire GB **70** T 18

Ulgham Northumberland GB **147** M 19

Ullapool Highland GB **186** G 12

Ullesthorpe Leicestershire GB **100** S 20

Ullock Cumbria GB **146** N 16

Ulpha Cumbria GB **146** O 16

Ulsta Shetland Islands GB **199** B 20

Ulverston Cumbria GB **146** O 16

Umberleigh Devon GB **53** V 15

Unapool Highland GB **186** F 12

Up Holland Lancashire GB **119** P 17

Upavon Wiltshire GB **70** U 19

Upham Hampshire GB **70** V 20

Uplawmoor East Renfrewshire GB **160** L 14

Upottery Devon GB **53** V 16

Upper Antrim GB **207** N 10

Upper Broughton Leicestershire GB **100** R 21

Upper Chapel Powys GB **87** S 16

Upper Knockando Moray GB **187** H 16

Upper Largo Fife GB **161** K 17

Upper Tean Staffordshire GB **100** R 19

Upperchurch Tipperary IRL **232/233** R 6

Upperlands Londonderry GB **207** N 9

Uppingham Rutland GB **100** R 21

Upton Wirral GB **119** Q 16

Upton Oxfordshire GB **70** T 20

Upton under Severn Worcestershire GB **87** S 18

Upwell Norfolk GB **101** R 23

Urchfont Wiltshire GB **70** U 19

Urlingford Kilkenny IRL **233** R 7

Urquhart Moray GB **187** G 16

Usk Monmouthshire GB **87** T 17

Uttoxeter Staffordshire GB **100** R 19

Uxbridge Greater London GB **71** T 22

Uyeasound Shetland Islands GB **199** A 21

V

Vale Channel Islands GB **66** X 17

Ventnor Isle of Wight GB **70** V 20

Ventry Kerry IRL **232** S 2

Vernham Dean Hampshire GB **70** U 19

Verwood Dorset GB **70** V 19

Vickerstown Cumbria GB **146** O 16

Victoria Cornwall GB **52** W 13

Vidlin Shetland Islands GB **199** B 20

Virginia Cavan IRL **219** P 8

Voe Shetland Islands GB **199** B 20

Vowchurch Herefordshire GB **87** S 17

W

Waddesdon Buckinghamshire GB **70/71** T 21

Waddeton Devon GB **53** W 15

Waddingham Lincolnshire GB **134/135** Q 21

Waddington Lancashire GB **134** P 18

Waddington Lincolnshire GB **134/135** Q 21

Wadebridge Cornwall GB **52** V 13

Wadhurst East Sussex GB **71** U 23

Wadworth Doncaster GB **134** Q 20

Wainfleet All Saints Lincolnshire GB **135** Q 23

Wainhouse Corner Cornwall GB **52** V 13

Wakefield Wakefield GB **134** P 19

Wakes Colne Essex GB **71** T 24

Walberswick Suffolk GB **101** S 26

Walcott Lincolnshire GB **135** Q 22

Wales Rotherham GB **134** Q 20

Walford Herefordshire GB **87** S 17

Walgherton Cheshire GB **134** Q 18

Walkerburn Scottish Borders GB **161** L 16

Walkeringham Nottinghamshire GB **134/135** Q 21

Walkern Hertfordshire GB **71** T 22

Walkington East Riding of Yorkshire GB **135** P 22

Wall Northumberland GB **147** M 18

Wallesey Wirral GB **119** Q 16

Wallingford Oxfordshire GB **70** T 20

Walls Shetland Islands GB **199** B 19

Walmer Kent GB **71** U 25

Walpole Norfolk GB **101** R 23

Walsden Calderdale GB **134** P 18

Walshall Walsall GB **100** R 19

Walsham le Willows Suffolk GB **101** S 24

Waltham North East Lincolnshire GB **135** P 22

Waltham Essex GB **71** T 23

Waltham Kent GB **71** U 25

Waltham on the Wolds Leicestershire GB **100** R 21

Walton Cumbria GB **146/147** N 17

Walton Powys GB **87** S 16

Walton-on-Thames Surrey GB **71** U 22

Walton-on-the-Naze Essex GB **71** T 25

Walton-on-Trent Derbyshire GB **100** R 19

Wanborough Swindon GB **70** T 19

Wangford Suffolk GB **101** S 26

Wanlockhead South Lanarkshire GB **146** M 15

Wansford Northhamptonshire GB **100/101** R 22

Wanstrow Somerset GB **70** U 18

Wantage Oxfordshire GB **70** T 20

Warboys Cambridgeshire GB **100/101** S 22

Warbstow Cornwall GB **52** V 13

Warcop Cumbria GB **147** N 18

Ware Hertfordshire GB **71** T 22

Wareham Dorset GB **70** V 18

Wargrave Wokingham GB **70/71** T 21

Wark Northumberland GB **147** M 18

Warkworth Northumberland GB **147** M 19

Warlingham Surrey GB **71** U 22

Warmington Northhamptonshire GB **100/101** R 22

Warminster Wiltshire GB **70** U 18

Warrenpoint Down GB **207** O 10

Warrington Warrington GB **119** Q 17

Warsash Hampshire GB **70** V 20

Warslow Staffordshire GB **134** Q 19

Warter East Riding of Yorkshire GB **134/135** P 21

Wartle Aberdeenshire GB **187** H 18

Warwick Warwickshire GB **100** S 19

Warwick-on-Eden Cumbria GB **146/147** N 17

Wasbister Orkney Islands GB **198** D 16

Wasdale Head Cumbria GB **146** O 16

Washford Somerset GB **53** U 16

Washington Sunderland GB **147** N 19

Washington West Sussex GB **71** V 22

Watchet Somerset GB **53** U 16

Waterbeach Cambridgeshire GB **101** S 23

Waterbeck Dumfries und Galloway GB **146** M 16

Waterford Port Láirge Waterford IRL **233** S 8

Watergrasshill Cork IRL **232/233** S 6

Waterhouses Staffordshire GB **134** Q 19

Wateringbury Kent GB **71** U 23

Waterlooville Hampshire GB **70** V 20

Waterrow Somerset GB **53** U 16

Waterside East Ayrshire GB **146** M 14

Waterville Kerry IRL **70** T 2

Watford Hertfordshire GB **71** T 22

Watlington Oxfordshire GB **70** T 20

Watten Highland GB **187** F 16

Watton Norfolk GB **101** R 24

Watton at Stone Hertfordshire GB **71** T 22

Waverton Cumbria GB **146** N 16

Wawne Kingston upon Hull GB **135** P 22

Weasenham Norfolk GB **101** R 24

Weaverham Cheshire GB **119** Q 17

Weaverthorpe North Yorkshire GB **135** O 21

Wedmore Somerset GB **53** U 17

Wednesbury Wolverhampton GB **100** R 18

Weedon Bec Northhamptonshire GB **100** S 20

Weeley Essex GB **71** T 25

Weem Perth and Kinross GB **160/161** J 15

Weeton North Yorkshire GB **134** P 19

Welbury North Yorkshire GB **147** O 20

Welby Lincolnshire GB **100** R 21

Weldon Northhamptonshire GB **100** S 21

Welford Northhamptonshire GB **100** S 20

Well North Yorkshire GB **147** O 19

Welland Worcestershire GB **87** S 18

Wellesbourne Warwickshire GB **100** S 19

Wellingborough Northhamptonshire GB **100** S 21

Wellington Shropshire GB **100** R 18

Wellington Telford and Wrekin GB **100** R 18

Wellington Somerset GB **53** V 16

Wellington Herefordshire GB **87** S 17

Wellingtonbridge Wexford IRL **233** S 9

Wells Somerset GB **53** U 17

Wells Powys GB **87** S 16

Wells-next-the-Sea Norfolk GB **101** R 24

Welney Norfolk GB **101** R 23

Welshampton Shropshire GB **119** R 17

Welshpool Y Trallwng Powys GB **87** R 16

Welton East Riding of Yorkshire GB **134/135** P 21

Welwyn Hertfordshire GB **71** T 22

Welwyn Garden City Hertfordshire GB **71** T 22

Wem Shropshire GB **119** R 17

Wembley Greater London GB **71** T 22

Wendens Ambo Essex GB **71** T 23

Wendling Norfolk GB **101** R 24

Wendover Buckinghamshire GB **70/71** T 21

Wensley North Yorkshire GB **147** O 19

Wenvoe Vale of Glamorgan GB **53** U 16

Weobley Herefordshire GB **87** S 17

Wernyss Bay Inverclyde GB **160** L 13

West Auckland Durham GB **147** N 19

West Bay Dorset GB **53** V 17

West Bergholt Essex GB **71** T 24

West Bexington Dorset GB **53** V 17

West Burrafirth Shetland Islands GB **199** B 19

West Calder West Lothian GB **160/161** L 15

West Chevington Northumberland GB **147** M 19

West Dean Wiltshire GB **70** U 19

West Down Devon GB **52/53** U 14

West Felton Shropshire GB **119** R 17

West Grinstead West Sussex GB **71** V 22

West Haddon Northhamptonshire GB **100** S 20

West Harptree Bath & NE Somerset GB **53** U 17

West Heslerton North Yorkshire GB **134** O 21

West Hoathly West Sussex GB **71** U 22

West Horsley Surrey GB **71** U 22

West Kilbride North Ayrshire GB **160** L 13

West Kirby Wirral GB **119** Q 16

West Linton Scottish Borders GB **161** L 16

West Lulworth Dorset GB **70** V 18

West Lutton North Yorkshire GB **134** O 21

West Malling Kent GB **71** U 23

West Meon Hampshire GB **70** U 20

West Mersea Essex GB **71** T 24

West Moors Dorset GB **70** V 19

West Overton Wiltshire GB **70** U 19

West Rasen Lincolnshire GB **135** Q 22

West Rudham Norfolk GB **101** R 24

West Saltoun East Lothian GB **161** L 17

West Sandwick Shetland Islands GB **199** A 20

West Tanfield North Yorkshire GB **147** O 19

West Tarbert Argyll and Bute GB **160** L 12

West Thorney West Sussex GB **70/71** V 21

West Town Donegal IRL **206** M 6

West Wellow Hampshire GB **70** V 19

West Wemyss Fife GB **161** K 16

West Wittering West Sussex GB **70/71** V 21

West Witton North Yorkshire GB **147** O 19

West Woodburn Northumberland GB **147** M 18

Westbury Wiltshire GB **70** U 18

Westbury Shropshire GB **87** R 17

Westbury-sub-Mendip Somerset GB **53** U 17

Wester Quarff Shetland Islands GB **199** B 20

Westerdale North Yorkshire GB **134** O 21

Westerdale Highland GB **187** F 15

Westerfield Shetland Islands GB **199** B 20

Westerham Kent GB **71** U 23

Westerleigh South Gloucestershire GB **70** T 18

Westfield Highland GB **198** E 15

Westgate Durham GB **147** N 18

Westhill Aberdeen City GB **187** H 18

Westing Shetland Islands GB **199** A 21

Westleton Suffolk GB **101** S 26

Westminster Greater London GB **71** T 22

Westnewton Cumbria GB **146** N 16

Weston Lincolnshire GB **100/101** R 22

Weston Underwood Derbyshire GB **100** R 19

Weston-super-Mare North Somerset GB **53** U 17

Westonzoyland Somerset GB **53** U 17

Westport Cathair na Mart Mayo IRL **218** P 3

Westruther Scottish Borders GB **161** L 17

Westward Ho! Devon GB **52/53** U 14

Wetheral Cumbria GB **146/147** N 17

Wetherby Leeds GB **134** P 20

Wetwang East Riding of Yorkshire GB **134** O 21

Wexford Loch Garman Wexford IRL **233** S 10

Weyhill Hampshire GB **70** U 19

Weymouth Dorset GB **70** V 18

Whaley Bridge Derbyshire GB **134** Q 19

Whalley Lancashire GB **134** P 18

Whalton Northumberland GB **147** M 19

Whaplode Lincolnshire GB **100/101** R 22

Whauphill Dumfries und Galloway GB **146** N 14

Wheathampstead Hertfordshire GB **71** T 22

Wheatley Oxfordshire GB **70** T 20

Wheaton Aston Staffordshire GB **100** R 18

Wheldrake York GB **134/135** P 21

Whickham Gateshead GB **147** N 19

Whissendine Rutland GB **100** R 21

Whissonsett Norfolk GB **101** R 24

Whitbeck Cumbria GB **146** O 16

Whitbourne Herefordshire GB **87** S 18

Whitburn South Tyneside GB **147** N 20

Whitburn West Lothian GB **160/161** L 15

Whitby North Yorkshire GB **134** O 21

Whitchurch Shropshire GB **119** R 17

Whitchurch Hampshire GB **70** U 19

Whitchurch Buckinghamshire GB **70/71** T 21

Whitchurch Herefordshire GB **87** T 17

White Notley Essex GB **71** T 24

Whitegate Clare IRL **232/233** R 6

Whitegate Cork IRL **232/233** T 6

Whitehall Orkney Islands GB **198** D 17

Whitehall Westmeath IRL **219** P 8

Whitehall Kilkenny IRL **233** R 8

Whitehaven Cumbria GB **146** N 15

Whitehead Antrim GB **207** N 11

Whitehills Aberdeenshire GB **187** G 17

Whitehouse Argyll and Bute GB **160** L 12

Whitekirk East Lothian GB **161** K 17

Whiteparish Wiltshire GB **70** U 19

White's Cross Cork IRL **232/233** T 6

Whitesides Corner Antrim GB **207** N 10

Whitfield Northumberland GB **147** N 18

Whithersfield Suffolk GB **101** S 23

Whithorn Dumfries und Galloway GB **146** N 14

Whiting Bay North Ayrshire GB **174** M 12

Whitland Carmarthenshire GB **86** T 13

Whitley Bay North Tyneside GB **147** M 20

Whitley Chapel Northumberland GB **147** N 18

Whitmore Staffordshire GB **100** R 18

Whitney-on-Wye Herefordshire GB **87** S 16

Whitsome Scottish Borders GB **161** L 18

Whitstable Kent GB **71** U 25

Whitstone Cornwall GB **52/53** V 14

Whittingham Northumberland GB **147** M 19

Whittington Staffordshire GB **100** R 19

Whittington Shropshire GB **119** R 16

Whittington Derbyshire GB **134** Q 20

Whittlebury Northhamptonshire GB **100** S 21

Whittle-le-Woods Lancashire GB **119** P 17

Whittlesey Cambridgeshire GB **100/101** R 22

Whitton North Lincolnshire GB **134/135** P 21

Whitton Powys GB **87** S 16

Whitwell Derbyshire GB **134** Q 20

Whitwell Isle of Wight GB **70** V 20

Whitwell Hertfordshire GB **71** T 22

Whitwick Leicestershire GB **100** R 20

Whitworth Lancashire GB **134** P 18

Wick Highland GB **187** F 16

Wick Vale of Glamorgan GB **53** U 15

Wick South Gloucestershire GB **70** U 18

Wicken Cambridgeshire GB **101** S 23

Wickford Essex GB **71** T 24

Wickham Market Suffolk GB **101** S 25

Wickhambrook Suffolk GB **101** S 24

Wicklow Wicklow IRL **233** R 10

Wickwar South Gloucestershire GB **70** T 18

Widdrington Northumberland GB **147** M 19

Widecombe in the Moor Devon GB **53** V 15

Widegates Cornwall GB **52/53** W 14

Wideopen North Tyneside GB **147** M 19

Widford Hertfordshire GB **71** T 23

Widnes Halton GB **119** Q 17

Wigan Wigan GB **119** P 17

Wiggenhall St Germans Norfolk GB **101** R 23

Wigglesworth North Yorkshire GB **147** O 18

Wighill North Yorkshire GB **134** P 20

Wigmore Herefordshire GB **87** S 17

Wigston Leicestershire GB **100** R 20

Wigton Cumbria GB **146** N 16

Wigtown Dumfries und Galloway GB **146** N 14

Wilberfoss East Riding of Yorkshire GB **134/135** P 21

Wilkhaven Highland GB **187** G 15

Wilkinstown Meath IRL **219** P 9

Willaston Cheshire GB **119** Q 17

Willersey Gloucestershire GB **100** S 19

Williamstown Galway IRL **218** P 5

Willingham Cambridgeshire GB **101** S 23

Willingham by Stow Lincolnshire GB **134/135** Q 21

Willington Derbyshire GB **100** R 19

Willington Durham GB **147** N 19

Williton Somerset GB **53** U 16

Willoughby Lincolnshire GB **135** Q 23

Willoughby-on-the-Wolds Nottinghamshire GB **100** R 20

Wilmslow Cheshire GB **134** Q 18

Wilton Wiltshire GB **70** U 19

Wimblington Cambridgeshire GB **101** R 23

Wimborne Minster Dorset GB **70** V 18

Wincanton Somerset GB **70** U 18

Winchcombe Gloucestershire GB **70** T 19

Winchelsea East Sussex GB **71** V 24

Winchester Hampshire GB **70** U 20

Windermere Cumbria GB **146/147** O 17

Windlesham Surrey GB **70/71** U 21

Windsor Windsor & Maidenhead GB **70/71** U 21

Wing Buckinghamshire GB **70/71** T 21

Wingate Durham GB **147** N 20

Wingham Kent GB **71** U 25

Winkfield Bracknell Forest GB **70/71** U 21

Winkleigh Devon GB **53** V 15

Winksley North Yorkshire GB **147** O 19

Winscombe North Somerset GB **53** U 17

Winsford Cheshire GB **119** Q 17

Winsford Somerset GB **53** U 15

Winsham Somerset GB **53** V 17

Winslow Buckinghamshire GB **70/71** T 21

Winster Derbyshire GB **134** Q 19

Winster Cumbria GB **146/147** O 17

Winston Durham GB **147** N 19

Winstone Gloucestershire GB **70** T 18

Winterborne Stickland Dorset GB **70** V 18

Winterbourne South Gloucestershire GB **70** T 18

Winterbourne Abbas Dorset GB **53** V 17

Winteringham North Lincolnshire GB **134/135** P 21

Winterton-on-Sea Norfolk GB **101** R 26

Winton Cumbria GB **147** O 18

Wintringham North Yorkshire GB **134** O 21

Wirksworth Derbyshire GB **134** Q 19

Wisbech Cambridgeshire GB **101** R 23

Wisbech St Mary Cambridgeshire GB **101** R 23

Wisborough Green West Sussex GB **71** U 22

Wishaw North Lanarkshire GB **160/161** L 15

Wistanstow Shropshire GB **87** S 17

Wiston South Lanarkshire GB **160/161** L 15

Wiston Pembrokeshire GB **86** T 13

Wistow North Yorkshire GB **134** P 20

Witchampton Dorset GB **70** V 18

Witchford Cambridgeshire GB **101** S 23

Witham Essex GB **71** T 24

Witham Friary Somerset GB **70** U 18

Witheridge Devon GB **53** V 15

Withernsea East Riding of Yorkshire GB **135** P 23

Withernwick East Riding of Yorkshire GB **135** P 22

Withington Gloucestershire GB **70** T 19

Withington Herefordshire GB **87** S 17

Withleigh Devon GB **53** V 15

Withnell Lancashire GB **119** P 17

Withycombe Somerset GB **53** U 16

Withypool Somerset GB **53** U 15

Witley Surrey GB **70/71** U 21

Witney Oxfordshire GB **70** T 19

Wittersham Kent GB **71** U 24

Witton Park Durham GB **147** N 19

Witton-le-Wear Durham GB **147** N 19

Wiveliscombe Somerset GB **53** U 16

Wivenhoe Essex GB **71** T 24

Wix Essex GB **71** T 25

Woburn Bedfordshire GB **70/71** T 21

Woburn Sands Milton Keynes GB **100** S 21

Woking Surrey GB **70/71** U 21

Wokingham Wokingham GB **70/71** U 21

Wold Newton North East Lincolnshire GB **135** Q 22

Wolferton Norfolk GB **101** R 23

Wollaston Northhamptonshire GB **100** S 21

Wolsingham Durham GB **147** N 19

Wolverhampton Wolverhampton GB **100** R 18

Wolverton Milton Keynes GB **100** S 21

Wolvey Warwickshire GB **100** S 20

Wolviston Stockton-on-Tees GB **147** N 20

Wombourne Staffordshire GB **100** R 18

Wombwell Barnsley GB **134** P 20

Wonersh Surrey GB **70/71** U 21

Wooburn Buckinghamshire GB **70/71** T 21

Woodbridge Suffolk GB **101** S 25

Woodchester Gloucestershire GB **70** T 18

Woodchurch Kent GB **71** U 24

Woodcote Oxfordshire GB **70** T 20

Woodenbridge Wicklow IRL **233** R 10

Woodford Galway IRL **218/219** Q 6

Woodford Halse Northhamptonshire GB **100** S 20

Woodhall Spa Lincolnshire GB **135** Q 22

Woodland Durham GB **147** N 19

Woodseaves Staffordshire GB **100** R 18

Woodstock Oxfordshire GB **70** T 20

Woodton Norfolk GB **101** R 25

Woofferton Shropshire GB **87** S 17

Wookey Somerset GB **53** U 17

Wool Dorset GB **70** V 18

Woolacombe Devon GB **52/53** U 14

Wooler Northumberland GB **161** L 18

Woolfardisworthy Devon GB **52/53** V 14

Wooperton Northumberland GB **147** M 19

Woore Shropshire GB **100** R 18

Wootton Oxfordshire GB **70** T 20

Wootton Oxfordshire GB **70** T 20

Wootton Bassett Wiltshire GB **70** T 19

Wootton Wawen Warwickshire GB **100** S 19

Worcester Worcestershire GB **87** S 18

Workington Cumbria GB **146** N 15

Worksop Nottinghamshire GB **134** Q 20

Worlaby North Lincolnshire GB **135** P 22

Wormit Fife GB **161** K 17

Wormshill Kent GB **71** U 24

Worplesdon Surrey GB **70/71** U 21

Worthing West Sussex GB **71** V 22

Wotton-under-Edge Gloucestershire GB **70** T 18

Wouldham Kent GB **71** U 23

Wragby Lincolnshire GB **135** Q 22

Wrangle Lincolnshire GB **135** Q 23

Wray Lancashire GB **146/147** O 17

Wrea Green Lancashire GB **119** P 17

Wreay Cumbria GB **146/147** N 17

Wrecsam Wrexham Wrexham GB **119** Q 17

Wrelton North Yorkshire GB **134** O 21

Wrentham Suffolk GB **101** S 26

Wressle East Riding of Yorkshire GB **134/135** P 21

Wrexham Wrecsam Wrexham GB **119** Q 17

Writtle Essex GB **71** T 23

Wrotham Kent GB **71** U 23

Wroughton Swindon GB **70** T 19

Wroxham Norfolk GB **101** R 25

Wroxton Oxfordshire GB **100** S 20

Wye Kent GB **71** U 24

Wylye Wiltshire GB **70** U 19

Wymeswold Leicestershire GB **100** R 20

Wymondham Leicestershire GB **100** R 21

Wymondham Norfolk GB **101** R 25

Wyre Piddle Worcestershire GB **87** S 18

Wyvis Lodge Highland GB **186** G 13

Y

Y Bala Gwynedd GB **119** R 15

Y Drenewydd Newtown Powys GB **87** R 16

Y Fali Anglesey GB **118** Q 13

Y Felinheli Gwynedd GB **118/119** Q 14

Y Fenni Abergavenny Monmouthshire GB **87** T 17

Y Ferwig Ceredigion GB **86** S 13

Y Ffor Gwynedd GB **118/119** R 14

Y Trallwng Welshpool Powys GB **87** R 16

Yalding Kent GB **71** U 23

Yarcombe Devon GB **53** V 16

Yardley Hastings Northhamptonshire GB **100** S 21

Yarmouth Isle of Wight GB **70** V 20

Yarrow Scottish Borders GB **161** L 16

Yate South Gloucestershire GB **70** T 18

Yattendon West Berkshire GB **70** U 20

Yatton North Somerset GB **53** U 17

Yaxley Cambridgeshire GB **100/101** R 22

Yeadon Leeds GB **134** P 19

Yealmpton Devon GB **53** W 15

Yedingham North Yorkshire GB **134** O 21

Yelvertoft Northhamptonshire GB **100** S 20

Yelverton Devon GB **52/53** W 14

Yeoford Devon GB **53** V 15

Yeovil Somerset GB **53** V 17

Yesnaby Orkney Islands GB **198** D 16

Yetminster Dorset GB **53** V 17

Yetts o´Monans Clackmannanshire GB **160/161** K 15

Ynysybwl Rhondda Cynon Taff GB **87** T 16

York York GB **134** P 20

Yorkton Gloucestershire GB **87** T 17

Youghal Eochaill Cork IRL **233** T 7

Youlgrave Derbyshire GB **134** Q 19

Yoxall Staffordshire GB **100** R 19

Yoxford Suffolk GB **101** S 26

Yr Wyddgrug Mold Flintshire GB **119** Q 16

Ysbyty Ifan Conwy GB **119** Q 15

Ysbyty Ystwyth Ceredigion GB **86/87** S 15

Ystalyfera Neath Port Talbot GB **86/87** T 15

Ystrad Aeron Ceredigion GB **86** S 14

Ystradfellte Powys GB **86/87** T 15

Ystradgynlais Powys GB **86/87** T 15

Ythanbank Aberdeenshire GB **187** H 18

Ythanwells Aberdeenshire GB **187** H 17

Z

Zennor Cornwall GB **52** W 11

Acknowledgements

The Best of Britain & Ireland – from the Air
Published in 2011 in the United Kingdom by
Vivat Direct (t/a Reader's Digest), 157 Edgware Road, London W2 2HR.

First published in the UK in 2005 as
The Aerial Atlas of Great Britain and Ireland

Copyright for this edition
© 2011 wissenmedia a division of inmediaONE] GmbH

We are committed both to the quality of our products and the service we provide our customers. We value your comments so please do contact us on 0871-351-1000 or via our website at www.readersdigest.co.uk

If you have any comments or suggestions about the content of our books you can contact us at gbeditorial@readersdigest.co.uk

This book was designed, edited and produced by wissenmedia

Colour origination Gerald Wetzel, Laubach, Germany
Printing and binding: Neografia a. s., Slovakia

IBSN: 978 1 78020 000 2
Book code: 400-508 UP0000-1

Picture Credits

(l=left, r=right, t= top, c=centre, b=bottom)

Front cover: Old Harry Rocks, Swanage, Dorset
© Angie Sharp/Alamy
Title Page: The Old Royal Naval College, Greenwich and the Isle of Dogs, London
© Jason Hawkes; www.jasonhawkes.com

Satellite Images: © WorldSat International Inc., 2005-2010, www.worldsat.ca, all rights reserved.

© Kevin Allen www.kevinallenphotography.co.uk 115(t); www.bigstockphoto.com 83(b) / grynka, 105(t) / Joris & Barbara; Imagery supplied by BKS Surveys Ltd. www.bks.co.uk 130, 210, 212, 214, 226, 234, 238; Hans Bracker 195; Cities Revealed Aerial Photography © Copyright The Geoinformation Group 18(bl), 56, 60, 74, 76, 82, 84-85, 80, 90, 92, 102, 106, 108, 114, 124, 128, 138, 140, 142, 154, 156, 164, 168, 188, 208; © CUCAP and with permission of Scottish Natural Heritage 178, 200, 202, 204; Digimap Ltd 67-69; © Copyright DigitalGlobe 182; © Copyright Kevin Dwyer 18(br), 221(t & b), 223, 229, 230-231, 237, 239, 240-241; Kenneth Ferguson Photography 164 (inset), 165; Forewick Stud 205(b); FreeFoto.com 155(b), 169(t); © Fugro-BKS 220, 222; © Getmapping plc 94, 122, 166; Glasgow School of Art Collection 167(b); Glastonbury Festivals Ltd 63(c & b); www.jasonhawkes.com 2-3, 19 (b, l & r) 77, 79, 84-85, 89, 93, 98-99, 103, 123, 143, 163(t), 172-173, 189(b), 193(t), 196-197, 216-217, 225, 227; Courtesy of David Houlston Photography and the Ironbridge Gorge Museum Trust 97(b); IFA Bilderteam 105(b); © Infoterra Ltd 88, 112, 126, 136, 148, 150, 170; © Infoterra Ltd (supplied by Skyscan Ltd) 192, 194; Isle of Man Tourist Board 131(r & b); www.istockphoto.com 75 / ChrisSteer, 95(c), / 1amgreen, 109(b) / simongurney, 127(b) / David McCready, 129 / onfilm, 136 / stephenmeese, 163(b), 167(b) / Martin McCarthy - Theasis, 169(b) / Lingbeek, 191 / Bertrand Collet; Courtesy of www.kilkennytourism.ie 235; © Last Refuge – Dae Sasitorn and Adrian Warren 8-19, 50-51, 54, 55, 59(t), 61(t), 62, 64-65, 72, 78, 81(r), 91(b), 97(t), 111, 113, 116-117, 121(t), 132-133, 139, 144-145, 151, 152, 157(t), 158-159, 171; Image Courtesy of Mapflow 2005 224; The Mersey Partrship (TMP) 125(b); Courtesy of the Northern Ireland Tourist Board www.discoverireland.com 209(b), 211, 213, 215; © Ordnace Survey Ireland 228, 236; © Mike Page 107(t & b); Parks Trust, Milton Keynes image by Nick Bland 109(t); www.graeme-peacock.com 153; Pictures of Britain 57(t & b), 59(b), 73, 115(b), 121(c & b), 141(t & c), 149, 155(t), 157(b), 177; RGB Aereal Photography – ©GeoPerspectives 104; Science Photo Library 162, 176, 180, 190, 209(t); Scotpix/Colin Smith 189(t); www.shutterstock.com 83(t) / Adrian Reynolds, 95(b) / godrick; © Simmons Aerofilms 184-185; © www.charles-tait.co.uk 179(t, c & b), 181, 183, 193(t), 201(t & b), 203(t, c & b), 205(t); Imagery provided by UKPerspectives.com 58, 96, 110, 120